William Etty

WITHDRAWN

Library & Media Ctr.
Carroll Community College
1601 Washington Rd.
Westminster, MD 21157

William Etty

The Life and Art

LEONARD ROBINSON

Foreword by Tom Etty

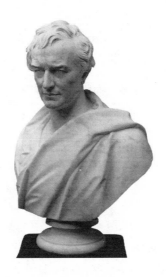

McFarland & Company, Inc., Publishers
Jefferson, North Carolina, and London

On the title page:
Portrait bust of William Etty by Matthew Noble (1850),
National Portrait Gallery, London

LIBRARY OF CONGRESS ONLINE CATALOG

Robinson, Leonard, 1916–
William Etty : the life and art / Leonard Robinson ; foreword by Tom Etty.
p. cm.
Includes bibliographical references and index.

ISBN-13: 978-0-7864-2531-0
illustrated case binding: 50# and 70# alkaline paper ∞

1. Etty, William 1787–1849.
2. Painters—England—Biography. I. Title.

ND497E8R6 2007 759.2 B—dc22 2006027391

British Library cataloguing data are available

©2007 Leonard Robinson. All rights reserved

No part of this book may be reproduced or transmitted in any form
or by any means, electronic or mechanical, including photocopying
or recording, or by any information storage and retrieval system,
without permission in writing from the publisher.

On the cover: *Nude Lying on a Sofa Against a Red Curtain* (oil on canvas, 14"× 24")
by William Etty, 1787–1849 (Bridgeman Art Library/Christie's Images)

Manufactured in the United States of America

McFarland & Company, Inc., Publishers
Box 611, Jefferson, North Carolina 28640
www.mcfarlandpub.com

For my wife,
with love
and much gratitude

Rossini, the great composer, was brought to see my works at the Academy; the Patriarch of Venice also, and others. One called me *"Il Diavolo,"* because I get the sketches like the pictures so rapidly;—some, "The English Tintoret";— and I do not know what stuff beside.
—*William Etty writing to his brother Walter Etty from Venice in 1823.*

The pride of the peacock is the glory of God.
The lust of the goat is the bounty of God.
The wrath of the lion is the wisdom of God.
The nakedness of woman is the work of God.
—*"Marriage of Heaven and Hell," William Blake.*

ACKNOWLEDGMENTS

Any one embarking on a study of the life and work of William Etty begins with a great debt to Alexander Gilchrist who, in 1855, published his biography of the artist. Gilchrist, visiting York and other places frequented by Etty, questioned many people who had known the artist even from childhood and gained firsthand information now denied to us. No apology is made for the many references to Gilchrist's work in the following pages. For much of Etty's life there is no other source.

Dr. Dennis Farr's book of 1958 was a useful mine of information, especially his indispensable Catalogue. I thank him also for his kind responses to my enquiries. There have been no other books of similar quality to these published since Etty's death. William Gaunt and Gordon Roe produced in 1943 an assessment of Etty as a painter but paid little attention to his life and career. There have been numerous pamphlets and articles appraising Etty and one must be grateful to these authors for keeping his memory alive.

The staff of the York City Reference Library, where so many of Etty's letters are now collected, offered considerable assistance in making these available and I am grateful to Miss Sue Rigby for granting me permission to quote extensively from them. Through the City of York Library and the London Library I have been able to trace relevant references in many publications. I was also able to refer to letters and drawings in the archives of the York City Art Gallery and I thank Richard Green, who was curator there when I was carrying out this part of my researches, for making this material available. Thanks are also due to Miss Christine Penney, Head of the Special Collections of the University of Birmingham, for providing me with copies of the letters passing between William Etty and Joseph Gillott which are in the University archives. The staff at the Borthwick Institute at York were extremely helpful during my researches into the Etty family records held there. I also thank the staff of the Royal Academy Library who helped me in my researches and the staff of the Guildhall Library in the City of London for assistance in tracing marriage details of various members of the Etty family who resided in London. The Rev. Andrew Walker, Rector of the Church of St. Edmund King and Martyr in London, was most helpful in providing information regarding William Etty's involvement in his church. Rosalin Barker of Whitby, Yorkshire, has been very generous in providing details regarding the Etty family, particularly of Tom Etty whose life she has researched. I thank Roger Bell for his generous help in tracing "lost" works. The staff of all the galleries from whom I have obtained images for reproduction have been most helpful and I was especially impressed by the willingness of the staff in galleries outside the United Kingdom to provide information. On a very personal note I would like to thank John Rhodes of York who photographed scenes in our city and so willingly did other similar work for me. So many items of information were gleaned from so many sources that it is not possible to record them all but I hope that anyone who assisted me and is not named will nonetheless accept my thanks.

But above all I wish to record my gratitude to Tom Etty of Nijmegen in The Netherlands whom I have had the pleasure of meeting on several occasions and who has been extremely gen-

erous in making available to me all the papers in his possession relating to his ancestor as well as passing on items of his family history relevant to my researches. It is true to say that without his generosity and encouragement I could not have begun to write this book.

Finally, but reserved to the end for obvious reasons, I must thank my wife for her encouragement and willingness to have me neglect many domestic duties while I carried out my researches and wrote this book. My thanks are especially proffered because during all that period she suffered from acute physical disabilities requiring many hospital treatments which she would not allow to deter me. I thank my publishers for being so understanding of the inevitable delays in delivering the final text.

TABLE OF CONTENTS

Between pages 152 and 153 are 16 color plates containing 28 illustrations

LIST OF ILLUSTRATIONS

By William Etty unless otherwise stated.

Illustrations in the Color Plates between pages 152 and 153

FOREWORD

by Tom Etty

Catherine (Kitty) Etty, one of the painter's favorite nieces, and her husband Robert Purdon lost their teenage son Charles in October 1844. Apprenticed in Scarborough, he died of typhoid fever. His uncle Thomas Etty wrote the day after his death to the painter, his younger brother:

> This morning Mr. Purdon with streaming eyes when he got a glance of his picture in the great parlor said could I possess a kingdom of wealth I would give the half of it to Mr. William Etty for his kindness in painting a likeness of my dear boy and so kindly in presenting the same to me shall never be forgotten by me....

This is how I got to know the painter when I grew up: as a man who painted his parents, his brothers and their families, several of their children and grandchildren, as well as other relatives and friends and who presented them with these pictures. All but a few of his pictures which were or still are in the larger Etty family are portraits. Not a single specimen of the paintings which made him famous and notorious during his lifetime and still for some time after his death was part of my father's small inherited collection. The most frivolous picture in it was *Drunken Barnaby*. This shows among others a healthy and good looking young woman at the doorstep of a country pub, as well proportioned as any Etty model but fully dressed for the kitchen job she was engaged in before the soak who gave his name to the title was carried out.

Not a single nude. My father sometimes wondered what the painter's Godfearing family back in Yorkshire thought of the work on which he built his reputation. Why even William's younger brother Charles, who became a sugar nabob in the Dutch East Indies and paid him for several pictures which he ordered, did not acquire one or two pictures painted for "the market" to include in the private art gallery he had in his house in Java and of which he was so proud.

After I had left the parental home with the dark and (as I thought then) dull family portraits I learnt about the painter's passions. His passion for the past (as he wished to see it), for the values taught him by his parents, for his native York, for his art and for those who had excelled in it. Strong and lifelong passions in a shy and modest man. Where he succeeded it was by perseverance and stubborn conviction rather than by raising his voice or making grand gestures. The family device *Vincit qui patitur* probably has been formulated by him.

I knew the painter, my great-great-grandfather John's younger brother, from what I have seen of his work, what is left from his correspondence and notebooks, Gilchrist's biography and some of the studies written about him, in particularly Dennis Farr's. Mr. Robinson had added a very interesting and rich book to all this which, I think, for the first time tries to fit the painter and his paintings in the setting of society and art life of his time. He has raised a number of questions of an artistic and of a personal nature which have, to my knowledge, not been raised before and his answers are giving new insights. I think that I know uncle William much better now.

Nijmegen, September 2006

1

PREFACE

Why write a book about William Etty? It is certain that for most people outside the City of York his name is unknown. Such are the vagaries of fortune that the memory of this man who was so highly esteemed in his life time is now virtually obliterated.

In York those who know of him, and they are surprisingly few, do so because of his local reputation for "saving York's walls." The popular account is of a nineteenth century philistine City Council planning to demolish York's medieval walls and city gateways (known, for obvious reasons, as "bars") in the name of "progress" and being thwarted single-handedly by a determined objector. But the truth is not so melodramatic. William Etty certainly played a prominent part in preventing the destruction of these structures but it was not a simple case of one man against the powers of authority. His was the famous voice raised in protest that all such campaigns need. He also campaigned to retain the medieval character of York Minster, that glorious monument to the city's unique history. But, somehow, that campaign is now not mentioned.

But William Etty deserves to be known other than as a local hero. His life may be said to have been that of a poor boy struggling against all odds to fulfill his dream—in his case, to become a famous artist. This dream he realized to an extent not now remembered by many. He was famously preferred by the Royal Academy over John Constable, something that many find so astonishing. But this very fact indicates the nature of art in England in the early nineteenth century and Etty's unique place in the country's art history. He had friends in high places and attracted the attention of royalty, though unfortunately not to his advantage. Undoubtedly what has mostly contributed to Etty's neglect is his choice of subject. It is not so much his obsession with the nude human figure that has made him unfashionable—that subject is as popular as ever it has been—but that he always painted within the academic tradition. He could not bring his subjects "down to earth." They had to be Olympian. We no longer decorate our homes with gods and goddesses. At least Etty's divinities were always decorous.

Etty was a man of exemplary character. The inscription on his tomb in York (reproduced in the following pages) paid lengthy tribute to his "sweetness of disposition" that everyone who met him found so genuine. There were no scandals in his life. No secret plots against others, no tantrums, no maliciousness of any kind. Some would say, hardly an interesting subject for the modern reader. It seemed unjust to dismiss a talent judged as outstanding by both his contemporaries and many even in the twentieth century. In his own time his technique was considered superior to that of Sir Joshua Reynolds—not, of course, that this counts for much today though there have been those who still thought so. Art is a subject on which there is never—indeed, cannot ever be—general agreement so it is hoped that this book will redress the neglect into which his name has fallen.

INTRODUCTION

Anyone in early nineteenth century England deciding to enter upon a career as an artist was bound to look to the Royal Academy for training, opportunities and recognition. Founded in December 1768 with royal patronage and thereby a guarantee against interference by future parliaments (which meant no political pressures could be applied) the Academy ensured that henceforth the visual arts would enjoy a privileged status in the cultural life of the nation. Upon election as a full Academician, a member was automatically created a "gentleman" and was entitled to the title of "Esquire." In the rigid English class system this was an important upward step in social mobility, marking the person concerned as someone of acknowledged respectability deserving of some degree of deference from those immediately below him in the social hierarchy and even some respect from those above. Moreover, every President of the Academy was automatically granted a knighthood and this certainly established every member as a person of importance since a gentleman's club with a titled president bestowed some degree of respectability. (Except Benjamin West who thought he deserved a baronetcy, which the king refused as being an honor too far.) So important and respectable were Academy Presidents regarded that even statesmen and noblemen consulted them on matters of "Taste" and "Social Decorum." As William Collins was to say, after his own election in 1820: "If it were not for the Academy, artists would be treated like journeymen." In return, members were expected to follow lives of exemplary rectitude and dignity and not to do anything that would bring the Academy into disrepute. James Barry learned this to his cost. The old notion that artists were to be included with actors and vagabonds as doubtful characters engaged in dissolute living with women of equally doubtful character had been abolished when George III appended his signature to the Instrument of Foundation. But the Academy had from the beginning the formidable and necessary task of defining "Art" and establishing a mode that conformed to the definition within a nation that had very little notion of either.

Foremost among European countries, Italy had a long tradition in the arts largely thanks to the power of the Church and the financially important families that controlled the city states and frequently also the Church. Artists had become embedded in the social structure and by the sixteenth century, when the wealthy became more aware of Italy's classical history, artists joined with poets in presenting ideals of thought and behavior befitting the noble aspirations that the rulers entertained. England had no such tradition. Briefly Charles I sought nobility through art but, search back into history as we may, we often can do no more than speculate upon the nature of the visual arts being produced at any time and whether they were intended as anything more than decoration. Certainly most art must have been of a religious nature, decorating the cathedrals and the churches but nearly all was destroyed or disfigured by the iconoclasts of the Reformation and the Commonwealth. Today we rely upon those comparatively few paintings in churches, often produced by local artisans, that survived beneath quickly applied whitewash. It seems that the barons and their associates had no interest in the arts comparable to that of their continental neighbors. For centuries England had been ruled by war-lords and they were more interested in warfare, tournaments, jousting and hunting than cultivating their spiritual virtues.

Even before the Reformation there had been a strong movement against images in churches and the embellishment of holy vessels with gold and precious stones. Fortunately some illuminated books have come down to us but they suggest very little pictorial development over the centuries. Books and notable handicrafts were associated with particular places and pre-eminent among these places was the City of York, the native city of the subject of this book. York was renowned for its stained glass, its library and its mystery plays and the consequent decorations necessary for their production. English secular art was largely confined to decoration. Tapestries concealed brick or stone walls and the general impression is that the English excelled in handicrafts. English embroidery was so famous that it became known as *Opus Anglicanum*. England had never been regarded as a country renowned for its pictorial art and those monarchs and their favorites who required their portraits to be painted invariably imported painters from the continent, either northern France or Flanders.

Elizabeth I, following the example of her father and always aware of her vulnerability, understood the need for good propaganda and unashamedly employed the arts to proclaim her right to the throne and her personal virtues. She and her courtiers brought in artists from Flanders and they, along with a small group of English artists, satisfied the queen's political needs by producing portraits, often allegorical or symbolic, in which Elizabeth was virtually deified. The English may have abolished the Virgin Mary but they had their Virgin Queen. Other artists responded to the queen's taste by painting miniatures of truly exquisite sweetness that clearly mirrored the atmosphere of the court that Elizabeth wished to present to the world. Portraiture as the principal form of easel-painting developed its own iconography, its purpose being to present the subject's social status and unassailable power. Under James I there was a new trend of more relaxed images but the public function of portraiture was never forgotten.

Charles I had more positive ambitions. He wished to collect works of art of established merit and to present himself as a cultured monarch. Advised principally by the Duke of Buckingham, although his own taste was impressively reliable, he bought a considerable number of important works from the continent and invited foreign artists to work at court. Van Dyck and Rubens were only the most well known artists whom he encouraged to work in England. Honthorst, Jordaens and Gentileschi were among others as well as many lesser names. Although Charles had a wide interest in the arts, in painting it was the portrait that remained both for king and courtiers the favorite subject. The Commonwealth Parliament introduced a period of puritan intolerance by disposing of his collection, partly to meet debts and partly to demonstrate their resolve to banish all satanic temptations.

Charles II on his restoration had to retrieve as much as possible but he did not possess either the interest or the taste of his father. He was determined to be monarch whatever the price. The art of the court has been described as cosmopolitan[1] with the king's secret Catholicism expressed through the employment of foreign artists more usually to be found in Rome or Versailles. England was still in a state of constitutional fragility and Charles' boast that the people would not remove him because they preferred him to his brother was all too true. Even so he had to act with circumspection and today he is mostly remembered for collecting mistresses and founding the Royal Society. James II secretly converted to Catholicism sometime between 1668 and 1671. The hatred of the Roman Church was so intense that his fate was sealed even before he succeeded to the throne. Although the Stuarts failed to establish themselves in the hearts of their subjects they were the first royal dynasty in England to accumulate a rich collection of works of art. Not, of course, that the country at large ever saw them but the favored aristocracy who did enjoyed an experience that remained with them and whose influence was passed on to their descendants. William III and Anne displayed little interest in the arts beyond encouraging some building but royal influence over the arts was by now no longer what it had been. The center of patronage was shifting towards the aristocracy and especially to the great landowners who were building new large country mansions to celebrate their wealth. There was no longer

any central guiding authority in the arts which obsequious retainers obeyed. Unlike in France where Louis XIV, realizing the power of the arts, was establishing an academy that would keep artists firmly under control. In its typically unstructured way England was changing the nature of its society almost without anyone noticing.

In the sixteenth century the English aristocracy had begun to realize the value of education. Hitherto the Church had controlled the seats of learning and for another century continued to do so, but the growing need for the aristocracy to provide ministers of state, ambassadors and similar functionaries propelled them into ensuring that their children should be ready to assume these tasks. Education in the universities was still directed towards providing an uncritical clergy but the classical learning to which the new students were introduced gave some of them a taste for literature and the arts. This developed over a generation or so into an independence of thought and, for some, an appetite for the new humanism that was seeping into the country from the continent. This had not been the intentions of those who had initiated their grandfathers into the pleasures of learning but all change leads to unpremeditated ends. Which is why the timid fear change. The consequence was the reinforcement of aristocratic taste over court taste as a determining feature in the arts.

Charles II had set the fashion for adorning walls and ceilings with Italianesque baroque concoctions of Olympic festivities. The Italian Antonio Verrio had been his favorite artist commissioned to rival the decorations at Versailles. Otherwise the king's tastes were limited to portraiture and Peter Lely was brought over from Holland to satisfy the royal demands. The aristocracy had been more than satisfied to have their portraits painted for posterity. Portraiture confirmed their importance in society. They would go down in history like the classical heroes. After Lely's death in 1680 and "The Glorious Revolution" of 1688, Godfrey Kneller shared the office of Principal Painter with John Riley and together they continued to paint the portraits of those in the seats of power, though Riley found the aristocracy difficult to work with. But the system was that the master painted only the face of the sitter; assistants painted the hands, the costumes, the backgrounds and the accessories according to their individual specialties. Kneller painted so many fashionable portraits, all in the prescribed manner, making them all look equally beautiful or handsome, according to their sex, that he earned the soubriquet "Phizz-monger." His studio was in essence a factory. So dominant was the portrait at this period that the more discerning complained that this was all English art consisted of and that most portrait painters were unskilled since too many untrained artists were seeking to meet the demand. The market was still dominated by foreign artists and very few English artists of this period are now considered worthy of consideration in any history of European painting. Although some patrons commissioned landscapes and marine subjects they were decidedly in the minority. Even here there was more demand for sporting and hunting scenes than anything else, thus beginning the rural aristocracy's obsession with sporting prints that has lasted even to the present day. England had nothing to compare with the great Dutch painters of the century. In a letter of 10th November 1699 the diarist John Evelyn wrote to Archdeacon Nicolson complaining of "our English paynters, who, greedy of getting present money for their work, seldom arrive to any farther excellency in the art than face painting."

This was how matters stood when George I succeeded to the English throne. He ruled a people he had been advised to distrust and governed by a parliamentary system with which he was unfamiliar. He had no interest in the arts and that left the field free to be occupied by those of the aristocracy who did. The walls, ceiling and staircases of the new great houses needed decoration. These frequently followed the Italian taste brought home by travelers, acres of sprawling gods and goddesses. Many houses had long galleries which could now house collections but these were more usually rows of portraits.

Horace Walpole (1717–1797), of whom more later, in his *Anecdotes of Painting* (written 1762 to 1771) said of the beginning of George I's reign,[2] "We are now entering the period in which

the arts were sunk to the lowest ebb in Britain." It was not the popularity of portraiture that dismayed him (he was himself an eager collector of portraits) but the poor quality of workmanship. Kneller lived on, he said, in "the most wretched daubings of hired substitutes to pass for his works."

In the early years of the eighteenth century the arts of portraiture and landscape painting were to be united in a subject that became very popular among the landed classes—the conversation piece. At first these were family groups engaged informally in conversation or taking tea in their drawing rooms. Soon they migrated to the garden terrace which offered opportunity to portray the family estate as background. This fitted in with the new taste in cultivating gardens. So arose such practitioners as Charles Bridgeman, William Kent, James Gibbs, Humphrey Repton and "Capability" Brown and writers of house and garden design who now produced a wealth of pamphlets and essays. Their creations were designed to keep nature within bounds in the classical Virgilian manner and sought to reproduce neo–Palladian dreams of Arcadia, complete with imitation temples and colonnades.

In earlier centuries a few members of the aristocracy had traveled abroad as ambassadors and special emissaries and had gained some knowledge of the arts in those countries. They had returned very aware that England was well behind her continental contemporaries and some had endeavored as best they could to redress the situation in their own houses. But few had been so enthusiastic as the fifth Earl of Exeter who, in the seventeenth century, traveled in Italy, bought virtually everything he laid eyes on, installed it at Burghley House in Lincolnshire and at his death left his family penniless. However, a handful of men who had kept abreast of developments abroad and had often traveled on the continent began to write essays designed to instruct the nobility on the elements of taste and design. Since the main source of their own ideas had been Italy, we begin to see numerous houses being built in the Palladian style, which they approved, and decorated in contemporary Italian Baroque, which they also approved and for which Italian artists were usually imported. This further encouraged ideas that a classical education was essential for a gentleman. English manners had for long been regarded as crude and distasteful and now those who ventured abroad began to adopt the elegant and often exaggerated manners of French and Italian aristocrats. Eighteenth century gentlemen were rich rather than cultured and unable to assess the merits of any art, whether pictorial, musical or poetic. With portraits they were on safe ground.

Art in England at the beginning of the eighteenth century generally consisted of works commissioned by the nobility who had been abroad or by the nobility who had been influenced by the advice of their better informed fellows. These were not the connoisseurs of a later generation though they were often well intentioned members of the nobility concerned for the welfare of their country and particularly fearful of England's being despised by foreigners. Historically it had always been the English who had despised foreigners but now, in their travels, these men were painfully aware how despised the English were. Nothing produced in England compared well with much that was available abroad. It was not just a question of surpassing the foreigners, it was also genuine anxiety about the state of English society if its intellectual and cultural standards were so low. If England was to be improved, her aristocracy must be better educated. There was more to be done than the universities were doing.

Anthony Ashley Cooper, third Earl of Shaftesbury (1671–1713), was not the first to attempt the improvement of aristocratic minds. John Evelyn, the diarist, had been well ahead but largely ineffective. William Aglionby had also tried. But these had been mere gentry unable to influence those above them in the social hierarchy. Shaftesbury's tutor had been the philosopher John Locke, to whom he owed his methods of enquiry into the nature of man though not always his published opinions. His *Characteristicks of Men, Manners, Opinions, Times* (published 1711) optimistically proposed that men were by nature altruistic, having been so created by the deity, and that they therefore desired to approve virtue. It was not lack of morality but *loss* of morality through

bad influences that moved men to evil. Therefore it was essential to expose children to good influences from the earliest age. Not an original idea, of course; Plato had propounded such views some 2,000 years earlier, but it seemed original at the time to men not overly familiar with the Greeks.

For our purpose Shaftesbury's importance is that, again like Plato, he believed that the arts were valuable influences and should be employed to construct a virtuous society. Expose the young to objects of beauty and it was more than likely that they would grow up to pursue virtuous lives. Shaftesbury was among the first of a small band of wealthy intellectuals who occupied themselves promoting what John Barrell has called "civic humanism."[3] Their principles derived from the Renaissance Florentine writers who had held that men needed suitable political and cultural association to give the purpose to their lives of securing a moral society for all to enjoy. Of course, this is as much a Christian principle as a Greek philosophical one but the eighteenth century men who now propounded it regarded it as essentially secular. They argued that personal and social morality did not depend upon expectations of rewards in an afterlife. "Virtue was its own reward." John Vanbrugh declared in his play *The Relapse* that "There's pleasure in doing good which sufficiently pays itself" and Alexander Pope in his *Essay on Man*, "Virtue alone is happiness below."

Shaftesbury's systematized philosophy was continuing a process that had begun much earlier in English poetry, of establishing principles in the arts where previously there had been none. This became very clear in architecture but in the art of painting it took some time to be recognized and established. Artists were notoriously independently minded, largely self taught and convinced that they had nothing more to learn. Attempts by concerned individuals in the earlier part of the seventeenth century to establish private academies came to nothing because artists refused to accept that academies should also offer training. The claim by these men that the early eighteenth century was an Age of Enlightenment meant for them that such wisdom as men could acquire was to be gained through reason and did not depend upon particular religious faiths. For Shaftesbury, Beauty was Truth and both were Good and all were to be found in and expressed through the arts. Such ideas have repeatedly occurred in human thought and cannot be claimed as original to Shaftesbury and his contemporaries but they are important because they appeared original to their fellow men who for the most part were unschooled in serious thinking. Shaftesbury urged his fellows when traveling abroad to look only upon the best art and the best architecture, to listen only to the best music and to read only the best poetry. This required some knowledge of what constituted the "best" and here Shaftesbury was at hand to guide his readers. So it was then that the travelers on the Grand Tour could go equipped with instructions to make sure they gained only what was morally good.

Jonathan Richardson (1665–1745), himself a portrait painter, applied the new ideas by proposing that art should always express noble qualities through the careful selection of subjects. For him portraiture should be confined to depicting the characters of great men. In three essays, but most notably in *The Theory of Painting* (published 1715), he set out his principles, first of all insisting that "tis not every *Picture-Maker* that ought to be called a *Painter*.... [T]is absolutely necessary to a History-Painter that he understands *Anatomy, Osteology, Geometry, Perspective, Architecture*, and many other *Sciences*...."[4]

Thus painters must be learned in more than their craft. Mere imitation or copying was not enough. But what Richardson was also propounding was the superiority of History painting over all other forms. He emphasized among other requirements the need for the artist to understand what he called "Antiquity." True art was to be found in the works of the Ancients because not only were these works produced according to the laws of symmetry, balance, proportion and all other ideals necessary for a work of Beauty, they invariably depicted Good and Noble men who were examples to their fellows in all the civic virtues. Or so he believed. To a large extent this was true, since it was mostly rulers and leaders, civil and military, whose likenesses had survived

in statuary, the paintings of the ancient world having for the most part perished. Though we today often doubt the extent of their virtues, they were in their times honored for their supposed contributions to the social good. The purpose of the commemorative statues had been to provide lasting examples to later generations. So, Richardson believed, should art be employed in his day. Thus it was that the painting of history subjects became regarded as the highest form of art, not just the history of a nation's triumphs but also the history of classical times and even the so-called history of the classical gods.

But virtuous subjects were not enough. It was necessary for a work itself to express "Greatness," by which was meant that not only had the subject to be worthy of being immortalized in Art, it had to look worthy. The work had to conform to certain rules of form but overall it was essential for everything to be done in Good Taste. This had been the opinion of poets since the days of Elizabeth but it was new for the visual arts to be regarded as anything more than "face-painting" or decoration. With grand houses declaring not only their owner's social status but also his knowledge and erudition, suitable forms of furnishing had to be devised. Two principles decided the choice: wealth and education. The art must be obviously expensive and it must also reflect the owner's classical learning. The sons of the aristocracy had been to the universities (Oxford or Cambridge) where all instruction was in Latin and where both theology and classical history, which included the mythologies, were the main subjects. This might not, in some men's views, be sufficient to provide true intellectual qualities but it was a foundation on which to build. These were the natural leaders of society and must be seen as such. They knew their social position was "natural," even divinely intended, because the aristocracy had always existed and, clearly, always would. It was from their ranks that ministers of state were chosen and they set the tone for their fellowmen.

Today we recognize certain men of the time as directing this development—the Earl of Shaftesbury, Lord Chesterfield, Sir Horace Walpole (i.e., the Earl of Oxford), Lord Burlington, Lord Kames being the principal names. Admittedly a small number and all aristocrats but all influential. Supported by men such as Francis Hutcheson, Jonathan Richardson, Joseph Addison, Thomas Reid, Edmund Burke, men of social standing even though not among the aristocracy, and equally gifted in literary expression, all their works have survived still to be read today.

First they had to accept that Good Taste did not exist naturally in men, not even alas among aristocrats, though it might well be naturally desired. Good Taste could be achieved by education. Later Joshua Reynolds was to declare that all men shared a common taste—a doubtful enough proposition—but that it required education to formulate it into a set of principles. Most early eighteenth century writers on the subject did not go so far as this. If Good Taste was a common quality then there was no distinction between the educated and the uneducated. As James Miller said in his play, *The Man of Taste* of 1735, if absolute taste did exist "a Peer and a Mechanick ... [could] indulge in the same diversions and luxuries," which was an "Outrage upon all reason and distinction." Some objected that the attempt to introduce rules of Taste was an attempt to introduce a standard taste. The rigid class system could not be challenged. Some men in the lower classes might, with difficulty, be allowed to move slightly upwards but it must never be questioned that the nobility were noble by birth and noble by nature. Samuel Johnson complained[5] that those who sought to establish a Rule of Taste were "The artful and fraudulent usurpers of distinction."

In an age when it was considered essential for a person of wealth to take the Grand Tour to acquaint himself with those treasures of past ages which England could not supply, it was also essential for such a man to conduct himself among foreigners in a manner befitting his position as an aristocrat and an Englishman. When Lord Chesterfield's illegitimate son went to Italy in the mid–eighteenth century, Chesterfield bombarded him with letters instructing him on the behavior expected of him—so many that 283 were later gathered together and published as valuable instruction for others.

There was one certain way in which an aristocrat could declare his superiority. Lord Chesterfield (1694–1773) advised his son that[6]

There are some pleasures that degrade a gentleman as much as some trades could do.... If you love music, hear it; go to operas, concerts, and pay fiddlers to play to you; but I insist upon your neither piping nor fiddling yourself. It puts a gentleman in a very frivolous, contemptible light; brings him into a great deal of bad company; and takes up a great deal of time, which might be better employed. Few things would mortify me more, than to see you bearing a part in a concert, with a fiddle under your chin, or a pipe in your mouth.

Also[7] "the minute and mechanical parts" of architecture should be left "to masons, bricklayers, and Lord Burlington has, to a certain degree, lessened himself, by knowing them too well." And in the same letter—

I would have you acquire a liberal taste of the two liberal arts of Painting and Sculpture; but without descending into those *minuties*, which our modern Virtuosi most affectedly dwell upon. Observe the great parts attentively ... and leave the trifling parts, with their little jargon, to affected puppies. I would advise you also, to read the history of the painters and sculptors.... All these sort of things I would have you know, to a certain degree; but remember, that they must only be the amusements, and not the business of a man of parts.

In an earlier letter[8] Chesterfield had advised his son:

Form a taste of painting, sculpture, and architecture, if you please, by a careful examination of the works of the best ancient and modern artists: these liberal arts, and a real taste and knowledge of them becomes a man of fashion very well. But, beyond certain bounds, the man of taste ends, and the frivolous virtuoso begins.

The arts were for the amusement of gentlemen, not for them to engage in. Chesterfield's letters to his son were, said Morris Brownell,[9] the eighteenth century version of Baldassare Castiglione's *The Courtier* (1528) and formed his *Vade-Mecum* for the Man of Taste. Castiglione had advised the would-be courtier that while he could play a musical instrument as a pastime and demonstrate his skill and knowledge of music, he must not admit to studying the instrument but always give the impression that his talents were natural gifts due to his birth. This advice he extended to every other attribute of a courtier. A natural courtier did not need to study, his abilities came naturally and, whatever he did, was performed "with a grace" due to his natural breeding. This view lasted until the First World War and we are reminded of those school boy magazine stories which always centered on what in England are called "Pubic Schools" but were nevertheless strangely popular among boys of all classes, where the hero of the Sixth takes up a cricket bat with which he has never practiced and brings his team to victory without the slightest effort. So, it was being suggested, would such boys behave when they assumed manhood and went out to serve the Empire. Breeding was everything. As Chesterfield put it, "Neither ought a man to put more diligence in any thing than in covering it: ... You may see then, how to shew arte, and such bent studie taketh away the grace of everything."[10] A man must demonstrate "a gentleman-like behaviour" and "the ability to be civil with ease." "The scholar, without good breeding, is a pedant." "Wear your learning, like a watch, in a private pocket like a watch; and do not pull it out and strike it, merely to show that you have one." Modesty alongside knowledge was a most desirable quality for no man was more unacceptable in polite society than he who was always parading his learning.

Richardson was not, of course, aware of Chesterfield's correspondence, which had not yet been written, but he was well aware that such views pervaded the whole of the upper classes. He sought to put matters right, since so long as such views held sway artists would continue to be regarded as no better that tradesmen.

'Twas never thought unworthy for a Gentleman to be Master of the *Theory* of *Painting*. On the contrary, if such a one has but a superficial Skill that way, he values himself upon it, and is more esteemed by others,

as one who has attain'd an Excellence of Mind beyond those who are Ignorant in that particular. 'Tis strange if that same Gentleman should forfeit his Character, and commence Mechanick, if he added a Bodily Excellence, and was capable of Making as well as Judging, of a Picture. How comes it to pass, that one that Thinks as well as any Man, but has moreover a curious Hand, should therefore be esteem'd to be in a Class of Men at all inferior?[11]

As the century proceeded some members of the nobility and some entitled to the titles "Gentlemen" and "Esquire" did practice painting, usually watercolors, since this style was considered more elegant as the necessary materials could be easily carried to a suitable landscape subject and a picture could often be completed in a single afternoon without much apparent effort. The acceptance of painting as a gentlemanly (and lady-like) pursuit was associated with the rise of Romanticism, though in the case of ladies of leisure it arose somewhat earlier with interiors, usually drawing rooms, and flowers being the usual subjects. It was in the mid–eighteenth century that drawing masters became popular adjuncts to families with daughters needing something to do. Most of these amateur painters had no interest in the theories of art, only in achieving accurate likenesses.

Richardson produced serious treatises on painting in all its aspects. He was particularly concerned that art should be moralistic and didactic as befitted the requirements of the educated classes of the time.

Common Nature is no more fit for a Picture than plain Narration is for a Poem. A Painter must raise his Ideas beyond what he sees, and form a Model of Perfection in his own Mind which is not to be found in Reality, but yet Such a one as is Probable and Rational. Particularly with respect to Mankind, he must as it were raise the whole Species, and give them all imaginable Beauty, and Grace, and Dignity, and Perfection. Every several Character, whether it be Good, or Bad, Amiable, or Detestable, must be Stronger, and more Perfect.[12]

It cannot be claimed that Richardson was wholly original but he was fulfilling a need of the times. His sources were mainly foreign, notably Giorgio Vasari, Giovanni Bellori, André Félibien, Roger de Piles, and Charles Du Fresnoy, as well as the earlier English writer, William Aglionby, though he did not identify them.

For most collectors it was not the writings of the well-informed and educated that influenced them but the opinions of the self-appointed connoisseurs who readily held forth on the merits, and more usually on the demerits, of paintings and sculptures that were now coming on the market. Few of them were wealthy enough to have traveled to the continent to see works firsthand but they had formed their taste on some familiarity with the writings of others and more usually by reference to their contemporaries in the field. Largely they relied on seeing works in sale rooms or in collections that they were allowed to visit.

It was more rewarding, if one could afford it, to travel to Italy oneself and see the works of the recognized artists *in situ*. Taking the conventional Grand Tour had begun after the Restoration. Men such as Sir John Finch, Baron Finch of Fordwich (1584–1660), more renowned as Speaker of the House of Commons under Charles I, had visited Florence after a period of exile in Holland and with others such as the Duke of Shrewsbury, who concentrated on Rome, promoted tastes in the strictly classical. These tastes prevailed and in the following century it was understood by all travelers that they were visiting Italy to confirm the supremacy of classical art. Membership of the aristocracy presupposed that any interest in the arts would be classical since one would have been educated at one of the universities. The works that were wanted were those from classical Rome, now being unearthed in increasing numbers, and by artists of the Italian Renaissance and later, nothing in between. In the large rooms of the new town and country houses one could hang the Old Masters alongside the family portraits, thereby enhancing one's own pedigree.

Horace Walpole, fourth Earl of Oxford (1717–1797), was perhaps not a typical connoisseur of the time since he built Strawberry Hill, which played a leading role in the English Gothic

Revival, but in other respects he was a typical gentleman of leisure with an interest in the arts. He entered upon the life of a man of letters after his achievements in politics failed to meet his expectations. He joined the current fashion for establishing what was to be called "Good Taste" and, though he affected the manners of the *dilettante*, he became an avid collector of portraits, medals and objects of historical interest though he never managed to acquire the necessary degree of knowledge to become a serious antiquarian. Study he found a dull occupation and he disliked scholarly discussion, which did not suit his proclaimed role of gentleman of fashion. As he said,[13] "Curious facts are all I aim at relating, never attempting to establish an hypothesis." It was essential to be the well informed amateur, never the expert, for that would reveal too much study. Walpole had little regard for English art, describing its early history as "tracing the progress of barbarism."[14] Of the art of his time he is no less scathing, regarding it as mediocre, condemning contemporary artists as doing no more than making "the dead live," and then not beginning "to live themselves until they are dead."[15]

Walpole's strictures, though well received by some at the time, earned him the reputation of being a "trifler," one who dabbled in his subject because a gentleman of fashion could not be seen to study anything in depth. Morris Brownell's biography, *The Prime Minister of Taste*, seeks to restore Walpole's reputation But, as he says in the final lines of his book:

> Walpole wasted his literary talent in trifles. And yet he was able to paint in his inimitable letters an unforgettable picture of the Indian summer of the English aristocracy ... the embarkation of the English aristocracy for the island of oblivion.

Indeed this is so but the English aristocracy took a long time to embark and a very long time to become ineffective. Even today some still think they have an important social role. Walpole was a typical aristocrat of his time. Like Chesterfield he wished to create a society whose hereditary rulers were gentlemen of elegant manners and refinement, wholly unaffected by the squalor of the poor or the ambitions of anyone struggling to earn some portion of the nation's abundant wealth.

By the mid–eighteenth century original works were in short supply and collectors were having to make do with the works of later artists provided they looked like Old Masters near enough to pass as such. Supply will always meet demand and very soon Italian artists were painting imitations and deliberate forgeries and dealers had established themselves in Florence, Venice and Rome, issuing catalogues and exporting crate loads of works on to the London art market. The importing of foreign works had already been viewed with alarm by painters and engravers in the seventeenth century so that, although not on the large scale as was later to be the case, they had successfully petitioned Parliament to forbid it. The Act was constantly ignored and was ineffective by the eighteenth century. Artists had frequently traveled to Italy to study painting (in France a branch of the Academy had been established in Rome for the purpose) but now they went to copy the Old Masters and bring them back for sale. In Rome they met the French artists there and learned much from them. The popularity of Italian art and Italian opera horrified the more robust xenophobes of whom there are always many in any age.

William Hogarth (1697–1764) campaigned ceaselessly to establish an English school of painting that owed nothing to foreign influences. He was an unashamed self-publicist and in the context of this Introduction he must be remembered for his book, *The Analysis of Beauty* (published in 1753). If Good Taste was founded in the classics and classical writers had asserted the natural virtues of Goodness, Truth and Beauty, then it was necessary for men of an enquiring turn of mind to define what each was. Goodness and Truth were comparatively easy to define but Beauty, being in an altogether different category, was tantalizingly difficult. Since Good Taste in the visual arts required that preferred subjects should be beautiful it was essential to arrive at a definition. In his book Hogarth returned to Pythagoras to propose that Beauty was not an absolute but was expressed through a variety of forms, such as Symmetry, Proportion, Balance,

Harmony. He also called upon Shakespeare for support—necessarily, since he wished to demonstrate that the English were well able to deal with these matters. He reminded his readers that for Shakespeare the appeal of Cleopatra had been "her infinite variety." But mere acceptance of "variety" could mean that there was no definition. Beauty, Hogarth finally believed, was to be found not in abstract qualities such as Grace or Sublimity but in a geometrical formula. A spiral drawn round a cone from apex to base produced a Line of Beauty which could be found in the body of a shapely woman (assisted, if necessary, by a suitable corset). There might not be a single Line of Beauty but such variations as he permitted were within a narrow range. So, despite his desire for Variety, he arrived at an Absolute. What Hogarth particularly did was to remove from classical art its traditional role as the sole exemplar of Beauty. As Steegman says,[16] such painters as Hogarth "abandoned their attempt to edify or improve mankind by means of the Noble or the Tragic and had changed from the Heroic to the Humble, from the Grand to the Domestic."

But it was not a change universally approved. An aristocracy raised to regard social inferiors with contempt were quite unable to find morally improving behavior in those obviously intended by nature to be vulgar. Hogarth's views smacked of democracy and that would mean giving political power to a class which was already regarded as "the Mob," a class that had bred levelers and revolutionaries. The English, even many of the poor, have always had a dread of revolution.

With the incursions of a new movement in the arts—later to be called Romanticism—the qualities Picturesque and Sublime, though used before, entered the artistic vocabulary with new significances. Beauty still required redefinition and Edmund Burke took up the challenge in his *Philosophical Enquiry into the Origin of Our Ideas on the Sublime and the Beautiful* first published in 1757. Burke found it convenient to tackle the subject by comparing the Sublime and the Beautiful, the former being applicable, in his opinion, to "objects [which] are vast in their dimensions; ... rugged and negligent; ... dark and gloomy; ... solid and even massive," whereas the latter describes objects that are "comparatively small; ... smooth and polished; ... light and delicate." These definitions are culled from various pages in Burke's *Enquiry*. It must be said that his book is hardly well structured and seems to have been devised to obscure his difficulties in reaching precise definitions but Burke was, with Uvedale Price, Payne Knight and the Rev. William Gilpin, among the most important exponents of the new aesthetics that was seeking to bring order into the disorderly field of aesthetic theory. For "order" was what everyone sought. The classical system demanded it and the chief objection that was later to be leveled against Romanticism was that it depended upon disorder and obscurity for its appeal, bringing accusations that it was a subtle attack upon the hitherto accepted rules of society. Which, of course, it was. By relating Taste to Ideal Beauty the classicists were insisting on a rigid formula that was self-apparent and readily discovered. Not for the first time Art was called in to buttress and underpin the prevailing social structure.

Francis Hutcheson had proposed, along with Hogarth, that beauty was "Uniformity amidst Variety" and was inclined to accept Shaftesbury's connection of beauty with moral perfection but most writers concluded that beauty was to be found not in moral qualities but in the attraction of particular forms. Hogarth's serpentine "line of beauty" and Burke's "smoothness," the appeal of the curve of a woman's neck and the rise of her breast, were examples of forms that pleased. These are, of course, features that have special significance to the male but Burke understood that he was seeking definitions applicable to the human mind, not to all nature. Animals would have other preferences. He is seeking those psychological factors which bring responses and in particular those which bring positive or, as he wrote, "independent" responses. Burke's *Enquiry* is deeply probing and often appears inconclusive and even rambling. Surprisingly, he states that "Proportion [is] not the cause of Beauty in the Human Species"[17] as had been the accepted opinion since classical times. This was a traditional rational view and it was no longer

enough to argue that reason governed the informed mind. Feelings and emotions were equally valid indicators of truth. Beauty was to be found in those shapes that had particular significance to the mind and aroused feelings of elation. Different creatures had different views of what constituted beauty and for mankind beauty was often, perhaps mostly, related to the attractions of the opposite sex. Recognition of beauty was a sensory activity and it all came down to the axiom, much quoted in the next century, that "beauty is in the eye of the beholder." Somehow the human mind prefers some shapes and arrangements to others, perhaps it is a matter of symmetry or balance or proportion and what we call "harmony," all ideas first examined by the Greeks, but when all is said and done, "we know it when we see it." Beauty has to arouse the mind and

> since it is no creature of our reason ... we ought therefore to consider attentively in what manner those sensible qualities are disposed, in such things as by experience we find beautiful, or which excite in us the passion of love, or some corresponding affection.[18]

Payne Knight criticized Burke on the grounds that he had succumbed to the appeals of feminine fashions and correctly argued that concepts of beauty changed as tastes changed. Beauty was no more than that which pleases. William Blake claimed that "the nakedness of woman is the work of God"[19] and Etty proclaimed Woman to be "the most glorious work of God"[20] in an age when women were notoriously subject to sexual abuses whether as aristocratic mistresses or working class servants. The idealizing of women has been a recurring restraint upon men from the earliest times and has been periodically reinforced whenever masculine obsessions became out of hand. The development of the cult of the Virgin Mary in the Middle Ages is but one example. Reinforcement was again necessary in the late eighteenth and early nineteenth century.

Eighteenth century connoisseurs inherited a tradition from Renaissance Italy that history subjects were the highest category of painting, a category which included both the Bible and the classical mythologies. Such paintings illustrated the noblest events in human history and hence the noblest men and women in history. The continued preference for portraits enabled portraiture to be included as history since, it was claimed, the subjects of portraits were the deserving persons of their time. The question was, how were other subjects to be regarded? A system of categorization was necessary. History painting could not include scenes from modern history unless they were elevated into allegories which usually meant depicting all figures in classical robes. George Vertue (1684–1756) recorded the admired painters of his age and set out the categories in which they excelled and thereby established the order of those categories. Today we may find it curious that landscape painting was regarded as the lowest on the grounds, as Reynolds also was later to declare, that landscape offered no opportunity for presenting moral virtues. Since virtue was the aim of art it followed that "low life" *genre*, in which the seventeenth century Dutch had excelled, had no place at all. It was partly because Dutch realism was disliked that landscape painting was afforded its low status. For here we have the basic tenet of those who judged art. Idealism, not realism, was the essential quality. But it was a quality that was to be gradually set aside. Walpole himself reminded his readers that Virgil had admired nature, so landscape did not appeal only to the uninformed. Nature could be classicised, as Poussin and Claude Lorraine had shown.

The fortunate archeological discoveries in Rome in the eighteenth century and, later, in Greece reassured the classicists and whether or not a new generation had been educated at the universities—and increasingly this was no longer the case—men of an enquiring turn of mind tended almost naturally to look to the ancients for artistic standards. These discoveries encouraged the belief that classical times had been a Golden Age when men and women lived in innocence, naked and unashamed, eager to pursue beauty and all the virtues, a view apparently confirmed by Johann Winckelmann (1717–1768), for those who read him. Although the present was seen as chaotic, for most in the upper ranks of society the Romantic alliance with dem-

ocratic and even revolutionary movements did not offer an acceptable alternative. On the contrary, it proposed the ignoring of rules, promoting the independent free spirit that did whatever it wished.

The word "aesthetics" had now entered the language claiming to present new concepts of art which, in fact, had long been emerging. Alexander Baumgarten's book *Aesthetica* published in 1750 proved too difficult for the general reader. Even so, the notion that all forms of art, and even nature can be brought together as a single subject for studying the concept of beauty proved very attractive. Through "aesthetics" art became subjective and emphasis was placed on the creator of works of art and less importance was given to patronage. Art was no longer to be what the patron decided. Romanticism preferred to regard the artist as self-inspired "genius" who expressed his own superior spirit and even regarded the public with contempt, especially, it would seem, those members of the public who paid him. It was, of course, a movement proclaiming its independence from the demands of the patron at a time when the free market was opening in art just as it was everywhere else. But above all, Romanticism was the product of the new philosophy that feelings can be trusted, even over reason, and that therefore everyone has something to say and equal rights to say it. Romanticism is not a single coherent philosophical formula but a cluster of attitudes and for this reason was highly suspect by those who looked for uniformity of purpose in nature. Romanticism became a movement that anyone could join and it was its very egalitarian appeal that made it so unpalatable to the conventional aristocrat. One man's taste was not as good as another's.

Beginning with a small *coterie* of aristocratic ladies and gentlemen in the seventeenth century the role of the drawing master had become very important in the lives of the wealthy in the eighteenth century. People, and especially women, with much time on their hands were encouraged to draw and paint (in watercolor) as a worthwhile use of leisure. Amateur but reasonably competent artists, who could never hope to obtain serious patrons, offered their services as drawing masters and for two centuries most wealthy families regularly employed drawing masters and music teachers to educate their daughters, and sometimes their sons, in these "noble arts." What is of importance is that landscape soon became the principal subject taught. Landscape was "neutral." It presented no moral or religious problems such as might be encountered by studying the figure, mythologies or Biblical subjects. It was this above all which raised landscape painting in the hierarchy of art and, in due turn, introduced Romanticism to the public as an acceptable system. Landscape paining could be exercised both at home and abroad and very soon every traveler carried pencils and a color box or, if they really could not draw and were wealthy enough, their own private artist to record scenes for them. Artist and patron became one.

Despite the anxiety of the new generation of artists to be free spirits, this was still an age of patronage. Today we are accustomed to artists producing works which they then offer for sale through galleries and exhibitions. This system had only recently been introduced and the Royal Academy had satisfied a need when it inaugurated summer exhibitions for its members—and also non-members, who had complained of exclusion. The history of art is largely a history of patronage and the changes towards a free market, with consequent changes in subjects and styles and in the public that supports the arts. It has already been indicated that the Church and kings and courtiers were the patrons of earlier ages but in the seventeenth century in England other aristocrats began to commission works directly from painters, sculptors and architects in the same way that their ancestors had commissioned furniture and tapestries and household goods. They continued to regard the commissioning system as directed towards craftsmen and included artists in that category. The eighteenth century was a period of emancipation for artists which continued into the nineteenth century. Fewer collectors preferred to commission in the old style of ordering a work with precise specifications but still chose works that conformed to the established classical styles of a previous generation because they could not trust their judgment to embrace the new.

Two paintings epitomize the change in aristocratic attitudes in the eighteenth century. Anthony Ashley Cooper, 3rd Earl of Shaftesbury, author of *Characteristicks*, was painted by John Closterman in 1701–02. His lordship stands against a pillar festooned with curtains, clad in a dressing gown which is deliberately made to look like a Roman toga. He stares out at us full of self confidence, a man sure of his place in the world. To our right his steward enters up steps apparently to receive his orders but he does not intrude on the space occupied by his master. This is the portrait of the aristocrat who has been reared in a classical tradition which he will never cast off. By comparison Brooke Boothby, future baronet, painted by Joseph Wright of Derby in 1781, reclines in a forest glade apparently thinking over what he has read in the book in his hand. The book is Rousseau's *Dialogues* which he had probably brought back after a meeting with Rousseau himself in Paris. Boothby had no wish to be depicted as a Roman senator nor as a disciple of the neo–Classicism which was by now being challenged by the new Romanticism. Whilst it was unlikely that Rousseau's egalitarian ideas would have found in him a fully approving disciple, Boothby was later to complain of "life's inanities" so indicating that he was far from accepting the assurances that his aristocratic world should have given him. Melancholy has been a common attitude adopted by poets throughout history. It did not signify low spirits or despair but the capacity to muse on subjects other than the trivialities of everyday life. However, whereas Shaftesbury knew the remedies for every social ill, Boothby did not. But Boothby is expressing at least one great change. His informal clothes tell us that he accepts the present, whereas Shaftesbury wishes he was living in an earlier age.

Rousseau's ideas, which influenced the philosophy of the late eighteenth century, had been first formulated in his book *Social Contract* as early as 1762 but, for the English, the French Revolution had demonstrated the dangers of libertarian principles. Shaftesbury, though for us today an aristocrat of the Old School, was in his time regarded as a radical since he re-examined the nature of morality and proclaimed man's essential altruism. It was his ideas, filtered through the writings of others, that shaped serious thought in the eighteenth century. In 1713 Simon Gribelin published his engraving of Paolo de Matthaeis' painting *The Education of Hercules*. Shaftesbury had seen the original work in Paris in 1712, published an essay on it in French and added this in English as a final chapter to his *Characteristicks* in 1713 before he died. The work, which Shaftesbury called a *Tablature*, depicts Hercules standing between the goddesses of Virtue and Pleasure, considering their respective invitations to join his life with theirs. Shaftesbury subjects the *Tablature* to an extensive examination which does not here concern us. He begins by re-titling the work, *The Judgment of Hercules*, and explains that Hercules has "to deliberate on the Choice he was to make of the different ways of Life" presented by the goddesses. What matters to us is not Shaftesbury's examination of the suitability of the painting (or engraving) to the subject but the need for everyone to choose virtue over pleasure, not so much as an outright denial of pleasure which can sometimes be desirable, but as a choice between civic duty and personal indulgence. Shaftesbury did not like allegorical art because, in his view, it was tainted with religious ambiguity and was often used to deceive but nonetheless Hercules' choice as here depicted was one that confronted everyone and should be correctly resolved. It was this choice that influenced the thinking aristocrat of the eighteenth century. One has to restrict oneself to the "thinking aristocrat" because so many were not and it is these that have colored perceptions of the century.

Those who feared the advance of democracy because they feared "the Mob" clung to the old classical principles of order, balance, moderation and, above all, government by an educated *élite*. It may be minorities who shape the world, and this was never clearer than in the centuries that form the background to the life of the man who occupies these pages. But it is usually the masses who experience the conditions that require reshaping and they must declare them and decide their own destiny. This was not the view of the eighteenth century. It was the nineteenth century that was to give the masses a voice and, as it did so, the old order slowly died and with it all the principles by which it had flourished.

Not only the self-appointed "Men of Taste" but also many artists recognized the need for English art to be guided towards an ideal to which all should subscribe. There were two models to which they could look, the Italian workshops of the Renaissance and the French *Académie Royale* founded in 1648. The former depended on the ability of the master artist controlling the workshop and on the education and taste of the patron commissioning his work. It was the obvious death of artists of ability and of patrons with discernment that was at the root of the problem with English art. While the second model was preferred by English writers on art since it established generally approved principles and taught reliable methods and provided patrons with standards of taste, there was at once objections from almost every artist that *they* needed no instruction, that was for others. There was also strong objection to any state or monarchical interference, which was notoriously applied to the French academy. There was however general agreement that the purpose of art was to educate and refine and that the most useful method was through the painting of history. Since no artist that England had yet produced could be accounted a successful history painter it was clear that something had to be done. Any English solution had to be a free enterprise system. So several private academies were established but quickly expired as members invariably quarreled. It was not until 1768 that four artists, William Chambers, Benjamin West, Francis Cotes and George Moser, formed a committee to further the establishment of an academy under royal patronage but not under royal control. It was typical English compromise. Twenty-two artists signed the eventual petition to George III which they presented on the 28th November 1768. The king was encouraged and on the 10th December 1768 he signed the Instrument establishing the Royal Academy and appointing the first forty artists to act as the Council. Joshua Reynolds was persuaded, apparently with difficulty, to become first President, on acceptance of which title he was knighted by the king to declare the royal approval of the new institution.

From the outset Reynolds worked untiringly for the Academy as well as pursuing his own lucrative career. At the first public assembly on 2nd January 1769, he delivered an address which was to be the first of no fewer than fifteen Discourses which, in published form, became the principle source of instruction for all Academy students. A School for students was established, with 77 in the first year, with provisions for drawing from living models after completion of a satisfactory period of drawing from cases. In his first Discourse, Reynolds declared: "The principal advantage of an academy is that, besides furnishing able men to direct the student, it will be a repository for the great examples of the art." He went on to require the students to observe "an implicit obedience to the rules of art, as established on the practice of the great masters— that those models which have passed through the approbation of ages should be considered by them as perfect and infallible guides." These words established the principle that Academic art was classical art and became the commandments for all future members of the Academy, though as time went on they were repeatedly challenged until today no one would dream of obeying them. But for men like William Etty, aspiring to membership in the one institution that could guarantee them recognition, reward and even fame, they remained commandments that could never be questioned. Notwithstanding the elevation of history painting to the highest rank, Reynolds and many others remained portraitists since this was what patrons wanted and would pay handsomely to get.

The Royal Academy contained the most eminent of artists of the day and it was they who decided what constituted success and therefore who could be privileged to join them. By the turn of the century, when the young Etty was settling in London, the summer Academy Exhibition had become an object of annual pilgrimage for all men and women of fashion, especially those visiting London for "the Season." For them there was no question what Art was. Art was noble. Art was spiritually uplifting. Art was "Good Taste." But essentially Art was what the Royal Academy declared it to be. (And always "Art" with a capital "A.")

CHAPTER ONE

The Etty family, Etty's birth and early years

On the 10th March 1787 the future painter William Etty was born, the seventh child of Esther and Matthew, in No. 20 Feasegate, York, England, a site now marked by a plaque on the wall of the side entrance to British Home Stores. York is an ancient city dating its origins from the Roman occupation c. A.D. 17. We will consider the city more closely later but for the moment its importance as an ecclesiastical center should be noted, it being the seat of the Archbishop of York since 625. The old part of the city is still surrounded by its medieval walls and its buildings date predominantly from the Middle Ages and the eighteenth century. Its antiquity and religious importance were to exercise a major influence on William Etty all his life. When William Howarth wrote[1] his *History and Description of the Ancient City of York* in 1818 he said of Feasegate, "The street is very narrow, the houses on the south side of it are of a miserable appearance, but those on the north side are more modern and more respectable."

Etty's birthplace was on the south side of the road. It has been suggested that the name, Feasegate, was originally Feasts-gate and referred to the feasts celebrated by the Jews who lived there in the early Middle Ages. Etty's first biographer, Alexander Gilchrist, said that the house was nearly demolished in 1848 when Feasegate was widened but in 1855 when he wrote his biography he recorded that it "stands to this hour."[2] A small pencil and wash drawing of postcard size in the York Reference Library (Archive No. Y.759.2) is titled "Residence of Etty the Painter" and dated 1878 (see page 25 below). It shows a shop front with central doorway, a bay window on the first floor and two small windows on the second floor. It seems to be attached to the buildings on each side, which is typically the case with shops in York even when constructed separately. The painting is of poor quality and unsigned but presumably it depicts the shop in Feasegate where Matthew had his bakery. There is nearby in Market Street a small shop which suggests this kind of building in the central area of York in the early nineteenth century.

Otherwise all we have to go on is *Nathaniel Whittock's Bird's-Eye View of the City of York in the 1850s* which gives a broad panoramic view of York with a wealth of detail that for the most part is accurate though Whittock often drew rows of identical houses to represent either attached buildings or terraces. In the case of Etty's birthplace the building can be discerned in the drawing only from the rear and so Whittock does not help us. In Etty's childhood Feasegate was one of York's principal trading streets leading into Thursday Market but by the mid–1850s it had deteriorated into a shabby by-road linking Coney Street with the new Parliament Street which had been opened in 1836. Thursday Market was renamed St. Sampson's Square after the nearby church. Etty's birthplace survived at least in part into the twentieth century. William Camidge, the son of John Camidge the Minster organist who, with *his* father the preceding organist, had been friends of Etty, wrote a short account of William Etty's life in 1899 and said "a portion of the house ... is still standing but improved out of all recognition."[3] The present building occupied by British Home Stores was erected in 1961 and so far as is known Etty's birthplace or what was left of it was demolished at that time. An inscription at the Feasegate entrance records Etty's birth.

THE ETTY FAMILY*
(compiled from information provided by Tom Etty of Nijmegen, The Netherlands)

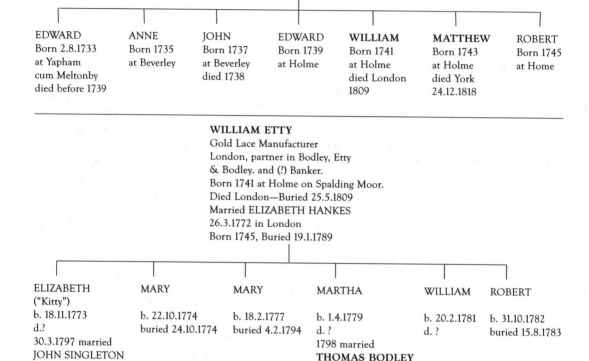

JOHN ETTY
Carpenter & Wheelwright of Holme on Spalding Moor b. 1705,
married MARTHA HARPER 14.11.1732 in St. Mary's, Beverley
moved to York 1777, Martha buried at Holme 1777, John died York 23.5.1779

EDWARD	ANNE	JOHN	EDWARD	**WILLIAM**	**MATTHEW**	ROBERT
Born 2.8.1733 at Yapham cum Meltonby died before 1739	Born 1735 at Beverley	Born 1737 at Beverley died 1738	Born 1739 at Holme	Born 1741 at Holme died London 1809	Born 1743 at Holme died York 24.12.1818	Born 1745 at Home

WILLIAM ETTY
Gold Lace Manufacturer
London, partner in Bodley, Etty
& Bodley. and (?) Banker.
Born 1741 at Holme on Spalding Moor.
Died London—Buried 25.5.1809
Married ELIZABETH HANKES
26.3.1772 in London
Born 1745, Buried 19.1.1789

ELIZABETH ("Kitty")	MARY	MARY	MARTHA	WILLIAM	ROBERT
b. 18.11.1773 d.? 30.3.1797 married JOHN SINGLETON CLARK (Clerk)	b. 22.10.1774 buried 24.10.1774	b. 18.2.1777 buried 4.2.1794	b. 1.4.1779 d. ? 1798 married **THOMAS BODLEY** (Gold lace merchant) d. 1858	b. 20.2.1781 d. ?	b. 31.10.1782 buried 15.8.1783

JOHN MARTHA EMILY

*Names of principal persons referred to are shown in **bold** type.

When Etty's first biographer, Alexander Gilchrist, visited York in the early years after the painter's death in 1849 he was surprised that York's inhabitants had very little knowledge of him. So Gilchrist's first task was to rescue his hero from oblivion. He sought to show that Etty had connections with locally illustrious persons and had exceptional natural talents which his parents had been wise enough to encourage. He discovered that the name "Etty" appeared no fewer that eight times in the Index of Wills preserved in York archives, referring to five distinct families in the North-Riding of Yorkshire. There was "a vague tradition afloat among Etty's kindred" that the family came originally from Scotland but Gilchrist discounted this.[4] There had been a John Etty, an architect, who had died in York in 1709 but Gilchrist was unable to link him to William Etty. There was another John Etty "of the City and Province of York, clerk" who made his will in 1739 and of whom Gilchrist felt more hopeful but this was not to be either. It does seem that John Etty, the architect referred to, had a painter son of the same name but he

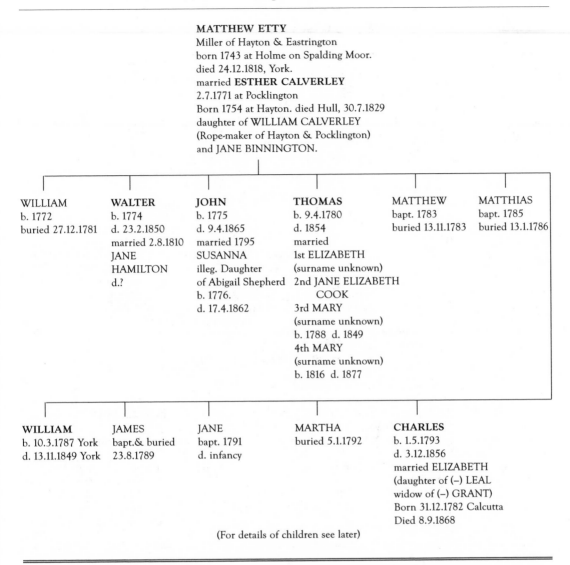

MATTHEW ETTY
Miller of Hayton & Eastrington
born 1743 at Holme on Spalding Moor.
died 24.12.1818, York.
married **ESTHER CALVERLEY**
2.7.1771 at Pocklington
Born 1754 at Hayton. died Hull, 30.7.1829
daughter of WILLIAM CALVERLEY
(Rope-maker of Hayton & Pocklington)
and JANE BINNINGTON.

WILLIAM	WALTER	JOHN	THOMAS	MATTHEW	MATTHIAS
b. 1772	b. 1774	b. 1775	b. 9.4.1780	bapt. 1783	bapt. 1785
buried 27.12.1781	d. 23.2.1850	d. 9.4.1865	d. 1854	buried 13.11.1783	buried 13.1.1786
	married 2.8.1810	married 1795	married		
	JANE	SUSANNA	1st ELIZABETH		
	HAMILTON	illeg. Daughter	(surname unknown)		
	d.?	of Abigail Shepherd	2nd JANE ELIZABETH		
		b. 1776.	COOK		
		d. 17.4.1862	3rd MARY		
			(surname unknown)		
			b. 1788 d. 1849		
			4th MARY		
			(surname unknown)		
			b. 1816 d. 1877		

WILLIAM	JAMES	JANE	MARTHA	CHARLES
b. 10.3.1787 York	bapt.& buried	bapt. 1791	buried 5.1.1792	b. 1.5.1793
d. 13.11.1849 York	23.8.1789	d. infancy		d. 3.12.1856
				married ELIZABETH
				(daughter of (–) LEAL
				widow of (–) GRANT)
				Born 31.12.1782 Calcutta
				Died 8.9.1868

(For details of children see later)

has disappeared into oblivion. But his existence was enough to start some writers on a false trail. Gaunt and Roe[5] record an entry in Ralph Thoresby's *Diary* under 5th June 1702, as follows:

> Evening sat up late with a parcel of artists I had got on my hands, Mr. Gyles, the famousest painter of glass perhaps in the world, and his nephew Mr. Smith, the bell-founder (from whom I received the ringing, or gingling spur, and that most remarkable with a neck six inches and a half long;) Mr. Carpenter, the statuary, and Mr. Etty, the painter, with whose father, Mr. Etty, sen. the architect, the most celebrated Grinlin [sic] Gibbons wrought at York, but whether apprenticed to him or not I remember not well. Sate up full late with them.

Gaunt and Roe agree that while "nothing could be more appropriate than to reconcile this architect, John Etty (who died in 1709), and his painter son, with the known ancestry of our subject ... candour compels the admission that nothing of the sort can be proven." Alison Sinclair, writing the chapter on "Eighteenth Century York" in Nuttgen's *History of York*, refers to "William Etty, noted by Cossins as Joiner and Carpenter, worked at Castle Howard and may have been the architect of the Mansion House; he was City Husband in 1709 and Chamberlain in 1716."[6]

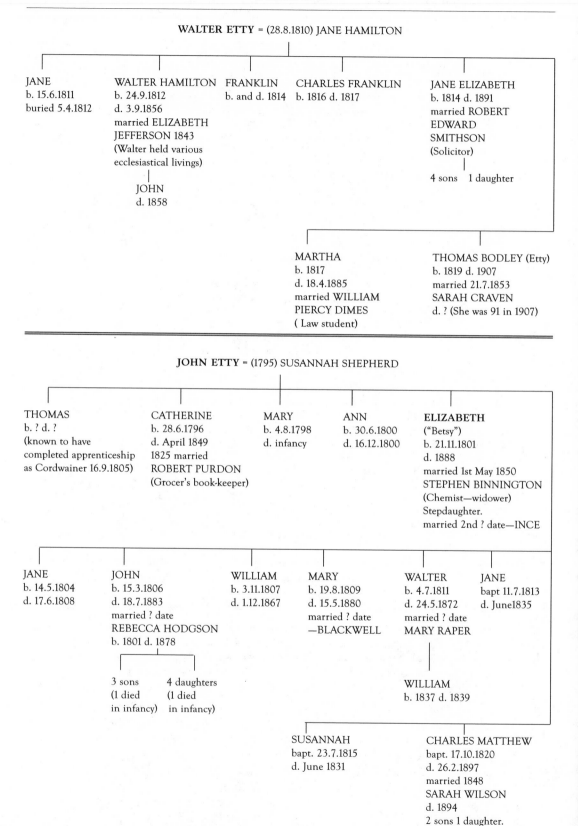

WALTER ETTY = (28.8.1810) JANE HAMILTON

JANE
b. 15.6.1811
buried 5.4.1812

WALTER HAMILTON
b. 24.9.1812
d. 3.9.1856
married ELIZABETH
JEFFERSON 1843
(Walter held various
ecclesiastical livings)

JOHN
d. 1858

FRANKLIN
b. and d. 1814

CHARLES FRANKLIN
b. 1816 d. 1817

JANE ELIZABETH
b. 1814 d. 1891
married ROBERT
EDWARD
SMITHSON
(Solicitor)

4 sons 1 daughter

MARTHA
b. 1817
d. 18.4.1885
married WILLIAM
PIERCY DIMES
(Law student)

THOMAS BODLEY (Etty)
b. 1819 d. 1907
married 21.7.1853
SARAH CRAVEN
d. ? (She was 91 in 1907)

JOHN ETTY = (1795) SUSANNAH SHEPHERD

THOMAS
b. ? d. ?
(known to have
completed apprenticeship
as Cordwainer 16.9.1805)

CATHERINE
b. 28.6.1796
d. April 1849
1825 married
ROBERT PURDON
(Grocer's book-keeper)

MARY
b. 4.8.1798
d. infancy

ANN
b. 30.6.1800
d. 16.12.1800

ELIZABETH
("Betsy")
b. 21.11.1801
d. 1888
married 1st May 1850
STEPHEN BINNINGTON
(Chemist—widower)
Stepdaughter.
married 2nd ? date—INCE

JANE
b. 14.5.1804
d. 17.6.1808

JOHN
b. 15.3.1806
d. 18.7.1883
married ? date
REBECCA HODGSON
b. 1801 d. 1878

3 sons 4 daughters
(1 died (1 died
in infancy) in infancy)

WILLIAM
b. 3.11.1807
d. 1.12.1867

MARY
b. 19.8.1809
d. 15.5.1880
married ? date
—BLACKWELL

WALTER
b. 4.7.1811
d. 24.5.1872
married ? date
MARY RAPER

JANE
bapt 11.7.1813
d. June1835

WILLIAM
b. 1837 d. 1839

SUSANNAH
bapt. 23.7.1815
d. June 1831

CHARLES MATTHEW
bapt. 17.10.1820
d. 26.2.1897
married 1848
SARAH WILSON
d. 1894
2 sons 1 daughter.

THOMAS ETTY = (1) ELIZABETH (Surname unknown)
2 children died in infancy
= (2) JANE ELIZABETH COOK

GEORGE	MARY	ESTHER	NAME UNKNOWN	CHARLES	MARGARET
b. 1808	b. 1810	b. date unknown	details unknown	b. 1812	b. 1823
d. in infancy	d. in infancy	d. date unknown		d. 1891	d. date unknown
date unknown		married 1845		(emigrated to	married 1848
		HENRY WATSON		Java)	THOMAS LOTHERINGTON
		(Hairdresser)			(Merchant's Clerk)
					1 daughter

= (3) MARY (surname unknown)
b. 1788. d. 1849

No known children

= (4) MARY (surname unknown)
b. 1816. d. 1 877

No known children

CHARLES ETTY
married (? date) ELIZABETH
daughter of—LEAL
widow of—GRANT
b. 31.12.1782 Calcutta
d. 8.9.1868

ESTHER MARTHA
b. 1818 d. 1821
Born and died at sea

MATTHEW WALTER
b. 31.9.1815 Calcutta
d. 11.7.1870 Red Sea

1. Married (? date) MARY BRUNFIELD d.1841

Son—EDWARD ETTY
1840—1856

2. Married 1861 JOHANNA CHRISTINE
PEREIRA b. 1840. d. ?

Gerry Webb in his book *Fairfax of York* mentions several Ettys in York in the early eighteenth century. He quotes a letter from Major-General Fairfax's agent (Mr. Clayley) dated 8th March 1706 reporting in regard to disposal of the remains of "an old rotten house in Skeldergate" that the General had thought of converting into a town house, that "Mr. Etty ye builder (as I writ formerly) offered [£]150 for ye materials."[7] Later Webb refers[8] to "Mr. Atty's house in Castlegate" and says that he was

actually Mr. William Etty, one of a family of York carpenters. William and his father, John, were also architects, William being associated with several important Yorkshire houses, including Castle Howard. He died in 1734. His son, Lewis Etty, became rector of St. Mary Castlegate in 1742 and lived in the house built by his father. Lewis died in office 31 years later and is buried in his church.

THE RUDSTON, CALVERLEY AND ETTY CONNECTION
(compiled from information provided by Tom Etty of Nijmegen, The Netherlands))
(Direct lines of descent only are indicated. Other children are not shown)

WALTER RUDSTON = FRANCES CONSTABLE
of Hayton, Yorks of the Everingham family

(9 other children)

SIR WALTER RUDSTON = MARGARET DAWNAY
1st Bart. Of Hayton
created Baronet by Charles I 1642

WILLIAM RUDSTON = HESTER SAVILLE

HESTER RUDSTON = WILLIAM CALVERLEY

SIR THOMAS RUDSTON = KATHERINE MOUNTAYNE

CHARLES CALVERLEY = CATHERINE MITCHELL

SIR THOMAS RUDSTON
last Baronet of Hayton

ELIZABETH RUDSTON = HENRY CUTLER
succeeded her brother son of Sir Gervais Cutler
of Stainborough Hall

WILLIAM CALVERLEY = JANE BINNINGTON
Of Hayton, Ropemaker c. 1709—1801
1710—1794

RUDSTON CALVERLEY = ANNE STOCKDALE
later Rudston Calverley-Rudston (married 1761)
of Hayton, adopted heir of
Elizabeth Rudston. He died 15.6.1806

John Calverley
of Hayton (Joiner)

ESTHER CALVERLEY = **MATTHEW ETTY**
1754—1829 1743—1818
married 2.7.1771 Miller and baker, York.

Names of principal persons referred to are shown in **bold** type.

So there were two Ettys who had been architects as well as a builder, a painter and a parson. It would satisfactorily provide our William Etty with a family background if he could be related to them but this does not appear possible. Nevertheless one is tempted to share the hope, obvious among others who have commentated on Etty, that these different men were branches, though distant, of the same family. Tom Etty of Nijmegen, The Netherlands, who possesses a considerable collection of family papers and many artefacts relating to his ancestor, has carried out valuable research into his family's history and has succeeded only in tracing his line back to William Etty's grandfather John, a wheelwright who lived on Spalding Moor. He was born in 1705 and was married to Martha Harper at Beverley's Church of St. Mary in the East Riding of Yorkshire (as it was then known) on 14th November 1732. In the Parish Register he is described as "John Etty of Pocklington" and that does appear to have been the area from which the family originated. Their first child, born in 1733, died in 1739. Five further sons followed, Matthew was to be the painter's father and William the generous uncle on whom the painter relied in his early years. It has never been possible to go further back than Etty's grandparents and Etty himself never laid claim to any illustrious lineage though his mother might have made some claim, as shall be seen.

If we refer somewhat frequently to Gilchrist's biography it is because he represents our sole source for these early years and also for certain events thereafter. Gilchrist had the advantage

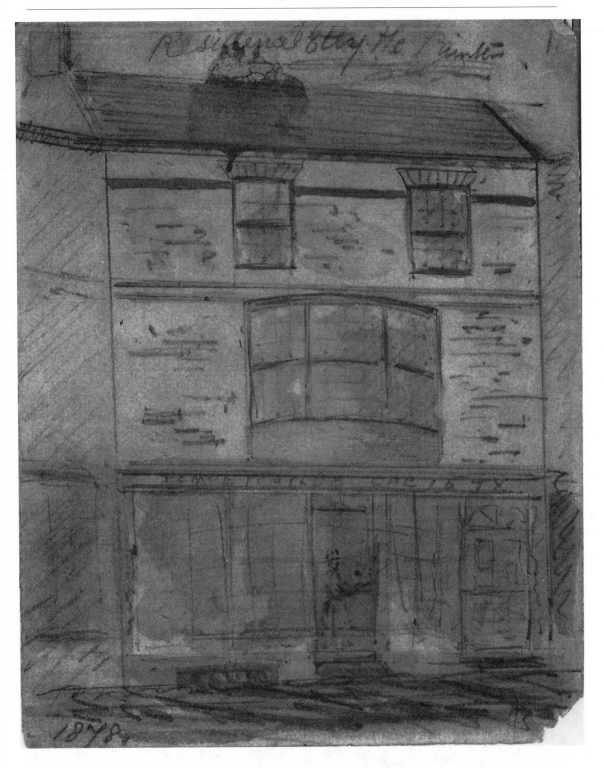

Said to be "Residence of Etty the Painter," pencil and wash, anon. (1878), York Reference Library, Y759.2.

of being commissioned to write his book within five years of Etty's death and being able to interview in York persons still alive who knew Etty personally, especially in his childhood. Very quickly these sources were no longer available. Etty's parents had no expectation that their son would one day be famous and therefore no obvious obligation to preserve records. So we are dependent on the researches that Gilchrist was able to undertake which were necessarily constrained by the details he either already knew or could gather from those whose memories must already have been failing.

However, there is absolutely no doubt that Etty's father was Matthew, a miller, baker and confectioner with a local fame as a maker of gingerbread. The family lived over the shop but the windmill which Matthew owned stood on The Mount to the south of Micklegate Bar. By Etty's death in 1849 this also no longer existed. Matthew Etty was, according to Gilchrist, "certainly superior to his position,"[9] by which he meant that he had had some education which might not then have been expected in a miller. Gilchrist quotes unnamed sources as stating that Matthew was "A high-learnt man" who "knew more than people supposed." He was said to have known about "the stars and the heavens" which suggests a smattering of astronomy. He was also said to be "fond of books" but "quiet."

Those who remember Matthew Etty speak of him as ordinary in intellect; homely, and, in his way, hardworking: a steady, careful citizen, not quick or brilliant. Of undecided character and easy temperament, he "did not trouble his head" about affairs.[10]

Matthew Etty (25.5 × 19.75 ins) (1811), Tom Etty, Nijmegen, The Netherlands.

In fact, a man who kept his opinions to himself and divulged little of his thoughts, one who worked conscientiously and invited no attention, the kind of man we have come to regard as a typical countryman. It seems that in stature his son resembled him, Matthew being described as "low" in build. As we shall discover, his son resembled him in character, being hardworking, quiet and little concerned with current affairs. Both parents were persevering, determined to carry through everything they embarked upon and it was the young Etty's perseverance that impressed everyone who knew him.

On the other hand Etty's mother, Esther, was regarded as having a sharp mind for business, being better educated than her husband. Contemporaries spoke of her as being of low stature and "eagle faced of Roman decision," one who could drive a hard bargain. According to Gilchrist[11] it was Esther who possessed the initiative necessary to further the family business. It was she

who set up her son Thomas as a baker and confectioner in Hull, arranging the purchase of a house and shop for him. Esther was a practical woman. She papered the rooms in the Hull house and generally supervised the decorations. Esther's management abilities were much appreciated by William Etty many years later when he moved house in London. Esther was a good mother to the end.

Matthew and Esther were not originally citizens of York and their early lives provide us with a remarkable story. Matthew, the son of the wheelwright John Etty, was living at Holme-on-Spalding Moor at the time he met Esther. He had a water mill there on the Rudston estate. Esther's father, William Calverley, was a rope-maker in the village of Hayton on the Hull Road, fifteen miles east of York. He claimed,[12] probably correctly, to be distantly related to Elizabeth Rudston who had married Henry Cutler, son of Sir Gervais Cutler of Stainborough Hall, later renamed Wentworth Castle when it was sold to the Wentworth family. It was not unusual for poor families to have distant rich relatives who for the most part either knew nothing of them or disowned them. Elizabeth was the sister of Sir Thomas Rudston, the third and last holder of the baronetcy created in 1642 by King Charles I in recognition of the family's support during the Civil War. The Rudstons had several claims to fame in local history but two episodes indicate that though they were, as might be expected, traditional Catholics at the time of the Reformation, they decided to accept the break with Rome. A Thomas Rudston is mentioned by Geoffrey Moorhouse in his book *The Pilgrimage of Grace*[13] as being among the East Yorkshire rebels in 1536 and that another Rudston of Hayton (Nicholas) was one of the Holderness Captains in the Pilgrimage. This latter Rudston, however, changed sides, declared himself to be "the King's man" and went so far as to disclose to his new allies an injudicious letter he had received from an earlier confederate though he subsequently tried to conceal the fact when he realized it would also incriminate him. The Rudstons were minor gentry of only local importance.

According to Gaunt and Roe[14] it was "popular tradition" that in the seventeenth century William Rudston, brother of Walter who had been created baronet, married Hester Saville and her daughter married a William Calverley. He was alleged to be the grandfather of William Calverley the rope-maker. Gaunt and Roe dismiss the story as "a pretty piece of folk-lore" but the story seems to be correct and it was sufficiently embedded in the Calverley family history for William Calverley to name his eldest son Rudston apparently to draw him to the attention of Elizabeth Cutler who lived in the neighborhood. On the death of her husband

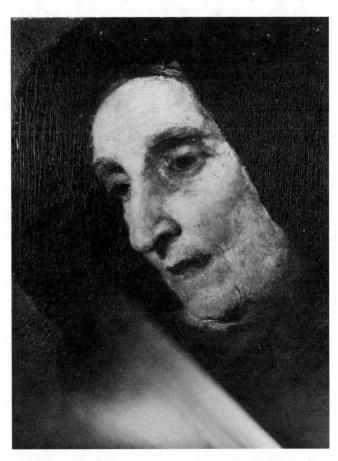

Esther Etty (detail of 1811 portrait copy, date and purpose unknown; 1811 original destroyed at Arnhem in 1944), Tom Etty, Nijmegen, The Netherlands.

Henry, Elizabeth Cutler succeeded to the Hayton Estate and, being childless, she adopted Rudston Calverley for the purpose of continuing the family name, officially describing him as her "cousin and heir general." This is confirmed by local records and it certainly appears that she accepted the Calverley's claim to kinship. When Elizabeth Cutler died in 1745, Rudston Calverley succeeded to her fortune with the condition that he adopt her maiden name. This he duly assumed by Royal License together with the Rudston arms "suitably differenced." Thereafter he was known as Rudston Calverley-Rudston and became Squire of Hayton. His sister Esther Calverley was born in 1754 and was taken into her brother's household to be reared "in accordance with the Squire's rank rather than with that of her brother John who continued to exercise his trade of Joiner in the same village."[15] The remainder of the family continued to live as poor country people in the area. Rudston Calverley-Rudston, as he loved to be known, was very proud of his position in local society and it is somewhat amusing to note that when he married Anne Stockdale in 1761 the word "Esquire" was omitted from the entry in the Parish Register and was inserted above the line after his name. One can imagine the reprimand the poor clergyman must have received for this oversight.

Somehow Matthew Etty, the miller, and Esther Calverley, the favored sister, met. The meeting was probably not at all unusual since Matthew's mill was on the Rudston estate. Matthew was twenty-eight years old and Esther was seventeen. In July 1771 Esther married Matthew in circumstances which are far from clear. Matthew was a man of very modest means. He rented his mill from Rudston who, as the local Squire, had riparian rights in the river which powered it. At this date millers were regarded as "middlemen," that is to say, they contracted with the growers of corn to grind it into flour for the growers to sell on to various dealers. The right to grind corn was limited to particular persons since millers had acquired a bad reputation for peculation. By regulation the grain had to be weighed before grinding and the flour weighed after grinding to ensure that none had been diverted to the miller's own use. For some centuries millers had been prohibited from dealing in corn and flour to prevent them mixing inferior varieties with other grower's corn to their own advantage. During the first half of the eighteenth century several of these practices had re-emerged and millers were generally supervised to guard against fraud. They were, however, by the late decades of the eighteenth century allowed to buy corn in markets and grind it into flour for their own use but clearly opportunities for substitution remained.

Matthew Etty's reputation throughout his life was always that of a straightforward and honest man but we can see that Rudston might well have regarded him with some suspicion. It is part of the Etty family history that Rudston was so affronted by the marriage that he immediately disowned his sister and evicted Matthew from his mill. According to Gilchrist[16] Matthew's brother William, who was already engaged in a lucrative business in London, offered to double whatever Rudston Calverley was willing to give his sister as a dowry, but Rudston refused to give anything. How this story arose is quite unclear but it was already accepted as fact when Gilchrist was making his enquiries in 1855. Whether William gave the couple a wedding gift is not known but as he was always a generous man it is very likely that he did, a possibility likely to be confirmed by the fact that the couple were soon able to set up in a baker's shop.

Since Esther's and Matthew's first child was born in 1772 (the precise date is unknown) speculation arises as to whether the marriage was forced upon them by the expectation of this child and that this was the cause of her brother's anger. Gilchrist mentions this child only in passing, referring to "one who lived long enough to show promise greater than ordinary; Esther's eldest-born, also a William, also gifted,—early evincing inclination for Design."[17]

This appears to have been based on no more than hearsay. Gilchrist gives no dates and knowing how anxious he was to spare the Etty family any embarrassments we are justified in seeking to explain his reticence. If there was no obligation on Matthew to marry Esther, the question arises as to why Rudston did not forbid his sister's marriage since she was only seven-

teen. The Marriage Act of 1753 required parental consent for marriages when one or both parties were under twenty-one years of age. Esther's father was still alive (he died in 1794) and either he or her brother as her self-appointed guardian could have prevented the marriage had they wished. The only other explanation is an elopement. No doubt Rudston considered that his sister had been seduced, possibly with Matthew hoping that he could rise in the world by marrying her. But the anger vented on Esther more suggests that Rudston blamed her as much as Matthew. If she was already pregnant that would have disgraced Rudston's own name and we have every reason to believe that he valued his local social position very highly. Local records reveal a high number of illegitimate children in the locality at the time, though it must be said the mothers were all daughters of farm workers, not the favorite sisters of socially ambitious brothers. Whatever the reason for her brother's anger, Esther's family, except for her brother, also disowned her, suggesting that her conduct had brought disgrace even upon them.

Esther and Matthew published their banns at Bugthorpe, a village some seven miles east of York, on the 1st July 1771 and were married the next day by special license at All Saints' Church, Pocklington, in the East Riding of Yorkshire. H. Wyke and Thos. Carnarvon were entered in the register as witnesses in the handwriting of the curate, T. Willcock. Their identities are not known and they may well have been employed on church duties such as verger and sexton. They were probably unable to write. It was not unusual for such persons to be enlisted when family members and friends were unavailable. Everything suggests some haste. It has not been possible to discover any registration or baptism of their first child. It was quite common at this time for births, especially first births, in rural areas not to be recorded. Registration was not a legal requirement until 1836. Baptism was usually the first record of a birth but this also was not obligatory. Not only were those of the rural laboring class often indifferent to the need to register births or even marriages but if, as was quite commonly the case, the first child had been conceived before marriage the parents would wish to conceal the fact. Puritan clergymen usually refused to baptize illegitimate children and, though their child was not technically illegitimate, and both Matthew and Esther were probably by now Methodists, it is also likely that they were sensitive about the events leading to their marriage. Illegitimacy had risen considerably in the second half of the eighteenth century, especially in rural areas, and one can well imagine Matthew wanting to protect Esther's good name. If the subsequent birth was registered then it is clear that this took place well away from their native homes since parish registers nearer to hand do not record it. Whatever the reason for her brother's anger, Esther's family, except for her brother, also disowned her, suggesting that her conduct had brought disgrace upon them. This must have influenced her desire for anonymity.

Etty himself never referred to his parents' life before their marriage. Matthew was already a Methodist and a Sunday School teacher. Tom Etty of Nijmegen possesses a Methodist hymn book which Matthew gave to a pupil, inscribed as "William Pack" of Hull. This may have been given before Matthew married and the recipient may have been "William Peck" who had a relative "Robert Peck," a printer in Hull who took William as an apprentice, as will be considered later. Spelling, even of names, was extremely variable. At some time Esther also became a Methodist and the two raised their children in that faith. It is unlikely that Esther would have been permitted by her brother to leave the Anglican church while she was in his household since he was very concerned for his position as Squire of Hayton and his standing with the local gentry. So the change must have taken place after she left. Matthew's connection with the Methodists has led some to refer to him as a Methodist minister but this is certainly erroneous. There remains the question why they named their first child "William." It is very likely they did so to express thanks to uncle William who had provided them with a dowry. The money for Matthew to enter business as a baker had come from somewhere.

Matthew and Esther settled in Pocklington where he set up as a baker. Bakers were somewhat lower in the social scale than millers and subject to many controls. There had always been

difficulty in ensuring value for money from bakers, that is, a standard size and quality of bread for a certain price. Traditionally these had varied throughout the country and often between bakers. Parliament tried to regulate size and price in 1709 and again in 1757 and 1763 but unscrupulous bakers had always managed to evade the law. Bakers were gradually permitted to deal in corn and flour as distinct activities from actually baking bread and also to deal directly with millers. One problem was preventing bakers who milled corn for others from taking some of the flour for themselves. Efforts to prevent bakers from entering into partnerships with other dealers in corn were ineffectual since such arrangements could always be kept secret. Finally governments abandoned attempts to control the activities of bakers, contenting themselves to fixing loaf sizes and prices.

It might appear that Matthew Etty had embarked on a trade that enabled him to circumvent the law but, again, we have no reason to think this was his motive. Millers and bakers were several rungs up in the social ladder of the lower "middling sort" and we can expect that brother William's success in London may have served as an example to him that hard work and enterprise could bring desirable results. At all times Matthew comes over as a totally honest man, an excellent example to his children. His business in Pocklington was not successful, so he moved to Eastrington where Walter was born in 1774. Eastrington did not provide them with a satisfactory living either so they moved to York in 1777 where he set up a more successful business in Feasegate. In due course, at some date unknown, Matthew acquired a mill in York on Holgate Hill so that he was able to buy corn and sell flour as well as supplying his own bakery, all of which was now quite legal. If the earlier speculation regarding their marriage is correct, the failure of their initial attempts to set up in business may be explained. They would be well-known in Pocklington, other members of the family lived there, and knowledge of the circumstances of their marriage would discourage acceptance in the community. Their move to York was probably due to their not being known in the city and there they could make a fresh start.

Gilchrist had some difficulty in tracing the dates of birth of William Etty's siblings but Tom Etty of Nijmegen and his father have carried out careful researches and it is now possible to be certain of these details which have very generously been placed at the author's disposal. Their first child, William, born in 1772, died in 1781. He was said to have shown some artistic talent though this seems to have been learned by Gilchrist from family memories some seventy years later.[18] Their second son, Walter, was born in 1774. John was born in 1775, Thomas in 1780 and two further sons, Matthew, born in 1783, and Matthias in 1783, both dying in infancy. William, the future artist, was born in 1787. There is every reason to believe that the second William was deliberately so named in order to replace the loss of the first William. It was, and frequently still is, quite common to ensure the continuance of a family name. After William came James, 1789, and a daughter Jane, 1791, both dying young, another daughter, Martha, 1792, and finally Charles in 1793. Of the total of eleven children only five survived infancy. Infant mortality was always high but the Ettys appear to have been very unfortunate.

William was born into a loving and caring family that was united in some adversity and in their determination to make their way in the world. Walter was to become particularly successful, joining uncle William in London. William attained his ambition and Charles, after an adventurous life as a seaman, settled in Java where he owned a flourishing sugar factory. John was to lose everything in unsuccessful property development though he continued apparently successfully as a miller and Thomas made some headway as a baker and confectioner in Hull. There is little doubt that Esther's education and training while with her brother, as brief as that period was, gave her insights into a better life which she wanted her sons to achieve. Of them all, only Thomas may be regarded as not particularly successful but, thanks to Esther's loving support, he survived the vicissitudes of a less than flourishing business and four marriages, one at least proving to be very unwise, with this fourth wife dying in the Hull poor-house.

The shape of things to come

It must be admitted that we really know nothing about William Etty's childhood. It was said that he suffered from small-pox when very young and that his face bore the scars throughout his life. Ordinary people with no expectations of fame do not compile records and at a time when writing was difficult even for those with a smattering of education, letters were usually few and short and seldom saved. There are many letters to and from Etty which have survived from his adult life but his own family were not natural letter writers and whatever written records might have been initiated in his early years are not now available. Biographers are often curious whether their subjects showed any early promise in their later skills and Gilchrist tried hard during his researches in 1855 to find some explanation for Etty's artistic abilities but even though he met men and women who had known Etty he could find little to enlighten him. He claimed to have seen some drawings or copies of drawings made by Etty's uncle William which he suggested indicated that talent for art was present in the family. Much of Gilchrist's second chapter is given over to these speculations. Uncle William became a partner in the Bodley family's gold lace business in London but whether this was due to his skill as a designer or as a businessman is not recorded. Gold lace had become a fashion necessity among the wealthy and fortunes could be made. Probably lace design appealed to him and Gilchrist was correct to assume some artistic ability but it is reasonably clear that if this were so he did not continue to draw. The Bodleys were a successful business family who apparently originated in Hull. Uncle William joined the branch that moved to London and here they not only traded in gold lace but were also reputed to be bankers which probably meant that they were no more that reputable moneylenders operating from their home in Lombard Street, a not uncommon practice.

It used to be thought that Uncle William had married Bodley's daughter, Elizabeth, but this is now known to be erroneous. Tom Etty of Nijmegen has traced William's marriage to Elizabeth Hankes of Lambeth. The marriage is recorded in the Parish Register for St. Dunstan in the East[19] as taking place by license on the 26th March 1772 between William Etty, bachelor, of All Hallows Lombard Street and Elizabeth Hankes, spinster, "of this parish," with Samuel Hankes and William Smith as witnesses. Neither the names nor professions of their respective fathers are recorded and the space for "other relevant information" is also blank. Probably Elizabeth's father was Richard Hankes and that William Smith attended as witness on William Etty's behalf since his father could not be present.

Though Uncle William did not marry into the Bodley family, one of his daughters in due course did. Tom Etty of Nijmegen has always been curious as to how William became a partner in the Bodley firm and especially how he was able to have sufficient money so early in his career to offer Matthew and Esther a dowry in 1771 when he was only thirty years old. Certainly marriage into the Bodley family would provide an explanation to both problems but this was clearly not the case. Who Elizabeth Hankes was and how William met her remain a mystery. Elizabeth's parents, Richard and Ann, had married in Stepney and she had been born on the 5th March 1748. Certainly uncle William's partnership in the Bodley firm resulted in further advantageous contacts between the families. The young William (the subject of this book) often visited the Bodley family when he was later an apprentice in Hull, which suggests that the Bodleys came from that city. Later, Thomas Bodley married uncle William's daughter Martha. Much later Etty wrote a letter to Tom suggesting that Robert Purdom, who by that time had married brother John's daughter Catherine, should visit "Doctor Bodley" because he was ill. Both Tom and Robert were then living in Hull so it appears that Bodley senior was not only himself living in Hull, probably a native of that city, but was a medical practitioner. The Bodleys' connection with Hull also offers the further suggestion that Matthew Etty may have had some earlier knowledge of them since he seems either to have spent some time in Hull as a Methodist Sunday school teacher or to have had a pupil, a "William Pack," who himself either lived there or moved there

to work. These conjectures, though interesting, do not greatly affect our story except that we shall encounter "William Pack," or a relative, again.

Gilchrist reports[20] the stories relayed to him that the young William drew on any available blank space, including the floor-boards in his father's shop or mill. In his brief *Autobiography*, published in two instalments in *The Art Journal* in 1849, Etty referred to his own early efforts with pieces of chalk or charred sticks—his attempts to make charcoal—and his first drawings on whatever material was to hand.[21]

> My first panels on which I drew were the boards of my father's shop floor; my first crayon, a farthing's worth of white chalk: but my pleasure amounted to ecstacy when my mother promised me that next morning if I were a good boy, I should use some colours mixed with gum water. I was so pleased I could hardly sleep.

Dennis Farr records an anecdote, "handed down in the family,"[22] that, when sent to deliver gingerbread and cakes to customers, the young Etty would stop to draw on the paving-stones. Etty himself recalled that a Mr. Hadon, a local tradesmen who bought his father's gingerbread, had once asked him to draw a horse and had given him a penny for doing so, also recorded by Gilchrist.[23] Later Etty referred to Mr. Hadon as his "first patron." Another such was a Mr. North who sometimes gave him halfpennies to buy chalks and let him draw on the iron sheets in his workshop.[24] Later in his childhood, his brother Thomas, then earning his living as a seaman, brought home for him a box of watercolors, the first proper paints he ever had.[25] All these stories can surely be safely accepted. At this distance from events there can be no other sources than Gilchrist and Etty himself for accounts of his childhood activities and interests.

In 1793 brother Tom was sent to Whitby to be apprenticed to John Chapman, a local ship owner, and from that port he sailed on whaling ships. After being shipwrecked he served in 1800 on a coastal trader to the Baltic where the whole crew was captured by Russian forces while loading in the port of Riga. The Russians had been allies of England against Napoleon but Tsar Paul I, believed now to have been insane, changed sides in November 1800 and so Tom Etty and his colleagues were prisoners of war. They were marched 150 miles to Fellinn in Estonia where they spent the winter in appalling conditions. Paul I was assassinated, his son Alexander I succeeded to the throne and Russia returned to fight alongside England. The captured crew were marched back to Riga where they arrived on the 19th May 1801, though unhappily lacking many companions who had died in the meantime. The ship continued trading and returned to Whitby in November 1801. A local Whitby historian, Rosalin Barker, published in 1992 an account of this episode entitled *Prisoners of the Czar*, based on Tom's own journal and the log of the ship on which he served.

After this Tom renounced life at sea, became apprenticed to his father as a baker (as was also John at this time) and in 1807 settled in Hull. William was only 14 years of age when Tom returned to England in 1801 and had already been in Hull as an apprentice, as shall be seen, for the previous two years.

Gilchrist also relates[26] that the young Etty would "stand entranced and sketch" the prints displayed in the windows of Todd's bookshop in Stonegate, York, and study "the busts at a 'sculptor's' window in Lendal" and look at "the Chinese figures and painted chests of the grocer, whither he was sent for Tea." Trevor Fawcett quotes these references[27] without question in his *Rise of Provincial Art—1800–1830* but they must surely have been pure speculations on Gilchrist's part, based on his observation of these places when he visited York after Etty's death. Certainly, as Fawcett says, these were the ways by which aspiring young provincial boys became familiar with the world of art. There were few collectors like Sir George Beaumont willing to open their doors to aspiring artists and even in London the young Turner relied on displays in the print shops. The standard of work these provincial boys saw would not have been of high quality. Even occasional exhibitions of local work would have afforded no idea of the kind of painting that the London market required. Although York had attracted artists producing top-

ographical scenes from the time of Francis Place and Wenceslaus Hollar at the very end of the seventeenth century, the city did not become a center for artists to visit until the final decade of the eighteenth century.

The earliest recorded exhibition in York was in April 1827 when John James Audubon brought his watercolors of birds on tour. The curator of the York Museum told Audubon that York was too poor a city to subscribe to the book he planned. When regular exhibitions of works of art were proposed, the *Yorkshire Gazette*[28] considered that they would be successful only if they coincided with the Assize and Race weeks when large numbers of outsiders came into the city. When Etty's friend the architect John Harper arranged an exhibition in York in 1836, the lack of support discouraged any idea of repeating the event. York's experience of public indifference was not unusual. Many other provincial cities had similar difficulty in mounting exhibitions. When the public did support exhibitions they seemed to favor the unusual and entertaining. In March 1829 a local York glass painter, T. Powell, successfully exhibited a diorama of six views on glass depicting dramatic landscapes. These events occurred well after Etty had left York. There are no records of such exhibitions during his childhood. York was not a place to encourage a love of fine art among sensitive youth. But the times are full of instances of determined children embarking against all the odds on unusual careers.

Apart from fortuitous encounters with examples of plaster casting, not available in every provincial town, Etty's only other likely source of knowledge of the visual arts was through book illustrations. By the mid–eighteenth century there was an increase in the publication of popular literature and especially of novels. By the end of the century the novel was well established and most were published with engraved illustrations, though not always of good quality. It may seem unlikely that Etty's parents, hardworking shopkeepers with a mill and a bakery business to manage and, moreover, with strong Methodist convictions, would spend money on fiction or time on reading it but most families that could read possessed a copy of Bunyan's *Pilgrim's Progress* and probably of Milton's *Paradise Lost* and *Paradise Regained* and also of Defoe's *Robinson Crusoe*. The appeal of *Robinson Crusoe* lay in its confirmation that savages were interesting, quaint but definitely inferior beings. Friday was not equal to Crusoe but his servant. These books could safely be read by children, always assuming they could get beyond the first lines of Milton. In fact, a bowdlerized version of *Robinson Crusoe* was printed for family reading to avoid references to Friday's nakedness. Illustrations would have been similarly treated. Novels such as Richardson's *Pamela*, of 1742, were more doubtful. The heroine *was* outstandingly virtuous and her employer Mr. B. was converted by her example. The novel appealed to women and clerics but the account of Mr. B. watching Pamela undress would not have been acceptable. Frances Hayman's designs were outstanding examples of superior illustration, as were all his designs for books, and so long as virtue triumphed and the pictures were uplifting such novels could be admitted into the home, even if only after careful trimming.

There was always Shakespeare, in one form or another, but enjoyment of his plays required a certain erudition not generally acquired by the ordinary reader. Charles and Mary Lamb published their *Tales Founded on the Plays of Shakespeare* in 1807, intended for children and therefore retold in suitable terms. These proved to be the version that adults also preferred. At the beginning of the century Mr. Thomas Bowdler was very active, his *Family Shakespeare* appeared in 1818, joining other works he had censored. In his version, young women could weep over *Romeo and Juliet* without any risk of following their example. Words like "breast" or "bosom" were amended to "chest" and whole passages were excised so that often plays, such as *Measure for Measure*, entirely lost their meaning. All this was well before Victoria's accession. Much attention was now paid to book illustration and most writers expected their works to be suitably embellished. Hubert Gravelot (1669–1773) introduced the French *rococo* style into England when he came here in 1733. He returned to France in 1746 with an alleged fortune of some £10,000, having obtained a reputation of a most ingenious draughtsman among the serious collectors. His plates

continued to be used long after he had left despite their becoming increasingly worn. In the 1860s they were decorating porcelain by the newly invented method of "transfer printing."

Well before this time English illustrators were copying his style but the subjects of English fiction were usually quite different from those of the French. Although women were the most eager readers of novels many were barely literate and had to struggle to manage more than the simplest text. In any case, fathers usually wished to supervise their daughters' reading. Novels had to be suitable for reading aloud within families, an evening task undertaken by fathers and brothers. Amusing domestic incidents were preferred subjects. Goldsmith's *Vicar of Wakefield* with its deceptive simplicity was immensely popular and its incidents and illustrations provided inspiration for numerous paintings of domestic genre and established a style of art extremely popular in the nineteenth century. Illustrated fiction was variously received. Most people welcomed illustrations as assisting the understanding of those whose imaginations needed stimulating. Others disapproved because illustrations might over-excite the imagination of young women. A more serious disapproval was that illustrations fixed images in the mind so that the imagination was constrained. This was still the age of monochrome reproduction and when works of art were reproduced the results were totally inadequate, especially if still dependent on engravings. But, as we shall later discuss, the acceptance into middle class families of illustrated books encouraged the development of new subjects in the fine arts.

We know that the young Etty tried his hand at genre subjects but these did not appeal to him. Poetry was increasingly read and usually illustrated either with lovelorn heroines or scenes of nature. Figures were often clothed in classical robes but increasingly in contemporary costume though fashions were frequently of a previous generation. Thomas Stothard, to become an admired associate of Etty, was a prolific illustrator of popular novels and poetry collections. By his own reckoning he produced some five thousand designs, with his clear line pleasing the neo-Classicists and his sentimentality appealing to the Romantics. There were by 1800 innumerable travel books illustrated with topographical views often by well established artists but we have no reason to suppose that Etty's parents bought these though probably uncle William and, later, brother Walter, accumulated a collection of contemporary books which the young Etty might have seen when he went to London.

It is equally unlikely that Etty's parents bought the magazines and journals that were increasing published, some of them illustrated, but they seem to have been sufficiently liberal minded to allow us to surmise that they could have admitted the more virtuous stories. In none of these would the boy have found those subjects which he was later to make his own. It is far more likely that he encountered only children's books, Bible stories, moral tales and traditional stories for the young, all illustrated with simple wood blocks. Before 1800 these books were mainly instructional, seeking to implant a general Christian morality, patriotism and sense of duty towards others through simple stories often based on traditional folk-tales. The quality of illustrations varied from crude wood blocks to technically accomplished engravings, some produced by such renowned artists as Thomas Bewick who was the first illustrator of this quality to produce a picture book for children in 1767. These books must have been enough to ignite in the young Etty the spark of ambition to become an artist himself. It may be that when later, as we shall see, his parents apprenticed him to a printer, it was his interest in books that led them to believe that this was to be the right career for him.

Education

Little is also known of Etty's education. In late eighteenth century England education as a necessary preparation for life was largely confined to the sons of the more affluent classes. Some enlightened fathers had their daughters educated, though the standards on offer to girls were inferior, but most parents believed that an educated woman scared off suitors and that a stable

marriage would prove unlikely since men generally did not like opinionated and informed wives. Most boys who received an education hoped to proceed to university, i.e., either Oxford or Cambridge, both of whom traditionally prepared graduates either for the Church or the Civil Service, unless, of course, they preferred, as many did, to live in idleness on their inherited estates. Preparatory education was received in those endowed grammar schools which had survived the Reformation or in schools endowed by enlightened philanthropists. Etty's class depended either on charity schools, usually provided by religious institutions, or on small establishments, often called "Academies," run by individuals, usually impecunious parsons or those who had failed to gain any professional preferment.

The poor were totally illiterate, learning just enough, if they were fortunate, to follow a trade or to become servants without being literate or numerate. Otherwise they joined the majority who scraped whatever living they could by doing odd jobs or, more often, resorting to crime. To counter this drift into ignorance and crime Robert Raikes (1736–1811) had established his first Sunday School in Gloucester in 1780, though he was not the true originator of these schools. Attempts to educate the children of the poor had been made in the seventeenth century and again by John Wesley in 1737. But Raikes' efforts were more lasting though it was not until the nineteenth century that his hopes were fully realized. In addition to religious instruction, Sunday Schools often taught basic literacy and simple arithmetic but these would have been insufficient for the career that Etty's parents had in mind for him. That Etty, the son of a baker, had any formal education at all must be regarded as exceptional. We may see the hidden hands of uncle William and brother Walter once more at work, paying the fees.

At a very early age the young Etty went to a Mistress Mason in Feasegate who either ran some kind of dame-school or looked after children. Gilchrist suggests[29] that he was sent there because the school was close to hand and cheap. No doubt, but it must be assumed that Matthew and Esther treated all their children similarly and Walter, John and Thomas had also been given some education. Certainly Walter was an educated man and John would not have been able to embark upon property development schemes without being both literate and numerate. Of Thomas we know very little but a shopkeeper needed similar skills. He had sufficient ability with words to keep a lucid journal while in captivity in Russia. Etty's attendance at Mistress Mason's establishment, whatever it was, though very probably only a child-minding arrangement, must have been when he was very young because later he went to a Mr. Shepherd in Bedern, behind Goodramgate. Once again we must assume that his brothers had been educated similarly. All this was a drain on the family finances but it is a tribute to the parents' concern for their children that they appreciated the value of learning at a time when it was not usual for children of poorer families to be educated. Bedern was then an area of impoverished respectability where men of small learning made a living teaching the sons of tradesmen. Between Etty's childhood and Gilchrist's visit in 1855 the area around Bedern depreciated very severely. Gilchrist described the area.[30]

> Then, a respectable, old-fashioned court of Schoolmasters; now, one of the most disreputable purlieus of York; where flocks of Irish and others herd, thirty or forty to a room. The once grave and quiet court of solid Seventeenth and Eighteenth-Century houses, where, for years since, the schoolboy loitered, is now enlivened by groups of shameless women, yelling and fighting in detachments, to the admiration of bystanders.

Gilchrist said that instruction was limited to reading and writing but, again, one must assume that some simple arithmetic at least was taught. He found someone, "a working carver and gilder named Binnington," who had been a contemporary of Etty's at Bedern.[31] This man described Etty as being about 8 or 9 years of age, "still, and timid and more like a girl or an old man than a boy" and frequently teased by his fellows with Binnington, so he claimed, "standing up for him." Even at this young age, Gilchrist's informant said, Etty was "sketching much in his copy-books." Everyone Gilchrist met appears to have recalled that Etty was "shy and

reserved." He goes on to say that the boy Etty had "a large head, sandy hair, and plenty of it, 'standing all ways,' above a face which the recent scars of small-pox had done little to embellish." Etty's large head was sometimes commented on later in life. Binnington claimed to have known Etty in his final years and said that his face was little altered, "there was the same look." After Etty's death his niece, Elizabeth, brother John's daughter always called "Betsy" (of whom a great deal shall be heard in due course), married a chemist named Stephen Binnington. One wonders whether the two men were related and that Etty had maintained contact with his boyhood friend, though nowhere recorded, and that it was through him that Betsy met her future husband or if not the man himself perhaps a relative. Gilchrist does not refer to Betsy after Etty's death and seems to have no knowledge of her marriage in May 1850, five years before his own visit to York. It seems unlikely that he did not interview her.

Etty attended the Bedern school for two years only until he was ten years old. He then went to an "Academy" in Pocklington under a Mr. Hall.[32] We do not have to rely solely on Gilchrist for this information since Etty himself referred to this period of his life (though not in his *Autobiography*), often visiting Pocklington when he stayed in York. At "Hall's Academy" he was a weekly boarder. It was a curious establishment since he had to provide his own food, which he brought from home after each weekend. There were actually eight of these so-called "Academies" in Pocklington at the time, each owned by someone with only modest academic abilities. Education seldom amounted to more than mastering basic grammar, reading, writing and arithmetic. So many "academies" could not have restricted their pupils to sons of local tradesmen, Pocklington being but a small country market town. Probably some of the minor gentry in the area sent their sons. However we know nothing of Mr. Hall and we can only assume that Etty's parents came to know of him during their short stay in Pocklington and decided that his was the most suitable, and no doubt the cheapest, school for their son, superior to anything they could afford in York. It seems very likely that Mr. Hall taught more than basic grammar since Etty was reasonably well read and although not educated in Latin, as many young men from the gentry were at the time, he was not unfamiliar with basic classical learning. Advertisements placed in newspapers by local schools seldom included Latin as one of the subjects taught. Most promised reading, writing, arithmetic, bookkeeping and "the globes," i.e., geography and basic astronomy, since many boys would probably go into either the army or the navy, or merchant shipping as Etty's brother Charles did.

Etty spent only two years at Pocklington and then, on 8th October 1798, aged just over 11 years, he went to Hull to begin his apprenticeship as a printer. It is very possible that Matthew and Esther believed that living away from home each week would develop their son's character and fit him for eventual apprenticeship. A reserved and timid boy used to being comforted at home every day was in need of "toughening." His education was probably planned to this end since a printer needed to be fully literate. Matthew and Esther must certainly be credited with putting their children out into the world equipped with the best advantages they could manage. Later, in November 1838, when Etty passed through Pocklington on his way to friends at Givendale he found that "the School House, in which I first imbibed Master Hall's lessons ... [was] no longer to be seen."[33] His memories of Pocklington were not unhappy. He frequently visited the place where "poor John Calverley, the ingenious, planning, and benevolent Uncle Calverley" had lived, the only members of Esther's family who had maintained contact with her. Possibly it was also this connection that had persuaded Esther and Matthew to send their son to Pocklington to be educated and perhaps, but this can only be supposition, the boy did not always go home to his parents at the weekend but found alternative comforts with his uncle. This could have been possible since later he fell in love with Uncle Calverley's daughter, the "cousin Mary" whose silent rejection so upset him as we shall in due course see.

Although there had been a long tradition of education in York when Etty went to school, York's educational opportunities had only recently started to recover from two centuries of neg-

lect. Edwin Benson concludes,[34] in his *History of Education in York,* that at the end of the eighteenth century York was even worse in this respect than it had been in the Middle Ages but he also shows that from about 1780 the position had been improving. Before the Reformation York had enjoyed a unique position due to the influence of the Minster since there had been a school attached to the cathedral probably as early as c. 627, founded by Paulinus. The famous Alcuin was headmaster there in 778 and though he left York in 781 to serve Charlemagne his reputation as a man of leaning continued to influence St. Peter's School well into the Middle Ages. Although education at the School was available only to the sons of "men of noble birth"[35] and concentrated on theology with philosophy and law as subsidiary subjects, this was customary at the time and continued to be so for centuries.

The number of churches in York in the Middle Ages—no fewer than forty-eight are recorded in 1377, most with their own song schools—ensured that many boys received at least a rudimentary education. This tradition was broken with the Reformation. York twice petitioned for the establishment of a university in the city, first in 1617 to King James and again in 1647 to the Commonwealth but neither petition received a reply. Probably the appeal that the north of England needed the benefits of learning because it was "abounding in popery, superstition and profanities, the fruits of ignorance" and the protestation that "we have been looked upon as a rude and barbarous people" did not encourage academics to leave the comforts of the south. The Reformation had closed many schools attached to religious establishments and nothing took their place over the next two hundred years. In the mid–eighteenth century there was a rapid gentrification of the city as the more affluent inhabitants of the countryside moved in, building town houses and taking an active part in the social life of the city. Their children had most probably been educated elsewhere, as they themselves had been before, but the following generation looked for schools nearer to hand.

The gradual rise of the middle class from the mid–seventeenth century onwards as a professional body of men had required more schools teaching reading, writing and basic arithmetic. As might be expected London saw the greatest growth but in many provincial towns there were more and more teaching establishments being set up by poor clergymen, widows and spinsters needing to make a living. York was particularly fortunate. Not only had the Corporation assisted the founding of the Blue Coat Boys' School and the Grey Coat Girls' School in 1705 but several charities had been established to provide schooling "to excite a spirit of virtuous industry among children of the poor."[36] It was being recognized that lack of employment often led to a life of crime. During the century several dissenting congregations set up Sunday Schools and soon found it necessary to teach reading, writing and simple arithmetic. Objections were raised to the teaching of secular subjects on the Sabbath but it was the general indifference of the people to whom the opportunities were addressed that gradually caused the schools to close.

York was probably exceptional among northern towns for the number of schools of one kind and another that were available by the end of the eighteenth century to parents who could afford to pay fees. It has been said[37] that between 1780 and 1833 there were at various times a total of 110 private schools in the city and of these at least thirty provided education for girls. Most would be run by single teachers with probably no more than twenty pupils each but it is unlikely many other provincial towns could have boasted so many. In Etty's case it is probable that his uncle William set the standard with his own success in London, though it must be admitted that his own swift elevation is somewhat unusual for the son of a country wheelwright. It must again be emphasized that Etty's mother's experiences as a child encouraged the family's expectations. While master craftsmen were by now educating their sons it was still not usual for small shop keepers to do so but perhaps Matthew Etty measured his position in society as that of a miller. We may also expect that Matthew would not allow himself to be surpassed by his brother. If William could educate his children so then could Matthew but probably not at the fees required in York, which were often one and a half guineas a week for non-boarders. It

is most likely that it was brother William and Esther that set the standards, with Matthew recognizing their value, and William providing much if not all the money.

Despite attending school, Etty was largely self-educated. It was in his apprenticeship years in Hull that he laid the foundations of whatever book-learning he possessed. Gilchrist refers to "the disadvantages of the exceeding slenderness of his regular education."[38] Of course, this is true, and Etty later regretted not having received a classical education, but however inadequate, his education did provide him with the ability to read and write and to express himself, an ability he was to put to good use in the many lectures he later gave. We know that Turner, certainly poorly educated, always had difficulty. His obligatory lectures to Royal Academy students were said at the time to be embarrassingly incomprehensible, whereas Etty, though finding public speaking burdensome, usually managed to express himself fluently. It is unlikely that he would have been accepted as a printer's apprentice if he could not already read and write with some accomplishment. Although English society was firmly based on a class structure it was not the strict caste system that operated on the continent. Social mobility was available to anyone who strove sufficiently hard provided he did not start at rock bottom with parents determined not to release him. The eighteenth century saw many young men climb upwards though it was less easy for women who for the most part had to follow what was called "the primrose path" if they sought some degree of wealth. Although some finished up as duchesses most did not get beyond the brothel. If young women coming from the country were lucky they might end their days as housekeepers.

Etty's close association with York as his boyhood home was now virtually over but the influence of the city of his birth remained with him throughout his life. Whenever there was any threat to his beloved city by the well-meaning but often ill-conceived plans of "improvers," Etty rushed in to defend the medieval walls and bars and streets and above all the building he most particularly cherished, the Minster. It is now less customary to encounter the view that art is entirely an autonomous activity uninfluenced by external events, neither by the character of the artist nor by the events which have shaped him as an individual. It is no longer heinous to propose that an artist is a creature of his time and place, with his art as much a product of his age as of his own nature or that this, in its turn, is also shaped by the surrounding influences of his life. The convention of declaring that we should look at "nothing but the paint" is now thankfully outdated. York was for Etty ever an acknowledged paramount influence and so important is York to our account of Etty's life that it is appropriate to consider that city in some detail.

CHAPTER TWO

"One of the fairest of England's cities"

So Alexander Gilchrist described William Etty's birthplace in the opening sentence of his biography. Gilchrist admired the city of York but not its inhabitants, whom he regarded as mean spirited and unappreciative of the great man who had given it so much. But it is true that no prophet is honored in his own land (or seldom so) and if York is today more a tourist attraction than a city proud of its history it is probably no different than any other town or city in the country. York, said Gilchrist in his following sentences, was "a queenly dowry of aesthetic treasure and Historic meaning." So it is still; a city with a diverse past and continuing architectural pleasures. Certainly, those who delight in living in this city know it as a place steeped in history with a wealth of buildings preserved as examples of every century.

Although York is mostly regarded as a medieval city its history as a center of importance goes back to the first Roman occupation in A.D. 71. It was a convenient garrison, then named Eboracum, for the legions whose task was to control the north. From this center of a wide plain they could move off in any direction as need arose. The river Ouse on which the fortress had been built was tidal up to this point and shallow draught boats could come up from the coast bringing provisions and military replacements. Eboracum was a small rectangular area with a bridge over the river to the south. The bridge subsequently disappeared and evidence for its existence has only recently been discovered. Later Ouse Bridge, originally constructed by the Danish Vikings, was the only river crossing until the building of Lendal Bridge in 1861. The fortress that the Romans constructed was probably the most splendid in Britain, being the headquarters of the *Dux Britanniarum* that commanded all the military forces in the country. It was in York in 306 that Constantine the Great was proclaimed Emperor by his troops. The Romans left in 410, or a little later, and with their departure what are now called "the Dark Ages" descended not only on Eboracum but over the whole country. The present work is not the place to discuss this title for the post–Roman period, which is frequently hotly debated. Numerous traces of Anglo-Saxon activity in the area have been excavated revealing a consolidation of urban living in a period of comparative peace. Called Caer Ebrauc, the township was really a Romano-British settlement still enjoying the comforts of Roman style living.

On Easter Day 627, King Edwin, who had married the Christian Queen Ethelburga, was baptized by Paulinus, who was already Bishop of York, in a small wooden chapel that may have been constructed on the site of the present Minster. Edwin did not live to see the first stone church completed and today we have no surviving remnants to reveal its nature. The early history of the Minster is uncertain. Egbert was the first to be recognized as Archbishop of York, from 732/4 to 766, and it was very soon that York became regarded outside England as a center of learning spoken of by the educated minority as *Altera Roma*. Here Alcuin was celebrated for his scholarship, so celebrated that he was summoned to Aachen by Charlemagne to instruct the leading members of his court. York's transformation into an ecclesiastical center of renown throughout Europe is today overlooked in the greater interest in subsequent events. The Viking

invasions of the ninth century changed everything. England had become the prey of land hungry Danes and in 867 they captured York after fierce resistance. They remained unchallenged for sixty years and in this time established an important trading settlement. Named by the Vikings Jorvik, from which the city's modern name is derived, the new settlement was quickly built up to the east of the former Roman garrison. Modern excavations have revealed that it was a place of thriving craft workshops and a market but it lasted only until 927 when the Saxon king Aethelstan seized it and the next twenty-seven years were consumed by perpetual fighting until the Danes were finally expelled in 954.

In the last week of September 1066, Harold was relaxing in York after the battle of Stamford Bridge, where he had defeated an invading force from Norway seeking to seize the crown after the death of Edward the Confessor. He repulsed another Viking invasion at nearby Fulford, then news reached him that another claimant, William of Normandy, had landed near Hastings on the south coast. He marched his troops hurriedly to repel the invaders but lost his life in the battle. With William's victory, life throughout England was changed beyond the recognition of those who lived through those times. The new king appointed Norman bishops and Norman barons and established a system of military authority based on castles and ecclesiastical administration centered on cathedrals which enabled him to rule a hostile people through loyal nobles, bishops often being granted civil titles. Everywhere local Saxon earls and their supporters rose against him. In 1068 William came to York to deal with an uprising there but the citizens quickly capitulated. William had a castle built on the confluence of the rivers Ouse and Fosse. Five hundred knights were left to garrison the city but in 1069 there was another rising and this time William built a second castle at Baile Hill.

But this was not the last problem that William had to face in York. In September 1069 a Danish force, having landed in the Humber, marched on York with English allies. The garrison left by William set fire to the city, which was mostly wooden houses, in order to deny them shelter but the fire got out of hand and destroyed virtually everything. The Danes took the city and William was forced yet again to march on York. He bribed the Danes to withdraw and then set about "harrying the North," as his violent retribution became known, resulting in the deaths of an estimated 100,000 people. The new city that arose from the fire was built on more ancient foundations and after only a year York again began to thrive, though it took several years for the recovery to be completed. City walls and gates were built and the river Fosse was dammed so that it would flood the lands to the east and provide a natural barrier. The castle that William built was renewed in subsequent years, the present Clifford's Tower dating from 1245 to 1262 being now the only part of the original castle to survive, and that was nearly demolished in the nineteenth century as we shall see. The citizens of York have always been ambivalent about their city, some even wholly uninterested, but all towns and cities have their history despite local attitudes which vary from time to time.

Today the most historic building in York, which all visitors wish to see (except those who come for the shopping), is the Minster. The present nave dates from 1291 and replaces an earlier structure whose history is varied and sometimes uncertain. These questions are not of concern. It is more to the purpose to emphasize the dominant influence that the Minster and its governing authority had on the city throughout the succeeding centuries. It was this influence that had so marked an effect on the young William Etty and which stayed with him throughout his life. Throughout the Middle Ages the city's religious observances were predominant features in the life of York's citizens. Mystery plays were performed annually for almost 200 years and were famous throughout the country. Although they have been revived they are no longer a regular annual feature. All Church festivals were celebrated with colorful processions when every householder was expected to hang out banners and decorations. There was much "pomp and circumstance." In the mid–sixteenth century, for example, the Dean of York was "invariably attended to the church on Christmas Day by 50 gentlemen before him in tawny coats garded

[*sic*] with black velvet and 30 women behind him in like coats garded with taffeta."[1] York, as the seat of the nation's other archbishop, was regarded as the second city in the kingdom. At its height in the Middle Ages, York had 48 churches within its walls together with friaries and other religious houses. After the Dissolution of the Monasteries, the London Alderman, Sir Richard Gresham, bought over 400 dwellings formerly belonging to York's religious houses, rented them out and channeled the proceeds to his business in the capital. Many such activities drained York and the north of its income but this example indicates the extent of wealth in the hands of the Church.

All Christendom in the Middle Ages was gripped by intolerance, especially directed against the Jews. In the final decades of the twelfth century there was considerable anti–Semitic agitation and York did not escape its effects. In March 1190 the Jews in York took refuge in the castle. The Sheriff ordered an attack and the building was set on fire with the result that some 150 Jews were either burned to death or committed suicide. York in these early years would not have been a pleasant place in which to live despite its growing affluence. All medieval towns were dirty and generally uncared for since there were no civic services to attend to such matters. Taxation for the general good of a community was unknown except when exceptional events required a special levy. York had a particularly bad reputation for its filthy conditions. Edward III, on a visit, declared it to be one of the most disgusting places in his kingdom. In common with every other city in the country, matters were not to be seriously dealt with until the nineteenth century.

Though York had received its first charter from Henry I (ruled 1100 to 1135) the English kings always viewed York and the north with suspicion because of historical claims to independence by that part of the country. Had the archbishops of York been willing to accept the primacy of Canterbury they would have reassured the kings and probably been granted a larger diocese.[2] At the time York could indulge its sense of independence. Its merchants were rich. York's fortunes depended on the wool trade and in the second half of the fourteenth century weaving provided most of the work with all its attendant trades. In the next century the trade began to decline as many of the mills were moved to the faster rivers of the Dales. The trade guilds were always conservative and resisted the introduction of new methods and restricted the entry of new trades and craftsmen. So York missed out on the mini–"industrial revolution" of the times. Here again we may recognize something of the conservatism that was a central part of William Etty's character. Some may say it was just the natural characteristic of Yorkshiremen who have a traditional reputation for unyielding determination.

The Black Death reached York in 1349 and subsequent outbreaks of plague in 1361, 1369, 1375 and 1391 accelerated the city's decline. There were plagues again in 1538, 1550, 1552, 1570, 1579, 1604 and 1631 and while divine causes were sought we today would look to the water supplies and the drains. The population fell but by the late sixteenth century was again rising. York had become politically important during the Wars of the Roses when the citizens decided to support Richard III who had already chosen the city as the headquarters of his Council in the North. England was under constant threat from Scottish invasions but, more seriously, English kings had always had difficulty in securing the full allegiance of the Percy and Neville families who controlled the English border lands, the Percys to the east and the Nevilles to the west. The future Richard III, while he was duke of Gloucester, formed associations with these families to control their activities. Even before his coronation on 6th July 1483, Richard had formally established the Council of the North which was required to meet every quarter in York to "hear examine and order all bills and complaints and other before them to be showed." The English geography and the centralization of political control in London made the north distant in every respect and this extension of the royal jurisdiction was essential if the north was not forever to harbor opportunist adventurers. There was already a Welsh Council established for similar reasons.

When Henry VIII broke with Rome and declared himself head of the Catholic Church in England there was turmoil throughout the country and particularly in the north where Roman Catholicism was firmly entrenched. The so-called Pilgrimage of Grace, at first intended as a peaceful march to London to persuade the king to change his mind, began in Louth in Lincolnshire in 1536. It soon assumed a more military character as Thomas Cromwell, speaking for the king, made it clear that such a proposal would not succeed. The movement rapidly spread and reached York in October of that year where a four day conference was held to decide future action. It has been estimated that between 30,000 and 40,000 pilgrims prayed in the Minster. This gives some indication of the strength of Catholic support in the northeastern counties. Both Henry and Cromwell sent assurances, which were soon seen to be false, which had the desired effect of dividing the pilgrims so that their subsequent military defeat was easily accomplished. The principal building that suffered from Henry's attack on the monasteries was the magnificent St. Mary's Abbey, built in the thirteenth century, that rivaled the Minster. Its remains in the Museum Gardens are testimony to the vandalism of the reformers.

After the Reformation the Council of the North met in the King's Manor, which still stands, until 1641. Attempts made between 1660 and 1664 to revive the Council came to nothing. In the Civil War Charles I moved his court to York for six months in 1642 but an alliance of the Parliamentary army and the Scots defeated the royal forces at nearby Marston Moor. York surrendered in 1644 and did not fight again. The Parliamentarians treated the city and its inhabitants comparatively well but there was some destruction of monuments and trade declined and buildings suffered disrepair for the rest of the century. The Minster authorities had continued throughout the Commonwealth to conduct Anglican services which the civic dignitaries attended, accompanied by perhaps most of the citizens, though on other occasions the Dissenters had sought to occupy the Minster. As part of the Anglican Church's campaign to re-establish the episcopacy after the Commonwealth, York succeeded in having confirmed its grant of a deanery. But in the ensuing years the Minster's finances were in dire straits, disputes broke out between the ecclesiastics caused for the most part by the difficulties being experienced by the Church nationally in determining the nature of its reforms. The Minster authorities particularly disliked James II's toleration of Roman Catholics. Successive archbishops generally accepted the many changes in church practice and they clearly followed the example of the Vicar of Bray in the early eighteenth century ballad who, after the Reformation, reconsidered his religious faith as successive monarchs acceded to the throne and boasted, in the popular satirical ballad, that

> My principles I changed once more ...
> ... and thus preferment I procured
> From our new Faith's Defender [and] whatsoever King may reign,
> Still I'll be the Vicar of Bray, sir.

Although after the Reformation York remained politically and ecclesiastically significant it rapidly declined economically due to competition from London merchants who traded directly with the continent. But it took nearly a century before York stirred itself to respond to the needs of a source of wealth that could regenerate the city. It seems that the city's notorious dislike of tourists has a long history. But there was much new money in the country and the leisured classes were growing. Many wished to escape from London in the summer and gradually new centers were established where, among other pastimes, young people could search out future spouses.

Horse racing was started on Clifton Ings in 1709 and moved to the Knavesmire in 1731 where it soon became an event of national importance. The Assembly Rooms, based on designs by Lord Burlington, were built in 1731 to 1735 and attracted many of the functions formerly held in King's Manor. In addition to race-week balls there were weekly functions and concerts throughout the year but the design, long and narrow with too many pillars, prevented the Rooms

from becoming the success they deserved. A theatre was erected in 1744 with Joseph Baker as manager. From 1766 it was managed by the famous Tate Wilkinson, to be replaced by the present Theatre Royal in the 1820s. The first theatre was recorded as "commonly called a granary but used as a theatre or playhouse."[3] This does not suggest a theatre of any consequence and its reputation was not of the highest, probably justifying the concern of the Minster authorities. Through his connections with the London theatres Wilkinson was able to attract leading performers so that under his management the Theatre Royal became regarded as the best of provincial theatres, though there were not many in those days. In 1730 the Corporation decided to lay out a tree-lined riverside walk to provide an attractive promenade for residents and visitors. This "New Walk," as it is still known, was described by the *York Courant* in 1754 as providing a prospect "not unlike nor inferior to any of the views of Venice." There were numerous public buildings erected in the century, the Debtor's Prison in 1701 (which may serve as a comment on the spendthrift lives of those frequenting the city), the Mansion House in 1726, Bishopthorpe Palace in 1763, the Assize Courts in 1773, the Female Prison (now the Castle Museum) in 1780, as well as innumerable private houses of considerable architectural distinction. The number of buildings connected with law enforcement suggests York's desire to be a safe and peaceful city for its new wealthy citizens though it is also true that as the only city of size in the Vale of York it drew its prison population from a wide area. It was a time of hope for the city which did not bring the lasting regeneration so badly needed. As Professor Patrick Nuttgens has written, "York ambled along sociably and complacently with barely a tolerant smile for its reckless neighbors."[4]

Unlike Bath, York could not attract the London nobility and functions usually managed to struggle along with civic dignitaries and professional men and their families and only a smattering of the local gentry. York's attempt to become the northern equivalent to Bath could only fail. York possessed no Beau Nash to direct its social life. In any case, one could not expect independently spirited Yorkshire people to obey the commands of anyone. Bath had the benefit of royal patronage but royalty showed little interest in the north. It was not until 1789 that the Prince of Wales visited York and cost the ratepayers a considerable sum in entertainment, as was his custom. It was too late for any benefits to accrue from this visit. Although public buildings and fashionable town houses were erected and new streets were laid out and many more proposed, everything was half-hearted. There was no civic conception that public money had to be invested to attract private money. Towards the end of the eighteenth century the number of aristocrats who lived in or visited York considerably decreased. Most took up permanent or at least long term residencies in London. The improved road system made London closer than before and though a journey might entail at least two days' discomfort with the further discomfort of a night spent in a less than hygienic inn with bad food, the capital was now regarded as within easy reach and worth the trouble of getting there.

Nonetheless York remained an attractive residential center for many of the northern gentry though the city's principal residents were now to be found among the professional classes. Many of these men (they were mostly men, the times being what they were) were interested in more intellectual pursuits than their predecessors; less card playing and drinking and dancing and more rummaging in book shops and meeting in literary and antiquarian gatherings. In 1794 a Book Society was formed so that books could be bought for members to borrow. It developed into the Subscription Library and was at first in Stonegate, then in Minster Gates and after 1811 in St. Helen's Square. Many of York's more intellectual interests had to wait until the nineteenth century to find expression. The York Philosophical Society was founded in 1822, occupying rooms in Low Ousegate and then, in 1827, obtaining a grant of the Crown land of St. Mary's Abbey where they built the museum which stands to this day. Concerts of secular music were held in the Assembly Rooms in 1823, 1825, 1828 and 1835. In response to this interest in music, the Festival Concert Rooms were erected in 1824 at the rear of the Assembly Rooms and was successful as the venue for many events ranging from concerts to public lectures. Thackeray lectured

there in 1857 and Dickens read his *Christmas Carol* there in 1858. The British Association held some meetings in the Concert Rooms in 1881 but a better appointed building had already been built in Exhibition Square, later to become the City Art Gallery. The Concert Rooms were demolished and to this day there is no building in York dedicated to public concerts, although possibly the University may claim this role for its Central Hall at Heslington. In 1827 the York Institute of Popular Science, Art and Literature was founded, at first in Bedern and then moving to St. Saviourgate. None of this, not even the music concerts, brought much money into York but it did increase the city's respectability. Many of these developments Etty did not live to see.

By the end of the eighteenth century, at the time of Etty's boyhood, York's general condition was such as constantly to give the city fathers great concern though very little incitement to radical thinking. The city was still small, with a population of some 16,800, and without any means of generating local wealth, being principally a market town set in the midst of the Vale of York many miles from any other town of size. The city had always been small; in the early sixteenth century its population was around 8,000 and by the end of that century the population was estimated at 12,000, at which figure it more or less remained until the mid–eighteenth century. Then a burst of commercial activity increased it to about 17,000 by 1801. York seems to have been a city that rubbed along as best it could relying on its historical significance as the seat of the Archbishop and its appeal, in the preceding century, to the lesser aristocracy and gentry who lived on their estates outside the city. It must have seemed to the more discerning citizen, though there do not appear to have been many of them at the time, that York was a city of whom it could be said ironically that it had seen better days. As Gerry Webb remarks, "It is probably no exaggeration to say that York owes the preservation of so much of its heritage ... to the lethargy and incompetence of many centuries of local government up to very recent times."[5]

Nevertheless York exercised a new charm. Charles Knight in his *History of the City of York* states that[6]

> the social fashions which characterized the Restoration period brought about permanent changes in the atmosphere of the life of York. Commercial considerations became definitely subordinated to social requirements. Unvaried, unadulterated country life ceased to charm wealthy country residents; the dear delights of fashionable life—assemblies, balls, theatres, card parties, wit, gossip, scandal; in one word, Society—had attractions and values for which the countryside in winter offered little substitute; and a town season became a *sine qua non* for everybody who aspired to be somebody, and could find cash or credit to obtain it. London was too remote; but York, the traditional social centre [sic] of the north, was available.

At the beginning of the nineteenth century there was a small luxury market both within and outside York but its main employment was in domestic service, never well paid. York was very much a divided city with a minority of gentry indifferent to the conditions of the poor. The appeal of picturesque Gothic to those who gathered round the Minster establishment prevented any sensible debate on the future of the city. The general determination was to preserve the *status quo*. Though several new streets of houses were built for those who came into the city with sufficient money or, more often, new frontages were built on to old dwellings, the city's prosperity was short-lived. London was the greater magnet and new roads and faster coaches drew the wealthier southward. York lapsed back into tranquility. This became its chief appeal to visitors.

The York of the decades before Etty's birth was a city trying somewhat half-heartedly to establish itself as a place where the gentry could live in sheltered, respectable refinement. It was hoped by the Corporation that the gentry would spend enough on luxury goods to encourage the growth of a trade more devoted to their needs. To some extent this succeeded but not as much as it would have done had the Corporation initiated more public works directed towards making York a city attractive to the wealthy. Certainly it had laid out New Walk and

had contemplated street improvements, always difficult in a medieval city, and had permitted the construction of the Assembly Rooms and the Theatre but by the 1770s the city was still regarded as dull and lacking in suitable entertainments.

One of the reasons was the attitude of the Minster authorities who exercised considerable influence and did not welcome change. They came into dispute with the Corporation of York on a number of occasions in the century because they feared the Corporation was likely to assume powers to license activities which the Minster authorities feared would present opportunities to attract enterprises they did not wish to see introduced. For example, in 1735 the Minster authorities successfully had petitioned against the licensing of play-houses by the Corporation and cited the case of a group of actors who had been allowed to perform plays, protesting that they were "reputed papists."[7] But much more important was the general antagonism throughout the century and afterwards by the Minster authorities to the Corporation's many schemes for "improving" the city. Sometimes the Minster was correct in its opposition and sometimes it was not, but its attitude was generally regarded as a constant irritant. Etty was later to enter into many of the disputes between the Minster and the Corporation but more particularly in opposition to the Corporation's plans to "improve" the city by demolishing many of the medieval remains because they were often sited in areas of deprivation which harbored petty criminals. It must be admitted that Etty, with his love of all things medieval, was among those who wished to keep York embedded in the past. York was not and still is not a city without divisions, between those who wish to retain the past and those who would sweep everything away and build something "modern."

While the Church continued its traditional role in the city there was a growing body of religious dissent forming among the lower classes who may be called, as they later were, "the respectable poor" and also among sections of the middle class. The Society of Friends had established a Meeting House in Castlegate in 1673. This remained until they erected a larger building in 1818. John Wesley visited York on at least twenty-seven occasions and in 1759 the Wesleyans erected the Peaseholme Green Chapel. In 1797 the Methodists seceded from the Wesleyans and in 1805 built a chapel in New Street large enough to hold 1,700 persons and in 1815 built yet another in Skeldergate to hold a further 1,000. They were the largest dissenting body in York. As the center of Anglican orthodoxy the Minster authorities should have been concerned by the spread of these groups but as far back as the Restoration the Minster stood aloof from these expressions of popular dissent and it is recorded that even at that time some aldermen's widows moved over to the nonconformists without any noticeable reaction. Dissenters never seem to have bothered the Minster authorities very much; apparently regarding their activities as no more than irritants by ill-educated ranters.

But these religious groups had an effect on the young Etty. Although his parents were Methodists he apparently found the services uncongenial, breaking with their faith as a young man and regularly attending Anglican churches whenever he could. The traditional liturgy, especially conducted in Gothic settings, greatly appealed to him. He was later to express severe disapproval of all Dissenters whom he seems to have regarded as ill-educated rabble rousers along with Chartists and other political reformers. Etty never forgave the reformers who had dissolved the monasteries or the Commonwealth iconoclasts who had destroyed the monuments and statues of the saints.

York remained indifferent to the greater changes taking place nearby. The new industrial entrepreneurs were establishing water-driven mills in the Pennines and on the rivers of the West Riding. York's only industry of note, the small glass factories, became more commercial while cocoa and chocolate making offered new employment opportunities but little else happened until the advent of the railways. This, it must be admitted, was largely due to the enterprise of one man who became both chairman of the railway company and Lord Mayor of York and was thus able to arrange with himself all that he wanted. There is in the railway archives a legal document

in which Thomas Hudson as Lord Mayor granted to Thomas Hudson the Chairman of the railway company the right to construct an entry through the city walls in order to build a rail station. Allan Armstrong[8] placed the blame for York's lack of economic development upon the nature of the grants and charters bestowed on the city in the medieval period. The eighteenth century historian F. Drake wrote[9] that

> our magistrates have been too tenacious of their privileges, and have ... by virtue of their charters ... locked themselves up from the world and wholly prevented any foreigner from settling any manufacture among them. ... The paying of a large sum of money for their freedoms with the troublesome and changeable offices they must often undertake would deter any person of enterprise from coming to reside in York.

Such complaints continued to be expressed throughout the century but successive Mayors and Aldermen, who for the most part were protecting their own commercial interests, persisted in demanding that businesses could be established only by freemen of the city who had to pay a fee to be admitted. They also had to undertake certain civic duties without remuneration or pay a fine to be exonerated from these duties. By 1833 it was being officially admitted that these conditions amounted to a restriction of trade within the city and in 1835 the Municipal Corporations Act withdrew the power to impose them. York's Company of Merchant Adventurers also insisted on the full implementation of its charter granted in 1580 which restricted to its members the sole right to sell goods imported from overseas (except salt and fish). A court case in 1827 set this restriction aside. A history of such deterrents to free trade had kept York relatively impoverished. By 1830 the West Riding towns were thriving centers of industry and York had lost out for good. Many citizens were openly satisfied that it had not joined the industrial revolution and while York escaped the consequent pollutions of industry and the grinding poverty of factory workers, it also missed the rapid increase in wealth that would have accrued to a good proportion of its citizens. For the most part those towns that attracted manufacturers had grown from villages without restrictive corporations and guilds, their attraction being in the first place an available water supply to power the machinery. The *York Herald* complained on the 26th May 1827, "We have no manufactures, we have no complicated machinery in operation; we have no weavers, no dyers, no shipbuilders, no mines."

While this was true in 1827 by the mid–1830s several important, albeit small, manufacturers had begun to operate. The York Flint Glass Company was established in 1835 and William Walker was now attaining a national reputation for his ornamental iron work, in due course being commissioned to provide the gates and railings for the British Museum.

Of course, today the citizens of York may be rightly pleased their city was not industrialized but a little more initiative would have laid the foundations of a flourishing economy. The professional classes of the nineteenth century appear to have consisted of many lawyers and doctors, the former due to the holding of the Assizes in York and the latter no doubt due to the city's poor sanitation. There seemed little point in establishing a Mechanics' Institute as was being proposed at the beginning of the nineteenth century. York was but a city of small family businesses. Even as late as 1851, when the total population had increased to 36,300, only some 16,000 were regarded as economically active (which included those currently unemployed but seeking work); 3,170 were then engaged in manufacturing; 2,440 in making and dealing in clothing and shoes (mostly shopkeepers); 1,220 in building construction and 1,130 in transport, of whom only 420 were employed by the railways, which is surprising since York was then a railway center constructing rolling stock; 2,800 were in domestic service with 910 in "other services" which included 560 in inns and similar establishments. The 1851 census revealed 900 "professionals" of whom 290 were in education (a tribute to York's standing in this field) and 150 were listed as "medical." There were 770 laborers and only 100 clerks. As C. H. Feinstein, who compiled these figures, remarks, "The structure of occupations was still very much that of a pre-industrial town, with an exceptionally large number of domestic servants ... and shopkeepers."[10]

Even these figures are considerably larger than those revealed in the 1831 census. Much was to change over the rest of the century but what must strike any investigator is the perhaps surprising fact that of a total population of some 36,000 only 16,000 were regarded as economically active. Of course, the total figure includes children but the proportion of non-employed (as distinct from unemployed) was surely high. It is not intended here to engage in a demographic survey of York. It is the appeal of York's historical and architectural heritage that is of concern just as it concerned Etty; nevertheless the general nature of the city of York at the time of his childhood must be understood, as both its condition and its history had a lasting effect upon him and very much influenced his affection for his birthplace and its medieval past.

As Richard Green, former curator of the York Art Gallery, has stated, "Before the restoration of the monarchy in 1660 there was little taste for Gothic architecture and there was no appreciation of the irregular character of the City with its maze of twisting streets and crooked timber-framed houses."[11]

When, over a century later, that intrepid tourist Celia Fiennes visited York, while she admired the Minster (as much for its size as anything, as Green comments), she thought little of the City itself: "...a meane appearance, the Streets are narrow and not of any length, and the narrowness of the streets makes it appear very mean ... the buildings look no better that the outskirts of London" (quoted by Green). Celia Fiennes preferred the approaches to the City because there "you see the towers of the gates and severall Churches in compassing the Minster and all the Windmills round the town, of which there are many."

Things were reckoned no better in 1812, when an anonymous "Young Lady" wrote a Diary of her visit to York. She complained[12] that the company was "chiefly ladies," and the streets "too narrow to be handsome," and that "this town [is] generally counted dull." She had obviously expected another Bath and was disappointed to find no young sons of titled families looking out for wives. But not everyone came to York seeking affairs of the heart. One traveler at the turn of the century remarked,[13]

> Everything has a quiet, pleasing and becoming air ... there is nothing about the place to indicate poverty or decay ... there are fewer beggars than in London, Manchester, Glasgow or Newcastle. The people, like the city itself, seemed all to have a decent and orderly look.

But, as this traveler adds, anyone staying with affluent friends and interested mainly in York's antiquities would be unlikely to visit the areas around Walmgate or the streets serving the river, all notorious for their thieves and prostitutes. The young Etty probably did not know much of these areas either. His parents would have protected him from contact with such places and such people. Certainly he never seems to have been sympathetic to "the lower orders." But in this he was typical of the general attitude of the middle classes and especially of those who had risen above the level into which they had been born. For them "God was in His heaven and all was right with the world." The turmoils of the sixteenth and seventeenth centuries were long forgotten, the excesses of the Prince Regent were stories of far away events and revolution had been safely confined to France. But these are subjects to be considered later. For the present the boy had his ambitions and his way to make in the world but his ideas had already been shaped by the history of his native city.

"Servitude and slavery"

Beginning an apprenticeship at 11 years of age was not unusual. Most boys of Etty's class would merely have followed their fathers' trades, learning as they worked. But if a young man was to achieve fame and fortune he had to aspire to more remunerative employment than tenant farming and shopkeeping. Generally the only way to do so was to enter an apprenticeship with someone in his chosen field. This entailed working for seven or more years without wages

in what was customarily regarded as "genteel servitude." Moreover, it also entailed paying a large premium for the privilege. Most trades did not require such a long period of training but it enabled the employer to obtain years of free labor which would be repeated with successive apprentices. The system had been introduced by the medieval guilds to control recruitment into trades to prevent over-provision and consequent lower rewards. In Etty's case we may suspect that his mother had ambitions for him assisted by promptings from Uncle William. Indeed, knowing as we do that Uncle William gave Etty financial assistance in his early years, he may well have paid for his nephew's education and his indenture fees when he began his apprenticeship. Once indentured an apprentice could not leave the service of his master without the payment of an extortionate fine. So Etty was, in effect, bound into slavery and that was certainly how he viewed it.

Life in Hull was not only unfamiliar to the young Etty but also uncongenial after the comparatively gentle pace of life in York. The city of Hull lies at the confluence of the river Hull and the Humber estuary. Its correct title is Kingston upon Hull though this name is seldom used except in official announcements. The town's importance as an east coast port was first recognized by Henry VIII who visited it and ordered the construction of a defensive castle against possible invasion. The Humber had been a principal route into the heartlands of England since the Viking invasions, but the only sieges it was to withstand were during the Civil War, with the royalists never able to conquer it. Although there had always been a port, used for fishing and imports both from the continent and London, Hull did not build its first dock until 1778. Other docks were then built and by 1846 the full arrangement of docks was complete. City status was bestowed in 1897.

Gilchrist described Hull as "memorable for mud and train-oil," a port "frequented by crowds of Greenland Whalers; fifty leaving at a time, instead of the few now faithful to it."[14] Gilchrist disliked Hull as much as Etty did. In Etty's day there was but one dock and three churches, "the whole, " said Gilchrist, "set ... in a vast expanse of monotonous levels, stretching beside the yellow waters of the Humber." Life in the dock area was busy and robust and no doubt very exciting to an adventurous mind such as Turner's, he who constantly haunted the docks in London. But Etty did not possess such a mind. The growing importance of the town and its dock would not have interested him and the town itself with far fewer medieval churches and ruins than York would have held no appeal. Certainly the constant inflow of sailors with their immediate resorting to taverns, brothels and street prostitutes, which were regular features of port life, would have appalled him. Twenty years later he wrote: "There are no Minster, or 'New Walk,' no antiquities, no pleasing recollections and associations of birth-place, or of pleasures long past, to detain me; but remembrances of servitude and all unpleasantness."[15] Etty was never known to refer to his time in Hull except as a period of personal misery.

Again Gilchrist supplies the information regarding his parents' decision to apprentice the boy to a printer. He says that "a neighbor's daughter had married a Letter-press printer, about to set up in a larger way at Hull."[16] It is suggested that Etty's mother and the neighbor's daughter arranged the apprenticeship but apparently not with the latter's husband since the printer, a Mr. Robert Peck, to whom the young Etty was apprenticed, already published a weekly journal *The Hull Packet* from his premises in Scale Lane, Hull, whereas the neighbor's son-in-law was just starting up in business. Etty entered into his indentures on the 8th October 1798. Much later in life when he was well established as an artist and living in comfortable apartments in Buckingham Street, London, he wrote to his niece and companion, Elizabeth Etty (Betsy), "Thursday 8th Oct. 1798—I left Mother's apron strings my little Boat to swim the Sea of Life in the wide world—" adding, after this mixed metaphor—"thou art now my tiller, Beloved Betsy" (undated letter).

He wrote similarly to his dealer, William Wethered, on the 8th October 1844:

This day forty-six years ago, I left my father's mansion—a humble but happy one—and my dear mother's apron strings and care: to be cast on the wide world among strangers:—at a distance from home, to strike out for myself and earn my bread; according to the primeval decree. Seven years of Bondage brought me near to that period when happiness dawned upon my life.

His life as an apprentice was not congenial. *The Hull Packet* went on sale every Monday and consequently a considerable portion of every Sunday had to be spent working. This was particularly objectionable to Etty who was always a deeply religious man. However, he managed to get through his work in time to attend "the High Church" in the afternoon or to "hear the feeling Rev. Mr. Dikes preach at St. John's" and often to have dinner with Thomas Bodley's parents who lived in Hull.[17] Etty's attendance at "High Church" is of interest because he had been raised a Methodist but already at this young age he had changed direction and preferred the Anglican Church. This sole reference to "Thomas Bodley's parents" is also of interest because it confirms that the Bodley family, with whom Etty was to become great friends and of whom we shall hear much later, was already well known to him. Uncle William had much earlier entered into partnership with the Bodleys in London but this reference to the Bodleys' being a Hull family suggests that the arrangements to do so had probably been negotiated in Hull with which city the Ettys were familiar. This would account for early suggestions that Uncle William had entered into marriage with one of the Bodley daughters, an assertion now known to be incorrect.

Mr. Peck was keenly interested in accumulating sufficient money to enable him to retire as soon as possible, which in due course he did. He worked his assistants and apprentices very hard, requiring them to rise at five o'clock every morning and often keeping them working till past midnight. But the training was undoubtedly valuable. It instilled in Etty the need to be punctilious and accurate in all he did. On the other hand, Mrs. Peck was considered to be "a kindly soul." Gilchrist claimed to have interviewed a former servant in the household who said Mrs. Peck was always ready to "spoil" the apprentices, allowing them "to carve for themselves" and always providing them with "new milk."[18] This was not the usual experience of apprentices.

However, Etty's continued interest in drawing was not well received. Mr. Peck considered such activities a waste of time and did not approve when he discovered that the young Etty had drawn his portrait. Fortunately brother Walter came to his rescue. He persuaded Mr. Peck that William should be left free to draw so long as he did so in his own time. Gilchrist recounts several episodes including the almost standard account of the future Academician's being able to draw objects in so lifelike a manner as to deceive his fellow apprentices into believing them to be real. He refers to Etty's early efforts at drawing whatever caught his fancy, events in the Hull streets or in the printing house, caricatures and imaginary scenes, nothing of great quality but including, says Gilchrist, "parts of the human figure," indicating his future interests.[19] How far this is based on actual research and how much on speculation we cannot know but it seems likely, having regard to Etty's general poor draughtsmanship, that Gilchrist exaggerates. Gilchrist also recorded that[20]

a collection of the crude Attempts at Drawing of the period has been religiously preserved, and bound into a volume, by the son of a Journeyman in the same office, named Walker. Some of these sketches (*in pencil*), were thrown off on stray scraps of paper: and given by Etty to their present possessor, when a lad,—even then an admirer. Others, done mostly with red chalk, in a fellow-apprentice's ciphering-book,—already covered with sums and rules,—were the product of evenings spent with Walker; and afterwards given to the latter: who "always thought" his companion would turn out remarkable.

He refers to drawings of "a pistol, a drum, a palette, a pewter-pot, an open knife or book, a printer's shears" and also watercolors of a sailor, paintings entitled "The Death of Buonaparte," "a Countryman taking his son 'to be made a Bishop of,'" "the Old Suitor" and "other thin boyish jokes." Gilchrist also claims that "after attaining a Box of Water-colours," Etty "sighing for promotion" produced some oil paintings of "A Country Church," "A Soldier on Horseback" and of a mechanical bird he had seen. If all this is correct, and we must presume that

Gilchrist had seen the drawings for himself, unfortunately nothing has survived. Some think it is probable that it was at this time that Etty painted his first work in oils, *The Missionary Boy*, though it is more likely it should be called *The Mission Boy*. Dennis Farr reports[21] that there are fragments of paper on the back of the frame which can be deciphered as "I well remember ... missionary boy at Hull painted York by W. Etty, R.A." This was pasted on the frame well after the date of execution but it suggests that there was a boy of dark complexion, perhaps from a ship, who was sheltered in the Mission at Hull when Etty was an apprentice there. It is very much a painting by an inexperienced artist. The subject's arms are tightly folded concealing the hands, always difficult features for beginners. Farr suggests the possibility that the title *The Mission Boy* indicates that he was a child preacher in the Hull Mission or that the painting was not by Etty at all but by George Franklin who was later Etty's studio assistant. However, there seems no reason to doubt the authenticity of the label on the frame.

During his time at Hull, Etty discovered the value of books. We know nothing of his tastes but must assume from his later reading habits that he now began to read translations or re-workings of some of the classics, almost certainly some Milton. It would not be inappropriate to suggest that the Bodleys introduced him to such books. As indicated earlier, it is likely that he received some very basic education in the classics in Mr. Hall's Academy at Pocklington, though not any knowledge of Latin. He was certainly better prepared in such matters than his contemporary Turner who always found difficulty in expressing himself whether in writing or in lecturing. Etty, though usually long-winded, was generally competent with words. His style has much of an earlier time, suggesting that he fashioned himself on the writings of earlier authors, particularly Milton in whom he was later to find many of his subjects. At some time he was to learn of the Greek and Roman myths. Most probably he first picked up the stories as references in other books and did not become fully acquainted with them until he attended the Royal Academy Life School. So little has been recorded of Etty's apprenticeship that we must conclude that it was to him, as he later said, a constant drudgery holding little interest beyond the eventual expectation of release. The last years "dragged heavily.... I counted the years, weeks, days and even hours," he recorded in his *Autobiography*.[22] Finally at 12 noon on the 23rd October 1805 his apprenticeship came officially to an end. When Etty came to write his *Autobiography* for the *Art Journal* in 1849 he referred[23] to this moment as "the *golden* hour" when he "felt such a throb of delight."

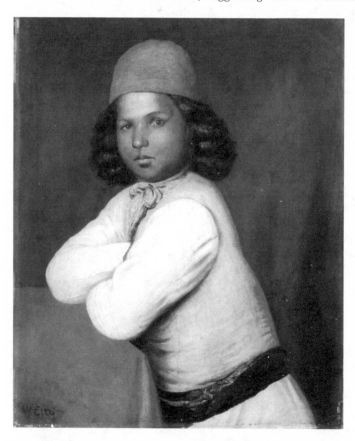

The Missionary Boy (25.25 × 19.875 ins) (?1805/6), York Museums Trust (York Art Gallery), YORAG641.

I was now *entirely* emancipated from servitude and slavery; I was flapping my young wings in the triumphant feeling of *liberty!* not the liberty of

licentiousness and jacobinism, but natural rational *freedom of body, mind and will,* to which for seven long years I had been an entire stranger!

Etty's disapproval of "jacobinism" should be noted. Throughout his life he was always strictly politically orthodox and heavily censorious of any divergent opinion. Despite his years of "slavery" Etty had clearly worked conscientiously. Mr. Peck wrote on his Indenture—"This indenture was faithfully fulfilled, to the satisfaction of the master and to the credit of the apprentice," of which testimonial Etty was justifiably proud all his life. In a letter dated 11th October 1825, written when he was 38 years old, Etty recalled his time in Hull as being one of "servitude, detintion [*sic*], captivity and all unpleasantness." As late as October 1849, writing to his dealer, William Wethered, he recalled how in 1798 he "was bound in fetters for seven years, and apprenticed to a Printer." Yet, as he admitted in his final years, he ever after paid his annual dues to the Printers Guild, as though safeguarding himself against a possible change in circumstances, and when he retired to York and took a house next to the printing house of the local newspaper he frequently called in to talk with the printers there and even occasionally set up type to demonstrate that he could still do it.

Anticipating his release from his apprenticeship Etty had written to his uncle William in London expressing his desire to become an artist and to move to London in order to prepare himself for such a career. After three weeks, now working no longer as an apprentice but as a journeyman printer for Mr. Peck, he received his uncle's permission to join his household at No. 31 Lombard Street. Here Uncle William's partner, Thomas Bodley, joined in encouraging him, support which continued throughout their lives and continued with his brother Walter. Etty was to write, as a footnote to his *Autobiography* in 1849, "I was infinitely indebted for encouragement, patronage, and support, in this my new professional career; and with three such benevolent persons to uphold me I soon began to work with ardour."[24]

Throughout his life Etty always acknowledged his debt to his uncle William, his brother Walter and to Thomas Bodley. Why both uncle and brother should take him into their care and safeguard his welfare in this way has never been explained. They did not do so for his other brothers. Perhaps they approved his ambition and did not approve his brothers' lack of ambition to such an extent that they felt the need to translate their feelings into practical assistance. Uncle William does not appear to have ever visited the other members of the family and brother Walter is known to have visited them only once.

According to Gilchrist[25] Esther wanted to include in her son's luggage his printer's apron, to which he was now entitled, so that he would still have his trade to fall back on. "He refused to take it; would follow his true calling, and that only; 'if he got but threepence a day at it.'" Such, suggested Gilchrist, was his determination. It seems Etty took with him no examples of his work, not having any, only a few pieces of chalk and colored crayons with which he set about convincing his uncle that he *could* draw. How far we can rely on Gilchrist's personally knowing these details we must leave open. Gilchrist frequently reported events he could have learned only indirectly and often his informants must themselves have learned of them indirectly. Etty now had to enter a second apprenticeship which this time he did with enthusiasm. He arrived at his uncle's house in London on the 23rd November 1805, aged eighteen and a half years. Although his uncle is reported to have "greeted him with friendly sympathy"[26] he must have been unsure of what he had taken on by giving his nephew hospitality since the young Etty had only ambition and nothing of any worth to show that might encourage his uncle to believe that his hopes were well founded.

CHAPTER THREE

Life in London

Alexander Gilchrist claimed to have gathered several tit-bits of information concerning Etty's reception by his uncle, as indeed he claimed always to have gathered similar tit-bits throughout the artist's life, but a modern researcher may often wonder how much credence may be placed upon them. Gilchrist often recorded *verbatim* conversations he could never have heard and which most probably had never been repeated to him so long after the events. Thus he claimed that after Etty had written his uncle from Hull asking permission to join him in London he was for three weeks "waiting with anxious anticipation each morning a summons to London" and that his uncle, on receiving a further letter of enquiry, said to his junior partner, "Another letter from this boy, what shall I do with him?" The junior allegedly replied, "Why, Sir, let him come on a visit to you for a few months. You will then judge what he is capable of."[1] It is a likely exchange of views but whether it actually occurred we cannot know. Again, according to Gilchrist, when Etty did arrive in London he at once took out a piece of chalk from his waistcoat pocket and drew a cat in so lifelike a manner that, on being placed against the fender, the drawing was mistaken by his uncle for an actual animal. This is customary praise from someone unversed in the subject, the notion that total verisimilitude is the aim of art, but applied to a chalk drawing it must have doubtful credibility. There followed other drawings, including one of uncle William's daughter (he had four daughters by this time), all of which so impressed everyone in the Lombard Street home that "dear brother Walter—who early separated from Home, had to some extent become a stranger to the rest of the family—henceforth took William into his care." Thus, whilst it was uncle William who had agreed to the young Etty's coming to London, it was brother Walter who actually assumed responsibility for him and "furnished him with cash," though we have reason to believe that uncle William provided much of it. "Mr. Bodley joined in the good work" and the youth commenced, as he later reported, "the exercise of my darling profession. For I may safely say, I never knew a year's happiness before."[2] He was nineteen years of age. As Etty himself was to record towards the end of his life in his *Autobiography*,[3] he was fortunate that his uncle was

> himself a beautiful draughtsman in pen and ink and who, if he had studied engraving, would have been in the first rank. He smiled on and patronised my *puny* efforts, but saw enough to convince him that my heart was *in it* alone. These three benevolent individuals, my uncle, and brother, and Mr. T. Bodley, united hand in hand to second my aspiring and ardent wishes: and having painted in crayons a head of your dear mother, Mrs. Clark, and also two successful crayon heads of my uncle's two favourite cats, I was encouraged in this my darling pursuit, and the sun of happiness began to shine.

The reference to "your mother" is to Elizabeth, uncle William's daughter, whose son had suggested Etty should write his *Autobiography*, which he did in the form of a long letter to him.

Etty's first year was spent in private study, drawing anything he could get hold of. In his *Autobiography* Etty recorded:

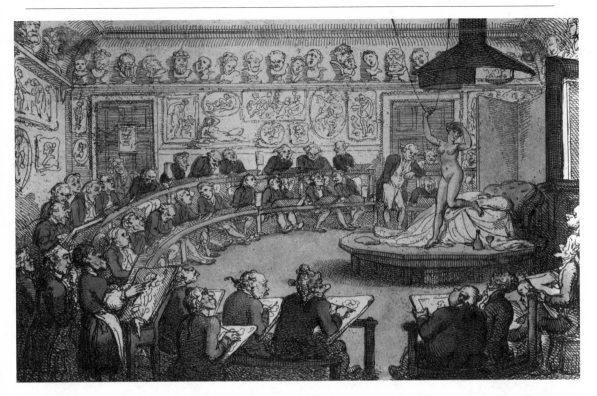

Drawing from Life at the Royal Academy, **by Thomas Rowlandson (aquatint), The Royal Academy of Arts, London.**

My first Academy, a plaster-cast shop, kept by Gianelli, in that lane near to Smithfield, immortalized by Dr. Johnson's visit to see *The Ghost:*—I drew in heat and cold; sometimes, the snow blowing into my *studio*, under the door, white as the cast.[4]

This is a tantalizing report since no other reference to a "studio" at this time is known. Either Gianelli allowed him to draw in his workshop or someone put a room at his disposal but, if so, it could hardly have been part of the house since it was obviously unheated and not secure against the weather. Farr[5] says that that this Gianelli "was almost certainly John Baptist (or Giovanni Battista) Gianelli, who is mentioned as a tradesman with premises at 33 Cock's Lane in Holden's *Triennial Directory*, 1805 and 1809." Gianelli is also mentioned in *Johnson's Directory*, 1817, as a "Plaster of Paris manufacturer." This, however, must have been another Gianelli since John Baptist died in 1809. He had a more notable brother, Giovanni Domenico, who settled in London in that year and died in 1841 and also a son who began to be known in 1809. The son mostly produced portrait busts. Certainly the Gianelli family was well established in London in the first half of the nineteenth century. Italian plaster-workers had been in demand in England throughout the eighteenth century and were recognized for a long time as most proficient and therefore in much demand. Although a minor figure, John Baptist Gianelli was regularly engaged in making plaster casts for wealthy collectors. He exhibited figures of *Flora, Hebe, Mercury* and *Venus* in 1777 and in 1789 executed four statues of *Isis, Flora, Antinous* and a *Discobalon* for the great hall of Carlton House as part of the final refurbishment for the Prince of Wales. He continued to work for titled patrons until his death in 1809.[6] Whatever the arrangement was between Gianelli and Etty the boy had clear aspirations. He chose a reputable sculptor to work with either as a studio assistant or as an apprentice or merely as a favored visitor. It must have been, however, that a fee was required and no doubt it was either uncle or brother who paid it. What is important is that by working with or for Gianelli, Etty was receiving

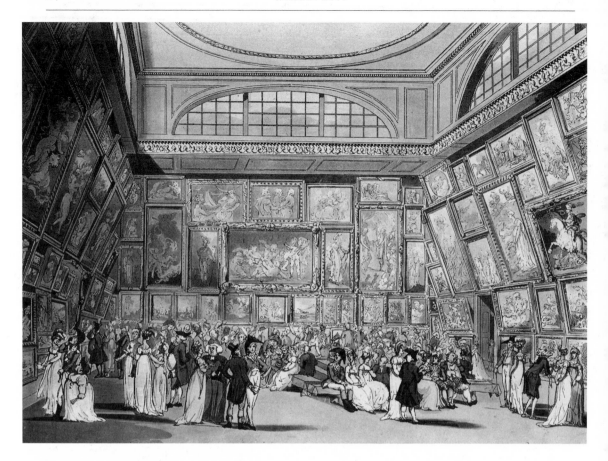

Exhibition Room, Somerset House, London, by Thomas Rowlandson and Auguste Pugin (aquatint), published 1 January 1808, The Royal Academy of Arts, London.

confirmation that classical subjects were those he had also to produce if he was to become a successful artist. He was preparing himself for the next stage in his development, studentship with the Royal Academy. It must also be presumed, though we have no evidence that this was so, that his three mentors in Lombard Street were of the same opinion, otherwise they would not have supported his ambitions.

We may assume that life in London was markedly different from what Etty had been used to in York. From a backward provincial city that showed no signs of advancing out of its rural complacency, Etty had moved to the most important city in the country, probably in Europe; a city renowned for its wealth, the profligacy of its ruling classes and the desperation of its poor. All population figures before 1801 are merely estimates with very little foundation but the first census taken in that year indicated a London population of some 960,000 but even that was far from accurate since many of the poor and some of the wealthy did not co-operate. London's population had been rising since mid-century and thereafter the annual increase was always in the region of 20 percent. London was eleven times larger than the next large city, Liverpool, and nearly twice the size of Europe's largest city, Paris. By comparison York, with a population of some 17,000, was insignificant. But it was not merely size that made London a place apart. London offered a different quality of life. All other towns were still consciously rural; London was urban and, though aware of the countryside on its borders, was more concerned with its unique character as the centre of wealth, fashion and culture. For the time its population was huge but its impact was the result of the city's small size. Nearly a million people were crammed

into little more than ten square miles. Well over half the population, living in the slums of the East End and Bermondsey, were never seen by visitors but within the fashionable areas of the City and Westminster there was plenty to attract their admiring attention. There were cathedrals, churches, parks, theatres, concert halls, coffee houses, pleasure gardens, gaming clubs and, for the less discerning, plenty of brothels. There were markets and streets of shops offering every kind of article that fashion demanded and wealth could afford. Foreign visitors were astonished by the variety and quantity of goods on offer. In England everything had always centered on London. From the Conquest onwards, most of the nobility had been attracted to the court for material advancement but now the gentry were moving into the metropolis.

But there was also more poverty and more crime. Both were inescapable. Foreign visitors who took the trouble to investigate were appalled by the extent of human wretchedness that existed side by side with apparently unlimited wealth and, for some, more to the point, with public indifference. Dr. Johnson in the 1780s had estimated that no less that one thousand persons starved to death in London every year, wholly disregarded by those in better circumstances. Matters were no different in 1800. Crime, whether it was street mugging, burglary, blackmail or murder, was so rampant that it was a common theme in novels and plays. Whereas in York crime and prostitution were largely limited to the riverside alleys, Walmgate and, more recently, in areas such as Bedern so that prudent men and women could avoid them if they wished, in London crime and prostitution were everywhere. No person was safe from attack in the streets at night. It was estimated that every evening several thousands of prostitutes lined the main thoroughfares, it being the only living available to most poor women. So great was the competition among them that prices were low and destitute girls working in back alleys often charged no more than a few pence, enough to secure a bed for the night in a common lodging house where they could usually expect to be raped. In the eighteenth and nineteenth century the demand for underage girls was met by the constant supply of orphans and cast off children. The "thieves' kitchens" described by Dickens in *Oliver Twist* were all too common. In some quieter areas young men would pounce on older men and threaten to accuse them of improper advances unless they handed over all money and valuables. Since homosexual behavior was a capital offence such accusations were to be feared. Whatever evil can be imagined was practiced somewhere. This widespread criminality and immorality was the subject of numerous pamphlets, sermons, tracts and poems issued by various campaigning societies which in due course encouraged the active establishment of a social *ethos* which has come to exemplify the Victorian period. But we must not over emphasize the general immorality of the times. It was certainly widespread, not least among the aristocratic classes, but the majority of people without doubt lived quite chaste lives. Jane Austen's picture of a sedate society, where a stolen kiss was the worst offence most girls would suffer, is probably correct enough.

The rudimentary reforms introduced in 1748 by Henry Fielding, surely London's first honest magistrate, may have paved the way for a police force but public objection was always strong especially when it came to providing money to pay for it. Local watchmen were supposed to patrol the streets at night to impose law and order but seldom did so or, if they did, their efforts were ineffectual. The sole law governing the policing of towns dated from the Statute of Winchester of 1285. In succeeding centuries there were numerous minor acts and orders imposing local arrangements but not until the Home Secretary, Robert Peel, managed to get his Metropolitan Police Bill passed in 1829, after much opposition, was there a general consolidating act relating to the imposition of law and order in the capital. Throughout the nineteenth century the police in London and elsewhere battled against public hostility and suspicion. Many were convinced that the police were but the beginnings of an authoritarian state and others objected to laws controlling behavior as a matter of principle. The Corporation of the City of London always opposed the formation of a police force and only agreed on condition that they administered their own force independently of the rest of London, a system still in operation. The Etty families

lived in the City of London governed by the Lord Mayor and Corporation, the area rebuilt after the Great Fire of 1666 had devastated most of it. More handsome buildings had been erected in the eighteenth century and overall there was an aura of considerable wealth and propriety, the latter sometimes erroneous. Living there presented the young Etty with the assurance of security and stability he needed. Not for him the sleazy environs in which Turner grew up. Ever religious and prudent in his behavior he seems to have been careful to follow a quiet industrious life concentrating on improving his skills as a painter, working from dawn to dusk and never wasting a moment in idle pleasure.

George III was on the throne and the country was at war with France. Nelson had defeated the French fleet at Trafalgar the year before but the war on land lasted until Waterloo (1815). However since wars were then waged by an army and a navy manned by volunteers, except for the activities of the press-gangs, only those families with members in the services felt much concern. For the rest the wars were happening remote from home and sooner or later "we" would win. Jane Austen's male relations who joined the Navy were seldom regarded as putting their lives at risk, though they must often have done so. Yet few could ignore the effects of war—especially the rising prices—though it is probable that most people did not see the connection. Politically, however, there was considerable unease and Etty must have heard his uncle and brother discussing these matters since they would have impinged on their business. Educated men were very concerned with politics and everyone, rich and poor, was aware of the central role of the monarchy. For all the century businessmen and men of leisure had met regularly in London coffee houses to discuss the news. Although George III and his wife outwardly lived lives of dull respectability, he was surrounded by relatives and hangers-on who were already beginning to rehearse the excesses yet to come in the period of the notorious Regency. News of the adulteries of the aristocracy and the frequent court cases brought to secure extortionate damages, often by husbands as guilty of improprieties as those they accused, were being reported in the news-sheets. Satirical cartoons exposed the personal lives of the rich and famous. Prints of these cartoons were customarily displayed in the windows of publishers and regaled passers-by who stopped to enjoy the free exhibitions. The loss of the American colonies did not assist the king's public image. Someone had to be blamed and the king was popularly regarded as equally culpable as his ministers. It was the Prince of Wales who provided the satirists with most of their material. His heavy drinking and whoring and his open hostility towards his father, problems that were to grow rapidly more serious, were already public knowledge. But there were also many other members of the aristocracy living similar lives and most of their exploits were made well known in the public prints. The period has been well documented with writers concentrating on the particular aspects that interest them.

We shall have occasion to refer to the extent of the indulgence of Regency England, and of the decades preceding that period, in the stereotypical sexual behavior of the times and also to the subsequent, and indeed consequent, abhorrence of all forms of sexual pleasure which has become the equally stereotypical view of what is known as "the Victorian Age." Neither view is wholly correct. Although some find it convenient to attach labels to different historical periods as though entire populations change attitudes at the end of every monarch's reign or of every century, the fact is, of course, that throughout history there have always been many and diverse attitudes among people existing together at the same time. Sometimes certain views predominate, often because particularly forceful characters campaign to ensure that they do, but more usually in every society there is a mixture of attitudes, opinions, morals and behaviors. Although there was a considerable increase in street prostitution in Georgian England and, perhaps surprisingly, also in Victorian England, most sexual activity occurred, as it always has, in private. A pious and prudent man like Etty could, if he wished, protect himself from most of the activity of which he would have disapproved. Certainly hundreds of prostitutes lined the principal streets of London at night but most public activity occurred in back streets and alleys. Certainly,

also, brothels were in plentiful supply but one had to know where to find them. London and most European principal cities have always had such a reputation. This is where wealth concentrates and where there is wealth there are always those ready to take it. Sin and cities have always been associated.

It is easy to forget that in that age of extreme contrasts, of unlimited wealth on one side and imminent starvation on the other, with depravity well spread overall, there was also a "middling sort" who deplored the society in which they were trapped. These people sought respectability and genteel living and practiced religious observance and "good works." They were the beginnings of the nineteenth century cult of charities on which so many of the poor depended. Puritanism, which is always a strong element in human nature and is as common in Christianity as in all other religions, had become especially vociferous in England after the Reformation. Reinforced by the greater tolerance of the Commonwealth it was now expressed in the various dissenting sects that flourished, particularly among the less affluent. But disapproval of the general life style of the rich was not limited to those who could not afford it. Already by 1790 a group of wealthy Anglican Evangelicals had met to campaign for improving the moral standards of the age by reviving the Church of England itself which had acquired a reputation for apathy that it must be admitted it deserved. Because they lived in the affluent area of Clapham they became known as the "Clapham Sect" and those who were also members of parliament, which included William Wilberforce, were dubbed "The Saints." Their influence was to take some years to make itself felt but well before Victoria's accession to the throne they had managed to establish in English society that sense of morality that we now associate with the queen. England was changing around the young Etty. It is doubtful that he was aware of it.

Yet even a man as indifferent to current affairs as Etty was could hardly fail to be totally unaware of them. Probably his piety of mind, the result of careful nurturing by equally pious parents as well as his own natural inclination towards religion and sober living, enabled him to ignore these matters as unsuitable for consideration. Yet, for all his ability to isolate himself in work, he must have realized that he had entered an altogether different world from the one he had left. Unlike Turner, who frequented the docks and studied ships and no doubt picked up information from sailors, Etty seems to have kept to the more respectable streets and probably hurried home after a day working with Gianelli to spend his evenings with his uncle and brother. He was used to York, a city of middle-class respectability with a surrounding sprinkling of minor aristocrats and gentry who lived their lives with the elegant decorum of characters in a Jane Austen novel. In Hull he had deliberately insulated himself from the poverty of that town. Insulation from the unpleasant was to be one of Etty's major accomplishments. The novels of George Eliot, though written much later in the century, look back on the England of her childhood and that of the young Etty and describe the even temper of rural life compared with the soul destroying demands of towns. If rural England was continuing, or endeavoring to continue, as though important social changes were not occurring, life in the growing towns and especially in London was quite different. Both Charles Dickens and Elizabeth Gaskell, who wrote considerably later, attacked the wealthy for their indifference to the condition of the poor. Gaskell urged that all classes should unite to solve the desperate problems that were increasingly apparent, but by then the social divisions were unbridgeable. Etty was later to know Dickens but he did not come to share his concerns. London was at the center of change, affected by the constant influx of unemployed men and women from the increasingly impoverished countryside, by the influx of fortune-seeking sons of families no longer enjoying the wealth of earlier times, and by anyone who believed that the capital offered opportunities to all, male or female, who were prepared to risk all.

What the young Etty made of his change in circumstances we do not know. There are no records of his responses to his new life except one surprisingly short letter in which he offered no comment beyond saying that he liked London very much. Perhaps he was merely reassuring

his parents. He does not appear to have concerned himself with London life, being content to live quietly with his uncle and to concentrate on improving his abilities. These years are dealt with in his *Autobiography* quite perfunctorily. He claims to have concentrated only on study. Life in No. 3 Lombard Street was congenial and protected from the outside world. His uncle and brother and their families were regular worshippers at the Church of St. Edmund the King and Martyr, conveniently also in Lombard Street so they did not have far to walk each Sunday, and we can well imagine their sedate evenings at home, after supper listening to readings from suitable books as was customary in all well conducted families. Etty must have learned of the king's illness and increasing signs of madness, though today we know it was not insanity, and he must have known that six years before his own arrival in London the Prince of Wales had been proposed, and rejected, as Regent, which Etty's uncle and brother must have approved. When the Regency was finally established in 1811 Etty was still immersed in his studies and as apparently indifferent as ever to such matters. We have to stress this lack of interest because hardly ever in his entire lifetime did Etty refer to contemporary affairs. Always the world seemed to go on around him unnoticed. All that mattered to him was the pursuit and improvement of his art. At this stage his ambitions were directed to the Royal Academy.

A second apprenticeship

It cannot be over emphasized how important the Royal Academy was to the artistic life of Britain in the late eighteenth century and in the century that followed. There had been many earlier attempts to found academies, all on a private basis, but all had failed usually because of disputes between the members. Successful artists were not usually willing to instruct others and none accepted that they needed any further instruction themselves. In an age when artists relied on patronage they were most unwilling to allow others to obtain access to their patrons. It was a competitive world. It was every man for himself and any agreeable arrangement between artist and patron (usually an aristocrat, very occasionally a monarch) was jealously guarded. Yet it was becoming realized that English artists did not bear comparison with their counterparts on the continent. The wealthy went on the Grand Tour and had their portraits painted by foreign artists and collected Old Masters, or, more likely, what were being passed off as "Old Masters." The history of the Royal Academy and its predecessors is fully available and will not be repeated here. The most important features of the Academy were (and still are) that it was a non-government institution, enjoying royal patronage which afforded it considerable authority and independence and that *instruction* was as important as opportunity to exhibit.

By the end of the eighteenth century it was generally accepted that any young man ambitious to earn his living as an artist had first to become a student in the Royal Academy Schools. This could lead to Associateship and the display of work in the annual exhibition which would bring him to the notice of the buying public and probably sales and even commissions. In due course a successful artist could even be elected to full membership of the Academy and then the commissions could often be more than a man could manage. Portrait painters were in the greatest demand and for some time it had not been unusual for a patron wishing to engage the most notable of portraitists to have to wait over a year for a sitting. The most famous artists had to employ assistants and so-called "costume painters" and "background painters" to fulfill their commissions. The tradition of seeking commissions from wealthy collectors on which artists habitually relied was giving way to the new market system of selling through exhibitions. Exhibitions were, in effect, shops but acceptance for exhibition required recognition of ability. It was essential for Etty to take this path if he was to succeed but first he had to accumulate sufficient work of good quality to present to the Academy to persuade them to accept him as a student.

Another reason for seeking entry to the Academy School was that tuition was free, though students had to provide their own materials. Nowhere else could a student obtain such an acceptable

standard of tuition for nothing. Although the Rules and Orders did not specifically say so, it was strict practice that all students were male until 1860, when an applicant deliberately signing her name as "L. A. Hertford" was admitted by mistake. In 1792 it had been decided by the Academy Council that studentship should be for life but free access to exhibitions should be limited to the first seven years. This coincided with the actual period of free tuition. From the beginning of its establishment the Council of the Academy had been concerned that every aspect of its activities should be immune from any accusation of misbehavior or disorder on the part of its members. Since it was the English disposition to regard artists as they did actors (and especially actresses) as "riff-raff" and moral degenerates, this concern was often well founded. Students everywhere were renowned for riotous behavior and so anxious was the Council to insure the Royal Academy should not become as lax in discipline as the French Academy and French studios that they set down rules with the punishment of dismissal. Every student was issued with a bound book of Academy Regulations. That issued to Etty is in the York Reference Library and it is indicative of normal student conduct that on every blank page he has drawn a figure, in his case every one a female nude. This would probably have been regarded as "disfigurement of Royal Academy property" had it been discovered.

Entry into the Academy Schools depended on recommendation from an established Academician together with evidence of ability to draw. This in turn required a suitable letter of introduction to the Academician from some other person of standing. Etty obtained a letter of introduction from Mr. Sharp, Member of Parliament for Hull, who lived at the time in Mark Lane in the City of London, and armed with this he approached John Opie, R.A., taking with him a drawing of *Cupid and Psyche*. The subject of the drawing was entirely the kind which the Academy would approve. Etty was sent by Opie to Henry Fuseli, R.A., who was then Keeper of Prints at the Academy, having attained that office in 1804. Fuseli had the reputation of being a martinet, controlling the students so strictly that many feared him. He was sympathetic to the quiet Etty and liked what he saw. Etty was accepted as a Probationer. He then had to produce drawings from the Academy's collection of plaster casts to demonstrate that he was suitable to be accepted as a full student. This meant making drawings in the approved Academic style which, of course, he had yet to learn. He presented studies of the *Laocoon* and, as he later reported, of Michelangelo's *Torso*, though he probably meant the *Belvedere Torso*.[7] He was successful and on the 15th January 1807 he entered the Schools as a Student.

This introduction to the teaching methods of the Academy instilled in students the belief that Art (always spelled with a capital A) meant the classical and the nude figure. This belief was reinforced as the training continued until the day came when the student was regarded as so advanced that he could be allowed to draw directly from the naked model. Drawing from the living model had from the beginnings of the Academy been a key requirement and the inclusion of female models had also been an early requirement. There were historical reasons for this. For about a century before the foundation of the Academy, artists had increasingly sought opportunities to study anatomy and drawing from the nude to enable them to attain the skills of their Italian rivals. These opportunities had been difficult to obtain and many artists had tried to found their own academies or schools but always with limited success. The Royal Academy set out to make these opportunities possible. But, of course, there had to be strict rules for students to observe since even in the eighteenth century there were strong vocal objections to the practice. Professional models were unknown and artists had always found themselves compelled to employ prostitutes or impoverished girls who had come to London to find employment and were already on the brink of a depraved lifestyle. Artists did not want to be associated with such persons and an organization which provided models for them absolved them from accusations of impropriety. Although more models were male than female, the impression left upon most students, as can be seen from drawings recording these classes, was that the training offered by the Academy centered around the female model and that they were now privileged to study the naked female

body in the name of Art. For many, and Thomas Rowlandson was clearly one, this was the longed for experience of youth but whereas in Paris this could lead to sexual liaisons, in London every obstacle was erected by the Academy to prevent students and models from meeting. The Royal Academy had to be above suspicion.

In the Academy Schools Etty at once found himself among fellow students of greater ability—William Collins, Benjamin Haydon, William Hilton and David Wilkie. Haydon and Hilton had ambitions to become history painters and since Etty soon acquired this ambition it was their example that stimulated him. Wilkie became a particular friend but Etty did not share Wilkie's preference for narrative genre. In his *Autobiography* Etty was to pay tribute to his colleagues. Haydon's "zeal and that of Hilton in the cause of historic Art urged me to persevere, and, by their example and precept, I certainly benefited and was encouraged."[8] Yet later Haydon was to say that he did not remember Etty in his student days, but he also denied knowing other fellow students who were certainly there with him. Already Etty was admiring "the taste and feeling of Lawrence."[9] By the time Etty entered the Royal Academy that institution was well established as England's prime authority on the arts. Etty described it in his *Autobiography* as "the *sanctum sanctorum* of genius."[10]

For most people art was what the Academy declared it to be and though from time to time a discordant voice would object to a particular work exhibited there or even to some matter of policy, such as allowing Fellows freedom to exhibit a certain number of works without prior approval of the Hanging Committee, for the most part the Academy was the unquestioned authority right up to the twentieth century. This general acceptance included its opinion that art should express ideas and not merely be a vehicle for presenting the public with attractive pictures that delighted the eye and the untrained imagination and nothing else. Certainly art had to engage in what was called "the pursuit of beauty" but beauty had to be presented in a moral context. It was held that there could no better service for beauty than the expression of historical virtues, of valor, patriotism and self-sacrifice. Those concerned with forming a social structure that was based on these virtues and who had witnessed approvingly the growth of a literature devoted to these aims, saw in the visual arts another tool for shaping the minds of their fellow men. History was not confined to actual or presumed events in the English past but included biblical events and events from the ancient world, and especially the latter since most of the well educated had been taught something of the classics. Inclusion of classical events meant depicting the nude or semi-nude figures of Greek and Roman heroes and then, by natural extension, the gods and goddesses. In any case, it was realized by most artists that even to depict a fully clothed figure it was necessary to understand the anatomy of the body beneath the costumes. Portraits by the late seventeenth and early eighteenth painters expose just how ignorant of anatomy they were.

In the original Instrument of the Foundation of the Royal Academy of the 10th December 1768 it had been determined in Article XVIII that

> There shall be a Winter Academy of Living Models, men and women of different characters, under the regulations expressed in the bylaws of the Society, hereafter to be made free to all students who shall be qualified to receive advantage from such studies.

Etty therefore found himself *required* to attend the life classes and study from the nude figure, both male and female and to accept that this was not only necessary training but also that there was nothing exceptional about it. Though not immediately. First he had to draw from plaster casts to demonstrate that he had the necessary ability to proceed to the living model. The Academy rules were expressly designed to prevent attendance in the life classes for private lewd purposes.

It was part of the School's tuition for the Academicians to deliver lectures to students and during Etty's first year it was John Opie's turn to do so. Well before Etty's time at the Academy

Joshua Reynolds as first president had delivered his famous fifteen *Discourses* in which he had laid down the purposes of the Academy and his views on the nature of art and the tuition that all students should receive. Subsequent lecturers knew that they were following in illustrious footsteps. Opie delivered four lectures on "Design," "Invention," Chiaroscuro" and "Colouring," all subjects then held to be of the greatest importance for artists. Lectures delivered to the Royal Academy were usually later published and those given by Opie were included with others by James Barry and Henry Fuseli in a collection edited by Ralph N. Wornum in 1848 and published by Henry G. Bohn of Covent Garden, London. Opie's ideas of history painting belonged to the more recent school of Academic theory. He did not insist on mythologies and the glorification of heroes but preferred to paint scenes from actual British history and scenes from Shakespeare—he painted seven pictures for Josiah Boydell's Shakespeare Gallery. Unlike many of his contemporaries, and the renowned Reynolds himself, Opie knew very well that many of the ideals of art were subjective and that it was not for him to lay down hard and fast rules but to encourage enquiry among his students. He declined to define "beauty": "Beauty being a word to the full as indefinite, if not as complex, as the word nature."[11]

> I will not undertake the perilous task of defining the word *beauty*; but I have no hesitation in asserting, that when beauty is said to be the proper end of art, it must not be understood as confining the choice to one set of objects, or as breaking down the boundaries and destroying the natural classes, orders and divisions of things (which cannot be too carefully kept entire and distinct); but as meaning the perfection of each subject of its kind, in regard to form, colour, and all its other associated and consistent attributes.[12]

Like all Academicians of his day Opie insisted on the ability to draw well, to attain which skill it was necessary to practice continually. It was also essential to study the human figure.

> If the artist possess not a thorough knowledge of the figure, if he understands not correctly the arrangement and play of all its different parts, their various and mutual dependencies on each other, and the appearances they must naturally assume in every given position ... his labor will be in vain.[13]

It was essential to make the figure appear to be alive. Opie objected strongly to contemporary French painting of the figure which was too closely based on the antique.

> It seems to be the principal aim of a French artist to rival Medusa's head, and turn everything into stone; and so far it must be confessed, to their credit, that, however they may have failed to equal the beauties of the antique, they have certainly copied, nay even improved on, its defects with uncommon success.[14]

These words must have caused some problems for his students. The principles of academic art were founded on the Antique and assiduous copying of casts was an essential part of a student's training. We know very well from all the examples from the various drawing schools, whether the Academy Schools or the later Schools of Design, that careful imitations were what brought a student medals and honors, even in the first half of the twentieth century. But the need to break away from tradition was already being suggested. Opie insisted that in painting heroic subjects, notwithstanding the need to depict them as natural human beings, the artist must not waste their powers on "all the train of nauseous minutiae" such as "hairs, pores, pimples, warts, stains, freckles." Such "detail must be sunk in the essential and predominant qualities of bodies; and that the business of painting, like that of poetry, is not to give a feeble catalogue of particulars, but a characteristic, comprehensive, and animated impression of the whole."[15] Opie had the highest regard for Titian and Rubens and spent much of his lecture on "Colouring" in dealing with them.

> It is unnecessary, therefore, to trace the history of colouring further back than the latter end of the fifteenth century, when its true birth seems to have taken place in Venice; at least, there the rudiments of all that makes it valuable and agreeable appear to have been invented by Giorgione ... and there they were first successfully cultivated and brought to perfection by Titiano da Cador.[16]

Speaking of Titian, Opie said "in colouring, [he] may be regarded as the father of modern art."[17] For Opie, Titian was the great example of an artist who continued to learn throughout his life, thereby teaching us that "it is never too late to improve." Whereas Titian possessed restraint ("he never overstepped the modesty of nature"), Rubens, said Opie, "is not one of those regular and timid composers, who escape censure and deserve no praise." On the contrary, "no man ever more fearlessly abandoned himself to his own sensations, and, depending on them, dared to attempt extraordinary things."[18] Regarding their respective methods of painting, Opie said:

> In comparing Rubens with Titian, it has been observed, that the latter mingled his tints as they are in nature, that is, in such a manner as makes it impossible to discover where they begin or terminate; Rubens' method, on the contrary, was to lay his colours in their places, one by the side of the other, and afterwards very slightly mix them by a touch of the pencil ["*pencil*" *was the contemporary word for* "*brush*"]. Now, as it is an acknowledged principle in the art, that the less colours are mingled, the greater their purity and vivacity; and as every painter knows the latter method to be the most learned (*requiring a deeper knowledge of the subject*), to be attended to with a greater facility, and, if properly managed, with greater truth and vivacity of effect, it must follow that this difference in their practice, which has been adduced to prove the inferiority of Rubens to Titian, indisputably proves the reverse.[19]

It must be anticipated here that later Etty was to examine and distinguish for himself the differences in technique between Titian and Rubens and come to terms with both. A serious problem was arising for artists eager to strike out in new directions and yet not to disown the past on which virtually all of their training was based. What were the subjects of art appropriate to the new century? Opie offered students an array of inspirations.

> Next to the study of nature, and the fine examples produced by the art itself, reading of various kinds, chiefly of history, natural history, voyages, travels, works of imagination, and above all, of poetry, in all its branches, may be considered as affording the most copious fund of materials, and importing the most powerful stimulus to invention.
> Poetry, in particular, bearing the closest analogy to painting, both arts setting out from the same place, journeying to the same end, and requiring the same kind of original powers,—both professing to improve upon their common models, to imitate instead of copying, to avoid the accidental blemishes and imperfections of individual nature,—to bring the scenes, actions, and persons represented before us, with all the attendant circumstances necessary to elucidate and embellish them, purified and exalted to the highest pitch of energy and beauty....[20]

Not advice that would, or could, be acceptable today but, at the time, of great importance and value to young students, often from families with no familiarity with the arts who, having been urged to bring invention to their art, would wonder in which direction to proceed. Etty certainly remembered Opie's advice but decided to restrict himself to a particular form of history painting in which he could excel. We can see as we follow Etty through his career that he never forgot the teachings he obtained from Opie. Opie gave only one series of lectures, in February and March in 1807, intending to deliver others. He died suddenly on April 9th of that year, aged only forty-six.

It was the tuition system that from the total of forty Academicians nine were elected annually to serve as Visitors

> to attend the Schools by rotation, each a month, to set the figures, to examine the performances of the Students, to advise and instruct them, to endeavour to form their taste, and to turn their attention towards that branch of the Arts for which they shall seem to have the aptest disposition.[21]

Professors of Anatomy, Architecture, Painting and Perspective were also appointed to give lectures but they were not always the best equipped to do so. In addition, the Academy had a library available one day a week to Students. Another of the Professors was Henry Fuseli who had been born in Zürich in 1741 and had come to London in 1763 where he at first tried to

earn a living by translating French, German and Italian books, in which as a Swiss he was accomplished. After seven unsuccessful years he took Reynolds' advice and turned to painting. He spent eight years in Italy, mostly copying the works of Michelangelo, and returned in 1779 sufficiently instructed to make a name for himself as the illustrator of Shakespeare's plays for Boydell's Gallery though success did not attract an appropriate income. He became an Associate of the Academy in 1782 and a full Academician in 1790. Nine years later he was made Professor of Painting, hardly a suitable appointment since Fuseli was predominantly a draughtsman. He delivered his first three lectures to students in March 1801, six years before Etty's admission to the Schools. Nine further lectures followed over the years beginning in 1806 and continued after Opie's death the following year. Therefore although Etty did not attend Fuseli's first lectures he was able to attend subsequent lectures as soon as he entered the Schools.

Fuseli was well read in the Greek and Roman classics and his lectures abounded with references to those authors. In his First Lecture he asserted that the Greeks were the true originators of art and that "*Religion* was the first mover of their art."[22] Being so motivated, the Greeks could not but invest their art with the most perfect forms. Whether Etty heard this Lecture when Fuseli later repeated it we do not know but it is most likely he did. Certainly these words would have confirmed for Etty that the classical nude was the most perfect subject for him to pursue. If we wonder whence Etty obtained his knowledge of the ancient myths perhaps we need look no further than Fuseli as an original source, no doubt augmented by additional reading. Fuseli did not spend much time discussing abstract ideas. Nature, he said, was a "collective idea" which could "never in its perfection inhabit a single object." Regarding Beauty, he did not intend "to perplex you or myself with abstract ideas, and the Romantic reveries of Platonic philosophy, or to inquire whether it be the result of a simple or a complex principle."[23]

Fuseli's method was to discuss "Ancient Art," "The Art of the Moderns" and then to provide advice on the various principles on which art relied—Invention, Composition, Expression, Chiaroscuro, Design and Colour, finally returning to his classical base, *The Method of Fixing a Standard and Defining the Proportions of the Human Figure with Directions to the Student in Copying from Life*. As might be expected this Lecture referred copiously to Greek sculpture of which the Academy possessed many plaster copies. Fuseli's theme was that all artists must strive for perfection for otherwise they had no right to practice the profession, an opinion with which Etty certainly agreed.

> Neither Poetry nor Painting spring from the necessities of society, or furnish necessaries to life; offsprings of fancy, leisure, and lofty contemplation, organs of religion and government, ornaments of society, and too often mere charms of the senses and instruments of luxury, they derive their excellence from novelty, degree and polish. ... A good mechanic, a trusty labourer, an honest trademan, are beings more important, of greater use to society, and better supporters of the state, than an artist or a poet of mediocrity.[24]

Fuseli was no believer that even an inferior artist should be encouraged because he possessed noble ambitions. In his view the Academy should deter students who could not achieve excellence. It was in the interest of society that its citizens should be inspired by the best and that mediocrity in the arts, as in everything else, should be rejected. In his view if a man could not excel in the arts (and presumably in any chosen profession) he had better try something else. To encourage mediocrity would result only in a general inferiority since no one would see the necessity for striving higher. These are not present day sentiments since too many of our schools of art seem content to allow students to follow their own devices, however inept, but Fuseli inspired serious students and Etty was ever serious and determined to achieve the highest that art could provide. Apparently recalling Fuseli's lectures on "Invention," Etty later recorded in a Notebook in either 1818 or 1819 several subjects which he wished to paint—"Subjects of Grandeur," "Subjects of Terror or Emotion," "Poetry," "Subjects of Feeling," and "Sunshine."[25] All these indicate that Romantic ideas were already forming in Etty's mind and must have arisen from Fuseli's words:

Invention in its more specific sense receives its subjects from poetry or authenticated tradition; they are *epic* or sublime, *dramatic* or impassioned, *historic* or circumscribed by truth. The First *astonishes*; the second *moves*; the third *informs*.[26]

Fuseli had proceeded:

The aim of the epic painter is to impress one general idea, one great quality of nature or mode of society, some great maxim, without descending to those subdivisions which the detail of character prescribes; he paints the elements with their own simplicity, height, depth, the vast, the grand, darkness, light, life, death, the past, the future; man, pity, love, joy, fear, terror, peace, war, religion, government.[27]

Ralph Wornum, editing the collection of these lectures in 1848, was frequently unable to prevent himself from commenting on the texts and sometimes suggesting amendments. In this case he thought Fuseli had incorrectly used the words "epic painter" and proposed "ethic painter" instead since in his view epic paintings were either heroic or romantic and *were* concerned with the details of incidents. But Wornum went on to assert, strangely, that Hogarth's *Marriage à la Mode* and *Rake's Progress* were epic works. There is little doubt that Fuseli well understood what he was saying. Later, in May 1850, Wornum was to write an article in *Art Journal* in which he traced the changing attitudes throughout history of the Roman and Protestant Churches to art and picked out Etty's paintings as illustrations of Christian virtues. All the lecturing Professors at the Royal Academy expected art to be didactic, it was simply a matter of which form of art presented moral lessons the most appropriately. Although, as must be expected, ideas had changed over the years it was still generally accepted that history painting was the highest form, remembering, of course, the diverse subjects that this embraced.

Fuseli devoted his Ninth Lecture to "Colour." Having dismissed the style of "historic colours" as practiced by the painters of Rome for being "dispersed over the picture till the whole appears like a bunch of flowers,"[28] he turned to the Venetians and in particular to Titian and Tintoretto. Titian, he maintained, went through three styles: "the first is anxious and precise, the second is beautiful and voluptuous, the third sublime."[29] Titian "imparted ornament a monumental grandeur." But Tintoretto was guilty of "the debaucheries of colour and blind submission to fascinating tints, the rage of scattering flowers to no purpose."[30] Ralph Wornum, in a footnote, reminds us that "this is not the general practice of the work of Tintoretto; he is frequently dark, opaque and muddy." Also that Tintoretto had declared his favorite colors to be black and white. But these were the distinctions drawn by Fuseli and though Etty always admired Tintoretto and was to be compared to him, he reserved his greatest praise for Titian.

Etty did not hear the lectures delivered by James Barry and did not meet him. Barry had been expelled from the Academy in 1799 following a public attack on Reynolds and other members of the Council, the only Academician ever to be expelled. He died in 1806 in great poverty and squalor, an indication that such rejection by the Academy could seriously damage reputations and opportunities. If Etty bought a copy of Wornum's collected lectures in 1848 it was far too late for them to have any effect on him. The lectures of Barry, Opie and Fuseli are as important as those of Reynolds but no longer command the same interest as the President's *Discourses* which were, of course, crucial in establishing the principles on which the Academy was founded. Nevertheless Barry, Opie and Fuseli continued his work in setting future generations of artists on the paths which the more informed patrons were to approve.

Etty worked hard and was able to write home to his parents that he liked "London extremely well and hope in the end, however vain the idea, that my name will not perish with my breath." Etty never forgot the assistance which Fuseli gave him during his career and especially during his early years. Fuseli became for him a "truly great and powerful genius" worthy to rank alongside his later hero, Sir Thomas Lawrence. Although the Redgrave brothers[31] praised "the sound training obtained in the Royal Academy while Fuseli was the keeper," listing Hilton, Wilkie,

Etty, Mulready, Haydon, Leslie, Jackson, Ross, Landseer and Eastlake as providing "sure evidence," they also quoted C. R. Leslie:

> Fuseli paid little attention to the students, and he [Leslie] approved of this course; telling us "that under Fuseli's *wise neglect*, Wilkie, Mulready, Etty, Landseer, and Haydon distinguished themselves, and were the better for not having been made all alike by teaching."[32]

If this was so, it would have run counter to the Academy's principles, which many later complained seemed designed to turn out artists lacking in originality. The Redgraves approved the Academy's training (or lack of it). "We may safely say the education they [i.e., the artists being considered] received, while it armed them with technical knowledge and executive power, did not in any way interfere with their originality."[33]

Leslie said, which the Redgraves also approved, "Art may be *learnt*, but cannot be *taught*." There were two parallel aims—to display originality and at the same time to conform to generally accepted taste. Until the present century it was never the ambition of artists to outrage the general public, artists were too dependent on the goodwill of patrons who in turn did not wish to offend their peers. Reynolds had frequently asserted that the educated man was to be discerned by his good taste and that good taste could be acquired by study of the right examples. These were, in his eyes, the classics. Thus all tuition of students was to be directed towards providing them with good taste. In Etty's case, although skill certainly had to be acquired, he seems to have received very little direct teaching in either skill or appreciation. That he succeeded at all was due to dogged perseverance. Thus, very much in accordance with British habits, the Academy frequently ignored its own principles and followed more expedient methods.

Writing of Etty in the 1860s, more than a decade after his death, Richard and Samuel Redgrave said that "...his progress was slow—so much so that his fellow students were rather inclined to say 'Poor Etty!' and to think that he had mistaken his vocation, but his self-confidence never flagged."[34]

Etty persisted and in due course he attained such facility that the new students joining the School "began to regard him with veneration." However it cannot be said that Etty ever became an accomplished draughtsman. Etty himself later recorded in his *Autobiography* that he much preferred painting to drawing and recounted that one evening when Fuseli was Visitor he was making little headway with his drawing so "I threw aside the chalk, took up my palette set with oil-colour, and began to paint the Figure. Ah there, says Fuseli, you seem at home. And so I truly felt."[35]

This account has sometimes been challenged since it was the general rule that only drawing was permitted in the Life School but a drawing by Rowlandson made in the 1770s shows a man with a brush and palette and another drawing by Holman Hunt depicts Etty in the Life School, though much later

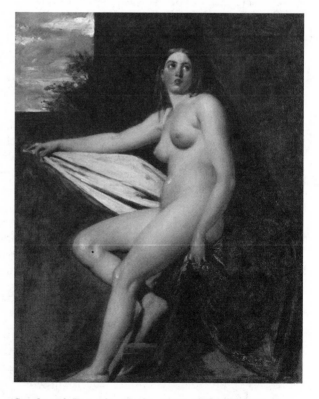

Study of Female Nude (late 1820s–1830s), **Royal Academy of Arts, London (photograph by John Hammond).**

when he was no longer a student, also with a brush and palette. Etty's preference for paint over any other medium stayed with him throughout his life. Though he was a competent draughtsman it seems that drawing to academic standards required too much effort. In most of his so-called "drawings," certainly those in the York Art Gallery archives, he appears to have been striving for a simplicity of line rather than depiction of form. In his use of color, Etty surpassed his contemporaries and for this he is rightly recognized. Throughout his life he produced painted studies when others would have resorted to drawings. What he learned from Fuseli was the beauty of line which he communicated through the dexterous use of the brush. Scenes of horror and violence had no appeal, certainly not the nightmares or any of the Romantic excesses which obsessed Fuseli. *The Destroying Angel, etc., The Combat* and *Benaiah* are more curiosities and works of a man eager to capture attention in the contemporary style than true expressions of the man himself. Although *The Combat* was highly praised, Etty was sensible to his own nature and knew that to pursue such subjects would not be congenial. Much later, as we shall see, in his *Judith* and *Joan of Arc* series, he drew back from the moments of violence and preferred to depict the moments preceding them. Etty's life-long concern was to express the happiness which surrounded his own life and which, he was certain, was God's plan for all mankind.

Fuseli was always attentive to the aspirations of the students who passed through his hands and to his credit did not try to mold them into imitations of himself. According to Gilchrist[36] when Henry Fuseli made his Annual Report as "Keeper" to the Royal Academy at the end of 1821, he particularly mentioned Etty, saying

> I should think myself guilty of neglect, were I not,—among those who pursue this method,—to mention Mr. Etty; whose unwearied perseverance of application, and steady method, well deserve to serve as an example to his fellow-students.

Gilchrist says that this Report "in Fuseli's crabbed, almost indecipherable handwriting,—presented by Fuseli's executors to Etty, was carefully preserved by him." It is not recorded in the Royal Academy Minutes and there is no trace in Etty's own papers. Gilchrist's account is all we have. The year 1821 seems late for Fuseli to comment in an annual report on Etty's progress of a student since he had by then ceased to be an official student for the previous five years though he continued all his life to claim students' rights to attend the life classes.

After the required period, if the Student showed sufficient aptitude, he was admitted to the Life Class. From the establishment of the Schools in 1767 four male models were engaged at a retaining fee of five shillings a week with the addition of a shilling for each night's work. Female models were not immediately engaged but two years later it was agreed the rate for female models should be half a guinea a sitting. The rules of admittance were strict. No student under twenty years of age, unless married, could attend. Also no other person, except members of the Royal Family, could be present when a female model was sitting. These rules were designed to appease those objectors who held that artists employed models only for prurient purposes and that young students permitted to draw or paint from living models would be led into moral depravity. Objectors were particularly concerned that the employment of models would be made opportunity for gratifying *voyeurs* and that Life Classes would degenerate into entertainments for wealthy young men, just as Sunday afternoons were spent by some, including women, watching the behavior of the inmates of Bedlam. Many models refused to pose even privately for artists if a third party was present, sometimes not even permitting a woman, though equally some insisted on a woman companion to ensure that the artist behaved with propriety. This subject shall be returned to later. In the Academy Life Class models had to be posed by the Visitor on a dais before students entered the room who also had to leave the room before the models moved from the dais. Students were separated from models by a rail and no conversation between students and models was allowed. Very soon questions began to be raised whether it was necessary for models to be completely unclothed and also whether it was necessary for "needless

fidelity" when drawing what the Council Minutes later in the century called "the unimportant parts." There was always a general understanding that models should be posed to conceal as much as possible.

Only one letter of his student days has survived, one written to his parents on the 10th April 1807 and which was discovered in 1847 by his niece-housekeeper Betsy.

> I am very well (thank God) as I hope this will meet you all; as great an enthusiast in my Art as ever. I like London extremely well, and hope in the end, however vain the idea, that my name will not perish with my breath but I have not time to launch into eloquent harangues on Painting, for tis just post time, so you will excuse it.
> Give my best love to Thomas and his family, who I hope are well; respects to Mr. and Mrs. Peck, etc. And believe me,
> Dear Parents,
> Yr. Aff. Son
> Wm. Etty

This letter was addressed to: Mr. M. Etty
　　　　　　　　　　　　　　At Mr. T. Etty's
　　　　　　　　　　　　　　Church Lane
　　　　　　　　　　　　　　Hull

Etty sent the newly rediscovered letter to his close friend Joseph Gillott, of whom much more later, with the following explanation, to be preserved by Gillott among other letters from Etty.

> An *autograph*—a curiosity
> 'This Forty years ago!
> Dear Joseph Gillott, Esq.,
> So you will excuse it!
> 　　　　and its *Tone of Colour*
> Betsy found it last week
> 　　　April 19, 1847

It is a great disappointment that we have nothing from this period to tell us of Etty's reactions to the experiences of the Life Class. His first entry into a room where there was posed a naked person—no doubt a male figure as this was the first encounter with a living model—must have left a lasting impression and even more so his first encounter with a naked female. He had, of course, grown accustomed to the human form during his years of drawing from casts and prints but encountering actual naked bodies, especially women, is known to have been the occasion for some excitement among many students. Rowlandson, of a previous generation, does not appear to have developed his response beyond the salacious. Etty, on the other hand, quite clearly regarded the human body as the material expression of divine beauty. Every youth looks forward to his first encounter with a naked woman and we can hardly expect Etty, for all his strict upbringing, not to have felt similar anticipations but no biographer of any artist who went through the Academy Life Class ever refers to such matters. We are expected to believe that artists, like doctors, view the human body differently from the rest of us.

Etty did not start out with the intention of concentrating on the nude figure. There are no reports of his producing such drawings when a boy or young man but rather stories that he drew everyday objects and domestic family scenes and portraits. Unlike modern young students Etty had no access to works of the Old Masters and discovered them only later. Gilchrist tells us Etty had first thought to paint landscapes

> The Sky was so beautiful, and the effects of Light and Cloud. Afterwards when I found that all the great painters of Antiquity had become thus great through painting Great Actions, and the Human Form, I resolved to paint nothing else.[37]

According to Gilchrist[38] Etty decided quite early

> God's most glorious work to be WOMAN, that all human beauty had been concentrated in her, I resolved to dedicate myself to painting—not the Draper's or Milliner's work—but God's most glorious work, more finely than ever had been done before.

Gaunt and Roe[39] quote these words as appearing in Etty's *Autobiography* but they do not occur there. The authors seem to have misread Gilchrist who places the words in quotations but, as is usual with him, provides no source. What Etty does say in his *Autobiography*[40] is:

> I have preferred painting the unsophisticated human form divine, male and female, in preference to the production of the loom; or, in plainer terms, preferred painting from the glorious works of God, to draperies, the works of man.

By the time Etty was a student Thomas Lawrence had established himself as "the Reigning power in English exhibition rooms:—in default of a better. He was not only the Fashionable painter: he was even reckoned a *Great* painter."[41] The Redgrave Brothers, writing in 1866, did not hold Lawrence in such high esteem.

> With every allowance, we can hardly place Lawrence in the first rank as a painter.... Lawrence had adopted a system depending on contrasts rather than on harmonies and the meretricious qualities of his art in this respect certainly left a bad influence....[42]

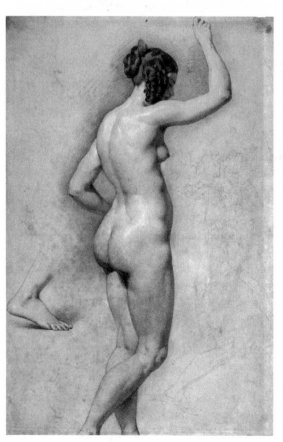

Figure Study: Standing Female Nude with Arm Raised (no date) 56 × 36.5 cm, York Museums Trust (York Art Gallery).

Portraiture competed with history painting as the path to follow, as it had for most of the latter part of the eighteenth century, and Etty was torn between the two. "There was perhaps no alternative for the untutored youth but to 'admire the taste and feeling of Lawrence.'"[43] In the meantime Etty had to satisfy his tutors and produce drawings from the model. He also had to absorb the lectures of the Professors and read the approved books. The final granting of the cherished diploma required not only exceptional ability as a draughtsman and painter but also acceptance of the tenets of the Academy. The *Discourses* of Sir Joshua Reynolds were required reading and by now had become the Academy's Bible and throughout the nineteenth century were promoted as affording the best principles on which an artist should base his career. By the end of the nineteenth century the *Discourses* were being presented by many Schools of Art as prizes to successful students. Not all the lecturers approved every opinion that Reynolds had expounded but it was not for a student to express doubts. Although founded only comparatively recently, the Academy was now the major art institution in the country with a tradition and a set of ideals firmly established. For the Victorians, art in England meant the Royal Academy and, though that period was some twenty-five years hence, this was already the opinion of most educated men and women. Later in the nineteenth century it

was almost a social obligation for the middle and upper classes to visit the summer exhibitions. At the beginning of the century it was certainly an obligation for the gentry and especially those spending "the Season" in London to do so if only to demonstrate that they were educated and cultured. But summer exhibitions' principal purpose was to sell the members' works in the same manner as the new shops were selling their commodities. Just as more people now went to a dressmaker or furniture maker to buy something ready made so too did the art collectors go to the exhibitions.

Reynolds had died only some thirteen years earlier, saddened by the disagreements that were already breaking out among the Academicians (the English are so skilled in disagreeing with each other—it is regarded by them as the sign of an independent mind)—and the Romantic Movement was already exerting its influence, but Reynolds was still the Grand Old Man of Art. William Blake might have hated Reynolds, branding him as a hypocrite, as a man "hired by Satan for the depression of art,"[44] but Blake was known only to a few and Reynolds was familiar to many. When, in December 1791, Reynolds decided not to seek re-election due to failing eyesight, he was urged to carry on and agreed to do so, though he died on the 23rd February 1792. The Council

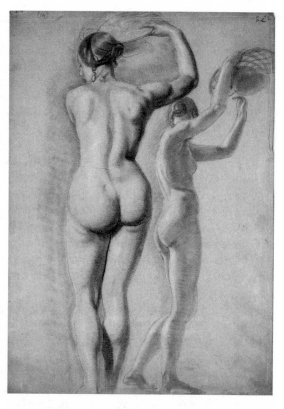

Figure Studies (pencil on paper) (no date), **Leeds Museum and Galleries/Bridgeman Art Library, LMG157870/12.**

Minute recording the occasion referred to him as "the figurehead of the Academy's first era." Right up to the First World War the name and reputation of their first President were revered by the Academicians and in 1923 the bicentenary of his birth was duly celebrated. Etty himself always held Reynolds in high regard and during the last years of his own life had wished to secure Reynolds' painting of *Dido* which he greatly admired.

A rewarding pupilage

The influence of Thomas Lawrence was now all pervading. In 1807 Etty decided to study, if he could, under Lawrence. His theatrical style and ability to produce flattering portraits had made him so acceptable to the English nobility and gentry that it seemed to every student wishing to produce fashionable work that they had to emulate his style if they wished to succeed. When Lawrence had first exhibited in 1787 Reynolds said to him: "In you, Sir, the world will expect to see accomplished what I have failed to achieve."[45] Lawrence had been made an Associate in 1971 and a full Academician in 1794. Exceptionally he was knighted in 1815 before being elected President in 1820, receiving twenty-one votes against one each for John Flaxman and John Jackson. He was re-elected unanimously every year until his death in 1830. His rise had been swift. He had been only twenty-two years of age in 1971, five years before the rule was made requiring Associates to be at least twenty-four years of age. He possessed great charm and elegant manners, which made him a favorite at Court as Reynolds never was. It says much for his ambition that Etty aimed so high. Thus determined, Etty obtained a letter of introduction

from Fuseli and Uncle William arranged an interview with Lawrence at which it was agreed that the young Etty could become a private student for one year for a fee of one hundred guineas, which Uncle William duly paid. There is an entry in Joseph Farington's Diary for July 2nd 1807 as follows: "Lawrence called. His new pupil, the nephew of Mr. Etty, Banker, is to come to Him this morning, & is to pay 100 guineas for instruction for one year."

It will be noted that Uncle William is referred as a "Banker." This is not the only place where such a description is appended to his name.

A room was set aside in Lawrence's house for Etty's use. It seemed a promising start but Lawrence proved to be typical of his age. Most artists were poor tutors, either unable or unwilling to instruct their pupils and many students came away from their year in a "Master's" studio none the better and none the wiser. Generally the reason was that the artists in most demand were too busy to spend time instructing pupils. Taking a student provided them with a guaranteed income for little effort. The students were able thereafter to append the words "Pupil of Mr. So-and-so" to their entries to the Academy's exhibitions and this assisted their chances of acceptance. Etty was for the most part left to his own devices, Lawrence seldom visited him in his room, gave very little instruction and the most that Etty gained from the arrangement was being allowed to watch the great man painting so long as he kept silent. Nevertheless Etty always regarded the year as valuable experience and forever after considered Lawrence to be his friend and supporter, very useful when Lawrence became President.

Lawrence had been born in Bristol on 13th April 1769, the family alleging descent from the twelfth century Sir Robert Lawrence, but this was often disputed. His father was a poor preacher, described by Kenneth Garlick as having "a pronounced streak of Mr. Micawber in him"[46] while his mother came from a family who thought she had married beneath her. After trying to make a living in Bath, Lawrence came to London in 1787 and lived in various houses, sometimes with his parents who had also moved to London. Some of his addresses seem to have been in too affluent a neighborhood for one so impecunious and in 1797 he moved into his parents' house in Greek Street after his mother died and his father moved to Gloucestershire. In 1813 Lawrence moved to the superior address of No. 65 Russell Square where, in 1821, he converted the attic into two rooms so that he could have his principal assistant working with him in his studio and his other assistants and pupils all together in a large room where they would not interrupt him. It was in Greek Street that Etty served his pupilage.

Lawrence had been through ten years of personal difficulty. Kenneth Garlick says,[47] "money matters and love-affairs practically wrecked him." He was living in Piccadilly, opposite Green Park, a most expensive address which he considered necessary to attract the right patrons, and he was spending "recklessly on painting materials," costs which Joseph Farington recorded as "shocking" in his *Diary*. On the 18th March 1801 Farington's *Diary* entry states, "L's circumstances are now so notoriously bad as to be common talk.—£400 to Middleton [*artists' colorman*]— £40 to Poole, &c. &c.—said to be 30 actions against him & it must end in Bankruptcy...."

Poverty and debt are not unknown companions for artists but few also spend recklessly at the same time. In common with many poor men of the time from wealthy families he was giving a public impression that he could not have sustained had it not been for generous friends. He was buying Old Master drawings and generously assisting other artists less fortunate than himself, but at this time all from other people's money. He was "cutting a dash" and it was certainly bringing him commissions which were of benefit in the long run. In the meantime he needed money and taking on pupils was one way of getting it. It would appear, as Kenneth Garlick states,[48] that Lawrence did not welcome others in his studio. Many artists prefer to work in solitude. Later, Etty also preferred to do so. We know Lawrence employed assistants from 1793 and presumably these were originally pupils. One of his pupils, Samuel Lane, told Farington in 1806, the year before Etty entered his pupilage,

He does not employ me in a regular way, & I lose much time in consequence of his being undetermined how to employ me. When I apply for something to work upon, He sometimes walks about uncertain what to give me, & at last puts into my hand a three quarter portrait, desiring me to paint to it *a plain background* which I can do in three quarters of an hour & I am then again without employ.[49]

Garlick continues:

To the young generation at home, Lawrence had always been generous. The situation is less easy to assess when it comes to his attitude to pupils and assistants. He was certainly not mean but he was thoughtless. He probably did not enjoy the proximity of others in his home or studio and this is understandable. As he kept no records himself and employed no one else to keep them for him, it is almost impossible to be sure of the numbers or names of those associated with him at any one time.[50]

The most that Etty gained from the arrangement was being allowed to watch so long as he kept silent. It was not an unusual system of pupilage at the time and Etty always regarded the year as valuable experience but its chief value was that Etty could thereafter describe himself as "Pupil of Sir Thomas Lawrence" and there is little doubt that through this early association Lawrence thereafter looked kindly on him and even felt bound to assist him towards full membership of the Academy, which in due course he did. Garlick says[51] that Etty "got but little out of it and felt that the hundred guineas which his uncle had put down for him might have been better used," but there appears to be no grounds for this suggestion. It is certain that Lawrence was merely following the customs of the times and Etty seems to have been satisfied. Using pupils and assistants to complete unfinished paintings and to lay in backgrounds was quite usual.

Richard and Samuel Redgrave were more critical of Lawrence than many of his contemporaries had been, though opinion among fellow artists was not always approving. The Redgraves complained[52] that Lawrence's method of painting was laborious, one sitter reporting that he had had to submit to forty sittings for his head alone. Lawrence, he said, was the slowest painter he had ever sat to. For a small portrait of George IV, Lawrence required twenty sittings just for the king's legs. Though the Redgraves described Lawrence's work as labored they concluded that the result was frequently "facile" and "slight" in appearance. They do not appear to have appreciated that Lawrence understood that a work of art should look spontaneous notwithstanding the labor involved. Nevertheless they agreed he had had a good influence on the Academy School by encouraging careful drawing, an accomplishment which, sadly, was not acquired by his pupil. For an artist destined to become famous as a painter of the nude it could be asked why Etty chose Lawrence, whose subject was portraiture. At this early stage Etty still thought this might also be his career. History painters needed to be proficient portraitists even though many of their figures were imaginary. The young student very often nearly gave up in despair. Try as hard as he might he could not achieve his desire of emulating Lawrence. "I tried, vainly enough for a length of time, till *despair* almost overwhelmed me. I was ready to run away; my despondency increased. I was almost *beside* myself; here was the turn of my fate. I felt I could not get on."[53]

But Etty was always grateful to his uncle for placing him with Lawrence. "Oh! what a man was my uncle with a family of his own, which he brought up most respectably, he found means and time to foster his brother's children and forward their views."[54]

This is the only occasion when any reference is made to Uncle William's support for his brother's children though one may often conclude that he must have done so. With both his uncle and his eldest brother behind him, the young Etty was always secure against the poverty which threatens most aspiring artists.

At one time Lawrence employed him to copy portraits by Reynolds of George III and Queen Charlotte, paying him 30 guineas for doing so.[55] It is known that Lawrence had retained some unfinished copies of paintings of George III and Queen Charlotte and it is clear that he had them completed by someone else. These may have been the works for which he paid Etty. There is in York Art Gallery archives an entry on the cover of one of Etty's notebooks, "June 27 received

of T. Lawrence 30 Guineas," obviously referring to the commission mentioned. This money was immediately passed to his cousin Thomas Bodley in repayment of a loan. There is another entry in the same notebook—

Dr./June 27/Borrowed of Mr. T. Bodley £8.0.0.
 Received of Mr. Lawrence £30.0.0.
Cr./ " " /Paid in the hands of Bodley 30.0.0.
 Paid Ditto. Ditto. 30.0.0.

The amounts do not quite tally and there is no explanation of two entries repaying £30.0.0. but though Etty was punctilious in repaying debts he was not always precise in the entries he made in his notebooks. In fact, his practice of making such entries was strange since they appear usually to be random thoughts jotted down as they occurred to him and not intended to be accurate bookkeeping entries. Such random notes continued to be made throughout his life. Although he once or twice referred to his Diary no such record has survived and it is improbable he kept a Diary. Tom Etty of Nijmegen has no knowledge of a Diary.

Etty was also able to copy several of Lawrence's own portraits and the style of his master can be discerned in some of the portraits he painted later. Not only the Redgrave brothers thought little of Lawrence as a model to be followed. C. R. Leslie said later that Etty may have acquired "a tinge of something in the house of Lawrence he might better have been without."[56] According to Etty himself (*Autobiography*) Lawrence advised him that "it is a great evil when a man's ideas go beyond his powers of execution."[57] Etty said he found this good advice but today we may well ask what would have been the consequences for Blake, Cézanne, van Gogh and so many others if they had accepted such advice and given up when they were young? Whatever shortcomings Etty may have had and never overcame, he always knew what he wanted to do and persevered. Etty always looked back with gratitude on his year spent with Lawrence but despite his pupilage, it was not until 1811, three years later, that he had a painting accepted by the Academy for exhibition. By that time Uncle William was dead, having died on 25th May 1809. His death deprived Etty of both friendship and financial support and also a home. It also meant that Uncle William did not see the fruits of all his careful nurturing.

Etty may not have learned much in the way of technique from Lawrence, except what he could pick up from watching and copying, but the pupilage was to prove valuable. Gilchrist said:

However problematic the benefit may have been, derived from Lawrence, it is more certain and more important,—when we consider Lawrence's example has sufficed to degrade and stultify English Portrait-painting—that his diligent pupil derived little enduring evil. Few thrown so directly under the influence of that skilful Mannerist have suffered less.[58]

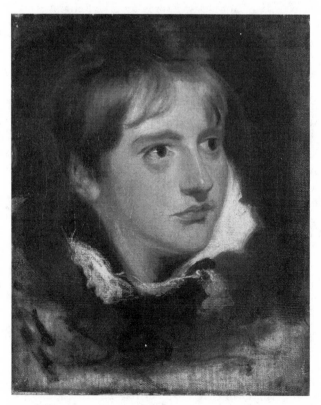

Jacob Pattison, sketch after Lawrence (14 × 12 ins), (?1807–08), York Museums Trust (York Art Gallery), YORAG96.

Etty learned the value of perseverance. He was never a man to give up easily and, though his early efforts clearly did not suggest a great painter to come—and this has been the experience of many artists—his determination to succeed and his life-long sense of indebtedness to his uncle and his brother ensured that he acquired some benefit from the year spent in Lawrence's house. Copying and finishing paintings was the usual lot of pupils and it was beneficial that Etty had to struggle to achieve even a faint mastery of his tutor's style. Lawrence was a kindly and courteous man and never forgot his pupils and there is little doubt that when he became President of the Academy, though he did not improperly promote his pupil's interests, the fact that he was often supportive did enable Etty to attract the attention of other academicians.

CHAPTER FOUR

Unsettled and solitary

With the death of his uncle on the 25th May 1809, Etty had to move from his house and find lodgings elsewhere since it would appear that his brother Walter could not accommodate him in his house. In one of young William's notebooks (in the possession of Tom Etty of Nijmegen) there is an entry, "Came to Mr. Underdown's apartments, August 24, 1809." He did not remain there long. There is another following entry, "Took possession of Mr. James' apartments, December 11th, 1809." Uncle William's will, made on the 23rd September 1807 (a copy of which has been provided to me by Tom Etty of Nijmegen), had been very generous to various members of the family. His own wife having died on the 19th January 1789, his household goods were left to his mother-in-law Mary Hamilton but all monies were shared among the remainder of his family. To John Singleton Clark, his daughter Elizabeth's husband, he left one thousand pounds and "unto my said Nephew William Etty, all my interest and shares in the London Institution to hold the same." The London Institution had been founded as recently as 1806 "for the Advancement of Literature and the Diffusion of Useful Knowledge." Members first met in a house in Old Jewry belonging to Sir Robert Clayton, until a building was erected for its use in Finsbury Circus in 1819, where it remained until its demolition in 1936. The Institution assembled a renowned library and lectures were given by "eminent scientific and literary men."[1] Uncle William's membership in the Institution indicates the serious nature of his interests and the quality of his mind, which must have influenced his nephew and encouraged in him the desire to become a worthy member of London's cultural life. What benefits accrued from "the interest and shares" in the London Institution is not known but they presumably ensured the young man's membership. Uncle William's son-in-law, Thomas Bodley, received in trust three hundred pounds for investing in "Parliamentary Stocks or Government Securities" to provide funds for the instruction of "my said nephew William Etty ... in the art of portrait painting until he shall have acquired such a proficiency as my said nephew William Etty ... and my said Son in Law Thomas Bodley think sufficient for his future progress in that Art" and if any of the principal sum remained it was to be "transferred to my said nephew William Etty on his attaining the age of twenty one years."

Thomas Bodley, besides receiving one thousand pounds for himself, was also given two hundred pounds in trust for investment in "Parliamentary Stocks or Government Securities" for the maintenance of his nephew Charles Etty (then eleven years of age) when he became twenty-one years of age provided he did not receive more than one hundred pounds a year. Uncle William seemed very concerned about Charles since he provided for a series of circumstances including Charles' death without heirs. He seems also to have been particularly concerned about his own son William, who was aged twenty-eight at the time and was to die later that year. The executors, John Smith (who witnessed uncle William's marriage), Thomas Bodley and William Atkinson (the architect), were instructed to purchase sufficient "Parliamentary Stocks or Government Securities" to provide his son with an annual sum of one hundred pounds. This was hedged with

conditions that suggest that the son was not able to control his own affairs although provision was made for his marrying and leaving a widow and orphans. Uncle William was concerned to think of every eventuality and he provided for the various possible circumstances that might befall his daughters Elizabeth and Martha, perhaps being widowed and having children to support. The will makes no provision for his other nephews, John and Thomas Etty, probably because he had already provided their education and also probably helped to set them up in their trades. He did not consider that he had any further obligations towards them. Similarly Matthew and Esther Etty received nothing, possibly because he had also attended to their needs whenever they had arisen. We are surely justified in so concluding since Uncle William was always generous and as he was providing for his nephews William and Charles it is most likely he had also done so previously for his other nephews.

Walter now succeeded to Uncle William's partnership in the business of Bodley, Etty and Bodley. He took over Uncle William's care for Etty and looked after him for the remainder of his life but for some reason he did not wish to have his brother in his household. Etty mourned his uncle's passing, as might be expected since William had so generously supported him. Walter was to prove a similar benefactor but in the meantime the young William had to make his way in the world and several years of hard work lay ahead.

After 1809 Etty lived an unsettled life, moving from one lodging to another. We are dependent on the Royal Academy Exhibition Catalogues for details of his addresses after 1811. Where he lived between 1809 and 1811 is unknown. The Catalogues give his addresses as—1811, 15 Bridge Street, Blackfriars; 1812–13, 23 Pavement, Moorfields; 1814–1819, 20 Surrey Street, Strand, the house which, according to an entry in a notebook, he took on 11th April 1814; again, according to the Catalogues, 1820, 92 Piccadilly and 1821–24, 16 Bishop's Walk, Westminster Bridge, Lambeth. Bishop's Walk was renamed Stangate Walk in 1822. He was eventually able, in 1824, to take a lease of part of a house in Buckingham Street off the Strand, at what was then regarded as a high rent of £120 a year. But by then his position was becoming assured. In the intervening fifteen years Etty's life was comparatively solitary. He does not appear to have made friends easily though all his contemporaries seem to have liked him, approving his retiring and unassuming nature. But he was a shy man and for a long time unsure of himself in company. He told Walter that he was lonely. Life in lodgings would have set bounds to his professional life. He was not yet among fellow Academicians with opportunities to attend meetings, dinners and similar functions, though when eventually he did, it was sometimes recorded by others present that he often remained silent the whole time, unable to break into the general conversation. Probably all this encouraged his continued attendance at the Life School. There he could meet students on common ground but it does not appear that even after election to the Academy he ever became close friends with fellow Academicians. He always felt more at ease with students, perhaps because they did not threaten his security by displays of a superior education which he lacked. He seems to have been largely a solitary man whose few friends were chosen outside the artistic *milieu*. His lifelong devotion to the Academy Life School suggests this. Whilst in the Life School he could have the use of models who did not cost him anything. Before he had his own private living accommodation he would have had difficulty in obtaining the regular use of models who were most likely not allowed in his lodgings. To overcome the difficulty of bringing models to his lodgings he sometimes hired a room elsewhere to serve as a studio but one can imagine that a man as shy as Etty might well have found it difficult to ask a model to pose naked in such intimate circumstances. Models were usually drawn from a social "underclass" who often expected that employment as models would lead to other relationships. Later, in 1830 after he had been elected to full membership of the Academy, he rented a room in Soho Square to serve as a studio and he continued this arrangement until 1839. This he may have found necessary to save embarrassing his niece Betsy who was then serving as his housekeeper.

It is usually stated that Etty was wholly dependent on his uncle and then his brother in these early years. But it may be that he earned some money through quite unrelated activities. After his death a story circulated that someone claimed to have seen Etty many years earlier collecting rents from door to door. It would not be improbable. Certainly in 1809 the outlook seemed bleak. His contemporaries were beginning to outstrip him. David Wilkie, only two years older, had already exhibited at the Academy in 1806 and in 1809 was elected an Associate. Benjamin Haydon, one year older, had sold his first picture, *The Flight into Egypt*, in 1806 for 100 guineas. William Mulready, also one year older, had exhibited in the Academy in 1804 and William Collins, one year younger, had begun exhibiting, though not in the Academy, in 1807. It was fortunate for Etty that his brother Walter decided to continue the support that Uncle William had hitherto given, a generosity which Etty never forgot. As Roy Porter states,[2] "An eighteenth century Englishman acquired his sense of public identity in relation to his birth, his property, his occupation and his social rank. Most women were defined by the honour of their primary male." For young Etty his identity was defined by his father, Matthew, a successful baker and miller in a provincial city. When he came to London his identity became related to Uncle William. After William's death it moved to brother Walter and it stayed there for many years. Walter's dominant position was reinforced by Matthew's death. Etty's constant indebtedness to Walter affected his view of his own status and there is no doubt he was forever the subordinate brother, even though the rest of the family admired him. Young Etty was always concerned that his status as an artist was not high enough. Many of his contemporaries, such as Turner and Wilkie, came from much humbler origins but possessed far more ability. Etty always found it difficult to move out of his original class, unlike Reynolds who determinedly moved out of his class, as did so many others. This was what the age expected.

Etty seems to have concentrated his efforts on perfecting his drawing but from the examples of his early work in the York Art Gallery he was still lacking in natural ability. His drawings rely on Flaxman, Fuseli and Lawrence, even Stothard, a mixed set of examples on which a student could fashion a personal style. Presumably Etty heard Flaxman's lectures to the Royal Academy in his position as Professor of Sculpture. These extolled the virtues of the Ancients, particularly the Greeks of the Classical period, and suggested as examples to be studied the engravings of works in various Roman museums. This was already an out of date standard for modern artists to emulate.

Finding his way

Although portraiture was not to be Etty's main interest he began his career like most young artists at the time by painting portraits of his immediate family. All artists have to earn a living and it was necessary for artists to acquire skills in portraiture since this was the principal kind of painting that the public wanted. From the beginning Etty had realized the need to be able to paint a competent portrait. In the days before photography the only means of securing a portrait of oneself and one's family to hand down to posterity was to commission a painted likeness or, at the very least, a drawing. Almost everyone with the necessary interest and money, which did not have to be of great extent if they were content to employ a minor or local talent, commissioned at least one such portrait in their lifetime. There is consequently a great deal of portraiture in local collections, frequently of indifferent quality. Etty was not an indifferent portrait painter but he never attracted the high society sitters who would have brought him fame. In any case, at this time Lawrence was the portrait painter in demand as Reynolds had been before him and an artist had to be outstanding to attain even second place to him. There was now no shortage of competent portraitists. Etty was not reckoned among the highest exponents of the subject though he often revealed an ability that could have brought him to eminence. In his early years he needed such opportunities to maintain the modest comforts he sought in life

and throughout his career he frequently received useful commissions to paint the portraits of the reasonably wealthy or, more usually, of their wives and children.

So Etty began his portrait painting among his own family, which is where most young artists find their patient sitters. His first portraits date from 1811 when he was 24 years old, although there is every reason to believe that he had made many earlier attempts as young artists do. We can identify portraits of Elizabeth ("Betsy") and Catherine ("Kitty"), both brother John's daughters and also of his father, all painted while he was visiting York in the summer of 1811. He told brother Walter that he had also painted a portrait of his mother but this has not survived. It was destroyed in 1944 while in store at Arnhem. Only a preliminary study, or a copy, probably made later for brother Charles, now exists. Kitty's portrait is today in a private collection. Etty described her as having "grown a tall genteel girl, 'tis a pity she is now from school, serving in the shop and making spice." Brother John was also a baker and Kitty worked in his shop as was expected of daughters of such families. She would have been fifteen years old. Of his portrait of his father he told Walter in a letter of 19th June 1811 that "it is almost too much for him poor man; he is weak and sitting in one position cramps him, & he stoops so much it is a difficult task." Matthew Etty would then have been sixty-eight years old. The portrait is still in the possession of the Etty family in The Netherlands and permission to reproduce it (see page 26 above) has kindly been given by Tom Etty of Nijmegen. There is an alleged portrait of brother Charles in a private collection and which Farr considers was also painted in 1811.

There is an intriguing *Family Portrait*, dated to 1810 (see page 79), which had always been regarded by the Etty family as depicting Walter, his wife and their daughter Martha with the young William standing to one side. This is not to be confused with the painting A *Domestic Scene*, which depicts seven members of Walter's family. The former painting was identified by Dr. Dennis Farr in 1968 as not of Walter Etty but more likely of John Etty since the figure to the left is very similar to the portrait of John in the Merchant Adventurers' Hall in York. If this is so then the woman is more likely to be John's wife, Susanah (*née* Shepherd), and the child their daughter Mary. The young man is certainly the young William. Farr therefore considered that the scene represents a room in Feasegate, York.[3] What this painting is without question is a contemporary version of those earlier eighteenth century domestic scenes depicting the gentry either in gardens or on terraces or in drawing rooms taking tea and holding polite family conversations. The lower middle classes of the early nineteenth century were now suitable subjects for art. It is unlikely that the young Etty perceived himself as making such a politically loaded statement but he was undoubtedly picking up the current fashions.

Etty's next dateable portraits of his family are of 1816. In that year his brothers Thomas and John sat for portraits. Very much later, in 1844, Etty painted a second portrait of Charles but this was also destroyed at Arnhem. Most of the early family portraits must have been made during short visits to York since Etty was, for most of his time during these years, studying in London. In 1836 Etty painted another portrait of his brother John, this time for John's daughter Elizabeth ("Betsy"). Perhaps curiously, Etty does not appear to have painted more than two portraits of Betsy, one in 1811 when he also painted her sister and another probably in 1840 when she was his housekeeper in London (see page 459). One is in a private collection, the other with the Etty family. Etty painted most members of his family, in the early years of his career and from those which have been seen it must be said that these early efforts are no more than might be expected from a young artist on the threshold of his career. They are nonetheless very creditable. Most came into the possession of Charles Etty, who built a room or gallery for them in Java and would often sit among them appreciating the handiwork of his famous brother. Charles apparently had little interest in the arts and appears to have held conventional views that painting should be restricted to portraiture. He owned only a few paintings of his brother's other subjects. Most of these paintings went to the Etty family in The Netherlands and some are still there.

The year 1811 was also when Etty first exhibited—*Sappho* at the British Institution and *Telemachus Rescues Princess Antiope from the Fury of the Wild Boar* at the Royal Academy. He was twenty-four years of age and, though some artists exhibited before this age, many had to wait much longer for recognition. But to remain for a while with his efforts at portraiture, his first commissioned works began in 1815. Gilchrist lists *Portraits of a Family* for that year, *Portrait of a Lady* for 1816 and *Portrait of the Revd. Wm. Jay of Bath* for 1818. William Jay was probably the friend who accompanied Etty to Florence in 1816. He also painted a portrait of *Miss Mary Arabella Jay* in 1819. During his visit to Venice in 1823 Etty met, according to Gilchrist, "a Mr. Wallace of Florence." They must have been already known to each other because Etty had exhibited a painting of *Miss Wallace* at the Society of Arts in 1820. Sometimes referred to as *Innocence*, this is a charming portrait of a young girl in the manner of Lawrence. An important pair of portraits of this period omitted by Gilchrist, no doubt because they were by then in America, were *The Revd. Robert Bolton* (see below) and *Mrs. Robert Bolton and Her Children* (see color plate 2). Robert Bolton's portrait was painted in 1818 and that of his wife and family either later that year or the following year. Bolton's portrait follows the classical format of Reynolds and Lawrence, with the subject standing against a fluted pillar and balustrade with the sea and a ship in full sail in the background. These details refer to Bolton's classical education and to his pending emigration to America. Mrs. Bolton and her children, Robert and Anne, present a family of classic calm, very much in the manner of similar subjects by Reynolds (*Countess of Hartington with Her Children*, of 1786–87) and by Lawrence (*Lady Acland and Her Children*, exhibited in 1818). Both had obviously been seen by Etty. Farr considers that the bowl of flowers included in the Bolton family portrait must be his first attempt to paint a flower subject.[4] Etty painted portraits only intermittently. He continued to do so into the 1840s though most of his more lucrative commissions were in the years from the early 1820s to the mid–1830s and these will be considered in their proper place.

Because Etty has come to be regarded as almost solely a painter of the nude figure, and more usually of the nude female, his occasional paintings of biblical subjects have been overlooked. At the beginning of his career he seems to have been uncertain which subjects should be his specialty. Biblical subjects enabled him to present moral principles which was, of course, the academic justification for including such subjects in the highest level of art. Apart from the studies he was required to make as a student, his earliest known finished painting of a religious subject is *David* of 1810. This was not exhibited and is now in the Russell-Cotes Gallery at Bournemouth. Farr suggests it might originally have been intended to be a studio study of a bowman.[5] It may have been given its scriptural title in the hope of being exhibited. So far as is known Etty did not paint another religious subject

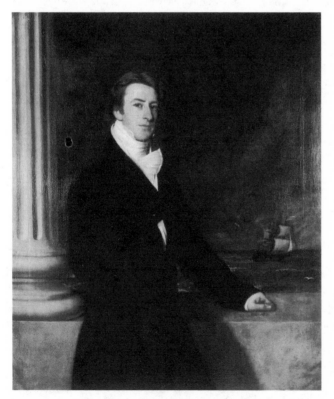

The Revd. Robert Bolton (1788–1857) (50.25 × 41.25 ins) (1818), Collection of New-York Historical Society (Accession 1942.349).

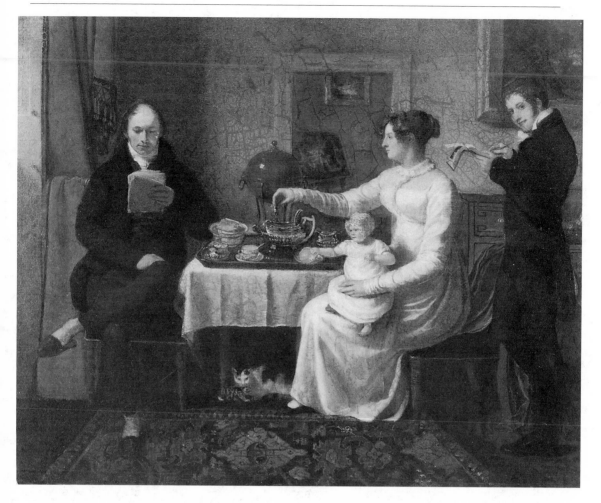

Family Portrait (dimensions unknown) (c. 1810), Tom Etty, Nijmegen, The Netherlands.

until 1816 when he exhibited *The Offering of the Magi* at the British Institution. This painting has apparently not survived. *The Disciple*, also known as *The Saviour*, now in the Tate Britain collection, is of unknown date. It was part of the Robert Vernon Gift to the National Gallery in 1847, transferred to the Tate Gallery in 1929. The Tate Gallery catalogue describes this painting as *A Study for the Head of Christ*. Two paintings of Christ are known, one being exhibited in the British Institution in 1844 as *Study for a Head*, but the actual dates of painting are unknown. The catalogue description of 1844 indicates the general unpopularity of religious subjects at this time. England regarded itself as a Protestant country, despite being officially Anglo-Catholic, but the prevalent distaste for everything Roman severely restricted painters to secular subjects.

There were two other categories in which artists could safely specialize but each required particular collectors. Paintings of landscapes and scenes from everyday life had been popular from the seventeenth century in Holland and had spread to England in the following century. Aristocratic travelers showed the most interest in landscapes, firstly as mementoes of their own travels and then as romantic experiments in the Picturesque and the Sublime. In England landscapes began as topographical scenes, wholly literal representations and often being no more than pictures of country estates. It was increased familiarity with the paintings of Claude and Rosa that encouraged artists and patrons to prefer a more imaginational treatment of the subject. In the eighteenth century English artists developed landscape painting as a serious art form,

especially in watercolors. But landscape painting did not appeal to Etty, despite his apparently early interest in it. His subject was always the human figure and such few landscapes that he did paint were really no more than sketches of local scenes for particular friends.

Scenes from everyday life, known as genre in the absence of a better description, also began to have a wide appeal. William Hogarth is probably the most well known English exponent up to the mid–eighteenth century though he is seldom included among the purely genre artists because his paintings invariably have a moral message whereas true genre is only illustrative. In England genre was usually anecdotal, taking its subjects from novels such as those by Swift, Richardson, Fielding, Sterne, Smollett and Goldsmith. These paintings formed most people's introduction to art and were regarded as at the opposite end of the scale from classical subjects. Etty was well aware of the appeal of genre. Many of his fellow students such as Wilkie and Mulready had already embarked on a career in these subjects. Wilkie's *Village Politicians* had been a success in the 1806 Academy Exhibition encouraging Mulready to follow his example in the following year. Etty was slow to accept the appeal of genre, probably because he already felt committed to history and allegorical subjects, but in 1812 he exhibited *A Domestic Scene* in the Royal Academy followed in 1813 by *The Fireside*, also exhibited in the Academy. The former has been referred to earlier and depicts five members of Walter's family. Presumably *Discovery of an Unpleasant Secret* of 1816, exhibited in the British Institution, was also a domestic subject. *The Gleaner* (now only attributed to Etty, c. 1815), *Drunken Barnaby* (1820; see facing page) and *Maternal Affection* (1822) appear to be all the other subjects of this nature that he painted. Farr is of the opinion that *Maternal Affection* is more a work of 1811 but Gilchrist lists it as 1822. It was exhibited in the Royal Academy in 1822 and in the British Institution in 1824. Most of these works have not survived. Interest in domestic scenes had been aroused by the private collections of seventeenth century Dutch paintings and they quickly became popular among the new middle classes as safe subjects to be displayed in one's home. Jeremy Maas states[6] that there were "thousands of painters" of this genre, though most are now forgotten. Julian Treuherz[7] regards genre as the form of painting most in demand throughout the nineteenth century and attributes this to "the middle class values of propriety and respectability, hard work, the sanctity of family life, piety and self-improvement." From the late eighteenth century the growth of interest in the novel had also aroused interest in the accompanying illustrations and such narrative domestic scenes provided many acceptable subjects. We will see in due course how these attitudes affected the reception of Etty's work when he began to exhibit. That genre did not appeal to Etty is no indication that he did not approve these values. On the contrary, he certainly did but he was by nature a traditionalist and exponent of the grand style of a previous age encouraged by his training. After his early experiments he did not return to these subjects. One explanation may be that Etty was not a reader of novels and had no anecdotes to illustrate. In some quarters novels were still suspect as a waste of time since they did not deal with facts and so were not deemed educational. The more pious went further, denouncing novels as lies and encouraging depravity. We have no knowledge of Etty's views on this matter but he does not seem to have been a reader of novels, probably in part because he applied himself so assiduously to painting and in part as a result of his strict upbringing by Methodist parents.

Slow beginnings and widening horizons

In London recognition came slowly. The art world had changed since Etty had first decided upon his career. All over Europe it was now governed by competition. There were now more artists that ever before and young artists had to attract attention by publicizing themselves as prizewinners of the Royal Academy, the British Institution or the other societies now being established. A new type of patron was coming along who often had no specific work in mind but was willing to buy whatever took his fancy in exhibitions. Patrons were no longer engaging artists to

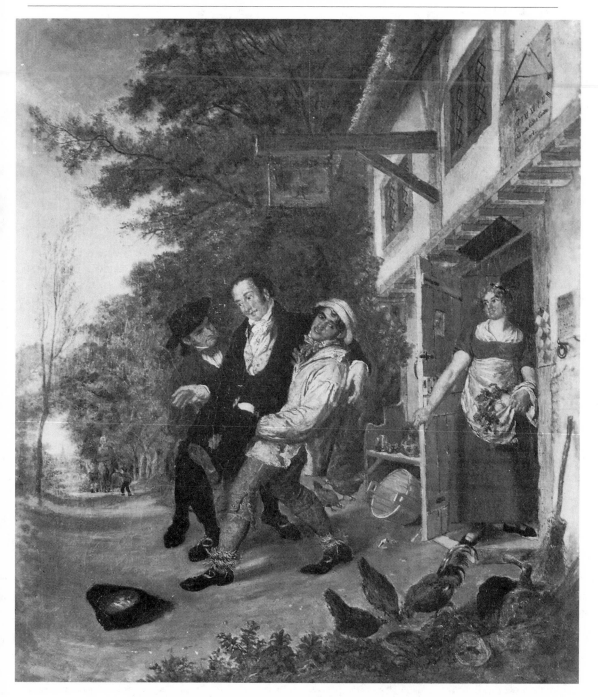

Drunken Barnaby (29.5 × 25 ins) (exh. 1820).

produce schemes for entire galleries or rooms but were buying individual works to make up a collection, often in private studies or libraries or sometimes scattered over the living rooms if they outran the original space intended. As we shall see later, paintings displayed in the family living rooms had to be such that the family would be agreeable to seeing them. Especially they had to be approved by the women in the family, notably the wife and mother. Mostly these new patrons owned smaller houses than those of the aristocracy whom they were replacing in the

art market. Their houses did not boast long galleries and they had no desire for large paintings that would occupy an entire wall. They wanted to furnish rooms with several medium and small paintings. But this did not necessarily mean that collectors had the same power as the earlier patrons. Although artists had to be more competitive they knew very well that most of the new collectors did not possess an informed taste and needed guidance. The Romantic Movement had encouraged artists, poets, writers and composers to regard themselves as specially gifted beyond other men, offering unique spiritual insights whom ordinary mortals should revere. Reverence did not often come their way but this did not stop them expecting it. The Royal Academy was perceived by its members as bestowing upon them a special aura and for the most part the general public was willing to agree.

Etty necessarily entered this market by competing for medals: "I tried for all the medals, gold and silver, and never got any of either class."[8] In his final years Etty was deploring, as old men do, the low state to which the world had fallen and comparing the ease with which his young contemporaries obtained recognition. He complained of "the bad and *mediocre* things that more or less get into all modern exhibitions."[9] It was already happening in his own youth. He decided that he could do better than his fellow students and got together half a dozen pictures, smartly framed and properly labeled, and submitted them to the Academy exhibition. Four were at once rejected, two were initially declared "doubtful." There was momentary hope, but in due course all were returned.

Having received advice from Thomas Lawrence that though his color was good, he "was lamentably deficient in all other respects, almost,"[10] Etty began to study the human skeleton and the drawings in books on anatomy as well as drawings from the antique made by other artists. He went to the London Institution in Moorfields where he was able to draw from plaster casts and stayed up late at night and rose before daybreak so that he could fill his days with study. In 1811 a small painting, *Sappho*, was accepted by the British Gallery and was purchased for twenty-five guineas. Later in the same year his *Telemachus Rescues Antiope from the Fury of the Wild Boar* was accepted by the Academy for exhibition. It was the kind of subject beloved by collectors who wished to demonstrate a knowledge of obscure myths. The story of Telemachus is recounted by Homer in the Odyssey where he is recorded as being the son of Odysseus and Penelope. Antiope was a beautiful girl who was, according to one legend, seduced by Zeus and, to another, was rejected by her husband after an adulterous relationship. Accounts of her history are varied and her encounter with Telemachus is but one of her adventures. Etty does not mention the exhibition of this painting in his *Autobiography*. He appears to have believed that his first exhibited painting at the Academy was *The Coral Finder* (color plate 1) but this was not until 1820. What is significant is that Etty had obviously been reading the Greek myths, probably through translations of Homer and others.

In 1812 he exhibited three paintings, *Cupid Stealing the Ring*, at the British Institution, and *A Domestic Scene* and a portrait, both at the Academy. In 1813 he had four paintings accepted by the Academy and in 1814 the Academy exhibited his *Priam Supplicating Achilles for the Dead Body of His Son Hector*, a subject from Homer's *Iliad*. Gilchrist said[11] that it was an unusual subject for Academy students thereby suggesting that this added to its appeal. Both Fuseli and Flaxman had made a drawing of the subject which may have prompted Etty. Its present whereabouts is unknown. We do not know how these works were received by the public. His contemporary, Charles Robert Leslie, a friend of Constable, later referred to Etty's early works as "black and colourless attempts at ideal subjects."[12] But Etty was painting in the approved method of history painters. Contemporary opinion was that the Old Masters had painted in somber tones to give their work *gravitas*.

General criticism of Etty's work at this time referred not to his subject matter but to his poor draughtsmanship. Etty himself recorded in his *Autobiography* how he studied assiduously to master this skill. It must be conceded that the criticism was justified. York City Art

Gallery's collection of several hundreds of drawings by Etty reveal his almost pathetic attempts to achieve a classical style based on Flaxman. Sheet after sheet of simple outlines of single limbs or torsos repeat these efforts. When he sketched out proposals for compositions he usually did so in generalized terms—they could be called "scribbles"—in which the desired figures are "found" by over-drawing the preferred outlines. This was a Romantic system of drawing, often used by Delacroix, but quite unusual in a Classicist. However it must be remembered that Titian was also criticized for poor draughtsmanship and it was to be Titian that Etty would seek to emulate. Etty was by nature a painter and a colorist. He could handle a well loaded brush but his efforts with chalk or pencil were less successful. His subjects ranged widely, not confined to the nude figures with which he is usually associated. Although he generally submitted such works as *Telemachus* he also at this time sent in domestic scenes and portraits. For a short period his main work returned to portraiture. It seemed it might offer a comfortable living.

Like all young artists eager to improve their abilities, Etty took every opportunity to see the work of established masters. Such opportunities were not so readily available then as they are today. There were no national collections. British governments have generally shown little concern for the arts and sciences and have been distinguished for withholding financial support for anything of a cultural nature. In this they have reflected the prevailing attitudes of the populace at all levels. The wealthy saw no reason to improve the condition of the poor and the poor saw no justification in spending money on "fancy" things such as the arts, which in any case they could not afford, when it could be spent to better advantage on food and housing. In the late Middle Ages it had been quite usual for even the poorest laborer to buy a religious print to stick to a wall in his hovel. But these were no longer religious times, or not of the same kind. Those of "the lower orders" who were religious, and there were many, were more usually Dissenters who strongly disapproved of "graven images." While many country and town houses for the wealthy were built in the eighteenth century and collections of paintings and sculptures were amassed to fill them, very few were opened to public viewing. Those that were usually restricted visitors to persons of obvious social respectability, other members of the gentry and occasionally to established artists. Students were rarely admitted and certainly no one of shabby appearance. Visitors could call when the family was absent and housekeepers, suitably rewarded, would conduct them through the rooms. Jane Austen describes such a visit in *Pride and Prejudice* and Etty himself in 1811 had visited Castle Howard in Yorkshire and Burleigh House, in Lincolnshire. Some more philanthropically spirited owners, such as Sir George Beaumont, encouraged students and even allowed them access for copying works as part of their training, but this was not usual. Generally it was only established artists and connoisseurs who were able to gain regular access by forming societies with the support of a local aristocratic estate owner who fortunately shared their interest, probably by having been abroad himself.

Apart from the wholly unique case of the Ashmolean Museum in Oxford, there were no public collections until the nineteenth century and the first was Dulwich College, a privately formed collection bequeathed in 1626 and increased by a further bequest in 1811 when Sir John Soane designed the present gallery. Until 1858 it was open one day a week to approved members of the public who were granted tickets. Etty was one of these. Although the British Museum was established in 1753 as the first national museum of its kind in the world, it did not embrace the arts of recent centuries. Most collectors were antiquarians and art as such did not interest them. The National Gallery opened in 1824 in Pall Mall before its move to Trafalgar Square. Before these collections were made available and for some time afterwards students relied on attending auctions where they might, if fortunate, see an occasional painting or piece of sculpture of some worth before it disappeared once again into a private collection. Otherwise they were condemned, as the young Etty had been, to relying on work by local craftsmen displayed in shop windows and to the cast rooms of the Royal Academy and the British Institution. Some

artists, despairing of selling their works through the recognized exhibitions, either occasionally mounted exhibitions of their own work in the hope of attracting purchasers or actually ran shops attached to their studios.

When in June 1811 Etty was in York he had taken the opportunity to visit Castle Howard— "and saw the Park, House & Pictures, which pleased me as well I think as any I have seen, particularly the celebrated three Marys, by Carracci, which after some difficulty I got to see, fine portraits by Vandyck. Sir Joshua, etc."[13]

It will be noted that he had "some difficulty" in gaining access, no doubt because he was not a person of recognized social standing. In the same letter he reported that he had also visited Stamford in Lincolnshire,

> where I stayed all night, and in the morning visited Burleigh House, which is just a pleasant walk from Stamford, thro' the Park, saw the House and Pictures, the last are very numerous filling upwards of twenty rooms, many very fine ones.

Burleigh House was more available to visitors. As anyone who has visited Stamford and Burleigh House will know, the walk between the two is not short. Etty would have delighted in Burleigh House, in its original form the home of William Cecil, chief minister to Henry VIII and Elizabeth I, and in its rebuilt form the home of the 3rd Earl of Exeter who gathered its vast collection that made him bankrupt. There Etty saw the Baroque ceilings painted by Antonio Verrio from 1699 onwards, flamboyant classical mythologies of sprawling gods and goddesses, and the staircase decorated by Thomas Stothard between 1799 and 1803, more mythologies but less grandiloquent. Thomas Lawrence had a high opinion of Stothard, describing him as "perhaps the first genius, after Mr. Fuseli and Mr. Flaxman, that the English school or modern Europe has known,"[14] thereby probably telling us much about Lawrence's own judgment. But in his day and after, Stothard was highly regarded, even described as "extraordinary" and possessing "genius" by his admirers, yet by the mid–nineteenth century he was virtually unknown, another victim of changing fashion. Because his father had been born in Stutton, near Tadcaster, and Stothard himself had received his education from five to eight years of age at a school in Acomb on the outskirts of York and then back at Stutton until he was fourteen years old, Stothard was always regarded by Etty as a fellow Yorkshireman, despite his having been born in Long Acre, London, and returning there when he left school. Stothard died in 1834, aged seventy-nine, after having been knocked down by a cab in the previous year. In his final years Etty met him several times and had a high regard for him but it is likely that Etty was unaware of Stothard's radical political opinions, which certainly did not accord with his own. Later Etty frequently visited the Dulwich College collection. Etty was never very communicative regarding his personal life, still less in regard to the works of art that he saw, generally being satisfied to express approval but seldom any criticism. He would doubtless have considered it as presumptuous to disapprove the works of others. Virtually all the works which would have been seen during visits to private collections or to auction rooms would have been those of Italian Old Masters, or more likely of reputed Old Masters and often inadequate copies at that. Most visitors would have formed the opinion that Italianate works of the sixteenth and seventeenth centuries were the only true art. Such visits reinforced all that Etty had been taught in the Academy Schools.

To improve his knowledge Etty paid a short visit to Paris in January 1815. Curiously, this, his first visit abroad, does not appear to have left a lasting impression. He did not refer to it in his *Autobiography* and Gilchrist does not mention it in his biography but as he was relying on letters, the *Autobiography* and the memories of friends and family, this is not surprising. Even so, he missed the letter that Etty sent to Walter describing his outward journey. Perhaps there were other letters to Walter but these have not survived. Dennis Farr first discovered that Etty had made this visit to France. It is most probable that Walter suggested the trip and very certain that he paid for it because Etty not only sent him a full account of the journey but also explained

how extra costs kept arising. The letter, dated "Dover Monday Jan 2" addressed to Mr. Walter Etty at Lombard Street, London, reveals all the problems of cross–Channel travel of the time.

The journey started well enough. Etty left Horse Guards Parade in London at six o'clock on the Monday morning with the moon still shining, the weather "bright and fine." He recounts how he often dismounted from the coach and ran on before, a usual custom with him since coaches made him travel sick, a usual complaint for many travelers, but everything went smoothly while he was still in England. He complains of the "indifferent dinner" (the mid-day meal) taken in Canterbury and the expensive price, another usual complaint of travelers, and then he sleeps overnight in Dover to awake to a morning of bad weather. He cleared his baggage with the Customs Office and then the captain of the ship that was to take them to Calais told him and his fellow passengers that as there was so few of them he would not be sailing until the next day. However, if they would agree to pay a further half guinea he would sail at once. Since another night's lodging would have cost a half guinea they agreed. Then began the haggling for a boat to take them out to the ship that lay anchored off-shore. There were still no docks or suitable jetties at Dover and transshipment from beach to ship was the only way of getting aboard. The owner of the boat announced that if they wanted to go they had to pay his price or stay behind and though Etty argued that he had already paid his fare in full before leaving London, there was nothing to do but agree. Again, this was common practice. Etty was learning the difficulties of foreign travel and more was to come.

The crossing was rough and terrifying. Etty had never been to sea before and the experience was, he wrote to Walter from Calais next day, not one he wished to repeat. Except that he would have to if he was to return. The crossing took twenty-four hours and he stayed on deck all night since going below made his sickness even worse. He was traveling without an overcoat, very foolish considering that this was in January, but presumably he did not possess one. Navigation was by sight and in due course the crew were searching the horizon to see the Calais light. After two hours it was seen and slowly the ship approached the shore. Then there was the waiting until boatmen came out to ferry them to the beach. Once again there was haggling over the price but Etty felt so ill he was glad to pay anything to get back again on dry land. Fortunately there was an "English hotel" with "a good fire a l'Anglais" and a warm bed in which he thankfully slept for most of the day. Then he had to visit the town Mayor, have his passport signed and arrange for a coach to Paris.

The year 1815 was the first opportunity for some time for English men and women to visit France. On 11th April 1814, Napoleon had signed his first abdication after the surrender of Paris the previous month. The Bourbons had returned to power in the person of Louis XVIII and Napoleon had been banished to Elba. For a time peace was restored and travelers could return to the continent in safety. David Wilkie and Benjamin Haydon immediately took the opportunity to do so as did Charles Eastlake. Perhaps it was their example that encouraged Etty. Turner had been to France as early as 1802 and he was always an intrepid traveler both abroad and in Britain. Etty was to prove himself adventurous, unlike Constable, who hated leaving the comfort of his own home. Whether Etty actually reached Paris on this first occasion we do not know but it seems very likely that he did since he obtained a passport enabling him to do so. For Etty the experience would have been that of "a countryman abroad" and we can imagine his wonder and excitement at having reached a foreign city which he could never have expected when he was young. Peace with France did not last long. Napoleon escaped from Elba in March 1815 and "The Hundred Days" began, culminating in his defeat at Waterloo on June the 18th.

It is very unlikely that Etty went to Paris to study French painting. John Opie had instilled in students a disapproval of French art. Etty undoubtedly went to Paris to visit the Louvre and its collection of Italian paintings. The Louvre was the nearest, and really the only, collection that offered public entry. Etty's time in France must have been sufficiently exciting to have erased

the memories of a frightening sea-crossing. He returned to Europe in September 1816 and went on to Italy, reaching Florence. He set off optimistically, writing to his cousin Martha, uncle William's daughter and Thomas Bodley's wife, on the 4th September from Dieppe, that he is "again safely landed on Terra-firma, after a tedious passage of ten hours." This, at least, was better than his first crossing. He gave her a complete account of his journey and assured her: "I am very much better than I was on Monday, both in body and mind." He went on to Rouen, which delighted him even as he found the Cathedral to be "inferior to York." But everywhere was always to be inferior to York. He reached Paris but was too late to have his passport signed which annoyed him as he had to wait until the next day. At the end of his first day he was "much fatigued and very low in spirits." It never took much to upset Etty and like most Englishmen of his day (and some to this day!) he found most things in France displeased him.

> You see, my dear Martha, what a fuss a poor traveller has to go through in this country;—and one, who is certainly not the best calculated at present for it; nor indeed, at any time. Happy England! could she but think so! But discontent and murmurings are not confined to your country.

At least, he was willing to concede that he was not the most accommodating of travelers. We see here also early signs of Etty's political thoughts which he did not often reveal. Always a convinced Tory he viewed any discontent, however mildly expressed, with disapproval. He would at times, though not often, voice objections to the Whigs and the idea of any parliamentary reform he regarded as almost tantamount to treason. Etty enjoyed the status quo and saw no reason why everybody could not.

Unfortunately the Louvre and the Luxembourg Palace were closed for the summer. On the 8th September he writes again to Martha:

> I hope I shall like Italy better than Paris, or I think I shall not feel resolution to stop a year. If I don't, I shall content myself with seeing what I think worth while; and then return. ... I am better in health, much, than when I left; shall feel still better when I am getting on. I know not how it is:—I feel much better when I am advancing, worse when I am set down. I am a strange mortal; must have either a weaker head or stronger feelings than most. Or else, the circumstances, under which I let operate on me.

These references to his health reveal the condition that was to afflict him throughout his life. Etty was not blessed with a strong constitution. He undoubtedly suffered from asthma and his respiratory problems worsened as he grew older. It says much for his strong will that he persisted to do whatever he considered necessary despite constant bouts of illness and, later, intense rheumatism, probably also arthritis, that often laid him low for days. On this visit he began the habit of writing a narrative of his travels for Martha and Thomas Bodley, which he was to repeat on later occasions for them. He and the Bodleys became very close friends and they shared with brother Walter his more private thoughts. Had he not written to them so frequently and frankly we would know far less about him. Gilchrist also refers[15] to a "curt Diary of travel" he commenced on September 21st that recorded his enjoyment of "the sublime and beautiful scenery." Etty's reactions to the journey through the Alps varied according to the time of day. In the sunshine he found the experience overpoweringly beautiful. Like all travelers through the Alps, and especially those experiencing them for the first time, he found the mountains, the valleys and the waterfalls filled him with awe. He was seeing snow capped peaks for the first time and though it sometimes rained he was always aware that he was seeing scenes from the ancient world: as he put it, "the seat of the Gods." But when he had to travel by night it was a different story.

> All is darkness, silence and solitude; save the rushing of the waters, deep in the valley below us,—a sound incessantly heard in these dreary regions. ... 'twas dark and horrible. ... Kept hoping every mountain was our last. But as we advanced, I had the mortification to find the rocks higher, the roads if possible worse, and the precipice still more awful; for the waters were heard roaring much farther beneath us.

Fear was never far from Etty's mind when he was in unfamiliar country in the darkness. In Florence his spirits deserted him. Writing to Walter on the 5th October he said,

I arrived here two days ago. It was my full intention to stop and study. I understand it is the most agreeable city in Italy. But my depression was so extreme as to influence my health. And now I feel unequal to the task of going to Rome and Naples. It would only be an accession of expense, without any positive advantage. I am certain it is not in my power to reside abroad, and am unequal to the fatigue of running about to see all that is to be seen. I have not yet lost the effect of my sprained knee. Under all these circumstances, you will, I know, excuse my determination; a determination not hastily, but deliberately made; and one that has already made me feel another man. I am not sorry that I *have* come, for three reasons. It has cured me of my passion for roving. It has cured me of *another passion*. And it has let me see there is no country comparable to my own.

The "other passion" Etty refers to was the idea that he had begun to entertain before leaving England that it was time he was married. Earlier he had asked Walter in a letter dated 24th July,

whether you think it would be advisable (supposing for a moment I could meet with an amiable girl with some property of her own) to take her with me as a wife, to be the companion of my bosom in a foreign land, to soothe my lonely hours, and by making me enamoured of home, preserve me from the effects of vice, and the contagion of example.

As Dennis Farr says,[16] "Strange as it may seem that a man of twenty eight should seek a brother's advice on such a personal matter, the letter clearly demonstrates William's dependence on his brother and his faith in his wisdom." Etty could never have been said to have been "worldly wise." He was always unsure of his own feelings, especially when they involved his sexual needs, which he seems to have regarded as implanted in him to test his spiritual virtues. What he really wanted was a companion to assuage his loneliness. Throughout his life he was to be a victim of loneliness and we shall see later how dependent he became upon his niece Betsy who became as close as anyone could be to his ideal, a woman companion who did not expect a sexual relationship. In Florence in the autumn of 1816, Etty was desperately lonely. He decided to return home and in another letter to Walter written on the 26th October from Paris, where he had arrived that day, he said that in Florence he "began to draw but could not proceed." In Milan, on his way back, he copied only a single head. He traveled through but hardly saw some half dozen Italian towns but he "had a greater desire to go home the last day than the first, finding it impossible that I could ever be happy about a thousand five hundred miles from all I love." Etty also excused himself from traveling further because the inns were filthy and also because accounts had reached him that the roads from Rome to Naples were infested with "Banditti" and "the exhalations from the marshes of the Campagna are very pernicious."

On his way back through Paris again he was able to meet the artist Jean-Baptiste Regnault. For a while he was able to work in the Frenchman's studio but he found it "a perfect bear garden" with "anarchy during the sitting" and the pupils a "rude set." He spent a week in the French Academy where the students were no better. Altogether one concludes that Etty was not yet ready for the advantages that firsthand contact with the art of contemporary and Renaissance Europe could offer him. He still had much to learn. At least Paris provided him with a supply of good quality brushes. He returned to England on the 23rd November, also a bad season for crossing the Channel, and he was glad to be home. It had been an unpleasant experience and he had not met it with the sense of adventure that one always finds in Turner. The timidity which was often noticeable in his youth still surfaced when he was on his own in unfamiliar surroundings. He could not speak any foreign language and so had no contact with any fellow being and his experience of customs officials, boat men, innkeepers, coach drivers and probably shopkeepers (though he does not mention them) left a sour taste.

In the summer of 1817 Etty had two paintings in the Academy Exhibition favorably reviewed by William Carey, the critic of the *Literary Gazette*. The two paintings were *Cupid and Euphrosyne*

and *Bacchanalians*, the second being described as "a sketch." Carey had been born in Ireland in 1759 where he had at first practiced as a painter and engraver but after an accident to his eye he turned to art criticism. He took an interest in English politics and wrote several pamphlets defending the Princess of Wales and one defending Queen Caroline. He became an art dealer and established his own gallery. He lived between England and Ireland for some years and eventually settled in Birmingham in 1834. He wrote copiously on contemporary art and was proud to have recognized the abilities of Chantrey the sculptor and Etty at early stages in their careers. Of the *Bacchanalians* Carey wrote that it

> is a fine classical invention. The upper part of the female is designed with a noble flow of outline. The Cupid is incorrect, but full of spirit. The brilliant harmony of the colouring is produced by delicious oppositions. There is a certain graceful negligence in the whole, and a true poetic feeling, which affords a splendid promise, if this artist studies to combine *purity of form* with his fine vein of imagination.[17]

The year 1818 was a momentous one for Etty in many ways. He exhibited in the British Gallery and in the Royal Academy. The paintings in the Academy were listed by Gilchrist as being *Blue Beetle* ("Portrait leavened by Historie"); *Portrait of the Rev. Wm. Jay (of Bath)*; *Ajax Telamon* and *A Study*. Another, unidentified, was referred to by David Wilkie as "a clever piece" when writing to Benjamin Haydon, an instance of Etty's appreciation by his fellow artists.[18] In the autumn of that year Etty entered a copy of Titian's *Ganymede* for an Academy medal for best student work.[19] Gilchrist related[20] that his fellow students, fearful that he would defeat them, invoked Academy rules to disqualify him. They claimed he had been too long a student (twelve years) and that he had taken his picture away from Academy premises to work on it at home, a practice not permitted since he could have obtained assistance. Etty wrote a long letter to the Council expressing regret for his misdemeanor. Although he was disqualified, the Council's Secretary told him that his picture had been judged "the best yet produced by the Painting-school" and that the President, Sir Benjamin West, wished Etty to call upon him. However Benjamin West was not available when Etty paid his visit and Martin Shee (later to become President himself) "acted for West with due eloquence." Etty remained proud of this incident for the rest of his life, recalling in his *Autobiography* that West had said that "it would one day be sold for a Titian."[21]

In the following year Etty exhibited at the British Institution *Manlius Hurled from the Rock* (see facing page), a work which he had painted in 1818. It escaped public attention at the time being little more than a re-worked Life Class nude but his choice of a little known subject indicated his knowledge of classical history, however he had come by it. Marcus Manlius had defended Rome against the Gauls and been made Consul in 392 B.C. only to be accused of treason in 384 B.C. when he was condemned to death by the traditional method of being thrown from the Tarpeian Rock. This was one of a number of classical subjects that Etty began exhibiting from 1820 onwards, emerging from obscurity and attracting the attention of serious collectors. Alas, like Constable, he was not able to present to his father the successful son he would have wished.

Death of his father

Neither Gilchrist's biography nor Etty's *Autobiography* or his surviving letters reveal very much about Etty's relationship with his father. Etty was such an assiduous letter writer that it is inconceivable that he did not regularly write home but only one letter to his mother has survived. We can only conclude that they were not the kind of people to keep letters. Neither do they appear to have been letter writers themselves. Etty's own surviving references to his father are contained in letters he wrote to his brother Walter and his friend and cousin Thomas Bodley but they are not numerous. On the 19th July 1811 he wrote to Walter regarding a visit he had paid to his parents, "my poor father is very much altered indeed, stoops a great deal, and cannot

hold a limb still, however he eats
pretty well and walks almost everyday
to John's, if the weather allows."

Brother John was then still living
in Walmgate, a road just within York's
walls. Etty was painting his father's
portrait and he told Walter, "he is
weak and sitting in one position
cramps him." There is in York Art
Gallery a hitherto unpublished letter
which appears to date from August
1813 in which Etty reports that he has
heard that his father, whom he had
not yet seen, having just arrived in
York, was in good health. This letter
is considered in detail later. If the date
is correct it would appear that Etty's
informant (presumably his mother)
had given a good account of his father
in order not to alarm him. There are
no other letters of this date reporting
on his father. Matthew and Esther
had for several years given up their
shop in Feasegate and were living in
Huntington, then a village separated
from York.

On the 24th December 1818
Matthew Etty died, aged seventy-five.
It does not appear to have been unex-
pected. Very little information of this

Manlius Hurled from the Rock (45 × 33 ins) (1818),
Birmingham Museums and Art Gallery.

event is known. Writing to Thomas Bodley, Etty recorded the event as "the first truly heavy
blow my heart ever felt," then immediately corrected this statement, "No! not the *first*." He
remembered the death of his uncle William, to whom he had owed so much. Matthew Etty was
buried in the graveyard of All Saints' Church, Pavement, York, it not yet being permissible for
Methodists to have their own cemeteries. Etty told Bodley, "Walter and I went to Clapton
the day he was buried. The sun shone but *my* heart darkened." That is all. It does not seem
that Matthew's death affected his sons so deeply but Etty was always dutiful. Matthew had been
reasonably successful in his business. He had made enough to own a house in Hull where Thomas
lived. He left his York bakery to his second son since his third son had his own bakery business
in Hull. His widow, Esther, inherited some £900, enough to keep her in reasonable com-
fort with assistance from her children. Ever after Etty always referred to Matthew as "my dear
father," usually coupling him with "my dear mother." His affection for his parents was unques-
tionably genuine. It may very well be that Matthew Etty had never understood his son's ambi-
tion to be a painter in London and probably he had not approved of the choice of subjects.
But we can deduce that Matthew did support his son's decision to become an artist, from a
letter which Etty sent much later to Joseph Gillott. In this letter, dated 26th June 1846, he
wrote:

... my father used to say to me "then folks will wonder!" There was a salute for an infant R.A.!! I do wish
he could have seen me on that stone, it would have gladdened my heart! He once said—when I was talk-
ing of Opie, and saying I fear I shall never be an Opie—Why not—why, thou should have a chance to be

one as well as another. He sleeps in peace, he was a good man! and I wake for a brief period longer, when I hope to meet him again never to separate.

The reference to "that stone" is to the carved inscription in the Royal Academy on which the names of all Academicians were recorded. It was always Etty's regret, as it was Constable's, that his father had not lived to see him elected. Since John Opie's fame rested on his portraits and such histories as *The Assassination of James I of Scotland* and *The Assassination of Rizzio* as well as scenes from Shakespeare, Etty was being more realistic than his father knew. Most likely Matthew Etty knew nothing of Opie's work and was simply encouraging his son with the typical Yorkshire assertion that he was as good as the next man. It was Esther Etty who often went to London and saw the exhibitions and knew what her son was painting. There is no record that she ever complained.

Success at home

Most of Etty's early works have not survived but by the 1820s he was well known in London and beginning to receive worthwhile commissions. Although his color was somewhat lush at this time it appealed to a certain type of patron who also enjoyed his voluptuous figures. In the *New Monthly Magazine* of 1st March 1820, William Carey declared that Etty was "advancing with the steps of a giant." He particularly praised his sketch of *Pandora*, which was exhibited that year at the British Institution. Carey described it as: "a piece of poetry in colours, conceived with much richness and grandeur of fancy, and executed with a daring fury of pencil [i.e., brush] and foreshortenings of great beauty."

Other critics were less generous and condemned Carey's "tasteless ignorance" and called Etty's paintings "paltry productions." When in 1825 Carey came to write *Observations on the Probable Decline of British Historical Painting from the Effects of Church Exclusion of Paintings*, he described Etty as "that inspired Lyric Painter." Dennis Farr records[22] that Carey was one of a small band of critics of the time who did not follow the tradition of writing vituperative reviews designed to ruin artists' careers. Nor did he follow the alternative custom of writing noncommittal reports to protect himself from criticism. Carey had strong views and expressed them positively, regarding reviewing as an art and the means whereby readers could obtain a sensible idea of a painter's ability. An important feature of art history is the changing role of critics from the eighteenth century onwards. They did not merely assess an artist's skill against established criteria, they also set out to form the taste of patrons, not recognizing that taste is an ever-changing fashion but believing that they were extolling eternal values.

In 1820 Etty also exhibited in the Academy Exhibition *The Coral Finder: Venus and Her Youthful Satellites Arriving at the Isle of Paphos* (see color plate 1). This painting was an instant success. It was snapped up by Thomas Tomkison, a maker of pianos, especially for George IV, for the insultingly small sum of thirty pounds, much to the annoyance of Francis Freeling, Secretary to the Post Office, who dearly wanted it. Francis Freeling (1764–1836) had the distinction of being renowned for his efficient management of the postal system, the Duke of Wellington declaring that under his management it was better administered than any in Europe. Perhaps it was not so marvelous an achievement in comparison to the abysmal state of European public services, but in an age when most public servants used their positions to improve their personal wealth Freeling was an exceptional man. He was widely learned, a fellow of the Society of Antiquaries and had collected a large and valuable library. In 1828 a baronetcy was conferred on him for his public services.

After the royal post was made available to the general public in 1635 it was until 1794 the practice that senders had to pay the required postage. In that year it was changed to the recipient having to pay to receive the letter because it had been found that staff in the post offices were destroying letters and keeping the money paid for postage, this being before the introduction of stamps. The new system, however, introduced other problems. Not only were rural people

often unable to afford the cost of receiving a letter but in many cases they did not wish to do so. A son or daughter who had left home for employment elsewhere and knowing that their parents could not read, would send a blank but addressed letter which served as sufficient information that all was well. In these circumstances receipt of the letter was refused. Thus quantities of letters were being transported around the country for nothing. Postage had always been one penny per letter though, for this, it was restricted to one folded sheet of paper. In 1801 the Penny Post became the Twopenny Post but twopence was beyond the means of many people. To pay for the French Wars postage was increased to sixpence and stayed so for twenty-five years. Etty, or his servant, did not always have enough ready money to take delivery and had to go later to the letter office to obtain the letters addressed to them. In 1833 a campaign began to reintroduce the prepaid system but at a uniform rate of one penny throughout the country. Thanks to Rowland Hill this was enacted in 1840, when postage stamps were also first introduced, and the principle, though not the charge, has remained ever since. Francis Freeling did not live to see this.

Francis Freeling, having failed to acquire *The Coral Finder*, commissioned Etty to paint, for the much more realistic sum of 200 guineas, a subject which the artist had long wanted to undertake, *Cleopatra's Arrival at Cilicia* (see color plate 3). Again, the central figure of Cleopatra is larger than her attendants and again the royal barge is dangerously overcrowded. Etty's delight in the figure always required that the subjects of his paintings should be nude or semi-nude and surrounded by nude female attendants irrespective of the circumstances. So it was in this case. Egyptian paintings frequently depicted women with naked breasts so Etty could claim to be historically accurate. Plutarch's account of this event had been used by Shakespeare in *Antony and Cleopatra*. It thus had many claims to be a history painting. When it was exhibited at the Academy it was an immediate success. C. R. Leslie wrote to his friend Washington Irving who was then in Paris that "Etty's *Cleopatra* is a triumph of colour. It has some defects of composition, but it is full of that exquisite kind of beauty, which he alone can give."[23]

Both paintings are eclectic in style. Etty always admired the French artist Jean-Baptiste Regnault and frequent echoes of his works in Etty's paintings are to be found, which is somewhat surprising since one would not expect Regnault's voluptuousness to have appealed to him. There are also suggestions of an increasing interest in Rubens whom we know Etty was now admiring. To have gained Freeling's approbation meant that Etty had gained the attention of a significant collector.

After Etty's death Leslie wrote in *The Athenaem*[24] that "one morning he woke famous, after the opening of the exhibition." *The Gentleman's Magazine*[25] said that the painting was the best of its kind. However, the Redgrave brothers criticized *The Coral Finder* for "the bad proportions of the models."[26] Cleopatra, as so often with Etty, is depicted much larger than her attendants and reclines naked in a decorated golden boat too small, also as usual, for the number of figures trusting its seaworthiness. It was a fanciful picture, somewhat gaudy and deriving some particulars from Italian artists, which probably added to its appeal among those who had traveled. This became a favorite painting among Etty's admirers. It was owned by Joseph Gillott in 1845 and has passed through many hands since. It is still in a private collection.

In his *Autobiography* Etty wrote:

> It made a great impression in my favour. Sir Thomas [*Lawrence*] jocularly said to me of it: "They, *the public*, leave Marc Antony"—meaning himself—"whistling in the market place, and go to gaze on your Cleopatra." The Old Times even deigned to notice me, though as much in the shape of castigation as any other; but still the *Times* noticed me. I felt my chariot wheels were on the right road to fame and honour, and I now drove on like another Jehu.[27]

Actually *The Times* did not review the Academy's Exhibition in 1821. Etty was perhaps recalling an article in *The Times* of 29th January 1822 which did notice *Cleopatra* but went on

to comment adversely on his painting *Cupid and Psyche Descending*, also commissioned by Francis Freeling, describing it as "indecent." Regarding Etty's exhibits in the British Institution in 1822, *The Times* wrote:

> we take this opportunity of advising Mr. Etty, who got some reputation for painting *Cleopatra's Galley*, not to be seduced into a style which can gratify only the most vicious taste. Naked figures, when painted with the purity of Raphael, may be endured; but nakedness without purity is offensive and indecent, and in Mr. Etty's canvasses is mere dirty flesh. Mr. Howard, whose poetical subjects sometimes require naked figures, never disgusts the eye or mind. Let Mr. Etty strive to a taste equally pure; he should know, that just delicate taste and pure more moral sense are synonymous terms.[28]

("Mr. Howard" was Henry Howard, R.A. [1769–1847], Secretary to the Royal Academy and a portraitist and painter of history and poetic subjects. He was particularly famous for using Milton's *Comus* as a source.)

In consequence of this criticism Freeling asked Etty to add some draperies to the figures in *Cleopatra*, though he changed his mind in 1829 and asked Etty to remove them. On the other hand Etty may have misattributed the review in the *Gentleman's Magazine* of May 1821. This commented, "in the school of painting, there are some pieces belonging to the highest class. Of these, the first is Etty's classical picture of Cleopatra's arrival in Cilicia."[29]

The Examiner[30] compared Etty unfavorably with Titian and Rubens who, the critic stated, "sometimes failed to give such subjects due effect. It would have been next to a miracle then if an early practitioner amongst us in that school were not found much wanting." Nevertheless the writer concluded that the work had "grace" and "is well worthy of the possession and must obtain the admiration of the tasteful for its composition and colour. ... It cannot fail of affording much pleasure." *The Morning Post*[31] declared it to be "the best of the fancy subjects" in the exhibition but *The Observer*, on the contrary,[32] said that "there is nothing which deserves the name of an historical picture and, indeed, not many which aspire to it."

Cleopatra's Arrival betrays a number of faults that are often found in Etty's work. They are worth drawing to attention here. When painting groups he frequently worked on each figure separately, often having only a single model whom he placed in different poses. But he generally failed to bring all the figures into a satisfactory coherence. He had a tendency to overcrowd his compositions and accessories, as in this case the boat, are sometimes absurdly out of proportion. It had long been the custom for painters of religious and historical subjects to emphasize the central figures, a device actually commended by Jonathon Richardson (1665–1745) in his books on the theories of art, which were still in circulation among the older painters of the time. Etty's patrons were prepared to ignore these failings, if indeed they regarded them as such. His eclecticism was quite usual at the time, it being commonplace for artists to "borrow" from each other. It has been by suggested by Dennis Farr[33] that Turner himself, in 1829, was not above "borrowing" from Etty for the background to his own *Ulysses Deriding Polyphemus*.

When Freeling's collection was sold in 1837, after his death, *Cleopatra* was bought by the dealer Farrer for 210 guineas. He in due course sold it to Henry Labouchere, who later became Lord Taunton, for 1,000 guineas. At later sales it sold for much less. It is now in the Lady Lever Art Gallery, Port Sunlight, Lord Leverhulme, who was collecting between 1896 and 1925, being a great admirer of Etty's work. *The Coral Finder*, originally bought for a ludicrous figure, appreciated in price over the years, being bought in 1849 for 370 guineas, but in subsequent sales prices fell. It was said to have been owned by the engraver C. W. Wass in 1848 who produced an engraving for *Art Union*.[34] Farr states,[35] though there is no documentary evidence, that Etty painted a second version; it is possible that the work owned by Wass in 1848 was not the original but a copy. These two paintings, to which some space has been given here, marked the arrival of Etty upon the London scene. Notwithstanding a few discordant comments the majority of the critics and the general public hailed them as popular works and certainly the general chorus of

acclaim established Etty's acceptance. As Farr remarks,[36] *Cleopatra's Arrival* "burst like a bombshell upon the Academy and the Public alike."

The painting remained a favorite with both the public and those claiming a special knowledge and appreciation of art. As late as 1846 when *Cleopatra* was again exhibited, this time at the Royal Society of Arts, Elizabeth Rigby, the future Lady Charles Eastlake, visited the exhibition on the 24th March and in her journal noted that "The Etty is a most wonderful picture; like Sir Joshua, he is an Old Master." So pleased was she that she visited the exhibition again on the 28th March. This time she was more effusive. "To the Exhibition again. What a mixture of the poetical, the allegorical, and the historical is that wonderful 'Cleopatra' of Etty's! What designs he must have made for that glorious confusion of figures!"

The Eastlakes were a formidable husband and wife team of whom there have been many in history. To receive her praise was an accolade indeed.

Etty exhibited other minor works in 1822: *Venus and Cupid Descending* also commissioned by Sir Francis Freeling as a companion to *Cupid and Psyche Descending*, and *Cupid Sheltering His Darling from the Approaching Storm*. Gilchrist comments[37] that "Etty's leaning at this period was more and more, to brevity of Canvas." His pictures were now smaller, reflecting the demand from collectors who needed a number of paintings to fill a single wall in one room. For *Cupid and Psyche Descending*, Etty quoted in the catalogue lines from Milton's *Comus*,

> Where far above, in spangled sheen,
> Celestial Cupid, Venus fam'd son, advanced,
> Held his dear Psyche—
> After her wand'ring labours long.

Quoting from such an illustrious source did him little good. It was not so well received as the earlier works, regarded as they were, as Gilchrist remarks,[38] "as minor flowers."

According to Gilchrist,[39] Etty set much store by *Cupid Sheltering His Darling from the Approaching Storm*:

It is a flawless piece of Painter's work, inimitably lovely; in sentiment, fresh, and captivating as a Fancy of Drayton's or Herrick's. *He* even imagined, "though not so extensive a Composition, it was perhaps a more complete Picture than the *Cleopatra*. ... I took at least more pains with the parts."

He was therefore mortified when it was exhibited, "judged worthy no better place than the Floor; to be hid by the legs of the spectators of a neighbouring and celebrated picture, and reflecting its colour on their Boots."

It was every painter's wish to be exhibited "on the line" but in those times so many paintings were accepted for exhibition and the available space so limited it was customary to hang paintings from floor to ceiling. Only exceptional works were hung at eye level.

In 1822 Etty also exhibited, at the British Institution, a first sketch of *Youth on the Prow and Pleasure at the Helm*. He was to exhibit the finished work (color plate 16) in 1832 at the Academy. In the meantime he made several studies of this subject but the dates of these are uncertain. The final version of this painting will be considered later.

Despite the relegation of *Cupid* to floor level, his earlier successes encouraged Etty to think of the next necessary step in his career. He had to be elected Associate of the Royal Academy as soon as possible if he was to achieve full membership as an Academician at a reasonable age. He was now 35 years old. Turner had been elected Associate in 1799, aged only 24, and a full Academician in 1802; Wilkie became an Associate in 1809, aged 24, and an Academician in 1811; Mulready became an Associate in 1815, aged 29, and an Academician the following year, while another fellow from his student days, William Collins, had been elected Associate in 1814, aged 26, and Academician in 1820. Etty must have feared that he was being left behind. Of all his notable contemporaries only Constable, born in 1776 and eleven years his senior, elected Associate in 1819, aged 43, but not yet a full Academician, could be regarded as still behind him. By

the rules instituted in 1769 when the class of Associateship was introduced, such members could not exceed twenty in number and full Academicians could be chosen only from among them. It was a matter of waiting for dead men's shoes. It was clearly time that Etty did something about it. That he did is revealed in a letter he wrote from Birmingham on the 28th May 1822 to his studio assistant, George Franklin:

My Dr. Franklin
 Pray on receipt of this—go to Haughton's and see whether he has got a letter from me requesting him to put my name on the list of candidates for Associates of the Acad. If by any chance he has not received it, do you see that my name is inserted in the list simply thus "*William Etty, Painter,*" as I am going to Devizes and shall not be back for a day or two, and the name must be put on the list *ere May expires* or I cannot be a candidate.
 Herein fail me not if ye love me
 Truthfully yours
 Wm Etty
 I shall see you in a day or two

Etty's efforts were unsuccessful. He had two more years to wait.

CHAPTER FIVE

The Grand Tour—A second attempt

In 1821 Etty's friend Richard Evans, who had also been a student under Lawrence, had visited Italy and had returned full of admiration for that country and its art. He wanted to return to continue his studies and persuaded Etty to go with him. Etty also realized that he ought to visit Italy as the birthplace of the kind of painting he admired and that it would be advantageous to accompany someone who had some knowledge of the country. In June 1822 the two set off. This time the Channel crossing was neither so long nor so disturbing as before. They crossed by steam-packet named *Dasher* which also carried mails and instead of taking twenty-four hours as did most sailing vessels, it took but three and a half, a merciful reduction. The road journey to Paris was, however, no more enjoyable than before. The scenery did not impress Etty and the journey took two days and a night requiring them to stay in one of the by now familiar uncomfortable inns. They stayed for two weeks in Paris.

They inevitably visited the Louvre where the biennial exhibition of the French School was being held. Perhaps somewhat reluctantly, since Etty did not normally approve the French artists, he had to admit (as he wrote to Lawrence[1]) that "in truth their efforts are highly creditable. ... It was thought not so good as generally, but really many were highly respectable, history of course I mean, the less said of their portraits, God knows, the better...."

As a publicly available collection, the Louvre greatly impressed Etty. He described it as "magnificent," and expressed the wish that England had something similar. Etty and Evans also saw the Rubens *Marie de Medicis* paintings in the Luxembourg Palace and Etty wrote home to Lawrence that they "look, I think, more splendid than ever."[2] Rubens as an influence on Etty may at first sight seem surprising. Rubens' attraction to the nude figure was usually dismissed in England as "carnal" but it was his rich use of color that appealed to Etty. After Titian, Rubens came a close second in Etty's estimation. Also in the Luxembourg Palace they saw works by Guérin and Regnault whom he described to Lawrence as "the best." Later, on his way back through Paris in November 1823, he again praised these two painters as being "two of their first men."[3] The effects of Guérin and Regnault on Etty have never been fully recognized. It was probably in Guérin's studio that he saw the model Mademoiselle Rose, who regularly posed there and many times for Delacroix who studied there between the years 1817 and 1824. At some time Delacroix painted a study of her which is so reminiscent of Etty that it is surely permissible to deduce that the two had met earlier than is usually supposed. Similarly there are paintings by Regnault that immediately bring Etty to mind, such as his *Three Graces* of 1793 now in the Louvre. Both Guérin and Regnault were elderly when Etty visited Paris—the former was to die in 1833 and the latter in 1829. Both are now usually dismissed as minor followers of David. Géricault was a pupil of Guérin, as was Delacroix, and if both moved away from their master as Romanticism attracted them this is only to be expected. The links between these painters and with Etty may not be regarded as strong but they were certainly important.

Etty and Evans took time in Paris to enjoy some of the tourist sights that were being offered.

They went to the *Théâtre Feydeau*, "a sort of Opera," took tea like any tourist in the *Palais Royal* and, wanting more music, went to the *Café d'Harmonie* which promised "nymphs" as waitresses. They had punch, coffee and tea served by "four or five Nymphs" dressed in white, blue and silver. They went on to Dijon where they visited a gallery and an "Academy" and then moved on to Geneva and over the Simplon Pass to Italy. This time he was more impressed by the scenery— "a stupendous barrier indeed ... the grand and the terrible."[4] After six days Etty and Evans were in Milan, staying only two days but seeing "the remains of the Last Supper," and then on to Piacenza to see "a few pictures in the churches" and then Parma, where they were "much delighted with the Correggios" and on to Bologna "with the large Picture [*Dead Christ*] of Guido [Reni] ... and the pictures of Carracci etc." Etty was pleased to tell Thomas Lawrence of his greatly favorable impressions in the letter he sent to his old master when he reached Rome. Then they moved to Florence, a total journey of sixteen days, with no fewer than five days over the Appenines, in a summer of intense heat. Writing of the weather, Etty told Lawrence:

> ... we entered Italy in the middle of the hottest summer, some of the oldest Italians have known, we, of course, had our share of its many *pleasures* (however, with all its drawbacks it is yet a glorious country)— the rivers were dried up, the roads dusty in the extreme, and one might almost have said with Satan, "Oh! Sun, to tell thee how I hate thy beams!" It has, I am persuaded, left a lasting and *warm* impression on both our minds.

In Florence they visited the Uffizi, the Pitti Palace, the tomb of Michelangelo and various churches and were suitably impressed, especially with "a fine Picture of Rubens Mars rushing into Battle."

The journey to Italy had astonished him with the beauty of the scenery. The weather clearly assisted to arouse in him a satisfaction that he had not experienced on his earlier visit. He recorded his delight with the mountains and the valleys and most of all the "the awful chasms and tremendous depths" of the mountain passes and the "thunder of cataracts" and then "the vast Solitude." These were the reactions of travelers who preferred the Romantic interpretation of nature, with its emphasis on the Sublime; the kind of feelings experienced by Turner, so we may be assured that Etty was not a man unaffected by emotion. Clearly the two never wasted a moment. It was, in the parlance of a century later, "a whistle-stop tour," but their sights were set on getting to Rome and then to Venice.

"The spell is broken"

After the short stay in Florence they went to Rome, taking four days in a *vetturino* instead of the usual five days, an interesting reminder of how slow travel was. They suffered the discomforts of inns "wretched to a degree unthought of." The weather during the journey was so hot that they had to stop and cut down branches of trees to form a canopy over the vehicle. But the distant view of Rome made it all worthwhile, as Etty described in his letter,[5]

> ... when we reached the brow of a hill—Rome spread out its towers on the plain beyond, backed by noble mountains, now of a hot purple, and rosy hues; the fields, owing to the long drought, were burnt to the colour of dust; and formed a striking contrast to the verdure of England.

He had opened his letter with expressions of delight.

> At last, my dear Sir Thomas, the spell is broken and I am in Rome! To write from *such* a place to the most distinguished painter in Europe, requires considerably more talent in epistolary correspondence than I possess, however, as you wished it I will endeavour to give you a sketch of our movements.

So he did as we have already seen and as he continued. He had hoped that Rome would "accord with those 'sights such as youthful poets dream,'" and so it proved, although he said he

preferred the upper part of St. Paul's Cathedral in London to that of St. Peter's, which he thought had too many statues. However the interior won his highest admiration: "if any temple is worthy of the Deity, surely it must be this."

The papal collection in the Vatican left him searching for sufficient words to sing its praises. "What a congregated mass of art and splendor is the Vatican! it is almost overpowering." He visited the Sistine Chapel.

With awe and reverence I enter the Sistine Chapel and hail its mighty Author! Great Heavens, what a Ceiling that is, and the Last Judgment too, however blackened by time and smoke; the ceiling far exceeded my expectations; what composition, what daring defiance of all difficulty, without mentioning its grand air and drawing—qualities we all know it possesses amply—what mastery [of] light and shade, what a beautiful and almost Venetian colour!

Etty went on to describe other paintings he had seen, by Domenichino ("full of novelty and beauty tho' not so glorious in colour as such a subject would admit of"), by Guercino ("the proper tone of historic colour"), by the Carracci ("its tremendous depth without black, its richness without gaiety, its deep toned shades and golden, subdued lights, reminded me of one of the best of Sir Joshua's own picture's color, his Dido"). In his letters and the others he wrote to Sir Thomas from Italy we see an increased confidence in his own judgment. Although Lawrence had asked him to convey his reactions he felt fully capable of expressing firm opinions to his old master and the President of the Royal Academy. Though not yet a full member of the Academy, Etty nonetheless felt himself fully competent to stand among his contemporaries as an equal, as indeed he now was. Inevitably he praised the Raphaels but regarded Michelangelo as the superior painter of the two. With the aid of Richard Evans with whom, he told Sir Thomas Lawrence in a letter, "I may safely say I have seen about twice as much as I should have done alone," he explored all the most interesting sites. Exceptionally he went on excursions to the surrounding countryside, declaring the landscape to be "fine" with October still hot.

He met the English sculptor Joseph Gott who was working on his *Venus and Adonis* and but for this and the fact that he was recovering from a fever Gott would have accompanied Etty to Naples. Poor Gott was to suffer a great disappointment. His *Venus and Adonis* was "broken to pieces" when being removed to exhibition and had to be re-carved.

While in Rome Etty fulfilled a number of commissions to paint copies of particular paintings, many having been required by Sir Thomas Lawrence himself before he left London. But what gave him special pleasure was being asked to paint a "finished Picture" of a landscape with an historic subject. His unknown patron asked for "some magnificent Scene on a River or Lake, with a distant shore, and a celebrated Ruin in the middle distance." In other words, a pastiche of a Claude Lorraine subject. Gilchrist reported this episode but gave no source for the story beyond stating "he writes home."[6] He states that Etty's "scale of remuneration at this period looks *now* fabulous." It was £25, small money today but then worth at least one hundred times as much. Other commissions followed but some were too small for him to accept. Etty was by now "a name" and he could choose which patrons to accept and which to decline.

Evans contracted malaria and stayed in Rome when Etty moved on to Naples. Here he met several English art collectors who were doing the Grand Tour. He made a night ascent of Vesuvius accompanied by a local guide, an event which so impressed itself on his mind that many years later he gave a lengthy description of the climb in his *Autobiography*.[7] Etty's account is given in his usual attempts at a literary elegance which did not come naturally. He set off in the evening "in a curious Neapolitan *cabriolet*." "The night steals on, and with her comes the silver moon, shedding her soft light on this enchanting scene. And lo! to the left, like another Chimera, Vesuvius; belching forth smoke and fire,—the mountain is most active tonight."

He engaged a guide. "Salvadore the guide was called. I bargained with him, and began the ascent on foot." The guide had offered him a mule but, as he wrote to Walter[8]: "I am neither

horseman nor assman, nor yet a muleman." The offer was declined. It was a steep climb to a hermitage where Father Francesco received them, astonished that they had climbed on foot. "He scarce knew of a traveller having done this." It was eleven o'clock at night and after some bread and cheese and wine they had a short sleep before beginning again. He had been careful not to drink too much. "The last monk is accused of intoxicating travellers for his own purposes." Other men also shared the room and Etty took comfort in "a good stout knife" he had with him, "and thought I would dig at some of them, if they thought fit to meddle with me." But nothing of the kind happened and after two hours he and his guide were again on the road, though it was no longer a road but a stiff climb among rocks. Soon the ground was shaking and they climbed through ashes so deep that they slipped back at every step. The heat burned his boots and he thought he would not be able to manage the final ascent but by hanging on to his guide's belt he managed it.

> It was a fearful struggle to gain the wished-for point, and *then*, gracious heaven!—what a scene of hell opened before my astonished eyes,—the crater vomiting from its deep-mouthed caves, thousands of tons of red-hot stones and lava, with the explosion of loud thunder, flashes of lurid lightning, and sulphurous flame.

They stayed there some time watching "this grand, yet appalling, scene" then began to think it was time to descend. They reached the hermitage again, had an hour's sleep on two chairs and as daylight began to dawn they returned to Naples where he took a dip in the sea to wash off the dust. He visited Herculaneum, admired the "Greek paintings from the Buried Cities" and drove back to Naples for another dip in the sea.

He had already met an Englishman named Henry Vint in Naples and together they went on another expedition to Pompeii. Etty was later to recall in his *Autobiography*[9]:

> We pic-nicked in the Palace-gardens of Pompeii; plucked delicious grapes, grown on the ashes of two thousand years:—which yet covered two-thirds of the interesting city. We rambled over its amphitheatres, temples, gardens, streets, its houses, and its tombs; and after viewing its statues, pictures, various refinements, arrived at nearly the same sage conclusion Solomon had come to, some thousand years before us: that there is little or nothing *new* under the sun.

Henry Vint proved to be an amiable companion. Dennis Farr[10] identified him as the husband of Martha Elizabeth Bigg, the daughter of William Redmore Bigg, R.A. (1755–1828). Bigg was a painter of rustic genre subjects and occasional portraits and a frequent exhibitor in the Academy. He was renowned for the extensive sentiment expressed in his paintings in which "obviously virtuous poor are very prominent."[11] Henry Vint was known as a collector of Italian antiquities and was elected a Fellow of the Society of Antiquaries. At the time of his meeting with Etty he had a villa on the Piazza Falconi, probably rented for the season, and allowed Etty to stay there for a month. Vint was exactly the kind of man that Etty wished to have as a friend and it appears the friendship did last, as Gilchrist recorded in 1844[12] that "the Painter tells Mr. Vint, that in the gloom of a London November ... the only sunshine I ever see ... is the gaslight shining on the Figure of Life.—We must go to Naples to see the Sun."

Apart from this there are no other references to Vint but this does not imply that they did not meet in the intervening years. Other references to other persons make it quite clear that Etty frequently met and often stayed with friends he did not mention in his letters. It is very possible that Vint introduced Etty to his father-in-law when he returned to England, though as Bigg was already an Academician, having been elected in 1814, it is equally likely Etty met him later after his own election.

It was at this time that Antonio Canova died, aged sixty-five, in Venice, where he had gone expecting to die and wishing to do so in his native city. Etty, who had met Canova in Rome before he left for Naples, through a letter of introduction provided by Lawrence, was surprised by the news since the sculptor had seemed so healthy. There were numerous people in Rome

who knew Lawrence and Etty met most of them. Canova had left a most favorable impression on Etty and it is clear that his work influenced some of Etty's own subjects. Canova's *Theseus and Centaur* of 1804–1819 is visible in Etty's *Benaiah* of 1829 and in his *Combat; Woman Pleading for the Vanquished* of 1825.

Three weeks after Etty climbed Vesuvius the volcano erupted.

> That part of the cone on which I stood on the night of my ascent, was blown into the air, and the whole outline of the upper part of the mountain changed by a tremendous eruption which sent its torrents of red-hot lava rolling down the mountain-sides, and its ashes into the distant city of Naples itself.[13]

Etty had experienced a unique moment in his life and witnessed a unique moment in the life of Vesuvius itself. As with every traveler who coincides with important events he remembered his visit to Naples for the rest of his life. But other great events were to come. In October he traveled back to Rome by chance in the same coach as the actor William Macready. This fortuitous event was to prove beneficial to Etty but he does not record it in his *Autobiography*. But, then, there are many important events he does not record. Reporting the occasion to friends, and in his private diary, Macready highly praised Etty as a traveling companion.[14]

> A short thin young man with very light hair, his face marked with the small-pox, very gentle in his manner, with a shrill and feeble tone of voice, whom we found a very accommodating and agreeable traveling companion, and whom through all his after-life I found a very warm friend.

It is worth reminding ourselves that everyone who met Etty remarked on his friendly nature and of his continuing loyalty. It is quite evident that there was nothing devious or dishonorable in his character.

The accidental encounter with Macready was to be the beginning of a lasting relationship between the two men. On his return to Rome in the autumn of 1822 Etty explored the city more thoroughly than he had done on his first visit and decided to make copies of as many of the Old Master paintings there that he could. He embarked on this task as others had done before him, partly to take home examples of their work to serve as models for his own and partly to learn their technique for his own instruction. In one of Etty's notebooks there is a list of forty-seven paintings which he probably intended to copy, though in the event he completed only a few. By far the majority of the works listed were by Venetian painters, indicating his general preference for that school. In letters to various friends and associates in London, Etty wrote at length of his pleasure in being in Italy and especially, so far, being in Rome. He wrote to Sir Francis Freeling on 31st October 1822 reporting his opinions of several Italian artists and describing the paintings he had seen. As always he praised dead artists but was less enthusiastic about the living. It is true that Italian art had suffered a considerable decline in the previous century. He declared that he would not in future recommend students to go to either Florence or Milan. Etty preferred the Venetians whose work he had already seen in Rome. He was to be even more convinced of their superiority when he got there. While in Rome he visited with Evans a Convent of the Capuchins to see Guido Reni's painting of *Archangel Michael Binding the Devil*. The painting he declared to be "fine" but it was the peacefulness of the Convent gardens that impressed him. He told Evans that he had "a good mind to turn Friar, and leave that World which gives me nought but disappointment."[15] But it was not merely the effects of the visit to the "calm, tranquil life" of the Convent, that roused in him such melancholy. Etty was in love and his love was not being returned. But this we will consider later.

Success in Venice

Etty set off for Venice in November, again leaving Evans behind but intending to meet him again *en route* in Florence. He wrote to Walter[16] that he expected to return to London in December and asked for a further twenty pounds to be made available to him as he could not risk being

without money while traveling. He had originally undertaken not to be away for more than six months—"that determination I will accomplish." But Venice still awaited and his resolution would change. The ease with which Etty often asked his brother to send him money suggests that he might have been drawing on his uncle's bequest, not on Walter's private funds. He went to Florence via Terni, to see the famous falls and lake, and also Perugia and Arezzo, all three places being diversions from the direct route but which no British traveler in Italy ever missed. In Florence he stayed this time only two days but spent them in the galleries.

The journey from Florence was undertaken in appallingly wet weather. Telling Walter of his experiences, he wrote: "We certainly went by Water, though drawn by mules." He encountered storms and cold. On the first night in the mountains there was no room for him and his companions at the inn where they were to stay. They had to go on a further five miles. At the next inn they had a meal but still no bed was available until a fellow traveler offered him a spare bed in his room. But the landlord's wife objected and told him to move out. Uncharacteristically, but encouraged by his fellow traveler, he refused and she eventually gave way. The next morning he was pleased to meet quite fortuitously with Evans who was on his way to Florence from Milan. They walked together as far as they could until they each hurried off to rejoin their respective vehicles.

Etty stayed a few more days in Bologna and then moved on to Ferrara, where to his surprise it snowed. Here he kissed the armchair where Ariosto had reputedly sat to compose his *Orlando Furioso* and visited the dungeon where Tasso was imprisoned for seven years for disturbing the wedding festivities of the Duke of Ferrara and Margherita Gonzaga and which Byron had also visited. Whenever he was abroad Etty alternated between being the studious artist and the delighted tourist. In early December he arrived in Venice. The city amazed him and he wrote to Walter describing everything with childlike enthusiasm.[17] "A thousand little alleys, with a *campo*, or square, in parts. ... The Streets are canals and the hackney-coaches gondolas. ... The Bridges with steps, are so numerous, you may go over fifty if you have a long walk."

In Venice the weather was exceptionally cold, "sufficiently cold for Siberia," he wrote. "Perhaps you good folks on the northern side of the Alps think we on this, are basking in sunshine, fanned by genial zephyrs, and a thousand other pretty things." But not so, he assured his brother. Whilst in summer "the heat is *almost* intolerable," at other times of the year "the weather gets cold, very cold;—unless in the sun, in the middle of the day." It seems to have rained all the time. But that could not dampen his spirits. Although it was "no comfortable place" he decided to stay as long as he could. "Venice arrested me!" he later declared. Etty had managed to stay in a lodging where he could obtain cups of tea but he still often made his own since he had brought his own kettle and pot and a supply of tea. Originally he had intended to remain for ten days. He stayed seven months. All the time he was making sketches and studies of the works of the Old Masters.

Charles Eastlake, whom he had met in Rome, had hoped to accompany him to Venice but had been unable to do so. It would have been a most instructive association had they traveled together and one that would doubtless have been of much subsequent benefit to Etty. Even so Eastlake and his wife became great admirers of Etty and, though a closer friendship might have developed, Eastlake and Etty remained on good terms. Eastlake was a friend of the Prince Consort and the recognized British authority on Italian art. He had given Etty a letter of introduction to the British Vice-Consul in Venice, Harry D'Orville. Etty wrote home[18]: "I have found a Friend, kind and helpful. Such was Mr. Vint at Naples; such is Harry D'Orville, a name for a novel, at Venice." Again it seems that his new friend invited him to stay with him, for letters addressed to Sir Thomas Lawrence were sent from "Casa di Signor D'Orville." He was introduced to the Consul, Mr. Hoppner, presenting a letter from Sir William Beechey, R.A. Hoppner was soon regarded as a friend and on Christmas Day "we dined there; on Roast Beef and Plum-pudding." D'Orville is praised in another letter for his kindness and years later he was

remembered in Etty's *Autobiography*.[19] "He took me to his house and hearth, and treated me like a brother—such I must ever esteem him." Once again Etty's own amiable character endeared him to everyone. Just as there are no records of Etty criticizing anyone so there are no records of anyone disliking him.

Venice greatly impressed Etty not least due to the fact that he was allowed to attend the life class of the Venice Academy as a student and here his work made a great impression. He was praised by the professors and by various Venetian dignitaries who came to watch him painting and declared themselves to be astonished by his skill. In his turn, Etty was greatly impressed by the Academy and its teaching methods and by the industry of the students, so different from those in Paris. The Academy also had its own collection of Venetian and Flemish paintings which he found inspiring. He was able to copy in the mornings, paint in the afternoons and draw from life models in the evenings. Sir Thomas Lawrence had himself toured Italy and was still well known in the Venice Academy. Etty clearly had doors opened to him on the strength of having been his pupil. Etty himself also made a great impression not only on the students and the authorities of the Academy but also on fellow Englishmen who were staying there. The professors at the Academia were impressed not only by the quality of his painting but also by his speed of execution. He wrote to Walter exulting in their recognition of his abilities.[20]

> I make the natives stare, and the Professors say, I am "*un bravo Pittore.*" ... The Professor of Painting, Martini, declares I paint more like an Italian than an Englishman. [*He*] makes signs—with the point of a knife,—if he was to prick my painting of the Figure, it would bleed. ... The other Professor, San Dominichi, a man of considerable genius, calls me "*Ercole*" (a Hercules), "*Un genio proprio*" (a true Genius); and brings people to see me paint, saying "*Quest' è un brav' uomo*" (this is a Fine Fellow). Rossini, the great composer, was brought to see my works at the Academy; the Patriarch of Venice, also, and others. One called me "*Il Diavolo,*" because I get the sketches like the pictures so rapidly;—some, "The English Tintoret;"—and I do not know what stuff beside.

Understandably Etty basked in his local fame and was proud that they heaped such praise on him, especially as they constantly associated him with Sir Thomas Lawrence whom they knew by reputation. Walter was concerned that his brother was producing enough original work. Making copies after the Old Masters was good training but he had his name in England to think of. He urged him to send home paintings for the Academy Exhibition but Etty was so enraptured by all he was seeing that he could not stop copying. Walter's concern is reported by Gilchrist[21] on the basis of Etty's letter to his brother referred to above.[22]

> You say it would be easy to send something for the Exhibition. Perhaps it would—easier than to paint it: situate as I have been, engaged, not only in seeing the immensity of things to be seen in Art, but in making memorials of a few of the best. If one spent all the time in painting originals, one might as well, nay better, be at home.

He compared himself to Charles Eastlake who "has been seven or eight years abroad. I do not know whether he would not better have been at home; incline to think he would, the greatest part of the time. And others think so too."

He went on to say that Eastlake did not appear to have achieved much but he could not join Etty in Venice as he had hoped since he had so many commissions that kept him in Rome. These, apparently, entailed making copies of paintings for clients in England, a necessary undertaking since he was dependent on such work to earn a living. This was not what Etty wished to do though he fulfilled such commissions for his old master, Sir Thomas Lawrence. It was certainly disappointing that Eastlake could not join him in Venice, as Eastlake's knowledge would have been very beneficial. Although Eastlake was working to improve his skills as a painter, he was also eager to improve his knowledge of Italian art. He rightly saw that the English collectors needed some authority on whom they could depend. His decision to become that authority was to prove a very wise one.

Etty's letters home dealt mostly with local events such as the persistent cold weather but he was delighted with Venice and regaled Lawrence with accounts of the churches he visited and the paintings he saw. "I am sure you must have been struck by the Tentorets here." He seems to have kept up a fairly regular correspondence with Eastlake in Rome and also with Lawrence in London. To the latter he expressed his concern[23] that "Painting on the Continent" (or what he has seen of it) is in a sorry state. The French, he said, made great efforts but "much that is desirable is mixed up with much that is bad." And "when we have seen French Art, we have seen the best of Continental Art." Of contemporary Italian artists he had a poor opinion but for former painters, such as Tintoretto, Titian, Veronese and Bordone, he had the highest praise. It may seem that Etty is playing safe, as so many do, by admiring the established Masters and not committing himself with the "Moderns," but those contemporaries whom he mentioned are now no longer known. History has agreed with him. Italian art in the late eighteenth and nineteenth centuries had deteriorated into mere academicism against which Romanticism was striving to make headway. Lawrence, who had been to Italy and especially Venice much earlier, obviously appreciated his letters and their well-informed judgments. Etty made a point of assuring his former teacher that wherever he went he heard his name and was "not a little proud to be able to boast of having been your Pupil." The Venetians had a high regard for English art, due, Etty assured him, to their knowledge of Lawrence's works which he had left behind him.

But there were drawbacks. Surprisingly, he found that he could not buy good materials, no prepared canvasses, no colors, no varnish. There was no color shop in Venice. He was driven to making his own varnish and had to send to Milan for colors but feared they would not be passed by the customs, "for the Austrians have made everything contraband." To Walter, Etty reported[24] he had been buying a few prints, and the Canaletti views for you; have taken up at the bankers the last £10, and am now using it." He again undertakes to return to London very soon. The weather was still cold. "My poor friend D'Orville has been, and is, seriously indisposed." Despite continued assurances that he would soon return to England, Etty stayed on in Venice. Though he wrote fairly frequently to Walter and only less frequently to Lawrence, he did not find time to write to many others. In a letter to Walter of the 20th March 1823 he regretted that he had not written to his assistant Franklin nor to "Clayton" or "Houghton" or some others. He was so busy working, making copies, studying in the Academy and making his own sketches. He wrote to Sir Thomas Lawrence,[25] still from the Casa di Signor D'Orville:

> There is here a very good Academy, as you know, the way in which the Antiques are arranged and lighted, is novel and beautiful and the life (del Nudo) and the other departments seem admirably arranged with regard to leading students thro' all the elementary stages of art—but Painting (Color) that rainbow vested dame, seems to have deserted the modern school of Venice.... Painting, on the continent, indeed, I am sorry to say, what I have seen, seems more or less dilutions of the French "*manière*." ...

After some discussion of a contemporary Venetian artist, Camuccini, now wholly forgotten, Etty says, "The Venetians, admirers of Canova, are much pleased with your munificent donation to his monument—I understand it is about 3 times as much as the whole Congress of Verona contributed!"

> You I am sure must have been much struck with the Tintorets [sic] here, in the Madonna dell'Orte Academy, Ducal Palace, etc., his Last Judgment, his small St. Agnes and his Crucifixion etc. what a glorious group at the foot of the Cross; really for composition, for pathos, for appropriate and harmonious composition of hues, and great executive powers, I have never seen it excelled, and rarely equalled—the poetry of his Last Judgment....
> Paolo Veronese's "Tent of Darius" is a beautiful assemblage of tones and hues.
> The church of St. Sebastian, where his ashes are, you have seen no doubt. There, and the tomb of Titian I have, you may be sure, made a pilgrimage to;

He was still in Venice in June. Writing to Walter on the 7th June he told him that "Poor D'Orville's health is so bad, he is obliged to leave Venice for ever. He has joined his family in Switzerland; where I must call and see him on my return." Again he asks for money.

> I shall go from here with about £28: which had I come home as at first intended, would have been enough. As it is, No! Send me a small remittance to the Bankers,—*Frères Schelin, a Venezia:* say £20. For God's sake don't write Vicenza, as you did on the last.

The arrangement between Walter and his brother for providing him with money seems to have been well established. He seems to have written frequently requesting money as though it were an entitlement. Perhaps it was, coming from the provisions of Uncle William's will. His letter suggested that he would soon be leaving Venice and returning home but this was not to be. Venice was too appealing. To Walter he had recounted in a much earlier letter (30th January) how he had seen

> the entry of the Emperors from the Lagunes, up the Grand Canal. It reminded me something of Cleopatra: the gaily-dressed gondolas, gondoliers in fanciful costume, rich tapestries hung from the palaces, and crowds assembled on the shores.

It seems not to have been the custom of artists and students to travel far from their home towns and we may attribute to this the number of local "schools" of Italian painting, each with their own characteristics. Etty told Lawrence, "I have given some students at Rome, notice of your opinion of Venice. Some talk of coming; but, I suppose, not immediately."[26]

Lawrence's renown seems to have spread all over Italy. He had visited Rome in 1819 after fulfilling certain commissions in Vienna. He had remained in Rome from May to December, painted only two portraits and employed others to make copies of Italian paintings for him. Nonetheless he had been accepted as the first portrait painter in Europe and a distinguished member of the cosmopolitan society that moved in European capitals. In Rome he admitted the public to his painting room where they saw the portraits he had brought from Vienna and so impressed were they that he became known as "Il Tiziano Ingleses."[27] In Venice Etty found that having been taught by Lawrence (so he claimed based on the one year spent in his house) gained him much reflected glory. If Lawrence had not already been awarded this title we may be sure it would have been bestowed on Etty.

Etty followed the usual custom of travelers abroad and sent home letters to his friends giving them an account of his activities, though not as frequently as both he and they would have liked. We know this must be so because the story reached England that he had fallen into one of the canals, causing Charles Landseer, the elder brother of the more famous Edwin, to circulate a joke that "he was henceforth to be called 'Canal-Etty.'" It may have been on this occasion that Etty lost his hat because the story also circulated that he had lost it in the canal—"blown in" it was said—and had been unable to buy a replacement large enough and had had to have a hat specially made. Perhaps Etty had fallen into the canal while trying to retrieve his hat. These stories are preserved as notes by an unknown hand in the Royal Academy Archives. The story of the hat would have amused his friends because Etty was always said to have had a disproportionately large head. No letters from Venice, other than to Walter and Sir Thomas Lawrence and one to Thomas Bodley, have been preserved.

Etty wanted to obtain a "finished copy" of Titian's *Venus of the Tribune*, now known as *Venus of Urbino*, in the Uffizi in Florence, which he had not attempted during his initial visit. So after staying seven months in Venice he returned to Florence for this purpose, having, as he told Walter, made "thirty studies in oil after the Venetian School, and Twenty in oil of Academic figures."

Before he left Venice he was elected an Honorary Academician of the Venice Academy along with Sir Thomas Lawrence, Etty having the duty of bringing back Lawrence's medal to present to him. Later that year, on 14th November 1823, he addressed a letter to Lawrence from Paris, where

he had stopped for a while on his way home, to tell him that he was bringing to him the diploma making him "an Honorary Member of the Imperial and Royal Academy of Venice." Etty could not forbear to pay tribute to his old master. "By electing you, they have honored their own body—by electing me, they have honored only myself." He apologized for not having written before. He had expected to return home for the past six months but had not been able to do so. He could not bring himself to leave Venice and had stayed well beyond his originally intended time. But, as it proved, this was not his final visit to Venice on this tour. He was to return.

On the way back to Florence he went first to Padua, staying there but one day, then to Vicenza and Verona to look at some paintings by Veronese and the alleged "authentic tomb of Juliet" and so to Mantua. On his way back from Mantua to Florence where he was to meet up again with Richard Evans, Etty met with some distressing incidents which he recounted at such length in his *Autobiography*[28] they take up a disproportionate amount of space. He had to arrange his own transport from Bologna as he had missed the public conveyance. "A *charabanc* for the mountains was bargained for" and off he went in the hope of overtaking "a *vetturino* who had, a few hours before, departed for Florence, as we were told, with a short complement of passengers." But despite having been assured that they would overtake it the horse pulling the *charabanc* was so tired that progress was slow. Etty made the mistake of stopping at a cottage for some milk and bread and the *charabanc* went on without him, a strange incident seeing that Etty had hired it. Nevertheless he hoped to overtake it on foot, indeed he had no choice, and so he did. Considering the occasion to be his own fault and ever being unwilling to invite trouble, Etty said nothing to the driver but set on to Florence which they reached without ever catching sight of the *vetturino* he had originally hoped to join.

Then another calamity struck. He discovered he had lost a notebook in which he had made many sketches when in Rome. At a convenient point where he could leave the *charabanc* with assurances that this time it would not go on without him, he went back on foot along the road in the hope that he might find the book. It was now night. He took with him a lantern and retraced in his estimation several miles. Etty was ever filling his anecdotes with extraneous details and so in his *Autobiography* we have a full account of everything that happened, including meeting a group of singing mountaineers, until suddenly beyond all expectations, he saw a brown shape on the road and—"*it was my book.*" He returned to the inn where he had left the *charabanc*, had a meal, a long sleep and set off once more for Florence.

In Florence he encountered difficulties with the Deputy Director of the Uffizi, Baron Montalvi, who would not allow him to make a full size copy of the Titian *Venus*, a usual restriction in these cases as a safeguard against substitution. But Etty had letters from the right people in Venice and he was able, through the intervention of the Secretary to Lord Burghersh, to obtain permission. The Baron tried to create "obstacles" but after ten days Etty began his full size copy. He sent it to England by sea. Writing to Walter, asking him to insure it for £100, together with another Titian copy already made in Rome, probably *Sacred and Profane Love*, he said that it was "thought to be the best he had done."[29]

Etty decided to return to Venice and he did so in August, this time accompanied by Evans and "a Mr. Wallace of Florence," referred to earlier but of whom nothing is known. During this stay he again met D'Orville who, being still very ill, had not gone after all to Switzerland. The weather this time was very bad, with violent storms and winds that did much damage. As was usual with Etty whenever he encountered storms, he wrote to Thomas Bodley that he thought "the end of all Earthly things was come."[30]

Etty justified revisiting Venice on the grounds that it was on his way home but Venice really was, as Gilchrist described it,[31] his "Siren City." August and September were spent making yet more copies. There were so many pictures he wanted to adorn his painting room in Stangate Walk. His letter to Thomas Bodley[32] is filled with accounts of his visits to Venice's most interesting sights. It is a report sent home by an enraptured tourist. "Of the 'Bridge of Sighs' I

hope to make a sketch," and so he did, several in fact, and from them he later painted the finished work now in York Art Gallery. Whereas a modern tourist can return with hundreds of photographs, each "snapped" in a fraction of a second, Etty and all travelers of his time had either to sketch the scenes for themselves or employ others to do so, each one taking perhaps at least thirty minutes, sometimes longer. Etty was not naturally a maker of sketches and he probably made only four in Venice at this time. But there were one or two paintings that owed their origin to his stay there.

Etty and Evans finally left Venice on the 7th (or perhaps 8th) of October. They traveled via Verona and Mantua, seeing Giulio Romano's frescoes in the Palazzo del Tè, and then to Milan. Here they stayed two days to visit the Cathedral, the gallery and to see Leonardo's *Last Supper*. Mantua had been a diversion and when they had tried to secure seats in the *vetturino* back to Verona they had difficulty with the driver whose demands they considered excessive. So Evans and Etty, being short of money, decided to walk the twenty miles or so through the night. But the rain was excessive and after having walked three-quarters of a mile they turned back and, after a hot dinner, took the coach next day. There were always so many difficulties attending travelers that only the most intrepid undertook the Tour.

There was also trouble with the Customs at Sesto, who demanded large payments before they would allow Etty to take his paintings and prints any further. He had already paid customs dues in Venice but these were held to be insufficient. He stood his ground and somehow succeeded. Etty was becoming accustomed to holding his own. Then at Arona the Customs also demanded payment. A tussle followed with Evans seizing hold of one of the guards which brought a demand for one thousand francs. They argued and gradually the price came down until "modest in the end" they accepted "a franc and a half, and five francs." At Isella there was another demand. But this time it was settled at "a franc or two" without difficulty. Then they finally left Italy and went over the Simplon Pass. In the mountains they had their usual trouble with inns, this time seeking one providing a cheap breakfast as they were running short of money, but finding instead a hospice belonging to the monks of the Order of St. Bernard. After providing the travelers with a good breakfast the monks refused payment. Next day they could afford to pay for breakfast in an inn. They moved on, sometimes riding, sometimes walking, until they reached St. Maurice. While having dinner here a fellow traveler enquired if they had lost anything. It appeared that a portmanteau had been found on the road apparently dropped from a vehicle. Etty not only recognized it as his but was able to provide the key that unlocked it. It had been on the roof of the coach and had been caught up in the branches of an overhanging tree and dropped on the road. Etty was relieved to encounter an honest man among all the scoundrels he had met.

On his way back to Paris, Etty had hoped to be accompanied by D'Orville, who had arranged to meet him in Vevey, but when he arrived there he found that his friend had already left. There were more encounters with Customs when they entered France. Every piece of baggage was opened and Etty's paintings and prints were threatened with confiscation. Although they had paid the French Consul in Venice the equivalent of three francs each for their passports, they had to pay two francs each for new ones. In addition there were dues to pay on their baggage. After several days' journey they reached Paris and found D'Orville in Paris. Etty does not appear to have seen him again after he returned to England. But again Etty made another new friend. He was introduced to Dr. Michael Henry Thornhill Luscombe, the English Chaplain of Paris, a man he was to meet many times again. Luscombe was born in 1776, had a Cambridge M.A. and was in 1825 consecrated as Bishop. He wrote several pamphlets on theology and founded the *Christian Remembrancer*.[33] He died in 1846. Yet again, the kind of man whose friendship Etty desired.

Etty and Evans stayed in Paris until January 1824. Here Etty spent most of his time in the Louvre, which was not open every day, and in the evenings in the Academy where he painted

from a variety of live models. He boasted to Walter that he "took the shine out of some of the Frenchmen there."[34]

Writing to Lawrence from Paris[35] Etty expressed his opinion of contemporary French art, offering astonishment that anyone could bother to go to Paris to study art when there was all the Italian Renaissance painters to look to for inspiration. French art was now beginning to reach across the Channel and appeal to a new generation of artists but not to Etty. His time in Italy had confirmed for him how right he was to follow the example of their Old Masters.

> Gérard has considerable merit I am very ready to allow; and the picture in question [*The Entry of Henri Quatre*] has points that are admirable. But altogether, I think it is detestable. How any man with Paolo Veronese and Rubens at his elbow, could mix up such a nauseous draught of colour! I cannot help thinking that Guérin and Regnault are two of their first men. The Students and young men I fear study better than ours, they have indeed more facilities for studying the figure, the consequence is, they have generally more power in drawing, when I have said this I have given them I think the greater part of their merit—they are (with exceptions doubtless) in general—noisy, boyish, dirty, and frequently rude (perhaps without intention) but I do not much like them, and what is worse than all, I understand from long residents here, that their moral character is at a very low ebb; indeed, so I should think.

What particularly displeased Etty was the freedom with which art students in Paris made *liaisons* with models. This was a feature that was seized upon by campaigners in England as demonstrating the dangers of painting and drawing from the figure, whether living or as casts. Etty knew that if one revered women, as he did, it was quite possible to maintain a purely professional relationship with models who were always pleased to be recognized as almost artists themselves and certainly pleased to be elevated, if only briefly, to the status of goddesses.

It was Venice that had pleased Etty more than anywhere else which is understandable; there he had been made so much of. Writing from Paris to Lawrence on the 14th November 1823, he explained,[36]

> When I went to Florence I made a finished copy of the Venus of Titian in the Tribune; and on the road (recollecting what you said to me of Giulio Romano) I went to Mantua, and found your eulogism on him amply deserved. Indeed, so delighted I was, that when at Verona I went again to Mantua with Mr. E. [*Evans*] and staid another day or two. That Chamber of Psyche—how novel, how classical, how every way extraordinary, it is quite a treat to find a series of Pictures that treats classical subjects in so learned, so antique a style—after being deluged with nothing but Saints, Martyrs and Virgin Maries by thousands, the imagination revels with delight in his poetic landscapes, his giants intimidate, and his females, tho' voluptuous in the extreme, have an air of greatness truly Roman....

It must have been another Titian than the one Lawrence had asked him to copy since Etty explained on his return to London in an undated letter to Lawrence from Stangate Walk:

> With regard to the Copy of Titian, I hope you will excuse my not having made that, I really am *tired* of copying, and had I any other means of possessing memorials of our great friends of Venice and Flanders without it, I should not have spent so much time in it as I have; but I thought it was of little use, my being abroad, did I not avail myself of what was around me, and postpone painting anything original till I go home.

This was always the problem for anyone visiting other countries. There were only two ways of bringing home examples of the art or the scenery of those countries, either make copies oneself or buy copies made by others. To make one's own copies might enrich one's knowledge of the technique of the original artist, but it consumed much valuable time. Wealthy travelers took with them an artist seeking employment to make copies for them but even that took time and often delayed travelers impatient to move on. It is likely, though nowhere stated, that Lawrence paid Etty for the copies he made, as this was the usual arrangement. This was how Eastlake was making a living at the time.

Although Paris always attracted Etty as a center for art, largely because it was so available, he did not regard it as a city in which he would wish to live or work. He did not share the increasing

tendencies among young artists to move there to escape the restrictions of England. He disapproved of its general gaiety and moral laxity compared with London. Strangely he did not have the same objections to Venice, yet that city had been renowned for the previous hundred years, if not longer, for its temptations. Paris provided him with first class painting materials unobtainable in England, items which he had been surprised to find were not readily available in Italy. He bought brushes, a lay figure, books on costumes, prints. Writing to Walter[37] asking for money to enable him to buy these items, he sought to persuade his brother that if he had a lay figure he would be able to paint fewer "naked figures in my pictures which some say is to be desired." The cost was £48, "appalling" he admitted, "but there is no escape." To secure it meant leaving a deposit and waiting twelve months for it to be made and sent to London. At this price and in these circumstances it must have been a life size figure usually used for the painting of costumes. He held out the additional advantage that he could always sell it in London for a large sum. Strangely, Etty also wanted to buy curtains for his London lodgings, "something cheap, strung on a simple rod of iron, ... which would not interfere with the light." He wrote as though only Paris understood the needs of artists. Etty was pleased to report that the French were beginning to accept that the English "can paint a little" but above all he highly approved the French government's attitude to art. "The Government has just ordered fifteen historical pictures. They manage these things better in France." The students were much better provided for than those in England. They had the Louvre readily available for study. "How I envy them the Luxembourg Gallery! What a foundation it would be for ours!" In England a National Gallery was still being considered.

France also had other advantages over England. There was free access to museums, essential for students, and "cheapness and variety of Living Models." The French, and especially Parisians, have always had a more relaxed attitude to the naked body and to sex than the English and it has always been one of the satisfactions of visiting artists that they could obtain more models more easily in Paris than at home. There was also the temptation for students and young artists and poets that casual sexual liaisons were more easily achieved in Paris. France was more tolerant of sexual activities than England and recourse to brothels was regarded as a male necessity. This would not have appealed to Etty but the availability of models certainly pleased him. He wrote home that "in the Evening Academy" he painted from "six different models—male, female and one boy." Brother Walter urged him not to neglect these benefits and not to think of a premature return because of either homesickness or pecuniary concerns; he was quite willing to finance him. But Etty was constantly thinking of home. According to Gilchrist,[38] he was looking forward to Christmas and with such return in mind he worked hard making the copies of the Masters that he wanted. He did not make the copy of Titian's *Christ Crowned with Thorns* that Lawrence had requested as this would have required a longer stay.

This was the most important journey abroad that Etty made, though he was to travel again. He and Evans had left London on the 23rd June 1822 and had returned in the middle of January 1824, not the six months originally intended but a whole year and a half thanks to Walter's generosity. He told Walter that he had more than completed his intentions. "My object was to see what had been done by the Great Names in Art. I *have* seen—and made upwards of fifty memorials in oil-colour." He did not wish to leave London again but should he ever do so he declared he would go for a longer period in order to accomplish yet more. He looked forward to the time when foreign travel would not be a necessity for an artist. With the "awakening in England towards Painting, I trust facilities for its practice will keep pace; and that a Painter who wishes to excel will have no need to exile himself from almost all he holds dear."[39]

A vain hope as it proved since for more than the next century any aspiring artist regarded it as essential to his development to spend some years in Paris. Travel in Italy had brought Etty into close contact with a bygone age when, it seemed to him, art flourished fully appreciated by all members of society.

Should I live in a classical country, surrounded by monuments of Art and Antiquity, with my fondness for classic lore, I should become a learned Antiquary inevitably. I so love the Olden Times, and the precious monuments of beauty they have left us.[40]

Time was to show that the "Olden Times" which he so loved were not those of ancient Rome and Greece, but the Middle Ages, and that the monuments he treasured were not classic temples but Gothic cathedrals. Etty had never shown any interest in the architecture that had gained favor during the eighteenth century. His love of the ancients was limited to their portrayal of the human figure and indeed this he had obtained from contemporary imitations of the Italian Renaissance artists. There are many reasons why he preferred Gothic architecture, the chief being his life-long love of York Minster. If there can be any doubts that the influences of childhood last throughout life, they must be examined against the example of William Etty. He never approved the fashion for building classical style churches, which he believed to be suitable only for pagan shrines. One of his reasons for condemning religious non-conformists was that they frequently built their chapels with classical porticoes and pediments. It must be admitted that Etty was inconsistent. Indeed he was not as fully educated as he himself would have wished. Although he painted classical subjects because they conformed to the Academic principles of "history painting," he was spiritually a Catholic traditionalist. In Italy there was no conflict between the two because that country had not adopted the Gothic, except in a few isolated cases. The Gothic had been largely confined to northern Europe where the classical styles were only slowly, and sometimes never, introduced. The English eighteenth century *cognoscenti* had lost contact with Rome and tended towards Deism. The Rule of Reason which they applied to their philosophy they also applied to their aesthetics. This world of thought Etty did not inhabit. He saw no incongruity in embracing opposites.

There is in York Reference Library a letter from Sir George Beaumont to Etty which suggests that this famous patron of the arts was well acquainted with Etty's paintings and thought highly of them. Although the letter is undated it is possible to suggest that it was written between Etty's return from Venice in early 1824 and Beaumont's death in 1827, probably nearer the earlier date. Sir George Beaumont writes:

Sir,
I did not receive your obliging invitation to see your sketches until the day before yesterday or I should certainly have called or if that had been out of my power during the last day I remained in town, at any rate have sent you an answer. I am well aware your sketches from the Venetian Masters must be highly interesting and when I come to London I shall with great pleasure call. My views of gratification are by no means confined to these sketches, your own works will be the grand object I shall look forward to with the greatest pleasure.
I am Sir Most truly yours
G. Beaumont.

Obviously Etty was seeking approbation from the best authorities to further his career. George Beaumont was well-known as a collector who encouraged young talent (he was an early admirer and supporter of John Constable) and a public statement of approval would have greatly assisted Etty, although by now Beaumont was losing his authority as an art critic.

"Fever of heart"

It has already been hinted that Etty was, at the time he went to Italy, in love, or more likely, thought he was. All the time he was away he had had a great weight on his mind, which condition Gilchrist described as "Fever of heart."[41] "On this, as on the previous, and a subsequent Journey, Etty was accompanied by his Love-sorrows." Who had been the subject of his affections while he was in France in 1816 is not known but Gilchrist reported[42] that "shortly before his

departure, the fervid Painter had fallen In Love:—'One of my prevailing weaknesses,' confesses Etty." Gilchrist said that he could not offer a very strict account of this event and we are left to imagine that it was but a passing fancy though, apparently at this time, not an unusual one. Certainly at the age of 29 years it must be expected that Etty had often contemplated marriage and sought out a likely companion. Now it seems that Etty had again believed himself to be in love with someone. This time we have some idea who it was. Before leaving England in June 1822 Etty had discovered he was in love with his cousin Mary. He had painted her portrait before leaving for Italy and found he could not keep her out of his mind. According to Gilchrist[43] he wrote to his brother Walter: "She is a charming girl, I always thought her so. My being with her ten days played the d—l with me. I told her what she had done to me."

But the lady had apparently responded with the modesty expected of her: "...the morning of my departure, during a momentary absence of her mother, all at once [she] said, 'Well, I am sure we are all much obliged to you;' and offered me her hand."

Poor Etty was nonplussed. "*What am I to conclude from this?*" Very probably Mary had decided that she should be looking for more than an impecunious artist. Etty wrote to Mary asking to "know his fate." He related how, while abroad, he returned every evening to his lodging expecting to find a letter—"*the* letter"—waiting for him. But an answer never came. He feared he "may have erred." To Walter and to his companion Richard Evans, who had been a fellow pupil under Lawrence and who was accompanying him in Italy, Etty confided his misgivings. He thought of taking up the monastic life but decided against this and wrote to Walter: "Tell me, too,—if you know,—whether there is any reciprocal feeling. It was so ambiguous: I know not what to think. She seemed to say *No!*—to act *Yes!* The sea of conjecture into which I am tossed, almost drowns me."[44]

In return Walter advised him about the obligations of marriage for which Etty thanked his brother. He thought it was now unlikely he would marry Mary—"if such an impossibility *should* come to pass, Mary, or just such another, in mild, sweet disposition, and in person, is the Lass for me!" In a diary (according to Gilchrist but no diary is now known), Etty wrote: "Beauteous, gentle, good, and kind;/ Angelic form, and angel's mind!" And "I could not wish her to have me if she does not like me!" Yet he complained in the same letter:

> How my feelings have been played with! At Naples, every day hoping, every day disappointed. A friend tells me a letter is sent to my house. I lose no time, set off home pretty quickly.—*Where's the letter?* "No letter come." Back I go, through the burning sun and bustling streets of Naples, till I find him who told me; fearful it should be lost.—The servant went to another place first: in my absence, the letter is brought. I hear *another* is come, and a *double* one; in another part of the town. Away I start, get it; and arrive home in a glorious heat. One of these, my heart says, must be *the* letter, that is to give some information. I look, and tremble while I look. What is my disappointment on finding the first from Evans, telling me *there was no letter!*—the next, enclosing one, but *not* in answer to mine!

When he returned to Rome his landlord told him that several letters had arrived for him in his absence. Once more his hopes were raised. There were two only and neither was from Mary. On October 20, 1822, he wrote from Rome to brother Walter thanking him for his advice which proved to be an "unsatisfactory letter" since it gave him much pain. "I have only found existence tolerable by applying to my Art; the strongest remedy my thoughts could suggest. Even *that* was insufficient. Advice is easily given in such cases; 'tis hard to put in practice."

He continued later in this letter: "I fear I may have done wrong: I fear I may have erred against propriety—perhaps delicacy. Yet I know not. If I have, it is an error of understanding, not of the heart. My other loves were scratches; this, a wound."

He wrote: "Though bruised, I trust I am not yet broken."

In his Italian notebook of 1822 in York Art Gallery Etty drafted a letter to cousin Thomas Bodley, a curious habit since all his letters appear quite spontaneous and frequently copiously amended. Any drafts he made were written on the same pages as drawings, often weaving their

way around the sketches. This particular letter, though undated, was written just after Walter
had written to Etty following the request for his opinion about cousin Mary's intentions when
he was so desperately in love with her, and reveals just how much he relied on his brother. The
fact that he felt it necessary to make a draft first suggests he was apprehensive about revealing
too much even to his dearest friend but nevertheless it is curious that he wanted Bodley to be
his messenger.

> Tell Walter I got his last kind and important letter and thank him for it. Walter, tho' always espe-
> cially dear to me yet I think he more and more endears himself every month by that noble and liberal
> spirit with which all his actions are characterized, by that kind and watchful solicitude for my welfare, by
> that tenderness for my feelings, in short by everything that can bind him closer to me, and like those
> benign planets, which cheer us with their light while they cherish us by their warmth, knows no shadow
> of a change. The communication he made to me on a certain subject, tho' it caused me some emotion
> at the time and a few pangs of regret, yet I thank God it has passed away like a cloud from the brow of
> the Apennines on a sunny morning and left me my accustomed tranquility. If she is happy I am satisfied—
> I wish not to bless myself at the expense of her affections and so Farewell, a long Farewell to thee Mary.

How all those who have suffered the pangs of love must sympathize with poor Etty. But
Mary had not played him false. He had no reason, beyond his own hopes and imaginings, to
believe she had fallen in love with him merely because he had fallen in love with her. Perhaps
he had hoped Walter would intercede for him with Mary but if so Walter was too wise to inter-
fere. Clearly she did not love him or, if she did, she did not want to marry him. As Gilchrist
says "of his many 'Attachments,' this was the deepest."

Whose daughter Mary was cannot be accurately ascertained. Uncle William had two daugh-
ters named Mary, one born in 1774 who appears to have died in the same year, and another
born in 1777 who died in 1794. No other "Mary" appears in the family as researched by Tom
Etty of Nijmegen. As for Etty's other uncles, John died aged five years and Robert died in infancy.
He had no aunts. Mary's name appeared frequently in Etty's subsequent letters and apparently
she remained unmarried, at least for several years since her name was never linked with anyone
else. There was a servant named Mary who was employed by Betsy's father and Etty once wrote
of her in a letter to Betsy, "I mean Mary Rollins" as though needing to distinguish from another
Mary. There was no man named "Rollins" who married into the Etty family so she clearly is not
the Mary referred to. One possibility remains which cannot, however, be confirmed. Perhaps
Mary was the child of John Calverley, the brother of Etty's mother Esther, who lived at Hayton,
near Pocklington. If so, she would have been his cousin through his mother. Etty had frequently
visited uncle John when he was at school in Pocklington and he continued occasionally to visit
him when he came to York. If she was John Calverley's daughter he would have had many oppor-
tunities to become closely acquainted with her. She, the daughter of a village joiner who appears
to have been a widower, might well have thought that a marriage that would mean leaving home
and family and going to London was not to her liking. So do we have here the explanation of
Etty's lifelong bachelorhood? Did he remember Mary for the rest of his life, hold her forever
dear and grieve his unreturned love?

Gilchrist quite rightly gives a lot of space in his Biography to this episode in Etty's life.
There seems little doubt that the love he felt for this unidentified young lady was very intense
and of great importance to him. Although he was to fancy himself in love again on several occa-
sions, no other rebuttal had the same disturbing effect. It will be considered later that "Mary's"
refusal was, in fact, a turning point in Etty's life.

A confession?

It was common knowledge, or so it was alleged by those of a moralizing nature, that trav-
elers abroad were constantly subjected to temptations. Certainly in the preceding century many

young men of means went to the continent in the expectation of indulging themselves safe from the eyes of their friends and families. Sowing wild oats was a recognized necessity for young men and, so long as they sowed them far from home, parents usually turned a blind eye. Etty himself knew this and recorded in a notebook Reynolds' advice to artists abroad—"Avoid, above everything, the loose habits and vicious manners of Italians." Etty had written to brother Walter asking for his advice on whether it would be prudent for him to marry someone with a little property and to take her abroad with him. He clearly had in mind two needs, first that a wife would keep him from the temptations that were believed to assail young men abroad and second that by having some property of her own the young lady would not be likely to agree to marry merely to secure her financial future. For Etty, quite sensibly, marriage had to be for love. Walter advised against marriage just yet. His young brother was not yet financially independent and marriage could be quite expensive. This exchange comes within considerations of why Etty never married and the whole subject will be dealt with a little later but here Etty's concern to place himself beyond temptation is of interest because of what may have happened while he was in Venice.

There is in York Reference Library a very curious "confession" written by Etty castigating himself for some unidentified lapse in moral behavior. Gilchrist included it in Chapter V of the first volume of his biography, that is to say in the years 1821 to 1822, but there is no evidence to justify this. As is too frequently the case with Etty's papers, the document is undated. It must however have been written somewhat early in his career and in Etty's case 35 years of age may be regarded as early enough. Etty's "confession" is worth printing in full since it not only illustrates his intense sense of shame for something he had done but also his typical inability to bring himself to name the nature of anything distasteful.

> Having now fully ascertained and proved the inadequacy of immoral pursuits to the giving of happiness [*words deleted*] pleasure and felt keenly their destructive effect to all peaceable pure and good and true enjoyment of God's works—it is my firm determination to resume my self-denying principles and desire ardently to make myself acceptable for him who made me; which determination I pray God assist me to keep knowing that without his assistance I am truly weak and unable to fight the good fight. Let me therefore say in my heart, I will arise. Go to my father and will say unto him Father! I have sinned against heaven and before thee, and am no more worthy to be called thy son, take me, I pray thee, as one of thy hired servants and God, the eternal prince of all Mercy and Goodness, will please to incline his ear to my prayer and strength my weakness, so that I fail not in running this important race which he has set before me. Teach me I pray thee, O God, ever to conquer and [*words erased*] command those passions which war against our peace and [*word erased*] of the soul and teach [*words altered and erased*] corrupt the [*words erased*] purity and innocence [*words erased*] me ever to look to [*words erased*] thee as my father [*words erased and over-written—illegible*] and surely ways of pleasantness and all thy [?] paths are peace! who art in heaven and to religion and virtue as my guardians on earth.

The number of corrections and erasures increase as this remarkable document proceeds, suggesting that Etty was anxious to express himself as penitently as possible, but the result is some confusion of thought. We can only conclude that he was in an extremely shamefaced condition for the sin, whatever it was, that he had committed. On the reverse of the page Etty wrote: "It will be right that you attend some place of worship every Sunday, that you avoid every tendency to the vice of swearing, and giving way to petty passions, which ruffle the surface of life and sour the disposition." These words have been added as though they were instructions given by a priest to a penitent and we may perhaps see in them a latent tendency towards the Catholic confession and the need for absolution. What act it was that required Etty to examine his conscience in this manner we do not know. Gilchrist, unable to question Etty's "Simplicity of Heart and loyalty to Conscience," contents himself with assuring the reader that "there was what ninety nine out of a hundred men would, among themselves, reckon little or nothing to confess."[45] Gilchrist goes on to say, "the general tenor of Etty's life was chaste and blameless." So, indeed, it appears to have been, for there was never a word of ill repute or scandal attached to his name.

Whether Etty had indulged in what the Victorians called "the solitary vice" or had succumbed to the temptations of one of his models or Italian women, we can only conclude from this "confession" that his moral standards were set so high that even a single lapse was for him almost a mortal sin. But since he wrote in this document of "immoral pursuits," using the plural, and "it is my firm determination to resume my self-denying principles," it appears that, whatever it was, it had been more than a single temporary lapse. If he had entered into a liaison with one of his models it was no more than many other men would have done.

It seems very likely that Gilchrist quoted this "confession" not only out of context but out of reasonable chronological order. It is more likely that Etty succumbed to whatever temptation it was while he was abroad and most likely during his long stay in Venice. But whether it was a single lapse or the consequence of joining the boisterous students of the Venice Academy in evenings in taverns and brothels, it meant for Etty that he had committed a grievous sin which had to be absolved. When we remember that the young milords on the Grand Tour frequently visited Italy and especially Venice for no other purpose we can in this present age remain quite unsurprised that he had done more than tasted the wine when it was red. We cannot believe that he had decided to drown sorrows and disappointments, he was not that kind of man, and he could not have felt that he was no longer obligated to Mary since he continued throughout his time abroad to hope for a favorable letter. We know that he was acutely dejected by not receiving a reassuring letter from Mary while he was away. One would expect that he would have returned to her and tried again to persuade her, but Etty's notions of proper behavior would not have allowed him to do so. A gentleman did not pressure a young lady. It is likely he had decided his hopes were finally dashed and had allowed himself to be caught up in unaccustomed boisterous company. During his first stay in Venice he was alone and probably felt the need for the company of students and fellow young artists in the evenings. It might only have been a few nights of heavy drinking, very dishonorable behavior in Etty's eyes. The document remains intriguing but sheds a strong light on his character.

CHAPTER SIX

Further successes and material improvements

On his return from Italy and France in January 1824 Etty began to prepare for the Academy's summer exhibition. That summer he exhibited *Pandora Crowned by the Seasons* (see color plate 14), the sketch which Carey had praised when he had seen it two years earlier in the British Institution. There is in the City Art Gallery, Birmingham, a much bigger version, albeit a sketch, which suggests that Etty originally intended a large painting for the Academy, which is now in Leeds Art Gallery. The Leeds painting differs markedly in composition from the Birmingham painting but it cannot be said that the result is wholly satisfactory. It was purchased by the President himself, Sir Thomas Lawrence, for three hundred guineas, a compelling indication of Etty's rise in status and a fine tribute from the master to his former pupil. Although praised by Etty's fellow artists, the painting was not well received by the critics. Sir Richard Westmacott's son, Charles, wrote[1]:

There is a captivating style of Painting that is not natural, and yet blends with it so much poetic inspiration and celestial beauty, that we are irresistably [sic] compelled to admire in despite of our more calm judgment. *Mr. Etty has a style of his own.* It is nothing earthly, yet his drawing beautiful, and his imagination exquisite. We sincerely wish we could induce him to be a little more terrestrial in his ideas, and we do not doubt of his becoming one of the greatest ornaments of the English School. His work has all the beauties of which we have been speaking, and is quite as full of what we consider the errors of his style.

Dennis Farr, who quoted this passage, was of the opinion that Westmacott probably wanted Etty to paint genre subjects similar to those of Wilkie and Mulready. There was a growing preference for these subjects but they did not appeal to everyone. Those critics who claimed some knowledge and appreciation of traditional subjects certainly preferred allegories and histories.

Pandora is a "fancy" picture of a central figure surrounded by reclining and flying figures, the latter presumably representing the four seasons. Pandora stands in the pose of a Greek goddess with a transparent material slipping from her hips scarcely satisfying contemporary expectations of modesty. The exhibition catalogue contained the following lines: "Pandora, the heathen Eve, having been formed by Vulcan as a statue, and animated by the Gods, is crowned by the Seasons with garlands of flowers."

The ancient legends record that Zeus had created Pandora as foolish, mischievous and idle as she was beautiful. She opened a box owned by her husband Epithemus and which Prometheus had warned him always to keep closed. From it flew out all the ills that plague mankind—Old Age, Labor, Sickness, Insanity, Vice and Passion. Only Hope remained in the box to encourage mankind to continue, though, as it always turned out, with little expectation that the ills would abate. Etty preferred the version in Hesiod's *Theogeny* (c. 800 B.C.) in which he recounted the history of the gods and the creation of the world. It is probable that Etty became aware of Hesiod through Flaxman's illustrations published in 1817. Hesiod's account is concerned to show that all the strife on earth is but a reflection of the strife that divides the gods, this being an ancient Greek attempt to explain the existence of evil. Etty also saw Pandora as another Eve and also as

another Galatea, sculpted by Pygmalion and brought to life by Aphrodite, though in the original legend Pandora was sculpted by Vulcan. Perhaps in such legends we see the artist's desire for the perfect woman whom he wishes he could create and make his own. This would be very much in Etty's mind after his own disappointments in love. The painting has all the marks of having been composed from separately posed models. Each figure is out of scale with the others, especially the crouching figure of Vulcan on the right, and the reclining female presents no relationship at all with the central subject. One wonders whether Lawrence's purchase was influenced by a wish to help an old pupil rather than genuine admiration. As Westmacott wrote, emphasizing his comment in italics, "*Mr. Etty has a style of his own.*" Indeed he had.

Etty was also busy during these years painting portraits. Most artists of the time were expected to be able to paint portraits and most had received some training but for many, portraiture provided "bread and butter" work to give them an income while painting the subjects which they really preferred. This was so for Etty. Few of Etty's subjects are now well-known. The Rev. Bolton had recommended Etty to his friends before he left England and some work resulted from these introductions. There are several portraits of men and women and children from 1820 to the mid–1830s. Most of the husbands were not men of renown but commissioning one's wife's portrait was always a flattering gift. Sometimes separate portraits of husbands and wives were commissioned, this being the custom of the time which artists no doubt preferred as it enabled the less proficient to recommence a portrait that had not progressed well without necessarily having to repaint one that was already satisfactory. At this stage in his career Etty was receiving commissions from persons of modest means. Thus we have *Mrs. Arabella Morris* (c. 1818), the daughter of the Rev. William Higginson, Rector of St. Peter's, Alvescot, Oxfordshire. She had married in

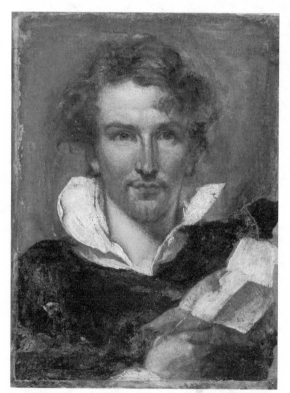

Self Portrait (1823), Maas Gallery, London/Bridgeman Art Library, MAA181783/235.

1817 and this portrait may be connected with that occasion. In the same year he painted *The Rev. W. Jay of Bath* and his daughter *Miss Arabella Jay* (color plate 14), both exhibited in the Academy, the former in 1818 and the latter in 1819. The portrait of the Rev. Jay appears not to have survived but an engraving of 1819 shows a conventional half-length portrait of a seated man. Etty appears still to be having difficulty with hands. Jay's left hand is a lumpy bunch of fingers and his right hand is judiciously hidden in his trouser pocket. Jay was a dissenting minister renowned as a preacher and the engraving was made as a frontispiece to his biography. His daughter, also half-length, is painted in a more Romantic manner as though in the open air and in a light breeze. She carries a basket of flowers. But once again Etty has not mastered the art of painting hands. Her right hand is held to her throat and her left hand up to her breast but both are clumsy, not matching the refined elegance of the sitter which Etty has been careful to suggest.

Mr. Joseph Arnould J.P., D.L., whom Etty referred to as then living at Peckham though he is recorded later as living at White Cross in Berkshire, was painted in 1820. He was probably a friend since Etty told Walter in July 1816 that he was having dinner with him. His mother *Mrs.*

Arnould also had her portrait painted in 1820. A *Portrait of Miss Wallace* was painted in 1820 though not so described until 1849 when it was exhibited in the Society of Arts. It was later, in 1860, titled *Innocence*. Nothing appears to be known of Miss Wallace or the circumstances of the painting and though it may be possible she was related to the "Mr. Wallace of Florence" who was with Etty in Italy in 1823 there is no evidence to connect the two. The portrait is head and shoulders only of a very pretty young girl painted in the style of Thomas Lawrence, no doubt too sweet for modern taste but equally no doubt very appealing to the gallery-going public of the time and certainly very acceptable to both sitter and presumably her father. *Mrs. Mary Newman* (painted in 1822) was a niece of Thomas and Martha Bodley who also lived in Cheltenham. For some unknown reason someone painted a second version in 1909.

Many commissions came to Etty throughout his life from friends and notables in York who engaged him during his frequent visits home. There do not appear to be any portraits of York personages outside Etty's family until 1825 when he painted the portraits of *Josiah Ingham* and his wife *Maria*. Josiah Ingham was a linen draper trading in York. He had married Maria Moser in 1820. The date 1825 is uncertain but is usually ascribed to these works since Etty visited York in the autumn of that year. In the same year Etty painted a half-length portrait of *Thomas Bodley*, his cousin, depicting him against rocks on a sea-coast. Bodley was then living in Brighton. Etty did not paint the portraits of his more notable York friends until the 1830s though probably in 1825 he painted his friend *John Camidge, Mus. Doc.*, then assistant organist at York Minster under his father and later organist from 1842 to 1858. Camidge had gained his doctorate in music in 1819 and Dennis Farr believes this portrait was painted some years later, so 1825 is a reasonable supposition.

By the mid–1820s it had become apparent to Etty's friends and certainly to his brother Walter that he ought to set himself up in accommodation more befitting an aspiring associate of the Royal Academy who would, if successful, then aspire to becoming a full member. Since his uncle's death on 25th May 1809, Etty had lived in a succession of lodgings as we have already seen. It was time he had a place of his own. In the summer of 1824 he moved from the Lambeth side of the Thames to leased rooms on the lower floor of No. 14 Buckingham Street, The Strand, on the north bank. His friends had been prompting him to make this move apparently on the grounds that the rooms would be more spacious. The role of Walter in this move is unclear but it does appear that he met the cost of purchasing the lease and perhaps of redecorating the premises. Gilchrist says[2] that Etty had "burdened himself with a lease of twenty-one years and a rent of £120; a serious increase of expenditure, warranted, seemingly, by improving prospects." After his move Etty discovered to his disappointment that his new home was not as satisfactory as he had expected, probably because it was on the ground floor, and he pleaded with Walter to allow him to return to Stangate Walk. Walter must surely have provided the money for Etty to acquire the new premises because he was troubled that his brother would consider him ungrateful. His letter of 29th June 1824 to Walter is the cry of a man in despair.[3]

<div align="right">14 Buckingham Street
Tuesday morning</div>

My dearest Walter,
 After all the trouble you have had, and all the expense that has been incurred, it may seem like ingratitude and flying in your face—to feel as I do—but believe me—I am here truly wretched—could I have foreseen one quarter of the unhappy feeling that has possessed me and yet paralyses me I would never have thought of leaving a place where I was truly happy, healthy and had a mind at peace—could I even ever like this place equal to my last which is impossible—the idea of the heavy expense, (the servant alone costing more than the other together) weighs down my mind and utterly unnerves me—O forgive me! forgive me, I entreat you—I will never do anything to disgrace you, or give you uneasiness after this, but I feel my happiness, and my health are gone, attached from the first to that dear place, where I have made some of my happiest efforts—because my mind was at peace, and I had an easy rest—and a

situation that could banish those clouds of melancholy that now hang over my mind—I feel that in leaving it I have lost almost everything dear to me, except yourself.

It was a distance that insured my health by rendering a walk to the Academy necessary, surrounded by spacious Gardens and the river air is purer—I had scarcely had a night's rest since I have been here—my stomach revolts from food that used to be grateful to me—in short I am truly unhappy in mind and body—Had I listened to my own feelings more than officious people who persuaded me, I ought to be in another situation I should yet have been happy—here it is impossible—the slow returns of a painter devoted to my line of art I am sure can never meet it were my mind at peace—how can it—miserable as I am—as I feel I must ever be here—O! let me go back! I entreat you! on my knees I would entreat you! to where I painted my Cleopatra my Maternal; Affection, and my Pandora,—there I can live—here I am dead to Art and everything—at an expence that I dread to contemplate, I have no wish but to live and die in Lambeth, a name ever dear to me, because I have been there truly happy, more so than I ever was, or shall ever be again unless I go back.

If you will, I will spare no exertions to get on in my dear Art—I will work my fingers to the bone but I will repay you some time or other all I owe you, except the grateful obligations I feel, which I fear are more than I can ever repay—for God knows I should think my dear Walter, my life too little in return for what you have done for me—I am now much in debt, which you and the idea of that, with the heavy outgoings of the present rooms—quite oversets me—together with the thoughts of the happiness I have left—O I should have thought of it before I grant—but I could not forsee what I have felt and still feel— and must ever feel here—O pardon my weakness—my dear Walter—but my nerves are aspen like. Grant me but this, and in my whole [? *word omitted*] shall I endeavour to repay you—I shall never be happy till you do—I feel it impossible—I declare I never was *so* unhappy—so long together, and I hope I never shall be so again—I don't wish to live in splendour, I wish to be great as a Painter, to live virtuous and happy—is all I wish. Let me then go while 'tis yet in my power! I conjure you, by the Love I bear you, by all your desires for my welfare—for I fear the effects of a refusal—I feel sensible that it would have some bad effect on my health, which God knows, is not strong—or what should be worse, my mind, which when so affected, is oppressed with a gloom indescribable.

O Grant it me! and I will yet live to be happy, and I trust to make you so too, at least I will spare no pains to try to do so,

> Pity and forgive me
> My Dear Walter, I can't help it
> and believe ever your Affectionate Brother,
> William Etty.

Walter endorsed this with the words "wretched Letter." It is clearly the outpourings of a man in mental distress though the cause is not merely that he is leaving his old haunts to which he has grown accustomed but also that he will in future incur more expenses than he believes he can meet. This is curious since it is obvious from the letter that Walter has some control over him and since we know that Etty was for many years in debt to his brother it would seem that Walter has arranged this move and this could only have been effected if Walter had bought the lease of the property and made Etty obliged to obey him. It is also clear that future expenses will fall on Etty himself, not on Walter, which may again seem curious since so far as we know Walter never imposed financial obligations on his brother. It was always either that Walter *offered* assistance or William asked for it.

However Etty was persuaded to stay and very soon found that he could enjoy his new home, mostly because it was, like Stangate Walk, close to the river. In Etty's day No. 14 Buckingham Street was adjacent to the river. Today the building that has taken its place is separated from the river by Victoria Gardens and the Victoria Embankment constructed between 1864 and 1870. Although most buildings fronting the river before this construction were old and dilapidated with offensive mud banks, No. 14 Buckingham Street must have been regarded as a somewhat prestigious building. Number 14 and the adjacent number 12 had been built in 1675 on the site of York House, the former town mansion of the Duke of Buckingham. Samuel Pepys lived in No. 12 from 1679 until 1688 when he moved into No. 14 and remained there until 1704. The house was then occupied by Robert Harley, the Earl of Oxford. He left in 1714 when the

Earl of Lichfield took over. Between 1735 and 1788 it was no longer a dwelling house but served as the Salt Office. It was rebuilt in 1791. No illustrious figures occupied it until Etty took occupation in 1824. According to *The London Encyclopaedia* (edited by Weinreb and Hibbert) Etty occupied the first floor, not the ground floor, but they also give Etty's entry into occupation as 1821, which is erroneous. Etty moved to the top floor in 1827 and his vacated rooms were taken by fellow artist Clarkson Stanfield, who moved in with his wife and there his first son was born in 1828. We do not hear anything of Etty's relationships with Stanfield until 1843 when Clarkson thanks Etty for praising his painting exhibited that year. Sir Humphrey Davy occupied the basement between 1824 and 1826 and carried out his experiments there on the prevention of corrosion of ships' hulls. Other notable persons occupied other houses in Buckingham Street— Peter the Great in Number 15 in 1698, Henry Fielding also in Number 15 in 1735, Peg Woffington in Number 9 from 1755 to 1757, David Hume and Jean-Jacques Rousseau in Number 10 in 1766 and Samuel Taylor Coleridge in Number 21 in 1799. Turner was to cast envious eyes upon Etty's apartments and try to secure them when Etty eventually left. Buckingham Street was clearly a "good address."

Etty always wished to live near a river and when he eventually retired to York he had to have a house on the banks of the river Ouse. "I could not bear to desert old Father Thames" he had written from Venice,[4] refusing to be enthralled by the canals. Being then still domiciled in Stangate Walk, he had associated himself with Turner's affection for the river. "Looking from Lambeth to Westminster Abbey, it is not unlike Venice." But from the lower floors of Buckingham Street the view of the Thames in the other direction was not so reminiscent of Venice. The cynic might have commented that in some respects the Thames *was* similar to the Venetian canals. In both cities the absence of any sanitation system meant that refuse, and especially human waste, was deposited in these waterways. In London the common practice was to collect human waste in cess-pits in gardens or, if these were inadequate, actually under parts of the houses themselves with consequences to the living quarters and the health of the occupants. These pits were periodically emptied by "night men" who carried the contents away to the country for use as fertilizers. In areas close to the river the houses were drained directly into the Thames and it was recorded that hundreds of pipes deposited raw sewage. The river was described by those seeking to remedy the situation as "a stinking open sewer" particularly foul during the summer months. This must have been the situation when Etty lived there since it was this condition that eventually prompted the construction of the Embankment with sewers under the roadway carrying the effluent to more distant disposal points.

In the 1850s the Thames became so foul that the summer of 1858 was called "The Great Stink." The stench was such that those who could do so moved away and Parliament met with wet sheets dipped in lime hanging over all windows in an attempt to neutralize the smell. Conditions were not yet so bad in Etty's time but they were bad enough for many to comment upon. So it is surprising that he described the air by the river as "pure." The fact is, of course, that no other system of sanitation was then known or, if known, was not to be contemplated since it would have required expensive works which no one was prepared to agree to. It remains curious today that persons with some social standing would wish to live in such conditions against the Thames but the river's traditional associations drew them there. Advantages were the expanse of open space of the river and the views and the availability of the many boatmen who provided what amounted to a river taxi service.

To assist Etty in his move to Buckingham Street and in settling in to his new home his mother came down from York, bringing with her a granddaughter, Elizabeth Etty, with the intention they would stay a few months and then return home. Elizabeth was brother John's daughter, a personable young woman who was admired by her male relations and already well known to her uncle. From the portrait made of her by Etty in later years she seems to have been, though not strictly "a beauty," very certainly attractive. The accounts available suggest that she was a

woman with a lovable and sensible disposition and Etty came increasingly to rely on her. Esther Etty returned to York but Betsy, as Etty always called her (all the nieces were given nicknames in the family), stayed for the next 25 years fulfilling the role of housekeeper. Very soon Etty moved to the upper floor of Buckingham Street, selling his ground floor lease at a loss, but by then he was in a better financial position and since the move meant "having nothing above him but the Angels," as he said, he accepted the loss with equanimity. He was also able to indulge his interest in keeping small animals such as rabbits and pigeons in hutches on the roof. His fondness for animals was later to make him claim that in the garden of his retirement house in York, he had a frog which came to him when he called it.

But the really important event attaching to his move to Buckingham Street was the beginning of his lifelong association with Betsy. She was her parents' second child, born in 1801 and therefore 14 years younger than Etty and 23 years old when she came to live with him. We know very little about her but the letters that Etty was to write to her whenever he was away reveal a growing affection and dependence on her that can only be regarded as a substitution for marriage. Betsy comes across to us as a very capable, level-headed and reliable young woman who easily took responsibility for the household which now had at least two servants. She does not appear to have been in good health for most of her life but as she lived to 82 years of age it is probable that she, like Etty himself, suffered from the effects of London fogs and the general dampness of the undrained city. Not for nothing has London been called throughout history up to the twentieth century, "the Smoke." What is very clear is that without Betsy, Etty could never have managed the complexities of life facing a shy and famous artist in London. With Betsy's arrival in Buckingham Street begins what must be regarded as the true love of Etty's life.

"An honor conferred"

On the 1st November 1824 Etty was elected Associate of the Royal Academy. This was the first time his name had been presented for election. William Allan, a Scottish painter born in 1782 and a friend of Etty's, was his strongest rival. Allan had been trained as a coach painter, had studied art in his native country and had moved to London to enter the Royal Academy Life Schools. He was much traveled in the near East. Allan painted scenes of Scottish scenery, oriental subjects and patriotic history, such as *The Battle of Waterloo from the English Side*. He also painted Russian scenes, one especially for the Czar, and was altogether financially very successful. On the first ballot Allan had a large majority but when the other two candidates, who had individually polled less than either Allan or Etty, stood down, Etty won the second ballot by sixteen votes to Allan's seven. According to Gilchrist,[5] Sir Thomas Lawrence, President of the Academy, privately regretted the Council's decision yet still assured everyone that "the accession of Mr. Etty to the Institution cannot fail to do it credit." It seems that most of the more influential members, including not only Lawrence but also Francis Chantrey, Martin Shee as well as David Wilkie, also preferred Allan. Lawrence confided his feelings to Wilkie in a letter the next day (the 2nd of November).

> You know the claims of Mr. Etty, and how much he may be said to be a Child of The Royal Academy, educated in it, its most assiduous Student—a former Pupil of the President, and a Man of the most blameless life, modest and natural manners.

Lawrence went on to say that all of these considerations could "hardly diminish the regret of the just admirers of Mr. Allan's genius," among whom he included himself; nevertheless he was "certain the accession of Mr. Etty to the Institution cannot fail to do it credit, I know even my own partiality for his merits would not have prevented my voting for Mr. Allan, had equality in numbers call'd for my decision."

Etty knew nothing of his old master's opinions in the matter and always believed that Lawrence had whole-heartedly supported his election. Yet Etty's election gained the approval of the critics. *The Times*[6] made the biting comment: "As matters are conducted at the Academy, this cannot be as an honour conferred on Mr. Etty: if it were, he had deserved and should have obtained it long ago." *The Times* also singled out for praise Etty's copy of Tintoretto's *Esther before Ahasuerus* which he had exhibited that year.

William Allan went on to great things. He was elected Associate in the following year, became a full member in 1835, seven years after Etty, and President of the Royal Society of Arts in 1838. From this distance we may feel some surprise that Etty was able to defeat him so resoundingly in 1824 but "history" subjects were still officially regarded as the highest form of art. It was no doubt disappointing for Etty that his father had not lived to see his success but his mother, who had done so much to encourage her son, was able to share his joy. Etty was now 37 years old.

It was from his election that, according to Gilchrist,[7] Etty began to hold social gatherings of his fellow artists in his rooms at Buckingham Street. Gilchrist states[8] that "Fuseli, Flaxman, Stothard, Constable and Hilton" were in the first group to come to his breakfast gatherings, followed later by "Maclise, Dyce and Herbert and their compeers; Turner supplying a connecting link between the two eras." This is surprising because Etty was not by nature a social creature. He found conversation difficult and was usually too shy to join in. As Gilchrist goes on to say: "Presiding as host with scrupulous attention, he spoke but little himself; watching the conversation as it passed from friend to friend." Etty was more at ease with one person at a time with whom he had learned to be intimate. These breakfast meetings, to which no one was particularly invited but to which any who could come did so, were not continued for long. They were found to be "much exciting Etty too early in the day." It is more likely that he found they interfered with his work. Etty was an early riser and liked to get down to painting as soon as possible. He did, however, encourage close friends to visit him in the evenings after he returned from the Life Class, which concluded at eight o'clock. Then, as Daniel Maclise reported,[9] it was "tea, in the making of which he prided himself; capital muffins and buttered toast. A few old friends were generally assembled. We closed the evening early, with perhaps a *petite verre* of Maraschino." A *petite verre* it certainly would be. Etty drank very little alcohol and did not encourage others. These occasions indicate that Etty was now recognizing his own place in the artistic life of London. He was also very popular among students for his unassuming friendliness. He did not stand aloof from them, posing as the "Master" whom they should admire. He would often invite the students of his Life School in St. Martin's Lane to tea and supper in his rooms overlooking the river.[10] Gilchrist places this account in the years 1837 to 1847 which is surprising as it suggests that Etty was still attending St. Martin's Academy as well as the Royal Academy Life Class. Very little is known of Etty's connection with the St. Martin's Lane Life School.

Further recognition—Meeting with Delacroix

In the same year, 1824, but before his election, unexpected recognition came from the Charleston Academy of Fine Arts, in South Carolina. They elected Etty Honorary Academician, a fact which Etty was pleased to record in the Royal Academy exhibition catalogue that year along with the note that he was already an "Honorary Member of the Imperial Academy of Fine Arts, Venice." What a ring those words had and how he must have hoped they impressed his colleagues in London. In 1827 he fulfilled his obligation by sending to Charleston an original work, *Study of a Male Figure (back view)*, which he thought would be a suitable subject for them. This Academy had been founded in 1816 but was disbanded in 1830, to be superseded by the Carolina Association in 1857. Etty was immensely proud of this compliment, which was the second diploma he received from a foreign Academy. When Etty came to write his *Autobiography*

he misremembered the dates of these events, declaring "Venice the second," forgetting that he had received the Venetian diploma in 1823. In 1825 he was made an honorary member of the Royal Scottish Academy. As Gilchrist was pleased to record,[11] he now had four diplomas "framed and glazed, on the walls of one of his rooms." The young man from humble beginnings in York had "arrived." He had only one more step to achieve—full membership of the Royal Academy.

In 1825 Etty exhibited *The Combat: Woman Pleading for the Vanquished*, which attracted considerable praise. *The Combat* did not illustrate any particular historical incident but rather was intended to express the virtue of mercy. It suffers, as usual with Etty, from being composed from single models assembled into a tableau. This painting, also like so many others, has a frieze-like composition derived probably from his having seen and admired works by Poussin and partly also from his admiration for John Flaxman. Probably also he had been influenced by the Elgin marbles (brought to England in 1816) and other Greek and Roman friezes displayed in London as well as those he had seen in the Vatican when in Rome. Nonetheless *The Times*[12] saw *The Combat* as "a masterly effort, and though defective in some respects, it realizes a union of the florid beauties of the Venetian school with much of the sober dignity and power of the Roman school."

The painting was purchased by John Martin, the painter. The Redgraves recounted the story[13] that Martin had rashly promised to buy it when he had seen it in Etty's studio, "if it was unsold at the Academy." He was shocked to find he had to keep his word. Farr completes the story[14] by recounting that Martin found the painting too large for his house and sold it to the Royal Scottish Academy. This confirms the point frequently made that the new class of collectors did not possess houses suitable for the large traditional paintings. Incidentally, the Redgraves say Martin paid £200, Dennis Farr says 300 guineas. Whatever the sum, it is likely to have been paid in guineas as Etty usually required payment in guineas as reflecting his professional status, a fact which some later purchasers complained about. William Carey, never missing an opportunity to promote Etty, later praised Martin's fine judgment in purchasing *The Combat* though apparently unaware he had been unable to keep it. So well regarded was *The Combat* that Gilchrist was pleased to record[15] that when "a gentleman of fortune" consulted Francis Chantrey, also an Academician, for advice regarding a painting he wanted for his staircase, Chantrey told him,

> you will not readily meet with so fine a picture as Etty's Combat ... the merit of the picture is unquestionable, its price surprisingly low: three hundred guineas. Artists and judges expected he would have asked *six* hundred at least. Its size alone stood in the way of various purchasers.

He told the gentleman that he had already "strongly recommended it to Mr. Watt, and hoped some friend may have the good fortune to possess it." (Mr. Watt is unfortunately unidentifiable. No one of this name is mentioned by Frank Hermann as a notable collector of the time.) As Gilchrist commented, this was high praise coming from "a reigning Power." An influential collector, the Earl of Darnley, also praised *The Combat* and commissioned Etty to paint *The Judgement of Paris*, of which more in due course. Darnley was an admirer of Venetian art, owning at the time Titian's *Rape of Europa*.

Chantrey would have served as an example to Etty. Born in 1781, the son of a carpenter, first employed as a grocer's boy in Sheffield and then apprenticed to a woodcarver, he had moved to London in 1802 where he achieved fame as a sculptor and was elected Associate of the Royal Academy in 1816 and R.A. in 1818. In 1835 he was knighted but that was yet to come. He died a wealthy man in 1841, bequeathing his property to the Royal Academy with money "for the encouragement of British Fine Art in Painting and Sculpture only" which included the purchase of "Works of Fine Art of the highest merit in painting and sculpture that can be obtained," provided they had been "entirely executed within the shores of Great Britain." In addition he left sums of money to assist the stipends of the President and Secretary. Under the terms of his will the bequest did not become available until 1875 because of domestic obligations but it has

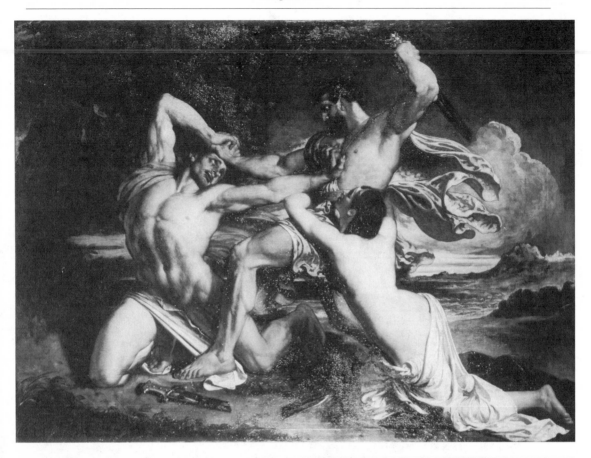

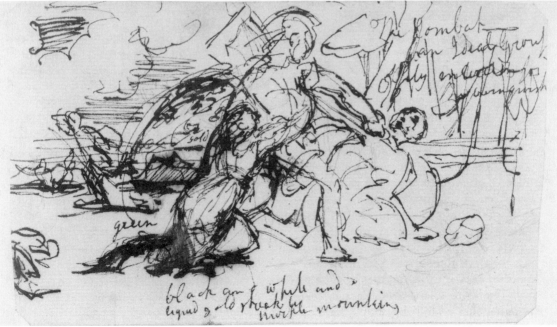

Top—The Combat: Woman Pleading for the Vanquished (100 × 135 ins) (1825), NG189; bottom—Study for "The Combat" (?1825), National Gallery of Scotland, Edinburgh, D 5060.

proved most valuable. Most of the works purchased are now in the Tate Gallery. Although Chantrey's final glory had at this time yet to be realized he had already achieved enough to assure any young man from a poor provincial family that if he had talent and worked hard he also could reach the pinnacles of fame.

In May 1825 the French Romantic painter Eugène Delacroix visited England, staying until August. He went to many exhibitions, met many English artists, though not Constable or Turner who were away from London, and made the general comment that English painters could paint grand scenes but were not skilful with the details. In respect of the history paintings this may be regarded as fair comment, though Dennis Farr believed[16] that Delacroix had in mind William Hilton's *Christ Crowned with Thorns*, not Etty's *Combat*. He admired Etty's *The Storm* which, according to René Huyghe,[17] gave him the initial idea for his own *Christ on the Sea of Genesareth*. During this visit Delacroix met Etty several times, as he did Lawrence and Wilkie and others. Delacroix admired Etty's "directness" compared with Ingres' detachment. However, Etty does not appear to have been able to respond to Delacroix's interest, probably because of language difficulties. When Delacroix left England in August of that year he wrote warmly to Etty regretting that he had not been able to see him again before departure.[18]

Londres, le 24 aout 1825

Monsieur,
 J'eprouve un vif regret d'être obligé de quitter l'Angleterre sans avoir eu le plaisir de vous revoir. Mon depart a été beaucoup plus precipité que je ne pensais, et ayant été quelque temps en Essex d'où je suis arrivé depuis peu de jours, je n'ai pu m'acquitter d'un devoir tout agreable pour moi, Veuillez donc en recevoir mes excuses aussi bien que Monsieur Calvert que j'avais rencontré et qui avait bien voulu m'inviter à le voir. Si vous venez a Paris, je me trouverai heureux si je puis vous y être utile en quelquechose. Agreez, je vous prie, l'assurance des sentiments distingués avec lesquels j'ai l'honneur d'être,
 Monsieur,
 Votre devouè serviteur
 E. delacroix
 Rue du Houssaye No. 5 à Paris
 Voudrez vous m'excuser de vous ecrire en Français, j'aurais été incapable à mon grand regret de m'exprimer dans votre langue.

Etty never responded, he never accepted Delacroix's invitation to visit him when he next went to Paris and there was no further contact between them. Gilchrist did not mention Delacroix, being either unaware of his meeting with Etty or preferring to ignore any possibility that the Frenchman might have influenced his hero. It may be that Gilchrist did not know of the meeting since Etty did not refer to it in his *Autobiography*. Although it seems that a friendship could have developed between the two painters despite the fact that neither could speak the other's language, Etty was unable or unwilling to introduce the heroic elements of Delacroix's nature into his own work. Their personalities were too different. Delacroix was flamboyant and adventurous, Etty retiring, shy and always anxious not to offend. The true difference between them was that Delacroix was a painter whom Kenneth Clark linked with Turner as "the greatest master of romantic painting,"[19] a man who embraced what he rightly saw as the new future based on the individual, whereas Etty was firmly rooted in the classical system in which the individual was subordinate to universal truths. Both men moved away from their roots; Delacroix rebelled against his aristocratic cultural background while Etty identified with the values of a class destined to become social dinosaurs. The uncertainty of the future appealed to Delacroix but Etty needed the certainties that the past appeared to guarantee.

Yet, perhaps, as is often the case, the two "opposites" could have forged a strong friendship had they met again. They would have enjoyed the contest of minds. Although Etty was shy with strangers he was a good conversationalist among close friends. It is to be regretted that Etty did not take opportunity to visit Delacroix. He would certainly have benefited from being able to see the Frenchman's work and would probably have learned how to compose a picture with

proper understanding of pictorial space. It is also to be regretted that Etty knew nothing of Ingres. Although the cold classical treatment of the nude would not have appealed to English collectors, some of Ingres' detachment would have counterbalanced Etty's tendencies towards the sensuality of Guérin and Regnault. It is in their appeal that we discover the hidden romantic in Etty.

A troublesome patron

The success of *The Combat* brought Etty to the notice of Lord Darnley, a man who regarded himself as very knowledgeable in the arts but often proved very troublesome. Darnley belonged to the class of old fashioned patrons in that he commissioned what he wanted and expected the artist to deliver precisely what he ordered. He chose the subject and the composition and made sure he got them. He commissioned from Etty *The Judgement of Paris* (see color plate 5) and agreed to pay £500. Etty set to work but soon had to contend with the continual interference of his patron who was always urging alterations until Etty declared in exasperation that he would paint the picture as he wished and "his lordship need not take it unless he liked."[20] This remark, somewhat untypical of Etty, nevertheless reveals his increasing confidence. He was no longer reliant on single patrons. If Lord Darnley did not want it, the painting could always be exhibited and sold to another collector. The Academy had changed the art market. The painting was completed for exhibition in 1826 when it attracted considerable praise.

The catalogue contained a summary of the Homeric legend explaining the subject to those who had not read their classics. In modern times it is accepted that the whole story was merely a usual classical explanation for a war between two powers for the control of the Black Sea trade. The story is still one of the best known legends of ancient Greece and the Judgment of Paris gives artists the opportunity to depict three beautiful women from different angles very much as they depict the Three Graces. Many sources have been attributed to Etty's version,[21] among them an engraving by Flaxman which Etty knew, and also one by Marcantonio Raimondi after a lost picture by Raphael, as well as Rubens' versions, one of which (see next page) had been part of the Duke of Orléans' collection until 1792 when it came to England, having been acquired by Lord Kinnaird. It was offered for sale by auction in 1813 and may then have been seen in the sale room by Etty, which was a usual way for works of art to be seen by the public. This version by Rubens was acquired by the National Gallery in 1844. It is most likely that Etty looked to Flaxman's engraving. In both Flaxman's and Etty's versions Paris is seated on the left of the goddesses, Minerva wears the same plumed helmet and Juno is depicted from the back with her head turned into Profile. In Ruben's National Gallery version the composition is reversed, Paris is on the right of the goddesses though Juno is again depicted from the back. But one feature is strikingly similar in both Rubens' and Etty's versions—Juno's peacock, which is absent from the other versions. Etty made two later versions, one in 1845 commissioned by Joseph Gillott for 100 guineas, and another, possibly later, sold in 1849 as a sketch for 100 guineas.

The painting was well received at the Academy exhibition, the critics being particularly enthusiastic. *The Examiner*[22] admired it in general saying that

> our ambitious painter has conquered nearly all with his masculine powers, for it not only provokes comparison with some fine old pictures—having been a favourite and frequent subject—but its large masses of flesh-colour and many naked figures demand great knowledge of the human form and its various tintings and character

but found the figure of Venus "wanting in those potent charms at which assembled Olympus was wont to gaze" and thought the positioning of her right arm was "awkward" but accepted that it was necessary in order "to obviate a difficulty which might, we apprehend, have been otherwise subdued." The critic was being delicate in his remarks as befitted the times—Venus was

obscuring her crotch. *The Times*[23] referred to its "brilliant and harmonious colouring, combined with graceful grouping and careful execution, such as no artist of the present day can equal." *The Times* art critic was now one of Etty's greatest admirers. However Lord Darnley remained not wholly satisfied and refused to take delivery of the painting. In 1827 the painting was exhibited at the British Institution, with Lord Darnley's consent though he said that he "would have wished to have suggested some alterations before it was again exhibited."[24] A modern viewer could not but agree. The figure of Paris is unsatisfactory with his awkwardly extended arm and the heads of the two frontally facing goddesses do not articulate plausibly with their bodies. We know that the heads were posed by friends of Etty and they look like attempts to avoid recognizable portraits in order to protect their modesty. It has always been a problem for painters of the nude that faces must be both impersonal and plausible, factually accurate but not suggestive of a particular individual. This was a recurring problem for Etty, who was very dependent upon models.

A note in the British Institution catalogue stated that the painting was "to be disposed of," suggesting that it was for sale. Etty had to store the painting in a warehouse and had to make several appeals for payment before eventually £400 was paid by Lord Darnley in a number of installments. Not until 1834 did his heir pay a final £75, leaving Etty still £25 short of the agreed price, as he complained in letters to Walter in June and July of that year. Many members of the aristocracy were still following the customs of their class inherited from the eighteenth century of not paying their bills if they could avoid them. In 1843 Darnley's heirs sold it to Andrew Fountaine for £1500. The painting is now in the Lady Lever Gallery, Port Sunlight, having been bought by William Leaver (Lord Leverhulme) in 1911.

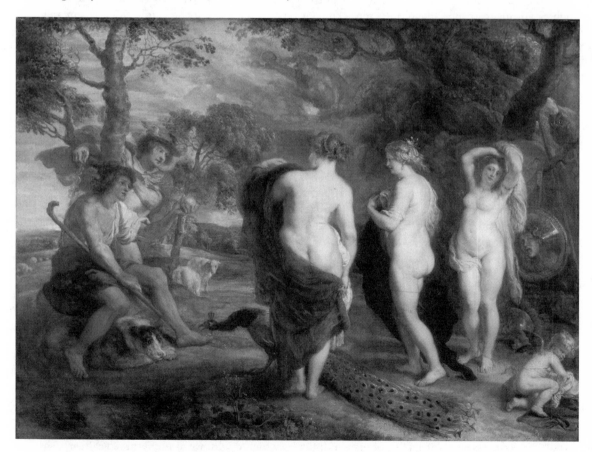

The Judgement of Paris, by Rubens (70.25 × 107.5 ins) (1826), National Gallery, London.

Revisiting York

Since leaving York in 1805 Etty had not revisited that city except in the summer of 1811, possibly in August 1813 and for his father's funeral in 1818. He had, however, kept up a steady correspondence with his family and his mother had visited him in London. Now in the autumn of 1825 he paid a return visit to his birthplace. He probably wished his family and friends to see the new Associate of the Royal Academy, an understandable display of pride. In 1825 Etty stayed with his friends, Mr. and Mrs. Bulmer on The Mount, who were also good friends of his mother. Not much is known about the Bulmers except that he had also risen from humble origins and was now a solicitor practicing in York. In due course they would move to "a good address" in Chelsea, London. Etty found that York was already showing signs of change since he had known the city as a youth of 18. The desire on the part of the City Corporation to "improve" York had been in their minds for several decades. In 1799, when Etty had been 12 years of age, a Committee of York Corporation had suggested that the city walls should be demolished partly because of their already ruinous condition and partly to enable improvements to be made to the nearby streets. This proposal had been rejected and the walls had been allowed to deteriorate even further, the usual ploy of those in authority who intend to get their own way in the end. Posterns had been demolished. The old Ouse Bridge and St. William's Chapel alongside had been demolished and the present bridge built in its place between 1810 and 1820. The latter was obviously necessary though the City Engineer had wanted to rebuild the bridge on a different site. York was growing in population but not in affluence. Visitors complained that it was a dull place with streets too narrow to be regarded as "handsome." It had little industry and was largely dependent on domestic service to provide employment for the poorer inhabitants. York had known better days, though since the Middle Ages its wealth had never been great. Attempts in the eighteenth century to rival Bath had failed. In the early nineteenth century there was a professional middle-class but their numbers were insufficient to generate a revival of the city's fortunes. The population was now growing as was that of all the country but this growth was almost wholly among the poorer classes and was causing problems for the Corporation. There was no prospect of useful employment and services within the city were inadequate to provide it.

The Corporation had to do something, and expanding and relaying-out the city seemed a possible solution. It was thought this would encourage visitors but whether to inspect the medieval remains or to attend the assizes and the races was not immediately clear. Public hangings on the Knavesmire were still a spectator sport along with horse racing. What was needed, it was thought, was a scheme of improvements to attract wealthy visitors who would spend money without making too many demands for changes in the inhabitants' way of life. Everyone was determined that manufacturing was not to be encouraged. Clearing the slums, of which there were many in Walmgate and along the riverside, and demolishing the barbicans, which were no more than public latrines through which no decent person, certainly no lady, would walk, were all projects clearly necessary. There also seemed to be a need for wider roads instead of the network of narrow streets and alleys within the walls. Etty's brother John had already moved to a better part of Walmgate and had engaged in some property development involving the building of small model dwellings. Apparently this had not proved financially successful. It was considered that more drastic solutions were necessary, such as demolishing the walls and the bars ands widening streets.

However, public opinion, or rather the opinion of the minority that counted, especially the Archbishop, Dean and the Canons, strongly opposed these ideas. We may assume that the majority of the population, having no vote and no economic status, also had no voice in these matters. Most likely they had no interest, which seems to have been a usual response to any question affecting the future of the city. It is also likely that any proposal designed to encourage visitors would not be generally well received, the usual objection being leveled against the

Corporation that they were more disposed to assist visitors than the citizens, it not being recognized that visitors brought much needed money into the city. Etty does not appear to have been concerned with economics or politics but solely with conservation.

During his 1825 visit much of Etty's time was occupied with members of his family and friends. He enjoyed New Walk, the riverside promenade, which had been completed in 1756 (after the City Corporation's initial decision in 1730). Trees had originally been planted in 1740. These were to be replaced in 1831 and 1832. Etty would have known New Walk when a boy so nothing here had changed very much except that the original trees were now fully grown and approaching the end of their lives. The proposals to demolish the walls had been postponed so their fate must have appeared secure. Etty did however learn of a proposal to demolish Clifford's Tower. The Tower, which was the only remaining part of the original York Castle, had been compulsorily purchased by the Corporation in 1823 from a private owner in whose grounds it stood. Demolition seemed such an act of vandalism that Etty wrote a letter of protest to the *Yorkshire Gazette* which was published on 8th October 1825. Actually the Corporation had already decided not to proceed with the demolition but Etty was unaware of this. In this letter Etty deplored the proposal and hoped that "some pen more powerful" would advocate the retention of the tower. He went on also to hope that the "enlightened policy which preserved New Walk" would be "exerted to save this famous ruin." Twenty years later he referred to this letter as "the first stone I threw at the Vandals." More were yet to be thrown.

While in York Etty undertook some portrait painting as was his usual custom. His women friends in York were probably of the opinion that he was primarily a portraitist; no doubt he thought better of telling them where his real interest lay. While staying with Mrs. Bulmer in 1825 he painted her portrait, producing a painting which Gilchrist said[25] was "much eulogized by Wilkie when in York some years after." Etty himself referred to it when writing to Thomas Bodley on the 11th October 1825, complaining of interruptions to his work owing to the sitter's ill health. He expressed himself to be pleased with it. There is no finished portrait surviving from this date, or indeed from any other date although it is known that Etty painted Mr. Bulmer more than once. The only known portrait of Mrs. Bulmer is a sketch of around 1845, in private hands. According to Gilchrist,[26] when Etty returned to London he sent some contemporary engravings to Mr. and Mrs. Bulmer, probably as an expression of gratitude for their hospitality, and received in return from Mrs. Bulmer a letter reminding him that he had recommended her to read the Bible, which she was doing "and hope[d] to profit from it" and counseling him to do likewise and not to be too absorbed "in the pursuit of Fame." As Etty was at that time no longer averse to working on Sundays, "he took the scolding to heart and amended."

"We must keep the foreigners from fooling us!"

For some time Etty had wanted to paint a work that would rival that of his contemporaries and especially of foreign artists. Like Turner he was aware that England needed to establish her own school of painting. Whereas Turner set out to do so in landscape painting, Etty entered upon the more formidable task of competing with the Italians in figure painting. This would invite comparisons with the Old Masters and the seventeenth century Baroque artists, but he was willing to take the risk. He decided upon a religious subject, which would confound his critics who regarded him as capable of turning out only endless arrays of nude females. It also would prevent them from comparing him unfavorably with such masters of the nude as Titian, Correggio, Poussin and Rubens. His main purpose was to establish the superiority of English painters over foreigners. He chose the Apocryphal story of Judith and Holofernes which epitomized for him all the virtues of patriotism and individual valor. He decided upon a triptych in the manner of the Old Masters so his intention to invite favorable comparisons was clear. Gilchrist claims[27] that Etty had stated, in an unidentified letter, that he had first conceived the subject

"when the solemn tones of the Organ were rolling though the aisles [of York Minster]." He wanted "to paint some great moral on the heart." For the left-hand wing he selected *The Maid of Judith Waiting Outside the Tent of Holofernes While Her Mistress Consummates the Deed That Delivers Her Country from Its Invaders*, for the central canvas, *Judith* (depicting Judith inside the tent about to strike Holofernes) and for the right-hand wing, *Judith Going Forth* in which Judith gives the head of Holofernes to her maid to be placed "in her bag of meat." He began with the central canvas but first he made a series of pencil and oil sketches. One of these, now in private ownership, was later mistaken to be a work by Géricault but other similar sketches confirm Etty's authorship. All drawings of this episode depict Judith just before the actual beheading, standing with uplifted sword in a very traditional patriotic pose of a heroine about to strike her blow for freedom. This was not Etty's first concept. Such preliminary sketches as exist suggest that he had a change of mind when planning the composition of this panel. He had originally proposed having Judith hold her sword outstretched but changed it to a vertical position to increase the dramatic impact. Farr thinks[28] that Etty may have been influenced by Paolo Veronese's painting of the same subject which was probably in London up to 1816 but then disappeared from public sight until 1904. It is now in the Ashmolean Museum, Oxford, with two pendants. Others of this subject by Veronese are at Caen and Genoa. Etty decided upon his treatment of the subject in order to avoid "the offensive and revolting butchery some have delighted and even revelled in."[29] He was undoubtedly thinking of Artemisia Gentileschi's paintings. Etty had no need to make a "statement" on behalf of women's rights. Etty's intentions are quite clearly stated in

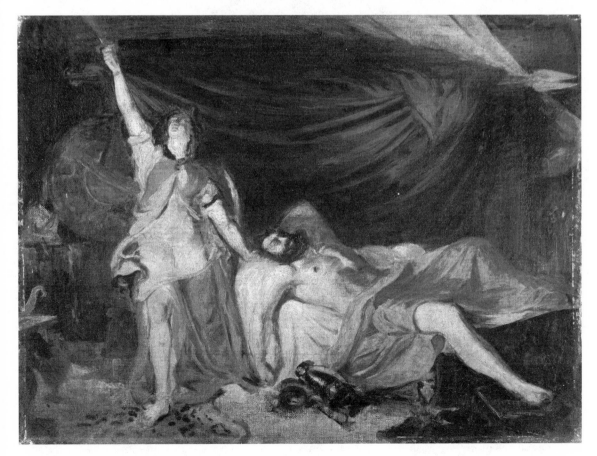

Study for "Judith" (12 × 16 ins) (c. 1827), York Museums Trust (York Art Gallery), YORAG72.

an inscription on the back of one of his sketches—"Honour and glory to the next Exhibition! We must keep the foreigners from fooling us!" and another—"AMBITION! GLORY! CONQUEST!"

The central canvas was painted first and exhibited at the Royal Academy in 1827 but remained unsold. First reviews by *The Times* highly praised the work, declaring that it should be placed in a church. However, there were no purchasers. Few English collectors wished to acquire religious works and certainly not of such a subject. It was loaned for exhibition in Birmingham. The Birmingham Society of Arts then wished to purchase it but had no funds. The Royal Scottish Academy applied to borrow it for exhibition but Etty feared damage would occur in transport and sent it to the British Institution instead. It still did not attract a purchaser. The Scottish Academy renewed their request to borrow, were again refused but, when they offered to purchase the painting themselves if another purchaser did not come forward, Etty agreed. There was then some haggling over the price. Etty wanted £500 but eventually agreed to 300 guineas without the frame. The painting was acquired by the Scottish Academy in January 1829. So pleased was the Academy with their acquisition that they commissioned the two wings which Etty painted in the following two years. Etty agreed to paint these pendants for 100 guineas each, thus obtaining the full original price while the Academy obtained a bargain. In return the Academy allowed him to take his time over these panels as he was eager to paint other works for London exhibitions. As the final series was not completed and exhibited until 1830, the three canvases should be considered herein in their proper place.

It is, however, appropriate to mention here that the subject of Judith had long interested writers and artists, who had presented her in various symbolic aspects, whether as a heroine rescuing her people from oppression or as one of the "monstrous Regiment of women"[30] who some still feared were threatening men and their self-approving dominant role in society. Some regarded her as essentially a virtuous woman who never sacrificed her honor before killing Holofernes and some saw her as no better than a whore, a self-seeking Jezebel. Each age treated her as it required. Today she is more often a heroine of the feminists. At the end of the eighteenth century Judith was adopted by the French revolutionaries as a symbol of liberation. Simon Pierre Mérard de Saint-Just made her the subject of a play (1789) and in French playing cards the figure of Judith replaced those of the queens. The symbol of Judith the liberator was adopted by all parties at the time and probably encouraged Charlotte Corday to assassinate Jean Paul Marat. Just as Holofernes was vulnerable in drunken sleep so Marat was vulnerable in his bath. Corday's act was seen in England as yet another consequence of revolution. Marat was admittedly evil but assassination was not the English method of unseating tyrants. Corday was represented either as heroine or villain according to political sympathies, but more usually the former and as such she was portrayed in pamphlets all over Europe. Alongside these images, that of Judith reappeared. Goya used her to symbolize the pent up anger of the Spanish peasantry against the aristocracy. Judith became a heroine of the Romantic Movement and, conversely, a criminal in the eyes of the authoritarians.

It is therefore of more than passing interest that Etty, ever the supporter of authority, should have chosen her as the subject of a triptych in the light of his own declaration that he intended her to epitomize the ideals of patriotism and devotion to one's country and to God. Certainly this was how most people regarded Judith and the Apocryphal story. We must assume that Etty regarded the whole episode as asserting the authority of a nation state against invading barbarism. Margarita Stocker suggests[31] that the Scottish academic establishment was engaging in the contemporary dispute regarding the retention of the Apocrypha in Bibles. They were already being omitted from English Bibles and were to be omitted from the Book of Common Prayer. In the 1820s the British and Foreign Bible Society had become engaged in controversy with Scottish Protestants because of the Society's custom of including the Apocrypha. The Scots regarded the Apocrypha as myth and were uncomfortably aware that Voltaire, among others, used the Apocrypha as evidence of the mythical nature of religion. The Scottish Protestants prevailed and the Apocrypha were henceforth excluded. Stocker also suggests that this did not please academic circles

Judith Coming Out of the Tent of Holofernes (118.5 × 108 ins) (1829), National Gallery of Scotland, Edinburgh, NG187.

in Scotland who were not supportive of the memory of John Knox and his tirades against the evil powers of women and his denunciations of Queen Mary. Perhaps therefore we may adduce that Etty, always a champion of women, was stating his case against Scottish Protestantism. It is unlikely that he approved Scottish antagonism towards England and the consequential reinstatement of Mary now seen as a patriotic martyr. There would be many reasons why the Royal Scottish Academy was eager to acquire the series.

Etty also exhibited in the 1827 Royal Academy exhibition *Hero, Having Thrown Herself from the Tower at the Sight of Leander Drowned, Dies on His Body,* a typically lengthy title of the times but now more usually referred to as *Hero and Leander.* This represented to some extent a departure in composition and style and handling from Etty's usual work. Although he occasionally attempted the

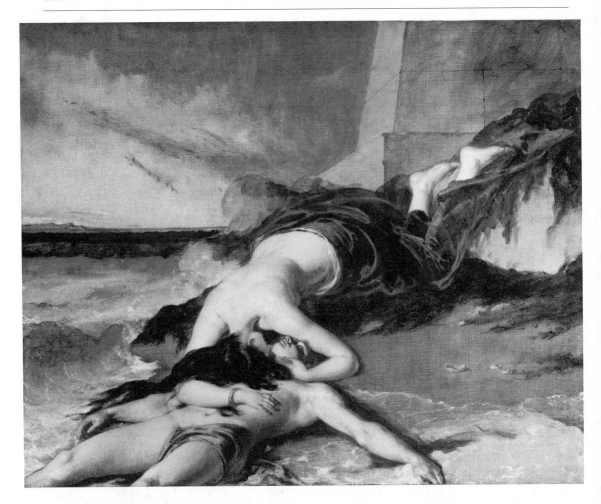

Hero and Leander (30.5 × 37.25 ins) (1827), Bridgeman Art Library, London; YAG-23524/f78.

foreshortened figure it was not usual for him to base an entire composition on diagonals. Of the two figures, that of Leander is the more successful; that of Hero is too long. This is only partly disguised by the drapery covering the lower half of her body. The wet sand is skillfully depicted and apart from the anatomical error this painting justifies Etty's claim that it was one of his best works. *Hero and Leander* is often referred to as a Romantic work and certainly it does express a mood of pathos and heartbreak, feelings which Etty had not before attempted. It is often suggested that its exhibition prompted Turner, never one to be outshone, to paint his own *Parting of Hero and Leander* in 1828. Etty's painting attracted little attention at the annual exhibition and was returned unsold to Etty's house where it was eventually bought by Thomas Thorpe, Senior, and passed to his son, and then to the Rev. Tudor Thorpe. Thomas Thorpe, who lived in Alnwick, Northumberland, was a regular patron and collector of Etty's work as was his son. Etty painted several versions of *Hero Awaiting Leander* and one of *Hero and Leander Parting*, all exhibited at various dates.

Etty also exhibited *Benaiah*, a subject taken from the Second Book of Samuel chapter 23 where Benaiah kills an Egyptian. Etty had a detailed knowledge of the Bible and would have known that Benaiah had joined with Zadok to proclaim Solomon as king and was an important figure in resolving the royal succession. For Etty, the historical Benaiah represented the moral

quality of "Valour" and this was his reason for choosing this subject. The composition of this painting is based on fighting figures on Greek and Roman friezes and is quite inferior among Etty's works. Gaunt and Roe[32] describe it as "somewhat grandiose and heavy, and it must be confessed that this amiable man did not excel in scenes of slaughter." *Benaiah* also did not attract any critical attention, all critics being more interested in *Judith,* which considerably enhanced Etty's reputation and standing among his fellows and without doubt determined their decision to confirm his place among them. *Benaiah* was re-exhibited in the British Institution in 1830 and was bought by the Royal Scottish Academy in December 1831 where it took its place alongside *The Combat* which they had bought from John Martin earlier that year. A second version (see color plate 5), painted at some later date, is now in York Art Gallery.

CHAPTER SEVEN

"I have triumphed!"

Etty did not have to wait long to be elected full Academician. On the 9th December 1826 the sculptor John Flaxman died and in accordance with the Academy rules the consequent vacancy had to be filled as soon as possible. It was too late to go through the necessary procedures for a successor to be found by the spring of 1827 so the election did not take place until 1828. Flaxman had been born on the 6th July 1755 in York where his parents were living at the time. His father had been a maker of plaster casts and moulds, usually working in Covent Garden, so he had had a more favorable upbringing than Etty. The Flaxman family moved back to London six months after John's birth and by the age of fourteen he was a student at the Royal Academy. In the next year he was already exhibiting in the Academy. Etty always felt a bond of sympathy with Flaxman, regarding him as a fellow citizen of York and forever reminding the City Fathers of the sculptor's origins—though to little avail. In his lifetime Flaxman had achieved fame but a fortune of only £4,000 at his death, large enough for the times but less than Etty was to accumulate. It was not difficult for the Academy Council to choose a successor. Etty's name had been submitted for election in 1826 but Henry Pickersgill and William Wilkins had then been preferred. Pickersgill was a successful portrait painter but Wilkins has disappeared into obscurity. What the Council needed was someone of equal stature also in the neo–Classical tradition. Flaxman had been renowned for his mild manners and sobriety of living and was well-liked by all who knew him. These qualities were also seen in Etty. Although the expulsion of James Barry for insulting his fellow members had occurred as long ago as 1799 the memory of that event still remained. Benjamin Haydon had also proved a troublesome colleague and Turner could often be rude and uncouth. Constable, an Associate since 1819, could express his disappointments with surprising tartness. What the Academy wanted was "a safe man" but also someone whom everybody esteemed.

Etty was proposed by the President, Sir Thomas Lawrence himself, which must have enhanced his chances. His principal rival was Constable. Elections were held on the 19th February 1828. In the first round Etty gained 16 votes and Constable 6 and, after the elimination of a third candidate, Etty received 18 and Constable 5. So in the second ballot poor Constable lost a supporter. It has always been the subject of surprised comment that Etty should have been preferred, but Constable was an unpopular man both for his general nature (some said he was "waspish" and "spiteful" and too ready to take offence though others thought quite otherwise) and his subjects—landscape—at that time were little regarded. In any case he had no interest in the current vogues for the Picturesque or the Sublime. His was a naturalistic view of the world based on an affinity with the seventeenth century Dutch painters. It afforded no opportunity for the *connoisseurs* to pontificate. Constable's use of the palette knife was also not approved. Etty was generally liked and his subjects, though often disliked by the public, were regarded as keeping alive the Academic traditions. Etty's pleasure at being elected was unbounded. As soon as he knew he wrote a humorously jubilant letter to his brother Walter and his partner William

Bodley who had continued to support him. To Messrs. Etty & Bodley, Merchants and Ship Owners, 31 Lombard Street, he wrote:

> Royal Academy Bay
> Saturday Night
> 19th Feb 1828
>
> To Messrs. Etty & Bodley,
> My Dear Owners,
> This is to inform you that your good Ship the "William Etty" arrived safe and came to anchor in bay to-night at ½ past ten after beating about so many years in the Attic (not Arctic) Ocean—after nearly being wrecked on the Coast of Italy, we put into Venice and were well caulked with Venice Turpentine—after combating many hard gales from Cape Difficulty and being nearly upset on Rejection Rock—and on nearing land a *Constable* got on board some of the Royal Ships and came out with 5 or 6 guns (swivels) but a broadside of 18 long forties sent him to the bottom and our Ship the Wm. Etty came in triumphantly in full sale and colours flying under a Royal Salute from forts Mulready, Chalon, Hilton and Collins—and the shouts of the spectators from the shore.
> This Despatch will be delivered to your Lordships by my faithful purser Franklin who has been with the ship most of her voyages and whose services strongly recommend him to the protection and promotion of the Lords of the Admiralty.
> I have the honor to be
> My Lords
> Your Lordships obedient Servant
> Pietro Pinelli
> which being translated means
> Peter Pencil R.A.
> P.S. It is with the most heartfelt concern that I inform my worthy owners that as soon as our Ship made harbour the R.As. came on board in such numbers as to devour several pieces of excellent cake which we had on board.

George Henry Franklin was Etty's assistant whose services he had acquired about 1816. He is first referred to in an undated letter which Etty sent to his brother Walter and which Walter endorsed "Wm. Etty 24 July 1816" although the paper is watermarked "1817." In this letter Etty says

> As they [i.e., the Hardcastle family with whom Etty was friendly] are very fond of prints I have sent Franklin to beg you will send by him *your large Folio—with the 8 Poussins* and the other selected Prints from my collection, and you shall have them all carefully returned.

Later in this letter he asks Walter to "send me by Franklin a bottle of your *Port* and one of *Madeira*—as I should wish to shew some return to the many civilities I have received from that worthy family." Etty was still dependent on Walter for support but this letter reveals that he was able to ask Walter to make gifts on his behalf. It also indicates that somehow Etty was able to pay an assistant, probably through Walter's help. Of Franklin himself little is now known. He clearly acted as Etty's studio assistant and general factotum. It was still necessary at that time for artists to grind their own colors and to prepare canvases, which Franklin did for Etty. He also packed Etty's bags when he traveled and ran errands for him. Etty's letters to Franklin, which are now in the York Art Gallery, indicate a close friendship but one founded on service. Etty frequently summoned Franklin to take breakfast with him as a preliminary to the day's work. Etty would require Franklin to buy his coach and railway tickets for him and to meet him off coaches and trains to assist him with luggage, though his niece Betsy increasingly undertook the responsibility of insuring his paintings. Occasionally in later years Etty addressed letters "Dear Franky" indicating their close friendship. Franklin attempted to become an artist in his own right, in 1828 exhibiting at the Academy a painting, *The Bather*, when he was described by a critic as an "imitator of Etty." At the sale of Etty's possessions in May 1850 Franklin bought several of Etty's studies and also his copy of Titian's *Venus of the Tribune* for seventy guineas. After Etty's death Franklin apparently ran a lodging house in London. A letter from Thomas Etty to

Franklin dated 14th May 1851 enquired whether he could accommodate Thomas and his daughter for seven or eight days so that they could visit the Great Exhibition. Franklin replied that he and all other lodging houses known to him were fully booked. He died in January 1860 in poverty, which Farr attributes to Etty's neglect, Franklin having been omitted from Etty's final Will. Farr suggests an estrangement but nothing is known of this. The *Literary Gazette* of 28th January 1860, in an obituary notice, said that Franklin possessed a number of Etty's studies and may even have painted some of them himself. The quality of studies attributed to Etty after his death is so varied that it is wise to be doubtful of many of them.

The very next day after writing to his "Dear Owners" Etty wrote equally jubilantly to Thomas Bodley (his cousin and life-long friend) and his wife Martha who were then living in Brighton.

> 14 Buckingham St. Strand
> Sunday Feb 20 1828
>
> My Dear Thomas and Martha
> I have triumphed!
> I am a Royal Academician of England! Last night the deed was done that's made me happy. Walter and me have been breakfasting with the *President* and did not get away until past 12. 18 to 5—I beat them! So unanimous a thing I am told has not for some time been know [sic] in the Academy.
> I am overwhelmed with joy. Oh that my poor Mother was here. I have just written she was as anxious about the event as myself. The kind of feeling evinced towards me by my brother artists in and out of the Academy on the event is most grateful to me. I have not now time to say more than that I desire to thank the Giver of all good that he has given me strength to attain this eminence in my country and to bless those friends whose support has strengthened me in the battles I have fought against the difficulties of Art.
> Yrs ever
> William

There is regrettably very little known about Etty's parents so it is not clear why he wrote "Oh that my poor Mother was here." Very probably she was ill at home and he would certainly have wished her to be present in London to join in his celebrations but whether nor not she was ill at the time, February would not have been a suitable time of the year for an old lady to make a coach journey from York to London. Like Constable, Etty always regretted that his father had not lived to witness his success. That his success was made known to his mother is clear from the terms of a letter he wrote to her.

> I am going to scold thee for not writing to thy son. You, that I expected to be the first, are now one of the last. What are you doing? That you do not write a single line to say "how glad I am!" Really you do not deserve any pancakes. *You* whom I most wish to hear from, say nothing.

Etty's curious reference to "pancakes" can be explained by the fact that this letter was dated "Pancake Tuesday." As disappointed as he was that his mother had not been the first to congratulate him, this did not stifle his natural humor. He wrote to various former patrons and old friends, so pleased was he with his success. To Sir Francis Freeling he wrote: "My feelings on this most wished-for event, you may imagine. It was perhaps of all things, nearest my 'heart of hearts.'"

To Mr. Bulmer:

> I have reached one of the highest pinnacles of my ambition, and now am waving my cap (with an eagle's feather in it), on that pinnacle; am too overjoyed to talk "common sense." I rejoice on my own,—a joy doubled on my Mother's account. My best regards to Mrs. Bulmer. I hope she will go and see my Mother [*that she*] may have some one to whom she can speak of her joy.

He wrote to brother Thomas and to Mr. North whom he always described as "my first patron."

> The little boy you used to give a halfpenny to, to draw a horse, has risen to one of the highest honours of his profession; was elected an Academician on Saturday night, almost unanimously. I was only an Associate before. I have sent you a *Morning Post*, in which this announced.

Who can blame him for wishing everyone to know of his success and to congratulate him? The small town provincial boy had made good. Obviously he wrote in similar joyous terms to other members of his family, most especially we must think to brother John, but the letters have not survived.

In May the British Institution decided to pay Etty the compliment of voting him £100 in recognition of his contributions to British art. This body had frequently rewarded history painters and it was a serious mark of its approval that Etty should have been rewarded in this manner. The sum must not be measured against today's values. In 1828 it was a considerable sum of money. The Royal Academy had often considered following a similar course but Sir Thomas Lawrence had not favored it, being of the opinion that no Academician would wish to suffer the ignominy of being passed over. He was wise to avoid dissensions.

Among the paintings which Etty exhibited at the Royal Academy in 1828 was *The World before the Flood* (see page 208). This was sold "off the wall" to the Marquis of Stafford for five hundred guineas. Etty was so pleased with this sale that he wrote ecstatically to Thomas Bodley:

> I know you will rejoice with us all, when I tell you that the principal part of the cargo of the ship "William Etty" (of whose arrival you had been advised), now landed at the Royal Academy Wharf, has been consigned to the Right Honourable the Marquis of Stafford, for five hundred guineas: the rest of the cargo being already owned by Lord Normanton and Digby Murray, Esq. ... After clearing out, we shall again put to sea; and hope for equally favouring gales next voyage.

Etty was now being regarded as "a rising young artist."[1] At 41 years of age he was hardly "young" and, with such recognition, surely his star had already risen. Gilchrist, who usually almost ran out of words of sufficient praise as he eulogized his hero, felt it necessary to add some words of warning. "The soiled Chaplet, which in its time has encircled so many noteless brows, was, moreover, of worldly moment. Etty valued it for its own sake,—being of the Faithful,—and also, for its incidents; the worldly status, and the vantage in the Market it entails."[2] It must be admitted, as one looks down the list of Academy members through the years, that the honor has in the past been too frequently bestowed on nonentities, men who achieved little and whose names are now deservedly forgotten. Gilchrist was only too aware that membership of the Academy would almost automatically enhance prices. As he says in the following sentences, that a picture sells for a thousand pounds "will convince a man, who cannot, unassisted, distinguish a Turner from a Tompkins, say." (Gilchrist presumably means William Tomkins, c. 1732–1792, described by Ellis Waterhouse[3] as "landscape painter and copyist" and "one of the most favoured painters of views of gentlemen's seats and picturesque views in their parks." He was elected Associate of the Academy in 1771, almost a founding member.) For Etty, membership of the Academy meant recognition that he was a painter of worth. There was no higher honor in England that could be conferred on him, except a knighthood, but this was, for artists, still reserved to presidents.

A familiar allegory reworked

It was now necessary, as one of the Laws of the Royal Academy, for Etty to paint and present the Academy with his Diploma picture. Gilchrist believed[4] that many Academicians found this an unwelcome task since they received no payment, as though election to membership was not reward enough. He considered that Etty's painting was a worthier sample of his work than most Academicians-elect often cared to send. He gave no details of the painting, probably because he did not know it firsthand though this did not prevent him from praising it. Etty selected as his subject one which had enjoyed considerable popularity in earlier times but which was quite unusual in the early nineteenth century. It was a sleeping nude nymph with two satyrs entranced by her beauty (see color plate 6). It was a subject that had frequently attracted artists and patrons from

the Renaissance onwards and which frequently aroused discussion regarding its propriety. Its origin went back to ancient Greece and Ovid where nymphs were frequently ravished by gods, shepherds and satyrs and gave birth to heroes or monsters according to the identity of their ravishers. For the gods it was opportunity to enhance the nature of mankind through the fathering of children by mortals. Shepherds and satyrs on the other hand represented the primitive desires in nature and the consequences of uncontrolled passion. Satyrs were a warning against the absence of moral law in nature. Moral law was the set of standards of Goodness, Truth and Justice known only by men and women, though in practice few women were credited with understanding. Later, many philosophers added Beauty but, in order to preserve the triadic mode, dispensed with Justice. (The problem of whether Beauty can be a *moral* truth is another subject and cannot be considered here.)

The Renaissance philosophers resumed the classical enquiries and often explored the subject through the arts. How far the moral truths intended to be conveyed were actually recognized by patrons of the arts depended on their learning and their own moral natures. Too frequently the subject was an opportunity for male *voyeurism* and such paintings often joined private collections of erotica. European monarchs and aristocrats usually had some examples in their palaces and houses and for connoisseurs the subject had a well-established history but in the early nineteenth century it was one which the English middle classes found difficult to accept. The use of mythology and allegory to present moral truths was by then an outmoded aristocratic convention. The choice of this subject confirms Etty's naivety. He frequently did not recognize that his subjects might cause offence. Etty was embedded in the ancient world and in the Italian Renaissance with an over-spill into the Baroque.

Male curiosity is difficult for many women to accept. The biological functions of the sexes are different but civilized society requires that each must be accommodated to the needs of the other. In ancient Greece the attractions of both male and female and the interest of each in the other were recognized. From the Renaissance onwards it became the accepted opinion that in pre-classical times men and women had often worn no clothing and that this had persisted into the classical period. The profusion of Greek statuary appeared to confirm this opinion. It was not recognized that most statuary was of male figures and that that they were often celebrating famous athletes. While gods were frequently depicted totally nude, early statues of goddesses are invariably depicted fully robed. Nude female statuary was exceptional and was, and only later, mainly confined to images of goddesses which were probably adorned with actual robes which were regularly replaced often with appropriate rituals. There are occasional records of statues of nude Aphrodites in shrines and it seems that often these attracted male *voyeurs*. The Church had an ambivalent view of the ancient world. St. Paul had condemned the Athenian philosophers but Gregory of Nazianzus had praised them, and he was not alone. St. Augustine of Hippo had been educated by philosophers before his conversion and was largely responsible for the adoption of Platonism by the Church to provide its intellectual basis. The Italian Renaissance, with its blending of humanism with a revived Platonism and a more liberal Christianity, reintroduced interest in the full nature of man, body, mind and soul. Renaissance popes were notoriously worldly. Art moved from the church to the palace and, being now the special interest of the wealthy, it was used to present whatever appealed to them in the wider world of common experience. The new willingness to accept the human figure as a legitimate subject—even popes and cardinals commissioned such paintings—permitted the depiction of the naked body and especially the female body. The female nude was presented as goddess or nymph, the ideal, the perfect, to be venerated, and as the patron gazed upon the vulnerable image he was expected to be filled with love and compassion and even adoration. As Botticelli had shown it was possible to conflate Venus with the Virgin Mary. The sleeping girl in the forest was at risk from the evils of the natural world. The patron was expected to adopt the principles of chivalrous knighthood. (This was the theme of John Everett Millais' *Knight Errant*, exhibited 1870.)

There was also a moral to be learned from the Biblical stories of Susannah and the Elders and of David and Bathsheba. Strangely, whereas David's desire for Bathsheba and his virtual murder of her husband could be excused, there was no such sympathy for the curiosity of the old men who spied on Susannah. The English middle-classes could just about accept the Biblical stories; Geeks nymphs and satyrs were too obviously lacking any religious message.

There is a wide range of meanings attaching to the mythology of the vulnerable female. Civilized values cannot countenance seduction of the unwilling and the definition of rape has been widened to include every act that is non-consensual. In primitive times it was believed that the seduction of women by gods was an essential process for constant renewal of the divine spark in man and the sons of gods had a special function in promoting virtues among humans. Castor and Pollux are the most renowned examples in classical mythology. On the other hand daughters of gods could be dangerous to human society since they introduced jealousy and strife, as we see in the case of Leda's other divinely fathered children, Helen and Clytemnestra. Satyrs were semi-animals, usually half-goats (renowned for their sexual appetites), and their offspring by women were invariably harmful. In the hierarchy of the primitive world they provided the link between man and nature, a link which held no benefits for man since nature was without moral law. It is probable that girls who had succumbed to seduction and became pregnant would sometimes claim that their seducer had been a god or satyr. By the Renaissance, satyrs were included among shepherds as subjects of Pan living an idyllic life of innocence and simplicity. Their seductions of nymphs were regarded as natural expressions of Arcadian love. It was, however, never acceptable for noble humans to seduce nymphs or to infringe the secrecy of goddesses. Sometimes nymphs formed the retinues of superior goddesses such as Diana and between them controlled whole aspects of the natural world. It was usually disastrous to encounter them if they were accompanied by their protective goddess and even inadvertent discovery of a naked goddess could be disastrous, as Actaeon found to his cost. The whole subject was linked with the female fear of being raped by animals or some subhuman or monstrous creature. In modern times this fear is exploited in science fiction magazines where aliens abduct human females. It is not only the fear of actual rape but also of the consequences of giving birth to a monster. The legend of Beauty and the Beast in all its forms is the story of love awakening in the subhuman and the impossibility of fulfillment.

The classical view of the natural world was entirely hierarchical. As well as a natural progression from the lowest level of natural forms, plants and animals, there were also ascending states of man from peasants to nobles and ultimately to kings and queens. The social system mirrored that of the unseen world, from satyrs through nymphs, minor gods and goddesses to the supreme god and goddess. Everyone was supposed to stay within his or her natural class. Nonetheless, ravishing a social inferior was not necessarily a crime or sin. Henry Fielding's *Tom Jones* refers to this viewpoint. The male desire for union with a young virgin appears to be a natural human characteristic and from the earliest times it was held that the most effective way of appeasing a god was to present him with a young virgin which, of course, meant sacrifice. Frequently the priest claimed to be taken over by the god and to have been granted the power to guarantee the continuing fertility of the land and the tribe. Of course, none of this was known before modern times.[5] Paintings of shepherds and satyrs gazing longingly on sleeping nymphs were for most people depictions of animal lust to be deplored. When depicted in contemporary scenes the subject became the mainstay of eroticism and pornography. Clearly Etty knew nothing of any of this but the subject was popular and still acceptable, at least among classicists, connoisseurs and many patrons. His method was to turn to the Old Masters for his subjects, believing that true Art was to be found with them.

It is generally held that Etty's diploma painting was derived from a similar subject by Poussin. Roger Fry writing in 1934[6] described it as "a *pastiche* of Poussinesque design" fitted together "with a careful and brilliant study of a nude model," though he proceeded to say that "the two

elements do not fuse. ... His nude refuses to become a nymph, and his satyrs remain mytholog-ical and are left in a different world." As Farr comments,[7] this begs the question. All figures are clearly mythological and there can be little doubt that they do combine to form a logical imagery. Fry, a self-acclaimed modernist, had difficulty in accepting such subjects as relevant to the art of any age. Farr refers to Poussin's painting *Sleeping Nymph Surprised by Satyrs* which is now in the London National Gallery and dated as 1626–1627. Another version appears in the attrib-uted paintings in Christopher Wright's *Catalogue Raisonné*, as *Venus Surprised by the Satyrs* in the Kunsthaus, Zurich.[8] Etty's composition is reversed and, although there are marked differences in detail, the similarities are too obvious to escape suspicion that Poussin provided Etty with his theme. There is also a resemblance in the pose of Etty's *Sleeping Nymph* with that of the Venus in a drawing by Van Dyck (now in the British Museum) taken from Titian's *Venus and the Andri-ans*. Similarly the sleeping nymph on the lower righthand side of Rubens' *Bacchanal*, now in the National Museum, Stockholm, offers a possible origin for Etty's sleeping figure. Jacob Jor-daens, whose work was well known to Etty, painted the story of Antiope in which the Theban princess was ravished by Jupiter who had assumed the form of a satyr. In Jordaens' painting, now in the Musée de Grenoble, Antiope lies asleep while Jupiter in satyr form gazes down at her. There are similarities between Etty's nymph and Jordaens' Antiope. Van Dyck also painted a version of the Antiope story, now in the Museum voon Schone Kunsten at Ghent, in which there is a similar disposition of the sleeping figure. There is also similarity in *Nymph, Satyrs and Cupids* by Carel Philips Spierinck, now at Hampton Court. Spierinck was Flemish; he trained in Brussels and died in Rome in 1639 when he was said to be only 30 years of age. His subjects are so similar to those of Poussin as to suggest a close association between the two artists. In 1660 the Hampton Court painting was listed as by Carlo Fellippo, probably a misreading of Spier-inck's name, but in 1960 was identified by Anthony Blunt as being by Spierinck. In 1828 this painting was in Kensington Palace before being moved to Hampton Court by William IV after his accession in 1830. George IV allowed artists access to the Royal Collection to copy paint-ings. They usually copied portraits by Reynolds, and Lawrence had required Etty to make such copies when he was a pupil and it is possible that Etty saw the Spierinck painting on one of those occasions.

One version of the Nymph and Satyr subject that Etty probably did not see is the painting by Abraham Govaerts (1589–1626) in Belton House, Lincolnshire, though Wyatt and Smirke were employed in the mid–1820s to "improve" Belton and both were known to Etty, though not affectionately. It is not recorded that Etty visited Belton House. This painting originally formed part of the collection of Sir Henry Bankes, who lived in Wimbledon and who purchased the painting for only sixteen guineas in 1754. After his death in 1774 his collection was acquired by the Brownlow family who then lived at Belton House. The house and grounds are now owned by the National Trust. Govaerts' painting is an idealized landscape with a sleeping nymph in the lower left corner with a satyr pulling off her concealing drapery. This is the more usual version of this subject.

There is a further unexpected version of a satyr spying on a sleeping woman in an etching and engraving by Annibale Carracci dated 1592 which must be considered. This is reproduced as plate 66 (Volume II) by Donald Posner and described by him in Volume I[9] as *Venus and Satyr* probably engraved from a painting by Titian, though an original has not been identified. This engraving is unusual in its explicit subject matter. Venus lies asleep on a bed and a satyr leans over her holding the sheet he has removed while he peers intently into her crotch. Behind Venus a Cupid hovers with threatening disapproval. Venus' general deportment is similar to that of Etty's nymph except for the disposition of her arms. Whether Etty had seen the original Titian or a copy of the Carracci engraving cannot be known. He had been in Italy in 1816 and in 1822 and had visited Bologna and Rome, both cities where Carracci had worked and in the latter visit he had made a point of seeing Carracci's paintings in the Bologna museum. Carracci's

"conversion" to the Venetian style after his stay in Venice in 1582 may well have endeared him to Etty who singled him out in a letter to Sir Thomas Lawrence from Rome (12th October 1822). That Etty knew Annibale Carracci's work is unquestioned. The salacious interest of the satyr in Carracci's painting was not an uncommon subject in Venetian art. In Titian's *Venus and Cupid with an Organist* of c. 1550 (Museo del Prado) and in his *Venus and Cupid with a Lutenist* of c. 1560–1565 (Fitzwilliam Museum, Cambridge) the instrumentalists display a similar interest which has led some critics to doubt Titian's authorship. Charles Hope commented that in these paintings the musician

> is supposedly revealing that he values visual beauty above the beauty of music. But considering that the prototype for all these works, the *Venus* painted for Charles V, was apparently a straightforward erotic subject, it seems unlikely that the derivatives, painted on what amounted to a production-line basis and evidently intended for less important clients, would have been significantly more complex in their iconography.[10]

Hope maintained that they were deliberately sexual and that Cupid is encouraging Venus to accept the musician's amorous interest. It is likely that Titian was indicating that, for all the high-minded claims of artists, musicians, poets and philosophers, the true appeal of feminine beauty was sexual, just as William Hogarth and Edmund Burke maintained much later, and that there was nothing reprehensible in this. In the background of Titian's painting a pair of lovers and a stag and a doe act out the eternal attraction of the sexes with a statue of a satyr and a peacock at a fountain—the fountain of life perhaps?

Another version of a sleeping woman being spied upon is found in Rembrandt's etching *Jupiter and Antiope* of 1659. The composition is similar to that of the Carracci etching but while Jupiter stares intently into Antiope's crotch this area is cast in heavy shadow to deny the viewer knowledge of her nature. This etching, like most dealing with this subject, depicts male *voyeurism* or curiosity and suggests the essential mystery of the feminine. These subjects did not escape the attention of the moralists who saw them as opportunities for male lasciviousness to assert itself. As early as 1700, John Oliver (1616–1701), a glass painter and master-mason who was also an engraver, produced an engraving depicting a man stealing up behind the Venus of Urbino as she lies asleep. The man was Colonel Francis Charteris (1675–1732) who had been dismissed from the army for cheating, dismissed from the Dutch service for theft, censured for fraud after rejoining the army as a captain, and eventually convicted for rape but pardoned in 1730. He was regarded as a typical profligate of the age and his image was included by Hogarth in one of the illustrations for *The Harlot's Progress*.[11] Oliver's engraving was intended as illustrating how *not* to view paintings of the human nude but, also, how inevitably they were viewed.

It is possible to cite many other examples of the subject but one that comes convincingly to mind, perhaps taking precedence over all others, is Palma Giovane's painting now titled *Jupiter and Antiope*. This was a favorite subject among Italian artists, including Titian and Correggio. According to the myth, Jupiter assumed the guise of a satyr in order to ravish the Theban princess Antiope and this is how Giovane depicts the god. Giovane lived and worked in Venice, from 1544 to 1628, and is regarded as having continued Tintoretto's style. Though he mainly concentrated on religious subjects he did occasionally paint myths and allegories. When *Jupiter and Antiope* was painted and for whom is unknown and indeed very little is known about it except that it was at some point in Sir William Hamilton's collection. Etty would not have seen it there but we can be reasonably confident that he did see it at Christie's in 1824 when it was sold for £4.4.0, a trivial sum even for those days. Hamilton died in 1803 and the painting must have passed to someone else by the time of the sale. Christie's records state that the vendor was "Sir A. C." and the Giovane painting was one of fifteen items, including some sculpture, purchased by someone identified only as "Taylor." Who "Sir A. C." was we do not know but G. Watson Taylor, M.P., was a very active collector, buying and selling, around 1824 and may well have been

Jupitter et Antiopa (10 × 8 cms), by Joseph Perini after Palma (1770) ©The Trustees of the British Museum, 1856-5-10-229.

the "Taylor" referred to since it is known he was sometimes mentioned in catalogues only by his surname. Whatever the truth, it is very likely that Etty had opportunity to see the Giovane painting. Attending sales merely to see worthwhile paintings and sculptures was a commonplace custom at a time when public exhibitions were rare.

The painting's present whereabouts is unknown but its appearance can be judged from an engraving by Joseph Perini. Perini's engraving depicts Jupiter in the guise of a satyr apparently removing the robes from a sleeping Antiope lying amid rocks with Cupid, also asleep, by her

side. Although the composition bears only a superficial likeness to Etty's diploma painting there is an important similarity which must be considered. Giovane's satyr is clearly not about to ravish Antiope but is replacing the robe over her naked body. So, it strongly appears, is the satyr in Etty's painting. Whereas in other versions the satyr is removing the only piece of material covering the nymph's nakedness, sometimes with a companion encouraging the violation, Etty has assured the nymph's modesty with extra concealing drapery. The satyr is not attempting to remove this. The satyr appears so impressed by the nymph's beauty and vulnerability that he pauses in admiration. His companion tries to prevent him covering her and it may well be that Etty intended to depict two aspects of the natural mind. It is an idea which reaches back to the Italian Renaissance.

One of the earliest of this theme is *The Death of Procris* by Piero di Cosimo (c. 1462–1515) in which the satyr looks tenderly upon the dead girl with the first stirrings of superior feelings that suggest that even base creatures possess some nobility. Cosimo, in common with many of his contemporaries, had probably been instructed by philosophers in the Medici court and was questioning the moral indifference of the natural world. It is likely, having regard to Etty's sympathy for women, his satyr respects the nymph's modesty and is anxious to protect her. It is proposed that we have here a reworking of the legend of Beauty and the Beast, the Platonic theme that beauty arouses noble feelings, a theme that remained central to all of Etty's art.

Many artists had painted versions of goddesses seducing gods and desirable mortals, such as Venus and Adonis and Cupid and Psyche in which the female flaunts her physical charms. Many wealthy patrons had their private collections of paintings and drawings just as some nineteenth century fathers had their private collections of photographs. Northern artists, needing to satisfy patrons who lacked knowledge of the Greek and Roman mythologies, presented them with versions of *Susannah and the Elders*, *David and Bathsheba* and *Joseph and Potiphar's Wife*. These subjects were also occasionally presented by Italian artists and Annibale Carracci also painted a *Susannah* subject. The Elders were regarded with disapproval but David, because of his position in the divine genealogy, was more difficult to deal with. Both subjects were convenient for those who wished to indulge their interests under the guise of religion. The favorite hero in these stories was Joseph, who not only resisted the temptations of Potiphar's wife but turned every situation to his advantage. Although one need not be minutely concerned with the source of Etty's inspiration it is necessary to bear in mind that the subject had been, and still was, very popular, almost at times quite commonplace. It was quite usual for an artist to refer to the works of others and so long as sufficient variations were made in the final work he would escape accusations of copying. References to the Old Masters had always guaranteed an artist's integrity but now the new middle classes had their own standards founded on English Puritanism. Etty's diploma painting deliberately expressed the high aims of his art and was not the naïve piece of work usually suggested, but his critics had their own public to please.

Etty began work on his picture as soon as the summer exhibition closed and he delayed going to York that year until he had finished the figures since he needed models. He took the unfinished painting with him and completed the background details in York. On his return to London in October he presented the painting to the Academy where, he told Mr. and Mrs. Bulmer in a letter of 13th December, "The Picture finished under your hospitable roof has been much admired; and has completed the business for which it was painted."

As a Diploma work it was not publicly exhibited but we may judge how it would have been received from the reception given to another work, *Wood Nymphs Sleeping; Satyr Bringing Flowers*, exhibited in 1835. The critic of the *Literary Gazette* (1835) denounced it as quite unfit for public exhibition. Whoever he was, this critic clearly did not recognize that the Satyr was not intent on violating the sleeping nymphs but was paying tribute to their beauty and presumably their innocence by offering them flowers. The critic seems to have been ignorant of the widespread use of the subject among accepted Masters whom presumably he would not have criticized, but

like most critics of his time he was more concerned to ingratiate himself with a puritan public than to further their knowledge and understanding.

On the 14th December Etty wrote to Thomas and Martha giving them final details of his election.

> My Dear Thomas and Martha
> The kind interest you take in everything connected with the good fortunes and success of "The Painter" makes me, I fear, in writing or talking to you a downright Egotist but I now [have] so few opportunities of either with you that when I do I have often a good deal to say and little time to say it—but one of the very pleasantest parts and consequences of success to me is the reflection of its pleasure from the hearts and faces and feelings of those I love and esteem and Fame herself to me would lose half the charms were she stripped of those fascinating ornaments.
> You know already of the preliminary articles of my Academic Election being prepared. I have now to announce to you the signing of the Definitive Treaty. His Majesty yesterday week did me that honor. Sir Thomas left town for Windsor at half past seven in the morning. When he was arrived, and in the presence of the King, someone came in and said Sir Thomas's servant was below with a port-folio. His Majesty then enquired what it was and was told—but Sir T. L. said it was not his intention to trouble his M. with it at that moment but would wait till he was more disengaged, as he was transacting business, but the King said; Oh, I will do it now, let it be brought up. It was brought and after making some enquiries he gave it a very flourishing and firm George R. As the President said it would be enough to falsify the reports in the papers of his ill health, for it was firmer than he could write it, and said his Majesty was walking and talking in a sort of Corridor or Gallery which he is fitting up in the richest manner and I understood was giving directions about it himself at the time, which I was very glad to hear as so many contrary have been circulated. On Sunday morning I breakfasted in Russell Square and he showed it me most unexpectedly and on Wednesday night last in the General Assembly I had the honor of being presented with it and after a few words of elegant compliment from the President he and the rest of the Members present shook hands with their new Brother and I took my place in due form— and as you will see by the Morning Chronicle I have sent you by this post I am to do duty in three offices next year!

(The letter continues with more personal news).

George IV was engaged in his continuing alterations to Windsor Castle which had taken up much of his time during his reign and which cost the country a considerable sum of money. Between 1824 and 1828 his architect, Sir Jeffry Wyatville, had completely altered the appearance of the castle. The reference to the king's health reminds us that George IV was approaching the end of his reign. A lifetime of dissipation and gluttony was catching up on him. He died eighteen months later on 26th June 1830, 68 years of age, which was remarkable for one who had so abused his body. This is one of the very few references to royalty made by Etty in his letters. He seems to have been unable to praise his monarchs, certainly not George IV, but was unwilling to criticize those who had been placed in authority over him, no doubt in his view with divine approval. As always, when he could not praise he chose silence. Etty would certainly have been faced with a dilemma had he paused to assess George IV. Nobody outside the Prince's circle of debauched cronies had a favorable word to say for him. From his adolescence he had been the subject of concern to his parents and ministers. He was one of Victoria's "wicked uncles" whose influence on the moral life of the country she was to give herself the task of obliterating. However, the Puritans, Dissenters and Evangelicals had already begun to do so. In the 1740s John Wesley had begun his mission to reform the Church of England to reclaim the poor for Christ and in the 1790s the Clapham Sect had begun their Evangelical Movement. Both were to be major forces in reshaping Victorian England.

Etty had good reason to be pleased with himself. Although Turner had been elected Associate in 1799 (aged 24 years) and a full Academician in 1802 (aged 27 years), Constable did not become an Associate until he was aged 43 and a full Academician until 1829 (the year after Etty). Constable was then aged 53 whereas at the time of his election to full membership Etty was 42. Constable always had a hard time with the Academy. When he paid the obligatory visit to the

President after his final election he was told by Sir Thomas Lawrence that "he considered him peculiarly fortunate in being chosen an Academician at a time when there were historical painters of great merit on the list of candidates."[12] Constable told his friend Leslie of this remark and it appears that he construed it as an indication that Lawrence considered he had not deserved election. Leslie went on to say

> So kind-hearted a man as Lawrence could have no intention of giving pain; but their tastes ran in directions so widely different, and the president ... had never been led to pay sufficient attention to Constable's pictures to become impressed by their real merit.

Whatever Lawrence's intention, Constable "felt the pain thus unconsciously inflicted." It would be typical of Constable to do so. It is more than likely that Lawrence was actually congratulating Constable for having succeeded over the history painters since their subject matter was usually the Academy's preference. While Lawrence himself would also have preferred a history painter to be have been elected, although, like Reynolds before him, he was a successful portrait painter, he must have realized that Constable's election had been no mean feat. In any case, Constable's work and he himself continued to be less than popular among his fellow Academicians, a fact which he never failed to notice. Etty was now among the great and the good and the famous. Whatever Constable may have felt about being first passed over in favor of Etty and then receiving only mild congratulations, he and Etty always remained friends. It was not like Etty to cause rifts with anyone. Constable, somewhat prudish by nature, did not like Etty's subjects but when, in January 1831, Constable posed a female model for the Academy Life School, he wrote to Leslie—"I set my first figure yesterday, and it is much liked; Etty congratulates me on it; do, dear Leslie, come and see it. ... My garden of Eden cost me ten shillings...."

Then on January 27th he wrote again to Leslie:

> I hope you will find an evening to come down to the Academy and see my Amazon. My labours finish there on Saturday. This figure is liked best of all. Etty is so delighted that he has asked me to breakfast to meet some friends, among them Mr. Stothard [*Memoirs of the Life of John Constable*, Leslie, page 188].[13]

By this time Stothard was 76 years old and only three years away from his tragic death, being struck down by a cab in 1833 and dying on 27th April 1834. Like Flaxman, Stothard was one of Etty's heroes. He frequently reminded the citizens of York that both men had links, although only tenuously, with that city in an effort to stir their interest in the arts. Gilchrist records (I, page 242) that Etty owned a small wooden cabinet specially devoted to works by Flaxman and Stothard.[14] Whether Etty knew anything of Stothard's strong radical opinions is doubtful, for he would never have approved of them. The fact is, and cannot be too strongly emphasized, that Etty possessed a naturally amiable nature and never had cross words with anyone. Consequently he attracted affection and no one could ever pick a quarrel with him. Constable, for all his personal disappointment for having his recognition so long delayed, could not lay any blame on Etty.

A fair exchange?

It was not the thought of making some money or suddenly having notions about his new status as an Academician that persuaded Etty to take a pupil, but the opportunity to secure a painting that he had long wanted. Samuel Leigh, a well-known publisher and bookseller in the Strand, London, wanted to place his son under Etty for instruction. Whether or not he could afford the fee for a year's pupilage we do not know but somehow the bargain was struck that Etty would take in lieu of money the painting *Bacchanalian Revel* by Jacob Jordaens that Leigh owned. This has been identified by Dennis Farr as *Bacchus and the Sileni*. In return Etty undertook, by written contract, to impart the knowledge which he had gained "after twenty two years'

study." Etty admitted that in securing the Jordaens painting he had "broken the Tenth Commandment" but so over-joyed was he that he wrote to his friend George Bulmer in York:

> I have got into my possession a very glorious picture by Jordaens, an old Flemish painter; a picture I
> have long cast a covetous eye on, but had almost given up hope of possessing. I would not take five hundred guineas for it. At least, it is fully worth that; and I would sooner have it.[15]

James Mathews Leigh, then aged twenty, entered Etty's establishment where he received precisely the kind of tuition that Etty had received from Sir Thomas Lawrence, which is to say, scarcely any. Leigh was not allowed to enter Etty's painting room except on invitation when he was allowed merely to watch his master at work. Etty did not like being watched so these occasions were limited. Leigh's main instuction came from copying. Other artists who had taken pupils had often used these methods and Etty believed this to be the normal system of pupilage. It had worked for him, so it could work for others. Leigh seems to have been well satisfied. He and Etty remained friends for years and in 1830 the two visited Paris together. It does not appear that Leigh had a great deal of aptitude for producing original works of art. He had begun exhibiting in 1825, before coming under Etty, and from 1828 until 1849 he was an infrequent exhibitor at the Royal Academy, the British Institution and the Society of British Artists. His subjects were mainly Biblical and historical. Later he published a play, *Cromwell*, but his real contribution to the world of art was through his abilities as a teacher in the very popular school he founded. He seems to have realized his greater interest in teaching quite early. In 1830 he wrote to Etty asking his opinion of a scheme he had for establishing an *atelier* in Paris. This came to nothing. In 1841 he set up his school in London after the death of Henry Sass, who had run one of the most successful private schools in the country. Leigh's art school was progressive, no doubt a result of his time with Etty. He admitted both men and women students, fuelling the debate regarding women students and life models. Among his students was Rossetti, whom he admitted without fee as he was too poor to pay anything. Leigh died in 1860, when Thomas Heatherly became Principal and eventually this became the famous Heatherly School of Art.

His mother's death

We have no early letters from Etty to his parents. Probably they were not kept as they were not themselves letter writers and they had no reason to believe that future generations would wish to have had their son's letters saved. A few sent to his mother after his father's death have survived. He usually addressed her as "My ever dearest Mother" and he used the familiar "Thou" of country folk. Gilchrist regarded "thou" as "common" and in his transcriptions of Etty's letters he changed it to "you" to make them more acceptable to the public he was writing for. What he did not realize was that in Yorkshire "thou" was as familiar a form of address as "tu" and "toi" are in France. Esther was very close to all her children and was always available when they needed help. Etty was particularly fond of his mother. We know that after his move to Buckingham Street, in which she particularly assisted him, Esther frequently came to London to stay with her son and seems always to have been a welcome visitor. The journey by coach of at least two days did not deter her. By 1827 the familiar problem arose of where the widowed mother should live. By that time Esther was seventy-three years old. She was still living at her home in Huntington but frequently visited Thomas in Hull; he appears to have needed more help than any of her family. She was getting too old to live any longer on her own. Etty felt responsible for her and Esther had declared that she would do whatever he advised. In a letter to her (22nd January 1828) Etty wrote:

> If thou wouldst like to come to me, I and Betsy will receive thee with open arms—and hearts; that is, if your health will permit the journey. God knows it would be a great pleasure to both of us. Thy Chair is yet there, and thy cat. My house would like itself, if thou wert smiling in the corner. ... If thou would like to live with Tom, it would be something towards helping him; and thou wouldst be among friends. But *I* should be delighted to see thee, and brew thee a *canny* cup of Tea.

In the event Esther decided to live with her son Tom in Hull. Certainly his need of support was greater. Etty's promise to give his mother tea was more than a social nicety. Tea was considered to have medicinal qualities as it had been from its earliest use in the Far East and after its introduction into England had customarily been sold by apothecaries as well as other shops. As late as 1805 it was still being weighed in apothecaries' scales. Tea was Etty's favorite drink and he seldom consumed much of anything stronger. In his notebooks he frequently exhorts himself to drink no more than two or three cups at a meal as though fearful he would become an addict. In his letter Etty also told his mother that he had recently informed Sir Thomas Lawrence that she lived in York and Lawrence had replied that he wished he had known because he had recently been in York and would have called to see her.

Esther lived only until the summer of 1829, dying at her son Thomas' house in Hull on the 30th July having only just returned from another visit to Buckingham Street. It is quite apparent that his mother's death affected Etty more deeply than had his father's. The death of Etty's mother is more fully documented that that of his father. Whereas Matthew Etty had been ill for some years before his death, Esther's death took Etty by surprise. She had paid him one of her frequent visits in the early summer of 1829 and had returned to York apparently in good health. Esther was one of those indomitable women who never let any circumstance defeat them, unlike Matthew who never visited his son in London nor, it seems, ever ventured far from York. After her departure Etty had sent off one of his customary letters giving her the latest news of his activities and then by return received, not the expected reply from his mother confirming her safe arrival, but a letter from his brother in Hull breaking the news that Esther had died. The greater blow was to learn that she was already dead when Etty had sent his letter, such was the delay in communications at that time. She had not learned the news of his latest success at the Academy exhibition. Etty set off for Hull at once only to discover when he arrived there that her body had already been taken to York for burial. At Hull there was uncertainty over the funeral arrangements but there was enough time for him to stay overnight there and catch the early coach next day to York. He arrived in time on Monday 5th August to have the coffin opened for his last sight of his mother before the funeral service at All Saints' Church, Pavement, where she was interred beside Matthew.

After the funeral Etty wrote a long letter to Betsy, who had remained in London since it was not customary then for women to attend funerals. It is from this letter that we know of the details of his journey and of the funeral. In this letter Etty wrote:

> For a day or two after, she looked, they say, almost as like herself and as beautiful as ever. She went off quiet as a lamb—or, as she is now, an Angel. God bless her!—at five to-day, we saw her dear body laid, according to her anxious desire, near our dearest Father; and thus accomplished her long-cherished hope—and with it, dear Father's also. They are happy, believe me! for they deserved it. Rest their souls in the peace of God! till we meet again. Mr. Flower, who christened me, read the prayers. The Clerk sang a hymn. That she was beloved, and deeply beloved by all, the tears and sighs that flowed plentifully, proved. A last sad sight; and then adieu my Beloved, sainted Mother! Adieu! Adieu!

This gives an indication of the brief funeral services of the day, especially for Methodists which, so far as we know, Esther had remained. As Methodists were still restricted in the performance of offices she was interred in an Anglican burial ground alongside her husband.

Strangely for Etty, he stayed in York in a lodging house but when his friends, the Bulmers, learned of this they invited him to their house. He stayed some time in York, visiting the Registrar to finalize details and also going to Hull to recover his mother's wedding ring where it had been left for him, it having been her wish that he should have it. This ring, attached to portraits of his parents, hung beside his bed for the rest of his life. After visiting Hull, Etty called on his mother's brother, John Calverley the joiner, in Beverley. John was eighty-nine years old and still mentally very active, living on a small pension from his previous employer. Etty's time in Hull and York enabled him to visit all his relatives, necessary acts of condolences for so united a family. Etty tried his hand at writing a poem in memory of his mother but it cannot be said that

he was a literary man. The following is taken from one of the notebooks in the possession of
Tom Etty of Nijmegen.

> Oh Mother dear, how oft I trace
> In Memory's dreams, thy pleasing face,
> Feel thy soft kiss upon my cheek
> Or clasp thee in a fond embrace.
>
> Thou, Memory, source of sacred pleasure,
> Keep vivid in my mental eye,
> These visions of my late lost treasure
> That while I live, they never die.
>
> How oft at night, thou, gently stealing
> On my silent thoughtful hour,
> With all a Mother's gentle feeling,
> On my head would blessings pour.
>
> While cheerfulness thine eye illuming
> With a bright and beauteous fire
> At thy dear heart was Death consuming
> All a Loving Son's desire.
>
> But thou had'st hopes so far exceeding,
> All that earthly pleasure gives
> That why should our poor hearts be bleeding
> When, with Christ, we know thou lives.
>
> Then, gentle Spirit, hover o'er us
> Watch us with an angel's care
> That Sin and Death may fly before us
> Is thy darling William's prayer.

Whatever we might think of its literary merit, this poem expresses Etty's genuine love for
his mother who had so willingly supported him in everything he did and, as an attempt at an
artistic form that was not his, it is no worse than much amateur poetry that was being published
at the time. Etty was obviously deeply upset by his mother's death. On his return to London he
placed an obituary notice in the *Gentleman's Magazine* for August: "July 30. At her son's, in Hull,
at an advanced age, Mrs. Esther Etty, mother of William Etty, esq., R.A. of London."

This was as much as the magazine allowed for persons not of public renown and it was
accepted only because Etty himself was renowned. He could not have placed such a notice when
his father died as he was not then even an associate of the Academy. Gilchrist records that Etty
was quietly pleased when Lawrence, seeing Etty's portrait of his mother, had said that she had
a "remarkable face" indicative of great qualities.

"The Vandals strike again"

Etty now became again actively involved in safeguarding the medieval treasures of his native
city. Earlier in 1829, on the night of Sunday 1st February, Jonathan Martin, set fire to York Min-
ster. Jonathan Martin was the brother of the painter John Martin, renowned for his melodra-
matic works of painstaking detail frequently depicting apocalyptic disasters and the artist who
had bought Etty's painting *Combat*. Jonathan was a tanner by trade with a self-imposed vocation
for reforming the Church of England, which led him to disturb church services, to threaten to
shoot the Bishop of Oxford (according to the *Dictionary of National Biography* but of Lincoln
according to Charles Dickens, who reported interviewing Martin in *All the Year Round*, Decem-
ber 1866). His delusions required him to set fire to York Minster. On that Sunday Martin had
earlier attended a service in a Methodist chapel in York and then went to evensong in the Min-
ster at four o'clock. After the service he concealed himself by lying down behind the tomb of
Archbishop Greenfield in the north transept. The verger locked up at six-thirty and Martin
began his preparations. He made two piles of prayer-books and cushions in the choir stalls and
set light to them. He escaped by wheeling to one of the windows the platform used to clean and
repair the interior, broke out sufficient glass and, with the aid of the rope of the prayer bell
which he had already cut down, he climbed out. Outside, he heard the Minster clock strike three.
He knelt down and prayed to God. All this he admitted during his trial, having no desire to
deny anything. At about seven o'clock on the Monday morning a choir boy coming to early choir
practice saw smoke issuing from a door in the west tower. The alarm was raised and much of
the interior of the Minster was found to be ablaze. The city fire engine was old and inadequate
and the crew incompetent. They tried for an hour to quench the flames but had to send to Leeds

and Tadcaster for more engines and by mid-afternoon twelve engines were engaged. The fire was finally quenched by early evening.

The culprit was soon discovered, having left behind him some tools he had stolen from a shoemaker with whom he had lodged in York. Martin was arrested on the following Friday in Hexham, Northumberland, still possessing pieces of the Minster hangings he had cut off to start the fire. He denied nothing, being convinced he had served God's will. He was tried at York Castle on the 31st March and found guilty but insane. After nine years of confinement he died in a London lunatic asylum. Because of Martin's connections with Methodism and official anxiety not to arouse sectarian ill-feeling, the prosecution at Martin's trial was careful to clear the Methodists of any involvement. This was particularly necessary as there had been a certain amount of public outcry against Methodism.

Ten days after the fire the Lord Mayor of York presided over a public meeting to launch an appeal for restoration. The Lord Mayor himself subscribed £50, the corporation gave £500, Archbishop Vernon contributed £2,000 (which may be seen as an indication of his wealth), Dean Cockburn gave £300 and the residentiary canons, £250 each. The Roman Catholic Sir Edward Vavasour gave £25 but the Minster Chapter itself said it could subscribe only £1,500. It is true that the Minster finances were in bad shape, a condition which had for long been the subject of investigation and complaint. Nonetheless £49,619 was raised and, later, after a London appeal committee had also been formed, the total reached nearly £60,000. Hearing of the disaster Etty wrote from London on the 20th February[16]:

> My heart has been almost broken with the sad intelligence of our dear Cathedral. But I thank God, though injured, it has escaped much better than might have been expected at one time. And there it stands! though partially desolated, yet in majesty, yet in glory.—I am only just recovering from the shock.

Although raised a Methodist he had moved to the Church of England and always visited the Minster whenever he was in York, regarding it as the most splendid building in the country. Etty donated £30 to the fund. This may not today appear to be very much but having regard to his financial dependence on others and to changes in money values it was as generous a subscription as could be expected and compares well with some of the other subscriptions. The Dean and Chapter appointed Robert Smirke to supervise the restoration work. Although a renowned London architect who was later to design the British Museum and to be knighted for his services, Smirke was little thought of by Gilchrist, who referred to him as a "*Builder*-Architect of small sympathy with Gothic and a superficial knowledge of it"[17] (I, page 279). Smirke's estimate for the restoration was at least £60,000, the sum eventually raised. Restoration proceeded without much disagreement on the part of local critics but Smirke was destined to face more hostility than he foresaw. Etty was not much concerned at this stage since all was going well and when he visited York in July he was so concerned with his mother's funeral that he seems to have been content with the progress being made. Restoration was completed by 6th May 1832, but in the meantime since the total raised was more than sufficient for the work (this alone indicates the considerable difference in money values) the Dean and Chapter decided to spend the balance on moving the 14th century rood screen so that, as they claimed, the pillars of the central tower could be better seen. This was generally regarded as a breach of faith since the subscribers had not been consulted. It was condemned as another act of vandalism. Now the storm broke and Etty placed himself in the thick of it. Canon Vernon was the chief protagonist, eager to move the screen, and his chief ally was Dean Cockburn, a man accustomed to having his own way.

The intentions of the Dean and Chapter were never clearly stated. Originally the proposal was to place the screen "farther back" in order that the bases of the pillars of the central tower should be "uncovered." But the critics suspected that the true intention was to remove the screen altogether in order to provide "a grand perspective" from the west end to the altar. Such alterations

were being undertaken or proposed in other cathedrals. Gilchrist attributed such ideas to "the infamous James Wyatt."[18] Etty learned of the proposals after he had left York and since he knew Smirke he wrote to him expressing his concerns. Smirke replied (18th September 1829) assuring him that nothing would be done against the general wishes and confirmed that all he wished to do was to reveal the pillars of the tower. "By the removal they wod [sic] be enabled to gain the desirable object of opening to full view the magnificent East Window, as the organ could then be placed in the two side aisles."

This aroused the suspicion that it was intended not merely to move the screen but to remove it altogether, for how else could the East Window be seen from the nave? The reference to the organ did not clarify matters, since the original organ had been destroyed in the fire and had to be replaced. Here there was another problem. Should it be rebuilt on the screen as before? or lowered so as not to obscure the east window? or should it be placed in two parts, one each side of the choir, so as to open up the view of the east window completely? The organ builders became so frustrated that eventually they sued the Dean and Chapter for additional costs—and were awarded £200. The dispute was not confined to York. Interested persons in London formed an association, "The Friends of York Minster," and recruited support. Meetings were held both in York and London where each side intrigued to outwit the other. Whenever resolutions were carried at these meetings the aggrieved parties called another meeting to overturn the decisions. The maneuvers of the parties were recorded in a letter sent to Etty by a correspondent who unfortunately failed to append his name. He must have been well known to Etty since the letter arose from a conversation with his brother Walter.

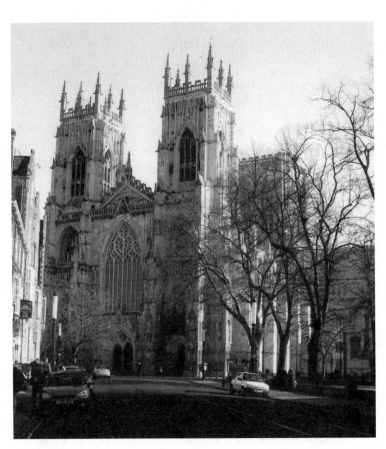

The Minster (West Front), York (photograph by John Rhodes).

Your brother called this morning and requested me to furnish you with a few of the leading points relative to the question that is considered justly so important to our country and to good taste and feeling—I shall endeavour to do it on the principle Othello recommended—nothing extraneous or set down aught in malice.

Soon after the calamity of the Fire a meeting was called for the purpose of setting on foot a Subscription for its Restoration—at this meeting the Canon Residentiary as the organ of the Dean and Chapter said that they could not depart from a model more excellent and beautiful than anything they could substitute in its place. On this being distinctly stated and distinctly understood a Subscription was entered into and a sum of nearly 60,000£ was liberally and nobly supplied for that purpose of Restoration. Soon after this [was] done some [three illegible words] friends of the Minster were alarmed at a Report that

the Dean intended to remove the Screen—the most gorgeous and elaborate Specimen of Gothic enrich-
ment in Europe—and not only that but this Removal involving consequences in the opinion of Anti-
quaries and judges in these matters involving half the beauty and antique arrangement of the Minster.
Alarmed at this they of course offered opposition to a scheme so diametrically opposite to all their origi-
nal intention and much irritation was caused—which being then listened to the idea was for a time
abandoned and Mr. Smirke assured me it would not be proceeded in and all was going on amicably.
However some little time after some friends of the measure disposed again to throw the Apple of Dis-
cord amongst us, got a meeting called at the Thatched House Tavern in London which ended in the
question being referred to the Friends at a General Meeting which they decided should be called in
York on the 29th of July last [*1830*]. Very well—the meeting took place, the question was discussed and
the Question put when a triumphant majority decided that question in favour of the original plan of
Restoration. We, the friends of the old Minster and antiquity again congratulated ourselves on its escape
from an audacious and wanton innovation—but again we were deceived. This meeting they decided was
"not satisfactory"—so at the conclusion of a County Meeting of address and condolence to his present
Majesty—to the astonishment and regret of us all—this odious measure *twice* before set at rest is pertina-
ciously and obstinately brought forward again tho' each time causing an irritation and feeling unexam-
pled in Yorkshire—and at a time when we were not aware of any intention of doing so. However, the
nobleman who was Chairman of the Fund arose and said that he certainly thought when the Subscrip-
tions were entered into they were given for its Restoration as before it was burned. This was followed by
loud applause. It was ultimately agreed amongst those present at that Meeting to refer it to another to
be called the 28th last December. This meeting (which the Chairman himself allowed to be irregular)
carried an amendment that the meeting of the 29th July last should be binding on the Dean and Chap-
ter and therefore we with some justice think we have got the victory. But the other party having a major-
ity of proxies in favour of the Removal (in spite of the amendment being carried which in all regular
proceedings negatives the motion) also consider themselves entitle to the victory. So it hangs yet—all we
contend for is *the purpose for which the Fund was raised, the Restoration and not the Mutilation of that splendid
Monument of the Olden Times.*

This is the head and front of our offending—no more.

Though we do not know the date of the letter it was clearly written a little after the meet-
ing which we know was held on the 28th December 1830. This was not the first indication to
Etty of the way things were going since he had already written a letter to the *Yorkshire Gazette*,
published 18th December 1830, with another letter to the *Leeds Intelligencer*. He began to attract
support from numerous friends both in York and London. Letters to Thomas Bodley have sur-
vived and give an indication of the measures that Etty took to enlist the support of his friends.

> 14 Buckingham Street Strand
> Saturday Even Dec 17
> [*apparently 1830*]

My Dear Thomas Bodley
 I have but a few minutes to spare this Evening before the Academy to *beseech* you to send addressed to
"Wm. Mills Esqr. Proctor, York" a *Strong Protest against those alterations to the Minster.* "Absent Subscribers
are requested to give their opinion by letters" so addressed—by advertisements they are requested So I
pray you *let it be the first letter you write for it must be at York about the end of the week* to be of any service.
"*dinna forget.*"

There follow personal enquiries and greetings.
 The campaign did not have the desired results and we find Etty writing again to Thomas
Bodley in January 1831. (There is some confusion over the date of this letter since Etty dated it
as "Wednesday 12th Dec 1830"—which would precede the former letter—but the cover is post-
marked "12 JA 1831").

My Dear Thomas Bodley
 I saw your letter to Walter and thank you for your kind attention and desire to save to our country
what the Fire has left of our noble old Minster. A crowd of her real Friends are rallying round the Stan-
dard of good faith, good taste and things as they were—amongst them great names and families—the
Cholmeleys, the Yarburghs [*sic*], Lord Faversham, the Dunscombes, the Wynns, Fairfax and many others

and Mr. Brook [*Brook & Bulmer*] and your humble servant. *Allow me to add yours.* Our object is, as a powerful writer says

"to scare those architectural vultures from their prey" by agreeing, in case this odious change is persisted in, to demand back our subscriptions which as you well know were subscribed for a very different [*purpose?*]—the *restoration* of that holy place as it was before the fire. My heart and soul is in the cause. Every single name of consequence and yours would much help us.

If the Subscriptions are called for—and they have allowed [*that we?*] distinctly have a right—we shall cripple their evil intentions and yet save her from ruin.

My love to Martha—yourself and young Martha. When I have more time I shall write you a more gossiping letter. This is business—*important* business.

But the Dean and Chapter were not disposed to give way, so documents were prepared and appeals made to the Archbishop of York and the King (by now William IV) with the threat of a suit in Chancery.

There is the draft of a letter in York Reference Library that Etty was proposing to send to the editors of local newspapers. The letter is undated but its contents indicate that it was written before the matter had been concluded. After a lengthy description of the beauty of York Minster and the need to preserve it, Etty dealt what was perhaps the most serious blow to the campaign to move the screen. It had been given out by the Minster authorities that the moving of the screen had been suggested by Robert Smirke, the architect.

Smirke had carried out restoration work in the Minster in 1811 and was the Minster's Treasurer from 1820 to 1850. His opinions on architectural matters were seriously regarded and, as we have seen, his words of reassurance had been unquestioningly accepted by Etty's correspondent. In his letter Etty recorded that he had met Smirke in Pall Mall, London, and had accosted him on the matter of the screen, to be told that Smirke denied any responsibility for the proposal to move it. Etty claimed to have said to him, "Well, but you are the author of this original Sin, are you not?" his answer was, "No! I assure you!" Smirke laid the authorship on a Mr. William Vernon but admitted he had accepted the idea when he was shown what was thought to be "the wall of a former choir." Having later discovered that this was nothing of the kind but the remains of a former building, Smirke had withdrawn his support for the proposed removal of the screen. Etty was understandably overjoyed on receiving this information and lost no time in informing the citizens of York through the press that the famous architect on whom the Minster authorities were relying was in fact on the other side in the dispute. He sent versions of the letter to *The Yorkshire Herald*, the London paper *The Morning Herald*, *The Leeds Intelligencer* and a fuller version to *The Yorkshire Gazette* whose editor printed it on the 18th December 1830. His revelations were useful ammunition in the campaign and the Minster authorities had to concede defeat.

In February 1831 the Dean and Chapter decided to withdraw from the fray, Archbishop Harcourt (father of Canon Vernon) having counseled Dean Cockburn "to cultivate peace rather than gratify Taste," a clear indication of the Archbishop's personal support for the removal of the Screen. The Dean announced that he had conceded to "popular prejudice," adding "for the present," and that the screen would be moved later at the expense of the Minster authorities, thus indicating quite clearly that he regarded the affair as once again merely postponed. This statement was wholly in accordance with the Dean's character, a man who would never be beaten. However, the matter was never again raised and the rood screen has remained in its 14th century position to this day.

Whatever the Minster authorities may have thought privately about Etty's intervention in the matter of the restorations, they do not appear to have held any personal grudges against him. In a letter dated 7th November 1832 to his cousin Thomas Bodley in Brighton, Etty wrote:

I have sent you a Yorkshire Gazette in which there is something about me. I have been made much of in York. This had an invitation to dine with the Lord Mayor at a public dinner. Had my health drunk, had

to make a speech! etc. etc. Was invited to an Evening Party at the Deanery—drank tea last Friday Evening at the Residentiary with the Revd. Vernon Harcourt and his Lady (the Archbishop's eldest son) and dined out more times than I now have time to tell you of.

Two years later in the course of a long letter to Thomas Bodley (dated July 13, 1834) Etty described his attendance at the evening service in the Minster, concluding with:

The Revd. Vernon Harcourt, eldest son of the Archbishop, one of the Canons and Residentiaries of the Cathedral and my great opponent in the matter of the Screen, came up to me, shook me by the hand, and was very friendly and affable! Asked me what I thought of the finishing of the organist's screen of tabernacle-work, etc. The pipes are bronzed. I told him I thought they would look less heavy in flat gold. He thought so too.

Oh how I should like you to see the Minster. It looks "all glorious within" and if anything on earth is worthy of Him who made us, it is it.

However vehemently Etty might express himself in print when he was waging his campaigns, he was never one to be personally antagonistic or offensive and for this his protagonists admired him.

This event, and indeed other events regarding the Minster with which Etty was associated, indicate that his interest in the Minster was almost wholly confined to the building as a noble Gothic structure rather than with the Minster as an Anglican institution. As has been already indicated, the Minster had been in debt long before the fire, largely because of the loss of rents derived from buildings which Dean Cockburn insisted on having demolished because they were too close to the Minster. One can see the Dean's point of view. On the south side the old Deanery had obscured the Minster and on the west side several buildings had obscured the fine west front. The old Deanery was replaced with a new Deanery on the north side. Apparently it was not pointed out that Dean Cockburn himself benefited from this work. Also there were buildings right up against the walls of the Minster on either side of the south door. These also were removed. All this demolition was no doubt advantageous aesthetically and gave the Minster a "presence" that it deserved. But it lost income which the Minster could not afford to lose and it cost money to rebuild the Deanery which the Minster did not have. These matters simmered for years and were not helped by Dean Cockburn's difficult character. In December 1836 Archbishop Harcourt wrote Dean Cockburn a letter in which he stated forthrightly that he could stand the Dean's attitude no longer.

I have in vain remonstrated with you privately on the manner in which you transact chapter business. I have a settled conviction that it can end in nothing but ruin and disgrace; you appear to me to consider the cathedral property as a wreck which may be torn up and shared among us.

Even so, it was some time before the Archbishop acted. In the meantime parliament embarked on reforming the Church of England. In 1836 the Ecclesiastical Commission was founded with the task, among others, of abolishing many ancient customs and instituting new ones, which required for some cathedrals the loss of endowments and their redistribution among poor dioceses. This action had been prompted by the growth in population in the industrial towns and it was not welcomed by the wealthier cathedrals who claimed that their endowments, having been given by local landowners and merchants in the past for their benefit, could not be taken from them. Dean Cockburn, seeing the loss of much needed money, wrote impassioned letters to the York newspapers protesting against the proposals. Durham Cathedral took the precaution of diverting its endowments to found a university and Dean Cockburn openly declared his intention to sell all the livings at his disposal so as to thwart the authorities. This is a complicated matter involving arcane Church law and we need not concern ourselves with the details but the Dean's proposal came perilously close to simony, the worst offence any prelate can commit. It was not until 1841 that the Archbishop finally acted and then because the Dean's

behavior was connected with another disaster involving the Minster structure and which will be considered in due course.

But the immediate matter of interest is why did not Etty appear to know of or be concerned about any of these matters if he was so closely involved with the well-being of York Minster? Although Etty knew Canon Harcourt and Dean Cockburn well, not on a day to day friendly basis but well enough to attend the same dinner parties and to converse with them, he appears either not to have been aware of the simmering discontents within the Minster, which, more-over, came into the public domain through the columns of local newspapers, or not to have concerned himself with them. One of Etty's close friends was owner of the *Yorkshire Gazette* and he certainly knew what was going on. We can but conclude that Etty's love of York Minster arose from its noble structure, its link with the nation's medieval past and its Catholic heritage. He loved the Minster building, its services, the sound of the organ, but in matters concerning its governance he had no interest. Etty believed firmly in a natural hierarchy of authority and interfering in the management of the Minster was not one of his functions.

CHAPTER EIGHT

"An irreparable loss"

At the same time that Etty was concerning himself with the restoration problems of York Minster he suffered what was for him a personal sadness of considerable severity. Etty had always regarded himself as most fortunate and most honored to have been the pupil of Sir Thomas Lawrence, if "pupil" may regarded as the correct word in the circumstances since Lawrence gave him very little instruction. He also regarded himself as equally fortunate and honored to have been proposed to full membership of the Academy by Lawrence himself when he was President. As a Council member he had access to Lawrence and was highly proud of the fact. It was very much a case of "poor boy makes good." Today Lawrence is more regarded for his output and contemporary fame than his contributions to the development of art. He certainly possessed extraordinary facility and despite settling into the mold of successful portrait painter (as did Reynolds) he remains probably the most glamorous painter England has produced. As President he was a considerable asset to the Academy and had the advantage, which Reynolds lacked, of being well liked by the king, which greatly assisted the conduct of affairs. It cannot be claimed that Etty's work shows many obvious influences from his time with Lawrence but, as Etty himself stated in his *Autobiography*,[1] he "admired the taste and feeling of Lawrence." Etty always regarded Lawrence as the perfect example. "Lawrence's execution was *perfect—playful* yet *precise—*elegant yet *free—*it united in itself the *extreme* of possibilities." There are one or two early portraits by Etty consciously painted after his example but the main body of Etty's work reveals little indebtedness to his master. It had been persistence and an obedience to Lawrence's requirement that he should copy old masters that had brought Etty through his pupilage. Etty considered the year to have been well spent but other contemporaries were less sure about the value of Lawrence's influences.

When Etty went to Italy in 1822 he wrote a series of long letters to his former master informing him of his progress through that country and assuring him of the value of his experiences. It had particularly pleased Etty that in Venice he had been allowed to paint in the Life School of the Academy and had been elected an Honorary Academician along with Lawrence himself, an honor no doubt bestowed partly because of his association with Lawrence. Lawrence opened many doors for Etty while he was in Italy. The relationship between the two men never cooled. Lawrence asked Etty to bring back for him his opinion of the Michelangelo and Raphael drawings in the Louvre. Lawrence clearly valued Etty's opinions on matters of art and, as we shall see later, this estimation of Etty's critical abilities was shared by many others. At the President's request he made several copies of Italian works for him, no doubt being paid for his services, although he particularly excused himself from making a copy of Tintoretto's *Christ Crowned with Thorns*, claiming he lacked time. He did not wish to spend his time in Italy being a mere copyist. In any case, he had a long list of paintings he wished to copy for his own purposes.

On 7th January 1830 when only 61 years of age, Lawrence died, an event which took Etty completely by surprise. In his letter of 27th January 1830 to Thomas Bodley Etty fully expressed his shock and grief.

My Dear Thomas and Martha,

You promised me, in your former letter, a boon, then out of your power to grant, you promised me "peace within and without"—you then did not know, my dear Thomas, of the thunderbolt that had so recently struck us—struck us to the heart—and deprived us of one, whose loss to his Country, the Academy and his lamenting friends, is in every sense irreparable! Even now it seems almost a dream, a hideous dream! To think that the Pride and Boast of that Country and his Brethren, He whose beautiful Smile and Delightful Manners and Cheerful Conversation so lately cast a Sunshine among us and around us when a few nights before he sat amongst us at Dinner, with health on his Cheek, and happy and cheerful as he could apparently be, to think that on that very *night week* at the *same hour*, he should droop his dear head in Death and shed dismay, when he was so lately giving us the hope of a long and happy enjoyment of his Powers, is indeed a striking illumination of what the Bible says—

"In the midst of Life we are in death!"

The night my Dear Friend and honored Master died, I heard Mr. Shee say he had been poorly—indeed it was me he asked whether I had heard of the President's being somewhat unwell—I said no!—and he said he *had heard* he had a shivering sensation—but that he was better—I went to Mr. Hilton the Keeper of the Academy and inquired whether he had heard of the circumstance—he had not—I told him I thought of going to Russell Square that night after the School was over to see whether there was any foundation for it—and I went. I knocked three times, but as I had not knocked *loud* I got no answer. I then rung and a little boy came. I asked if it was true that Sir Thomas had been unwell. He said he had been poorly some days. I asked if he kept his bed. He said not exactly but that he kept his bedroom and sat by the fire. I told him to go and take my compliments and say that I had called hearing he was poorly and wished much to know how he was. "Now sir," the boy said. "Yes now" I answered. He said "I can't go into the room Sir—his Doctor is with him and I must not go—but he is a great deal better today!" "Well, if that is the case, I must be satisfied but don't forget to make my best Compliments and say that I called to know how he was." Gracious and merciful God! he was dying about *that very moment, about nine o'clock* in a small bedroom, in the upper part of the house. But that I knew not—nor the boy—for Sir Thomas did not wish it to be known he was poorly. Indeed he felt so much better that he had a gentleman, his Executor and Lady Croft had been sitting by him in his bedroom and reading and conversing, and so well did he feel that he said cheerfully when tea was brought up "I'll officiate. I'll make tea for you tonight" and did do so. Afterwards, he requested them to withdraw for a few moments and feeling faint asked if there was a fan in the house. The servant got one, and tried to refresh his languor by fanning him, but he soon after felt himself going, and said "I am dying," casting his eyes upwards. He fell back and left this world for ever.

Having described Lawrence's last moments as later recounted to him, Etty paid affectionate tribute to his old master and a President with whom he believed he enjoyed a special relationship.

Thus perished a man who for splendor and brilliancy of talent, for benevolence and gentleness of heart, for elegance and suavity of manners, for humbleness and beauty of person, has left no parallel in England, or in Europe, and left a vacuum that no one can adequately fill—and few if any approach. Peace be to his gentle Soul. Peace to his Noble Ashes! for if ever Nature stamped nobility on man that man was Lawrence.

We must believe that Etty was sincere in his mourning for Etty was never a dissembling man. It can be safely concluded that in so far as he was able Etty had always kept before him the figure of Lawrence as his mentor, for Lawrence undoubtedly possessed all the elegance of manners expected of a gentleman at this time. Etty as a poor boy from a country town would naturally take such a man as his example if he wished to make his way in London's cultural life. Etty proceeded to give his cousin his account of Lawrence's funeral in St. Paul's Cathedral.

I followed, of course, his dear Remains to their last sad home. Since the days of Nelson there has not been so marked a funeral! The only fine day we had for a long time was that day! When the melancholy pageant had entered the great western door and was half way up the body of the church—the solemn swell of the organ and anthem swelled on the ear and vibrated to every heart. It was deeply touching, more almost than I could bear.

The service was proceeded with, the organ echoed thro' the aisles, the sinking sun shed his parting beams thro' the west windows and We left him alone in his glory!

Lawrence's death came as a surprise to all his contemporaries. William Sandby[2] recounts that at the annual dinner of the Artists' Fund held a little before, "his departure was nearer than he, or any who listened to him, then supposed." Sandby records that the pall bearers at Lawrence's funeral were the Earls of Aberdeen, Gower and Clanwilliam, Lord Dover, Sir Robert Peel, Sir George Murray. John Wilson Croker and Mr. Harte Davis. George Somes Layard[3] also relates the circumstances of Lawrence's death. A post-mortem examination was required because Lawrence had not shown earlier signs of serious illness. This

> failed to discover sufficient reason for death, and that "the real cause was probably depletion of the blood-vessels; or in other terms, this great and estimable character was bled, or rather had bled, to death"—thus more than hinting that Lawrence had been killed by phlebotomy.

Although some disputed this there was general opinion that Lawrence had been healthy enough to continue for many years but that he suffered from "a condition of blood-vessel" with a likelihood of sudden death increased by the blood-letting which was current practice.

The Council of the Academy was now faced with the difficult problem of electing a new president. It was clear that they had very few suitable candidates and although *The Times* of 11th January 1830 listed William Beechey, William Etty, William Hilton, Henry Howard, Thomas Phillips, Henry Pickersgill, Martin Shee and David Wilkie as having being "spoken of by their respective friends" as "a proud list to choose from," it soon emerged that the contestants would be Beechey, Augustus Callcott (not mentioned by *The Times*), Phillips, Shee and Wilkie.

The obvious shortcomings of the available candidates prompted Francis Chantrey to suggest to Shee that a change should be made in the method electing presidents and that the post should rotate among the forty Academicians. Shee correctly objected that such a procedure would lower the Royal Academy in public estimation and reduce the office to a merely administrative one with no distinction placed on the holder. The election was held on the 25th January 1830. Shee received eighteen votes, Sir William Beechey six, David Wilkie two and Callcott and Phillips one each. Chantrey was among those who voted for Shee. Gilchrist, who erroneously recorded Wilkie having received but one vote, expressed undisguised contempt for the Council's decision. But Wilkie was a shy man and would have been ill at ease with royalty and other high ranking persons he would have been required to meet, as indeed would have been the case with Etty had he been selected. Wilkie's biographer, Lord Ronald Sutherland Gower, described Shee as "only a mediocre painter" but agreed that "he made an excellent P.R.A., more tact and *savoir faire* being required for that office than high artistic talent."[4] Benjamin Haydon, who had little good to say of anyone, regarded Shee's appointment as "one of the most fatal blows ever inflicted on the dignity of the Academy since it has been established, and will lower it in English and Continental estimation."[5] He went on to describe Shee as "the most impotent painter in the solar system" and being an Irishman of "great plausibility; a speechifying, colloquial, well-informed, pleasant fellow, conscious of no great power in art and very envious of those who have." In fact Shee was a modest man who said of himself

> without a movement on my part, without an attempt to employ the smallest influence, in or out of the Academy, knowing that I have neither wealth nor power, or influence with the great, and that I have never basked in the sunshine of Royal favour ... in spite of all this, they have made me President.[6]

As a Council member Etty had had to share the responsibility of electing a new President and was no doubt relieved that his name had not been submitted. He reported to Thomas Bodley, in the letter previously quoted, that "We have filled up his vacancy in the best manner we are able." He went on to describe Shee as "an accomplished scholar and excellent poet, an orator and a gentleman." According to William Sandby[7] Shee had begun life as a painter in Dublin and first exhibited at the Royal Academy in 1789. For a few years he was a comparatively successful portrait painter but he achieved more success as a writer. He had even written a play.

The Council's choice proved very sensible. Shee became a very popular and successful President and a fierce defender of the Academy's privileges. Even Haydon eventually had to admit as much. C. R. Leslie, who had voted for Wilkie on the grounds, as he later stated, that "he united more requisites for high office than any other in the Academy" also admitted that "Sir M. Shee made so incomparable a President, that I am glad the majority did not think as Collins and I did at the time of the election."[8] Shee was knighted in the following July and appointed painter in ordinary to the King (William IV), Wilkie also having been similarly appointed after Lawrence's death. William Sandby reported that the years following Shee's election "were not favourable for the promotion of the arts."[9] Less lectures than usual were delivered in the Academy. Much of Shee's energies were given up to promoting the establishment of the proposed National Gallery. The political climate, with the current emphasis on economic "retrenchment," was not favorable and there was a growing resentment towards the Academy by members of Parliament on the grounds that it was "a Royal, aristocratic, privileged, exclusive institution, opposed to the social equality so much contended for at the time by a section of the House of Commons."[10] Shee addressed a letter to the Secretary of the Treasury and subsequently met him to present the Academy's case. The Secretary did not disclose this to the Government, who therefore did not make the Academy's case known to the Commons, who, in May 1834, demanded detailed information from the Academy regarding their activities. Shee responded that as the Academy was not under the Government's jurisdiction but under the patronage and protection of the King, the Commons had no power to control its proceedings. Shee also consulted the King who agreed that the information required by the Commons should be provided since it could only show the Academy in a good light, which in the event it did. The Commons had to recognize that they had no grounds for condemning the Academy. Over the years the Academy was to have many reasons to be grateful to Shee for the benefits it received due to his skilful interventions.

But the strains of office coupled with increasing ill health took their toll. Shee resigned from office on 28th May 1845 on the grounds of "advanced age and long protracted illness" but all the Council members signed an Address calling on him to change his mind.[11] They called him "our triumphant champion in the hour of need" and promised to relieve him of many duties if he would continue in office. He consented and with Queen Victoria's agreement (as Patron) he was granted a pension of £300 a year. In the following year the Secretary to the Academy, Henry Howard, resigned his post to be replaced by his deputy John Prescott Knight. In 1850 the Treasurer, Sir Robert Smirke, resigned in ill health. The Keeper, George Jones, announced his intention to resign by Christmas that year. There is little doubt that Shee's own ill health was increased by the strain of so many changes in his colleagues on the Council. On the 19th August 1850, Sir Martin Shee died aged 81 years. His last words were recorded by Sandby as—"Do not wish for a long life; you see the state to which I am reduced."[12] Shee was a Roman Catholic and by his own wish, no doubt to avoid the constitutional problem that would have faced the Church of England if a service had been requested in St. Paul's Cathedral as was usual, he was given a quiet funeral at Brighton. Etty's comment in his letter to Thomas Bodley at the time that the Council had filled up the vacancy caused by Lawrence's death "in the best manner we are able" had proved to be more prophetic than he knew.

Mixed reactions

Having considered the affairs of the Royal Academy thus far we now have to return to an earlier year—1830, which had opened with the death of Sir Thomas Lawrence, and which was to prove an eventful period for Etty and for the country.

For Etty, the fire at York Minster which had occupied him in the preceding year continued to take up much of his attention in 1830 because of the plans to move the rood screen. This

subject has been considered in the preceding chapter as the two events of restoration after the fire and the moving of the screen proceeded together but throughout 1830 and up to February 1831 the campaign against the move continued and took up much of Etty's time. After the death of Sir Thomas Lawrence, which considerably affected him, he had to set to work to complete his entries for that summer's exhibitions. He also had his commitment to the Royal Scottish Academy to fulfill, the painting of the wings of the *Judith* triptych. He sent to the British Institution *Venus and Cupid*, a painting which Gilchrist appears to have confused with *Venus and Cupid Descending* which had been exhibited in the British Institution in 1822. The two pictures are not alike, not even in size, the *Venus and Cupid Descending* being a panel twenty-seven inches by twenty, while the other painting is on canvas and measures twelve and a half inches by seventeen and a half. The former is a fanciful piece, with Venus and Cupid on a cloud descending upon a distant landscape with part of a rainbow above them. Etty sought to contain the figures in a circular composition with draperies billowing in the breeze. The figure of Venus is one of his best forms but the whole idea is lightweight and whimsical. The other picture is a straightforward recumbent Venus holding the young Cupid in that kind of vague landscape in which Etty usually set his figures.

The Academy Exhibitions were held between the end of April and the end of May in each year. It was one of his exhibits in the Academy exhibition in 1830 that attracted the most violent criticism. Etty submitted not only the two *Judith* paintings but also *Candaules, King of Lydia, Shews His Wife by Stealth to Gyges; The Storm* and *A Dancer*. It is difficult to understand why he painted *Candaules* (see color plate 6) or why he exhibited it. The subject comes from Herodotus (I, chapter 8), who recounts that Candaules was so proud of his wife's beauty that he compelled his chief minister Gyges to see her naked so that he could judge for himself that the king had the most beautiful wife in the world. He arranged for Gyges to hide in the royal bedroom while his wife, Nyssia, undressed for bed. She realized what was happening and accused the king of dishonoring her. She commanded Gyges to kill her husband and marry her, which he did. It is a curious story and there are a number of versions. Some ancient writers maintained that it was the goddess Kybebe who was seen naked by Gyges and who made him her spouse, enabling him to claim divine right to the Lydian throne. Others said that it was a shepherd who found a ring that made him invisible so that he was able to spy unseen upon the queen and kill the king. There are other minor variants as is usual in ancient Greek myths. Etty chose the more usual story and depicted Candaules reclining on the bed while Nyssia, seen from the back, prepares to join him, with Gyges peering from behind a curtain on the righthand side of the picture.

It is not a subject often met in mythological art but Jacob Jordaens (see next page) had painted a version in 1646 (now in Stockholm). Jordaens depicts a full length back view of Nyssia as she is about to climb into bed. On the right hand side the coarse looking character of Gyges looks towards her while Candaules himself, wearing a crown, can be seen over his shoulder. Together they look like conspirators about to commit a crime. Nyssia looks back towards the viewer with a coquettish smile as though fully aware of what is happening, though a small dog at her feet presents a symbol of fidelity which is surely doubtful. She has the plump figure and fully rounded buttocks usual in Dutch and Flemish nudes and Jordaens is clearly presenting an erotic image for the delectation of the viewer. The chamber pot at the foot of the bed introduces an indecorous note and suggests that his painting is another version of *Susannah and the Elders*. Etty's painting does not offer a Biblical parallel. It does no more than illustrate models in typical Life Class poses. In Etty's version Candaules reclines side view on his bed and Nyssia stands, back to the viewer, with one arm raised in the conventional and implausible pose of a model who would be provided with a suspended rope to hold on to. Etty frequently had difficulty in positioning arms, usually conventionally above the head as though he does not know what to do with them and wants to get them out of the way so that he can concentrate on the torso. His interest in the torso at the expense of the limbs often attracted critical comment. Whereas in Jordaens' version

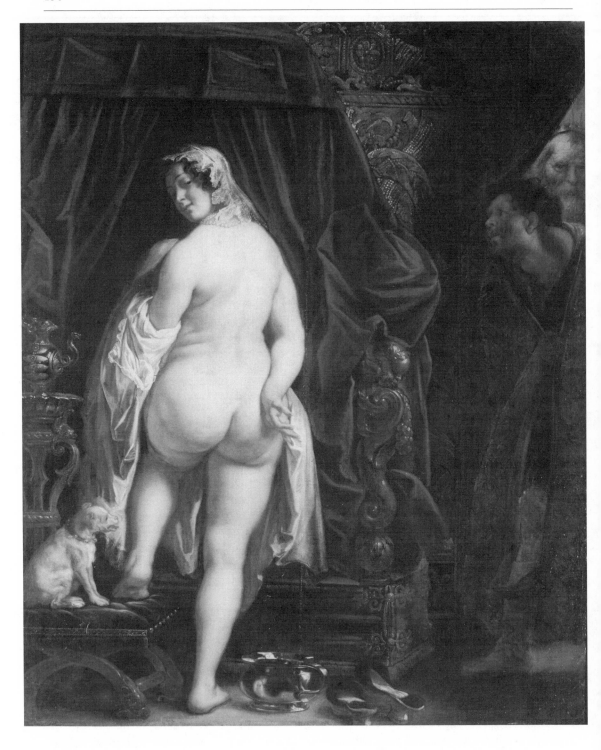

Candaules, King of Lydia, Shews His Wife by Stealth to Gyges, One of His Ministers as She Goes to Bed, by Jacob Jordaens (193 × 157 cms) (1646), National Museum of Fine Arts, Stockholm.

Nyssia is knowingly presenting her physical attractions to the viewer, in Etty's she is exposing herself unsuspectingly to Gyges.

It is far from clear why Etty chose this subject. Men spying on naked women has always been a favorite subject for artists and writers and arises from natural male curiosity and the determination of women to guard their secrets. A. D. Harvey has pointed out[13] that "during the eighteenth century, and for some hundreds of years previously, it had not been customary for lovers or even married couples to see each other naked," and that to do so had become regarded as improper. He suggests that around 1800 the "contemplation of female nakedness became, if not more respectable, a little more normal." But, of course, only when undertaken between married couples and by mutual consent. To connive with another man to trick the woman into exposing herself was obviously highly improper and indecent and a violation of her modesty.

Gilchrist[14] had difficulty in accepting Etty's painting. He said:

> The *Candaules* ... affords almost the only instance among Etty's works, of an undeniably disagreeable, not to say objectionable subject having been chosen as the theme for interpreting the nude form, and development of harmonious colour.

It is unbelievable that Etty would not have known that both the critics and the exhibition public would find it quite inadmissible, indecent, even obscene. The theme of male *voyeurism* is always dangerous and if satyrs leering at nymphs were unacceptable why should he have expected the gallery-going public to approve of human beings, and alleged historical figures at that, doing so when such subjects were usually confined to the more salacious prints? Why did he not explain his purpose? The original theme of the myth was that women should no longer be regarded as chattels but as possessing personal rights which had to be respected and which they were entitled to enforce and would certainly do so. These were principles with which Etty agreed. He did not agree with the Puritan view that the human body was "mere filthy flesh" or that women were "whores of Babylon" or "Satan's snares" or any similar epithets. At all times he revered women and was well known for treating his models with full respect, wishing only to present women as quasi-goddesses. It is not known how Etty became aware of the story of Candaules, Gyges and Nyssia. We can only assume that he had come across it while reading Herodotus. Originally Gyges had been the more important character, killing the king of Lydia and developing the city as a military power. Gyges was an historical person (c. 680 to c. 648 B.C.) but the name Candaules and the episode with Nyssia were invented by Herodotus and appear to be a variation of the legend linking Gyges with the goddess Kybebe to provide him with divine authority. Whatever the reason for Etty's choosing this subject, notwithstanding the disapproval of the critics, it soon found a purchaser. It was bought by the collector Robert Vernon who presented it to the National Gallery in 1847, where it remained until 1929 when it was transferred to the Tate Gallery.

When the three *Judith* paintings were exhibited at the Royal Academy in 1830, the latest to be painted and now to be seen for the first time, *Judith Going Forth*, was praised by *The Times* in its issue of 1st May 1830 as "this artist's usual brilliancy of color and correct drawing" and in its issue of 4th May 1830 with the words—

> The attitude of the heroine is admirably conceived, and the face of the maid very expressive. The distant landscape is painted with great force and skill. The whole picture is a masterly production, and well worthy of Mr. Etty's acknowledged talents.

But in the issue of 12th July 1830 there was a complete change of attitude. It appears that the original critic had been replaced and the new reviewer used the opportunity to express his opinion of the Academy and its members. He began his review with the explanation—

> The brief and hasty notice with which we usually follow the opening of the Exhibition, although sufficient to satisfy public curiosity at the moment, we do not consider, after a more deliberate review and consideration of its contents, as a just and sufficient estimate of its merits or imperfections

If the readers thought they were about to get a more considered approval of the works on exhibition they were to be surprised. The writer launched into an attack on the Academy, mainly objecting to the right of members to submit eight works each without the hanging committee first assessing their worth and so occupying "all the space on the walls of the exhibition within range of the eye." He then went on to single out some of the exhibitors, including Etty, whose works should have been removed "to spare the blush of modesty." The reviewer expressed the usual opinions of those who objected to the nude in art. "Representations of the human form become disgusting, unless spiritualized by the purest taste and judgment; and the way to accomplish this purpose is not by gross exaggeration of the distinguishing forms of sex."

When we look today at the works to which objection was taken we are hard put to it to find any exaggeration of "the distinguishing forms of sex" and we have to ask what the critic meant. The conventions of the time did not permit any references to anatomical details of a sexual nature, even the word "breast" was outlawed. "Bosom" was as far as a writer might go and then only if used in a kind of abstract manner, not suggestive of any physical application. The writer was appealing to the prejudice and bigotry which were taking hold of the public mind through the activities of Evangelicals. In a particular reference to *Judith* he wrote—

> Mr. Etty has inverted the head of his *Judith*, and as for any thing that the picture contains in respect of taste or sentiment, it might, without much loss to the arts, be turned to the wall. ... We have often bestowed the most unqualified praise upon Mr. Etty; indeed, we admire his devotion to art, and his attainments in colour and execution; but he must pay more attention to design, and purify his feeling for naked form....

But there was no nudity in the *Judith* paintings. The critic was apparently objecting to Judith's leg thrust forward and naked to the thigh. Etty could at least take comfort that the reviewer's strictures also fell upon others. Turner, though admired in some works, attracted some heavy criticisms. "Would it not have been kind towards Mr. Turner to have rejected some of his works?" and "Mr. Turner ... must be informed of his approaches to absurdity...." Wilkie's portrait of the king was heartily disliked as was his painting of King Alfred. Of Constable's scenes the critic said "one picture is almost a *facsimile* of the other," which may perhaps be accepted in some cases as a just criticism, and generally the reviewer objected that landscape painters were lacking in ability to paint figures and should therefore become acquainted with the study of this subject. All in all it was a trenchant review of the exhibition and few came through unscathed. This reviewer returned to his complaints in a later article in the issue of 20th July when he suggested that "pride and self-respect, which are the natural concomitants of genius, will be more likely to keep a man out of the Academy than bring him into it." These reviews brought approval from "A Constant Reader" whose letter in the issue of 23rd July concluded with the words: "The Academy has sown the seed of its own ruin, by establishing the fatal principle, that the highest genius was not necessary to the highest place."

The writer of this letter was presumably referring to the election in the previous year of Martin Shee as President of the Academy in succession to Sir Thomas Lawrence. Regarding the reviewer's objection to Judith turning her face from the viewer, Etty wrote to *The Times*:

> I have thought it right to make Judith looking towards these guards themselves; conceiving she would, as a matter of course, do so. I understand I have been censured for so doing; because it turns the face of the Heroine away from the spectator. It is a principle with me, as far as lies in my power, to endeavour to make my heroes or heroines act as they would do if placed in similar circumstances in reality; without thinking or caring which way they turn their faces: endeavouring to forget all consciousness of Art. ... And I am the more reconciled to this mode of treatment, knowing how much may sometimes be gained by leaving something to the spectator's imagination. It seemed to me the natural and spontaneous mode of feeling and telling the story.[15]

This, suggested Farr,[16] showed that Etty had moved away from the neo–Classicism of an earlier generation. In the *Judith* series he was seeking realism and, by appealing to the feelings

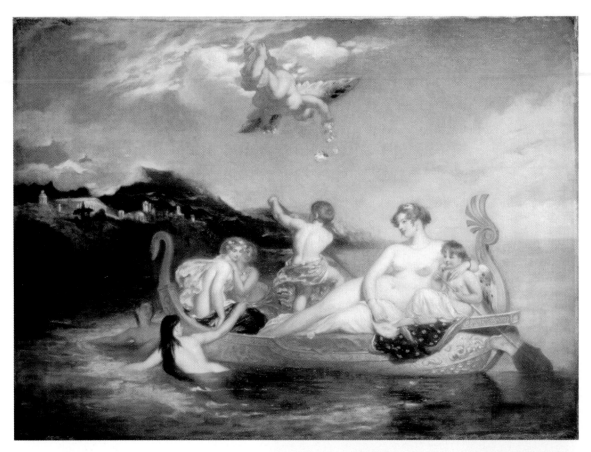

The Coral Finder: Venus and Her Youthful Satellites (replica) (29 × 38.5 ins) (c1820–48), Tate, London 2005.

Head of a Girl
(?copy of painting by Thomas Lawrence) (?1807–08), Agnew's, London, UK/Bridgeman Art Library, AGN 125621/172.

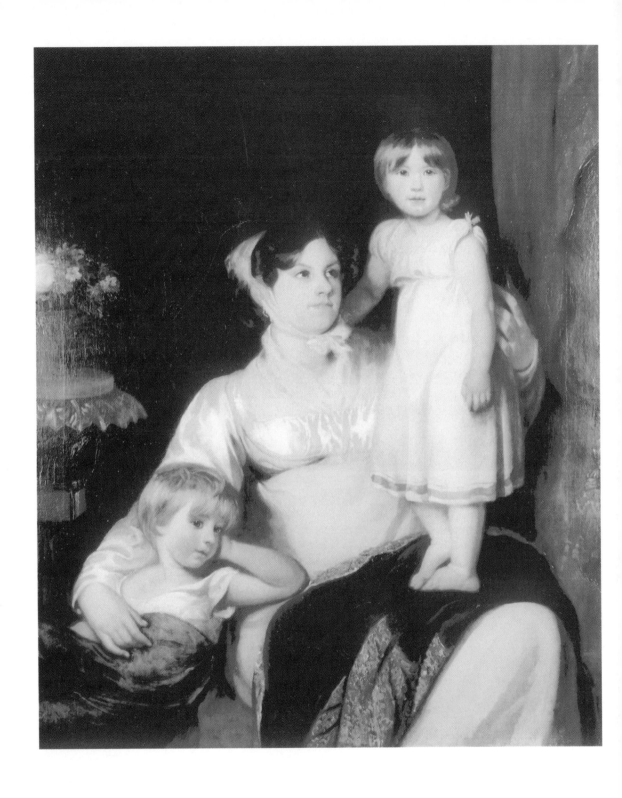

Mrs. Robert Bolton (Anne Jay Bolton, 1793–1859) and Children, William and Anne (50.75 × 41.25 ins) (1819), Collection of New-York Historical Society (Accession No. 1942.350).

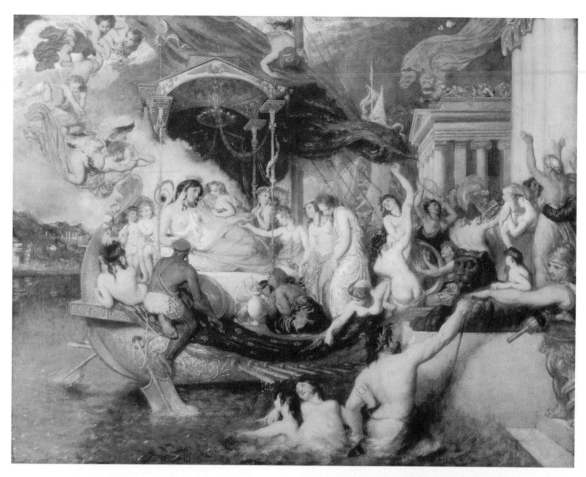

Cleopatra's Arrival in Cilicia (42.25 × 52.25
ins) (1821), National Museums Liverpool,
Lady Lever Art Gallery, LL3589.

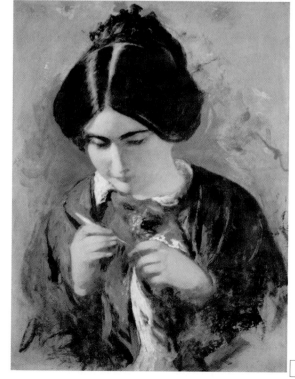

Study for "The Crochet Worker"
(Miss Mary Ann Purdon)
(26.5 × 20 ins) (?1849),
York Museums Trust (York Art Gallery)/
Bridgeman Art Library, London;
YAG23551/117.

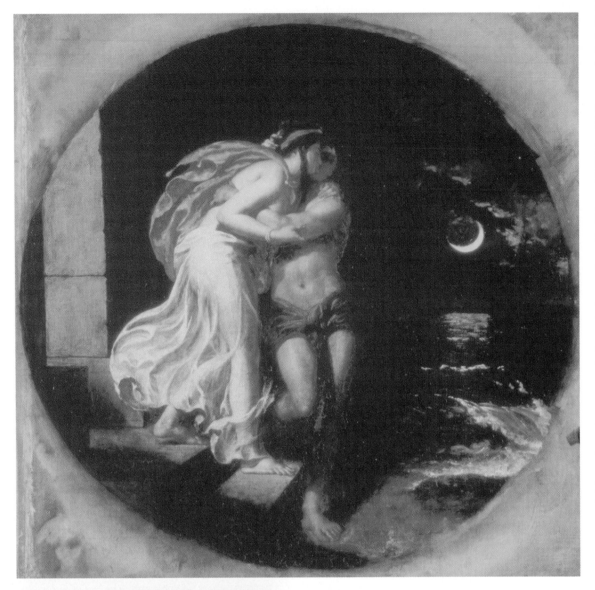

The Parting of Hero and Leander (32.5 × 33 ins) (1827), Tate Britain, London 2005.

Grapefruit and Grapes (10 × 10 ins) (date unknown). This is an exceptional subject—if correctly identified. A small variety of grapefruit had been discovered in Jamaica in 1814 and soon became popular in England and America where it was developed into the modern fruit. Williamson Art Gallery & Museum, Birkenhead.

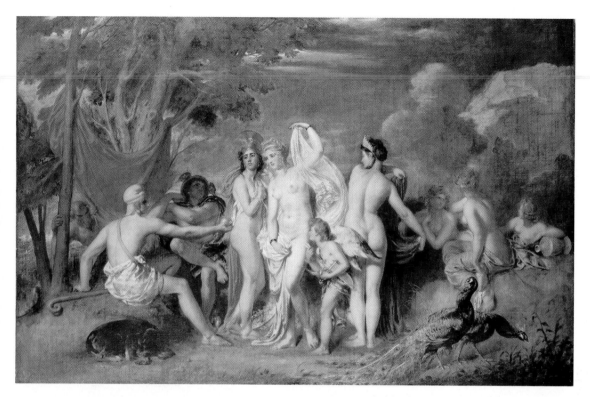

The Judgement of Paris (70.25 × 107.5 ins) (1826), Lady Lever Art Gallery, Port Sunlight/Bridgeman Art Library, WGL193081/78/78.

Benaiah
(23 × 30 ins).
This painting
is the smaller
version exhib-
ited in the
Royal
Academy,
1829. York
Museums
Trust (York
Art Gallery),
YORAG79.

Sleeping Nymph and Satyrs (51 × 70.5 ins) (1828), The Royal Academy of Arts, London.

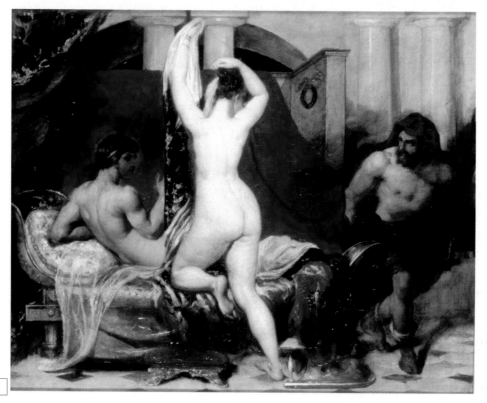

Candaules, King of Lydia, Shews His Wife by Stealth to Gyges, One of His Ministers, as She Goes to Bed (exh. 1830), Tate London, 2005.

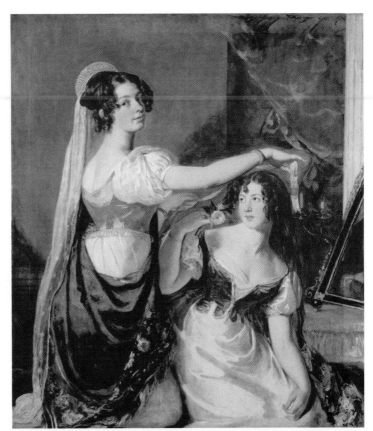

Preparing for a Fancy Dress Ball: Italian Costumes (60 × 51.5 ins) (1833), Christie's Images/Bridgeman Art Library, London; CH35025/117.

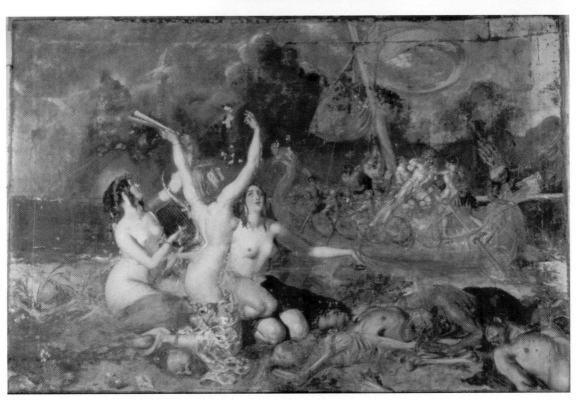

The Sirens and Ulysses (117 × 174 ins) (1837), Manchester Art Gallery.

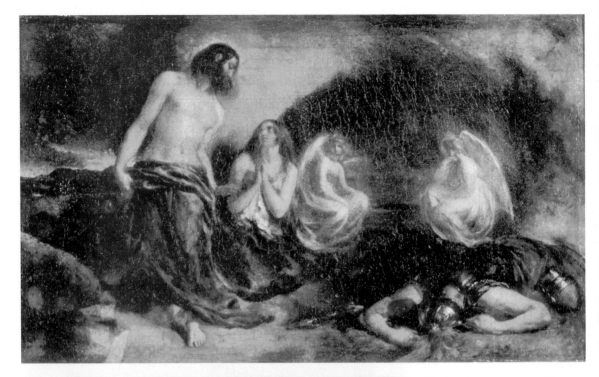

Christ Appearing to Mary Magdalen after the Resurrection (15.75 × 26 ins) (1833), Tate, London 2005.

Elizabeth Potts (33.5 × 28.25 ins) (1831), York Museums Trust (York Art Gallery)/ Bridgeman Art Library, London; YAG23527/117.

Britomart Redeems Faire Amoret (35.75 × 26 ins) (1833), Tate, London 2005.

CIRCE, WITH
THE SIRENS
THREE,

AMIDST THE
FLOW'RY KIRTLED
NAIADES.

Scene from
Milton's
Comus: Circe
and the Sirens
Three (118.5 ×
182.0 cm)
(1846), cour-
tesy Art
Gallery of
Western Aus-
tralia, Perth.

An Israelite
(13.5 ins
diameter)
(date
unknown),
Williamson
Art Gallery &
Museum,
Birkenhead.

10

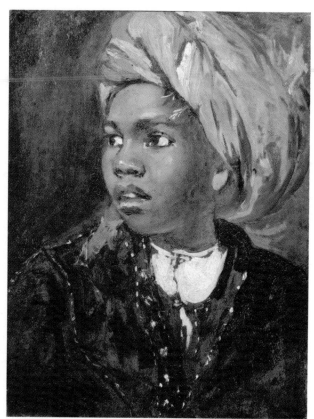

Study of a Negro Boy
(20 × 14.5 ins) (?1833),
York Museums Trust (York Art Gallery)
Bridgeman Art Library, London;
YAG23594/172.

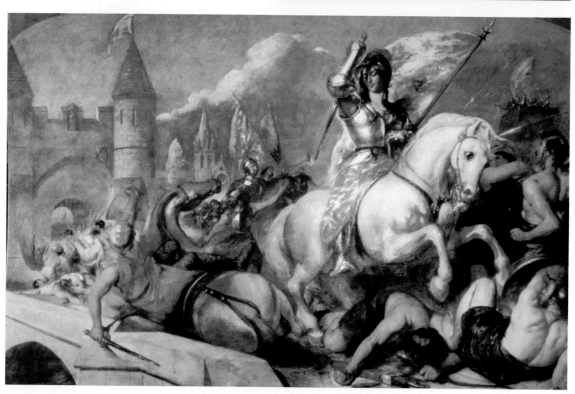

Joan of Arc Makes a Sortie from the Gates of Orléans and Scatters the Enemies of France
(117 × 180 ins) (1845–47), courtesy Musée des Beaux-Arts, Orléans.

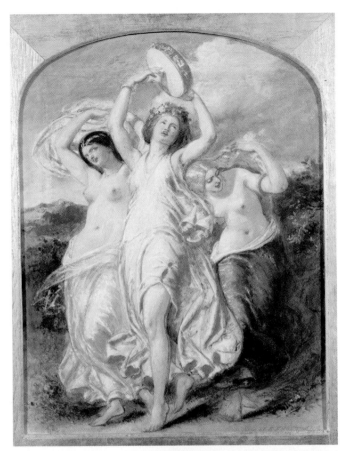

Bacchantes,
by William Edward Frost
(dimensions unknown) (c. 1850),
Private Collection (Bridgeman Art
Library), MAA201372.

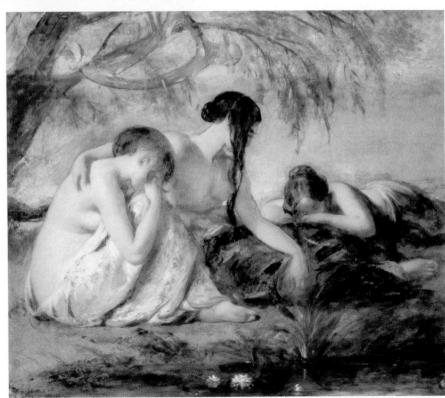

A Group
of Captives
(23 × 26.5
ins) (exh.
1848),
courtesy of
Harris
Museum and
Art Gallery,
Preston,
England.

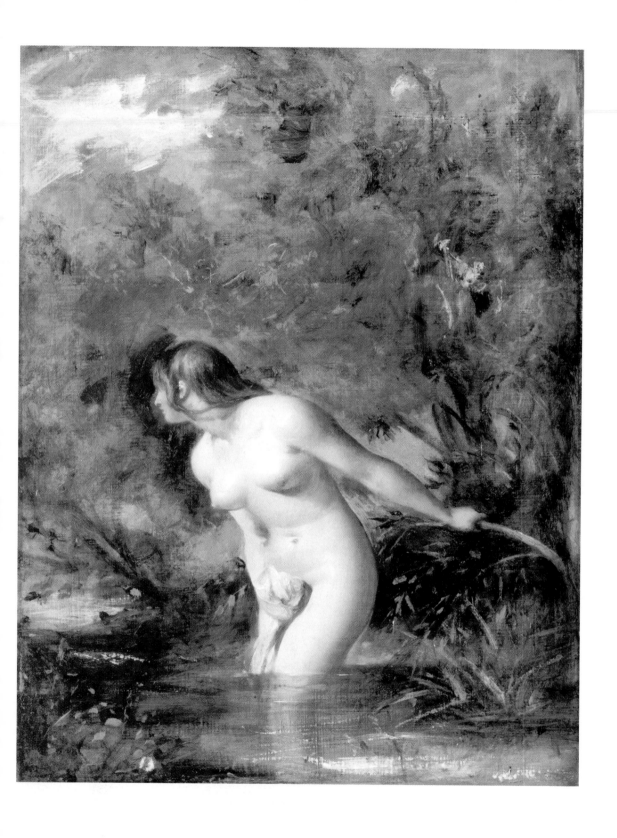

The Bather: "At the Doubtful Breeze Alarmed"/Musidora (25.25 × 19.75 ins) (1846), Tate, London 2005.

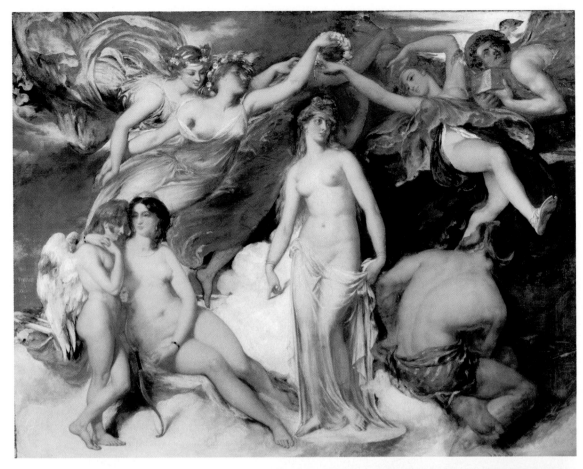

Pandora Crowned by the Seasons
(34.75 × 44.125 ins) (1824), Leeds
Museums and Galleries/Bridgeman
Art Library, London;
LMG112911/78.

Miss Arabella Jay
(30 × 24.75 ins) (1819),
Tate, London. 2005.

The Bather (?exh. 1846),
Leeds Museum and
Galleries/Bridgeman Art Library,
London; LMG157871/12.

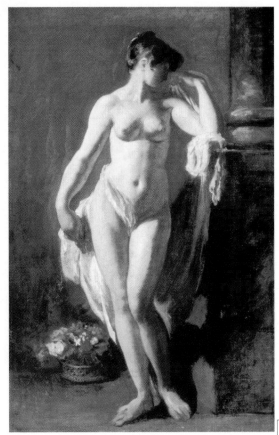

Standing Female Nude (40 × 25.5 ins)
(c. 1835–40), Tate, London 2005

15

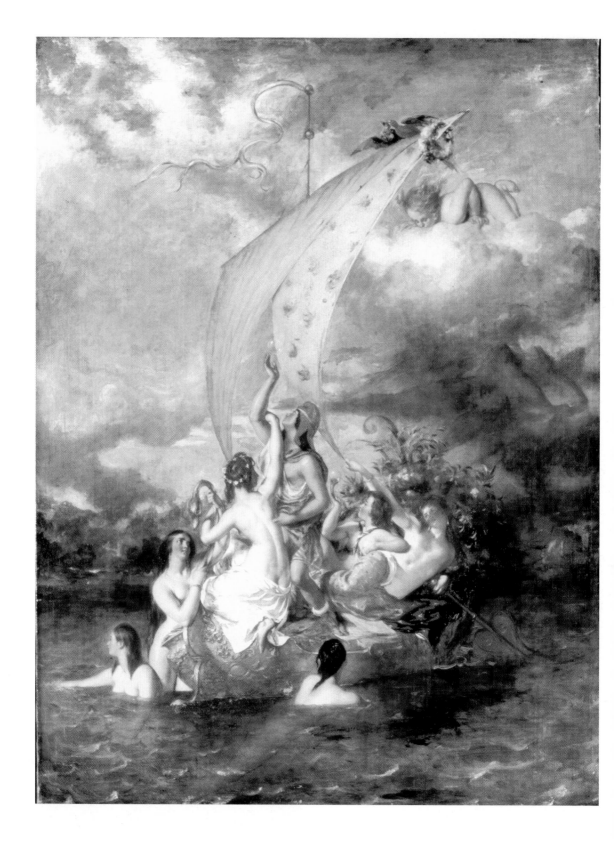

Youth on the Prow, and Pleasure at the Helm (62.5 × 46.25 ins) (1830–32), Tate, London 2005.

of the spectator, a measure of Romanticism. This marks an important though perhaps minor change in Etty's art. Moving from a purely Poussinessque and neo–Classical imagery he now often injected a more fanciful atmosphere often bordering on *rococo* and certainly more Romantic in treatment. It may be said that he moved from Titian to Correggio, from Rubens to Watteau, even, perhaps, it might be suggested, sometimes towards Boucher. He had not wasted his time in the Louvre and Luxembourg Palace but he sadly misjudged the British public who were no longer interested in foreign artists. He had picked up numerous influences but had not always assessed them before assimilating them.

The exhibition of *Judith* in Edinburgh brought praise from another quarter. William Carey, who had earlier published a favorable notice of Etty's work, wrote a long letter to the *Yorkshire Gazette* (29th May 1830) under the pseudonym *Ridolfi* which he frequently used, though why he did so is difficult to understand since Carey was always eager to air his opinions. Carey explained in his letter that he was writing purely out of "public consideration." He had learned that Etty was a native of York though of this he was not certain being of the opinion that he had been born "in the vicinity of this city" and he wished to record his appreciation of this "triumph of the British pencil" (as the artist's brush was then described). He stressed that he did not know Etty, had never met him and was "exempt from the partialities which are, in some degree, almost inseparable from personal acquaintance or friendship." Having thus established his credentials, Carey proceeded to write a lengthy encomium in praise of the subject, of Etty's treatment of it and especially of the "anatomical science" and intensity of feeling that Etty had depicted. Carey's praise knew no bounds. The painting (he was, of course, reporting only on the first panel of the triptych) was a "noble picture."

> There is an intense fervour in the expression and action of Judith.... The form of this lovely Hebrew is of the highest order, and her beauty is rendered more affecting by a certain air of noble simplicity, the true essential of historical grandeur.

The letter filled almost a whole column printed in the small type of the time. It was an effusive outpouring by a critic who wished his readers to know that he had never seen such a magnificent work of art. But Carey felt he had still not said enough. He concluded:

> I am sensible that I have not done justice to this great work of art. It is not easy to point out all its excellences in the limit of a periodical journal. There is no part of the composition that does not show the fine invention and great practical power of the artist.

How much then we must regret that we can no longer see this painting and its companions in their original condition. Though the editor of the *Yorkshire Gazette* (who was a friend of Etty's) was doubtless pleased to print such a communication from a London critic, it is unlikely that it made much impact in York outside a small group of local devotees. But Etty must have gained considerable reassurance that he was well on the way to fame, for here was a leading writer on the arts declaring that his painting expressed "the true essential of historical grandeur." Etty could now truly regard himself an "historical painter."

Etty's other painting that year, *The Storm* (see next page), might have passed for a Romantic work expressing human passions through the forces of nature had Etty not included in the catalogue a quotation from the Psalms. A naked girl clings to a semi-naked man in a cockle-shell of a boat whose sail is about to be blown away. The composition is diagonal and the general theme is of terror and desperate hope. It could have been interpreted as a statement of feminine love depending on male loyalty and resolution. The catalogue note said: "'They cried unto Thee and were delivered; they trusted in Thee, and were not confounded.' *Psalm xxii, v. 5*." The public was not impressed by their plight nor convinced by the quotation. The *Gentleman's Magazine* of May 1830 described it as "a sad failure."

The painting went next to the British Institution exhibition in 1831, did not attract a purchaser and went on to the Royal Scottish Academy in the same year and then to the Royal Man-

chester Institution in 1832. When it was exhibited in the Royal Scottish Academy two further quotations were added to assist acceptance: Psalm cvii, v. 6—"They cried unto the Lord in their trouble, and He delivered them out of their distresses" and v. 25—"For He commandeth and raiseth the stormy wind, which lifteth up the waves thereof." Religious texts might have ensured acceptance had not the unfortunate girl been naked. *The Storm* was purchased by the Royal Manchester Institution in 1832 for eighty-five guineas, fifteen guineas less than the asking price, but everyone knew that Etty could easily be beaten down. It is now in the Manchester City Art Gallery.

A change of Academic patronage

On the 22nd June 1830 George IV died at Windsor castle, which had increasingly become his favorite retreat. His passing was not an event for national regret and it was said that many cheered in the London streets at the news. Neither as Regent nor as King had George attracted any public estimation and only his immediate friends had cause to mourn his death.

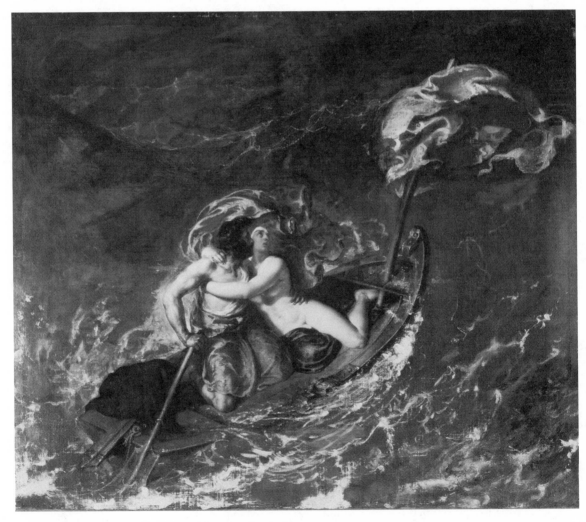

The Storm (35.5 × 41.5 ins) (1828), Manchester Art Gallery/Bridgeman Art Library, MAN62942/100.

So much has been written about his life and behavior that there is no need to repeat details here. Etty seems to have decided to ignore the King's death and, perhaps to avoid the obligation to attend the funeral, also to have tactfully absented himself in France where, as we shall see, he became involved in matters more dangerous than he had anticipated.

The last ten years of the king's reign had been difficult politically for him as he had had to accustom himself to a Tory government of which he did not approve. George had tried to bring about the fall of the government by continually discrediting the Prime Minister, George Canning. In between his unsuccessful attempts to re-assert the old powers of the monarchy he accomplished a number of useful beneficial acts for the nation's arts. In January 1823 he had presented to the nation his father's library of nearly seventy thousand books. It was hardly an act of generosity, he was not interested in books. The government was probably not so grateful as they might have been since it was left to them to find a suitable building to house them. The British Museum was the obvious choice but its premises in Montague House, Bloomsbury, where it had been since 1759, were too small. It was decided to replace Montague House with new galleries and a library and work began relatively quickly to designs by Robert Smirke. The new museum was not completed until 1852 and although admittedly never an ideal building for such an extensive collection, it was a considerable achievement for a nation that never showed much interest in the arts. In the same year, 1823, George had persuaded the government to buy the paintings in the collection of Sir Julius Angerstein and again because of shortage of space in the National Gallery's existing building, it had to be housed in new premises in Pall Mall. Not until 1838 did the national collection finally move to Trafalgar Square but the Angerstein acquisition at George's instigation certainly made the large permanent gallery inevitable. There is therefore a certain appropriateness in the fact that the colonnade from Carlton House, George's earlier home, should have formed the principal entrance to the National Gallery when it was eventually completed. This will be considered later in its due place since, as might be expected, Etty had decided views on the subject which he publicly expressed. George's main interests remained at Windsor where he commissioned Sir Jeffry Wyatville to change the whole character of the Castle, removing its medieval appearance to produce a palace suitable for a modern king.

When George IV died the Royal Academy lost a royal patron of more than symbolic importance. George died unlamented by the general populace but the Academy had lost a staunch supporter and, moreover, one with an astonishingly good taste in the arts despite his general vulgarity. Among artists there was concern that his patronage would not be continued by his brother William and this proved to be the case. There was also concern among politicians and the informed public that a change of monarch might bring social instability at a time when there was already much dissatisfaction among the poorer classes. William's indecisive mind and general unsuitability were to be the despair of ministers. The status of the Academy depended on its royal patronage. In this, George had been generous but William had no interest in the arts and did no more than carry out what had now become part of his royal duties. He formally approved the move of the Academy from Somerset House to Trafalgar Square and officially opened their new premises on the 28th April 1837 but displayed little enthusiasm. The Academy had to learn to accept royal indifference. Later, Prince Albert was to be a staunch supporter and encouraged Victoria to support the arts but after his death neither she nor any subsequent monarch showed any interest. With the accession of William IV the critics and parliament felt free to launch their attacks and kept them up ever since.

With the life-styles of George IV and many of the aristocracy so conspicuous and so disapproved most people blamed inherent defects in the House of Hanover itself and dislike of the Hanoverian kings persisted well into the nineteenth century. Walter Savage Landor wrote in 1855[17]:

George the First was always reckoned
Vile, but viler George the Second;
And what mortal ever heard
Any good of George the Third?
When from earth the Fourth descended
God be praised, the Georges ended!

Although it is possible to complain that Landor was unduly censorious of the first three Georges, especially George III, no one could deny the deserved opprobrium for George IV. Landor's comment that George IV *descended* when he died would not have gone unremarked.

William had spent much of his life in the navy, which made him generally popular. He had joined with his brothers in opposing their father's policies and although he had liberal tendencies he was not consistent; he supported Catholic emancipation but opposed the emancipation of slaves. As a young man he had formed a liaison with the Irish actress Mrs. Dorothea (Dorothy) Jordan, who bore him ten children over twenty years (she already had five children from elsewhere). Their relationship ended in 1811, to which she agreed, when William was compelled to marry Adelaide of Saxe-Meiningen. She received a handsome allowance and moved to France where she is believed to have died in 1816. William's was a marriage of royal necessity but Adelaide was dutiful in her support of her husband though they had no living issue, their two daughters dying in infancy. Until his accession the two lived in semi-retirement in Bushy where most events in public life seemed to pass them by. His private life was generally regarded as a good deal better than that of his brother and consequently he was received as a welcome successor, so much so that when in his first days as king he walked down St. James's Street, ordinary people greeted him and, it is reported, one lady actually kissed him on the cheek. When his retinue rescued him he commented, "Never mind all this, they'll soon get used to it." He asked for his coronation to be a simple affair without the customary sumptuous banquet so that it was dubbed "the half-a-crown-ation" (half-a-crown being two shillings and sixpence).

William's inability to grasp the fundamentals of statesmanship or to be decisive led to so many vacillations that his ministers were compelled to take control over events many of which were then still within the power of the monarchy. When he uncharacteristically attempted to appoint an unpopular Tory government, it had to be dissolved in 1834 when the Whigs gained a majority, thereby establishing the obligation of British monarchs to appoint ministries that had gained electoral support. It was unfortunate for William that his reign coincided with a period of political upheaval. There were problems of parliamentary reform and catholic emancipation as well as "the Irish Question" which had long festered and also the popular opposition to the Corn Laws. The times were changing and politicians were ill-equipped to understand the nature of events. The increasing industrialization of the country was moving wealth from landowners to manufacturers and a new class of factory workers was evolving. The old forms of out-work were disappearing and disgruntled laborers were wrecking machinery. Everywhere people of every class were becoming aware of new social possibilities. Movements demanding various "rights" were openly vociferous—the right to education, the right to vote, the rights of women, the right to religious freedom, the right to form trades unions, the right to shorter working hours, the right to a living wage; almost everything was demanded and traditionalists feared that all that they regarded as essential to a stable society was threatened.

The economic consequences of the French Wars and a succession of poor harvests which increased the price of food had resulted in the spread of distress among the poor to which the Government's response had been the building of workhouses. Whilst it was recognized that absolute poverty and the increase in the orphaned poor could not be allowed no one knew what to do and, as usual, various temporary systems were attempted in trial and error methods, none of which was satisfactory. But one should not be too harsh on the politicians; many of these problems presist. Opinions then were more sharply divided and as *The Times* reported after the

passing of the Reform Act of 1832, there were many "jackanapes" who wanted those demanding reform to feel the "edge of the sword." The Reform Act itself was the work of the Whigs against the opposition of the more traditional Tories and it passed largely because the king threatened to swamp the House of Lords by creating sympathetic peers. So William was not entirely inept. His ministers soon learned how to manipulate him.

We find few references in Etty's letters to his friends to any of these events but those remarks he does make indicate a lack of sympathy with any action to change the *status quo*, although when Parliament did enact changes they became for him the new *status quo*. Etty was not a "political animal." For Etty, as for his fellow academicians, the problem would have been William IV's total lack of interest in the arts. He had succeeded George IV as patron of the Academy but he does not appear to have paid any interest except in one case in 1834. The House of Commons demanded details of the terms of the Academy's occupation of Somerset House, which was still its premises, and also precise details of such matters as the numbers of annual exhibits and exhibitors, the number of Professors and the number of lectures each was required to deliver. It was a clear attempt by Parliament to assume control by demanding accountability. The President, Martin Shee, refused to comply without the King's consent, thereby indicating quite plainly that the Academy was under royal patronage and that it was the King himself who, as an act of grace, was favoring Parliament with the information. Otherwise William IV did virtually nothing until he opened new premises, which proved to be temporary, in Trafalgar Square a few months before he died in 1837.

Unpleasant experiences in France

George's funeral and William's coronation do not appear to have interested Etty very much. As usual there are no surviving comments, if he ever communicated any to his friends. Whatever Etty's private feelings, he set off, early in July 1830 just after end of the Summer Exhibition, to cross the Channel for his fifth visit to Paris. It had been nearly seven years since he last visited the continent. He crossed to Dieppe from Brighton after a preliminary visit there to his cousins, the Bodleys. He sailed by day and was pleased that on this occasion he was not seasick and the crossing proved uneventful The boat arrived at Dieppe about eleven in the evening and he straightaway went to a hotel where he spent the night. He rose early and went for a walk, made some sketches, visited the church and at ten o'clock after a late breakfast he set off for Rouen. He did not stay there long but, anxious to reach Paris, he took the remaining place in a diligence going overnight to that city. This part of his journey confirmed his ever-present fears that travel on the continent was an experience to be avoided. He complained in his later letter to Thomas Bodley that the "diligencies" were too large so that he had to share the inside with five other travelers, being wedged in the middle and so too far from the window. He had to be satisfied with occasional bursts of wind, "comparatively sweet moments." Coaches were always difficult for Etty since he suffered from travel sickness and asthma.

In Paris he met up with Walter's wife and her two daughters, his former pupil James Leigh, two members of the Bulmer family, a Mr. Isaac Brandon and Bishop Luscombe who, in 1825, had been appointed Embassy Chaplain in Paris. Luscombe had now become well known to Etty and may be regarded as having a formative influence on his religious development. Together they visited the Louvre and other places of interest. The weather was inclement with rain and thunderstorms to which Etty referred when he wrote home to Betsy on Sunday the 11th July:

> It is dark, being near ten o'clock, and a great storm commencing. I have been looking out of the window. The lightning shines out every moment like sunshine; and the thunder is rolling in long peals at a distance. ... I hope soon to tell thee about it, face to face some night at tea.
>
> How often, how tenderly, I think of thee! what art thou doing, and thinking, and planning, wishing; think of thee, and my sweet, quiet Home—*thou* who mak'st it doubly sweet to me—What a contrast to Paris! It is well worth while to come here, to be sensible of *its* value.

While I write, the storm increases in power, and flashes terrifically in blue flashes through my case-ment. The wind roars; the rain falls. The thunder peals louder and louder: as if God spoke in anger to the gay and giddy multitude of Paris (and all of us indeed), as they crowd to the theatres, balls and *cafés*.

What a place it is! If I had a daughter, she should *not* be educated here. Pleasure and amusement are the idols. And little do they think of that which is a woman's domestic honour and chief praise.

Etty was referring disapprovingly to his brother Walter's having sent his daughter Jane Eliz-abeth to a finishing school in Paris, this being the reason why Walter's wife was in Paris at the time. It was by now usual for Etty to write affectionately to Betsy whenever he was away and he had soon acquired the habit of doing so at least weekly, usually on Sundays. He had come so to rely on her that he could not bear that they should be parted. As the years progressed he wrote to her in ever more affectionate terms, causing some to suggest that their relationship had ceased to be wholly familial. Certainly his dependence developed into deep affection and probably love but the evidence of his voluminous correspondence with her strongly suggests that their rela-tionship was always that of uncle and niece.

He stayed at a lodging house he had previously used and only saw the rest of his party "now and then," taking them to see various churches and places of interest. Otherwise he spent his time copying paintings in the Louvre. He also visited "some of the principal Artists in their Ate-liers and saw what they were doing." He decided that he did not like Paris as well as he had on previous occasions, but worse was to come. The weather was consistently appalling with so much rain that streets were flooded. "Last Sunday," he wrote in the same letter to Betsy,

> one of their principal streets was like a River. As indeed, most of 'em are when a heavy shower falls;— cant be crossed except on planks; coaches, gigs, and carts, splashing in them knee-deep; sewers not being common. The scenes are then, to an Englishman, most extraordinary and amusing:—not so, if he is *out* in it.

How Etty could believe that things would be better in London in such circumstances is difficult to understand. There was no effective system of draining London streets in 1830 and none was required until 1848 and even then it was merely spasmodic until the closing years of the century. London could hardly have been much better than Paris in the drainage either of streets or houses. But Etty was always an Englishman abroad making unfavorable comparisons. "Not that I am sorry I have come. It is the best thing one could do. It quiets all restless long-ings." So his visits to the Louvre were rewarding, this being the nearest town with a public gallery where he could study Old Masters. Local students found his daily routine amusing but were reportedly impressed by how quickly he could make copies. He visited old acquaintances and met his former pupil James Leigh who was no doubt pursuing his idea of opening an *atelier* of his own. He made a copy of Titian's *Christ and His Disciples at Emmaus* and also, somewhat sur-prisingly, of Ruysdael's *Fresh Breeze, Sea-Coast*, which he described as "just like Brighton." The time passed pleasantly. He visited the Tuilleries Gardens the next Sunday and found them thronged with young men and women but, in a letter of the 18th July to Betsy, expressed his disapproval—"I like not these things on a Sunday. It goes much against my grain." Despite his inclinations towards Rome he was still influenced by his earlier Methodism. Apparently he was unaware that foreign visitors to London invariably commented on the behavior of Londoners in public places on Sundays, especially London Fields where there was reputedly much flirta-tious familiarity between the sexes of the poorer classes. Certainly the middle classes behaved with propriety but by no means all went to church or chapel.

By now the weather had changed. It was very hot and fatiguing but he worked on in the coolness of the Louvre. A new idea struck him. He asked Betsy: "I suppose I shall be accused of High Treason, if I ask you to have a look at Rubens and the Low Countries: should so much like to see them ere I return:—and in *your* company."

This suggests that Betsy should join him but it was, of course, out of the question. She

could not travel to Paris unaccompanied. It was an idea he stored up for the future. In any case, other events made such a proposal impossible.

By the 27th July it was becoming obvious that trouble was brewing in Paris. People were assembling on the streets and expressing their discontent. The previous day Charles X had published three ordinances: abolishing the chamber of deputies, restricting the freedom of the press to such an extent that everyone regarded it as virtual abolition, and reducing the electorate to landed proprietors only. These ordinances had been prompted by the continual hostility to the king's autocratic attitude to the government. He was not a man to accept opposition. The resultant uprising was confined to Paris where armed demonstrators took to the streets, erected barricades and prepared to oppose the military. But, confined to the capital though it might be, it was a serious threat to the monarchy and became known as the 1830 Revolution. Etty found himself caught up in the situation although, as usual with him, he seems to have believed that he could stand apart and remain unaffected because, as a foreigner, it had nothing to do with him. On his return home to London in early September, Etty wrote Thomas Bodley a long account of his experiences from which the following extracts are taken.[18]

At first, on Monday 26th July, although crowds were gathering on the streets, he went about fulfilling his plans of visiting the Louvre and other art collections. He does not seem initially to have realized what was happening. He and Bishop Luscombe went to the Palais Elysée Bourbon to see "the finest Flemish Pictures I have ever seen as a collection." That evening he visited an old friend, Isaac Brandon, drank tea with him, "talking about Poets" and then on the way back to his lodging was challenged by "a sentinel" who warned him that all was not peaceful. Drums began to beat, soldiers cleared the *cafés* and "that night the fray began." Next day he went to the Louvre but while there a friend came to warn him that "the People were collecting in great commotion and were all shutting their shops and the alarming appearances began to manifest themselves." Then news came that "the people have massacred a spy and were reported to be dragging his body in triumph around the Palais Royal." He stayed in the Louvre until it closed at four o'clock and found the streets full of shouting people "hurling vollies of stones on a large body of cavalry galloping up and down the Rue St. Honoré." "The mob" had taken prisoners, the soldiers charged with fixed bayonets and Etty and his companion had to run into the Palais Royal for safety. Even so, Etty ventured out that evening to visit Bishop Luscombe. Soldiers were everywhere. He saw a woman in a shop selling gunpowder to anyone who wanted it. Her husband disapproved and shot her dead before Etty's eyes. "He shoots her through the head; in a moment she is lifeless at his feet." This made Etty realize just how serious the situation was. Despite being timid by nature he decided to walk about to see for himself what was going on.

[I] went up the Rue de la Paix towards the Italian Boulevards, I thought the upper part of the street looked suspiciously calm,—and few people; while the other part had more (near the soldiers). Just as I was about to turn the corner, on comes the Mob, in full cry:—*Vive la Charte!* and a thousand other cries. Smash go the splendid lamps. On they come. A *porte-cochère*, just closing, afforded me and two or three others time to get in at the door (of a strange house), ere the porter closed it. With fierce cries they carry on the work of destruction. And there we were, not knowing what would become of us. In course of a quarter of an hour, they seemed at a greater distance. And we gladly escaped this nightly havoc.

It was a frightening experience. There was "the rattle of musketry, drums beating arms, the crackling of fires." He went back to his lodging and heard the sounds all night. Yet still he did not understand what was happening. For Etty it was "the Mob" who had risen against their social superiors, the long-dreaded fear of the English affluent classes. Next day he went to the Louvre again. The attendants asked if he really meant to work there, to which he replied, as he reported, "Oui si vous plait [*sic*]," always pleased to display what little French he knew. He encountered only two Englishmen, one American and three Frenchmen. He thought once or twice of leaving but hearing cannon fire decided to stay. The attendants were "not comfortable," so eventually everyone left to find running battles on the streets. For the rest of his stay in Paris, Etty followed Falstaff's

advice "not to seek the bubble reputation in the cannon's mouth" but to go out only for such necessary purposes as eating at such *cafés* as were open.

Thursday 29th July, "the day which finished the fate of Paris," wrote Etty to the Bodleys, saw the worst of the fighting. Barricades had been set up, "great baskets filled with stones" and the cavalry charged down the streets. He tried to find somewhere to buy something for dinner but shots were fired and the *café* he approached "put up the remaining shutter in quick time." A wounded man was carried by. People were tearing up the pavements to form barricades. "The alarm and anxiety on all sides were terrific" and Etty began to realize that he might be killed after all. He decided to call, rather belatedly, on Mrs. Bulmer and her daughters, which he said was as well since that morning the Louvre was attacked. He found the ladies "much alarmed." After staying with them a while he set off back to his lodging but decided "If I was to die, I had rather die in the open air." So he set off to look around, "saw noble trees, the growth of ages, cut down and lying across the street; armed men flocking westward, and in the Quartier Mont-matrre, a group of Revolutionists parading with the tri-color flag and drums, armed."

About four o'clock, the firing having slackened, he set off to return to his lodgings and

found the scene changed, the soldiers were beaten, the Mob were keeping guard at the street ends, the tricolor flag mounted on the Barricades and groups of half-tipsy, victorious Revolutionists armed, were met everywhere and looked anything but amiable.

Etty proceeded in a very frightened state of mind but "got home without molestation."

The next day Friday, the fighting had ceased, the People and Liberty had triumphed over all opposition, tho' it was said the cessation was only for twenty four hours, and that Marmont, Duke of Ragusa, was to enter Paris at night.

He set off to visit Walter's wife and her daughters. Their house had been in the thick of the fighting but by the time Etty reached them "they had in some measure recovered themselves and seemed as well as under the circumstances could be expected." He bought some currants, bread and wine for lunch and stayed with them for an hour or two and then set off back to his lodging. It certainly seems curious that he did not visit either Walter's wife or Mrs. Bulmer and their respective daughters until several days after the beginning of the uprising but persisted in working in the Louvre. Probably he believed them to be the responsibility of Bishop Luscombe. Clearly he had no intention of abandoning the purpose of his visit to Paris. By this time the Duke of Orléans had entered the city and accepted the office of Lieutenant General which seemed to be generally acceptable to the people. Etty still felt threatened as he went through the streets although he was "not molested or insulted—and reached home in safety," as he told the Bodleys.

Etty's attitude to the uprising was ambivalent. At first he clearly thought it was nothing to do with him as an Englishman and that he could pursue his plans of painting in the Louvre without being in any way affected. Then his attitude became unsympathetic to "the Mob" whose cause he obviously did not understand. If politics in England held little interest for him, then politics abroad certainly held none. Like most Englishmen at the time (or indeed at any other) he was unaware of the political and social changes that were taking place throughout Europe. It must be concluded that even the developments in England in the constitutional roles of King and Parliament were of no interest and that he took for granted the comparative freedom of the British press. He would have been wholly ignorant of the political and social conditions in France, or anywhere else. Etty strongly disapproved of any expression of popular unrest and armed uprising was something he not only had never experienced but regarded as wholly con-trary to civilized behavior. He never understood why the poor could be disaffected. Yet, in the final days of this short uprising he seems to have changed sides. He writes of seeing two corpses in the streets. "What is that!—look! there are two of the dead! two who struggled in the cause of freedom and fallen." He collected anecdotes of personal sacrifices and walked about Paris

noting how many streets were stained with blood. He appeared to be realizing the terrible price paid by people who had sought "freedom"—whatever that meant in France. By the time the uprising was over and the king had capitulated he was able to accept that it might have been necessary after all. He wrote to Thomas and Martha Bodley:

> I am not sorry to have been there, and to be able to say that I have been there but it was in truth an alarming yet impressive scene. It can never be erased from my memory nor the goodness of God that tho' I was out all the days, yet preserved me from harm.

As usual Etty believed he was under a special protection, a conviction that stayed with him all his days. It is most unlikely that he had any idea why the uprising had taken place. He certainly did not refer in his letters to the king's actions which had precipitated events. He did not seem to understand the genuine social problems involved, nor did the fact that the general populace accepted the Duke of Orléans as their governor suggest to him that they had no desire to overthrow the established order provided it offered the degree of democracy that would satisfy them.

Etty gave a briefer account of these days in his *Autobiography*[19] in which he referred to "the Three Days' Conflict and the flight of Charles *Dix*" followed by a stormy night "—I never witnessed anything like it—I really thought the end of all things was at hand." He was relieved to return to England and at Dover he "went on Shakespeare Cliff and turned to the tranquil blue sea that divides us from France. It was just like Landseer's picture of "Peace." "'Happy England,' said I, '*if only* thou art sensible of thy true happiness.'"

These were the events Delacroix celebrated in his painting *Liberty Leading the People*, which he exhibited in the 1831 Salon and which the French government bought for 3,000 francs—and which it later regretted. Delacroix portrayed the allegorical figure of Liberty as a bare breasted heroine of the Paris streets wearing a Phrygian cap and holding aloft the tricolor as she leads the insurgents over the barricades. It is directly descended from his *Greece Expiring on the Ruins of Missolonghi* of three years earlier. Delacroix was still the revolutionary, optimistic that a new world of liberty, fraternity and universal peace was just over the horizon waiting to be inhabited by those brave enough to overthrow the powers who oppressed them. This was certainly not a view shared by Etty, who all his life doubted that the dreams of political visionaries could ever come true. He saw society forever divided between Good and Evil, the Manichaeanist view of the world which Christianity has always denied but which many have nonetheless always found appealing. We will consider Etty's beliefs later in the context of England's political problems.

"An affair of the Heart"

Yet in the midst of all this upheaval Etty had found occasion to fancy himself in love—yet again. Gilchrist said[20] that "In Paris, he finds a sister-in-law, with her daughter; also a fair friend from York, who had immediately preceded him, and *her* daughter." By the end of his visit Gilchrist said[21] Etty "had insensibly become enamored of a beautiful girl and accomplished young friend, some twenty years younger than himself, who had barely ceased to be a schoolgirl—an Englishwoman but not this time in England." He was now 43 years old, the young woman was therefore a little over 20 years of age, hardly still a school-girl but probably just out of a French finishing school. No details are given of their meeting but she was clearly the young woman earlier mentioned. Etty declared his love but she, while promising to "feel great esteem and affection," decided against him by reason of "disparity of years." It might seem to have been love at first sight but Gilchrist said Etty had known her for many years and that "he had more than once, from admiration of her as a subject for his Art, painted her portrait, when she was a child; and,—what was less prudent for his peace,—when she had ceased to be a child."

It would appear therefore that he knew her in England and she must have been the daugh-

ter of a friend of the family. Gilchrist gives no authority for any of this but places occasional words and sentences in quotes as though relying upon some letters which have not survived. As has been remarked before Gilchrist frequently recorded conversations he could not have heard and incidents he could not have witnessed. Probably he was drawing upon records no longer available or on the recollections of others whose identities he did not record. Though we cannot always trust the details, there is no need to doubt the veracity of the incidents. Gilchrist said[22] that Etty remained so much in love with her that he attempted many times later to paint her portrait but was denied permission "by the responsible powers: lest past unhappiness be revived." This is yet again another instance of Etty imagining that he had fallen in love with a young woman, so many years his junior that he could feel protective towards her rather than truly consumed with passion which was probably alien to his nature. Etty appears to have been one of those men whose interest in women was more avuncular than connubial yet Gilchrist asserted that "he was once more IN LOVE; deeply, desperately, and again, almost hopelessly.—indeed, *quite*, this time." "The love-storm—that 'miserable madness, though not without its *délices*,' was vehement as the last, while it continued, and he as vehemently unhappy."[23] In time he saw the young woman married to someone else and in due the course the mother of "numerous pretty children."

Older men falling in love with, or more usually desiring, younger women was not uncommon at this period and was becoming increasingly regarded as presenting a social problem. Among the general population the age of marriage gradually increased over the century as men waited to attain some economic stability before taking a wife and in consequence the age difference between husband and wife increased. By the mid–nineteenth century a difference of five years was quite normal. But it was among the wealthy and especially among the classes seeking quick social advancement that the real problem arose. Either the woman brought an attractive dowry or one of the parties brought an equally attractive title, also usually, but not always, with money and property. Young heiresses were particularly vulnerable. Novelists of the time often introduced elopement, seduction and blackmail into their plots. It would appear that one of the attractions of Bath was the seasonal influx of young marriageable girls. However, no one could accuse Etty of being mercenary in his view of women. Although he had on an earlier occasion asked his brother whether he should seek a wife with some property of her own, this was not so that he could acquire it, which was the legal consequence of marriage at the time, but to ensure that she was not marrying him merely for financial advantage. Etty seems to have been incapable of contemplating marriage to a mature woman, one of his own age, but felt more comfortable with someone inexperienced. He was by no means alone in this. In an age when the generality of the population never openly faced sexual questions he would undoubtedly have found difficulty in introducing a spouse into his life.

The notion that marriage should be companionable arose in the seventeenth century and was urged by the more Puritan preachers as an antidote to mere sexual attraction. The counterview remained that marriage was a dynastic contract, a view that the nobility was unwilling to abandon. Throughout the eighteenth century there were predominately two views of marriage and each had its adherents. In 1726 Daniel Defoe complained that most marriages were decided by the appeals of "the money and the maidenhead" and added that "persons of a lower station are, generally, speaking much more happy in their marriages than Princes and persons of distinction."[24] Etty could look to his brother John for evidence of a happy marriage and to his brother Tom for evidence of an unhappy one. Probably, like Dean Swift, he thought it would be safer to take a young girl straight from school and train her in his ways.

Etty and politics—Reactions to reform

The events in Paris caused waves of reaction across the Channel. For some time there had been a movement among the more liberally minded Whigs that the English electoral system

needed reform. Not only was the vote restricted to males who possessed a 40 shillings freehold assessed to land tax or, in boroughs, to freemen only or in some areas to those possessing some ancient and arcane privilege, there were also considerable differences in the degree of representation that each electoral area enjoyed. There is no need here to examine the matter in any detail, which can be quite readily investigated elsewhere, but the term "Rotten Borough" must be familiar to everyone as describing those places with excessive representation and where members were "placed" by local interests rather than elected. The Reform Movement had begun proposing remedies in 1780, to extend the franchise and to ensure a more democratic system, though not, it must be said, approaching anything like that which would be acceptable today. The campaign was contested long and bitterly through no less than five distinct phases before a bill with some chance of success was eventually placed before Parliament in the autumn of 1830, though it was not to be passed into law, after much amendment, until 1832. Events in France since 1789 had not encouraged acceptance and the latest uprising in the summer of 1830 presented opponents with what they considered to be a prime example of what would happen if "the Mob" was let loose. Most Englishmen had only a passing acquaintance with French politics or, indeed, with English politics, and they were ready to believe that the French uprisings were the consequence of extending rights to the ungrateful poor who then demanded more rather than to their having no rights in the first place.

Unfortunately Etty appears to have been of this opinion. In one of his few comments on contemporary affairs, he wrote to brother Walter expressing the view that "Reform was an evil." He also, but on no more than two occasions that can be traced, declared that the Whigs would do the country no good. In a letter of the 16th August 1831 to Mr. and Mr. Bulmer he wrote: "I am like yourself, sick of the hackneyed phrase REFORM; fear it will, like the Whigs, never do much for us."

Etty held the conventional opinion of the time that the poor were no more than a "Mob" who would run riot, loot and ravage the country if they were not kept under control. He looked back to the years of the Reformation when churches and monasteries were ransacked and to the Commonwealth when iconoclasm was even more widespread. The rule of the common man meant anarchy. Now, some of them were wrecking machinery and some were trying to form trades unions, which everyone regarded as an unwarranted challenge to employers. The poor attracted scant sympathy. They were held to be responsible for their own condition through idleness, drunkenness and a natural inclination to crime. Every one was seen as the "Captain of his Fate." It was everyman's duty to improve his condition if he could and clearly, therefore, those who did not achieve this had not tried hard enough. The poor had only themselves to blame. To extend the franchise to the "Mob" would result in social chaos. But the Reformers had no such plans. They proposed limiting the franchise to those males who occupied a house of at least £10 annual value. This retained the property qualification so beloved by politicians but changed it from ownership to occupation. It would at least be applied consistently over the country. But more important were the proposals to remove disproportionate representation by relating the number of members in a constituency to the number of voters. For the times these were bold proposals but some who were promoting the Bill had other motives and the consequences were of the most significant importance to the development of English society. When eventually the Reform Bill was passed in 1832 it had the effect of raising tradesmen into the lower middle classes by including them among property owner-occupiers.

Etty knew nothing of this. We have no evidence that he ever engaged in political discussion or troubled himself by thinking very much about politics. His opposition to Reform was based on his preference for traditional forms. He was one of those who say of anything they prefer—"It has stood the test of time." He certainly did not view the events of that week in July in Paris with the Romantic imagination of Delacroix. He would have been at a loss to see in the insurgents any bare-breasted Marianne mounting the barricades. No symbol of *liberté, egalité,*

fraternité, but rather a pack of discontented ruffians seeking to usurp the rightful power of those in authority. Had not God himself sent a storm to signal divine disapproval? Certainly Etty wrote later that "the People and Liberty had triumphed over all opposition" but this was only a momentary opinion influenced by the obviously unsatisfactory state of politics in France. Safely back in England he could reflect that here things were done differently, largely because the "People" had little to complain about, or rather, the people with whom he consorted. Etty had probably never seen a London slum and his knowledge of the poor was confined to those he would have ranked as "undeserving," the thieves and pick-pockets, the beggars and the women who lined the streets soliciting passers-by. But the English certainly did things differently. Dissatisfied they might be but they did not take up arms and threaten their king; they had done that once before and had not liked the result. Now they just asked for the vote.

We cannot regard Etty as a pioneer who used art to proclaim a new Jerusalem. There were few in England at this time who were doing so, and those who were or had done so, like William Blake, did not view the future as political reformers but as religious prophets. The Romantics were visionaries but of a different kind. Mostly they confined their ideas to requiring art to express feelings rather than pure reason. What they wanted was an art that appealed to those who had not been confined to a classical educational straitjacket. Such views did not appeal to Etty. In politics the English Tories could achieve all he desired and in religion he had the Church of England and its traditions. The so-called "Age of Revolutions" was not to reach England.

CHAPTER NINE

A tour of the north

The spring of 1831 saw the conclusion of the current disputes at York Minster and the submission of works to the Academy exhibition. Apart from *Judith Coming Out of the Tent of Holofernes* the others were minor pieces, *Sabrina*, *Nymph Angling* and *Window in Venice During a Fiesta*. Sir Francis Freeling bought *Sabrina* for one hundred guineas and Robert Vernon bought *Window in Venice* for £100, while *Nymph Angling* (see next page) was bought by Charles Birch for forty-five guineas when it was subsequently exhibited in Manchester. *Judith* met with qualified praise. *The Times* of 6th May declared it to be "well-executed; but the subject is hardly worth the labour that has been bestowed upon it." The new critic of *The Times* could never bring himself to like anything that Etty exhibited.

In August 1831 Etty decided that as he was to take the third canvas of the *Judith* series to the Scottish Academy, and being always concerned that the carriers of the time were not to be trusted with valuable and fragile goods, he would use the occasion to visit some places that he had never seen before. His concern was well founded. When later, in 1857, Turner sent his painting *Rockets and Blue Lights (Close at Hand) to Warn Steamboats* to Manchester for exhibition he insisted that it be sent by horse and cart as he did not trust the railways. Unfortunately it was seriously damaged in an accident at a level crossing and could not be shown. Accidents by carriers were commonplace. Etty's decision to use the occasion to visit the north of England was sensible. Most of his contemporaries did so as a substitute for the Grand Tour which was now too expensive and regarded as old fashioned. For over a century there had been travelers who, either because they could not take the Grand Tour to Italy or had wished to vary their experiences, had visited the picturesque scenery of Wales, Derbyshire, the Lake District and Scotland. Many artists had also toured these areas to make sketches for more ambitious paintings. Among them, Turner was the most eager traveler, having made his first tour of the North in 1797 when only eighteen years of age. In 1831 he made one of many visits to Scotland and it may have been this which alerted Etty to do something similar. On 16th August Etty wrote to his friends, the Bulmers, in York that he would be leaving soon for "Scotland via York."

> To vary the monotony of a route I have so often taken, I intend to go to Leicester; thence, through Derby, Sheffield, Leeds, to York. By which means, I hope to see—what I am so fond of,—more of the beauties of Landscape and natural scenery. After resting a day or two in York, I think of going by Durham, Alnwick, etc., to Edinburgh; shall probably see a *little* of the Lakes and Mountains of Scotland; and may, in all likelihood, come back through the Lake scenery of Cumberland, Westmoreland, and the North of Yorkshire, to York.

He did, in fact, also visit Glasgow and the Highlands, though he did not venture very far north in Scotland. Unlike Turner he did not ride horseback and always relied on public coach services, so he was limited where he could go and though this restricted him to main roads there could be little expectation of comfortable journeys, roads then being often little better than tracks. On the other hand he was more venturesome than Constable who disliked all traveling,

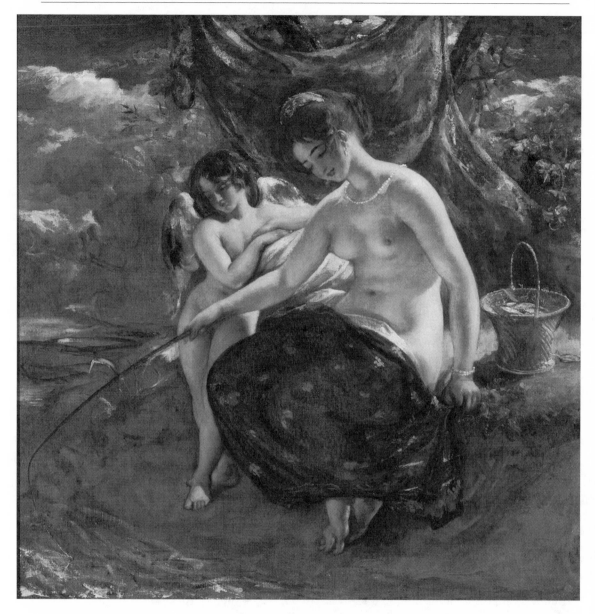

Nymph Angling (22.5 × 21.5 ins) (1831), Private Collection/Bridgeman Art Library, London; VFS109710/78.

preferring the comforts of home. Writing to Thomas Bodley from Durham on the 3rd of September Etty was enthusiastic about the speed of the coach named the *Red Rover* on which he had traveled, though critical of the over-employment of the bugle used to herald a coach's approach to any habitation. "We went sometimes at a tremendous rate; for we got to Town in about five hours. ... I saw all my friends I expected to see, at Leicester, Derby, and York; could not accomplish Bakewell and the beauties of Derbyshire."

In Durham he went to the Cathedral and, as ever, was drawn into comparisons with his much loved York Minster. He stayed long enough to attend evening service on the Sunday.

Ensconced in a stall, and amongst the dark old tabernacle work, a little effort of the memory carried me back to my dear Minster before the late calamity. ... It is a very noble structure, of an earlier date than

ours, and though inferior in beauty, has much, very much, to be admired, and has *had* much more, but a tasteless and unfeeling fellow of the name of Atkinson,—let his name be known!—a disciple, I suppose of that barbarous Wyatt, who spoiled Salisbury and Lichfield Cathedrals, had it washed over with thick whitewash. Columns of beautiful, variegated marble, tombs of exquisite workmanship, painting and gilding, marble shrines of saints, warriors sleeping in armour: all were swept into one insipid, overwhelming, clogging whitewash. I would have such a wretch dipped, for once, in a tub of whitewash himself, and see if his friends would know him when he came out!

William Atkinson (1773?–1839) was indeed a pupil of James Wyatt (and was probably the same William Atkinson who had been executor to Uncle William's will). He had started as a carpenter and after his pupilage gained a gold medal from the Royal Academy in 1795. Etty continued to complain about Atkinson's treatment of Durham Cathedral, especially the removal of the Chapter House "a few years ago." Gilchrist noted his own approval of this removal, "by way of making a clear space round the Cathedral,—... an emendation due to the united genius of Wyatt and Bishop Harrington." But Gilchrist went on to deplore the rest of the work carried out by the "Restoring spirit" at Durham, the removal of the organ screen and "the whole interior of the Church [*which*] is rudely laid bare from Galilee to Altar-Screen, the meaning of the Choir falsified, and the Medieval plan 'improved upon' and marred."[1]

Etty did not report on Newcastle nor his visit to Alnwick where one would have expected him to have visited the Castle and seen the Duke of Northumberland's collection of paintings. He was eager to get to Edinburgh and deliver his *Judith*. To Walter on the 18th September he wrote:

I found my friends had long been expecting me. ... Though many people are out of Town, I have found as many as I wanted. For they are very hospitable; and have made much of me: asking me out to dinner every day since I have been here. Which, with four or five days' fag at my Pictures, has been my employment in full, together with seeing a little of Edinburgh.

Etty's reference to "four or five days' fag" refers to the custom of the time to retouch and even repaint sections of paintings whenever they were exhibited. The excuse was that they had suffered in transport but it was also an opportunity to strengthen areas declared in previous exhibitions to be weak in execution. He had already written a longer account to Betsy on the 14th September.

After looking about me for one day, I attacked my Pictures; dusted, washed, rubbed, and varnished out, where I thought they wanted it; and then began to paint, principally on the one where Judith gives the Head to the Maid. After several days' painting, I think I have infinitely improved it. All here are surprised at its great improvement, and at the harmony, unity,—and I think I may add, without much vanity,—the grandeur of the whole *Three*. They are in a fine light; and I should like Walter, Thomas Bodley, Thee, and old Franklin to see them.

All that done Etty felt free to make some excursions. On the Sunday he took a coach to the Vale of Roslin and saw the ruined castle, then on to Dalkeith Castle where he saw the collection of pictures, including some much admired "Canalettis, Views of Venice." After Edinburgh he moved on to "manufacturing and dingy" Glasgow which he did not enjoy. From here he made an excursion to Dumbarton and Loch Lomond. He spent a day in Glasgow "to retouch some hasty scrawls I made while passing up the Lake," as he told Thomas Bodley by letter of the 15th October. Then off along the Clyde to see the Falls where he left the coach for a walk in "scenery wild and romantic as Painter could wish." After being directed to the Boniton Falls he was

alone with Nature; Nature so impressive and exciting;—the thunderous cataract, the rocky cavern, the light, wild foliage dancing over the deep and dark ravine, through which, the waters hurriedly rushed, white as ocean in its foam and anger, clear and dark in its depths.

Here is evidence that Etty, though entrenched in Academic history painting, was probably as naturally Romantic as many others of his day, able to respond to the emotional appeals of

Nature which he would have expressed had he also been a natural landscape painter and had he been able to accept the Romantic belief that the old academic rules should be discarded. From Glasgow he moved to Carlisle, traveling through "a most pelting and pitiless storm" so that despite his cloak he was "wet through ere noon." Carlisle was but a staging post and he went on to Penrith the following day. Again it rained all day. He traveled "inside" to Keswick and from there took the *Lake Tourist* to Kendal. The name of the coach indicates that the Lake District had for long been attractive to tourists. He saw "all the Lakes and Waterfalls in the way, that a heavy rain would let me." This was a disappointing introduction to the Lake District but one which many visitors both then and since have experienced. He stopped *en route*, having a letter of introduction to "Professor Wilson, the Edinburgh Poet, who has a pretty place on Windermere.... I stayed on Saturday at Bowness." Etty said nothing about his encounter with "Professor Wilson." It was customary for him to describe the places he visited but seldom the people. He was by nature quite unwilling to comment on other people. He was never judgmental, saying little if he approved and less if he did not. He attended church on Sunday, went on to Kendal and the next day, the rain having ceased, he had "a most pleasant ride through a pretty and interesting country by Settle, Skipton-in-Craven, etc., every hour bringing me nearer to my dear Minster and native city."

We get the impression that Etty was really a reluctant but necessary traveler. He makes his various journeys principally because they were important to advance his profession as a painter. He usually visited people, rather than places, and does so to sell or deliver paintings but very seldom offers comments. He was interested in buildings if they were old, preferably medieval, and always he made comparisons with York and York Minster. When occasionally he was able to visit lonely places where he was confronted with wild nature he was overcome with wonder at the magnificent spectacle but it did not last long. Unlike Turner he never returned loaded with sketches to be transmuted into finished works. The "hasty scrawls" he made at Loch Lomond are unusual for Etty and they never reappeared as painted subjects. Whereas Turner could remember scenes in detail and needed only the merest sketches to record essential details, Etty seems to have had no visual memories which could be set down on paper or canvas. When he reached York after this tour he soon returned to his real interest. Writing to Thomas Bodley on the 30th December he said that he had arranged the loan of some of his paintings from private collections and had sent them to Edinburgh so that his works would fill "all the sides of a very large Exhibition Room" at the Scottish Academy along with his *Judith* series. "Thus, then, one of the first wishes of my Life is accomplished: and all my large Pictures are fixed permanently in Edinburgh, in one grand focus. For which, I desire to be thankful to God with all humility."

Etty realized, as most of his contemporaries did, that his reputation depended on having as many of his works exhibited as often as possible. There were no other means of keeping one's name before the public. Critics reviewed only the summer exhibitions, mostly in London though some provincial cities were now mounting annual exhibitions. Newspaper editors were no more interested then in the arts than most of them are today. The gallery-going public was small and many in the provinces could not afford to travel and stay in London. If they could not go to the art, then the art had to go to them and this was increasingly happening. Local exhibitions did not, however, result in many sales. The interested public visited the exhibitions principally to keep abreast of developments in the arts.

In these years Etty also occasionally submitted genre subjects for exhibition. One clearly based on an incident he had seen in Venice, *A Window in Venice during a Festa* [sic] (1831), depicts a group of three young women, one back view, at a window. There are two versions of this painting: one was purchased directly from Etty by Robert Vernon for £100, was gifted by him to the National Gallery and is now in Tate Britain; the other had a more mixed history and is now on permanent loan to York Art Gallery. Etty also painted two versions of *The Lute Player*, one exhibited in 1833 and purchased by Thomas Bodley for £100, and another exhibited in 1835 and purchased by

Robert Vernon, price unknown. This also was later gifted to the National Gallery and is now in Tate Britain. There is also a third version which appears to be a preliminary study. Farr considers[2] that the Vernon painting was the original version, being more fully painted. The treatment of the clothing confirms the general view of English genre painting that there was always more interest in "materials" than in sentiment. A *Lady from Behind,* now in a private collection, appears to belong

Window in Venice during a [Fiesta] (24 × 91.5 ins) (1831), Tate, London 2005.

The Lute Player (17 × 19 ins) (1833), Mallett & Son Antiques Ltd., London/Bridgeman Art Library, MAL47200/198.

to this period and may well have been a preliminary study for one of the figures in *The Lute Player*. This latter painting when exhibited was accompanied by the following verses in the Catalogue:—"When with sweet notes I the sweet lute inspired,/ The fair ones listen'd and my skill admired."

In the subsequent British Institution Catalogue "soft notes" is substituted for "sweet notes" suggesting that it is not a direct quotation.

The *Dangerous Playmate* (1833) was probably bought by Robert Vernon directly from Etty. If an entry in Etty's Cash Book for that year refers to this purchase then Vernon secured it for £20. It was later published as a lithograph in 1836, 1852 and 1853. *The Duet*, though begun in 1834, was not exhibited until 1838 and was another work purchased by Robert Vernon. *Genre* subjects did not hold much appeal for Etty, who seems to have painted them only to demonstrate that he could do so in the face of the growing interest of the public in such paintings.

"A general allegory of Human Life"

In 1822 Etty had exhibited at the "British Academy," that is, the British Institution, a sketch entitled *Sketch from One of Gray's Odes*. It depicted a boat full of naked youths, male and female,

Il Duetto ("The Duet") (15 × 19.375 ins) (begun 1834), Tate, London 2005.

evidently sailing off to an island to celebrate the rites of Aphrodite and Eros. It brought to mind the legends attaching to Cythera, the southern promontory dedicated in classical times to Aphrodite who was said to have emerged there into the world from the sea. Cythera was traditionally associated with love, not always of a spiritual nature, and Watteau's painting *Departure for the Island of Cythera* of 1727 was a version that hid behind the guise of a masquerade but left little doubt that the voyage was being undertaken for sensual pleasure. Etty's painting was another example of his naivety. *The Times* critic in his review of the 29th January 1822 had wholeheartedly condemned it, but *The Times* critic usually did: "...we take this opportunity of advising Mr. Etty, who got some reputation for painting *Cleopatra's Galley*, not to be seduced into a style which can gratify only the most vicious tastes."

It might have been thought that Etty's sketch, which had been exhibited, as Dennis Farr says, at the height of the raffishness which characterized the behavior of the then Prince Regent and the old Whig aristocracy, might have been accepted by those who attended art exhibitions, but already by then a new movement was gaining ground, that of the cult of respectability. The moralists had begun their onslaught on "sin," that ever present human defect against which they were to wage perpetual war throughout the century. Very few had yet realized that the moralists needed sin and depended on it, for without their absolute certainty that almost everything was sinful their lives would have had no purpose. By painting these subjects at this time Etty was silently mounting his own version of the world, one based on love and beauty and Divine approval. On the other hand the Puritan view was that all pleasure was sinful and though sexual activity

was regrettably necessary it was nevertheless unfortunate. It was probably not approved by God but accepted by Him on this basis, and as far as possible it was to be avoided. They seem to have hovered between regarding sex as a temptation offered by God to test their faith and seeing it as a temptation offered by Satan to taunt God. They wrote many pamphlets trying to come to terms with the problem but were never convincing. By Etty's time the English Puritans were less vociferous than in the previous century but the Evangelicals had taken over much of their ground. They were less censorious, seemed better equipped to deal with the problems of sexual temptation and were mainly concerned to reform society. They were especially troubled by the extent of prostitution and the dangers to females. Naturally, in the pursuit of their aims they were concerned to prevent the pursuit of "vain pleasures" and to this end were very engaged in the education of the young. Whereas the Puritans' prime interest was personal salvation, the Evangelicals were anxious to establish a moral society.

It could hardly be expected that responsible parents would wish their children to see advertisements for what were obviously excursions of free love. This is what many saw Etty's painting to be. Today young people travel to their own islands of love, mostly situated in the Mediterranean, where they engage in, and presumably enjoy, a two weeks' annual ritual of irresponsibility. Holidays in the nineteenth century for those who could afford them were sedate affairs of walks on the promenade and gathering sea-shells among the rocks. Sea bathing was becoming acceptable but not for the more respectable parents who shepherded their children away from such temptations. Although today we more usually see pictures of early bathers swathed neck to knee in black wool this was not the experience of early visitors to the sea. Men usually bathed naked, quite separately from women, and it was frequently complained that many young women who bathed in "shifts," i.e., a garment similar to a night-shirt, deliberately lay at the water's edge and allowed the waves to lift them above their waists. Young men lingered with telescopes and young girls walked up and down in giggling groups. Whatever their parents had to say, the young wished whole-heartedly to visit the Island of Cythera or return to Arcadia.

Strangely Etty returned to the subject of his original sketch when, in 1832, he exhibited a finished version at the Royal Academy without a title but with quotations from Gray's *The Bard*. This time it was praised for its color and poetic fancy. The quotations were partial only; those lines he omitted are given in parentheses.

> Fair laughs the Morn, and soft the Zephyr blows,
> (While proudly riding o'er the azure realm)
> (In gallant trim the golden vessel goes;)
> Youth on the prow, and Pleasure at the helm:
> (Regardless of the sweeping whirlwind's sway,)
> That, hush'd in grim repose, expects his evening prey.

The Bard, written in 1757, was said by Gray "to be founded on a tradition current in Wales that Edward the First, when he completed the conquest of that country, ordered all the bards that fell into his hands to be put to death." John Martin's painting *The Bard* of 1817 was also based on this poem and is a more literal rendering. *The Times*' new critic of the 24th May 1832, though more kindly than his predecessor, confessed that he could see no meaning in the painting, certainly not as illustrating Gray's poem and, indeed, it is difficult to see the poem's relevance. The lines come from that part of the poem which refers to Richard II, who was destined to be deposed by Henry and reputedly murdered on his orders. Sometime later, Etty told the dealer, C. W. Wass, in an undated letter, "the view I took of it as a general allegory of Human Life, its empty vain pleasures—if not founded on the laws of Him who is the Rock of Ages." Farr also comments,[3] "Youth in its careless pursuit of pleasure is heedless of impending doom, symbolized here by a dark shadowy, cloudlike figure, the 'Being of the Whirlwind,'" the reference to which had, however, been omitted from the lines quoted. No doubt Etty was seeking to illustrate Richard II's irresponsibility with his court directed more to pleasure and graceful living

than to the traditional pursuits of kingship but the painting seems quite inappropriate for the moral as expressed by Gray. It is just another picture of the classical Nereids, some of the fifty daughters of Nereus seeking to entrap sailors, and no stretch of the imagination can apply it to Gray's poem unless the lines are wrenched out of context. Its composition and general treatment suggest more the light-hearted *rococo* confections of Boucher than the sermon that Etty appears to have alleged.

The painting, now given its present title of *Youth on the Prow and Pleasure at the Helm* (see color plate 16), was bought by Robert Vernon directly from Etty at an unknown figure though he noted on the 7th August 1832 that he had received £250 from Vernon "in part payment for Pleasure at the Helm." When, later, Vernon bought Constable's *Valley Farm*, Etty's painting was moved to a different position to make way for it. Constable was a little gleeful at Etty's having to move for him. He wrote to C. R. Leslie, his friend and later biographer,[4] "My picture is to go into the place—where Etty's "Bumboat" is at present—his picture with its precious freight is to be brought down nearer to the nose."

Vernon gave Etty's painting along with others to the National Gallery in 1847. In 1949 it was transferred to the Tate Gallery where it now remains. It was engraved in 1850 by C. W. Sharpe with the title *Youth and Pleasure* and was published in *Art Journal* in April of that year. It has frequently been exhibited, as recently as in the Tate Gallery's exhibition *Exposed: The Victorian Nude*, 2001–2002. The curator of the exhibition, Alison Smith, wrote of this painting[5]:

> *Youth and Pleasure* belongs to the category of poetic romance. ... [*It has*] the theme of transient pleasure, an idea Etty pursued in another R.A. exhibit of 1832, *Phaedra and Cymocles on the Idle Lake*, a similar work in a number of features, and also expressive of women's sexual power over men. ... The role of the nude as a moral exemplar was one way of making the genre acceptable on ethical and religious grounds.

However, the general public and the critics were not disposed to view Etty's paintings as moral allegories. All they saw were naked bodies, and mostly female ones, and that meant sin. It was remarkable that so many people who claimed to be pure in mind could see sin in everything.

Defender of antiquities

The Church of St. Edmund the King and Martyr in Lombard Street, London, was the parish church of the Ettys. Several of their marriages and burials took place there. In the years 1832–33 the church required repairs which, according to R. H. Harrison in his *History of the Church Since 1870 (a pamphlet published by The Ecclesiological Society)*, were carried out "under the superintendence of Messrs. Walker, Etty and Collinson." "Walker" may have been Thomas Larkins Walker, architect and pupil of Augustus Charles Pugin. "Collinson" is not known. He was not the well-known Pre-Raphaelite painter who was too young at the time. Harrison states in a footnote that "Mr. Etty was probably Walter Etty, brother to William Etty, R.A." If this is correct it might assist in understanding Walter's position in the firm Bodley, Etty and Bodley. Perhaps the suggestions, often made, that uncle William and brother Walter had been recruited into the firm because of their abilities as designers, were correct though Walter was referred to in his lifetime as a "banker." On the other hand, William Etty's own involvement at the time in repairs to the Abbey Church of St. Albans and to St. Saviour's Church, Southwark (now Southwark Cathedral), might have persuaded the St. Edmund's church council to consult him. This seems more likely. Whatever the facts in this matter, it is undisputed that Etty painted two figures for the reredos of the church—*Moses* and *Aaron*—and this may be regarded as confirmation that he was indeed the consultant in the restoration work. Of the two paintings *Aaron* (see next page) is the more successful, the figure of *Moses* (see page 183) suffering from the small space available, with the right arm appearing distorted, but neither can be regarded as outstanding.

Dennis Farr describes Etty at this time as having a reputation as "a defender of antiquities."[6] He was not only well known for his activities on behalf of York's medieval past but whenever there was a threat to any building dating from the Middle Ages he could be relied upon to write to the newspapers urging conservation. When St. Alban's Abbey was in need of repair Etty attended a meeting at the Thatched House Tavern in St. James's Street where a report was given as to the measures necessary for the Abbey's preservation. The meeting,[7] chaired by Earl Verulam, was addressed by the Bishop of London, Sydney Taylor (the newspaper proprietor and a friend of Etty's), Lewis Cottingham (the architect) and William Etty, among others, supporting proposals for saving this ancient structure. Repairs amounting to £347 had already been carried out and a further £728 was required to complete immediate work but altogether £7,000 would be needed for full restoration. The committee had £2,400, which was a large amount for the times,

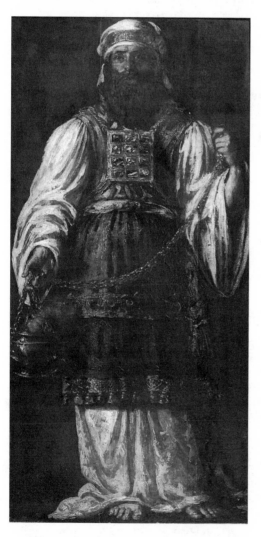

Aaron (52.75 × 23.5 ins) (1833), The Church of Edmund the King and Martyr, Lombard Street, London (photograph by Tim Wainwright with permission of the Rev. Andrew Walker).

so it was not without funds for undertaking the task. At the meeting, £500 was collected, with Etty contributing an unrecorded amount. An appeal was launched to all clergymen throughout the country to open local subscription lists, the appeal being made that if the people of Yorkshire could restore York Minster after the fire of 1829 then surely the people of Hertfordshire could do likewise for their abbey. Lewis Cottingham had complained in a letter dated 10th August 1832 to Etty that he was having difficulty in getting "the degenerate Monks of St. Albans" to allow him to proceed with the work of restoration. "They have no sense of duty towards the Abbey. ... They have again put off our proposed meeting, stating that it is *very* inconvenient to the Archdeacon, the Rector and the Mayor."

When a meeting was finally arranged Etty was invited to attend. Although the appeal had been successful there was later some disappointment that insufficient conservation and too much restoration was carried out but it has been usual for architects until quite recently not to distinguish between the two, preferring to undertake new work in which their design skills could be admired.

At the meeting at the Thatched House another appeal had been made for funds to rebuild St. Peter's Church, Birmingham, which had been destroyed by fire. Whether Etty was involved in this work is not known. But he was involved in another project also dealt with at this meeting. The altar screen of St. Saviour's Church, Southwark, was being restored and a report on progress was received. At the same time the Lady Chapel and the nave of this church were under consideration for repair. The tower and choir had already been repaired and the roof of the nave removed in 1831 as unsafe but not replaced. The Churchwardens had already demolished the Bishop's Chapel and wished to demolish the Lady Chapel but in January 1832 the majority of parishioners voted for its restoration. Etty supported restoration of the Lady Chapel and the roof of the nave. This

was generally accepted but the churchwardens were still unwilling. Etty enlisted his friends Sydney Taylor, proprietor of the *Morning Herald*, Lewis Cottingham, the architect who was often engaged to restore London churches, and James Savage, also an architect and former fellow student at the Royal Academy. Taylor wrote editorials supporting restoration and all three became members of the Committee of Restoration. Savage's skills lay in building bridges. It was Cottingham, with his experience of renovating churches, who was given the task of restoring the Chapel. Gilchrist wrote deploringly of the result.[8]

> For a ruinous, authentic fragment, something quite different was substituted; a free translation, a consistent conjecture; not the Ladye Chapel conceived by the thoughtful heads, fashioned by the bold and skilful hands, of the thirteenth-century Artists; but a Ladye Chapel of Mr. Cottingham's compilation, assisted by a Committee of Gentlemen; and executed to a pattern by nineteenth-century masons. Such is "Restoration." Nothing less than wholly new work can display an architect's learning; or supply the Masons with a job.

The distinctions between "repair," "renovation," "renewal," "restoration" and "conservation" were never clearly understood and most architects preferred to impose themselves on the work and produce something new and frequently inappropriate. The rest of St. Saviour's was inadequately repaired by Henry Rose in 1839. Later in the century it was decided that St. Saviour's should become the Cathedral church of a new diocese to serve the increased population south of the Thames. A new nave was then constructed and the thirteenth century church, much altered, became a Cathedral in 1897.

During the night of the 16th October 1834 the Palace of Westminster burned down. The cause of the fire was bizarre. Workmen had been instructed by the Clerk of Works to burn the wooden tallies which the

Moses (52.75 × 23.5 ins) (1833), The Church of Edmund the King and Martyr, Lombard Street, London (photograph by Tim Wainwright with permission of the Rev. Andrew Walker).

Exchequer had for centuries used to record the nation's taxes. They were no longer required now that ledgers had been brought into use. Apart from the fact that valuable historical records were being destroyed, the action was highly dangerous since the destruction was taking place in the crypt and there was a great deal of timber construction and paneling in the Palace. The fire got out of hand and despite the employment of twelve fire engines (every one wholly inadequate even for house fires and quite useless for a fire of this magnitude), sixty-four firemen, fifty soldiers and most of the Metropolitan Police Force, the blaze spread from the House of Lords to the House of Commons and by next day most of the Palace had been consumed. For many reasons, so usual and always to be expected in any project of this kind, reconstruction did not begin until 1837. It was however necessary in the meantime to decide what to do with those parts which had survived the fire.

One of these buildings was St. Stephen's Chapel or, more correctly, its walls. The original chapel had probably been founded by Edward the Confessor and had been rebuilt by Edward I.

It had been secularized in 1547 at the Reformation and by 1550 was the meeting place of the House of Commons. Its height and absence of a nave made it very suitable as a debating chamber. Members sat in the choir stalls facing each other, the custom observed to this day, and the Speaker's chair occupied the place where the altar had been. It is believed that the custom of bowing to the Speaker derives from the original genuflexion to the altar. The chapel therefore had a long history much venerated by those concerned with maintaining English traditions. In the fire of 1834 the chapel was almost totally destroyed and soon it was being proposed that the remaining walls should be demolished for safety reasons. As might be expected such a proposal alarmed Etty who could never accept that any ancient structure should be interfered with. He drew up a petition against the demolition though he did not state what he wished to be done. Apparently the walls were to be left, unsafe though they might be. It seems that several copies of the Petition were prepared each with its separate list of signatories. There are three copies in York Reference Library with each list headed by Etty's own signature.

St. Stephen's Chapel.
We the undersigned, having heard that it is the intention to "take down without delay" the Walls of the Chapel, "with a view to safety" and feeling strongly, as we do, its value, as one of the most important and interesting of our national monuments, not only on account of its intrinsic and unique beauty as a work of art, but also on account of the many glorious and sacred recollections with which it is identified; its having echoed the eloquency of a Pitt, a Fox, a Burke, a Sheridan and a Chatham—its having swayed, at the most eventful period of our history—the destinies of Europe, its having been in its "high and palmy state" the admiration of the most enlightened foreigners, Erasmus and others—its having been founded by the Hero of Cressy and Poitiers himself, and having been the Temple in which Queen Phillipe—and their gallant son, the Black Prince offered up their thanksgivings for their triumphs over the enemies of their country, For those and other considerations as Englishmen and as Artists we solemnly register our Public Protest against the Act as an unnecessary destruction, of one of the noblest specimens of the ancient arts and historical monuments of England.

The three separate lists of signatories are:

Wm. Etty R.A.	Wm. Etty R.A	Wm. Etty, R.A.
N. Cottingham	George Gwilt F.S.A.	L. N. Cottingham F.S.A.
Jas. Savage	(Union of St. Southwark)	Jas. Savage
S. A. Hart	George Smith	C. Stansfield, R.A.
Daniel Maclise	Edward Johnson	H. Perronet Briggs R.A.
(Mercers' Hall)	(Laurence Pountney Lane)	Richard Evans
	Joseph Gwilt	G. Bolton Moore
	(20 Abingdon Street	
	Westminster)	

Clearly Etty had difficulty in obtaining the signatures of persons of public standing. It is worth noting that Etty had been careful to include among recent politicians associated with the Chapel, the names of both Tories and Whigs. The Petition had no effect and in due course architects were invited to submit plans for an altogether new building to house Parliament. In due course, also, Etty was appointed to serve on the committee to select the decorations for the new building. This will be considered later in its due place but it is worth noting here that Etty was regarded as a person of importance whose opinions on these matters deserved respect. Etty has too often been dismissed as a minor nineteenth century artist because his subjects no longer attract general appeal. This was not the view of his contemporaries.

The letters of Ridolfi

As early as 1817 when Etty was but thirty years of age his sketch of *Bacchanalians* had attracted approval from the critic William Carey. Carey has been referred to before but he once again enters the scene to champion a favorite artist. He had been born in Ireland in 1759 where he

had at first practiced as a painter and engraver but after an accident to his eye he turned to politics and art criticism. He took an interest in English politics and wrote several pamphlets defending the Princess of Wales and one defending Queen Caroline. He became an art dealer and established his own gallery. He lived between Ireland and England for some years and eventually settled in Birmingham in 1834. He wrote copiously on contemporary art and was proud to have recognized the abilities of Francis Chantrey the sculptor and of William Etty at early stages in their careers. In 1818 he declared that Etty was "advancing with the steps of a giant."[9] In 1826 he described Etty as "that inspired Lyric Painter" in a book he published on the condition of British painting and in the same year he praised John Martin for buying Etty's *The Combat*.[10] Carey continued to praise Etty's work and in May 1830 his review of Etty's *Judith and Holofernes* was published in the Yorkshire Gazette. Carey appeared to believe, no doubt correctly, that Etty's fellow citizens in York needed to be informed of the great man the city had produced.

In October and November 1832 he sent three letters to the editor of the *Yorkshire Gazette* extolling Etty's painting, which had originally been called *The Destruction of the Temple of Vice* but had been exhibited at the Academy that year under the much more descriptive title *The Destroying Angel and Daemons of Evil, Interrupting the Orgies of the Vicious and Intemperate*. The painting had been commissioned as early as 1822 by Henry Payne of The Newarke, Leicester, for as little as sixty guineas but it had not been finished until ten years later. On completion Payne paid £130, Etty's perceived importance having increased over that period. The painting was described

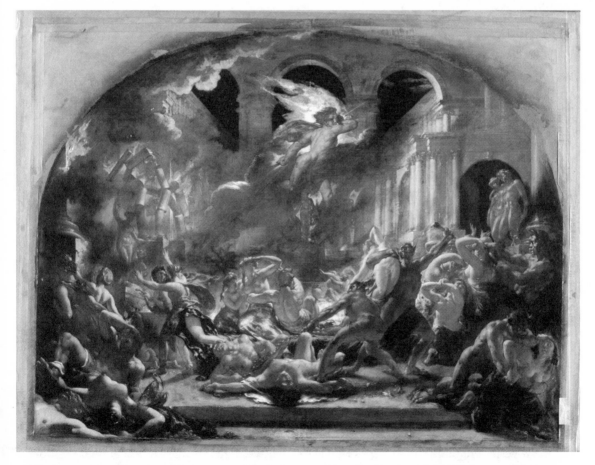

The Destroying Angel and Daemons of Evil, Interrupting the Orgies of the Vicious and Intemperate (36 × 46 ins) (begun 1822, finished 1832), Manchester Art Gallery.

in the catalogue as "A finished sketch of that class of compositions called by the Romans 'Visions,' not having their origin in history or poetry." It was an apocalyptic subject of avenging spirits (in this case demons) carrying off the sinful who have been interrupted in the midst of an orgy whose nature is suggested by various naked bodies. Etty had no doubt expected it would appeal to the religious who would see in it some references to the Book of Revelation. If they did, they were no doubt relieved that their copies of the Bible were not illustrated.

It was an exceptional subject for Etty to have attempted. The painting was full of action though, upon close examination, it was obvious that as usual Etty had put together a number of studio poses of figures in violent attitudes. The composition was entirely symmetrical. Figures rush away from the center where a supine body lies either comatose or dead. Groups of figures huddle in the lower corners on each side and overhead a flying daemon is enveloped in flames. It was a real *tour de force* and, according to Gilchrist,[11] attracted "the general admiration of brother Academicians who pronounce it 'a picture, not a sketch.'" Etty himself was well pleased with it, declaring it to be "for magnificent extent, and composition, unsurpassed by anything I have ever done." It was entirely different from any other picture he painted and it would be true to say that had he concentrated on such work instead of his general studies of nudes he would have made a greater impact upon the critics and the public than he did though, it would have to be admitted, even of such moral subjects everyone would have ultimately tired. The newspapers were less impressed. *The Times* critic wrote facetiously on 24th May 1832,

> As far as we can comprehend [Etty's] picture, which is much more intelligible than his language, it represents a quantity of able-bodied demons, who appear to be angry at the ladies for having stayed out so long, and who are come to fetch them home accordingly.

Although many faults can be leveled at the painting, not least the fact that its subject was more suited to another age, it did not deserve this flippancy, which the critic must have adopted only to amuse his friends and to demonstrate his own self-regard for a wit he obviously did not possess. He could never have seen a Flemish painting of the Last Judgment or similar apocalyptic subject. One can imagine a pale impecunious curate enjoying the approval of equally pale young ladies and their mothers over the tea-cups.

The letters which Carey sent to the *Yorkshire Gazette* and signed pseudonymously *Ridolfi* were of considerable length and one wonders what the staid readers of that newspaper made of them with their detailed descriptions of every figure depicted in that large work. In his first letter of 27th October 1832 Carey declared that York "may well be proud of her son." "His works have been, from time to time, most unjustly disparaged and abused by envy and ignorance under the pretext of criticisms." He complained of the "puffing of mediocrity and so much malign censure of excellence, that all periodical criticism is liable to be looked upon with suspicion as a mercenary trade." In his next letter of 10th November 1832 he was pleased to report that the Royal Academy had conferred on Etty "the highest honours next to President." He did not, he declared, "fall into the egregious error of supposing that my published opinions were the cause of this happy effect" but he could not forbear pointing out that he had recognized Etty's genius some twenty years earlier.

Although the editor of the *Yorkshire Gazette* was a close friend of Etty's and only too pleased to help his cause, it is unlikely that Carey's eulogies made much impression on the paper's readers. Northerners notoriously have little regard for the opinions of Londoners, as Gilchrist was to complain. Carey described the painting as an "astonishing picture" which should have been bought for the King's Palace or the National Gallery or the British Institution. As usual with Carey he proceeded to describe the painting in great detail for the benefit of those who would not be able to see it. At least Carey always did his best to enable readers to base their judgments on a description, unlike other critics who merely expected their readers to accept their opinions without question. He took up about 44 column inches excluding his introductory remarks. Recalling his first acquaintance with Etty's paintings some twenty years earlier, he wrote:

I was much struck by the classical elegance and gaiety of his ideas, and the light airy taste of their execution. Their sportive grace was occasionally set off by glimpses of sublimity, which evinced a fervid mind with a fine vein of elevated invention. His subjects, with a few historical exceptions, were almost all poetical groups, but they were chiefly the poetry of his own rich imagination.

Since Etty's death little has been said of his "poetical imagination" but during his lifetime and for some years afterwards there were those who perceived in his work not the pseudo-classicism that has often been leveled against him but strong Romantic and poetic elements. Carey had recognized these qualities in his letter: "…in whatever he painted, although one might wish those slighted parts more fully defined, there was, on the whole, a redeeming grace and spirit. Nothing tame, heavy, or commonplace, was ever seen on his canvass," and again, "the female is, undoubtedly, the greatest test of an artist's skill, and, in this fainting figure, the taste, feeling, science, and fearless prowess of Etty are seen in their utmost glory."

As if 44 column inches were not enough (which he reduced in his subsequent published version), Carey sent a further letter, of almost the same length, which was duly published in the *Yorkshire Gazette* on 17th November 1832. Once again he gave detailed descriptions of every figure in the painting with occasional sentences of unqualified praise: "The deep science, great practical skill, and powerful effort can only be judged by being seen" and other appreciative comments, such as,

> The spirit, variety, and contrast of action and attitude in these groups, is admirably set off by a graceful display of attitude and the very beautiful contours of the principal women. The execution is of equal vivacity;—daring, rapid, fiery. Everything appears as if struck out, at once, with a creative spirit.

He paid a final tribute:

> It is impossible not to feel the commanding prowess of Etty, in designing the human figure, when the eye passes from the vigorous muscular character of these two fallen male figures, to the exquisite roundness and beautiful outlines of the fainting female; that light and glory of his pencil [*i.e., brush*] with all her delicate and lovely foreshortenings.

To quote further would be but to repeat over and over Carey's unstinted praise for this painting. At last, having written three lengthy letters, he declared, "I am obliged, most unwillingly, to bring my subject to a close." He thanked the Editor of the *Yorkshire Gazette* for allowing him to exceed "the limits which the arrangements of the most literary newspapers can, without extreme inconvenience, allot to a subject, unfortunately, of so little public interest as the Fine Arts."

No doubt this lack of interest was as common to readers of local newspapers then as it is today but Etty was fortunate that the editor of this particular newspaper was a personal friend. Editors of provincial newspapers were always pleased to receive letters and articles from London, especially when written by notable authorities; it gave their newspapers a welcome advantage over their rivals.

Carey admitted to being so impressed by this painting that he declared, if he could have afforded it, "I would, at my own expense, have gladly printed a critical and descriptive tract, in 8vo. on this picture, for gratuitous distribution." He did the next best thing. He persuaded Henry Payne, the painting's owner, to bear the cost of printing 500 copies of these letters, with additional notes, privately published for free distribution under the title *Ridolfi's Critical Letters on the Style of Wm. Etty, R.A.* Payne was undoubtedly eager to justify his purchase and to further the renown of the artist. The *Additional Notes* were almost twice as long as the three letters together. In them Carey discussed the current condition of British art. Etty's name hardly appears but at the end Carey wrote:

> The Scottish Academicians acted wisely in selecting a British Artist to do honour to the British School of historical painting, to embellish the chambers of their National Institution.... They had a splendid

circle of living British Artists to choose from, and selected ETTY, as being in the first class, and in the highest order of the highest department. Fortunately that Artist looked into the sacred volume for his subjects, and in the story of Judith, added largely to his fame. Those grand compositions triumphantly proved that his powers are fully commensurate to their enviable estimate of his genius.

Of course, we must admit that Carey's high regard for Etty was extravagant and reflected the generally parlous condition of British art at the time but, in considering Etty's place in the history of British art, attention must be paid to the varying receptions his work received. Carey was certainly not the only person, whether critic, collector or mere well-wisher, who lavished praise upon him. Carey and Etty never met, a fact which Carey emphasized in his letters, it being a matter of principle with him not to befriend artists lest he be accused of personal bias. Why Carey chose the pseudonym *Ridolfi* is unknown. For all his erudition and enthusiasm for British art, Carey did not have much influence with either his fellow critics or the general public although the new President of the Royal Academy, Martin Shee, had expressed in a letter to Carey (27th June 1830), his "great pleasure to see that your exertions, for the promotion of these objects ['the Cause of the Fine Arts'] have been so generally appreciated in this country as well as in your own."

Gilchrist was not so appreciative of Carey's support.[12]

Ridolfi is more fervent than articulate; and the expression of his admiration, not conspicuous for literary value. The vague sense that in these glowing performances of a living Painter lay something to be admired was laudable. Silence would, in his case, have better befitted it than Criticism; in which, as so often happens, the unconscious sense loses its way, and degenerates into Nonsense. The grain of good seed is overpowered by a quick and rank growth of weeds.

Unkind words for one who shared Gilchrist's admiration for the artist. It could hardly be said that Carey had a "vague sense" of Etty's worth. The fact is that Carey was a recognized art critic and authority at the time even if much of his fame rested on his own assiduous efforts to promote himself. It is still not uncommon for a critic who is a household name to owe his fame to his self-advertisement, not to have his opinions endorsed by his fellows and yet always to be sought by the editors of television programs when something needs to be said about a contentious artist.

A second Ridolfi

In the 1830s there were many collectors and self-styled connoisseurs who thought highly of Etty's work. Some of them wrote to him offering advice when they could not more actively assist by purchasing a painting. The most notable and persistent of these encouraging supporters was Thomas Myers. He was a lawyer, the only son of Thomas Myers Senior, also a lawyer. He lived in Tilney Street, May Fair (as it was then spelled), an area which had been first built on in the 1660s and by the mid–eighteenth century had expanded into the most sought after part of London in which the wealthy wished to live. Although recorded as being called to the Bar on 24th January 1831, Myers Junior, in whom ill health persisted, did not practice. Having been educated at Eton he had some knowledge of the classics which he frequently drew upon to suggest to Etty suitable subjects for his attention. He began writing to Etty in a letter dated 25th July 1832 and maintained a steady correspondence until his last letter of 4th May 1844. His general concern was that Etty should concentrate on painting "grand" pictures for which he believed there was a demand among the wealthier collectors. Myers' letters are held in York City Reference Library and reveal him as a man with too much time on his hands, because of the poor health to which he probably willingly succumbed since he was financially well provided. He became an admirer of Etty's work in 1832, the year when Etty exhibited *Youth on the Helm and Pleasure at the Prow* and *The Destroying Angels and Daemons of Evil, Interrupting the Orgies of the Vicious and Intemperate.* These

are large works—*Youth at the Helm* measures 62 by 46 inches and *The Destroying Angel* measures 36 by 46 inches—and Myers constantly urged Etty to paint similar large works with subjects that proclaimed a knowledge of classical themes. Myers was convinced that a wealthy clientele existed who would buy such works. Whether he was correct in this advice is probably unlikely as the nature of patronage was changing and the new class of collectors did not own houses with rooms large enough to accommodate such paintings, especially as they required frames suitable to show them off. But there was within the new class of *nouveaux riches* collectors a number aspiring to the status of their aristocratic predecessors. Taste for large paintings of nude subjects certainly arose later in the century but there were no longer in the 1830s enough patrons willing to acquire large works which would dominate a room and announce their owners' importance. But more important disadvantages than the size of rooms were the objections of the women in the family to the subjects that history painters, and Etty in particular, usually painted. Hanging paintings in long galleries or in libraries was quite a different matter from hanging them in living rooms that were in everyday use. The women of the family did not have to entertain friends in the former rooms but they did not wish their friends to be confronted with paintings of nudes when taking tea in the drawing room or sharing dinner in the dining room.

Myers began by signing his letters "Ridolfi Minor" in imitation of the letters of William Carey which he had obviously recently read and approved. Only as the correspondence progressed did he reveal his identity. Myers heaped advice on Etty in a constant stream of letters which he seems to have written from his sick bed. His curious disjointed style suggests more than a physical ailment. Myers used a great deal of underlining which is indicated by italics in the letters that follow. He also freely sprinkled his letters with commas, a not uncommon habit of the time. Many of these have been omitted for the sake of clarity. In a letter of the 21st September 1833 Myers suggested that some of the poems by Wordsworth and Thomas Moore could provide suitable subjects for Etty and quoted lines from Wordsworth's *The Boy* and Moore's *Girl* from *Irish Melodies* as likely to bring him to the notice of the young Princess Victoria since these were her favorite poets. Etty did not respond to these proposals. Then Myers suggested what seemed to him to be an original idea. In a letter of 23rd December 1833 he wrote:

> Let me recommend you to take some of your female faces—I wish you could get their figures too!—from *our aristocracy*—Mrs. Lane Fox, Lady Ellenborough, Lady Hamilton, etc. You might do this *quietly*—& it, certainly, would raise the demand for your works—both with those who did & those who did not find out the likeness. There is fashion even in Beauty in some degree.

On the 26th December he had other ideas. Etty should paint *The Fall of Phaeton* as described by Lucretius, with the further suggestion that it should rival in size Turner's *Childe Harold's Pilgrimage* which had been exhibited in 1832. This, he thought, would appeal to Sir Robert Peel. Turner's painting measured 56 by 97.75 inches, a considerable challenge.

According to Gilchrist[13] "a zealous friend," whom he does not name, suggested "pleasing and appropriate subjects, communicated in batches of six or eight at a time, with accompanying quotations transcribed" but on the whole Gilchrist did not think that Myers had much influence on Etty. In this Gilchrist was clearly wrong. On the 14th January 1834 Myers wrote to Etty from Thaxted Cottage in Essex where he was staying with the brother-in-law of the late Lord de Tabley. He had learned that his Lordship had intended to give Etty a commission but had died in 1827 before having done so. Lord de Tabley had had in mind two subjects, *Thesis Ordering the Nereids to descend into the Sea* and *Ulysses and the Sirens*. Both subjects were from Homer, the first from Book 18 of the *Iliad* and the second from Book 12 of the *Odyssey*. Myers thought that these subjects would find ready purchasers and wrote that "Flaxman has designed *both* subjects, in outline, in his *Illustrations of Homer*, published by Longman. *See them too.* He has considerably overcome the difficulty of the lower parts of the figures of the Sirens being those of fish."

Flaxman's solution had been to swathe the sirens, who sat upon a rock, in draperies from

the waist down. It was some time before Etty responded by painting *The Sirens* (see color plate 7) and exhibiting it at the Royal Academy in 1837 but there can be little doubt that he owed the idea to Myers. Myers wrote dozens of letters over the years, every one praising and exhorting Etty to paint large mythologies. His main body of correspondence with Etty was in mid–1835 and again 1836 between 3rd April and 1st May. Whether Etty wrote in reply to Myers is not known but it is unlikely he would have ignored so persistent an admirer and equally unlikely Myers would have continued if Etty had ignored him. If letters were written they have not survived.

Instead of immediately painting *The Sirens* Etty returned to another work, *Hylas and the Nymphs*, which he had already submitted to Royal Academy in 1833 but had not found a purchaser. He submitted it to the British Institution in 1834 where it was bought by Mr. Serjeant Thompson for £160 as recorded by Etty on the 5th May. Twenty-five years later it was resold for 400 guineas but a further three years later (1866), was again sold for 270 guineas. This painting illustrated the story of Hylas, the legendary son of Theiodamus king of the Dryopians in Thessaly and a favorite of Hercules whom he accompanied on the expedition of the Argonauts. The myth told how Hylas went ashore at Kios to fetch water and was carried off by nymphs attracted by his beauty. Hercules sought him without success and threatened to ravage the land if Hylas was not restored to him. Once a year the inhabitants appeased Hercules by seeking Hylas and shouting his name, hence the ancient Greek phrase "to cry Hylas" as meaning to search in vain. The story was printed in the Academy Catalogue of 1833. Thus a visit to the Academy Exhibitions was usually also an opportunity to discover the ancient myths.

Dennis Farr considered[14] that by 1834 Etty was losing his reputation as a history painter and cites *Hylas and the Nymphs* as an example of his move from classical subjects which would normally have been regarded as historical. *Hylas* is really a bathing group such as could be found in Titian's *Diana and Actaeon*, Correggio's *Leda*, Gainsborough's *Diana and Actaeon* and a little later in pictures of bathers by William Mulready and William Frost. Hylas is indistinguishable from the nymphs who gather round him and this is an example of the "feminization" of subjects which, as Steegman pointed out,[15] had entered English art through the fashion for sentiment and the advent of women artists such as Angelica Kauffmann (1741–1807). There were many reasons for this; the preference for the picturesque with its "softer" landscapes, the popularity of romantic subjects in poetry and novels and the fact that male models were not available to women artists, many of whom referred to their own bodies viewed in mirrors when painting female nudes.

Along with *Hylas and the Nymphs* Etty also sent *Britomart Redeems Fair Amoret* (see color plate 9) to the Academy in 1833. The subject was taken from lines from Spenser's *Faerie Queene*, Book iii, Canto 12. Spenser's long celebration of Queen Elizabeth, "The Virgin Queen," who was credited with establishing peace and prosperity in a hitherto troubled realm, is a multiform allegory presented in both medieval and Renaissance language at a time when English was being developed into new forms by poets and playwrights. It is now regarded as an archaic work appreciated mainly by scholars but in its day and for a century or so it was hailed as a masterpiece of literature. It is typical of Etty that he should look back to such a work when he wished to portray the virtues of Honor and Chastity. Spenser had combined a number of old tales revolving around the mythical figures of Britomart and Amoret, the latter a chaste virgin holding out against the desires of Scudamour, with the maiden warrior Britomart intervening to defend Amoret's honor. Although not specifically stated to be so, Britomart is one of the personifications of Elizabeth that occurs. Canto 12 is too long to quote and, in any case, would undoubtedly tire a modern reader who was not a student of the period. Etty's richly colored painting was well received and was bought by a "Mr. L., of Manchester" for £157 according to the entry in Etty's Cash Book for August of that year. Eventually, in 1849 it was sold to Lord Charles Townsend for 520 guineas, another example of Etty's failing to bargain sufficiently.

Etty began and abandoned several paintings in the autumn of 1833 and the spring of 1834.

Hylas and the Water Nymphs (35.5 × 45.625 ins) (1833), Anglesey Abbey/The Fairhaven Collection (The National Trust)/NTLP/John Hammond.

Only two portraits were sent to the Academy exhibition in 1834. One of them—*A Cardinal*—Etty later referred to as one of the best heads he had painted. This cannot be the one listed in Farr's catalogue[16] as the latter was first exhibited in 1844. Etty was inclined to use this title for many paintings.

Myers continued to "advise" Etty but his continued correspondence will be considered later. It seems strange that Gilchrist, who must have been aware of his identity and persistence, mentions him only once and then not by name. He was of the opinion that Etty "endured his gratuitous adviser with incredible patience and good humour" but generally ignored him. Gilchrist says that Etty "granted him many privileges [and] was pleased with the admiration, and stayed not to weigh it; quietly let the rest go by; taking particular care to follow none but his own counsels."[17]

This may not have been wholly true.

A variety of portraits

Despite the mixed reactions to his allegorical subjects Etty continued to receive commissions for portraits. Irregular commissions came from friends and those who knew that they could obtain a good likeness for a reasonable price. Portraiture was always highly regarded and since he had to make an independent living he frequently accepted commissions from persons

of standing. As they came only intermittently it is more convenient to consider his portraits in groups.

A very important commission had come from Welborne Ellis Agar, 2nd Earl of Normanton, in 1828 to paint the portraits of his children, the young *Lady Mary Agar and the Hon. Charles Agar*. A fee of 150 guineas was paid. This painting is sometimes known as *Guardian Cherubs*. It is "a fancy painting," undoubtedly composed as required by the Earl himself. It shows three portrait heads of Lady Mary Agar as a child looking down from a cloud on the sleeping figure of the Hon. Charles, also as a child. In the sky above are several angels. The canvas appears to have been reduced in size. Lady Mary was the earl's only daughter. She had been born in 1822 and so was only six years of age at the time. The Hon. Charles had been born in 1824. He became a Captain in the army and was killed in 1855 during an attack on Sebastopol. This painting was included in the *Works of Living Artists* exhibition by the Birmingham Institution in 1829. Some time between 1827 and 1829 the portrait of *Miss Emma Davenport* was commissioned by her father Burrage Davenport as a gift to his wife Hannah. Emma, who had been born in 1807, was married in 1829 and died in childbirth a year later. It seems very likely that the portrait was intended as a memento and should therefore be dated more firmly as 1829. Death in childbirth was an unfortunately common occurrence. Another sad memento of such an event is the portrait of *Mrs. Sarah Clayton*, painted in 1829. Mrs. Clayton had been married in 1824 and died in 1829 aged only twenty-two years.

Etty had a considerable number of friends in York among the professional classes and whenever he visited his home city, as he did regularly after 1825, he was frequently called upon to paint their portraits. He carefully maintained his public image among the professional people in York and, while he did not unduly court attention from the most influential, he did cultivate friendships with those of the right social standing. He was no longer the son of a struggling baker but a famous artist, member of the Royal Academy and a person of some position among the cultured minority in the capital. He had achieved all that he had wished and probably more than he had expected and it was only natural that he should feel proud of his accomplishments. This was, after all, a time when a boy with ambition had to climb his way upwards through his own efforts and though Etty had been financially assisted by an indulgent uncle and later by a supportive brother, his progress had been due to his own determination and abilities. It must be said that Etty was ever modest and undemanding, never unduly claiming for himself a greater recognition than was his due but nonetheless mindful that he could rightly take his position in the best professional company. On the whole the English aristocracy and professionals have seldom been wholly unwilling to accept into their ranks anyone who has demonstrated ability to rise in the social scale through personal effort and possession of accepted skills, providing they also acquired suitable social refinements. For centuries it had been recognized that artists came from all classes. Such skills were not the preserve of the wealthy. Indeed, on the whole the wealthy were generally devoid of such skills. The Grand Tour had demonstrated that if the wealthy desired to bring back pictorial records of their travels, they had to engage young men able to draw and paint in watercolor and that most of these came from the poorer classes. So, acceptance of this son of a local baker into the ranks of the more affluent professional classes was not at all unusual. Often these were friends and York notables who would regard themselves as honored to be acquainted with an Academician and especially to be painted by him.

In York Etty was already numbering most of the persons of importance among his friends. He had access to their company and was frequently invited by them to dinners and other social occasions. He felt most at home with these people since he could meet them on equal terms without having to be concerned to maintain his own position as a painter of eminence. They accepted him as such without question. Two of his closest friends were Mr. and Mrs. Bulmer who lived on The Mount, the road leading from the Knavesmire to Micklegate Bar, the ancient and principal gateway to York from the south. The Mount was, with Bootham, the most fash-

ionable road in which to live. George Bulmer was a solicitor who was, for a time, a partner of John Brook, another close and dear friend. Etty often stayed with the Bulmers when he visited York but although they were the closest of friends Etty never addressed them other than formally, being always concerned to observe the proprieties expected from gentlemen. He painted Mrs. Bulmer's portrait as early as 1828. In a letter of 14th October 1828 to his mother, whom he had left at his London home in Buckingham Street during a visit north, he explained that he had just finished a portrait of Mrs. Bulmer and had presented it to his friends that very evening. However it does not appear that Etty ever painted a portrait of George Bulmer, which is somewhat surprising considering that he became Under-Sheriff for York. Etty did paint another of his wife, around the year 1845, which appears to be a study for a more finished portrait which probably never materialized. Earlier, on 19th March 1844, Etty wrote to Mrs. Bulmer that he was painting "your little god-daughter. Her sweet eyes, pretty little face, and her being a sort of pet of yours, seduced me to depart from my usual denial of Portraits. I took some pains with her, and I hope succeeded."

This painting, if finished, has not survived. There is a curious reference to "Grand Mama Bulmer" in a letter from Etty to his brother Walter, dated 16th December 1846 and written from Buckingham Street, which throws some light on the Bulmer family. He wrote—

So you have had Grand Mama Bulmer by you when writing—good companionship in a snowy day—they have I suppose given up their gypsy bivouacs and boiling the kettle in the green lanes—I am glad she is near you for tho a Gypsy and of course a vagrant, she is a good woman and a warm friend, like my kettle.

The Bulmers had apparently risen from poverty as did so many at this time. They certainly rose high, making their way into London society, eventually residing at 2 Belle Vue, Chelsea.

Etty also painted the portrait of his earliest patron, Mr. North, who had had the smithy in Feasegate where the young Etty had drawn animals in chalk. North was now retired and obviously living in some comfort. Portraits of other York friends were also painted but they do not appear to have survived. Gilchrist is regrettably vague in many details and several of Etty's friends he mentions by name only are not identified further. A number of portraits of local personages were commercial commissions. One such was that of *Samuel Adlam Bayntun* who, though originally from Devizes, was returned as Member of Parliament for York between 1830 and 1832. Requiring to commemorate the event he commissioned Etty to paint his portrait, so it can be dated to the years 1830 to 1832 but not with greater certainty. Samuel Bayntun was not destined to live long. He died in London in 1833, his age being reported as either 28 or 30 years.

James Atkinson, whose portrait (see next page) Etty painted in the months of September and October 1832, was a personal friend. Atkinson was a local surgeon with a keen interest in the antiquities of York and regarded in his day as an eccentric. He began a medical bibliography but never progressed beyond the letter B. He kept parts of his patients, obtained from his operations, in a private gallery in the Yorkshire Museum, a collection which, according to the York Art Gallery catalogue of 1963, was "hurriedly presented to the nearest hospital when he died." Atkinson was a founder member of the York Philosophical Society, founded in 1823 and of which Etty became an honorary member in 1829. It was through their membership of the Society that Etty and Atkinson became close friends. Etty's portrait of 1832 was particularly admired by the Scottish painter and Academician Sir David Wilkie who expressed the view that it was the finest portrait in all England.[18] Certainly at the peak of his career Etty could paint masterly portraits and Etty himself regarded it at the time as the best he had done. Gilchrist records the general opinion of James Atkinson as "a man of intellect and originality, one of the worthies of York."[19] He was also credited with a ready wit which often gave unintended offence by its pungency. Atkinson had a house in Lendal and Gilchrist records Etty's pleasure in being able to sit in his garden overlooking the river, a memory which stayed with him and influenced his own choice of a retirement home. Later, when Etty prepared for his retirement in York, Atkinson played a major

part in supervising the alterations to his future home behind Coney Street, alterations with which Etty was well pleased.

Another of Etty's closest friends, *John Brook*, a York solicitor who was County Clerk of Yorkshire, had twice served as agent to William Wilberforce during his election campaigns. In 1820 he had been Staff Bearer to the Earl Marshal of England at the coronation of George IV. Brook was particularly active in York society. He had founded the local newspaper *The Yorkshire Gazette*, which was politically conservative, and campaigned to save York's walls, matching Etty's own opinions on both counts. It was to *The Yorkshire Gazette* that Etty addressed most of his letters for publication. Although a traditionalist, Brook supported numerous organizations that favored intellectual advancement. He founded the Subscription Library, was a member of the York Philosophical Society and the York Musical Society He was known as "the father of the Yorkshire Law Society" and had been Under-Sheriff to seven High Sheriffs of Yorkshire. Brook was especially concerned to retain all the antiquities of York and supported Etty's efforts to safeguard the Minster. In this he ranked alongside James Atkinson in voicing protests against attempts by both the ecclesiastical and the civic authorities to demolish and alter whatever was old. It was to John Brook that Etty in 1832 communicated his offer to paint an "historic or poetic picture" of York to be placed in a public building—he expressed the hope it would be the lecture room of the Philosophical Society—if Bootham Bar was not demolished as then proposed. Brook regarded this to be a rash promise and did not pass on Etty's offer. In the event a sum of £300 was raised by public subscription and Bootham Bar was saved although it was modified by having one side removed and a false construction erected in its place. When Etty objected to this, his local critics accused him of having an "indiscriminate regard for Antiquities" (Gilchrist I, page 343). A painting of Monk Bar, York, said by Gilchrist to have been produced in 1838, may be the late manifestation of Etty's offer. In October 1838 Etty painted John Brook's portrait, commissioned by the York Musical Society from whom it passed in 1872 to the Philosophical Society and is now in the collection of the York City Art Gallery. Etty painted a copy for the Brook family but the present whereabouts of this is now unknown. The close friendship between Etty and Brook lasted until Etty's death in 1849. Less than a year later, John Brook died and, following his wishes, he was buried in St. Olave's Churchyard close by his old friend.

Portrait of James Atkinson **(29.5 × 24 ins) (1832), York Museums Trust (York Art Gallery), YORAG-983.**

More often Etty's clients were persons of quality but small means living in London or elsewhere who wished to express their regard for a wife or daughter. Frequently such commissions were for female portraits. Among Etty's colleagues in the campaign to retain the original condition of York Minster was the Rt. Hon. Charles Watkin Williams

Wynn, M.P., and the holder of several offices in the first three decades of the century. In 1833 he commissioned Etty to paint his two daughters, Charlotte and Mary, subsequently titled *Preparing for a Fancy Dress Ball*. It is not wholly successful, being reminiscent of poses more often associated with Etty's nude subjects. The figures are stiff as though having held their positions for too long. The sisters are not in fact preparing for a ball, they are fully dressed and ready and have adopted playful poses for the artist.

In late 1833 Etty was asked by Thomas Potts to paint his daughter's portrait. Potts had been introduced to him by Thomas Bodley. Potts lived at Clapham Common, an area of impressive houses owned by City merchants and many well-known figures such as Wilberforce and Lord Macaulay, members of the famous Clapham Sect. Potts had earlier engaged William Edward Frost (1810–1877) who was showing promise as a painter of portraits as well as mythological and historical subjects. Etty himself was already influencing Frost, who shall be addressed later as a follower of Etty. On the 19th December 1832, Etty

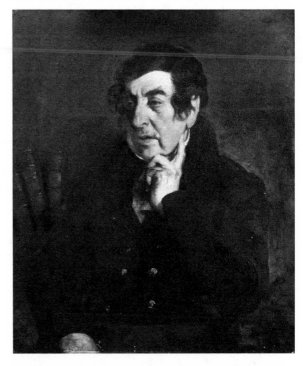

Portrait of John Brook (29.5 × 24 ins) (1838), **York Museums Trust (York Art Gallery), YORAG982.**

wrote to Bodley following the latter's enquiry for a suitable artist to undertake a small commission: "Since you left, it has occurred to me, that young *Frost* (Mr. Potts protégé) would be very likely to do it well and reasonable—he is a very clever modest lad—only mind you don't tumble in with a Frost."

The final words are typical of Etty's being unable to resist a pun. Gilchrist omitted these words as though fearing they might have a doubtful meaning, as perhaps they did. It was also typical of Etty that he should be willing to help a younger man. He had first met Frost in 1825 when he had advised him to study as Sass's School. Later, in 1829, he helped him obtain a post in the British Museum. In that year Frost became a student in the Academy Schools. This episode illustrates Etty's increasing reputation with persons of financial standing. Of the portrait of *Miss Elizabeth Potts* (1833), all that is known is that Etty was paid sixty-five guineas and that her mother required that the sitter's identity should not be disclosed when the portrait was exhibited at the Royal Academy in 1834. During another visit in 1834 Etty was called upon to paint the portrait of a local young lady whom he described at the time as "a York beauty." She was Miss Mary Spurr, the second daughter of John Spurr. The painting was exhibited in the Royal Academy with the title *Study from a Young Lady*. Dennis Farr records that a label on the painting gives the title *The Beauty of the North*. Etty was clearly impressed by Mary Spurr's beauty, which fits quite properly with his life-long appreciation of the female form.

The portrait of *Mrs. J. F. Vaughan* was probably painted between 1835 and 1840. Louisa Elizabeth Vaughan's claim to fame is that in 1893 one of her sons became Cardinal Herbert Vaughan. The family's Roman Catholic connections no doubt contributed to Etty's accepting this commission. Gilchrist does not mention the family, not surprisingly, as he avoided all reference to Etty's Catholic sympathies. It is a competent enough portrait with perhaps a somewhat too elegant neck on unevenly positioned shoulders. About the same time, between 1837 and 1840, Etty was

commissioned to paint the portrait of *Eliza Cook*, a well-known poetess of the time. Her work, first published in 1835, was popular for its domestic sentiments and moral messages, themes which were becoming increasingly in demand in Victorian Evangelical society. Etty painted her, head only, half-turned to the viewer's left, with ringlets and high collar, and with an air of quiet meditation, demure and innocent, which would have appealed to her readers. She edited her own journal in which her poems appeared, this being one of many such periodicals that often provided the only reading admitted to middle class households. She died in September 1889, aged seventy-one.

Etty's portraits were produced spasmodically, either, in the case of his friends, as opportunity offered or when he was fortunate enough to receive a commission. Two examples of such portraits are those of *Julia Singleton* and *Rebecca Singleton*, daughters of his friends at Givendale. The former is ascribed a date of about 1835 and the latter about 1840. Both are in the York Art Gallery, which regards them as studio works, but this is unlikely as Etty did not operate a studio system. They would have been painted when he was in York visiting the Singleton family and there seems little reason to doubt that he himself painted them as gifts. Portraiture did not constitute a significant part of Etty's output. Today many do not realize that he painted portraits but their quality is generally satisfactory and in some cases very good. Portraiture was expected of an Academician and the fees provided a welcome income. Portraits also appealed to many of the visitors to exhibitions and kept an artist's name before the general public. A few more portraits were yet to come. Most of the portraits remain in private ownership and the present locations of some are not known.

CHAPTER TEN

"The War of the Walls"

In York today William Etty is remembered, if he is remembered at all, for his campaigns to save the city's medieval walls from destruction, and among those who do have knowledge of his campaigns they have assumed over the years a greater importance than they probably merit. His voice was certainly raised and his pen employed many times and not without results. The Corporation of the City of York had long been troubled by complaints about the condition of the city walls, bars and barbicans and by constant pressure from those who wished to see everything medieval removed and York rebuilt as a modern city. It was not merely a desire to modernize York that activated the "improvers" but also recognition that the city had fallen into a dilapidated state so severe that public hygiene and other social concerns demanded action. Numerous accounts have been written of this long running dispute, many of them colored by desires to champion one side or the other and some by a sense of indebtedness to a single figure for his stubborn campaign to save everything medieval at all costs.

William Etty has attracted a degree of support that modern research has suggested is much overstated. Geoffrey G. Curr sought to redress the imbalance and in his essay *Who Saved York Walls? The Roles of William Etty and the Corporation of York*, which he contributed to the *York Historian* in 1984, he set out a convincing argument that more credit should be given to the City Corporation for their attempts to grapple with the problems facing them. In doing so he tended to undervalue Etty's contribution to the campaign because Etty died in 1849 and the "war of the walls" continued for another forty years. Etty may not have been able to complete the task he set himself but it can be claimed that he entered the fray at a critical time when the voice of a famous "son of York," as local newspaper editors described him, had the power to persuade the interested public and some of those in authority that precipitous action should be avoided. It is true that Etty was a renowned "defender of antiquities" and seldom saw any need to interfere with established circumstances. His motto would have been, had he ever thought of proposing one, "let well alone" for he hardly ever recognized that whatever existed from an earlier age might not be as well as it could be. A convinced Tory by nature he was a traditionalist in everything.

The Minster fire in 1829 had diverted local attention from the vexed problem of what to do about the City walls and it is necessary to go back some years to provide some history of the campaign in which Etty was to become involved. The Corporation was faced with a number of problems which stretched their resources. Maintaining the walls was a heavy drain on the City's finances. The walls no longer had any civic purpose, they existed only as reminders of a medieval history which at the beginning of the nineteenth century had little appeal to the majority of York's citizens. The Romantic love of ruins did not yet stir many hearts. It has ever been the complaint in England that its citizens do not value their heritage but apparent indifference to

the past has always been the consequence of there being much needing to be done to rectify the present. The Corporation was faced with the need to remove areas of slum dwellings, particularly those where prostitution and crime were known to be rife, and also to lay out new streets to facilitate the additional traffic which an increasing population was encouraging.

It was the rise in population which presented the Corporation with its main stimulus for action. In the sixteenth century the population of York had declined but by 1800 it was back to the figure of nearly 17,000 of over a century earlier and throughout the nineteenth century it continued to increase, as the populations of towns did everywhere, multiplying nearly five times in the hundred years to 75,500 by 1900. The cause was the same everywhere. Agriculture was needing fewer workers, the wool and cotton mills and manufactories offered employment and the towns attracted the rural unemployed who falsely believed that remedies would there be available. The subject has been so well researched that there is no need to reconsider it here. Nowhere did employment opportunities match the increase in urban populations and the problem of the unemployed poor was a constant worry to the York civic authorities as it was everywhere throughout the country. Although statutory remedies were available, albeit inadequately, generally governments and local authorities were disinclined to offer relief to the poor because they believed that to do so would only encourage more rural immigration and increased idleness. Reformers were engaged in constant campaigns, urging that giving the impoverished some initial spending power would provide an impetus to effort. Furthermore they maintained that the existence of slums spread disease beyond their boundaries. But the immense cost of rebuilding houses, providing proper water supplies and drainage systems, hospitals and similar public works was beyond the country's capacity. Virtually nothing had been done in the country since the Romans left although the population had increased at least tenfold. England was not alone in this. All over Europe the problem had never been recognized and matters had drifted on the familiar principle that if things had worked in the past they would work now. What was sought was some system of profit to encourage initiative but the works that were necessary did not offer such possibilities since the immediate beneficiaries were either the poor who could not pay for them or the more affluent who declared they did not want them.

York Corporation's income was largely limited to rents, fines and similar imposts, quite insufficient for financing any schemes which would give employment or improve the city. The early eighteenth century attempt

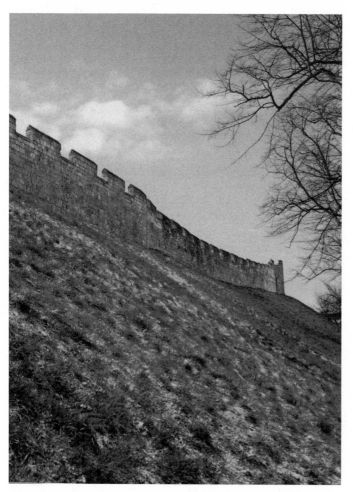

The City Walls, York (photograph by John Rhodes).

to establish York as a northern alternative to Bath—with the building of the Mansion House in 1726 (ahead of London by several years) and the Assembly Rooms in 1731 and a whole clutch of Georgian town houses throughout the century—had not proved to have lasting effect in attracting wealthy visitors. The general opinion of visitors was that York was "dull" and its streets "too narrow to be handsome." It was obvious that something had to be done but some local antiquarians objected to road improvements on the grounds that they would encourage yet more visitors during Race Week and the Assizes, the public executions always being popular among the less desirable elements of society. Just as later the invention of railways was deplored by those who feared an influx of unwelcome visitors to their towns so there were those who feared the visitors who would be attracted by improved amenities. It is again noteworthy that this view has largely prevailed in York until quite recent years. The country became divided between those who saw economic advantage in adopting all the new improvements and those who feared the disruption of their traditional tranquility. Etty's own objections to the railways were that they brought noise, smoke and factories and general disruption of that quiet life

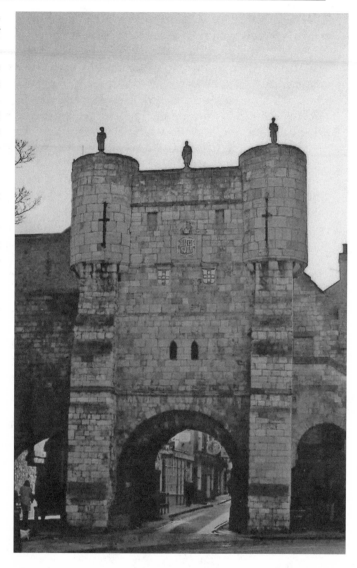

Bootham Bar, York (photograph by John Rhodes).

which he associated with a past age that should never be displaced.

There were several reasons why something had to be done about York's medieval structures. The bars (city gates) had already received attention because the barbicans associated with them had become public latrines and a danger to health. Many citizens, especially women, refused to walk through them and as the bars were few in number this had become a serious civic problem. The bars were also now often too narrow for coaches and it was to York's advantage to encourage coach traffic, situated as it was on the road from London to Edinburgh. The city walls had become ruinous through constant pillaging of stone for building work. In many places, houses, which were little more than hovels, had been built against them and had attracted the low life which was so typical of most eighteenth century towns. Paintings of eighteenth century York may give a picturesque and Romantic view of the city, but paintings do not smell. Walmgate alone had a fearsome reputation as the haunt of criminals.

The Corporation had already decided that existing streets should be widened and new

streets laid out. This meant removing the bars and much of the walls. A petition had been presented to Parliament in 1800 for the necessary powers to be embodied in an Act. Local business interests had supported the petition and the local newspapers approved the proposals and those who attended the public meetings on the subject had also welcomed the idea of clearing away the medieval encumbrances. The main opposition came from the Archbishop, the Dean and the Canons of the Minster. The Archbishop and the Dean were father and son (of the Markham family) who had been appointed through the intervention of George III and they persuaded the king (so it was said) to oppose the Corporation's petition. So nothing came of this proposal. The Corporation, however, did remove parts of the walls where they claimed this to be possible under an earlier Act of 1763. By 1812 opinions had somewhat changed and a group of town councilors now supported the Minster authorities. Part of Micklegate barbican had collapsed in 1810 and the Corporation's attempt to remove it altogether was prevented by a majority of the Commoners who represented the wards. By 1820 the barbicans of three of the bars had all been partially or wholly dismantled. In 1826 the Micklegate Barbican was removed. This aroused some opposition because this was the entrance to York from London and was regarded as an essential part of this bar, one which travelers from the south first saw when they came to York. Sir Walter Scott is reputed to have added his objection. But it must be said on the Corporation's behalf, that this was the entrance point to the only bridge over the river Ouse and, as was reported at the time, a showman's Van, of unusual dimensions, could not squeeze itself through and entered the city only by using a breach in the walls which, of course, should not have existed. To this day large vehicles cannot pass through Micklegate Bar and, as this is written, the Corporation have prohibited entry to vehicles through Walmgate Bar.

Various influential families began to support the campaign to retain the walls and by the 1820s the York newspapers had also changed sides. The view began to gain acceptance that the walls should be restored and laid out as a promenade. A public subscription was opened in 1824 and a petition to the Corporation was prepared but money was slow in coming in and when in 1829 the fire in the Minster diverted public attention, the idea was put aside. It was revived in 1831 when it became the subject of political differences between the Tories and the Whigs among the local councilors. Geoffrey Curr considered that Archbishop Markham was more responsible for saving York's

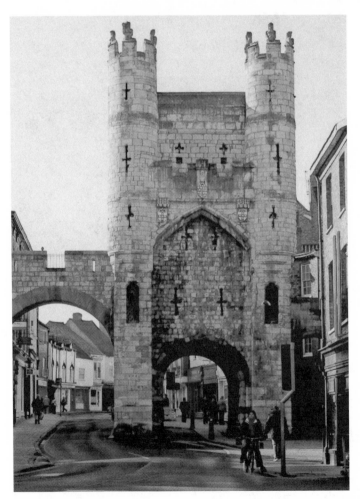

Monk Bar, York (photograph by John Rhodes).

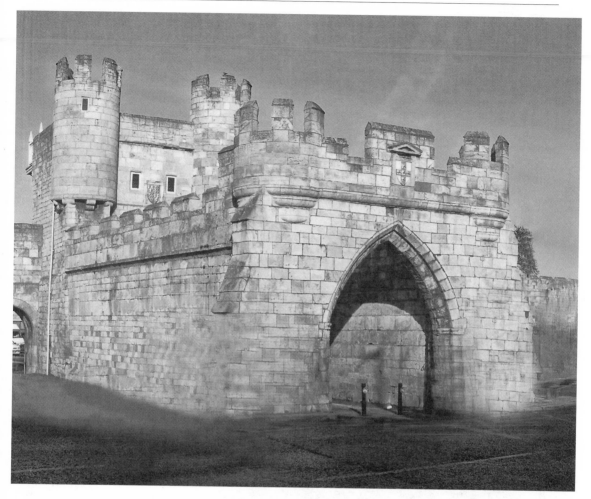

Walmgate Bar, York (This is the only Bar still with its Barbican) (photograph by John Rhodes).

walls than probably anyone else and, of course, the Archbishop and other senior clerics did have a considerable influence in local politics simply by making their views public.

Etty first became concerned about the future of the City walls in 1828. His mother had advised him that it was proposed to demolish some lengths of the walls. There had been earlier agreements between the Corporation and the Archbishop that the Monkgate barbican, the Castlegate postern, and the Micklegate barbican should be demolished. These agreements did not include the walls. On the 31st May 1828 Etty had written to his mother:

> You petrify me about the walls. Is it possible such barbarians exist in the 19th century in York? York that gave birth to Flaxman, the glory of the country, and the admiration of the foreigner. Forbid it Heaven and blast them with its lightnings! But I hope that no such thing is intended. It cannot be. It must not be. A subscription should be set on foot to keep them in repair. Myself, and several other Yorkshiremen, will put our name and money down to save my native town from such a disgraceful act. Let each use his endeavour and so that if it can be conceived it cannot be perpetrated. Set the ladies to work. They influence mankind. They extend themselves in Charities. It is one to preserve to us the memorials of our ancestors and the relics of ancient days.

Etty does not appear to have done any more at this time. He had his obligation to the Academy to fulfill—to paint his diploma picture. When he visited York later that year he would have

heard that the walls were not to be demolished after all. In 1831 the Corporation, with the support of the Minster authorities, removed the Bootham barbican on the grounds that it was "not fit for any female of respectability to pass through." This was a common complaint about all the bars and other parts of the walls. Horse manure was piled against what remained of the walls in Walmgate and the barbicans were commonly used as latrines. Having no money to restore them, the Corporation favored the cheaper solution of demolition. It became the general opinion that the barbicans should be removed but the walls retained.

Etty began his engagement with the City authorities over the walls and bars in February 1832 when he sent £50 to the subscription list for saving Bootham Bar. Visiting York later that year Etty was pleased to find that the bar and the walls were being restored. In his letter of 18th February 1832 sent to his friend John Brook for publication in the *Yorkshire Gazette*, Etty denounced the Corporation for their earlier intentions to cut down "the noble trees of the New Walk" (alongside the River Ouse) and expressing pleasure that this plan had been defeated. Etty was a regular subscriber to the York newspapers, there originally being four of them, *The Yorkshire Gazette* presenting the Tory viewpoint, *The York Herald* and *The Courant* which the *Herald* absorbed, and the *York Chronicle*, these representing Whig opinion. Allowing for the transport by coach to and from York any letter would unavoidably be published a week or so after the event originally giving rise to it but provincial editors always welcomed letters from London, especially from a correspondent as famous as Etty. In this letter of February 1832 Etty urged that "a little stir will save the Bar, and in saving it, save many more precious remains in York."

York is yet, with all her losses of Posterns, Barbicans, etc., unique in her Antiquities, ecclesiastical and military. Rob her of them, and she is "poor indeed." With all your improvements, patching, and cobbling, you can never make York a uniform, "well-built" City. But keep her Antiquities, and she will always possess a charm, an interest, far beyond that of most other towns, however regular their streets or "handsome" their houses....

A disregard for the monuments of their ancestors, is one of the strongest marks of an unthinking, barbarous, sordid, and even brutal age.

Geoffrey Curr considered that the newspapers did more to influence the repair of the walls than Etty could. This must be correct since the press was able to maintain a continuous campaign but they did, after all, rely on contributors and especially those of some renown. In his letter Etty pointed out that the appearance of the approaches to York had now become important

Micklegate Bar, York (photograph by John Rhodes).

and that travelers from London should be given a favorable first impression. He particularly referred to the road from Hull, with which he was most familiar, since he habitually went there first when he visited York as his mother and other members of his family now resided in that city. The city walls were, he claimed, "interesting, picturesque and beautiful" and should be maintained.

In 1833 the Government set up a Commission of Inquiry into "the Existing State of the Corporation of York," which was a source of deep embarrassment to the city's business and professional interests. The leader of the Whig majority in the Corporation (Jonathan Gray) raised the matter of the walls during his evidence to the Commission, which angered his opponents but had the effect of focusing attention on the need to do something about York's antiquities. The view was becoming accepted that York should "modernize" with the construction of better approaches to the city and of wider streets within the city and by demolishing the older houses and erecting buildings more in keeping with the city's commercial ambitions. Between 1810 and 1830 four new banks had been established. Between 1821 and 1831 there was a nearly 50 percent increase in the number of houses and by 1831 the population stood at over 26,000 against 17,000 at the beginning of the century. But York was still predominantly attracting agricultural trade. In 1826 the cattle market was re-sited outside the walls, at first with some 7,400 pens, later increased by a further 4,000 pens after 1830. This brought far more traffic than the road system could manage. The public complained about the confusion, the mess from manure and the general interruption to other business, and especially the inconvenience to pedestrians. The barbicans were the chief targets for demolition but to the surprise of the Corporation there was a strong public demand for their retention. York citizens now wanted both to modernize the city and to retain its antiquities. The York Philosophical Society and the Footpath Association, with Etty a member of both, took leading roles in campaigns for preserving the walls. Restoration began in Walmgate where not only neglect but deliberate plundering of the stones had left the walls in a ruinous condition. This work required money and fund raising balls were held in the Assembly Rooms but only £40 was raised.

There was a lapse of some five years and then the threat to the walls was renewed. In the original campaign attention had been focused on the Walmgate walls as well as Bootham Bar. Earlier fund raising events, such as a fancy dress ball in the Assembly Rooms, had raised very little, it being noted by the press that very few townspeople had shown support. It has always been the prevailing view among the generality of York citizens that the Roman and medieval ruins were of interest only to visitors but they did not have to live in the city with its many inconveniences. It has until quite recent times been the view that York did not need the money that tourism introduced. Now the question was raised, in 1837 in a debate within the Corporation, whether additional lengths of the walls should be restored. In another letter to the editor of the *Yorkshire Gazette* dated 8th July 1837, Etty returned to the subject, this time referring to the proposal to remove Micklegate Bar.

Beware, I say again, how you destroy Antiquities—guard them with religious care, they are what gave you a decided character and superiority over other provincial cities—you have lost much—take care then of what remains. I wish that we had in our country—as they have in France, an officer called *Conservateur des Monuments Publiques* to guard them from the invasion of petty and private interests and preserve as records of the past and landmarks for the future.

Alas, Etty again did not realize that appeals to the examples set by other countries had only the effect of confirming that English customs were superior. In this letter Etty urged the restoration of the walls and the barbican and towards this end he sent his subscription of five pounds, regretting that he could not donate more. Five pounds was a not inconsiderable sum at the time and, bearing in mind how little York's citizens were prepared to contribute, it was at least an exemplary gesture, particularly bearing in mind that Etty was ever conscious of his financial

dependence on his brother Walter. The Corporation agreed only in principle to repair further lengths of the walls.

When the York and North Midland Railway Company came to York in 1839, George Hudson was both chairman of the company and Lord Mayor of York. He arranged that his company should have the power to form an opening in the walls to enable a station to be built at Toft Green on the south side of the river on a site parallel to Micklegate. For this privilege the company paid the sum of £5,000 to the Corporation. Despite an attempt to have this money devoted to restoring the walls, Councilors decided to use it to reduce the Corporation's debts. Such a move seemed only prudent. However, a restoration committee was formed to raise funds and by 1842 there was a total of 82 subscribers. Geoffrey Curr compared the subscription lists of 1829 and 1842 and found that there had been a change in support with more middle class subscribers at the later date. In 1829 there had been only thirty signatories of whom only thirteen were natives of York. Of the total, eleven were from the aristocracy, gentry and the Minster establishment. Altogether it had been a pitiful response. In 1842 not only were there more signatories, eighty-two in number, forty-five were members of the York Philosophical Society and fifty-six were, or had been, members of the Corporation. Forty-seven were natives of York. Of course, many appeared in more than one category but the social position of those subscribing was markedly different from that in the earlier list. There were no members of the aristocracy, no gentry and no clergy, but there were many nonconformists. Most were businessmen, some were professionals of whom the majority were lawyers. A total of £244 1s 0d. was raised Although the number subscribing was still small, the fact that they were influential citizens meant that the list of names was significantly important. The tide was turning against the demolition of the walls.

Etty's letter to the editor of the *Yorkshire Gazette* in January 1838, when the railway company's breach of the walls was being proposed, was trenchant in its condemnation. He objected to the claim that this would be a "great improvement" to the city.

> God protect her [York] from such improvers is my prayer. Those who have like myself lately seen the "great improvements" they have lately made in and near York, may be like myself—a little sceptical about the Taste of that company in improvement.

In another letter to the newspapers, also in January 1838, Etty wrote:

> It has always appeared to me a great mistake in our political economisers that they think sums of money applied to the restoration or production of works of art, as so much money thrown away. Let me ask them what increases or causes the great influx of Strangers to Paris—to Antwerp—to Holland—to Rome and the other great cities of days that are gone. Rob them of their objects of Art and Antiquity, and then see if the tide of strangers spending their money amongst them would not instantly stop. They know this well, and consequently nurse their finances with a jealous care. Suppose you take away from York her Minster and her Antiquities, what is she? A mere nothing. Then as you value our native city, protect them and preserve them by every means in your power, it is your *interest* to do so, if you will not do it from *feeling* their value—be assured it is your interest to preserve them and I yet trust you will.

Etty well knew that any appeal to the citizens of York had to be through their pockets but he did not also realize that York citizens were not particularly eager to encourage "strangers" to their city—and they certainly could not accept that foreigners could manage their affairs better. In any case, they had more important things to spend their money on than some old stones.

Probably in 1838 Etty produced four paintings of York's Bars. Three of these—*Inner View of Walmgate Bar, Outer View of the Same* and *Micklegate Bar*—have not survived so far as is known. *Monk Bar*, now in the collection of the York City Art Gallery, bears a label on the back describing it as *The York Gate* but there is no doubt as to its identity. In any case, there is no such bar as "York Gate." The label was probably attached while with an anonymous Lancashire collector.

These paintings of York's antiquities were unusual subjects for Etty and must be seen as expressing his objections to the proposals to demolish them. Etty delivered two lectures on the subject of the York walls and antiquities during his visits to the city in 1838 and 1839. In the second lecture, the notes for which are preserved in York Reference Library, he inveighed again the formation of an arch through the walls to allow the railway company to build a station at Toft Green.

> What a lovely walk it used to be from Micklegate Bar along the Walls, to North-Street Postern: ancient fortifications, grey battlements, verdant fields, and smiling gardens on either hand; finished in grand perspective by our noble Cathedral in one of its finest points of view. Go and look what it is now! ... And for what have the Walls been broken? Absolutely without any real necessity: as it is now, I believe, generally allowed. I am informed that the eminent Engineer Stephenson, himself declared it unnecessary; and advised against it: I am sorry to say, ineffectually. The mixture of dwelling-houses and picturesque garden-ground within the Walls reminded me of Rome. *Altera Roma*, I used to think with complacency. What is it now? *Altera inferno* more like! We walk side by side with trains of interesting coal-waggons; have the satisfaction of being smoked by passing Engines. and the pleasure of hearing the music—not of the robin, the blackbird, and the thrush—but the whistle of the train from Leeds.

Such sentiments were being uttered and would go on being uttered in towns and villages throughout the land; and, as in York, they would go unheeded. The building of a station within the city walls did prove to be a mistake. It required trains continuing northwards to reverse out of the city to resume their journey and *vice-versa* when traveling south. The present station was built between 1866 and 1877 and enabled through-lines to be constructed, thus simplifying train movements and reducing delay. George Hudson had been determined to make York a terminus from London and allowed personal ambition to overcome sound judgment.

The Etty papers held in the York Reference Library are unfortunately usually lacking dates of their composition. Letters to newspapers are drafts, although it is usually possible to trace their finished form in the newspapers themselves, also held by the Reference Library. Etty's lecture notes are also undated and do not always indicate the institution to which they were delivered. One such set of notes, obviously intended for a York audience (presumably the York Philosophical Society), expresses his delight that strong public feeling has been roused against the demolition of Bootham Bar. He spoke out against "this barbarous project of the levelling faction" and expressed the hope that the opponents of the scheme would "religiously preserve these sacred relics that Time has still left us." It probably did not assist Etty's case that he associated religion and the sacred with the walls since

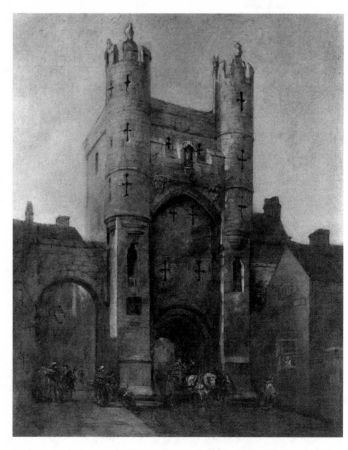

Monk Bar, York (30 × 24 ins) (?1838), **York Museums Trust (York Art Gallery), YORAG64.**

they had been built for secular purposes but he was prone to clad everything old with a patina of holiness. What it cost Etty to make these speeches we can well imagine. He was a shy man who disliked speaking in public and it appears from most accounts that he frequently did not deliver them very effectively. It seems that he read monotonously and in a low voice but so outraged was he by proposals to remove any part of York's antiquities that he felt obliged to speak out. After his death a contributor to the *York Herald* (28th April 1855) expressed another view of Etty's compatriots by referring to him as "Poor Etty" from whom "even necessary demolition" would bring a remonstrance. But that invites the question—what would this contributor have regarded as "necessary demolition"?

Of course, Etty did not conduct a single-handed campaign against a "barbarous" Corporation as Gilchrist proposed. But, equally, he was not as ineffectual as Geoffrey Curr was inclined to suggest. Etty had a following among the professional families of York who responded to his appeals and used them to enhance their own expressions of concern for the city to which they were so attached. Etty saw himself as an important personage, as indeed he was in the London art world, who had an obligation and a right to speak out on matters affecting his native city. Etty had an unbounded love for York and especially for the Minster and other antiquities which he correctly saw were threatened by a general indifference which, it must be admitted, has always been a problem facing those who cherish the city's historical associations. He did not shirk from opposing the Minster authorities if this seemed necessary but he conducted his campaigns, though with vehemence, always with discretion. He retained everyone's respect and goodwill. It is quite unlikely that things would have turned out differently if Etty had not taken part but, then, this can be said of any individual protagonist. Slavery would have been abolished even if Wilberforce had never lived but this does not mean that his campaigns did not hasten events by stirring popular feelings. It was the combined efforts of men and women such as Etty which persuaded the authorities to preserve what was left for the good of the city. Although the campaign was finally successful only long after his death, Etty played a significant part in ensuring that victory.

Whenever there was threat to the city walls or to any other medieval structure Etty wrote a letter to the local newspapers and he maintained his campaign almost until his death. But despite his concerns and constant letter writing, when he died in 1849 only about half the length of the walls had been safeguarded. In the 1850s Joseph Rowntree began a new campaign for their removals and the building of new streets and houses to improve the condition of the city's poor. Rowntree represented the Walmgate ward on the Corporation, a ward which was notorious for its poverty and crime. His motives were of the highest moral rectitude. He could not accept the idea that money should be spent on cosmetic improvements designed to appeal to visitors when the poorest citizens lived in squalor. By clearing the area and re-housing the inhabitants, York would be improved both for its citizens and its visitors. Rowntree attracted much support and "the war of the walls" began again. It was a long and acrimonious battle in which the Corporation frequently found itself being expected to spend money on restoration when urgent new civic works were also required.

By 1880 the Minster establishment was opposing restoration of the walls—a reversal of their earlier position—claiming rights to certain sections which overlooked the Minster and the Dean's garden. This was the nub of their objection as Geoffrey Curr points out. These dignitaries had realized, very belatedly, that a promenade on the walls would affect their domestic privacy. The Gray family offered similar objections, claiming rights to the walls at the rear of Gray's Court which were, in fact, well-founded. The Corporation decided to ignore these claims but in the face of threatened legal action, it postponed a decision. After a successful campaign by those favoring restoration, the Dean and the Gray family retreated and made a gift of their rights to the Corporation. It was not until June 1889 that the walls were finally declared to be totally restored and an official opening ceremony was held. The Minster bells were rung to celebrate

the event and to assume a civic responsibility which had not always been apparent. But the "improvers" did gain some victories. St. Leonard's Place had been constructed in 1831 with the loss of a section of the walls, two new bridges were built, Parliament Street was formed and there was a piece-meal widening of streets though, in general, the medieval street pattern was retained.

"Some great moral on the heart"

Etty's name is not connected with religious works in the mind of most of those who know of him despite the fact that he painted several during his lifetime. They never constituted a major part of his output but many of them were well received at the time. England since the Reformation was not sympathetic to religious subjects in art, regarding them as papist and idolatrous. Only Catholics and High Churchmen acquired them, usually as an act of defiance. After a few such works in the 1810s he did not paint another until 1823. This was a *Crucifixion* worked up from a painting attributed to Van Dyck which he had seen in the Borghese Palace. Its history is not known before 1902 when it was bought for fourteen guineas. It appeared again in the sale room in 1942 when it was bought and presented to the Greek Orthodox Cathedral of St. Sophia in Moscow Road, London, which had been built in 1877–82, designed by Sir Gilbert Scott's son, John Oldrid. *John the Baptist* followed in 1824 or 1825. Nothing is known of this painting until it was sold in 1849 for thirty-eight guineas. The drop in prices indicates the lack of general interest in religious art. Etty resumed painting religious subjects during the 1830s probably

because of his growing interest in Roman Catholicism. Greater freedom had been granted to Catholics in England by the *Roman Catholic Relief Act* of 1829 and from this time onwards they increasingly took part in public affairs. Unlike many of his contemporaries Etty welcomed this growing tolerance though he was not disposed to extend it to Dissenters which is surprising since his parents had been Methodists.

A surprising work of 1828 was *The World before the Flood* (see page 288), clearly based on Poussin's *Bacchanalian Revel before a Term of Pan*, which Etty sold to the Marquis of Stafford for 500 guineas.

Etty's major religious work of this period was *Benaiah* (see color plate 5), exhibited in the Academy in 1829 and depicting the exploits of one of King David's captains as described in II Samuel, chapter xxiii, verse 20—"And Benaiah the son of Jeholada, the son of a valiant man, of Kabzeel, who had done many acts, he slew two lion-like men of Moab...";
Etty stated in his *Autobiography*,[1] "my aim in all my great pictures has been

John the Baptist (19.75 × 16 ins) (?1824/25), York Museums Trust (York Art Gallery), YORAG83.

The World before the Flood (59 × 80 ins) (1828), Southampton City Art Gallery/Bridgeman Art Library, London; SOU133091/96.

to paint some great moral on the heart" and in the case of *Benaiah* it was to depict *"Valour."* In this case the moral appealed to the Royal Scottish Academy who bought a smaller version in 1831. The large version is in York Art Gallery, having been bought in 1827 from James Brownleigh Hunter of Edinburgh. Its frieze-like composition with figures holding poses chosen more for the comfort of the models than for the expression of violent passion and fear indicates how Etty was constrained. There is also some debt to Flaxman. As Dennis Farr points out,[2] Etty's ambitions were based on John Opie's principles as laid down in his lectures and also on Henry Fuseli's earlier lectures, which Etty would not have heard but of which he may well have been made aware. Opie had maintained that painting "presents to us the heroic deeds, the remarkable events, and the interesting examples of piety, patriotism, and humanity of all ages; and, according to the nature of the action depicted, it fills us with innocent pleasure, excites our abhorrence of crimes, moves us to pity, or inspires us with elevated sentiments."[3] Fuseli also had emphasized the moral purpose of art, saying that "the aim of the epic painter is to impress one general idea, one great quality of nature or mode of society, some great maxim..."[4] Though Etty believed that the great allegories could present such moral truths, the most perfect subjects were to be found in religion and especially in the Bible. Perhaps in another age he would have concentrated on these subjects but nineteenth century Britain offered little encouragement to an artist who drew inspiration from Catholic Italy. Though critics might complain that contemporary art was concerned with "bold execution and glaring colours" and lacked the ability to "raise, elevate, touch or address the soul," as Lytton Bulwer said in 1833,[5] they were seldom supportive when it tried. It is noteworthy that Bulwer went on to praise Etty for his "vigorous and fluent drawing, and bursts of brilliancy and light" although also complaining that he combined "an

imitative affectation of the errors as well as the excellence of the Venetian School."[6] After the exhibition of *The Storm* at the Royal Academy in 1830 Etty produced no more religious subjects until 1833 when he fulfilled the commission from the Church of St. Edmund the King and Martyr in London for paintings of *Aaron* and *Moses* for the reredos.

It is difficult to date many of Etty's religious works as most were not publicly exhibited but were either commissioned by or sold to private collectors. The dates of their first sales from these collections are usually known but not when they were acquired in the first place. In all about three dozen religious works were produced over the years but some seem to have been conceived as nude figures and then given religious titles to satisfy a purchaser. There are thus three paintings of *Eve* and another three of *Mary Magdalen*, whom by now custom required to be a repentant nude figure kneeling before a crucifix. In 1834 Etty sent *Christ Appearing to Mary Magdalen* (see color plate 8) to the British Institution. This had originally been intended for engraving in *The Sacred Annual for 1834* but Etty was so dissatisfied with the engraving that he decided to exhibit the painting so that it could be assessed firsthand. It was highly praised but probably because it was for the critics a welcome change from his usual nudes. However, it cannot be said to be a successful painting, being poorly composed and loosely painted and really no more than a sketch, which was probably the reason why it was unsatisfactorily engraved.

The Prodigal Son was exhibited in the British Institution in 1836 and purchased by a Mr. James Stewart who sold it on for eighty-five guineas in 1839. A second version was exhibited in the Royal Academy in 1838 and bought by William Beckford. *The Good Samaritan* was exhibited in the British Institution in 1838. Farr relates[7] that there is an inscription on the reverse stating "Painted by Wm. Etty R.A. And presented by him to his Friend R. Cartwright, Esq., in Testimony of his sense of his unremitting Attentions to Wm. Etty, during a long and painful illness, March 1839." Cartwright was a doctor who appears twice in Gilchrist's account—in 1828 when he is reported as enquiring several times regarding the health of Etty's mother, and in the winter of 1846 when, referred to by Etty as "my medical friend," he attended Etty for his attacks of asthma.[8] In the winter of 1838/39 Etty lost a number of his friends, including Sir William Beechey, James Lonsdale, and William Jay of Bath, whose father was well known to Etty. All deaths deeply affected Etty, making him too aware of his own frail state. No "long and painful illness" is mentioned by Gilchrist at this time but we know from letters written to the Bodleys that Etty was constantly ill with severe respiratory attacks throughout his life and had to make frequent calls upon his doctor.

A missed opportunity

In London during these years Etty had another cause to occupy his mind. During his lifetime Sir Thomas Lawrence had acquired what was regarded as a fabulous collection of Old Master drawings. One year after Lawrence's death, in 1831, the Royal Academy voted the sum of £1000 towards the purchase of these drawings for the nation. Sir John Soane also offered £1000. The Government declined to assist the acquisition and the named beneficiaries of Lawrence's will also refused to assist the proposal.[9] Lawrence's will proved complicated and difficult to execute but by June 1835 his executor, Archibald Keightley, was able to consider the disposal of this collection. He sold all of them to the dealer Samuel Woodburn. Sandby lists drawings by Leonardo da Vinci, Michelangelo, Raphael, Rubens, Rembrandt and many others by Italian, German, Flemish and Dutch artists. Woodburn estimated that Lawrence had spent £60,000 accumulating this collection, an enormous sum for the time, especially for one who was always impecunious. In 1836 Woodburn began to exhibit selected items, obviously to excite interest with a view to lucrative sales. The members of the Academy began to consider how they could be acquired for the nation. Woodburn asked for £18,000 for the lot. The Council of the Academy having already voted £1,000, with Sir John Soane offering another £1,000, the race was now on

to secure the rest, a state of affairs only too familiar. Etty, feeling his debt to his own master, was early in the field to arouse public interest. In a lengthy letter to the *Morning Herald* on 25th February 1836 he laid out the case for England to succeed to the role of the great Renaissance patrons by purchasing these drawings and so give the National Gallery which was then in a house in Pall Mall, "in the class of *Drawings* a superiority over the Louvre itself." The National Gallery was not established in Trafalgar Square until 1838 and then only in part of the building that it shared with the new premises of the Royal Academy, a matter to which we shall return later. In his letter Etty extolled the virtues of Lawrence as an "illustrious artist" who was "one of the brightest ornaments" and sought to persuade the public in general and Parliament in particular that by acquiring these drawings they would rank among the most enlightened of their time. Etty recalled that Prince Talleyrand had paid repeated visits to these Drawings and had told the government ministers who had accompanied him—"*Si vous n'achétez pas ces choses-là vous êtes de barbares.*" Etty went on to compare the English and the French in their respective attitudes to art and made the mistake of suggesting that in France they managed these things better. Again he did not realize that for the English to be compared with any foreigner merely confirms their own superiority. It was common knowledge among the English that the French were a decadent people whose art was lascivious and whose general morals were degenerate. Etty asked,

> Why is our Gallery of the Old Masters called the National, seeing that the pictures are not, for the most part, of our nation? I should like to see a *truly* National Gallery, one that with pride and pleasure an Englishman might show; where the virtues, the heroism, and genius of his country might be *recorded*, to the most remote posterity.

In his efforts to rally the public to his cause, Etty introduced too many subjects for debate and was inconsistent, unfortunately often a weakness of his when presenting an argument for a favorite cause. He was insufficiently selective and too inclined to throw in everything in the hope of appealing to a wide range of interests. To persuade Parliament to spend a large sum of money (whatever it would be after public subscriptions which, at the typical £20 offered by one wealthy supporter, would not have been much) on purchasing drawings was a sufficiently difficult task in itself. Drawings cannot be placed on permanent display and there is always a suspicion when drawings are taken into a collection that they may never be seen again. To ask also that the National Gallery should be reconstituted to collect and exhibit only patriotic English art not only had no relevance to the Lawrence drawings, which consisted mostly of works by foreign artists, it was so contentious as to require separate discussion altogether. It had been hard enough to get a National Gallery established in the first place—one room only in a building in Pall Mall—it was quite unlikely that its character could now be changed without considerable dispute. In any case, this suggestion contradicted Etty's appeal to purchase drawings by foreign Masters. Then to compare the English unfavorably with the French, when the Revolution and the French Wars were still within many people's memories, inevitably killed all hopes of attracting sympathy. So no money was forthcoming and the collection was gradually sold off and dispersed.

Illness and convalescence

Etty's poor health was beginning to take its toll. He was frequently afflicted with respiratory difficulties, which today we can diagnose as asthma, which grew steadily worse. Also he developed arthritis in his hands which in due course was to make holding a brush very difficult. Throughout the winter of 1833–34 he was unwell and by February 1834 was seriously ill. Writing to Thomas Bodley in an undated letter, but clearly written in February, he referred to

> the malady preying on me: which has taken away all my energies of body and mind—at least for the present. ... I feel scarce the strength of a kitten. A severe cough, sore throat, hoarseness, low fever, and soreness all over, deprive me of all interest and pleasure in my pursuit.

Farr suggested a complete breakdown but the symptoms are more akin to a severe attack of influenza. Etty mentions that the task of cutting a piece of mill board was too much for him—"I assure you I looked at the effort with dread." He reported that Betsy did the job for him "with her usual care and kindness." This was the beginning of the many periods of severe illness which troubled him for the rest of his life. Looking back over his life and knowing the circumstances of the time we can now confidently say that winters in London with frequent and often continuous fogs, aggravated by the excessive number of coal fires pouring sulphurous smoke into the atmosphere, were most unsuitable for his respiratory condition, which was developing into chronic asthma. He wrote of looking forward to going to York and by the end of June he was ready to make the journey but before doing so he accompanied Jane Etty (Walter's daughter), Cecily Bulmer (daughter of his friends in York) and Betsy "to see the Correggios at the National Gallery which have just been purchased at the expense of twelve hundred guineas."[10] Apparently Jane and Cecily were staying with him, Jane being accustomed to traveling away from home. Visiting an exhibition unchaperoned would have been indecorous and Etty was ever mindful of his obligations to ladies. The influence of Correggio on Etty's development has never been fully studied though Etty himself referred to Correggio at least twice, once in a letter to Sir Thomas Lawrence from Paris in 1823[11]—complaining of the "narrow nationality" of the French he wrote: "Titian, Correggio, Paolo, Rubens, throw down their pearls before them in vain" and again in his notebook where he jotted down painting techniques to be followed—" Chiaroscuro: Correggio, Rembrandt, Rubens and Nature." Etty was forever learning from selected masters and Correggio was among them.

Traveling by coach was tiring especially for anyone who, like Etty, traveled "outside" which he invariably did since he could not be confined to the airless interiors. He usually traveled directly to York which meant crossing the Humber by ferry at Barnetby, but this time he went first to Lincoln and stayed overnight. On this his first visit to Lincoln he took opportunity "to compare the architectural beauties of the two great Cathedrals and also the state of the service in each."[12] As much as he admired Lincoln Cathedral he preferred York Minster. From this time on he began to break his journeys at Lincoln, no doubt in order to reduce the fatigue of a continuous journey. On arrival in York one of his first tasks was to write a reproving letter to Thomas Bodley.[13]

> I am going to write to you tho' you did let me be five or six weeks confined to a sick room without a line from you to cheer me. But it is past. "Sufficient for the day is the evil thereof." I feel I am gradually losing the remains of my enemy by the influences of my native air, and the garrison that my illness left in my frame are dropping off one by one.

In York he spent much time at first taking familiar walks but chiefly in visiting the Minster both to admire the building and to attend services which always uplifted him. He took possession of a house on the Mount—"I have taken a little wooden box at the top of the Mount ... [which] has caused much amusement to us all here."[14] The four roomed cottage which he rented at nine guineas a year "including taxes" was situated directly opposite his father's former mill and thereby greatly pleased him. Various friends took him for drives into the country. His most enjoyable excursion was a tour of North Yorkshire arranged by John Brook and Mr. and Mrs. Bulmer. Etty so enjoyed this tour that he wrote three long accounts to Thomas Bodley. Only two letters have survived and these are reproduced here since they reveal very clearly how thrilled Etty was to be able to visit the Yorkshire countryside in the company of very close and dear friends. Etty's descriptive powers are somewhat limited, he is never critical and always delighted by whatever he sees and experiences. He has a shortage of suitable adjectives, over-employing certain of them. Nonetheless his account is worth reading since it expresses so much of Etty's simple and generous nature.

Mount, York
29th August 1834

My Dear Thomas Bodley

I know you like travelling, you shall travel with me—in your own arm-chair, and I will carry you over hill and dale, in it, by yoking it to my Pegasus—but before I yoke him in good earnest to take you to the Moors, not of Barbary but of Yorkshire, I will tell you of a pleasant day I had nearer York, only four miles off; at Poppleton on the pleasant banks of the Ouse, is one of those old country churches [*St. Everilda's Church, Nether Poppleton*] and quiet churchyards, which we see only in our country—and which I am sure, you like—a few trees surround it—the tombstones overgrown with lichens and high grass—the silence only broken by the sighing of the breeze thro the foliage and herbage—in the church an ancient monument in black letters on brass—very interesting generally—and beginning and ending with a sentence—something like this—"How vain are all the pleasures of this life"—The clergyman of this church is Mr. Charles Camidge, son of the organist of York Minster—he is in character and conduct an honour to his cloth. He is married to an interesting young person, daughter of Mr. Hartwick of Hull. We were to dine with them one day some weeks ago. We set off from York about 2 o'clock in a carriage—the day was fine and the breeze pleasant. It—Poppleton—is a remote country village, behind the house is a garden, behind the garden a paddock or field, on the right a rich wood and leading down to a declivity nicely planted to the river Ouse, near which is a summer house—where we all drank tea—commanding a beautiful turn of the river.* We had a very pleasant dinner and after seeing the very pleasant prospect of the river we adjourned back to the house where we had music and prints to look at particularly etchings of Rivalx's [*sic*] Abbey and Fountains Abbey, with which I am sure you would be pleased—and after a delightful day arrived at home in good time in the evening.

I have also to tell you that I have been some other little excursions one to Booth Ferry during which I saw Howden and Selby churches, both of them very early and fine specimens of our ancient Ecclesiastical Architecture. In the former I found a monument of a Crusader in Chain Armour, which I sketched. The Choir of Howden *Cathedral* (it has been) is in ruins, so is the Chapter House and are beautiful tho in ruins. The country we passed thro rich and well wooded, golden with harvest and laughing in luxuriance.

Now Etty begins the letter that he really set out to write.

On Wednesday week, Mr. Brook, myself and his servant in one carriage—Mr. Mrs. and Miss Bulmer in another (both open carriages) set off from York on a tour. We set off about seven. The morning was a little misty, yet the sun shone, and gave promise of a fine day. We had ten miles to go to Stillington where we had breakfast. Mr. Brook was our Cicerone knowing well the county—the points to go to and the best way of approaching the points we had in view to visit. Our first point was Gilling Castle—the residence of the Fairfax's. We entered a wild and woody part of the park, after passing the lodge. Turning short to the left, we drove into the avenue over the velvet turf of a rising ground, a perfectly regal approach thro long lines of fine old trees wide apart. The green velvet avenue near a mile long—till arriving on the brow of this grand green avenue the Castle was a little way distant we alighted. The family having been apprised of our coming very politely received us. We were shown a room for which the ancient part of the Castle is celebrated. It is unique. Sitting in it you may fancy yourself living in the time of Henry the 7th—three centuries ago. It is beautiful and perfect. The oaken polished floor, the painted window—the ancient painting—the inlaid wainscot—the magnificent view from it all very enchanting. The terraced garden—the ancient tower—all together magnificent. They gave us some luncheon in this very room and after showing us the rest of the house we took our leave and drove to Duncombe Park where we saw the Pictures—the cloth laid for dinner. There is a Titian Venus & Adonis, a Portrait by Rembrandt, A Martyrdom of St. Andrew by Carlo Dolci and a Picture from Ariosto—which were the four pictures which pleased me most. We walked on the magnificent green velvet lawn or Terrace. What possessions has Lord Faversham—late Duncombe—375,000 acres!!! In one direction he can ride over 24 miles of his own property. It is immense. It was formerly the estate of Villiers Duke of Buckingham.

After which, on our road to Kirkbymoorside—our quarters for the night—we visited Kirkdale, a most secluded and romantic valley in which a very ancient church with a sundial dated 1006. The church rebuilt in reign of Edward the Confessor. It is far remote from any town, and the silence and solitude of

The vicarage and garden still stand, though no longer fulfilling their original purpose. Recent excavations in Nether Poppleton have revealed an early medieval moat such as usually surrounded a monastic building and also the foundations of an Elizabethan manor house as well as many Saxon objects.

the valley—betwixt high hills covered to the summit with woods—and the rocky torrents running thro the valley, made it one of the most striking scenes I ever saw. The very great antiquity of the church and its secluded and beautiful situation and the curious inscription bearing the date, which I regret I can't send you. After this we drove to Kirkby Moorside and while tea and mutton-chops were preparing we walked up to a wooded hill which commanded the town and the setting sun—read the gravestones, peeped into the church, walked to our inn, had tea and ham and chops and pigeon-pye [sic] and cakes, and after sleeping well, rose in pretty good time to see a morning brilliant and clear as France or Italy could boast. We again, some of us, 3, mounted the beautiful wooded hill that commanded the country round. A finer morn never Aurora smiled on. The air was clear and blue to intense and the prospect enchanting. We returned, breakfasted, then set off for the village of Lastingham, the birthplace of Jackson the painter.*

By the way—we went to but not into the famous cave at Kirkdale where the fossil remains of an hyena, rhinoceros, elephant, hippopotamus and other animals were found. The entrance was too high up and too narrow to get to well. We went to Lastingham by a route that Mr. Brook had found by chance in going to a Water-Mill in a wild and romantic Valley. Thro this wild and almost Alpine Valley he took us, now toiling up a hill and then crossing the brook, till delighted and amused we at last arrived at this pretty village in a valley sheltered from the South by high and wooded hills and on the North by the wide and desolate moors. It was just such a spot as a poet would like to be born at and like to spend his last years—remote, secluded, peaceful as an Alpine solitude. The crystal mountain stream ran rippling over gravel—how I longed to drink. We arrived. The church is celebrated. Its antiquity, its beauty, its crypt and its situation all command attention and demand it. Jackson has taken great pains with it—presented a picture to it—lit it beautifully with gold coloured glass—the effect lovely—you do not see where the light comes from and the effect is magical. He has done a great deal for the church and a tablet gratefully records his meritorious exertions. The religious effect of light thrown on the picture which is Christ in the Garden of Olives. The touching tribute of regard to the memory of one whom I had esteemed as a countryman, an artist and a friend—and the recollection that he was now no more, overcame me to tears. I visited his aged mother. She was almost double when I went in but I said I was the friend of her son, she raised herself up, said she had heard her son talk of me, and was delighted and when we went away gave me a blessing with a fervently truly religious [illegible]. We walked up the hill, gathered some small wild strawberries and bade adieu to the birthplace of poor Jackson.

We went home another route over the Moors—a tremendous bad road, ruts half a yard deep and hills so steep we were obliged to walk. We crossed the country to meet the vehicles and had to climb a hill almost perpendicular. At last we reached them toiling up the hill, went into a farmhouse, where a poor old woman invited us in. It was kept by her son. She said she had lost her husband and burst into tears. He was 72 she said. She had nursed him for a year and 19 weeks, without taking her clothes off to go to bed.

I hope you have taken up your abode ere this in my hotel—the York—and hope the waiters are attentive.

The letter ends abruptly because it was the usual custom to fold a large sheet of paper to form four pages and to fill them all, stopping when the final page was completed. Postage at the time was charged on the number of sheets of paper used and seldom was more than one sheet used. The reference to "my hotel—the York" is to Etty's home in Buckingham Street, London, which he always called an hotel when writing to the Bodleys since they visited him so often.

According to the letter dated 27th October 1834, also sent from York to Thomas Bodley, there had been a previous, second letter giving further details of this tour but it is not among the papers in York Reference Library. Gilchrist who quoted extensively from the first and third letters did not mention a second letter. It is not among those owned by Tom Etty of Nijmegen. It must be presumed lost. The following is the third letter that Etty sent to his friend.

27 The Mount York Friday
Oct 27 1834

My Dear Thomas Bodley,

I am desirous of fulfilling the promise I gave you of sending you a 3rd and last letter from York like Hamlet's ghost—"my hour is almost come" and I must "render up myself" tho' not I hope to "devouring and sulphrous fumes" as he says—but to my dear Betsy and my duties in town.

*John Jackson, 1778–1831, a fellow student of Etty's in the Academy Schools, was elected R.A. in 1817.

Varied and pleasant excursions with Mr. Brook and my friends Mr. and Mrs. John Bulmer have improved my knowledge and admiration of my dear native county—which I thought and believed beautiful before—but doubly so now. I in my last [sic] finished the second day of our tour by our sleeping at Helmsley, near the remains of the Castle of that name, and which is in itself an interesting and wildly picturesque ruin, but the main attraction of the day was Rievaulx Abbey which we approached by driving past Duncome Park which we had seen before—and coming over a field to a gate, the gate of the Terrace of Duncombe Park. The morning was beautiful but the astonishing Dioramic View of a most rich and magnificent valley how shall I describe. I confess I cannot. I never either in Italy or Switzerland saw a finer thing. Hill after hill, valley after valley, clothed with the richest wood, in all the varieties of Light and Shade, and all forms of loveliness and beauty, and peace, met our delighted eyes, and immediate beneath us, like a beautiful Picture or Diorama, was the beautiful Abbey itself, shining in the morning sun. The mountain stream of the Rye, here sparkling in the sun, there rushing over rocks, or lodging itself in the romantic solitude of the vale of Rievaulx.

After following our guide to two or three points over the velvet lawn of this magnificent terrace, commanding one of the finest views in the world, we descended a precipitous path to the woods till we reached the valley and proceeded to the examination of the Abbey closer and in detail and, however beautiful it appeared from above it, it was no less so near. The desolation in which it stands, the wild grass and the nettles growing over the high altar where the pealing anthem had swelled the notes of praise, the stones of the fallen arch form hillocks in the aisles grown over with turf and moss—the shelter of asps sometimes and its pinnacles the resorts of rooks and jackdaws- all this perhaps draws more deeply on our sympathies that when there is more appearance of care—and more of the trimness of landscape gardening—and certainly deep and solemn was the impression it made. Miss Bulmer was gathering wild flowers and moss among the ruins and had nearly met the fate of Cleopatra or Eurydice for she was gathering them in the immediate neighbourhood of two asps coiled together laid amongst the moss of the Abbey. They on being disturbed darted into the moss and disappeared. Had I the wealth of Lord Faversham I would restore this glorious remain and the anthem of praise should echo along its lofty aisles once more.

We thence drove alongside the beautiful and romantic Vale of Rie and ascended towards the Hambledon Hills or Moors where we found a sensible variation in the climate, much colder and went into the edge of the Moor where an abrupt descent (called the White Mare of Whitsun Cliff—from a mare and her rider having been dashed to pieces there) gave us a most extensive birds eye view of a valley and a large lake in the immediate neighbourhood underneath—so high men and cattle immediately beneath seemed like specks or flies. Returning back we went to the well known inn where the racers of Yorkshire are trained on Hambledon, and found the keen air of the hills had sharpened our appetites for some excellent bread, butter, cheese and porter which we left the worst for our contact. On remounting we then descended thro a ravine of rocks and trees worthy of Salvator Rosa, gradually developing scenes of great beauty and wildness, till at last a rich and beautiful vale discovered enshrined in its bosom the beautiful remains of Byland Abbey, a crystal stream running by its side, sheltered from the North by the Hills and redolent in variety of fascinating prospect of hills, woods and streams. It contains the greatest portion of the frame-work of one of the noblest oriel windows I have seen at its West End.

From thence we drove to the pretty village of Coxwold rising on the side of a hill. A noble Village Tree in its centre, a crystal fountain at its entrance and crowned at the top by its fine church and churchyad—and on the right the old parsonage house occupied by Laurence Sterne the author of T. Shandy. From thence to Newburgh House, the residence of the late Ld. Falconbury, with its noble sheet of water in front—Swans—and a very fine park, and some pictures. The saddle and pistol of Cromwell the daughters of whom married into the family. A heavy shower of rain came on as we entered the house and by the time we had done looking over it, it was nearly over. The family dont reside at this beautiful place but prefer London. A single housekeeper showed us thro' the solitary rooms where pictures and antique volumes of scarcity and rarity are mouldering into dust. Two large dogs barked to their own echo in the stone court-yard and all seemed desolate and forsaken! From thence we drove to Easingwold where we had a meal in which the attractions of dinner and tea were united, and darkness and the moon brought us back to old Ebor!

After this tour Etty was taken on another three-day tour of Yorkshire. He had persuaded his friend Mr. Sydney Taylor, editor of the *Herald* newspaper, and his wife to come from London to join the party. Taylor was good company. As Etty had already told Betsy in a letter dated 7th September, "Sydney Taylor repeats fine pieces of poetry, and delights us all. He is in his

Seventh Heaven of rapture with the Minster; says, it far exceeds his expectation. He and Mrs. Taylor are delighted with York generally."

Etty proceeded in this letter to tell Betsy of the tour of York on which he conducted his guests, showing them the City Walls, the St. Mary's Abbey ruins, the Roman Multangular Tower and New Walk, all the places in which Etty himself delighted. Taylor was so captivated that Etty says he was "a mile almost behind, running into all the entrances and recesses, fancying he was defeating an attacking army, sending hero after hero tumbling into the trench below." He continued in the same letter—

> Since which I have been another tour of three days with Mr. Brook, Mr. and Mrs. Bulmer and Mr. and Mrs. Sydney Taylor to Byland, Rievaulx, Fountains, Shedleigh,* Ripon Minster, Knaresbro etc. etc. and our enjoyment was much increased by the great zest which Mr. and Mrs. Taylor have for these places. On Monday last, Mr. Brook, Mr. and Mrs. Bulmer went to see Kirkham Abbey approaching it by Howshem, Cholmondeley's Estate, and a most charming drive it proved. We were on highland, the River Derwent wound serpentinely in the beautiful valley beneath enlivening scenes of great beauty till the ride was finished by the sweet valley of Kirkham with the abbey in its bosom.

This is all Etty has to say of his second tour. Although he had enjoyed his excursions into the Yorkshire countryside he was anxious to return to London. Writing to Betsy on the 19th October he explained why he was so long absent from Buckingham Street. "I am anxious to see thee—most anxious because I know thou will be thinking me long and because hope deferred maketh the heart sick." He went on

> I find the winter nights in York long without the Life Academy—it is pleasanter in the summer—and as for Dinner and especially Card Parties I have not that love of them as to wish to exchange the delights of study for them—but I have found no wants of hospitality or kindness in this our dear native city but at present I have had about enough and shant be sorry to give my darling child a kiss and thank her for all she has done for me.

Earlier in this letter he had said: "There is some talk in several circles of a subscription for a picture of mine as a permanent ornament to York—perhaps it will all end in talk but I will hope not." Unfortunately it did. York people were ever reluctant to part with their money.

Etty stayed longer than usual in York that year, not returning until early December. Although his poor health had been the reason for delaying his departure he had not entirely enjoyed his long convalescence. York in late autumn and early winter was not conducive to his nature. Though grateful he objected to so many entertainments that his friends generously arranged for him. So he filled in his time painting. This enabled him to have a surprising number of pictures ready for exhibition in 1835. A portrait group *Preparing for a Fancy Dress Ball* (the sisters the Misses Williams Wynn), *A Beauty of the North* (Miss Mary Spurr), *Venus and Her Satellites* (see page 219), *The Warrior Arming* (or *Godfrey de Bouillon the Crusader Arming for the Battle*—see page 218), *Phaedria and Cymochles on the Idle Lake, Wood Nymphs Sleeping, A Magdalen (Kneeling)* and *The Bridge of Sighs* (see page 216), all at the Royal Academy, and a second version of *The Lute Player* (see page 217) at the British Institution. In addition he had, as usual, painted the portraits of the daughters of friends and relatives. So, as would be expected, Etty had made up for lost time. He had also written a letter to the *York Courant* objecting to proposed renovations to All Saints' Church, Pavement, where he father and mother were buried and where he had been baptized. Before returning to London he had visited Manchester to see the art exhibition there and this was when he was immediately given a commission by Daniel Grant worth one hundred guineas and taken to see a factory and a steam engine, both of which impressed him though he was glad to get away from all the grime and noise, modern industry having no appeal to him.

The Warrior Arming was bought by Robert Vernon for 100 guineas. Vernon was now regularly collecting works by Etty, having in the previous year bought *The Persian* when it was exhibited

This is probably Studley; Gilchrist omitted this name in his reporting of this tour, being unable to identify it.

at the Royal Institution. *The Warrior Arming* serves to illustrate Etty's new interest in English medieval history, an interest that was beginning to be shown by many others and which was to flourish in the work of the Pre-Raphaelites who were not as innovative as they later liked to claim. Etty had been reading Thomas Keightley's book *The Crusaders*, published in 1834, and he had also began to collect items of armor and even whole suits which he used as accessories in his paintings. Sometimes they were used in his mythological subjects. Also at this time he was consulting Sir Samuel Meyrick, regarded as an authority on medieval warfare and weapons. *A Warrior Arming* is among Etty's most accomplished works except for some darkening due to the use of bitumen, a new fashion among painters which Etty unfortunately adopted. Etty became, as we shall see, very interested in medieval customs and managed to combine this with a continued interest in classicism. *Study of a Negro Boy* is believed to date from this period, probably for the figure looking over Godrey's left shoulder. The facial similarities between *Godfrey* and *The Persian* indicate employment of the same model.

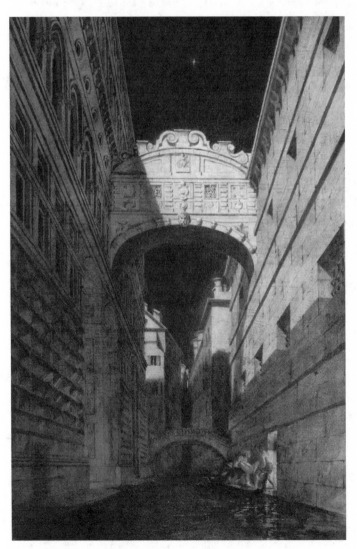

Bridge of Sighs (31.5 × 20 ins) (1833–35), York Museums Trust (York Art Gallery)/Bridgeman Art Library, London; YAG23518/159.

Venus and Her Satellites (more properly another *Toilet of Venus*) attracted very severe criticism for the extent of its nudity whereas *Phaedria and Cymochles* was generally reviewed quite favorably. The *Venus* was bought by the Rev. E. P. Owens, who had bought from Etty before, for a figure reported to be "just under 300 guineas." The *Phaedria* had been sold prior to exhibition for 100 guineas to Wynne Ellis. It was sold in 1874 for 510 guineas. The subject is not well known and was taken from Edmund Spenser's *Faerie Queene*, Book ii, Canto 6. Etty used Spenser's *Faerie Queene* as a source for several paintings, indicating that he had read at least some of this work. Ellis was a Whig Member of Parliament known for his liberal views and one of the largest silk mercers in London. Though Etty disliked Whig opinions he was too wise to refuse Whig money!

An exhibition in York

Late in 1835 John Harper, the architect and Etty's close friend, decided to follow the example of some other cities and arrange an exhibition of works of art in York. He enlisted the help of other friends, including James Atkinson and presumably John Brook and George Bulmer, though of these we cannot be sure, and they

obtained the use of a house owned by Mr. Taite. In February 1836 arrangements were well advanced and Regulations governing the exhibition had been drawn up and were being circulated to likely exhibitors. On 29th February a copy was sent to Etty in London. It seems that he may have questioned the suitability of the date of opening the exhibition as the following letter not only requests works for exhibition but explains the choice of date.

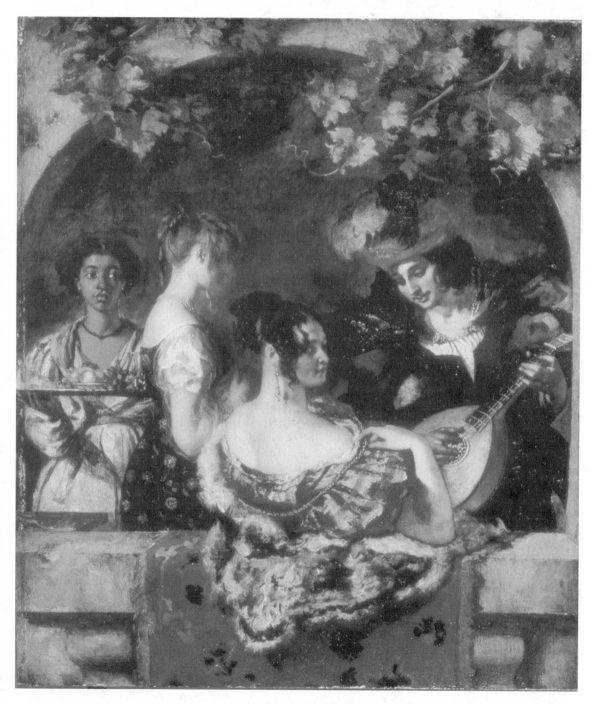

The Lute Player (24.75 × 21 ins) (1835), Tate, London 2005.

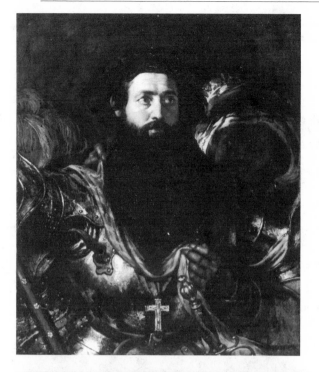

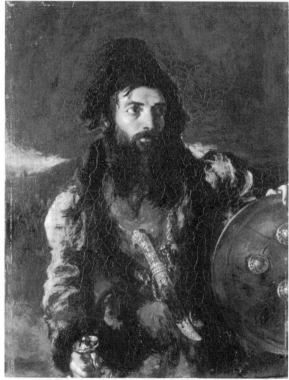

Top: The Warrior Arming (Godfrey de Bouil-lon) (34 × 28 ins) (1833/34), Manchester Art Gallery. Bottom: The Persian (16 × 12 ins) (1834), Tate, London 2005.

Sir,

I beg to enclose you the Regulations for the York Exhibition, and to request respectfully in the name of the Committee that we may be favoured with something from your pencil. Mr. Atkinson has read me your letter to him and requests me to state that the Exhibition will be open to the public on the 6th June and that any works which you or any of your Brother Acade-micians may be kind enough under your aus-pices to favour us with, will be most joyfully exhibited—if received previous to that day. If we had deferred its opening until the close of the Royal Academy Exhibition, we should necessar-ily have lost the season when York is favoured with most of its visitors from Scarborough & Harrogate on their way to those places. We should also have lost the Summer Assizes, if not also the Races. These are the reasons that have operated with the Committee together with the impatience generally felt in the town for its opening.

Nothing I can assure you, Sir, will compensate me for the omission of one or two of yours.

I have requested Mr. Green to leave with you 12 circulars which you will greatly oblige the Committee by distributing.

With respect I beg to remain Sir, Your Most Obed. Servant

The letter is damaged, missing its date and the signature is lost but it is clearly from the Secretary of the Committee.

Etty sent eleven pictures, some of them recently painted and some which he had pre-viously sold and had persuaded the owners to lend. Four York citizens loaned portraits by Etty. On the 8th June Edward Harper wrote to Etty thanking him for his support.

The character & superiority which they give our exhibition above all other local ones entitles you to the warmest thanks of the Society you have so greatly favoured & to deeper gratitude than I can express.

We have sold about 200 5/– tickets & have sold 9 pictures.

We have upwards of 400 pictures nearly filling 5 Rooms in Mr. Taite's house.

Harper hoped that sufficient funds would be raised for building rooms suitable for a per-manent annual exhibition but this was not to be. Although the Exhibition did not lose money, there proved to be insufficient support and with insurance alone costing £2,000 there

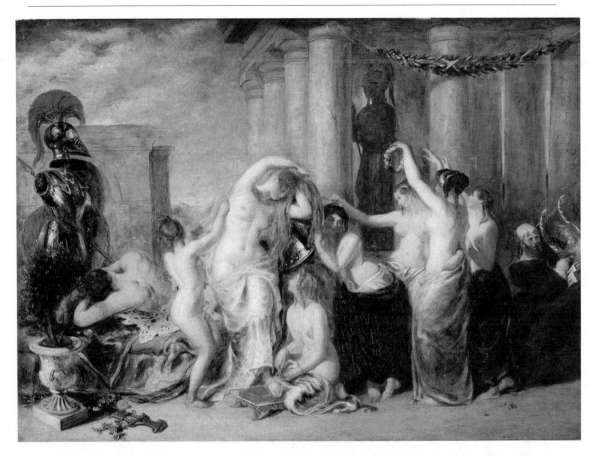

The Toilet of Venus (Venus and Her Satellites) (31 × 43.5 ins) (1835), York Museums Trust (York Art Gallery)/Bridgeman Art Library, London; YAG23585/78.

was no repetition of the event. It is an indication of the preferences of York citizens that whereas, even to this day, musical concerts have usually succeeded in attracting satisfactory attendances, exhibitions of the visual arts have seldom done so. It was a general complaint among the *intelligentsia* of the time that whereas it required no mental effort to listen to music, viewing paintings necessitated some prior knowledge of art if they were to be appreciated and this was sadly lacking among the general population. Among Etty's exhibited works was *A Family of the Forests* which he had already shown that year in the Royal Academy Exhibition. In the Academy catalogue the entry for this painting was accompanied by a quotation from Hesiod: "They lived with calm untroubled mind." There is a similarity of subject but not of form with Delacroix's *The Natchez*, which had been painted some time between 1823 and 1835 in which year it had been exhibited in the Paris Salon. Delacroix's painting illustrated the theme of Chateaubriand's Romantic novel *Atala*, published in 1801. The hero's granddaughter, living in America, had, with her American Indian husband, fled from the French who were destroying his tribe. She gave birth to his child and the family lived happily apart from so-called civilization. The story satisfied the "Primitivist" theories current at the time in France by presenting the family as "children of nature."

Although it is reasonably certain that Etty's painting was not directly inspired by Delacroix's painting, he may have gained some information about it either from Delacroix in 1825 or during his own visit to Paris in 1830. The theme of arcadian innocence would not have been inimical to Etty but it was, for him, an unusual painting inasmuch as it was neither mythological nor

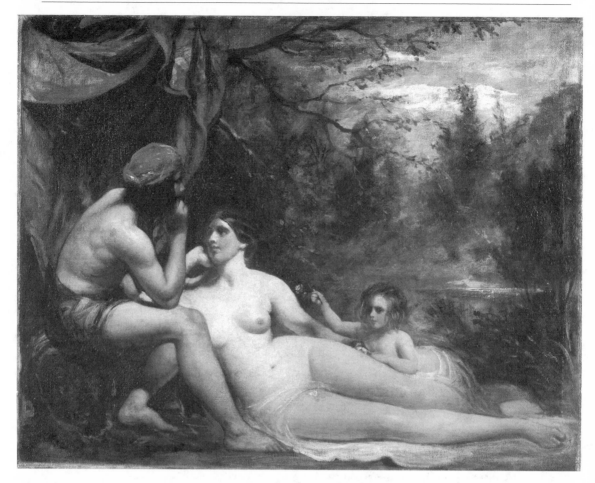

A Family of the Forest (22.5 × 31 ins) (exh. 1836), York Museums Trust (York Art Gallery YORAG90).

allegorical but a romantic work illustrating the Rousseau ideal of "The Noble Savage" with which we would not expect Etty to empathize, but he very probably was unaware of Rousseau's writings except perhaps by repute. The picture suffers from Etty's usual defect when combining two or more figures in the same composition. The outstretched female figure is excessively long, some ten heads in length. The male figure is about nine heads in length but this is not apparent as the figure is sitting. The figures do not appear to be to the same scale and this gives an appearance of imbalance which detracts from the composition. A shorter female figure, not reclining in a studio pose designed to be held for an hour or so at a time, would have improved the work. The inconsistency arises from Etty's usual problem of combining separately posed models. John Harper bought the painting for £50. When John Harper died in 1842 it passed to Edward Harper. It was sold in 1856 for 192 guineas with the title *The Forest Family*. Joseph Gillott owned a painting known as *The Flowers of the Forest* and in 1870 a painting with the title *The Forester's Family* was sold for sixty-one guineas. They may be safely said to have been the same work with varying titles according the current owner's preference. It is now in the York Gallery collection.

Among the other paintings submitted by Etty for the York Exhibition was *Adam and Eve at Their Morning Orisons*. Originally it was *Adam and Eve at Their Prayers* but Farr believes the final word was changed to "orisons" at the suggestion of Thomas Myers who was never reluctant to offer

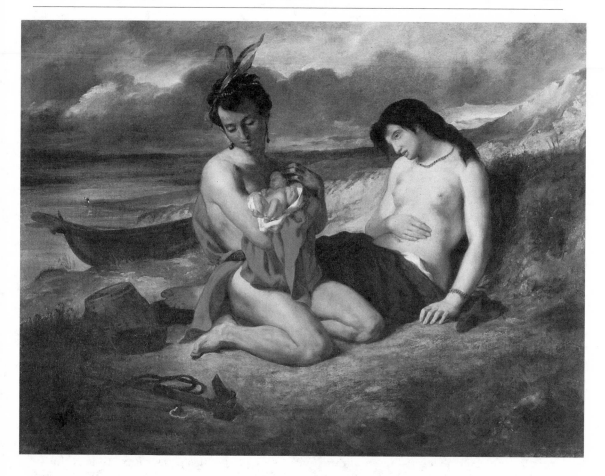

The Natchez, by Eugène Delacroix (?1823), Private Collection, Bridgeman Art Library, BAL003371.

Etty his advice. The painting had been commissioned by William Beckford, renowned for his eccentricity, so we may perhaps place some responsibility for the title upon him. From 1807 until 1822, Beckford lived in seclusion in Fonthill Giffard, which he decorated in extravagant Gothic style, filled with paintings, sculptures and curios, and where he built a 260 foot tower which fell down just after Beckford sold the property. Beckford went to live in Bath where he was to die on 2nd May 1844. He had a high regard for Etty whom he described as "the only Painter for Immortality of his day." Beckford wanted a painting to fit a vacant space over a door and a typical nude group by Etty was what he requested. For his part Etty set about the work in what was for him an unusual manner. Instead of drawing from several models and compiling a figure composed of the "best parts" of each, he sought out models whose figures he considered to be appropriate to the subject. He wanted to paint not just a physically accurate man and woman but figures expressing "pure and devotional feeling," to quote Myers from one of his many letters on the subject. He may not have been able to engage a female model willing to pose nude alongside a nude male model, which would have been unusual at the time. It is more likely that he sought out, as Gilchrist suggested,[15] a female figure, "nearly perfect" though with a waist "not round enough" which he had to amend. Tight corsets notoriously deformed the waist. Gilchrist does not refer to the male figure so presumably he was a model Etty already knew. It is known he had several favorite male models he regularly employed.

Etty sent *Adam and Eve at Their Orisons* to York for its first public exhibition though with

what response from the good citizens is not known. Probably, as it was a Biblical subject, the local clergy felt unable to complain. Etty also sent *Mars, Venus and Cupid*, its first public showing. This was exhibited at the Academy the following year where it was sold to Thomas Cartwright for 120 guineas, clearly a price too high for any York collector had one been interested. It cannot be regarded as a successful work. Venus has too narrow a waist, attracting the usual criticism that Etty's female models wore very tight corsets, and Mars is obviously a soldier more used to standing to attention than to posing for artists. Nonetheless it sold for 370 guineas in 1845.

A strange appointment

In March 1836 Etty was invited to join a group of famous names to form a voluntary committee to enquire into no less than a plan to improve London's water supply. Why he was chosen is unknown but clearly he was already attracting the attention of those in places sufficiently elevated in society to have influence in such matters. The committee met at the Institute of British Architects and it would seem that this institution had become involved because any scheme to provide the metropolis with a new water supply would require the building of pump houses. The committee, though technically voluntary in the sense that no member was paid for his services, had been established by the President of the Board of Trade, C. E. Poulett Thompson, later Baron Sydenham. He appointed Lord Euston to be chairman and invited Charles Eastlake onto the committee no doubt because of his renown as a man learned in most subjects who was regularly called on for his advice. Other members of the committee were Michael Faraday, Charles Wheatstone, John Britton and Joseph Turner. Wheatstone was a man of many parts, inventor, musical instrument maker, professor of experimental physics at King's College, London, recipient of numerous academic honors and active in developing submarines, electro-magnetic machines and other devices. He was knighted in 1868. Britton was a popular antiquary and topographer who wrote many books on English architecture and the countryside. Faraday's fame is, of course, well known. In 1836 he was scientific adviser to Trinity House. Faraday and Wheatstone were the only members of the committee with obvious qualifications to examine technical schemes of the kind before them. Why Etty and Turner were chosen is a mystery. We can only assume that Charles Eastlake had some influence.

The origin of the committee is typical of the time. The artist John Martin (1789–1854), known today for his visionary scenes of the Apocalypse, had long had an interest in improving the waterfront of the River Thames. He had proposed various architectural improvements, especially the building of one continuous terrace linking London Bridge and Westminster Bridge, resurrecting Sir Christopher Wren's ideas after the Great Fire of 1666. By 1832 he was concerned to introduce an improved water supply to the capital. One must say, "not before time." Little had been done to provide London with water since the Middle Ages. Most people relied on wells, which, because of the geological nature of the area, were often artesian. These at least offered some expectation of purity. Ordinary wells did not. In the later seventeenth century and during the eighteenth century several companies had been granted licenses to pipe supplies from springs beyond the city boundaries (then not very distant) and even from the Thames itself. Often water was conveyed by open conduits but so obviously polluted were they that by 1750 very few were being used. It was said that water was no longer drunk in London. Everyone preferred the safety of beer. In the first twenty years of the nineteenth century there were nearly ten different companies purporting to supply water and competition was so fierce that eventually the inhabitants protested against the continual excavation of roads for laying new pipes. But virtually all the water came unfiltered from the Thames, though when questioned the company directors always maintained the water was safe. As the Thames was also an open sewer opinion gradually hardened that something had to be done.

Several schemes were proposed. Among them was that by John Martin. In 1834 he decided

that the water should be drawn from the Thames above Teddington Lock where it was relatively clean and pumped into a reservoir. This was to be an ornamental feature with a fountain and imitation water falls. The height of the reservoir would provide a gravity feed via aqueducts but there does not seem to have been any proposal to filter or purify the water. Since there was no knowledge at the time of bacteria and similar dangers Martin may be excused this omission. Had the scheme materialized probably the mere appearance and smell of the water by the time it arrived at the stand-pipes and street fountains for general consumption would have alerted suspicion. But perhaps not, since all water delivered to London at the time was foul. A Select Committee on Metropolis Water in 1834 declared Martin's scheme impracticable. It lay dormant for two years and then in March 1836 the voluntary committee was appointed to re-examine it.

After seven meetings the Committee reported that Martin was a genius who had devised the simplest and "the most completely effectual plan" as well as one of the cheapest. But Parliament was unpersuaded as it often was when called on to make decisions. Seven years later Martin asked to be heard by the Royal Commission on Metropolis Improvements to put forward his other plans for building a Thames embankment and other schemes. He was given one afternoon only to explain his proposals in brief. They were rejected on the grounds that they did not equal the claims of other schemes. Thomas Page, a renowned engineer of the time, observed that "until the value of sewage shall be more evident and a proper system adopted for using it, the Thames must continue to be, as it has often been designated, the great drain of London."[16] Thus, until it was profitable to remove sewage from the Thames to provide manure for agriculture, the danger to health would remain. A spokesman for the Water Companies gave as his opinion that God had provided human beings with "special organs to prevent one from being poisoned with water" and deplored the mischief caused by those who spread "pestiferous tales" about pollution.[17] Not until the famous "Great Stink" of 1858, when the Thames was receiving even more sewage than before in an unusually hot summer, did Parliament pass a Bill for the purification of the river and Joseph Bazalgette was appointed to produce a scheme for providing the whole of London with a proper drainage system.

This was a time of numerous committees and commissions as Parliament sought to examine schemes for the improvement of society's numerous deficiencies, always of course with the hope that nothing need be done. Numerous proposals for improving London's water supplies were advanced and rejected, with the various water companies invariably objecting. Real solutions did not materialize until the Metropolis Water Act of 1902. It would be gratifying to think that Etty played a small part in the long struggle to make London a safe place to live, but that would be wishful.

More advice from Ridolfi Minor

In 1836 Thomas Myers resumed his earlier correspondence to give Etty further advice. Between the 3rd April and the 1st May 1836 he wrote six lengthy letters of which the following are two examples. Myers indicates that he knows the subject of the painting Etty was currently working on, which was *The Sirens and Ulysses* as Myers had proposed two years earlier. It was no doubt this which emboldened him to write again. Myers always suggested literary subjects as most likely to appeal to clients and he had his own curious preferences for what these should be.

Tilney Street May-fair
17th April 1836

Dear Sir,
When not too ill, I have been much engaged to write before. I now write in bed.
As I am sure you cannot do better than *finish Fancy "forthwith"*; I think "thoughts that *breathe*" might be represented by "*flowers*," & "words that *burn*" by "beams." Beattie says in his Odes,—"*Fancy's flower & Fancy's beams.*" He also says in his Odes,

"———————————bright
In *Fancy's rainbow* ray."
& *Byron* says, in his *Prophecy of Dante*—
"His *Fancy* like a *Rainbow*"
This simile may be of some use, as a hint to the *colouring of the Picture & perhaps* as to the *attire of Fancy* herself.

Do let me urge you, & do let me *persuade* you "*to take time by the forelock*" much more than you have done lately.

You have a Sketch—you told me—for Savage's *Morning. Proceed with that.* And as, when I was on your throne, or whatever you call that round red thing, you asked me what I most recommended of the subjects Ridolfi minor had sent you; let me *induce* you to *make Sketches*, for *Leda—Orion—Venus Rising—The Year* (from the Spectator)—*Europa—Spring* (from Gray) which might be a Prelude to *the Year*—and the *30th Ode of Horace*.

Do practice the "grande aim," which you *preach*. To say truth, none of your works this year, with the exception of *Adam & Eve*, painted I find out for Mr. Beckford, which I am glad to know, though you did not tell me.

(I am called by some of my friends "*the communicative Mr. Myers.*" I shall call *you*, the *uncommunicative* Mr. Etty!!) With the exception of *Adam & Eve* none of your works this year—supposing *Fancy* not to have been completed—sufficiently *high* for many whom I know are anxious to patronise you.

It is worthy of remark that since 1832, when Ridolfi the Great took your cause in hand, *so nobly & so usefully*, & when you had Gray's *Pleasure—the Destructive Angels—& Phaedria & Cymochles* you have never been in such great force as you were then, nor has your "*aim*" been so "*grand*," though one would have supposed that the energetic advocacy & excellent advice, which Ridolfi the Great gave you, would have made you to still more "greatly daring" *paint*.

Ask your good sense, how different would have been your situation, if, every year since you had exhibited 5—which is generally *Turner's*, & I think a prettier & "luckier" number than 3—if you had 5 works of "grand aim," painted after the *highest Classical Authors* who supply you with a good many subjects, the strong temptation of several of which, I really marvel, how can you resist.

Myers goes on to urge Etty to overcome his tendency to procrastinate. Etty was always finishing works for exhibition at the last minute, but in this he was not alone. Turner almost repainted some of his pictures *after* they had been hung. Myers then advises Etty always to paint from the model,—surely unnecessary advice in his case—if he wishes to achieve a lifelike image. Three days later Myers sent Etty another long letter advising him in some detail how to paint the picture in which the figure of Fancy is to be the central subject.

Tilney St May fair
20th April 1836

Dear Sir,
What I am about to write are thoughts that came into my head spontaneously, & at different times, & have not been much considered by me. You of course will not adopt any of them, without examining them well; & take them up, or throw them down, exactly as you think best.

It struck me that *Fancy* might have a *chaplet of Peacock's Feathers*; that Bird abounding in "India," & being sacred in many parts of it.

It also struck me, that *Fancy* might have a *Chaplet of Wings*. Plutarch mentions such a crown; so does Pindar. Wings would be more emblematical of the soaring flights of Fancy, even than single feathers; & the Wings might be composed of any coloured *Indian* Feathers that you thought would most harmonize with the rest of the Picture; perhaps Green & gold [*yellow*].

What "wand" do you think of? A *Laburnum* wand in blossom, (as it should be) came into my head. The cool green leaves, contrasted with the yellow ringlets of the flowers, would not be unimportant.

The "pictured urn" I hope you will take great pains with, both in its shape & in its picturing.

The *flowers "scattered"* from the "urn," representative of the "breathing words" should be selected from *those flowers into which fabulous history has changed some of its ideal personages.* Such flowers may with more truth, or at least more reason, be said to "breath." The Narcissus, the Hyacinth (which is very available as they are in such varieties, *in colour*) the Sunflower, the Lotus, & the Flower into which Adonis was changed, & the Flowers into which many others were changed, furnish you with a large choice.

I cannot say how the "beams," as symbols of the "burning words," can be introduced to most advantage.

But I have no doubt you can manage that; perhaps by mingling them with the flowers falling from the urn.

Might your second female figure be *Iris*; with her bow "brought forth in purple cradled in vermilion, baptized in molting gold & swathed in dun" ("Iris there, with burnished bow") This would suit Beattie's idea.

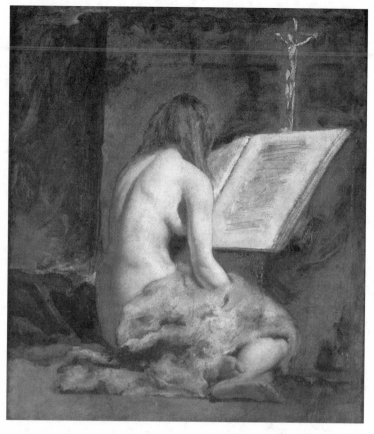

The Penitent Magdalen (date unknown), Ashmolean Museum, Oxford/Bridgeman Art Library. AM098708/156.

Myers then went on to quote lines from various poets which describe the different mythical figures. He also added a postscript dealing further with the problem, as he sees it, of "Fancy's" chaplet. Then the very next day he sent another letter making further suggestions for treating the figures in this painting, which seem to be a product of his own wishes rather than of Etty's likely intentions. His chief concern now was with the wand. He suggested it should be "of the *Fuschia*, the dark green leaves of which tinged & *veined* with blush, together with the *dark blood red* bells of its Flowers would be fanciful enough." He continued to present Etty with his ideas and asked in a letter of 28th June 1836 whether Etty had made any progress "with Gray's & Wharton's *Fancy*." So there were apparently three authors on whom Myers was drawing for this subject—Beattie, Gray and Wharton. He apparently got nowhere with Etty on this matter but this did not diminish his zeal to offer constant advice. Letters continued over the years, often at almost daily intervals. Whether Etty ever painted this subject is difficult to say. No painting with the name in the title or meeting the description has been traced. Nonetheless the detailed advice offered by Myers is of interest as indicating how Etty was bombarded by this persistent admirer. It also illustrates the ideas which an artist was expected to conjure with when approaching an allegorical subject. Etty, however, was by now preferring to sell through dealers and to take their advice on what was marketable.

Myers continued to write to Etty offering advice and one letter, dated 12th August 1836, is particularly interesting because it also confirms that Etty did reply to Myers' letters and apparently in quite confidential terms.

You have observed to me, how much you regret you had not a Classical Education. It is a great misfortune: it is the greatest misfortune perhaps of our Art: it is a shame to a country like England that it should continue. But you might counteract this disadvantage in a great degree. Take Dr. Johnson's advice, study the best Translations—read, mark, learn & inwardly digest them—& seek the Society & converse & [*word missing*] advice & assistance of those who have had this advantage, & who have not neglected, but profited by it. Your Patron, Mr. Owen is one of these. Mr. Mitford in Suffolk, near Aldeburgh, & also a Clergyman, and formerly a Patron, & still an excellent judge & ardent

admirer & advocate of art is another. There are numbers of others whom you will meet with & whom you should have no difficulty in consulting.

Myers, like so many of his class, still believed that only a classical education could fit a man for advantage in the world. He, and they, did not realize that England was changing and that what was going to be needed was a population, which would include the working classes, educated in the sciences, engineering, various trades and practical skills. One is reminded of Mr. Thornton in Mrs. Gaskell's *North and South* who, though a mill owner, felt the need to read the Greek philosophers. Education in both the classics and in the sciences is no doubt most desirable but social pressures determine which shall predominate and in the early nineteenth century it was becoming increasingly obvious that the country's future prosperity required more knowledge of the sciences and particularly of engineering. This was understood by Albert, the Prince Consort, who was able to combine an interest in both branches of learning and to press for a wider understanding of the country's economic needs, albeit against much opposition. In December 1836 Myers sent Etty some translations of Virgil, Pindar and Ovid with advice to paint more classical subjects.

Chapter Eleven

Divergent opinions

When Etty finally completed and exhibited *The Sirens and Ulysses* (see color plate 7), which had excited Myers' interest in 1836, it was his largest and most important work to date. It measured 117 inches high by 174 inches wide and was hung in the Academy's new rooms in Trafalgar Square which it was to share for some years with the National Gallery. The theme came from Pope's translation of Homer's Book 12 of the *Odyssey* which Myers had earlier recommended. Flaxman had illustrated this publication and Myers had pointed out that Flaxman had "considerably overcome the difficulty of the lower parts of the figures of the Sirens being those of fish."[1] He had concealed these parts with draperies. Etty accepted the myth that the Sirens became fully human when out of the sea. Although he usually ignored Myers' advice it seems he must have responded in this case. Nevertheless his is a totally independent composition with the Sirens in the foreground among the remains of former victims as Ulysses and his companions struggle with their ship in the background. Ulysses is remarkably large in comparison with the other sailors but the three Sirens have the same proportions, which was not always so with Etty's figures. But as usual they are studio poses, probably of the same model in three different positions, and also as usual Etty presents them holding out their arms in conventional "artistic" attitudes. It is very likely that Etty's work was always affected, and adversely, by his regular attendance at the Academy Life Classes where models were "set" in a traditional manner. In an age of realism such a setting would be impossible of acceptance but such principles were then a century hence. If the human figure was presented it had to be heroic, classical and "artistic." We cannot judge, as many attempt to do, the culture, arts, tastes, or the *ethos* or *mores*, of past ages by those of the present. We do not foresee our future either.

Etty's painting illustrated lines from Book 12 of Alexander Pope's translation of Homer's *Odyssey*—

> Next, where the Sirens dwell, you plough the seas;
> Their song is death...
> O stay, and learn new wisdom from the wise.

The work was long in planning but fairly short in execution. He began in November 1836 and finished in April 1837. He took great care with the work, actually visiting a mortuary to sketch from corpses, which fact somehow became public knowledge and did not endear him to some critics. The painting received a mixed reception. Many among the public expressed themselves to be shocked by the sight of corpses and the *Spectator* (6th May 1837) condemned it as "a disgusting combination of voluptuousness and loathsome putridity—glowing in colour and wonderful in execution, but conceived in the worst possible taste."

In contrast the *Gentleman's Magazine* (June 1837) devoted a lengthy appreciation to this painting in its review of the exhibition.

Several studies for "*The Sirens and Ulysses*" (20 × 25 cm) (c. 1837), York Museums Trust (York Art Gallery).

Mr. Etty avails himself of the assistance of a model in all he undertakes. Nature is his handmaid, and to her he has recourse, whatever may be the theme upon which he is employed, so that the accuracy of his details may be safely taken upon trust; it might otherwise be imagined that the proportions of the principle figure in this picture were a little extravagant. This picture is the largest, and, in our estimation, by far the finest that Mr. Etty has ever painted. It is an historical work of the first class, and abounds with beauties of all kinds. The story of the *Syrens* [*sic*] *and Ulysses* is one that was admirably adapted to Mr. Etty's pencil and he has in every respect done it the most ample justice. We are surprised to hear exceptions taken to the subject of the work, as there are certainly few passages in Homer, or any other author, ancient or modern, to which the talents of the painter or sculptor could be more legitimately addressed.

The reviewer went on to praise Etty's other contributions to the exhibition—*Mars, Venus and Cupid* and *Adam and Eve at Their Morning Orisons*—described as "splendid little paintings, and would grace any gallery in Europe." The *Gentleman's Magazine* was usually approving of Etty's work.

Thomas Wright of Upton Hall near Newark, who occasionally bought Etty's work and whom Etty regarded as a close friend, wrote to the painter on the 25th October 1837 that had the National Gallery exhibited its recent purchase of Rubens' *Brazen Serpent* either before or at the same time as the Academy's exhibition there would have been no criticism leveled against Etty's painting. Wright understood the general level of the critics' understanding. They would never object to a recognized Old Master, not even a Flemish one, because it had "stood the test

of time." Most regarded their task as that of damning all newcomers. As has always been the case with newspapers, editors slanted the contents to satisfy the tastes of the readers they wished to attract and then did their best to ensure that these tastes became embedded in their readers. The nature of presentation depended on the political and religious views of the proprietors.

Sirens and Ulysses proved too large for most collectors. It did not sell at the summer exhibition and Etty had to wait until October that year when he was in Manchester at dinner with Daniel Grant who offered to buy it with *Samson and Delilah*. Etty had already sought £300 for the *Sirens* and £100 for *Samson* but taken by surprise and hopeful of a sale he proposed £300 for the two. Grant had £250 in ready cash and dangled it before him. After some hesitation Etty accepted it. As usual, Etty could not drive a bargain. Perhaps he was persuaded by Grant's tale of woe that "business was bad" and that he had lost as much as two thousand pounds that year. This notwithstanding, Grant had been betting that day at the races. Grant already commissioned *Venus and Her Doves* but had only previously glimpsed *Samson and Delilah* and had not even seen *Sirens and Ulysses*. Such was Etty's reputation.

Despite the criticisms of some reviewers, who seem to have been more concerned to promote their own careers as dispensers of vitriol, Etty regularly received unstinted praise from collectors and admirers. One such was William Gifford Cookesley (1802–1880), a classical scholar educated at Eton and King's College, Cambridge, who became assistant master at Eton and

Delilah Before the Blinded Samson (28.5 × 35.75 ins) (?1837), York Museums Trust (York Art Gallery)/Bridgeman Art Library, London; YAG23475/96.

eventually rector of Tempsford, Bedfordshire. He published numerous classical textbooks, sermons and miscellaneous pamphlets in the manner of successful Victorian clergymen. Far from objecting to Etty's subjects he was an enthusiastic admirer whose regret was that he had insufficient money to buy other than minor works. Writing from Eton in May 1838 he expressed his earnest wish to buy a painting exhibited at that year's Academy.

Sir,
I have been very much struck by your picture, No. 16, at the Royal Academy that, although I am not a rich man—but on the contrary a very poor one—yet I could make an effort and a sacrifice to get so very beautiful a work of art into my possession. If your works fetch the price they *ought* to gain, I fear the work in question is out of my reach, but still as one does not give up a favourite hope, or a darling idea, in a hurry, I am tempted to ask you whether you are disposed to part with the picture specified and if so what is the price? Will you allow me to say that the gratification I have derived from seeing your pictures is very great, and deserves my best acknowledgements? I know myself to be incapable of flattery—will you give credit for as much? I cannot help regarding you as the greatest painter of human form and flesh that this country has produced; nay, I know of no painter produced by any other country whose excellence as a flesh painter is greater than your own. I hope you will prove that all you have yet done is nothing compared with that I feel you are capable of achieving. I am no manner of artist and have no knowledge of the rules of art. My opinion therefore is quite worth nothing, except as I suppose that a picture to be a good one, must please the unlearned as well as the skillful, though I am fully aware that many a picture pleases the unlearned which pleases no one else.
Believe me, Sir,
with sincere respect for your genius,
Your obdt. servant,
W. G. Cookesley

It was unfortunate that having praised Etty so handsomely, Cookesley then said that his opinion was worthless. One would have expected him to rely on his classical learning to present himself as a person of taste. No. 16 in the Academy Exhibition that year was *A Bivouac of Cupid and His Company*, being a group of partly draped nymphs reclining in a forest clearing with one holding Cupid whilst another cherubic figure climbs a nearby tree. The nymphs are inconsistent in scale, one being noticeably larger than the rest, as is so often the case with Etty. This painting, as with many others at this period, show a marked falling off in his skill, either because of his continuing ill health or his increasing eagerness to exhibit as many paintings as possible. The *Gentleman's Magazine* (June 1838) described it as "a clever thing ... though a repetition of his former works. The artist's manual powers are superior to his invention." Cookesley was unsuccessful in securing this painting. It is later recorded as being purchased by Joseph Gillott in 1845 from the dealer Richard Colls for £438, a figure we must expect to have been well out of the reach of the Eton schoolmaster. Had it been then customary for works to be purchased by installments Etty would no doubt have sold to a wider public. As it was, only the rich and powerful would sometimes demand the right to this procedure having initially undertaken to pay the full price.

A contributor to *Fraser's Magazine* in June 1838, calling himself Michael Angelo Titmarsh, in an article entitled *Strictures on Pictures* wrote a satirical account of that year's Academy Exhibition, giving all the academicians mock titles, such as Daniel Prince Maclise, Archbishop Eastlake and Edwin Earl of Landseer. Etty received an honorary Dukedom. Of Etty, "Titmarsh" wrote

And now we arrive at Mr. Etty, whose rich luscious pencil has covered a hundred glowing canvasses, which every painter must love. I don't know whether the Duke has this year produced any thing which one might have expected from a man of his rank and consequence. He is, like most great men, lazy, or indifferent, perhaps, about public approbation; or also, like great men, somewhat too luxurious and fond of pleasure. For instance, here is a sleepy nymph, most richly painted; but tipsy looking, coarse, and so naked as to be unfit for appearance among respectable people at an exhibition. You will understand what I mean. There are some figures, without a rag to cover them, which look modest and decent for all that; and others, which may be clothed to the chin, and yet are not fit for modest eyes to gaze on. *Verbum sat*—this naughty "Somnolency" ought to go to sleep in her night-gown.

Had "Michael Angelo Titmarsh" known Etty personally he would not have called him "lazy" or "too luxurious and fond of pleasure." But writing under this pseudonym, the young William Makepeace Thackeray (1811–1863) was still struggling to make a living from his pen, so posing as an elder statesman enabled him to dispense advice which would not have been accepted had his real age been known. *Somnolency*, for all its immodesty, sold for £45 in Liverpool and was later resold in 1849 for 210 guineas to the collector G.T. Andrews, another example of Etty's inability to sell at proper value. It is now in Aberdeen.

Etty had also painted a second version of his 1836 *Prodigal Son*, which Beckford bought after it had been shown at the Academy Exhibition. This later version has been lost. In the same article in which "Titmarsh" criticized *Somnolency* he praised this version of the *Prodigal Son* as "a far nobler painting.... It is a grand and touching picture." The earlier version, of which the later version seems to have been a direct copy, has all the symbolism and pathos of a moral subject that could appeal to lovers of genre.

Although Etty did not often paint still-life subjects, in September 1839 he painted the first of a series, *Pheasant and Peach*, which is now in York City Art Gallery under the title *Still-Life: Dead Pheasant and Fruit*. It is a curious painting, lacking any formal composition. The dead pheasant, which was probably a gift from his friends the Singletons of Givendale, has been flung down on a table with a peach in the foreground and the whole has an impromptu appearance of objects being painted just as they happened to be. A letter of the time, addressed to Walter, refers to a pheasant that was received from the Singletons and painted before it was plucked for cooking. *Flower Study* was probably painted later that year. This consists of two bowls of flowers painted with very loose brushwork in what would later be regarded as an impressionist manner. Its present whereabouts is unknown. Etty returned to still-life subjects in the mid–1840s. It seems that although they were not a major part of his output he had no difficulty in selling such works.

Gilchrist recorded[2] that Etty took "lessons in Perspective from Mr. Moore" in which skill Gilchrist admitted Etty "had small native gift." This was George Belton Moore (1806–1875) who was painting and drawing master at the Royal Military Academy, Woolwich and also at University College, London. According to Christopher Wood[3] Moore had been a pupil of A. C. Pugin and exhibited from 1830 to 1870 in the Academy, the British Institution and the Society of British Artists. He later published two books, *Perspective, Its Principles and Practice*, 1850, and *The Principles of Colour Applied to Decorative Art*, 1851. Etty was never too proud to admit his defects and to seek advice in remedying them.

Somnolency (29.5 × 24.5 ins) (1838), Aberdeen Art Gallery & Museums Collection.

It was not so unusual as it might sound for an Academician to seek additional training. It has similarly not been unusual for established composers to obtain training in skills in which they are not proficient, counterpoint being a typical example. Singers (at least, opera and concert singers) continue training all their lives. In Etty's case it does appear that his lessons did not add very much to his powers. His pictures seldom needed knowledge of perspective, since they were frequently based on frieze-like compositions, though it must be admitted that when he placed figures in the background they often lacked credible proportions. There is, of course, a tradition in art dating from earliest times that figures are given proportions suitable to their importance and we can find numerous examples where religious figures and classical heroes are depicted much larger than their supporting attendants but this method had been long discarded in the quest for greater realism. In Etty's case there is no doubt that the disproportions arise from figures' being painted from separately posed models and, once started, they were not corrected. Sometimes there is obvious intention to present a stylized composition.

"Beauty, action, masculine vigour"

Early in 1835 Etty had advised his dealer Richard Colls[4] that he had in mind to paint a large work of the rape of Proserpine. "There is a subject I hope to paint, before I am much older,—after my own heart, and I think of your sort." It would be a painting depicting "beauty, action, masculine vigour" with opportunities for him to paint "landscape, sky, motion, agitation, flowers, and freshness." The word "rape" would not, in the event, appear in the title, which was to become *Pluto Carrying Off Proserpine.* He did not want Colls to mention this to anyone since "one does not like to be anticipated, as I have been." While at York that summer Etty began to make preparatory sketches, mostly of horses. It requires a dedicated horse painter to depict these creatures convincingly and although at first sight it seems Etty has been successful, in the finished work the proportions and stances of his steeds are doubtful. The painting was not to be completed until 1839 when it was exhibited at the Academy and priced at 500 guineas. It was sold to the famous collector Lord Northwick for £350. As was so often the case it was resold in 1872 for 1,000 guineas and eventually sold in 1949 for forty-five guineas. The painting remains in private ownership. The subject comes from Milton's translation of Ovid's *Metamorphoses* and may well have been suggested by Thomas Myers.

> In that fair field of Enna where Proserpine,
> Gathering flowers, herself a fairer flower,
> By gloomy Dis was gathered.

"Dis" was an alternative Greek name for Pluto. Milton obviously preferred it as the monosyllable was necessary for scansion.

There are signs that certain features in the composition have been painted out. A flying cupid with a torch and the head of a fourth horse appear in an earlier sketch and may have been in the painting as exhibited since *The Times* of 7th May 1839 refers to a flying cupid: "young Love, in flame-coloured taffeta, floats over all." The attendant nymphs who merely fill vacant spaces and adopt the usual studio poses are well painted as individual figures but present such unconvincing attitudes, mostly not expressing alarm, as to expose once again Etty's difficulties when composing from separately posed models. This is the painting in which some of Etty's contemporaries, whom he referred to as "Noodles," thought the females should be clothed though why they should consider them objectionable is incomprehensible since only Proserpine herself presents a fully frontal aspect. The painting is in a private collection but reproductions show the female figures partly draped which indicates that despite Etty's own remarks the "noodles" were victorious. *Pluto Carrying Off Proserpine* is an unusual picture in Etty's *oeuvre.* It seems quite out of character that this mild mannered man should have chosen to depict such a sexually

violent scene. We can only assume that either he wanted to paint a subject that was a favorite among Italian Old Masters or wished to illustrate a common assault upon female virtue which he would vehemently deplore. As is so frequently the case with Etty he has left no indication of his reasons for choosing this subject nor of any other artist's work that might have influenced him, though Farr suggests[5] an engraving by Picart of Giraudon's sculpture of the subject at Versailles which, in its turn, was derived from a design by Charles LeBrun.

There is however a possible clue in the fact that during his visit to Italy in 1816 Etty stopped briefly in Genoa. As he always took every opportunity to acquaint himself with the art of every city in which he stayed it is very likely he saw some paintings by Valerio Castello (1624–1659) who had been an apprentice there in the studio of Giovanni Andrea de Ferrari before embarking on a brief career that lasted less than ten years. Castello specialized in subjects in which he could display his love of violent action and bright colors. Among these were *Rape of the Sabines* and *Rape of Proserpine*, now in the Galleria di Palazzo Reale. Though the compositions of Castello's and Etty's versions are different both are vigorous and share some common details. Castello's two horses and Etty's three charge off to the left, in both there are prostrate women in the foreground and fleeing women to the right. Castello's Pluto leaps from his chariot to carry Proserpine in the general direction of action to the left while Etty's Pluto drags her backwards, though the arms of both Plutos encircle their victims round the waist. In Castello's version two cupids hover in the sky and it must therefore be significant that in Etty's original version a cupid also flew overhead. Castello was included by Rudolf Wittkower[6] among "the giants of the Baroque age." If Etty was able to embrace Rubens he would surely have been willing to take some ideas from his Italian contemporaries.

Turner also exhibited a painting of the same subject but his version concentrated, as would be expected, on the arcadian scenery with the figures being little more than "staffage." It must appear that Turner exhibited this painting alongside Etty's out of rivalry. It is known that Turner often regarded Etty, among others, as rivals and could never bear the thought that anyone might outshine him. In 1849 Turner's *Venus and Adonis* was described by the *Athenaeum*[7] as "Titian, Sir Joshua Reynolds and Etty in about equal proportions." In 1860 E. V. Rippingille wrote an account of the two artists working side by side on Varnishing Days in the Academy whispering to each other and obviously enjoying their rivalry. It is very likely that Turner had somehow learned of Etty's intentions in 1839 and decided to compete. Etty had been several years working on the subject and news could easily have reached Turner. Turner's painting had a mixed reception which is worth reporting.[8] The *Athenaeum* of 11th May described it "one of the best of his landscapes," the *Art Union* of the 15th May called it "a gorgeous piece of wild imagining—abounding in proofs of genius," but the *Spectator* of the 11th May rejected it as "utterly unintelligible," while *Blackwood's Magazine* of the July issue described it dismissively as "Pluto frying the frigid Proserpine.... Turner's draperies are all asbestos and here are figures that look like sulphureous tadpoles ... detestable and childish in colour..."—quoted here to indicate the ridicule which critics would employ to destroy an artist's career.

Thackeray, still writing as Titmarsh, complained about Etty's painting in *Fraser's Magazine* of June 1839 that "A great, large curtain of fig-leaves should be hung over every one of this artist's pictures, and the world should pass on, content to know that there are some glorious colours painted underneath."

But the *Art Union*, which was then a new magazine edited by Samuel Carter Hall that had first appeared on the 15th February 1839, was willing to accept the nude figure as a subject for artists. It wrote more encouragingly in its issue of May 1839, although not of *Pluto and Proserpine* but of another of Etty's paintings, *Diana and Endymion*, also in the 1839 exhibition. This painting is now lost and it is not possible to describe it but we may assume that Etty had used the subject to portray both the nude male and female forms in poses that depicted the goddess falling in love with the sleeping youth according to legend. It was purchased by George Knott,

one of Etty's admirers, for £100 and later sold in 1845 for 210 guineas. It was resold in 1878 for 300 guineas and again in 1922 for 330 guineas. It was unusual for Etty's paintings to hold their prices into the twentieth century and in 1935 it sank on resale to 52 guineas, and after the war its whereabouts became unknown. The *Art Union* reviewer wrote[9] of Etty's exhibits:

> Mr. Etty is not conspicuous in this exhibition, as he ought to be. His powers are of the highest order, and though he is seldom happy in the selection of his subjects, he has qualities which make some amends for his defects. With most amazing genius, with industry, perhaps unparalleled, with a thorough knowledge of the "machinery" of his profession, he is rarely successful with the mass, simply because he aims to satisfy the judgment rather than to touch the heart. Now this, we submit, is neither politic nor just. It is the noblest privilege of art to inform and gratify universally; to make the more elevated class of subjects familiar and easily understood, and not so as to paint as to be "caviare to the general." We are not of those who raise a silly and impure outcry against his painting the "Human Form Divine"; but we join with those who protest against his so continually selecting themes that excite no sympathy and rouse no generous emotion. His powers are great, his capabilities greater, and we, therefore, the more deeply grieve at finding him very frequently doing as little good for mankind as the priest who preaches his sermon in Latin.

This is an interesting opinion to be expressed publicly at this time because whilst it suggests, as Farr points out,[10] that Etty was losing touch with the gallery attending public by painting subjects that appealed to him rather than to them, it was an unusual point of view at the time because it recognized a new class of art buying public quite different from the aristocratic collector who had maintained art in the previous century. It was a view that was to determine the nature of art throughout the nineteenth century but was to be rejected by the end of the century when the *avant garde* began to determine the role of art. Certainly by 1839 the nude figure was no longer acceptable to the general public. This had nothing to do with Victoria's accession to the throne for she had no objection to the nude, often buying such works and refusing to be steered away from such paintings by apprehensive curators. It was the power of Evangelicalism and dissenting religious bodies who were instilling into the new middle classes their centuries old conviction that the human body was sinful. More to the taste of the critics and the public to whom they were appealing were religious subjects that did not attract accusations of "popery." Illustrations of the parables were safe—*The Prodigal Son* (1835), *The Good Samaritan* (1835) and, still to come, *The Repentant Prodigal's Return to His Father* (1841).

The Good Samaritan (1835) Courtauld Institute (National Trust), London.

The National Gallery

Like most British artists, Etty had often expressed concern that the nation did not possess a national collection of importance such as France had had available to the general public since the end of the eighteenth century. In England there had always been a reluctance on the part of Parliament to establish such an institution, partly because of the general objection that the state should not interfere in anything and partly because most of the members of Parliament were landowners who either had no interest in the arts or did not regard it as necessary, or even sensible, to make art available to the general public. In 1777 John Wilkes had suggested that the Walpole collection at Houghton, about to be sold, should be acquired for the nation. Instead the collection was sold to Catherine of Russia and Parliament was spared the task of doing anything about it. An early advocate for a National Gallery of Art was a Frenchman, Noel Desenfans, who had been born in Douai in 1745 and had come to England to teach languages. Marriage to a wealthy heiress enabled him to become a dealer, at which he was highly successful. He began his campaign for a National Gallery in 1799 and in 1802 proposed that the Government should create a national collection to which he would freely contribute but such an idea was considered "new-fangled" and "French" and was rejected. Desenfans bequeathed his collection to a friend, Sir Peter Bourgeois who, when he died in 1811, left his pictures to Dulwich College. Private bequests to institutions were regarded as more fitting by members of Parliament who did not favor government funding of anything except wars. William Buchanan, an Edinburgh lawyer who had come to London in 1802 to set up as a dealer, soon began his own campaign for a National Gallery. He drew attention to the number of private collections that were up for sale and urged the government to purchase them as a nucleus for a national collection.

In 1805 members of the Royal Academy advocated a national collection. Sir Joshua Reynolds offered his private collection if the Academy could take over buildings to house it, but these buildings became the Lyceum Theatre and again Parliament was spared. After Reynolds' death James Barry, unfortunately always an unpopular man, revived the idea of a national collection and used the words "National Gallery" for the first time. Barry was expelled from the Academy for offensive conduct and again Parliament was spared. The formation of the British Institution did not assist matters. The Institution wanted to be the national collection and time was spent overcoming the rivalry between that body and the Academy. There were already national collections in Vienna, Paris, Amsterdam and Madrid with one planned for Berlin. Foreign visitors to England frequently expressed surprise that a country so wealthy as England did not possess a national collection but members of Parliament knew that their country ordered things better. Most Englishmen did not see the role of government as encouraging culture, which was regarded as a private interest of no economic value. There were more pressing matters to consider; foreign trade was diminishing and unemployment rising and the country was still feeling the financial effects of the French wars. But on the whole England enjoyed a socio-political stability that was typical of many leading European nations and the English hierarchy was, as Roy Porter said,[11] uniquely tough. By the turn of the century it was being strengthened by the new class of industrial entrepreneurs whose increasing wealth and political control ensured that conciliation was never to be considered and certainly no hint of compromise. Although many in the new class were anxious to acquire a culture that their origins had denied them, it was always to be their private possession, seldom to be shared. But the working people had no tradition of sharing the culture of their social superiors. They had their own culture and in this they were no different from working people anywhere else. They certainly had no interest in visiting galleries and museums to look at the works of foreign artists. So in this the country was united, except for a troublesome minority, and Parliament felt vindicated.

Nevertheless, earlier in the eighteenth century the British Museum came into existence

through a series of maneuvers that successive governments had partly assisted and partly been unable to avoid. The history of the formation of the British Museum gives an insight into the official minds of the time when confronted with the need to decide upon matters relating to the arts. The physician and collector, Sir Hans Sloane, who died in 1753 had, in his will, offered his enormous collection of antiquities and works of art to the government for the sum of £20,000, about a quarter of what it had cost him to assemble them and far less than their current value. Parliament surprisingly agreed, probably because the works were objects of antiquity, thousands of manuscripts as well as prints and early Chinese drawings which no government could sensibly refuse. At the same time they purchased the Harleian Collection of manuscripts for £10,000, as well as the Cottonian Library, principally to establish a library. However Parliament did not provide the money. It was always the view, and has remained so among supporters of a certain political persuasion, that the arts and all similar activities should not be financed through general taxation on the grounds that not everyone would be interested. It was preferred that opportunities to contribute should be extended to those who were interested and if insufficient money was forthcoming then this was evidence that the facilities were not needed. No account was paid to the educational and cultural benefits that would result. Plato's view that the arts elevated the general *ethos* of a people was not generally accepted. It must be remembered that it was the view at this time that the state had no obligations towards the education of its citizens. So a public lottery was organized which in the event raised a total of £300,000 thereby justifying Parliament's opinion. The fact that the appeal of a lottery was the opportunity it offered to win prizes only confirmed the view, still held in some quarters, that to succeed governments have to acknowledge human avarice. Montague House in Bloomsbury was purchased for £10,250 to house the collection. Another £13,000 was spent on repairs and in 1759 the museum was opened to the public. Apparently the considerable balance was set aside for further purchases.

In 1757 George II presented the Royal Library of 10,500 volumes to the collection, a shrewd move which relieved the monarchy of maintaining it. In 1823 George IV presented the library of 120,800 volumes collected by his more learned father, another shrewd move. The constant addition of books and items from collectors no longer wanting to meet their costs resulted in such a vast collection that in 1823 it became necessary for Montague House to be considerably enlarged. There was already a scheme to extend the British Museum to include collections of paintings but, when the government received six million pounds from Austria repaying a loan made some twenty-five years earlier, several members of the administration saw opportunity to establish a separate gallery for paintings.

The growing need for a national collection of works of art came to a head in 1823, firstly by the offer of Sir George Beaumont to give his collection of paintings to the nation when a gallery was built and also by the death of John Julius Angerstein. Beaumont was himself a painter and held very firm views on the nature of art. He encouraged young artists and, as Leslie wrote,[12] he was

> a sincere friend to the Arts, but in many things a mistaken one. He was right in his patronage of Wilkie and of Haydon, but he ridiculed Turner, whom he endeavoured to talk down. He did the same with respect to Stothard, and though personally very friendly to Constable, he never seems to have had much perception of his extraordinary genius.

Beaumont owned Rubens' *Le Château de Steen*, Canaletto's *Stonemason's Yard*, Claude's *Hagar and the Angel* and many others as well as some works attributed to Rembrandt and Poussin. His taste was somewhat conventional and "safe" but his collection, though small, was of considerable importance. Angerstein had been a successful London merchant, a philanthropist and collector of the fine arts. His collection contained Titian's *Venus and Adonis*, del Piombo's *The Raising of Lazarus*, Rembrandt's *Woman taken in Adultery* and *Adoration of the Shepherds*, five paintings by Claude, *Marriage à la Mode* by Hogarth and several others. Both collections were so obviously

important that Parliament could not refuse to agree to their acquisition. A scheme was placed before George IV by Benjamin West with the support of Academicians. A house at No. 100 Pall Mall was acquired and the collection moved in on 10th May 1824. Unlike the circumstances in the case of the British Museum, Parliament did not have to purchase the paintings that were offered. The cost of buying a house was comparatively small and such was the strength of the campaign for a National Gallery the government could not refuse.

However not all artists welcomed the formation of a National Gallery. Benjamin Haydon recorded that he had found Sir Thomas Lawrence in the new premises "purple with rage" saying, "I suppose they think we need teaching." He also recorded Thomas Stothard saying, "This will do for us!" meaning, "this will finish us."[13] Yet Haydon himself said he found the gallery delightful. Constable also doubted the wisdom of establishing a National Gallery of Art. In a letter of 6th December 1822 quoted by Philip Hendy, former Director of the National Gallery,[14] he had said:

> Should there be a National Gallery (which is talked of) there will be an end of art in poor old England, and she will become, in all that relates to painting, as much a nonentity as every other country that has one. The reason is plain; the manufacturers of pictures are then made the criterion of perfection, instead of nature.

How Constable could claim to comment on the condition of art in any other country is curious since, so far as is known, he never visited the Continent. Objections may seem strange coming from the greatest supporters of the Academy but the fear was that the government would seek to demand an official style of painting as Louis XIV had done in France and use the National Gallery to acquire only approved works. There was some disapproval of the fact that the bulk of the acquisitions had come from a foreigner. Angerstein had come from Russia as a child and like so many immigrants had shown much business acumen (a characteristic not always apparent in native Englishmen). Having become a Lloyd's underwriter by the age of twenty-one, his achievement was to change it from being merely a group of men meeting in a coffee house to an international institution well established in the Royal Exchange. Farington commented in his Diary[15] that Angerstein "is much respected for his good heart and intentions, but is considered deficient in Education and very embarrassed on all occasions when He is required to express himself." He had made his money in the City and had "chosen to associate chiefly in the West End of the town, so that He is one who the Citizens say, *comes among them* for what He can get." The last remark was intended as a compliment. Angerstein was deemed to have recognized his educational deficiencies and had decided to mix socially with those who could improve his cultural status. He was thus placed among the respectable members of London society and the propriety of receiving his gift could not be questioned.

Later it was going to be necessary to reassure some over other offers of works to the Gallery. Sheepshanks and Vernon also gathered their collections from the profits of trade, not even through the respectability of banking. For ten years the national collection, such as it was, was housed in Pall Mall. More paintings began to be acquired as soon as the Gallery was established. Soon larger premises were required and the Trustees looked to Trafalgar Square, recently so named. The Pall Mall premises became unsafe and the pictures were moved to temporary quarters nearby. In the meantime the Royal Academy had also been seeking new accommodation, Somerset House where it had been since 1780 now being wholly unsuitable especially for the Schools. It must be recalled that Etty's nightly journeys to the Life Class were to Somerset House, near the river Thames so unsuitable for his asthmatic condition in winter.

Trafalgar Square, as it has been known since 1835, was originally partly occupied by the King's Mews, which had probably been sited there since the reign of Edward I who kept his falcons and falconers in the premises. Geoffrey Chaucer had been Clerk of the Mews and there was also a chapel where daily services were held. Burned down in 1534 they were rebuilt as stables in the reign of Elizabeth and in the early Stuart period were used to lodge Court officials.

After the battle of Naseby the Parliamentarians kept some 4,500 Royalist prisoners there. Christopher Wren's plans to reconstruct the stables were not fulfilled but this was done in 1732. In the later eighteenth century the stables housed a menagerie and were also used to store public records. Georgian London seems to be full of instances where historic buildings and sites were used for mundane purposes. The whole site was cleared in 1830 as part of John Nash's Improvement Scheme for the Charing Cross area—part of the Prince Regent's ambitious proposals to rebuild London—but the scheme never progressed beyond site clearance. Charles Barry leveled the site in 1840 and built the terrace on the north side with flights of steps. Nelson's Column was not erected until 1839, after a subscription was raised in the previous year by the Nelson Memorial Committee thirty-three years after his death. The whole project took four years, with the stone statue finally raised into position in 1843. The bas-reliefs at the base of the column were not completed until 1849 and the four bronze lions designed by Edwin Landseer were not set in place until 1867. The constant delays became a national joke but were regarded as typical of British unwillingness to spend money on public works. The proposal to build a National Gallery on or adjacent to the site thus came long before plans were made to use it as a public memorial to England's most famous sailor. It soon became clear that, after years of indecision, the site suddenly became desirable for conflicting uses (as is so often the case) and the planning of the Gallery was affected by these other interests. The principal problem was, of course, that London was a long established city with many claims upon its space. Governments were not yet regarded as having the many public obligations that are now expected of them and in England, perhaps more so than in some European nations, it was still regarded as essential to the success of any enterprise that it should be privately provided. As Roy Porter said, quoting Sir Lewis Namier. "Every country and every age has dominant terms, which seem to obsess men's thoughts. Those of eighteenth century England were property, contract, trade and profits."[16]

Nations do not suddenly change at every century's end and the principles of the eighteenth century continued to dominate Englishmen's minds until the accession of Victoria in 1837 and beyond.

Etty was inevitably concerned about these developments. He wanted both new Academy buildings and a new National Gallery and expressed concern over the proposal that they should share the same building. As was usual, members of Parliament were seeking means of demonstrating that they would not spend much on the arts. A few curious schemes seem to have been considered. One in particular worried Etty. In an undated letter in York Art Gallery he wrote to an unknown recipient that an architect (unnamed) had said he would build the Gallery "over a range of shops!!! in consequence of the value of the ground!!!" Etty facetiously suggested that the Gallery "should be let in stands—like the other bazaars and that Raffaello, Titian and Correggio be hung behind the Caps, bonnets, combs and other very pretty things, which are so much more useful."

He referred to "Bonaparte's character of us—a Nation of Shopkeepers.'" He added a caricature of a row of shops with a small sign "National Gallery upstairs." These proposals were consistent with the belief that that every public need must be met out of commercial profit and satisfying it must not be undertaken unless it does. Fortunately the nation's pictures did not have to share buildings with haberdashers and ironmongers. In 1831 the Trustees of the National Gallery accepted the design submitted by the architect William Wilkins (1778–1839), who was vilified from the outset by those many connoisseurs who objected to the façade. Originally Wilkins had wanted to bring the façade right on to Trafalgar Square which would have resulted in a larger building but objections were raised on the grounds that this would have obscured the view of St. Martin's in the Fields. The building therefore had to be set back. Construction did not begin until 1833 and it was not until April 1838 that it was opened to the public. However, despite having been spared the company of shopkeepers the national collection had to share accommodation with the Royal Academy. It was immediately apparent that the building had

not been designed for both. It was already too small for the purposes of either body. Martin Shee, who was now President of the Royal Academy, strongly protested against sharing the accommodation, urging that the site should be wholly used to house the Academy. He might have prevailed but for the acquisition by the Gallery of several large works requiring considerable exhibition space. The two institutions perforce had to remain neighbors, at least for a while. Much later, in 1853, the Parliamentary Select Committee inquiring into the state of the arts in the United Kingdom recommended that the National Gallery should abandon the building to the Royal Academy and move out to Kensington Gore. But it was the Academy that moved, to Burlington House in 1868, a century after its foundation.

The importance of the National Gallery in the artistic life of London and the nation cannot be overstated. For the first time artists, students and the interested public could see works that had hitherto been available only by traveling abroad or negotiating permissions to view with the owners of large town or country houses. Hitherto only a small minority of collectors had been willing to share their prized possessions and then only with those of the upper classes and established artists. Even so, visiting the Gallery could be a daunting experience for the inexperienced and it was a long time before the poorer classes felt sufficiently bold to enter its formidable doors.

"A nasty little pokey hole"

As we have seen, the story of the National Gallery is bound up with that of the Royal Academy. The first eleven years of the Academy's existence had been spent in a building on the south side of Pall Mall. This building no longer exists. It had previously been occupied by Aaron Lambe, an auctioneer, and then as a print warehouse. As was so usually the case, important institutions would be established and then no suitable premises were made available. From the first the building was too small but despite this the Academy enrolled large numbers of students, fulfilled its undertaking to employ living models of both sexes, formed a library with the appointment of a Librarian and held annual exhibitions. The Council was determined the project should succeed and they were soon looking for larger premises. Their eyes lighted on Somerset House in the Strand and in 1771 they moved into part of it. The original building, which was demolished in 1775, had had an interesting history. It had been built between 1547 and 1550 for Edward Seymour, the first Duke of Somerset and Lord Protector of England in the reign of Edward VI. After his execution in 1552 it passed to Princess Elizabeth. On her accession to the throne she gave part to Somerset's son, the remainder being retained for meetings of the Council and to provide accommodation for visiting ambassadors. In 1603 it passed to Queen Anne of Denmark as her residence and during her lifetime was the scene of many masques organized by Inigo Jones and Ben Jonson.

After the Restoration a gallery was built on the river front and in 1676 it was refurbished to become the first building in England to have parquet floorings. When Queen Charlotte decided in 1775 not to live there, preferring Buckingham House, Somerset House was surprisingly demolished. In what might be regarded as an act of sheer vandalism it was decided to replace it with government offices, the first purpose-built large block of offices in the country. Fortunately Sir William Chambers, the Surveyor General, was given the design commission when the appointed architect, William Robinson, died in 1775. The present building was the result and London has reason to be pleased. The Royal Academy had already moved into the original Somerset House, having taken over rooms made vacant by the expulsion of certain royal retainers by the personal command of George III. Consequently in the rebuilding, provision was made for the needs of the Academy who stayed there until early 1837. This was the building that Etty was used to and where he regularly attended the Life Class for the first thirty years of his career in London. When he moved into Buckingham Street in 1824 he was less than half a mile away, well within walking distance.

In 1837 the Academy moved into the eastern half of the new building in Trafalgar Square which it was destined to share with the National Gallery until 1869. Although the accommodation of each institution was self-contained they had to share the main entrance. The Academy's portion consisted of five exhibition rooms on the first floor. This enabled them to be lit by glass roofs. There were corresponding rooms below. There was also an adjoining room for the collection of plaster casts and an exhibition room for sculpture on the ground floor. The Life Class was held in a room in the dome. It was to this that Etty laboriously climbed most evenings when he was in town. The accommodation was not wholly convenient and almost everyone was critical. From the beginning the Council considered it necessary to apologize to the public. A note was appended to the catalogue of the first exhibition in 1837: "It may be proper to observe that, in consequence of the great number of works sent for exhibition this year, it has been found impossible to assign places to many of those which have been accepted."

In other words, the place wasn't big enough. Worse still, when an exhibition was open to the public some of the rooms intended for the students could not be used. During the rest of the year the students spread into the exhibition rooms but this meant that special exhibitions could not be held, had that been desired, which, fortunately for the students, was not yet the Academy's policy. There was one advantage: students of the Academy were allowed free access to the Gallery to copy paintings and, being next door, this was very convenient. Etty says very little about the early years of the Academy in Somerset House probably because he was sufficiently satisfied with the accommodation there, which seems to have been the case. William IV gave no support to the Academy, which fact Etty would have privately deplored but he would not publicly have expressed an opinion. However there is a report of a royal visit to the Academy in its new premises in Trafalgar Square recorded by Gilchrist in the year 1837.[17] This must have been when William IV opened the Academy there on the 28th April.

> The New Gallery opened at twelve to-day to the public. Before two, 600 Catalogues were sold. I was there. The people poured in like a torrent. The day was fine; and the Exhibition looked glorious. ... On *Friday*, at one, came the King, in full state, with a long *cortège*; martial music playing, the Colours presented, the Guards under arms all along this Temple of the Arts. ... The President and the Council attended him through the rooms; where he spent about two hours. On returning the King showed himself at the Portico, which is elevated. Crowds cheered him heartily. The music struck up. The old King bowed, took off his hat, descended to his carriage, and departed.

The royal opening, which had of course preceded the opening to the public, was William's last public appearance. Etty had the satisfaction of seeing four of his paintings in the Academy's first exhibition in its new premises—*Samson and Delilah, Adam and Eve at Their Orisons, Mars, Venus and Cupid* and *The Sirens and Ulysses*. For once the critics did not question the inclusion of his paintings.

Although the king had assisted the move of the Academy to Trafalgar Square he was critical of the new building, describing it as "a nasty pokey hole."[18] It was certainly inadequate and very soon the rooms were found too small to exhibit all the works submitted and which the Council wished to hang. The National Gallery took possession of its half of the building in 1838 and the joint use was certainly useful for students who could move easily into the National collection for study whenever they wished. Two Academy presidents, Martin Shee and Charles Eastlake, were also Trustees of the National Gallery. After Eastlake's death in 1865 Thomas Uwins, R.A. became Keeper of the National Gallery and Sir William Boxall, R.A,. became Director. The association was beneficial to both institutions, but the premises were too small for both to occupy, especially as the National Gallery was continually enlarging its collection. In 1851 the Academy addressed a memorial to Queen Victoria praying for more space in the hope that the National Gallery would move from Trafalgar Square and in 1856 there was actually a suggestion that the Gallery should be sold to make way for a hotel. The Academy sought to buy the whole site to circumvent these proposals but negotiations took a long time, as usual, and in 1859 the

Chancellor of the Exchequer (Benjamin Disraeli) offered the site at Burlington House and for the Government to build new Academy premises. As Government funds would be provided, Disraeli could not promise that the Academy would remain independent but if they preferred to use their own funds the Government would still provide the site and guarantee independence. The Council chose this option. It was eventually decided to retain the existing buildings of Burlington House and extend them to designs by Sydney Smirke, brother of Sir Robert Smirke. Work began in April 1867 and the Council held its first meeting in the new premises on the 24th November 1868. This brief account of a much more checkered history than need be recounted here is taken from Sidney Hutchison's *History of the Royal Academy*.

Most of Etty's references to the Royal Academy are to the exhibitions and the paintings he submitted. We know he regularly attended the Council meetings but he does not appear often to have spoken and, when he did, it was, according to C. R. Leslie, a fellow Academician,[19]

a great effort, yet he was never silent on any question in which he thought he could serve the Academy. The first speech he made at a general meeting was to propose a very useful measure, which he carried; but he was so nervous that he could scarcely articulate, and it was painful to witness how much the effort cost him.

Etty regularly attended the Council dinners but, again, we have reason to believe he hardly ever joined in the conversations. We must imagine that the other members were very loquacious and poor Etty, who always found it difficult to break into conversations, spent most if not all of the evenings in silence. Even in informal groups he found participation difficult. Successful group conversation depends on one's taking part from the outset. Etty was most likely too unsure of himself to present an opinion until it had been well considered and then it was too late. He was not an opinionated man and probably felt ill-educated though he had no need to feel so. There were others, Wilkie among them, whose education was no better but it was seldom Etty's custom to meet his peers informally for convivial entertainment. Most of the accounts we have of Etty meeting others is at formal dinners where polite exchanges took place over the meal and speeches were delivered afterwards. Etty may not have enjoyed these occasions but he enjoyed being invited. It confirmed his acceptance as an artist of status. In the Academy meetings he subscribed to Turner's sentiments that the institution must never be criticized, artists owed it so much.

An important appointment—The Schools of Design

When the Academy moved from Somerset House to share premises with the National Gallery in Trafalgar Square its vacated premises were taken by a new enterprise, the School of Design. This had been long in gestation, a very usual feature of anything innovative in Britain at that time. The idea of such an institution had first been mooted in the early years of the century. Many people who were concerned with the state of Britain's trade abroad had come to realize that the design of British goods competing mainly in Europe was inferior to those being produced by those countries. Exhortations in the press and at public meetings had failed to bring any response, English manufacturers being generally unwilling to produce original designs, relying instead on copying the designs of competitors. Parliament became concerned that the country's foreign trade was not flourishing as it should and needed to do. If manufacturers would not train craftsmen and designers perhaps the Government should promote such training. In 1835 a Select Committee had been appointed to inquire into whether special Schools of Design should be established and, if so, how they should be managed and funded.

Mr. James Morrison, M.P., appearing before the Committee as a witness, expressed the general dissatisfaction when he said[20]:

We have been very much superior to foreign countries in respect of the general manufacture, but greatly inferior in the art of design. ... [W]ith regard to several of our large towns, though there are persons that are called designers, yet they have not been educated as such, and in point of fact they know little of the principles of art.

Every witness appearing before the Committee had his own catalogue of complaints and his own remedies. Some wanted all industrial designers to be trained in the fine arts as well as applied design, others did not; some blamed the decay of taste among the general public, others blamed the lack of good examples provided for the public to contemplate; some claimed that to teach design would result in standardized products while others urged that designers who lacked any aesthetic training could not be trusted "to run wild." Only one witness discussed the nature of academies of art, or rather their nature as he saw it, and that was Dr. Gustav Waagen, the Director of the Berlin Museum, who was on a visit to England and had achieved a considerable reputation. He argued in support of "free art," citing the examples of Raphael and others of the Italian Renaissance who had had no institutional training. He likened academies to Dutch gardens where gardeners were required to clip trees all to the same forms. More than this, Waagen declared academies to be destructive. They encouraged men of mediocre talent and the greatest geniuses were excluded.[21] Of course, and as usual in such cases, there was truth on all sides except, perhaps, Waagen's general condemnation. He was influenced by continental examples where ruling powers exercised considerable authority over their national academies. This was by no means the case in England.

The Committee moved slowly and Benjamin Haydon began his own campaign for the establishment of Schools of Design. He spoke at public meetings throughout the country and was eventually called before the Committee in 1836. He attacked the very idea of academies as Waagen had done. Nevertheless he approved of the Royal Academy Life Schools where students had to study both casts and the living model but he deplored the system of the forty full members' having to take turns to instruct students. Students did not receive consistent training. He wanted specialists in particular subjects to be appointed and he wanted this system to be extended to the proposed Schools of Design. The Committee was in danger of degenerating into a trial of the Royal Academy and matters were not improved when the Academy's President, Sir Martin Shee, was confronted by Haydon and Waagen, surely an unusual procedure for a witness to be interrogated by another. According to Haydon's account Shee lost his temper, challenged the Committee's authority and had to be brought to order by the Chairman. However, the minutes of the Committee do not confirm Haydon's account and represent Shee as outwitting his opponents.[22]

We need not be concerned with the details. It is sufficient to know that tempers often flared and the Committee Chairman had an unenviable task in maintaining order. It seems clear that the Chairman had allowed the Committee, or the witnesses, to extend its terms beyond investigating the need for Schools of Design and had brought the Royal Academy itself under scrutiny. It had allowed persons and bodies to use the proceedings to air private grievances. Sir Martin Shee was quite correct in objecting that the Committee could not examine the Academy. It had been established by Royal patronage and was not subject to Parliament in any particular at all.

In due course the Committee reported, objecting in principle to academies of art, claiming the Royal Academy was an exclusive body (it cited the case of the engravers who had been excluded from membership on the grounds that they were craftsmen). It preferred "free competition in art (as in commerce)" and objected to the Academy being able to take public money "at the door" (i.e., at exhibitions) "without bearing the direct burden of public responsibility."[23]

The Committee was using the opportunity to claim that the Academy should be removed from Royal patronage and placed under Parliamentary control. But nothing was to come of this. The main body of the Report emphasized the need for the training of industrial designers. "The direct application of the Arts to Manufacturers ought to be deemed an essential element." The

Report argued that while *local* Schools of Design would eventually result in the Arts to "eventually strike root and vegetate with vigour" it would be better "if a more *central* system be adopted."[24] Quentin Bell states[25] that "it cannot be said that the Schools of Design were produced by the Report of 1836" but that the evidence submitted in 1835 had so shocked the Government that it decided to do something even before the Report was submitted. The Report's proposal that the provincial Schools should be placed under the control of a central London School, which should, in turn, be controlled by the Government, was accepted since they would all depend on public funding. As there was at that time no Ministry of Education, control was vested in the Board of Trade on the grounds that the Schools would be serving the needs of industry and trade. This was agreed and the President of the Board of Trade appointed a Council to fulfill the functions of control. The Council consisted of several prominent Academicians and some minor manufacturers, it being clear at the outset, as it had always been, that the major manufacturers saw no need for the Schools and did not intend to co-operate. The Academicians appointed were John Gibson, a prominent sculptor, David Wilkie, and William Etty. This was Etty's first important appointment to a government office and marks the high regard in which he was now held.

The Council decreed that the Schools were not to teach the study of the human figure either from casts or the model on the grounds that the kind of designs that were necessary for manufacturer and trade would not include the figure. Apparently designs were to be either from natural floral forms or abstract. We have to assume that Etty could not have approved since he always maintained that study of the figure was essential for all artists. As he was by temperament a quiet man who did not confront opponents since it was not his nature to dispute with those who disagreed with him, we must assume that he kept quiet but remained determined as was his custom. The London School, which became known as the Normal School, was established in 1837 and the few provincial Schools which had already been established by various local arrangements were brought under its aegis. New provincial Schools were not established until 1842, largely because of manufacturers' determination not to support them. In the meantime the Council embarked on founding a policy for the management of the Schools and in particular deciding what the curriculum of studies should be. They appointed as their Secretary and Director William Dyce, who was making his name as a successful painter, having come from his birthplace Aberdeen to London in 1823, and who had published a pamphlet proposing the kind of art education that should be available to students. The Council sent him to France to prepare a report on the Schools of Design there but he was so enthusiastic that he went on to Germany and studied the School in Berlin. His consequent report of 27th April 1838 resulted in the remodeling of the course at the London School and such provincial Schools as already existed and prepared the way for more Schools.

There were, however, continuing disputes surrounding the Government's proposals. Most local manufacturers refused to send their young designers to the Schools, usually arguing that tuition was unnecessary since all that was required of them was to copy existing designs. Also, they did not want their employees to be taught *how* to design since this would so improve their skills that they would either demand higher wages or find employment elsewhere. Another point of dispute was whether the Schools should teach only design. Many argued that they should not offer training in art as a subject since this was not required and, again, would so improve skills that the best students would be encouraged to become independent artists and so be lost to their employers. Employers absolutely refused to pay for training in skills either that they did not require or that might benefit another employer. But above all disagreement centered on whether, if design and art were to be taught, it was necessary for the student to study the human figure. Most employers objected and so, of course, did local religious leaders. Joseph Haydon, who had been active in supporting the Schools, argued strongly for including study of the figure and for live models and casts to be made available. William Dyce, on the other hand, held that drawing the human figure should be introduced only at the end of each course and should be

made available only to those students who showed sufficient ability. There was an additional problem. By now many designers in industry were young women, which in practice meant that they were mainly copyists. In the pottery industry most of the painters were women. It could not be permitted that they should be able to draw from life, especially not in the company of fellow male students. As might be expected, Etty supported Joseph Haydon.

But, surprising as it might be to us today, there was another objection to the introduction of Schools of Design. Compulsory education was not yet a legal requirement and there were many who objected to such an idea, holding that the lower classes did not need to be educated to perform the duties required of them and that it would be dangerous to educate them since they would undoubtedly acquire subversive ideas. Most manufacturers objected to all forms of state interference in anything, especially when it meant paying through taxation. As early as 1825 *The Yorkshire Gazette* had expressed the concerns of most of its reader in what may be seen as typical of the views of the more enlightened manufacturers[26]:

> We are friends to the Education of the Poor; we are anxious for the success of every measure which is likely to advance them in the scale of society, to improve their manners and to amend their hearts; but we cannot see without concern, what is going on in some quarters, nor remark, without reprobating, the pains which is taken, under pretence of increasing the means of knowledge, and extended learning.

The author went on to express his objection that in the Mechanics Institutes, which were being established, the students did not study theology. This must mean, he said, that their work would not be guided by religious principles. How adherence to a particular faith would improve the design of steam engines was not explained. He went on also to complain that too much education would encourage ideas of social equality. The existing social distinctions would be destroyed and what would happen to the country then? Of course, general education would affect the nature of society, as we today can see, but at that time what objectors depended on were the principles set forth in popular hymns:

> The trivial round, the common task,
> Should furnish all we ought to ask.[27]

and

> The rich man in his castle,
> The poor man at his gate,
> God made them, high and lowly
> And ordered their estate.[28]

These were sentiments that we might expect Etty, with his strong Tory opinions, to approve but he wholly agreed with educating those who showed promise. After all, he had benefited from education but that had been privately financed. It was unlikely he would have agreed with *universal* education any more than he agreed with universal suffrage. Schools of Design were intended for those who already showed promise but could not afford to educate themselves further. They were also really intended to serve the needs of manufacturers if only they could see it. It was *applied education* that was being offered. We know that Etty admired philanthropy and it was the intention that employers would meet the costs of training their employees. That was a typical nineteenth century opinion of how things should be done.

In 1838, when paying a visit to York, Etty expressed concern that his native city did not possess a school devoted to the teaching of art and design. In October of that year he read a paper entitled *The Importance of Art and Design* to the Council of the York Philosophical Society of which he was a member. He urged the establishment of a School and the Council was sufficiently impressed to ask Etty to repeat his lecture to a public audience on the 5th November. He is reported to have read his lecture badly but the audience received his ideas sympathetically. *The Yorkshire Gazette* of 10th November 1838 reported the lecture in detail. Etty's theme

had been the need for "the establishment of a School for Promoting the Fine Arts" so that more people would appreciate "the great works of art" rather than the delights of "the gin-palaces and public houses." This was not the declared purpose of those promoting Schools of Design. They were not part of the Temperance Movement. Etty's lecture was, as usual, long and rambling, failing to concentrate on simple principles and so allowing opportunity for any objector to pick on particular points to demolish his case. The manuscript of the speech is in the York Reference Library and is too long to reprint in full but some excerpts will give an indication of Etty's style. He began by addressing his audience as "My Friends and Countrymen," probably intentionally reminding them of Marc Antony's speech in Shakespeare's *Julius Caesar*, then opened by saying:

> When I look around me and see the men of talent and attainment assembled to hear my few poor remarks on the subject I am about to speak—I almost repent my own temerity in offering on the spur of the moment and at so short a notice to touch on a subject as that of the [*words illegible*] Beauty and Importance of the Fine Arts to our Country but when I assure you as I do most sincerely that it arises from no desire to obtrude myself on your nature but from an earnest wish to do any little good that may lie in my power to my native City for whose preservation and welfare I feel and have long felt the deepest interest. On these grounds then I appear before you and feel assured I shall meet with that candid and unprejudiced hearing—which a will to do good deserves—however deficient I may be in the [*words illegible*].

It will be seen that Etty had a weakness for long sentences and so his speech progressed:

> ... there are far nobler objects of human ambition than that of making a good percentage [*of*] five per cent for our money—or to use an expression of [?*Turner*]—that of adding guinea to guinea—and to one of those objects I should be glad to be the means of calling your attention to, and that is the Cultivation of the Arts of Design as applicable to Painting, Sculpture and Architecture and also to the Arts of Manufacturing and Commerce of the Country. That the seeds of these Arts are like those of Poetry and Music sown in the natural mind of man—I think must be obvious to all—the most savage and uncivilized races show Design and Ornament in their utensils, dress, arms, etc—the Esquimaux—the last link of humanity on this side of the North Pole—decorate with some taste and ingenuity their seal skin dresses, tobacco pouches and weapons....

Etty went on to quote examples of the decorative arts among the Maoris of New Zealand, the North American Indians, the Mexicans (presumably the Aztecs), as well as the ancient Greeks and Romans, until he arrived, as might be expected, at "the Glorious Fabric of the Minster itself." No matter what speech he made Etty could be relied upon to include York Minster as the finest example of all the arts. In this case he was speaking to a gathering of York's most intellectual minds, so he knew his audience would be sympathetic. So indeed they were. Many speeches were made in support, a resolution was carried that a Society for the Promotion of the Fine Arts should be established and that the Hospitium in the Museum Gardens should be used and, more to the purpose, that a fund should be started. Fine words—but nothing came of them. In the meantime, back in London Etty discovered that support for Joseph Haydon was waning. He realized that conditional access to the life model was better than no access at all. He therefore moved his support to William Dyce. Dyce's proposals could at least gain some support among employers and half a loaf was better than no loaf, and there for a time the matter rested.

CHAPTER TWELVE

A change of monarch, a change of style

When, on the 20th June 1837, William IV died and Victoria succeeded to the throne it might have seemed that henceforth Great Britain would be ruled by ministers since, it was soon reported by no less than Albert, her future husband, that the young queen was "incredibly stubborn and her extreme obstinacy is constantly at war with her good nature; she delights in Court ceremonies, etiquette and trivial formalities.... She is said not to take the slightest interest in nature and [enjoys] sitting up at night and sleeping late into the day."[1] Not suitable material for any wife of his and clearly not suitable to be a monarch of the greatest power in the world. But this suited Lord Melbourne, the Prime Minister, who soon wheedled his way into her favors and was able to run the country until Albert married her after all on 10th February 1840. Albert soon changed her way of life and at once promoted the image of the sober family of spotless character so different from that of her predecessors. Such a change was unquestionably necessary and Victoria adopted Albert's principles because she could see that he was so much cleverer than she was. Continual child-bearing now kept her from taking the firsthand interest in state affairs that she had developed under Melbourne's guidance. It was Albert who took control and began what was to be known as "the Albertine Monarchy." Represented as both dominating and disinterested, according to the prejudices of those reporting on her, Victoria settled uneasily into family life but was ready to project the image of caring wife and mother that Albert required. In the early years of their marriage the young couple appeared light-hearted, arranging fancy dress balls at which they assumed the roles of medieval kings and queens, always agreeable to Victoria who loved dancing.

Sidney Hutchison's *History of the Royal Academy* makes no mention of Victoria's accession to the throne. Her automatic assumption of the patronage of the Royal Academy probably escaped her notice. It would certainly not have interested her and not until her marriage did she begin to pay any interest in the arts. It was Albert who brought into her life an appreciation of music and the arts. It was Albert who sometimes attended the Academy's annual dinner and Albert who conducted Victoria and their increasing family round the exhibitions. It was Albert who became concerned over the nation's general lack of interest in the arts and especially in the poor designs of British products. Both were concerned about the behavior of the Queen's late "wicked uncles" and the bad examples they had set the nation, but it was not the Queen who introduced the popular image of "Victorian England." It was Albert with, of course, much assistance from the religious leaders in the country.

Various biographers have remarked on Albert's serious mindedness and his virtues. One, Stanley Weintraub, in his book *Albert Uncrowned King* (1997), said that his virtue "was indeed appalling; not a single vice redeemed it."[2] The Duke of Wellington later found him to be straitlaced and prudish, not at all "the man's man" that the old soldier was used to. But, as we shall see, Albert was at heart an amiable man, a loyal friend to those he admitted into intimate relationships, a loving husband, by no means a prude but, on the contrary, very broad minded.

Albert always distinguished between his public and his private *personae* and he very quickly taught the Queen to follow his example. The image of Victoria that has come down to modern England of a puritanical, forbidding figure, is a fiction of history brought about by her theatrical displays of grieving widowhood after Albert's death.

Gilchrist makes no mention of the succession of Victoria and she does not appear in his biography until she and Albert commissioned the decorations for the Royal Summerhouse in 1843, an event so important to Etty that it will be dealt with very fully later. Whether Etty paid any interest in Victoria's coronation in June 1838 cannot be ascertained. There is absolutely no reference to the occasion in any known letter that has survived. He appears to have been wholly immersed in his work throughout the year. As regards painting new works, 1837 was a quiet year for him. He exhibited only *Samson Betrayed by Delilah* and *The Sirens and Ulysses*, with the latter attracting sufficient attention. But 1838 was a busy year. He exhibited eight works, seven of them at the Royal Academy. Among them was *Miss Lewis as a Flower Girl*, which has some interest for supporters of York Art Gallery. It is not known who Miss Lewis was except for a mere reference to this painting by Gilchrist.[3] A painting purporting to be this work was presented to York Art

Gallery by F. D. Lycett Green in 1955 through the National Art Collection Fund. The Fund's advisers were presumably satisfied that it was by Etty. Since then it has been demoted to being merely a work of the "English School c. 1830" on the grounds that it has "little in common with Etty's work." It is reproduced here for the reader to judge.

Victoria's succession had no effect on the Academy or on Etty and his colleagues but Albert's increasing influence did. The Prince showed much interest in the arts and encouraged Victoria to do the same but, though she attended exhibitions and collected works of art, as also did Albert, she displayed no public interest. Albert's influence on Victoria was invaluable. He trained her in state affairs, especially in foreign policy in which English tradition allowed the monarch to have a controlling role. In the arts he surprisingly encouraged a liberality of ideas which appeared at first sight to be contrary to his nature. It is now known that from the first days of her marriage Victoria discovered the pleasures of sex[4] and this seems to have shaped her own ideas on art. Neither she nor Albert disapproved of the nude in art, they gave each other gifts of paintings of the nude figure, and when visiting exhibitions she surprised, and

Miss Lewis as a Flower Girl (30 × 25 ins) (1837). According to Gilchrist Vol. II, page 63, Etty painted "Miss Lewis as a Flower Girl" in the summer of 1837. This painting was presented by F. D. Lycett Green to York City Art Gallery in 1955 with this title. In the Gallery Catalogue of 1963 it was listed as " The Flower Girl, English School," c. 1830, with the statement that "the picture has little in common with Etty's work." York Museums (York Art Gallery)/ Bridgeman Art Library, London; YAG23474/117.

often embarrassed, officials by her determination to view such works. Albert was more discreet. Of the two it could be said he was the more circumspect. But he was determined to shape Britain into a world authority on everything and this particularly included the arts.

Etty knew only twelve years of Victoria's reign and it was largely Albert who affected his life. As ever, Etty approved everything the monarchy thought and did. It was not for him, a mere subject, to question his Queen. She had been appointed by God to rule and as God's anointed she was due his complete obedience. There was one incidence, to which we will come, which was to demonstrate his loyalty. What became important to Etty was the confirmation of the strict morality that the Evangelicals and other religious groups were establishing. Whilst Albert may not have wholly approved of such rigid doctrines, it suited his purpose that the royal family should appear sympathetic. It established in the minds of the public that the royal family was sober, religious and honorable, which of course it was. Despite Victoria and Albert's acceptance of the propriety of Etty's kind of art, they had no objection to the middle class rejecting it if this cemented their relationship with the people. Albert was careful never to say anything contentious in these matters but always to urge that the British needed to be educated in the arts and to improve the design of their products both to improve taste at home and to increase exports abroad. It was not Victoria who assumed patronage of the Royal Academy but Albert. He became friends with Charles Eastlake, a much traveled, well educated and highly regarded figure in the art world who also painted history subjects, portraits and landscapes and encouraged his appointment to various bodies where the Prince wished his views to be made known. When in 1850 Eastlake succeeded Martin Shee as President of the Royal Academy, Albert specially attended the annual dinner to demonstrate his support. When letters and petitions had to be sent by the Council to the Queen they made sure to include the Prince as his support was vital.

It must be said that the tastes of the Queen and her Consort were often uninspired, in the pictorial arts ranging from Edwin Landseer to Franz Xavier Winterhalter. Landseer satisfied their love of dogs and the outdoor life; the latter their love of elegance, beautiful women and romantic fantasies. In poetry it was either pastoral idylls or grandiloquent epics. When the Queen appointed Tennyson as Poet Laureate in succession to Wordsworth it was more than an official duty. They had better taste in music, though here again their predilections were unremarkable. Both could play the piano reasonably well. Mendelssohn became a friend and frequent visitor. Given the low level of appreciation of music in England at the time it must be admitted that Victoria and Albert did their best to improve it. They had inherited a nation that was, culturally, quite philistine. The country was at the mercy of landed proprietors on the one hand, whose leisure was still spent in field sports or playing cards, and manufacturers on the other, whose leisure was spent devising schemes for making more money. There was a small class of intelligentsia, publishing and reading books on modern philosophy, science and religious criticism, trying hard to understand the changing world in which they lived. It is known that Victoria often read such books. But, most important, there was an ever increasing middle class demanding respectability and social recognition and ready to toe whatever line would bring them to that happy state. In practice this meant aspiring to the status of those socially above them and making sure that those below them did not join them. As *The Times* leader wrote in September 1851: "What is most coveted in this country, more than wealth, more than talent, more than fame, more even than power, is aristocratic position, to obtain or improve which other things are only sought as the means."[5] The writer was, of course, chiefly referring to the manufacturers, the Victorian *nouveaux riches*. In due course, many of them would realize their dreams.

Albert's sudden death in December 1861 was to leave Great Britain with a problem. There was no longer a strong head of state with firm ideas that would benefit the nation. Victoria's breakdown lasted until her death and she alternated between stubborn refusals to sanction necessary political actions and unwillingness to make up her mind about anything. What her ministers

were increasingly concerned about was satisfying the middle class who were growing ever more influential and she had to learn that it was they she had to please. Though the Queen stayed aloof from public life, much to the annoyance of her ministers and the irritation of her subjects, the latter were always quite sure that she approved of the life-style they had adopted and of their campaigns against the decadence which they saw as the result of increasing religious indifference. For, unfamiliar as it might be to many, the reduction in church attendances at the beginning of the century, although made up during the century, was once again falling by its end. But that was to come. In the first half of the nineteenth century everyone could see, as they had hoped, that the influence of "the wicked uncles" was being swept away.

A childlike humor

Although most people who knew him often referred to Etty's gentle and simple nature, apparently few were aware that he had a sense of humor that bordered on the childlike, if not the childish. Playing word games became a popular pastime for many Victorian fathers seeking both to entertain and educate their children and, in the absence of today's sophisticated and often unsuitable forms of entertainment, families frequently gathered in the evening to enjoy communal activities that could be shared by all ages. The essential purpose was, of course, to control the children's upbringing and the intention was to develop them into copies of oneself. Etty had no children in his circle but he did have a close friend who seems to have enjoyed his jokes. This was Thomas Bodley, his cousin by marriage to Martha, uncle William's daughter. The letters passing between Etty and the Bodleys (in the York City Reference Library) give a great deal of information regarding Etty's career and also reveal Etty's sense of humor. He clearly felt at ease with his cousins, for whom he had the deepest affection. Bodley also encouraged Etty to pursue his ambitions, so it was to Thomas that Etty wrote his triumphant letter when he was elected a full Academician, confident that they would share his joy and understand his mood. It was also to Thomas and Martha that he confided his grief on the death of Sir Thomas Lawrence, knowing that they would understand how the loss of his old master had affected him. Etty felt able from time to time to ask Bodley to support the campaigns for the restoration of York Minster and York Walls and also to subscribe to such projects as the purchase of John Constable's *Cornfield* for the National Gallery.

Thomas Bodley presumably held a financial interest in the Lombard Street firm of Bodley, Etty and Bodley, and was well able to respond to William Etty's appeals. Etty and the Bodleys frequently visited each other. The Bodleys lived for a time at Brighton and then at Cheltenham. Etty often went to stay with them at Brighton and did so to paint studies of the sea for *Sirens and Ulysses* he was working on. He also often stayed with them in Cheltenham when he was traveling to pursue commissions. He had numerous friends around the country where he could stay, it clearly not being attractive to stay in inns or so-called hotels. Gilchrist states[6] that Etty always referred to Thomas Bodley as his "First Master" in recognition of the support he gave him from the beginning. His first loyalty seems to have been divided between Walter and Thomas, but Walter's support was financial whereas Thomas offered encouragement.

Etty often wrote to Thomas and Martha Bodley in humorous terms, when he wanted them to visit him, representing himself as a hotel keeper recommending his rooms and the meals that Betsy organized and referring to 14 Buckingham Street as the "York Hotel" or, later, the "Royal York Hotel." When the Bodleys stayed in Buckingham Street in 1834 during one of Etty's absences, he wrote[7]

Delighted to hear of your taking up your quarters at the old York Hotel. We shall always endeavour, by civil treatment and reasonable charges, to keep our old and respected customers. In this age of competition and cheapness we shall rely more on the qualities which have given our old establishment its character, than by any affected refinement to captivate new-comers.

In 1842 he was still continuing this humorous style of correspondence. In a letter dated 10th March of that year he wrote to Thomas Bodley:

As the Landlord of the York Hotel, York Building, has arrived from York, he wishes to give notice to his good friend Thomas Bodley that his Hotel has been undergoing a repair and renovation. It is now ready for the reception of Travellers, if of the right sort and good and well aired beds and airy bedrooms may be had, and hopes no [illegible] will be found.

In a later letter Etty wrote:

I forgot to name one essential recommendation to our old established concern, its superior eligibility to Gentlemen fond of the "Cold Water Cure," namely the noble Thames rolling under our window so that if any deficiency of the means of cure should occur, a bucket dropped down at high water might not be very far off filling if anybody would kindly lift it over the wall. And a choice cellar of wines qualify the water viz. Bronte and Old Port and Burgundy of the most approved Vintage. On these and other advantages we confidently rest our claims for the continued support of the old Friends of our old establishment assuring them that no exertions shall be wanting on our part to deserve a renewal of their favor and support.
 We have the honor to be, Sir, Your most obedient hosts
 Etty & Co.

On the left hand and bottom margins of this letter Etty drew a pen and ink sketch of a person lowering a bucket from an upper window into the river. He ignored the condition of the Thames into which hundreds of drains from riverside properties discharged untreated effluent and which was in the summer months frequently so offensive that campaigns were beginning to be mounted for some remedy. At this date the Thames extended to the end of Buckingham Street where No. 14 was situated on the river bank. Victoria Embankment was not constructed until 1864 which enabled sewers to be laid conveying effluent away from the river although at first only further downstream. These works, long realized by reformers to be necessary, had become urgent following several outbreaks of cholera and the Great Stink of 1858. Etty never seems to have commented on these conditions and only once did he mention the 1830s cholera outbreak in York. He is not to be numbered among the reforming minds of the nineteenth century.

Etty's humor sometimes pervaded a whole letter. He would often address Bodley as a medieval knight at arms, issuing summonses to attend a royal court and giving details of events to be seen in London as though they were jousts or pageants. Any recent difficulties he had experienced he described as though they had been battles between medieval armies. Interest in the Middle Ages was spreading, largely through the novels of Walter Scott, an interest already taken up by the young queen and her consort in the balls they arranged. Edwin Landseer painted Victoria as Queen Philippa and Albert as Edward III, commemorating a fancy dress ball in which they had so appeared. Quite apart from the fact that this was a silent appeal by Albert to be crowned king, it depicted the Romantic view they took of the role of monarchy and of themselves. In the new spirit of the times local pageants were frequently organized as village entertainments. The reinstatement of the annual May Queen during the nineteenth century was a nostalgic celebration of an idealized medieval village life and even the aristocracy occasionally engaged in pageantry with mock tournaments. Etty himself now often painted historical subjects from the medieval period and soon the young Pre-Raphaelites would burst upon the London art world. Notwithstanding his principal interest in neo–Classicism, Etty also loved everything medieval, largely because he so closely identified himself with the spirit of York Minster. When in 1831 he sold *Benaiah* and *The Combat* to the Royal Scottish Academy he wrote to Thomas Bodley (23rd December 1831):

I know you will rejoice with me at the Victory obtained by my Warriors. They have taken Edinburgh by Storm, and entrenched themselves in the city, under strong embrasures, it is thought they will not be easily dispossessed of their stronghold.

On another unidentified occasion, possibly in 1833, he sent a lengthy account of an event to Thomas Bodley as though describing a medieval siege. "The Knight Godfrede de Bouillon, Valiant and Constant of the renowned Order of Chivalry of the Red Cross, to his Trusty and Well-beloved Cousin, the Chevalier Thomas de Bodley, honourable, just and true, sends his Greetings!"

Godfrede, as Etty called him, was Godfrey, or Godefroy, of Bouillon, c. 1060–1100, a leader of the first crusade. Although not renowned for military prowess he was known for his piety. He is regarded as having been more of a pilgrim than a soldier or politician, refusing the proffered title of king of Jerusalem and taking instead that of "advocate of the Holy Sepulchre." In later times he was idolized as a leader, a king and a legislator but was actually none of these but rather a quiet, pious knight fighting for the return of Jerusalem to the Church. In 1833 Etty began his painting *The Warrior Arming or Godfrey de Bouillon* (see page 218), which was bought by Robert Vernon for 100 guineas when exhibited at the Royal Academy in 1835. Godfrey was clearly the kind of knight that appealed to Etty's own pious nature and in this letter he associates himself with him. The letter continues and

... informs him that according to orders himself, his trusty squire at arms and seconded by the Auxiliary Forces of the Six united–Sovereigns, he marched at break of day and planted his forces in front of the Bridge and Moat of the Convent of the Garde Doloureuse—and having sounded the Charge on the Trumpets the Pursuivants sent in a challenge to surrender the besieged—it is supposed terrified by the formidable array drawn up before it—and after a short parley, agreed to surrender—claiming however to march out with honour of war, which was granted, as all true and honourable knights wish not to insult the vanquished and unfortunate. The portcullis was then drawn up, the drawbridge let down and after a flourish of trumpets heard within the Castle, the tramp of horses on the drawbridge, the nodding of the red and black plumes and the glitter and flash of armour in the first beam of the morning sun showed the besieged were fulfilling the terms of the capitulation and when all had defiled into the plain, myself, my knights at arms and the forces of the Six Allied Sovereigns passed over. The Banner of St. George and of the Holy Red Cross unfurled and floating in the wind and took full and ample possession of the Castle, Convent and Courts thereof, and planted them on its highest Tower. The Bell of the Convent was rung. The Shouts of Victory and Conquest was [sic] heard from afar. Te Deum and High Mass was [sic] sung in full choir. The Knights arranged on each side in their panoply. The effect was solemn, imposing and touching to the last degree. Largesses were given to the multitude and the sun sunk in the golden west leaving security and holy peace. Watch and Ward have been duly appointed. Men at Arms have been duly stationed and duly relieved at those Posts of Honor it is important to watch. We have been the more particular in this matter for the reason that a scout of the enemy was seen late in the evening before the conquest reconnoitering the weak points of the fortress—or perhaps "to see the nakedness of the land was he come"—however, fear him not, he and his errand are now obsolete. The proud banner of Thos de Bodley floats in the morning breeze from the highest turret of the Castle—and may it long is the wish of Trusty and Loving Cousin—Godfre de Bouillon.

What Thomas Bodley made of this rigmarole we cannot imagine. To which event it refers we do not know but if 1833 is the correct date, as is noted in pencil by an unknown hand on the original, Etty may have been recording his visit to Edinburgh when the Scottish Academy agreed to pay him the final installment they owed him for the three *Judith* paintings. He certainly seems to have been carried away by his reading of the history of Godfrey de Bouillon, envisaging his own visit to Scotland as a crusade. Sometimes Etty wrote to Thomas Bodley in a version of French which he had picked up in Paris, such as in this letter of 7th October 1843 written from Buckingham Street:

I seize a moment ere the post goes to say that I have heard you [are] coming to the "Great Babylon." I merely wish to remind you that the *Hotel de York* stands in the same place, sur le bord de Thames ou est le [sic] grandes et petites apartements, garni a [illegible] presentiment—et le meme maitre d'hotel et marliesser [?] et domestiques et le bonne vin—et d'l'leau [sic] frais abonnement pour lave, et les tableaux apres le grande maitres d'Louvre et Venise, etc., etc.,—Veni, venez donc.
Adieu Mon Ami
Guillaume de Etty

Etty was frequently inclined to humor when addressing other close friends. He would summon them to an evening gathering in this manner. One such missive was this mock theatre bill sent to Franklin, his assistant, and presumably also to his ex-pupil James Leigh and is a further example of his childlike sense of humor:

> Immense Attraction! Unbounded Overflow!
> Unprecedented Novelty!!! for the 110th Time!
> Theatre Royal, York Buildings, Adelphi!
> This Evening, Tuesday Sept 17 1833
> Their Majesties' Servants will perform the Admired Play in Two Acts
>
> *Tea and Toast*
>
> Bohia [*sic*]—Mr. Etty
> Kettle Holder and Burn Finger—Mr. Leigh
> Toast—Mr. Franklin
> After which—a Grand Italian Bravura
> SONG
> by Signor Cotterelli
> who has been engaged at an immense expense from Naples
> for this Night Only
> After which
>
> Martin's Grand Diorama of the Destruction of Jerusalem by the Jews!
> with Five Hundred and Fifty Thousand Figures!!!
> Finishing with a Shower of Fire and Brimstone
> After which
> Frankenstein
>
> The part of Frankenstein (for this night only)
> Mr. Franklin
> The Dresses, Decorations and Properties, all entirely old
> The Scenery by Messrs. Franklin, Leigh and Assistants
> The Music expressly for this occasion by Signor Kettle
>
> To conclude with the Laughable Farce of
> Turn Out
>
> N. B. All orders must positively be refused at the Doors during the
> unprecedented run of Tea and Toast

If the humor seems to us today to be childlike, if not childish, we must remember that nineteenth century families frequently amused themselves in such a manner. The invitation was clearly based on the extravagant advertisements that theatre managers published in the newspapers and also posted on walls in the vicinity of their theaters. Whether Betsy or any of the servants also attended is not known but it is unlikely. The reference to "Martin's diorama" is, of course, to John Martin and his apocalyptic paintings and also to the kind of scenery often used in theatrical spectacles. Many scene painters became well-known artists—Clarkson Stanfield was one—and frequently they painted large dioramas that stretched right round the stage and sometimes were unrolled from one side to the other to suggest movement through countryside. Etty was humorously suggesting suitable uses for Martin's grand productions.

Panoramas had been in use as exhibition pieces since 1788, in Edinburgh, and 1792, in London. The huge expanse of canvas set up in semi-darkness in which spectators were placed with only the canvas illuminated produced the effect of real scenes being witnessed. Perspective and distance of depicted objects were cunningly distorted and it was on this and the concentrated lighting that the illusion of reality depended. Panoramas were soon very popular and in 1793 the most elaborate was erected in London. Hitherto the canvas had been a half or three-quarter circle but in that year Robert Barker constructed a special building in Leicester Square with two rooms for displaying canvasses that totally surrounded the walls. The larger room was

ninety feet in diameter and forty feet high and viewers stood in the center able to see through 360 degrees. Other exhibitors used large canvasses on rollers so that immense scenes could be unwound before viewers. Needless to say, battle scenes were very popular, the famous being the *Battle of Trafalgar, The Bombardment of Algiers* and *The Defeat of the Turks by the Greeks.* In 1822 a new development, the diorama, was first shown in Paris and reached London the following year. Dioramas offered changes in scenery by the use of layers of painted gauze, scenery methods often used in harlequinades and pantomimes, and were very popular for displaying scenery with different lighting effects. Dioramas required specialized buildings for controlling the lighting and, as different scenes were presented in succession, the spectators sat on benches which were winched round so that the different scenes could be viewed in turn. Buildings were costly and the dioramas themselves took a long time to paint—the patent holders, Daguerre and Boulton, painted only one a year so a continuous attendance of spectators was necessary. Nevertheless several were constructed in English provincial towns and also in Edinburgh and Dublin. The technical difficulties and costs of producing dioramas meant that panoramas were more widespread and well-known. Etty's reference to Martin's "diorama" is clearly a mistake, his canvasses, though large, would have been regarded as panoramas. It is worth mentioning that on the 21st March 1829, the *York Herald* advertised the exhibition made by Mr. T. Powell, a painter on glass in Coney Street, of a diorama with six views ("the greatest number ever exhibited together in this Kingdom") painted by "Mr. Cocks of Vauxhall Gardens." Two painters are recorded here and their relationship to the work is unknown. However, the exhibition ran for some weeks twice a day with "a select band in attendance." It must be remarked, regretfully, that while such exhibitions appealed to the citizens of York, art collections did not.

Critical appreciations

When the young William Makepeace Thackeray was writing his art criticisms for *Fraser's Magazine* in the late 1830s, he made the following comment: "Look for a while at Mr. Etty's pictures and away you rush, your "eyes on fire," drunken with the luscious colours that are poured out for you on the liberal canvas, and warm with the sight of the beautiful sirens what appear on it."

Thackeray was not always approving of Etty's work. In June 1839 he objected that "A great, large curtain of fig-leaves should be hung over every one of this artist's pictures, and the world should pass on, content to know that there are some glorious colours painted underneath."

Thackeray admired Etty's skill but not always his subjects. He was a strenuous supporter of contemporary art and artists and vehement in his condemnation of the treatment that the public, and even royalty, often meted out to them, as we shall later consider.

Large allegorical paintings were becoming less easy to sell, so though Etty continued to paint his nude figures he more frequently ignored mythological subjects. He began to title his paintings as nymphs or fauns or satyrs without a specified subject. Even as early as 1834 his *Hylas and the Water Nymphs* (see page 101) had been conceived as a bathing group. It also owed much to Correggio and sold without difficulty for 160 guineas. There were also numerous works which did not require knowledge of the mythologies to which the titles referred. *Sabrina*, which he painted twice, in 1831 and again in 1841 (see next page), is one such. Neither *Venus* nor *The Three Graces* required expert knowledge for a client to appreciate the forms presented. *Wood Nymphs Sleeping* of 1835 was no more than a device for depicting recumbent models, certainly a common enough subject for Renaissance Italians, but it was not well received. *The Literary Gazette*[8] declared it to be unfit for public exhibition. The objections seems solely to have been that a nude male, back view only, was present in the same painting as two females. Etty seems to have been so affected by the hostile criticism in this case that he sold it for £55 to the dealer Richard Colls who later sold it for £500, which indicates at least one admirer, which is all an artist needs for each work he produces.

Sabrina and Her Nymphs (24 × 30 ins) (1841 version of 1831 painting, present location of earlier painting unknown). Leicester City Museum Service/Bridgeman Art Library, London, LCM139825/85.

Etty's most successful single nude figure in his later years was *Musidora* (see color plate 13) exhibited in 1843 at the Royal Academy. There are at least four versions though one at least may be a later copy. The subject comes from James Thomson's *The Seasons: Summer* in which is described how Musidora is surprised by Damon while bathing in a stream. It is possible that Etty knew of Gainsborough's painting of the same subject when Robert Vernon owned it. It had, for some, the drawback that it depicted a naked girl being spied upon, though the figure of Damon is not shown, but since every picture of a nude necessarily suggested a spectator who was usually the viewer himself, this did not reduce its general appeal. The principal version was bought by George Knott for 70 guineas and sold two years later for 225 guineas and again in 1853 for 345 guineas, further evidence that Etty was consistently underpaid for his work. The painting is also known by an alternative title, "The Bather: 'At the Doubtful Breeze Alarmed.'" This comes from the lines from Thomson's poem that inspired the painting.

> But desperate youth,
> How durst thou risk the soul distracting view; ...
> With fancy blushing, at the doubtful breeze
> Alarmed, and starting like the fearful fawn.

From 1825 onwards Etty painted many single nude figures, both male and female, frequently as studies. Some were purchased soon after execution, others had to wait until they were discovered after his death. These works are often regarded as superior to his more formal compositions.

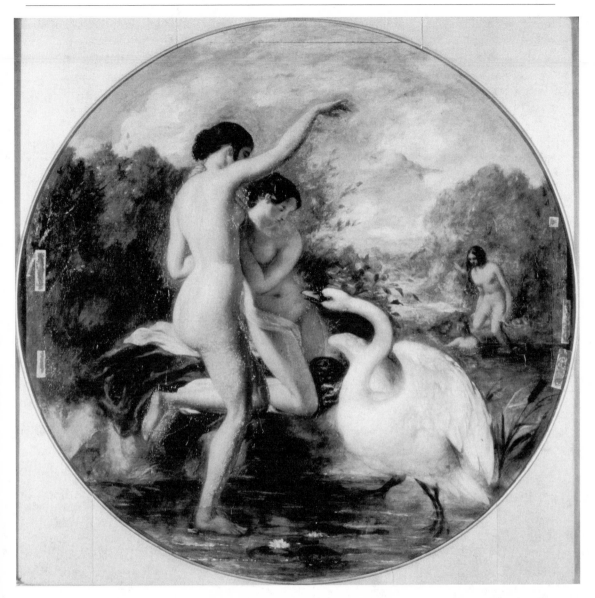

Bathers Surprised by a Swan (38.825 × 38.5 ins) (1841), Tate, London 2005.

Many of Etty's new patrons had not received the classical education of their predecessors. Many would not have been familiar with such mythological figures as Andromeda and Pandora and would not have been able to interpret allegories in strictly conventional terms. Also many would not have known who Musidora was but they could appreciate the aesthetics, or other qualities, in the vision of a beautiful young woman bathing naked in a forest pool. Later Gustave Courbet was to satirize such scenes and not be well received for doing so. For the moment many in England continued to find the idealized nude an acceptable subject.

There has always been in the last two or three centuries a minority who have strongly objected to the depiction of the female nude, complaining that such paintings (and, later, photographs) pander to a depraved masculine taste. Their complaint appears to require that men should never admire the physical attributes of women but as this runs counter to natural psychology, and to the needs of biology, we can but assume that the complaint arises from some deficiency in the

complainants themselves. Certainly Etty had his due share of objectors but that he could number women among his admirers is confirmed by a letter, also in York Reference Library, from Mrs. Elizabeth Davies of St. Leonard's Place, York. As late as the 23rd June 1845 she referred to

> ... your charming little Psyche with her attendant Cupids—so completely are they impressed on my mind that they have occupied my waking & sleeping dreams, and I have obtained my Husband's permission to tell you how much I should like to possess either *that Gem* or one nearly resembling it.

Learning that she could not obtain the picture of Pysche she agreed that Etty should paint another subject but she continued to praise her original choice. Since Etty painted *Psyche and Cupid* in more than one version, as adult figures and as children, it may be that Mrs. Davies was referring to the latter.

Sometimes objections were raised by members of the public on the grounds that Etty had not done justice to his subjects. Two such complaints dated some seven years apart, in letters which Etty retained and which are now in the York Reference Library, make this very clear. In each case the writer is unknown. The first letter dated London, Friday Evening, July 29th 1830 but not signed, is stringent in its criticism.

> The writer of this Note presents his complts. to Mr. Etty, of whom some years since he bought one of his Works. Another he has since possessed by bequest. He came to Town this year with the full intention of buying a third at the Somerset House Exhibition; never giving Commissions thinking Artists do not succeed so well with them. But really the three Works by Mr. Etty are much too slight in subject, *and* he must also beg leave to add too slight in execution, too, for him to buy one of them. He must consequently postpone until some future period his full intention of possessing a third Work of Mr. Etty. The Writer of this Note hopes he will be excused for observing that such slight Works are not exactly expected from an Artist of Mr. Etty's high standing; which if he continues to paint, he must content himself to rest satisfied with a lower class of patrons, a smaller amount of price, and an inferior degree of reputation.

Andromeda and Perseus (30 × 24 ins) (c. 1840). Manchester Art Gallery/Bridgeman Art Library, MAN-62943/100.

This letter confirms the high regard in which Etty was held by serious collectors. Although the second letter is undated it is possible to deduce that it was written just after July 1837 since it alludes to the first occasion when the Academy Summer Exhibition was held in Trafalgar Square (the building now housing the National Gallery), it having been previously held in Somerset House.

> Sir, An hereditary and almost permanent Gout has for many years prevented my visiting the Exhibition of the Royal Academy but last year and this year milder attacks of my old companion have permitted my seeing the Exhibitions which I more rejoice in as last year was the last Exhibition at Somerset House and this year was the first Exhibition in Trafalgar Square.

I should say that I have been, until my health prevented me, a Collector of Modern as well as of Antient [sic] Pictures, am myself an Amateur Artist and fondly attached to the Fine Arts. Your works in the last two Exhibitions, for until then I have not seen your productions for several years, are the motives which induce me to offer you a few remarks, with the best of intentions. Allow me to say that I was never more struck than with the very different merit of your several works. *The Sirens and Ulysses*, and *Samson*, and *Psyche and Venus*, were excellent and quite worthy of your standing in the Academy and your reputation with the Public. They were works of which none of the Antient [sic] Masters need to have been unwilling to have been the Painter. While on the other hand *Doves and Venus; Man, Woman and Child of the Woods* (a sort of Irish Huddle) and *Mars and Venus* (the best of these three) were platitudes quite unworthy of an Artist who could paint a production like the *Sirens and Ulysses*. *Sirens, Samson* and *Psyche* would procure any artist a name while *Doves and Venus* and *Mars and Venus* and the Irish *Man, Woman and Child* would go far to take away the reputation of an Artist who had previously acquired any.

I never saw any six works by the same Artist which were so contradictory as criterions of his power. May I press you to avoid such works as the latter three I have named. Great Painters should be engaged on great works. I do not mean so much size as subject. It is so in all professions. See the Poets. Would Homer, Virgil, Milton and the rest ever have enjoyed their fame had they employed themselves upon platitudes? Depend on it, to be great, great opportunities are necessary—the matter must be great, platitudes will not do.

The writers of these letters had noticed a recurring weakness in Etty, which he had obviously not corrected during the seven years between the letters. He was producing too much work for it all to be of a uniformly high standard. Anxious to sustain his position as an artist of consequence he submitted as many works as the Exhibition rules allowed and did not subject his paintings to rigorous critical examination to ensure that weaker works were not submitted. The reader can make some judgments for himself from the examples illustrated here. *Man, Woman and Child of the Woods*, one of the subjects of the first letter, later to be known as *A Family of the Forest* (see page 220), has been discussed in a previous chapter. By referring to it "as an Irish huddle" the writer reveals that he has not understood the purport of the painting and that he is ignorant of the Irish people. However, it is true that it is poorly composed, failing to rise above a studio composition. The female figure is far larger than her male companion and the whole is obviously compiled from separately posed figures.

Mars and Venus also suffers from being composed from separately posed models. The figures do not relate to each other. The model for Mars has clearly been a soldier earning some extra money. He stands dutifully on guard while Venus, who was one of Etty's usual models, exhibits a sinuous voluptuousness intended to be seductive, since Venus was attempting to persuade Mars to stay with her, but as the models were separately posed the painting is divided into two unrelated figures. Venus also suffers from a condition upon which many critics remarked. The unnatural narrowness of her waist is due, it was commonly alleged, to women's bodies' being constrained by corsets. Whether or not the body retained its constricted condition when corsets were removed, Etty was reproducing the pinched waist required by fashion. Because of the emphasis on the pinched waist, Venus and many other females in Etty's paintings, have broad hips and therefore large buttocks which encouraged the criticism that Etty was obsessed with "breasts and bums." Furthermore the hands and feet of his female figures are often too small, attracting the objection that he was interested in the figure only from the neck to the knees.

It was more usual for Etty to be criticized for painting female figures that were excessively naked. Discreet indications of the body were acceptable but not total nudity. It is typical of Victorian prudery that while a nude female figure only slightly obscured by transparent drapery would often be regarded as acceptable, the absence of such inadequate covering rendered the subject indecent. In May 1835, John Rocke of Ludlow, one of many minor gentry in the provinces who occasionally bought paintings to adorn their houses, felt obliged to refuse the picture that Etty delivered to him.

Having a wife and *nine* children, and three of my daughters grown up, I really think, that I could not exhibit the nymphs and faun to their continued gaze without feeling sundry misgivings, as to whether I

was doing right, by exposing his fine picture (for that is the least that I can say of it) continually to their view; and at the same time whether I should be justified under the circumstances, in expending quite so much money on such an occasion. Believe me, it causes some pain on my part to write this much, but it is very like the truth. I hope, however, one of these days, to be able to obtain from you a finished little picture of a smaller size than the one in question; that shall possess *beautiful nudity* to a certain extent combined with somewhat less of Amazonian boldness than the present nymph. One of Owen's elegant female figures, with *bare shoulder,* and one side (at all events) of a beautiful bosom, *fairly exposed* (as this is the point in which your masterly hand is unequalled) with drapery from then to the middle of the thigh and a little elegant and appropriate foreground, I certainly could put up in my Drawing Room, in the best light without causing any squeamish sensations in anyone; either a recumbent beauty, or otherwise, just as you might judge proper. If you should feel any inclination to supply me with such an elegant little subject, and I should value it all my days; and twenty five sovereigns, I should be most happy to provide for such an occasion. Depend on it, the price with me would always be a secret. I have merely presumed to throw out this hint, if at any time you might have leisure and inclination for such an occasion; but this, of course, I must leave entirely to your decision. I am quite sure that Owen well be always delighted with the beautiful Picture he has obtained from you; and well indeed he may for it is to my mind, one of the most exquisite works of modern art, that it has ever fallen to my lot to admire.

The "Owen" referred to was the Reverend Edward Pryce Owen who lived in Wellington, Shropshire, and was an occasional purchaser of Etty's paintings. His opinions of Etty's subjects appear to have been less "squeamish." It was he who bought *Venus and Her Satellites* for "just under 300 guineas" in 1835 and which may be the painting to which Rocke refers. Owen also wanted to buy *Samson and Delilah* in 1837 but his offer of one hundred pounds was insufficient. Etty subsequently sold it to Daniel Grant, together with *Sirens and Ulysses,* for two hundred and fifty pounds the pair, clearly an inadequate sum.

Criticisms by contemporary artists and critics tended to be directed against Etty's inability to present the female body as an idealized nude. Faces were not sufficiently neutral, reminding viewers of the faces of women seen in the street. Yet, if not idealized, his faces were stylized and it must be said that all his figures, the female ones especially, exhibit hardly any variety. One would have thought that this might have satisfied his critics that he was not depicting true to life individuals. The general feeling was that his figures were often too seductive and therefore presented not abstractions of female beauty but the attractions of carnal pleasure. This has always been a problem confronting the painters of unclothed figures and has become known as the distinction between the naked and the nude. The first artist to deal seriously with this subject was Walter Sickert in an article in *The New Age* of 21st July 1910, though it had been recognized, but not closely examined, much earlier. Sickert wrote that "the nude was the naked clothed in Art" and this is the distinction that most critics made though they did not state it so succinctly. Writers in Etty's day usually expressed discomfiture that he failed to present his figures sufficiently detached from common experience. It was not only that the faces of his figures seemed almost familiar, though often similar, but their bodies were too much like real flesh and not either ethereal or sculptural. They were far too real. There was an unspoken acceptance of a convention that idealized goddesses did not exhibit sexual attractions but realistic nudes did and it was this association that made such paintings unacceptable. It was already a complaint made against French painting that the nudes were too "real" and seductive, but this was what the new generation of French artists intended. It could not be accepted in Victorian England. As early as 1822 when he exhibited *Cleopatra's Arrival in Cilicia,* the critic of *The Times*[9] advised him "not to be seduced into a style which can gratify only the most vicious taste." The critic went on to condemn the painting: "Mr. Etty's canvass is mere dirty flesh." *The Times* was to be Etty's most disapproving critic. When in 1828 Etty exhibited *The Dawn of Love* the critic of *The Times* wrote[10]:

The drawing is free and flowing; the line of beauty is admirably observed throughout; and the colour, though rich, is perfectly natural. The subject is, however, handled in a way entirely too luscious (we might, with great propriety, use a harsher term) for the public eye.

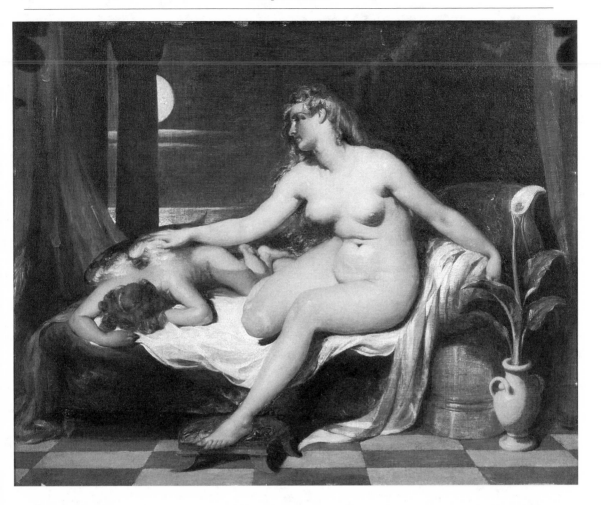

The Dawn of Love (20 × 24 ins) (1825), **Russell-Cotes Art Gallery (Bournemouth/Bridgeman Art Library), RUS68480/78.**

Indeed it was much too suggestive of a night of pleasure for any Victorian father to allow his wife and daughters to see. It was a subject so untypical of Etty that one finds difficulty in understanding why he painted it. Whatever might be thought of the inevitable appeal of feminine nudity, Etty never painted a subject so obviously expressing physical love. Perhaps he was intending to express the unity of the spiritual and the physical but it was not a usual theme for him. Nevertheless, the subject had an honorable heritage. Titian and Veronesa had painted similar subjects—Venus and Adonis, Venus and Mars, Cupid and Psyche—but Etty had failed to make his figures mythological. *Venus and Her Satellites* (or *The Toilet of Venus*), also of 1835, was strongly criticized. *The Times* critic berated Etty[11]: "This painter has fallen into an egregious error. He mistakes the use of nudity in painting and presents in the most gross and literal manner the unhappy models of the Royal Academy...."

Why the critic should imagine the models were unhappy in their required poses is a mystery. Models were quite accustomed to assuming any pose of an "artistic" nature and there is certainly nothing in this painting to suggest that they had been required to pose indelicately. *The Times* critic sought to increase his own importance and to reduce Etty's by referring to him as "this painter" as though he were unknown. *The Observer* was even more trenchant. "A brothel on fire, which had driven all the Paphian nymphs from their beds into the courtyard would be a modest exhibition compared to him [sic], for they would at least exhibit *en chemise*."

He went on to complain that several ladies were deterred from visiting the corner of the room where the painting was exhibited and so missed seeing paintings exhibited by other artists. Nonetheless the Reverend Owens was quite ready to buy it. Etty became accustomed to criticisms directed toward the eroticism of his paintings and began no longer to be concerned by them. When, in 1835 he exhibited *Pluto Carrying Off Proserpine*, he was subjected to objections by some of his fellow artists on varnishing days that his figures were too nude. In his notebook he jotted down for April 25th: "To Royal Academy to meet the ideas of the Noodles." Then on May 1st: "The Noodles at me again. Begin to put in white and gold draperies." Then he had a change of mind. For May 2nd he noted: "Last day of varnishing. Took off the thick paint and restored the transparencies."[12] At some time they were restored, perhaps by someone else, to satisfy a later purchaser. It has long been held by many women that they are themselves embarrassed by pictures of naked women, especially if they see them in the company of men, since they claim that men are thereby assisted in imagining them naked. This must now be less an objection than in former times. As the nineteenth century wore on more women, usually the younger generation, were ready to accept the nude as an art form and women art students campaigned vigorously for the right to study the nude figure from life. The nude has never been an easy subject for the English to accept, so strong do the influences of evangelicals remain. For some inexplicable reason many of those who believe that God made man and woman also believe that what He made was indecent. Etty was equally bemused by the objections leveled against him since no such objections were directed against the nudes of the Old Masters. Mostly, of course, these figures were so idealized that viewers could claim higher aesthetic responses. It was left to Manet to demonstrate with his *Olympia* that Titian's so-called *Venus of Urbino* was very much a real person, a Venetian courtesan preparing herself for a client. While Rubens and Jordaens remained unacceptable, few felt able to condemn the Italians.

Painting the Lady Mayoress

Probably of all the portraits that Etty painted of York's notable citizens none was so important as that of the Lady Mayoress. Gilchrist[13] regarded it as a near disaster because of its hostile reception by the local press but this was most probably due to the lady's unpopularity. Elizabeth Nicholson had met her husband while she had been a shop assistant in York. She was poorly educated and did not know how to adapt herself to the social classes she entered as her husband "rose in the world." She certainly lacked social graces and as her husband gained higher and higher status, also from shop assistant, then to partner, City Councilor, Lord Mayor, Member of Parliament and eventually the famous "Railway King" of British commerce, she was increasingly out of her depth. We can only feel sorry for her. She was caught up unwittingly in her husband's devices and she dutifully supported him as best she could but she was the constant butt of unkind jibes and cruel humor. Whatever the local press decided about her portrait the correspondence that passed between Etty and the Lady Mayoress makes quite clear that both were satisfied and for the Lady Mayoress herself having her portrait painted was one of the most important events in her life. It is easy to see why she thought this. Elizabeth Nicholson had been the child of a poor family, inadequately educated, if at all, and without any preparation for her later position in society. She was the sister of Richard Nicholson who owned a draper's shop in what is now College Green, York, near the east end of the Minster. On the 17th July 1821 she married George Hudson who had recently been made her brother's partner. In the Parish Register Hudson had himself described as "silk mercer" thereby already displaying the ambition which was to bring him to great heights and then down again.

The story of George Hudson is well known in Great Britain; though it is probably not so familiar elsewhere, it will not be recounted here. Stated briefly, he was a typical entrepreneur of the time. He early saw the advantages of the railways and the opportunities for making a for-

tune. From the outset he was determined to progress in the world, a noble ambition well in accordance with Victorian principles and those of the eminent Samuel Smiles. Unfortunately like many other ambitious men he lacked the moral integrity necessary to number him among the great men in history. Hudson believed, like so many who have risen fast in the world to positions of power beyond their original hopes, that commercial success required the granting and receiving of favors or, as we would today say, bribery. It is most likely that he did not believe that he was acting unethically, certainly not fraudulently, but merely in accordance with commercial custom. In his later defense he claimed that he had broken no law, and this was true, but he should have known that the frenzied speculation of 1720, known as "The South Sea Bubble," had brought financial disaster for many and imprisonment for some. Although conceived to pursue a different course of speculation, the "Railway Mania" was none the less highly speculative, dishonest and inevitably destined to fail. Those who succumbed to Hudson's false promises were inspired by greed and lacked any sense of social responsibility but this was becoming so endemic in English society that Charles Dickens frequently introduced into his works characters suffering from this moral defect.

In 1827 Hudson inherited a small fortune from an uncle and with this began to climb the social ladder. He assumed a number of local positions, for example membership of the York Board of Health, and became prominent in the York Tory party, soon becoming its Treasurer and the director of a spinning and weaving company, though this soon failed. He then began his main career as the leading force in railway investment promising exceptional dividends to shareholders. The Hudsons now entered the higher ranks of London society and it was here that poor Elizabeth encountered the heartless snobbery that was to make her life so unhappy. George Hudson himself was treated with secret contempt by his fellows but as he came bearing gifts his vulgarity and ill-temper were tolerated. Most entrepreneurs rising in society endeavored to acquire the "polish" of their new class but the Hudsons were unable to do so. Hudson rose quickly in local politics and in 1837 was elected Lord Mayor of York. He was already Chairman of the York and North Midland Railway so the way was clear for him to bring the railway to a terminus inside the City walls. Hudson now began to set his mark on York with lavish civic entertainments. His profligacy—with other people's money—was reported to Etty by Cicely Bulmer, George Bulmer's daughter, in a letter from York dated 9th April 1838.

> York is generally dull after the Assizes and were it not for our gay Lady Mayoress who gives Parties and Balls without end, the folks would be suffered to go on in their usual quiet way which perhaps would be more to their real comfort than collecting in heated rooms to *play cards* or mix in the mazy [?] dance. I just fancy how glad you would be to make your escape and steal out of such a situation to breath the fresh air.

It was, of course, her husband who was requiring the Lady Mayoress to arrange so many entertainments and we may well assume it was often at public expense. There is, incidentally, an interesting example in this letter of the etiquette practiced at the time. Although Etty and her parents were close friends and she knew him very well, Cicely Bulmer addressed Etty as "Dear Sir."

Etty had little ability in money matters and seems to have been genuinely unconcerned to make a personal fortune, so he was fortunately not afflicted by the obsession to get rich quick which dominated so many of his contemporaries. He always disliked railways and deplored the "railway mania" that was sweeping the country. He knew nothing of the tricks that were being employed to persuade people to invest in what were often non-existent shares. Hudson's principal method was to keep issuing shares and out of the proceeds to pay high dividends on previously issued shares without actually investing the new shares. To succeed, this system required the constant issue of ever more shares, just as chain letters require a constant and increasing supply of participants This was doomed to lead to ultimate collapse if only because there was not an unending supply of investors. Hudson subsequently claimed that this was not illegal. It

was true that at the time there was no law forbidding the practice simply because there had been no reason hitherto to condemn it. It was nonetheless fraudulent and unethical and was, as a result of Hudson's operations, made illegal. Whether Etty met Hudson early in the latter's career is uncertain but he did meet him socially on at least one later occasion and was won over by his apparent bluff honesty, which ensnared many others. It must be admitted that Etty liked meeting famous men though he did not go out of his way to do so. The occasion of meeting Hudson may have arisen from the commission to paint the Lady Mayoress' portrait which, he probably hoped, would lead to further commissions in York.

So Elizabeth Hudson had her portrait painted and it was duly exhibited. The public and the critics poured ridicule upon it, ridicule directed both at Mrs. Hudson and Etty himself. They objected to the complexion he had given her and also to her dress—"A devil incarnate, with such a cap!" was one explosive comment. Mrs. Hudson was renowned for lacking dress sense, being inclined to over-do the accessories. It seems that opportunity was being taken to chastise the hapless lady for "getting above herself" rather than to belittle Etty. English society was heartless. The higher classes vigorously protected themselves against invasion but would accept a gifted person from the "lower ranks" provided they always remembered their "station." The classes from which social aspirants rose were bitterly envious of anyone who succeeded and condemned them for "getting above themselves" and, worst of all, "forgetting their origins," that is to say, their old friends. The socially ambitious had a difficult time and their rise was seldom fully accepted for at least two further generations. Poor Elizabeth Nicholson was never going to be allowed to forget her humble origins. That she was always ill at ease in the life that her husband imposed on her can be seen from a remark she made when he finally fell. "The happiest part of my life was when I stood behind the counter and used the yard measure in my own shop."[14]

Mrs. Hudson treasured Etty's portrait. She regarded it as establishing her as a person of consequence and a fit wife for so famous a man as George Hudson. One had to be "someone" to have had one's portrait painted. In a letter (undated except for "Monkgate Oct. 11th" but very probably 1839) she acknowledged its safe receipt, apparently on its return from exhibition which was a usual first requirement for any painting by an Academician. Her effusive words are worth quoting in full:

> Many thanks my Dear Sir for your obliging note which I received on the 9th Inst. and the case arrived on the morning of the same date, consequently it could not be unpacked till this morning & I hasten to say its enclosure is in beautiful condition—but I feel quite at a loss how to express my grateful acknowledgment, in the first instance as relates to your own splendid production—which I shall ever highly prize on your account, & I assure you my Dear Children will exceedingly esteem. Your valuable painting I trust at an after date it may serve to remind them of their affectionate Parent. The frame is splendid and adds to my previous deep obligation—Therefore pray once more accept my most grateful thanks for your friendly, splendid, elegant & delicate attentions—
> With kind regards to your Niece—
> Ever believe me, my Dear Sir,
> Yours very truly,
> E. Hudson.
> P.S. At your convenience pray let me know whether the case is to be returned to your address or the frame maker.

A week later, on October 18th, Mrs. Hudson again wrote to Etty from the Mansion House, this time in the third person and in some obvious embarrassment.

> The Lady Mayoress presents her compliments to Mr. Etty and in reply to his Noble Note she is induced to acknowledge that accidentally last [illegible] she happened to reflect upon the events of the day and it occurred to her that whenever she described the formidable appearance her Picture formed she was certain her worthy spouse would immediately remind her of their increased expenditure this year consequently they make a [illegible] of curtailing every unnecessary self-indulgence until they retire into private life. Therefore the [illegible] Mr. Etty will kindly forgive the Lady Mayoress for [illegible] my to allude to

this affair. She intends to leave the Mansion House a little after 11 o'clock this Mon [?*Monday*]—should that time suit Mr. Etty.

(The bearer will await his reply)

It can only be deduced from this letter that Mrs. Hudson was preparing Etty for her husband's decision to delay payment for the portrait. It may seem strange that the Hudsons should have been concerned about their expenditure on such items as personal portraits since George Hudson was already preparing the ground for his intended position in London society. Apparently Mrs. Hudson quickly regretted suggesting that the Hudsons were needing to watch their spending since the very next day she sent Etty a further note, this time couched in personal terms, apparently in response to a letter received from Etty but which has not been preserved.

My Dear Sir,

I am sorry my application should serve to annoy you however I trust you will kindly forgive me. I should not have to approach you on this painful subject but as Mr. Archer proposed he should undertake to suggest these matters for your consideration I [*illegible*] slipped into this unhappy position. However I trust you will forgive my unintended folly and as my Brother is coming here next Saturday he will take charge of both my Portraits for you.

Much obliged E. Hudson

It is unclear from this letter exactly what the problem was that faced Mrs. Hudson. If it referred to the preceding letter we may conclude that there was some difficulty over payment. Mrs. Hudson was obviously following the demands of contemporary good taste that such matters should not be directly discussed but merely alluded to as vaguely as possible, with reliance upon Etty to behave in similar manner so that embarrassment would be avoided. Negotiations through a third party—her brother—would ensure that this would be so. What is of interest is Mrs. Hudson's reference to "both my Portraits." This is the only record known to the author that Etty possibly painted the Lady Mayoress twice.

Etty's painting methods

Everyone who has a serious interest in the art of painting recognizes that Etty's technique was superior to that of most of his contemporaries. The comment made that if one could cut the flesh of his figures they would bleed suggests in itself a considerable ability to represent the human form. We know that it took him years of study and hard work to achieve this technique. Even those who disapproved of his subjects felt obliged to praise his abilities. At the beginning of his career he had to accept the criticism that his paintings were black and colorless, the result of his desire to paint heavy shadows in the style of the Old Masters, or at least as the Old Masters had survived with their layers of dirt and yellowing varnish. His initial concern was with form. Being criticized by Lawrence for his weak drawing he had to practice draughtsmanship to the exclusion of color. As he set down in his early notebooks for his own instruction, "Let your principal attention be to the Form; for without *that*, the best Colouring is but chaos." This was Etty's problem when considering Turner's paintings. Although declaring that Turner had "done some of the finest things in the world, ... when he abandons Nature, I must abandon him," adding that some of Turner's late works were "fiery abominations."[15] On the matter of color, he noted, also in a notebook,[16]

Paint with one colour at a time, in Flesh, or at the most with two;—twill give cleanness and clearness of tint. And let each layer of Colour be seen through. Or, in other words, manage it so, by *scumbling*, that the tints underneath appear. It will give depth, and a fleshiness of effect, impossible to get by *solid* colour.

Other instructions he noted for himself. "Keep yellow out of the head and extremities: at least, till last. ... Effect is produced by *opposition* of light and shade, warm and cold colour."

In preparing to paint a subject Etty drew out the main lines in charcoal. Although he wrote in his notebook, "*Drawing* is the soul of art" he was merely repeating the instructions of the Life Class. He did not advise drawing the subject in detail. It is known that he was not proficient in doing this, being far better equipped to do everything with the brush. But he dutifully recorded what he had learned. "When drawing from the Life, avoid that slovenly and unartist-like method, of scrawling over your paper or canvas with a variety of confused and unmeaning lines."

This is astonishing coming from Etty for, as can be seen from almost all his drawings, this is just what he so frequently resorted to. He probably drew some comfort from the well known comments by artists that Titian also could not draw. It was expected at the time that all artists should be able to produce classical style drawings such as were taught in the Academy Schools. Etty's draughtsmanship may be more readily related to that of Delacroix. Both usually prepared their compositions with a network of lines that seem to have been put down at random until a form revealed itself. This system of "found" lines is no longer uncommon and the author has experience of its actually being taught. The many sheets of simple line drawings in the York Art Gallery are mere outlines of limbs and torsos in which Etty is trying to acquire the classical technique of Flaxman, but unsuccessfully. When put to it he could produce quite acceptable drawings but most of these appear to have originated in the Academy Life Class. Gaunt and Roe record[17] that Etty gave the following advice when painting from life:

> In sketching your Figure, mark in your distance from part to part as you proceed, by a dot; and then, strike the line true and beautiful at once,—if possible; if not, with as few lines as you can. ...
>
> When you have got the outline true, beautiful and faultless, then put it in with Oil-colour, dark, and sometimes with a little yellow-ochre and lake. This is generally enough for one sitting....
>
> At the *next*, set your palette with black and white, a little red (Indian as good as any). Mix up your tints: a little black and red for the shadows,—keeping them in the first colour warmer than you see them, for scumbling over. The next tint is a union of the three colours, making a sort of iron-grey; which must melt tenderly, at the edges only, into the adjoining tints. The next gradation is black and white; the next, lighter still, until you come to the Local colour (a little red and white), and next that, the high light....

There may seem to us today to be too much use of black but we are accustomed to the high tones introduced by the Impressionists. Contemporary taste required richness of color and deep shadows and a general tone of importance in a painting. Etty followed the painting customs of the time of painting the general form as a preliminary sketch. He was always tempted to emulate the Italian Old Masters by introducing dark shadows, often with disastrous results. Holman Hunt, recording Etty's methods as taught to him as a Life Class student,[18] gave as his opinion that

> His choice of paints was not beneficial as an example to the young, for while at first he seemed to have brought certain vivid pigments for the background only, they all came gradually into the vortex of his sweeping hand, and before he had painted half an hour, emerald green and Prussian blue appeared to be made to do service in flesh. He was intoxicated with the delight of painting, and when, after a careful reloading of his brush, he drove the tool upwards in frequent bouts before his half-closed eyes, I don't think that, had he been asked suddenly, he could have told his name.

These remarks are particularly revealing because they suggest a very advanced use of color—such as one finds with Delacroix for example. Etty appears to have painted with the intensity of a Romantic, not the precision of a Classicist though, as Farr suggests,[19] "Etty could never shake himself quite free from an outmoded classicism." Farr was undoubtedly correct to suggest that the meeting between Delacroix and Etty was more productive than has been imagined. It is regrettable that Etty did not record the exchanges between these two artists when they met, apparently several times, in the summer of 1825. But Etty was largely unimpressed by French painting except for that by Regnault and Guérin, and although invited by Delacroix to call on him when he was next in Paris, he did not do so. Further meetings might have been beneficial. Nonetheless some English critics at the time compared Etty very favorably with his French con-

temporaries in his use of color. An anonymous critic, signing himself merely "D.D.," writing in *The Times* of 5th April 1838 and reviewing an exhibition in the Louvre, made the somewhat surprising remark that "If the reader can fancy Etty and Watteau mixed together, he may have some idea of this delightful artist." The artist referred to was Camille-Joseph-Étienne Roqueplan, pupil of Barron Gros and a landscape and genre painter, not comparable to Etty in subject matter but, in the critic's view, his equal in the use of color. "D.D." went on to say that Roqueplan's "luscious colour" was to be found in "some of the glorious sketches of Mr. Etty."

We also know that on his visit to Paris in 1823 and subsequently to Belgium he carefully studied Rubens' technique of laying down colors side by side instead of premixing them on the palette. This method he found produced a more brilliant effect, something which the later French Impressionists were to discover, though Etty did not separate the different pigments on the canvas. Though initially laid down separately they were brushed in and so it is not always apparent that this is the technique he has used. To this extent Etty was willing to experiment.

Etty made constant notes of his painting methods as instructions for his own practice. This habit was partly due to the fact that he never ceased to think about his work. When he was not painting he was thinking about painting. Even his reading was directed towards finding subjects for painting. But, as Gaunt and Roe noted,[20]

> Etty's method ... did not depart in any important particular from classic canons. Etty was not an experimentalist or one who arrived intellectually at first principles within those magnificent and enigmatic words—Form, Proportion. His doctrine was one of simple faith and hard work.

He was temperamentally far from Delacroix and perhaps he realized that fact when they met. It is profitless to discuss the two as sharing either ideas or methods. Etty might have moved closer had the two continued to meet, for it is most unlikely that Delacroix would have changed. However, it must be constantly emphasized that Etty was temperamentally averse to change. He believed in the familiar and the traditional. It might be true to complain that he was unadventurous, even timid, and certainly this is so. But for him any change was dangerous. He constantly looked back to the Reformation and sometimes to the Commonwealth and to the havoc wrought by those events.

In the matter of painting, Etty had developed his familiar palette and he stayed with it, with only a few changes, and again often disastrous ones, in his later years. He believed in constant practice of accepted principles. "A few colours; Naples yellow, light red, Indian red, a little vermilion, lake, Terre verte,—or blue,—raw umber, burnt ditto, and black; are about enough," he recorded in a notebook. "The application, practice must give you." When it came to preparing pigments, which artists still had to do themselves, the invention of ready prepared paints in tubes being some way off, he noted:

> As to the vehicle to paint with: a little sugar of lead, finely ground, about the size of a bean, rubbed up with your palette knife; in a teaspoonful of mastic varnish. Add to this, two teaspoonfuls of cold drawn linseed oil. Mix them well together. If you like, add a little spirits of turpentine, as much or as little as you please. And with a large brush rub over the canvas or picture you have to paint on. ... This is a vehicle that will keep the flesh tints pure.

Dennis Farr quoted Charles Eastlake[21] in his *Sixth Discourse to the Royal Academy*, 10th December 1863, when he compared Etty with Reynolds, who would lend students one of his own studies to copy,

> a head painted only in white, black and red: the shadows being of course lighter than were ultimately to be, in order that the final glazings might be duly transparent. ... Many of you may remember that Mr. Etty in his Academy Studies (which, assuredly, were not deficient in final richness and force) began in the same manner.

Farr commented that "he was a much sounder craftsman than Reynolds." Etty "can only occasionally be detected using bitumen," though, as we know, the use of bitumen ruined several

of his paintings in the late 1820s. But, as Farr also commented, "it mortified him to realize that he had been painting for nearly eight years before discovering the magic of glazing in half-tints."

But Etty was not the only artist to come late to this technique. In Britain it did not become recognized practice until the 1820s. Etty's method was conventional enough but it requires more than adherence to method to make a satisfactory work of art. Close examination of any work by Etty will surely convince that, notwithstanding his obsession with one subject and his use of bitumen in his middle years, his technique was most proficient. He was essentially a painter in oils and when he was required by the Prince Consort to paint a fresco, which required the application of tempera to damp plaster surfaces, he could not do so. He was accustomed to correcting his work but fresco does not allow this. There can be only one application which, relying on the chemical reactions in the drying plaster, integrates with the surface as it dries. Later applications of tempera always flake off. Also the colors dry much lighter and allowances must be made for this. Such techniques were quite alien to oil painting.

Although we have little to guide us it seems clear that Etty was a silent worker, concentrating on his subject to the extent that the model ceased to be a person entitled to his separate attention. Letters recommending models sometimes comment whether or not they keep quiet and still, both necessary features in his opinion. He objected strongly to the noise and boisterousness of Parisian teaching studios. In his treatment of models as subjects it is clear that he had accepted without question the teaching of the Academy Life Class. All his figures look more or less alike. It was said to be impossible to recognize any particular model either in the faces or the anatomical details of the torsos. As Gaunt and Roe remark,[22] even though the model may have been malformed and ill-nourished she appeared in the finished work with "grand curves and healthy rotundities as in that vaguely apprehended classical world of his ideal." But Etty's chief concern was to produce rich colors which even his harshest critics had to admire. In seeking this end he developed a stronger palette so that in the final decade of his career many of his works are unduly bright and sometimes lacking in overall harmony. Even so, despite these later faults, Gaunt and Roe were able to declare: "Technically, Etty is superb. He has the true secret of the oil palette, that of giving richness, an inner life, meaning and value to the pigment so that it is not merely an area enclosed by an outline but form itself."[23]

Among his colleagues it was not his color but his compositions that attracted criticism. They are not always plausible, being "put together" from separately posed models. From such preliminary drawings that have survived it is apparent that he often began with only a generalized idea of his intentions and worked out the final composition on the canvas. Despite shortcomings his colleagues regarded him very highly and to be so judged by his peers was to satisfy his life-long ambition.

Chapter Thirteen

"I am not a Protestant" ... "I am not a Catholic"

The feature that stands paramount in Etty's character is his devotion to his religious faith. Of that there can be no doubt. His parents had been Methodists. Why they had adopted Methodism is not known but since Esther at least would have been most certainly raised in the Anglican Church (her traditionally minded and socially ambitious brother would have ensured this) they must have changed their allegiance early in their life together. It is possible—but admittedly only speculative—that the circumstances of their marriage caused this change. It was not easy to be a Methodist in 1771, the year of their marriage. Although the Methodists had not yet separated from the Established Church, many ecclesiastical authorities banned the Wesleys and their preachers from Anglican pulpits. Methodists were not Dissenters but many within the Anglican Church regarded them as very close to being so. Etty had a strict Wesleyan Methodist upbringing and as he himself says in his *Autobiography*,[1]

> ... it was impressed on my mind by my dear parents, and echoed feelingly in my own heart, a love and fear of Almighty God, and a reference of every action to his divine will; a confidence in His friendly mercy, a fear of offending Him; and I may safely say, I never for one moment forgot the path of virtue without the bitterest feeling of remorse and ardent desire to return to it, the only path of sunshine, happiness, and peace.

But Etty's period of apprenticeship in Hull seems to have been the time when he gravitated towards Anglicanism, attending every Sunday, as he says, "High Church in the afternoon" and hearing "Rev. Mr. Dikes preach at St. John's."[2] As we have seen, when he was apprenticed to Robert Peck of the Hull Packet, he objected to having to work on Sundays. We know nothing definite of his church attendances or religious observances during his student years but it must be assumed that, living with his Uncle William, he continued regular church attendances, without doubt at the Church of St. Edmund the King and Martyr in Lombard Street, which was William's and Walter's church. In 1833 he produced two paintings for the reredos and probably advised on the church's repairs. Not until his maturity does he refer to his opinions in these matters but we do know that Etty always had a love of ritual and tradition and in the 1830s he began to number several Roman Catholics among his friends.

Etty was ever a conformist in matters of behavior and personal morality. He was a pillar of the Church and a model member of society. Along with his fellow members of the Victorian middle class, even before Victoria's accession, he was God-fearing and law-abiding in the most demanding sense. He does not appear to have examined very far below the surface of anything. It is therefore not surprising that in both religious and political matters he reflected the nature of what was regarded as "respectable society." Under George III, whose reign from 1760 to 1820 covered all of Etty's young life and formative years, the Tory party assumed the leading role in British politics and thereby in ecclesiastical matters. G. M. Young points out[3] that in the earlier Hanoverian period the Anglican hierarchy nominated by the Government had been predominantly Whig and the clergy appointed by the laity had been Tory. After 1760 the Government

increasingly appointed Tories. The result was to consolidate the wealth of the Church among political allies. The Archbishopric of Canterbury and the Bishopric of Durham were worth £19,000 a year each and other bishoprics were worth in excess of £10,000, but the parishes attracted on average £285 each. Some were less than £100. As Young demonstrates, a family devoted to Church service could secure £10,000 a year between them through fathers, sons, nephews and sons-in-law, often living in adjoining parishes and pooling resources. For this they did very little, leaving most of the pastoral duties to curates receiving about £80. The alliance of Church and Government brought the Anglicans back into the forefront of society where it had previously lost ground to the Dissenters. The Anglican hierarchy was university educated and even local curates were usually reasonably well schooled, whereas the Dissenters drew their preachers from their own local ranks, men with "the gift of tongues" but very little theology. The Church felt secure in its establishment status and its superior education and had little need to exert itself. A very articulate minority thought otherwise.

For a young man like Etty, eager to make his way in the world and to mix on equal terms with some of the best minds of the time, even though he was always aware of his own shortcomings, conformity to the Anglican Church was advantageous. However, it is not suggested that Etty adopted a particular faith for purely material purposes. He was scrupulous in everything he did and all the evidence indicates that his allegiance to the Anglican Church arose from a genuine belief in traditional values and rituals. He was not attracted to the Evangelicals and although the Oxford Movement had its appeal the fact that it was outside the main stream of the Anglican Church was enough to deter him. His gradual move towards Roman Catholicism was influenced by a growing belief that since Rome was the older Church it was more traditional, more true to the original faith, but these were not good times for Catholics and conversion to Rome would have been too decisive a step to make. He praised the Roman Church for its love of the arts and wished the Anglicans were more supportive but that alone was not sufficient for a change of allegiance. The Dissenters' abhorrence of the arts was in itself enough to put them beyond consideration but quite early in his life he had decided that their strict morality, perhaps what he already regarded as bigotry, was not for him. An artist devoted to the nude as the Ideal could find no common ground with such men.

Although Roman Catholics were very much in the minority and were still barred from public offices, there was less hostility between the Anglicans and the Romans than in earlier centuries and certainly less than the Dissenters always reserved for either of them. The Tory clergy were sympathetic to "High Church" doctrines and could readily remind themselves and others that the Church of England was not Protestant but Anglo-Catholic. The development of the various religious movements, and their secular opponents, throughout the nineteenth century reveals a situation that was far from homogenous as popular histories represent. In the new mobile state of society it was quite usual for a workingman to begin as a Dissenter, move to the Methodists or similar nonconforming body when he became a foreman or supervisor and finish up with the Anglicans if he finally became a manager. As he progressed he changed his chapel or church as he changed his houses. To go to church in their own carriage was the aim of every ambitious family.

In Etty's case the change from Methodism occurred quite early and does not appear to have been influenced by ambition. If the "William Pack" of Hull who received the hymn-book from his father Matthew was related to Robert Peck to whom Etty was apprenticed then any influences from his employer would have been to remain a Methodist. Brother Thomas, then living in Hull, was a member of the Waltham Street Methodist Chapel, but somewhere between York and Hull William Etty had changed. Although we know nothing about Mr. Hall of Pocklinson it is possible that he ran a Dissenting Academy of which there were many in the country appealing to small businessmen and professionals to whom the Church of England was unacceptable. One would expect Matthew and Esther to prefer such a school. Later Etty was to admit to disliking Hull because

it contained too many Dissenters' Chapels. As the Bodley family was living in Hull and he often visited them, it is possible they were early influences. When he moved to London with the ambition to become a professional artist his change of faith was more than fortuitous. His uncle and brother were certainly regular worshippers at the Church of St. Edmund the King and Martyr in Lombard Street, the street in which they also lived, and we have already seen that the family played some part in the church's restoration.

The Anglican and Roman Churches encouraged the traditional historical subjects and conformity to the established Church would have made Etty an amenable member of the Academy. Although his principal interest was the female nude he did not concentrate solely on this subject. Throughout his career Etty painted some three dozen religious subjects which, compared with more than seventy mythological subjects and a further two hundred nude figure studies, indicates that though they were not his principal interests as an artist, they were regarded by him as an important part of his output. They were produced with a variety of intentions, some in response to private commissions and some for exhibition in the Royal Academy with the hope of an interested purchaser, but only two were directly commissioned by ecclesiastical authorities. He claimed that his two most important religious series were conceived while attending religious services. His *Judith* triptych was begun in 1826, when Etty was 39 years of age. The subject was "first conceived," according to Gilchrist,[4] in York Minster, "when the solemn tones of the Organ were rolling through the aisles." Again according to Gilchrist,[5] Etty told his dealer Colls that he first thought of painting the *Joan of Arc* series whilst attending a service in Westminster Abbey in 1839, when he was 52 years of age.

Of the numerous Biblical subjects there is now uncertainty over the provenance of some, as many were later assigned to store-rooms or otherwise hidden away since such subjects became unfashionable. *Benaiah*, ascribed by Gilchrist to 1829 when it was exhibited in the Royal Academy, and *Delilah before the Blinded Samson*, ascribed by Farr to 1837, are both in York. There is also a smaller *Benaiah* in the National Gallery of Scotland. Farr describes only this painting though he includes the York version in his "Catalogue." Etty frequently painted more than one version of a subject, usually copies, and it is always difficult to be sure which was painted first. Gilchrist's description of *Samson Betrayed by Delilah*, does not match the York painting and the location of his version is unknown. The date of the York painting is not known for certain and Dennis Farr is of the opinion that it is not stylistically typical of Etty's work and so some doubt may attach to it. It may be the painting purchased by Daniel Grant of Manchester in 1837 but the view now is that that was the other *Delilah* painting. In the Sotheby catalogue of 11th February 1959 it was titled *Esther and Ahasuerus* and said to be by Etty after Tiepolo. There is in the Royal Collection Etty's copy of Tintoretto's *Esther before Ahasuerus*. During his visits abroad Etty often painted copies of works by Old Masters that appealed to him but it is improbable that any would have been later ascribed to him as original works. It is more likely that Etty on his return painted free versions from memory. Sometimes titles of paintings were changed to make them saleable. *David*, c. 1810–12, in the Russell-Cotes Art Gallery and Museum, Bournemouth, is believed by Farr also to represent a bowman. Sometimes changes of title were made to encourage acquisition by clergymen. Several *Eves* and *Magdalens* probably began as nude studies but were renamed to allow them to grace a parson's study.

Until the passing of the Roman Catholic Relief Act of 1829 it was wise to conceal any sympathies towards Rome. While paintings of vaguely scriptural subjects might be accepted, images of God, Christ and the Virgin were regarded as papist since they were likely to be venerated. For Dissenters this was particularly objectionable as veneration gave them the status of idols. Anti-Catholic feeling had been strong, often violent, since the Reformation and particularly since the reign of Mary Tudor. Catholics were forbidden to occupy most public offices though in some places, as in the north and in York, Catholics had been less subject to hostility than elsewhere. In London feelings had traditionally run high.

Less than a decade before Etty's birth, the most extreme expressions of anti–Catholic feelings had erupted in London and had left a memory that took long to be erased. On Friday the 2nd of June 1780 some 50,000 people had assembled in St. George's Fields, Southwark, and then marched to Parliament to protest against the repeal of any anti–Catholic laws. This was not a spontaneous assembly but had been organized by Lord George Gordon a Member of Parliament and founder and leader of the Protestant Association. Gordon would today be recognized as a religious bigot incapable of extending understanding or tolerance to anyone of a different opinion from his own. Although he had earlier been a lieutenant in the navy, he had been refused further promotion and had resigned himself to pursuing a parliamentary career. This he was able to do through the purchase of a seat for the pocket borough of Ludgershall, between Aylesbury and Bicester in Buckinghamshire, which had been procured for him by General Simon Fraser to prevent Gordon from standing against him in Inverness-shire. By this device both were returned unopposed. Gordon made anti–Catholicism his special subject and hoped to frighten Parliament into acceding to his demands. The assembly he organized in St. George's Fields got out of control. Many broke away to attack foreign embassies and chapels and a squadron of dragoons was called out to restore order. This the soldiers could not manage and rioting continued day and night until the 6th of June during which period attacks had been extended to the Irish, their property and all other foreigners and their property that were encountered. The original religious fervor developed into general xenophobia. Several streets of buildings were burned down, three prisons were attacked and the prisoners released, Downing Street and the Bank of England were attacked and a Distillery in Holborn was ransacked. This resulted in so many rioters' becoming drunk that they could be subdued. Lord George Gordon was arrested and tried for treason but was acquitted thanks to the skilful defense by Thomas (afterwards Lord) Erskine on the grounds that he had not intended the consequences. However twenty-one persons were hanged as ringleaders of the riot. It was estimated that 850 people had been killed.

Although the Courts acted, Parliament was wary of introducing any legislation to improve the condition of Catholics. The Gordon Riots had been another warning to respectable citizens of what happened when "the Mob" took to the streets. To some extent Lord George Gordon assisted the emancipation of Catholics inasmuch as his actions were strongly disapproved by the more liberal minded. When he fled abroad, seeking sanctuary in France, he libeled the Queen of that country, sought refuge in the Netherlands and was banished back to England where he was arrested and sent to prison for five years, dying in Newgate in 1793. None of this helped his cause, especially as he had in the meantime converted to Judaism. The general public and particularly the politicians remembered the Gordon Riots for decades and were resolved to keep Catholics "in their place" as though they had been responsible for the disturbances.

Etty appears to have kept his own religious opinions under constant scrutiny. In letters from Italy in 1816 he wrote disparagingly of "the effigies of Popery" and of "some Popish ceremonies going on" but gradually his views mellowed. By 1834 he was finding in the High Anglican services of York Minster suggestions of Roman Catholicism that appealed to him. He began to accuse the Protestants of robbing the Catholic Church of its places of worship. He was privately concerned that strict Protestantism did not approve of the arts, especially not of painting and sculpture and most especially not of depictions of the nude figure. Writing to Walter on the 17th August 1834 from 27 The Mount, York, i.e., the home of his friends Mr. and Mrs. Bulmer, he told him of his recent visit to Howden Church and Selby Abbey. At Howden, now a ruin, he had found the tomb of a Crusader which had awakened religious feelings, while at Selby he was appalled by what he called "mutilations." "There has been a Monastery there ere the *blessed* Reformation as the Protestants call the Robbery and Spoliation of the Church." Later in the letter he said that he had been to a service in York Minster. "We had a new anthem taken from the *Catholic Service*—like as the Minster was." Then later still in the letter—"Dr. Camidge is

enriching the Collection of Anthems by adding new ones adapted from the Catholic Masses by Mozart and other good Catholic composers."

In a letter to Thomas Bodley written from York and dated "Sunday afternoon July 13 1834" he said:

> Mrs. Bodley [*Thomas Bodley's mother who lived in York*] is praising our Minster, pleasing me by saying it was the "Beauty of Holiness. "By the way I think the Protestant parts of the Church of Christ are not sufficiently awake to those (in my opinion) *important* adjuncts, which might be so at least, *The Arts*. Who shall say that Architecture is of no importance after coming out of York Cathedral? Or who shall say when the Anthem swells in tones of glory that Music is not? Nous verrons. I *must* write an Essay on the importance of Religion!!

There is absolutely no doubt that the total effect that York Minster and the services there made on Etty all his adult life was the reason for the attraction of the Roman Church. He always remembered that the Minster and all English Cathedrals had originally been built by Catholics and he saw little evidence that the Church of England had ever emulated their example. He does not seem to have responded to St. Paul's Cathedral, probably because it was not a medieval structure. In fact, Wren's blend of the Classical and the Baroque offended many and by the beginning of the nineteenth century it was being proposed by those interested in the subject that there should be distinct styles for different classes of buildings, i.e., public buildings should be Classical (which usually meant Grecian), churches should be Gothic and domestic buildings should be Jacobean which, for most, meant "the Olden Times." The Romantics favored Gothic for everything. Applied to ecclesiastical buildings Gothic reminded everyone of their Christian heritage, though one might have thought that Romanesque would have been better suited to emphasize antiquity. But the Anglicans favored ornamentation and nostalgia and it is noteworthy how much decoration was added to Wren's original structure during the course of the century. Consequently in due course when they began to build their own chapels the Methodists generally preferred the Classical because they associated Gothic with the Anglican Church. The move by many Anglicans towards Rome was undoubtedly assisted by so many medieval cathedrals that had originally been Catholic and which had been taken from them. It was not difficult, when attending a High Anglican service in a Gothic cathedral, to imagine the effect of the Catholic Mass before the Reformation.

There is little doubt that Etty's increasing sympathy for Roman Catholicism was encouraged by Anglican services in York Minster. In letter after letter, especially those to Thomas Bodley, Etty described and praised every feature of the Minster and of the Anglican services. Gilchrist records[6] various occasions when Etty revealed in unidentified letters his problems over whether to continue with the Anglicans and the difficulties he was having accepting Catholicism. He declared that he had "anathematized" "the Spoilers of God's Holy Temple" and "execrated" "the memory of Henry VIII." He declared that he would not become a Papist "as long as you [*the Anglicans*] possess York Minster or Westminster Abbey.... I shall live and die a Protestant. I love my native Church, the Church of my Baptism." The fact that he had been baptized an Anglican meant no more than that Methodists at the time were usually unable to use their own chapels for such events. Even so, it is not unlikely that his parents had already taken the customary step of moving back to the Church as their personal fortunes improved. We simply do not know but one fact is certain, Uncle William and Walter, who were so supportive, were certainly Anglican and their example would have influenced him. Etty himself could be satisfied with Anglicanism so long as its services were celebrated in medieval Gothic cathedrals. Gilchrist records that in 1836 when a lady of his acquaintance "had taken him to task for his heterodox leanings" he had replied that he was

> in his heart's core deeply and sincerely of the Ancient Faith—*Catholic*—not of the Daniel O'Connell school, but that of Alfred, St. Augustine, St. Bernard, St. Bruno, and Fénélon and not forgetting Raphael, Michael Angelo, and a host of other great and good men.

He added, "Rubens a Catholic, too." Daniel O'Connell (1775–1847) was a renowned Irish politician who campaigned all his life for Catholic emancipation. Through so ardently expressing his opinions he was challenged to a duel in Dublin and after wounding his opponent he was arrested while trying to escape to the continent. He was bound over to keep the peace. The Catholic Association which he founded to redress the grievances of the Irish peasantry was suppressed by Act of Parliament in 1825. He was elected Member of Parliament for County Clare in 1828 intending to cause a constitutional problem by affirming the right of Roman Catholics to be members. His intentions were thwarted by Parliament which in the meantime passed a bill admitting Catholics. He could not be at the center of that constitutional problem so he refused to take the oath of supremacy and was barred from the House. In 1831 he was arrested for evading proclamations forbidding certain Catholic activities. He founded a Catholic newspaper, *The Nation*, which became the mouthpiece for his many campaigns. He was again arrested in 1844 for causing "discontent and disaffection" but was released on appeal. He died in Genoa where he had gone to recover his health after a lifetime of endless activity. Such a man was not likely to appeal to Etty.

Catholicism attracted Etty through its liturgy and ceremonies and the decorated churches, abbeys and cathedrals that had been built in its name. High Anglicanism met his needs whilst at the same time relieving him from any obligation to protest against the official discriminations against Catholics. Writing to Betsy in 1839 he described his feelings after attending Vespers in the Minster.[7] "Oh! Holy Mother Church! dear Catholic Church! how deeply I venerate thee: thou, who produced such glorious efforts." In the notebooks which he kept between the years 1839 and 1845 he wrote on one occasion: "I am not a Protestant—because a Protestant is one who protests against the Catholic Religion—but being in Mind and Heart a True Friend and Believer in the Holy Catholic Faith I pray God to direct me in the way I should go."

In another entry he wrote:

> My heart and mind I feel to be more Catholic than anything else—but I do not turn Catholic at least at present for several reasons, among which are the following: Auricular Confession: Being shut out of those glorious Minsters they have erected, and obliged to worship in those poor Chapels, which they are banished to, at least for the present.

He experienced spiritual feelings amounting to rapture when he entered the cathedrals, especially the Minster at York which became for him the most special religious edifice in England. If he had converted to Rome he would have been required to worship in more recently built churches and he could not abandon his beloved York Minster. As Gilchrist remarked,[8]

> His sympathies were all with the religion of the Old Times, with the builders of York and Westminster, the Painters of the Vatican, of the Sistine, and of the Palaces of Venice.—"Oh, that I could have seen my Country," he will exclaim, in his letters to his Niece, "when her brows were crowned with gems, like what our Abbeys, our Cathedrals, and Churches once were! When schism had not split the Christian world into fighting and disputing fanatics; when the dignity of Christ's holy temple and of this worship were thought improved by making the Fine Arts handmaidens thereto; and the finest efforts of the soul of man were made subservient to His glory."

"The fighting and disputing fanatics" were for Etty the Dissenters and the Methodists who challenged the authority of the Church. He had no knowledge of the causes of the Reformation and of Luther's break with Rome. He judged the Dissenters as much by the chapels they built as by the nature of their faith. For him no honor was paid to God by men who

> build up a Box of Brick, make a hole to get in, and two or three others to let in the light. No! The men who could raise structures like York Minster, who could apply the best, the most glorious of Arts to the service, honour and glory of Him who made and sustains us, and,—by *thus* applying them, and drawing nearer to Him in prayer and praise,—soften, sweeten, ameliorate the ruggedness, selfishness, and barbarity of our nature; the men who could do this, could do what the Roman Catholics have done, come nearest to my feelings of what a Christian should be.

So, said Gilchrist "declares the Painter to a friend" sometime in 1837 but the identity of the recipient is not revealed though it is known that Etty was at this time freely mixing with Catholics such as Augustus Pugin, John Rogers Herbert and Clarkson Stanfield. It is worth pointing out that Herbert and Stanfield were both members of the Royal Academy as were several other Catholics including the President Sir Martin Shee.

In the notebooks in the possession of Tom Etty of Nijmegen there are several poems which Etty composed expressing his strong religious faith. The sentiments are not particularly Anglican or Catholic but of a general nature which any devout Christian could declare. It is not possible to date these poems precisely but one is on a page adjacent to the poem he wrote on the occasion of his mother's death in 1829.

> When I wake from safely sleeping
> And behold the twilight grey
> Thro my lattice silent peeping
> Gentle harbinger of day,
>
> Now swells my grateful heart to Thee,
> God of Life, and Light and Love,
> That Thou safely has kept me
> Shadow'd by Thy wings above.
>
> When with Darkness Danger hovers
> O'er the couch of curtain'd Sleep,
> Thou with Shield of Safety covers
> Those Thy Mercy loves to keep.
>
> Then let me at Thy Altar pour
> The incense of a grateful heart
> And pray that to my dying hour
> I never from Thy Paths depart.

The word "incense" ensures that this is not a poem written by a Methodist but otherwise it is a declaration of faith that any Christian could approve.

Etty frequently unburdened his private feelings upon his brother Walter. It was not unusual for him to indicate his religious sympathies in letters on other subjects. Writing to Walter in August 1841 regarding his journey, with Betsy, from London to Hull, he refers to seeing "Lincoln's glorious Catholic Cathedral" and adding "The Protestants' hate and abuse cannot erase the glories and benefits they have shed on the land." In another letter (undated but suggested by Farr to be within the years 1840–42) also to his brother Walter he laid out his position as clearly as he could.

My Dear Walter

I am not a Catholic, nor probably ever shall be (unless they get their own Cathedrals back again) nor have I any wish to convert you to that faith but I am, and trust I ever shall be an advocate for Truth and Justice in opposition to cant and charlatan and as such I challenge Mr. McGhee, or any other Mister, to contravert the following facts:

That—We are indebted to the Catholics for most that is great or good which our ancestors have handed down to us.

That—We are indebted to the Catholics for the introduction of Christianity into Britain.

That we are indebted to the Catholics for Magna Charta, the Trial by Jury and most of those laws, the boast of our country.

That we are indebted to the Catholics for all that is great and good in ancient architecture Painting Music (and the Arts that add so great a charm to life) in Christian Europe.

That they were in this country vilified, robbed of all their professions, and just rights as men and as Englishmen in many cases murdered, expatriated—turned out of their holy places into the wide world, and lest they should return to those respected and revered sanctuaries, the lead was stripped off, and those "holy and beautiful houses" made ruins and frequently pig-styes.

That they were not only robbed, and in many cases murdered, was not enough for Protestant Justice

they must now add insult to injury, and by falsehood, abuse and calumny, attempt to blacken the character of them, recollect what Christ said—

"Thou art St. Peter, on this Rock will I build my Church, and the Gates of Hell shall not prevail against it."

An indication of Etty's growing tendencies towards Catholicism is provided by events in 1838 and 1846. In August 1837 Etty had met Augustus Pugin, the architect engaged with Sir Charles Barry in rebuilding the Houses of Parliament after the fire of 1834. Pugin had converted to Catholicism in 1833. In May 1838 Etty attended by invitation the ceremonial opening of the Roman Catholic chapel of St. Mary, Oscott College in Birmingham, in the design of which Pugin had taken a leading part. Full High Mass was celebrated, a quite unusual event for this country at the time. In July 1846 Etty visited Pugin at his home in Ramsgate. While there he attended Mass in Pugin's private chapel. He wrote to his brother Walter describing his satisfaction. "It is wonderful the admirable way in which everything is done, so solid, good, and truly comfortable, without nonsense and frippery." Dealing with these events Gilchrist related[9] that "In his bedroom, he set up a very pretty *dilettante Altar*." Gilchrist refers to a letter to an unidentified recipient as the source of this report. Daniel Maclise told Gilchrist[10] that Etty had on one occasion objected to his depicting a group of monks "engaged in rather a convivial manner at the board" in his painting *The Bow of the Peacock*. "He was both serious and severe with me for this." As is so often the case, the convert was stricter than those born to the faith.

But it was not a good time to be a Catholic in Britain if one hoped for social advancement. Although there were now several Catholics in political positions most avenues were closed to them. There was throughout the country the continued fear that Rome intended to reclaim Great Britain so Catholics were better kept out of any positions of influence. Ever since the Catholic Relief Act of 1778 there had been campaigns for its repeal. As the movement for greater inclusion of Catholics gathered pace the newspapers frequently published articles against any further tolerance. Catholics were still regarded as "spies for Rome," the general view being that they did not intend to be satisfied with partial recognition, they would not stop campaigning until they had complete equality in everything. Travelers from abroad would often go into print deploring the conditions in Catholic countries, the domination of the priesthood and the lamentable superstitions of the poor which the priests were accused of encouraging. Nearer home was the example of Ireland, as though England was not contributing to that country's parlous state. All these accounts fed the Englishman's natural xenophobia.

Etty frequently referred in his letters to his constant thanks to Almighty God for his blessings, making affirmations of the spiritual benefits he had experienced from attending services in the Minster. He does not seem to have discussed religious matters very often with his friends or, if he did, he did not mention the occasions in his letters. In one letter there is a reference to what appears to have been an unwilling participation in such a discussion. Writing to Betsy from Buckingham Street on the 22nd August 1846 he says:

... at half past eight the illustrious W.B.S. to a Sally Lunn and Tea, a full house of the Flogging System punished me for my presumption and a Discourse on Morality and "the Movement" left me not a Leg to Stand on. Ann was jawing in the kitchen and I in the Parlour till near Eleven, when his Highness departed as highly gratified with the Festivity of the Season, as I was by his "Movement" off.

We know from a previous letter dated 2nd February 1845 (which is referred to elsewhere) that "W.B.S." was William Benjamin Sarsfield Taylor, a painter of landscape, battle-pieces, genre, literary, historical and architectural subjects, as well as an etcher and engraver, writer on art and critic—in fact a general jack-of-all-trades—who had been born in Dublin in 1781 and had in his early years served in the army in the Peninsula Wars. He never attained any distinction as an artist but was well known in his lifetime as a writer. For a short time he was a member of the Royal Institute of Painters in Watercolours, was connected with the Society of Arts, Manufactures

and Commerce (through whom it is possible Etty came to know him) and was in later life the Curator of the St. Martin's Lane Academy. Although he exhibited from time to time at the Royal Academy he was never admitted into membership. His reputation appears to have been fairly high in London art circles; the fact that Etty always referred to him as "the Illustrious W.B.S." suggests this, though Etty was clearly being heavily sarcastic. Taylor died in 1850.

"The Movement" is either the Tractarian Movement which originated in 1833 with John Henry Newman, Edward Bouverie Pusey and John Keble, authors of *Tracts for the Times*, or the subsequent Oxford Movement which they formed in 1841. Most probably the latter, having regard to the date of the letter. They rejected the royal supremacy over the Church and therefore the English Reformation itself and objected to the growth of rationalism in the Church of England. Although not initially intending a return to Rome the founders and many of their supporters moved rapidly in that direction. Pusey and Keble did not actually convert to Rome but Newman did in 1845 and was at once ordained. After a stormy period during which he was prosecuted for libel and was frequently attacked in the press he was created Cardinal in 1879. Newman's conversion was regarded as a significant success for the influence of Rome in England. Etty clearly had no interest in theology and would probably have been unable to take part in any serious discussion on the subject. The appeal of Rome for him lay in its medievalism, the architecture of its cathedrals and the mystical quality of its rituals. For him it was the original faith established by Christ and therefore the true faith. He decided these matter on very simple criteria.

In November 1847 Etty was still concerned with the problem of whether the Roman Catholic faith was better suited to promoting the arts. He asked the opinion of a fellow Academician, Charles Eastlake, whom he knew very well and who was to become President of the Academy in 1850, being then knighted, and Director of the National Gallery in London in 1855. Eastlake, ever courteous, replied on 12th November 1847[11]:

My dear Etty, In reply to your "momentous question"—"whether in my opinion the Roman Catholic or the Protestant Faith is best adapted for promoting the Happiness and best Interests of the Human Race"—I have no hesitation in saying that I think the Protestant Religion is best adapted for such purposes. On the other hand, & with reference to another part of your letter I cannot but admit that the arts have flourished most under the inspirations which the Catholic Faith prompted & the dignified encouragement which it held forth. Still, I think it would not be right to attribute all the excellence of art to that influence only, for in Catholic countries now—in Italy & in Spain for instance—the arts have sunk although the religion is unchanged, & although the mere demand for some works of art, consecrated to Religion, is still great.

Eastlake continued with a recommendation to Etty to read a book recently published entitled *From Oxford to Rome: And How It Fared with Some Who Lately Made the Journey*. Eastlake wrote: "I know it only from Reviews but think, from the passages I have seen, that it may contain an *experimental* answer to your question."

Etty in his reply indicated that he had bought the book and undertook to read it. As we know, Etty did not convert to the Roman Church but clearly remained sympathetic and saw no reason why the two Churches, of England and of Rome, could not reunite. A principal problem for Etty was that he strongly objected to any dissent and whilst it is likely that his move towards Roman Catholicism was partly due to his need for authority and certainty, he was unable to make the final move because this would also have amounted to dissent. According to G. M. Young[12] it was estimated that in 1830 for every 120 Church of England adherents there were 80 Dissenters and 4 Roman Catholics. The figures for Dissenters included Methodists but these were a large enough total to worry the establishment as were the Roman Catholics who, the authorities believed, were particularly threatening because they were part of a world wide organization determined to return to power

Etty was surprisingly antipathetic to Methodism given his family background. In a letter dated 4th September 1841 to his friend Sydney Taylor he wrote:

What ostentatious Temples the Methodists are building after the Pagan Model, i.e., York and Hull. Lofty, unnecessary porticoes, Ionic Columns, "thick as leaves that strew the brooks." Candelabras of gilded brass, crimson linings to the pews and cushions, organs—Hull is truly the hotbed of dissenters and Chapels lay as thick as hail.

Perhaps one reason why Etty did not join those who were converting to Rome was the realization that one consequence would be to cut himself off from many of his friends. Etty was always careful to retain old friendships, especially the friendships of his fellow citizens of York. As an Anglican center with a strong Methodist minority, York was an uneasy a place for Catholics, as it had been for Jews, of whom there were now few in York. Etty was always a welcome member of the Minster congregation, he knew the Canons and Deans and in particular Dr. Camidge the organist with whom he maintained a close friendship. The Minster provided him with all the tradition he craved.

"Premiums for Crime"

Etty's political opinions and his attitude to some of the social problems of the day become apparent in his reaction to an event that shocked the nation and very much himself. In June 1840 there occurred the first of a number of threats against the Queen which appalled the nation and generated lavish expressions of both loyalty and eagerness for severe retributions. Etty was among those who publicly declared his horror and anger. In the three years since her accession Victoria had attracted a public support which had not been evident for royalty in the country since Elizabeth. At long last, it seemed, the nation had a monarch which it could respect. Etty was an unquestioning monarchist, a loyalty which he had felt as much for Victoria's predecessors as for the Queen herself. The young Queen and her consort were pillars of strict morality and family values, virtues which bound them to everybody in the country. For too long the country had waited for such a couple. When the Queen was attacked by a young man with pistols, Etty regarded the event as challenging the very institution of monarchy, indeed the fabric and stability of the kind of society he relied on. He turned to the newspapers to express himself with exceptional vehemence.

The episode, often omitted from standard works on Victoria's reign, was recorded by writers later in the century. A full account was written by Richard R. Holmes, F.S.A., Librarian to the Queen, in his book *Queen Victoria*, published in 1897:

> On the 10th June 1840, an event occurred which created intense excitement throughout the country. While the Queen and the Prince were driving in the afternoon along Constitution Hill on their way to Hyde Park, a young man named Edward Oxford advanced within a few yards of the carriage, and fired a pistol at the Queen. He missed his aim, but, as the carriage proceeded on its way, the would be assassin called out, "I have another," and discharged a second pistol, again without effect. The Queen's first thought was for her mother, and changing her route to Belgrave Square, the Duchess of Kent heard of the attempt and of her daughter's safety at the same moment. ... The trial of Oxford for high treason was held in the Central Criminal Court on 8th July. The jury returned the verdict "Not guilty on the grounds of insanity" and the prisoner was therefore ordered to be detained during her Majesty's pleasure. After thirty-five years' imprisonment at Bedlam and Dartmoor he was released on condition that he would emigrate to Australia.

Charles C. Greville in his *A Journal of the Reign of Queen Victoria*, published earlier in 1885, had given a less full account but with a few more details. He stated the date of the incident to have been the 12th (not 10th) of June 1840 and said the royal party was "shot at by a lad of eighteen years old." He went on to describe the assailant as "a half-crazed pot-boy." Greville also gave details regarding the trial. Initially there was doubt as to whether the attempt on the Queen's life could be regarded as high treason. There were no satisfactory legal precedents. It is possible the jury was directed to return the verdict that they did in order to avoid a constitutional crisis.

It would have been most unwise to have suggested that there existed a desire by anybody to assassinate the Queen. Such a claim would have suggested some dissatisfaction with her and the existence of plots and plotters. The early decades of the century had been most disturbing for the country as a whole and the poorer classes in particular. There had been riotous assemblies by the aggrieved poor in 1816 in Spa Fields and in 1819 in Manchester ("Peterloo") and the famous Cato Street Conspiracy in 1820. There had been economic depression in the 1830s with low wages and food shortages. It was politically essential to be able to claim that the accession of the new Queen had brought civil peace to the country. But the Chartists had begun their campaigns in 1838 and there were real fears among the aristocracy, the landed gentry, the middle classes and the politicians that England was at risk from revolution. Two further abortive attacks on the Queen in May and June 1842 fuelled these fears. It is of interest that the Queen personally intervened in the judicial process surrounding these later events to ensure that such attacks were not regarded as high treason, as she objected to the death penalty. In the 1840 incident the judges and the politicians between them found a solution. No sane person would attack the Queen. But for Etty the verdict of "not guilty on the grounds of insanity" was more than he could stomach. He prepared a letter for a national newspaper giving vent to his indignation.

The letter exists in draft form in the York Reference Library and is undated and the intended recipient newspaper is not indicated. It is possible it was not even submitted. Actual publication is not known but the draft is important as illustrating Etty's strong royalist views. Etty was not usually satirical and certainly not in regard to such a serious subject. The letter is so vehement in tone, it was clearly written in anger. It reveals Etty's strong principles, not in respect of the extent of his patriotism and of his veneration of the Queen which were typical of the time, but in regard to his attitude towards criminality in general. The letter contains reference to another attack on the person "of a most lamented individual" who is later referred to as a Minister and later still as "a most respected and amiable gentleman, holding a most important office." This person must have been Spencer Perceval, prime minister from 1809 to 1812, who was assassinated in the lobby of the House of Commons on 11th May 1812 by John Bellingham, a bankrupt who blamed Perceval for his ruin. Although Bellingham was held to be insane, he was hanged. This was the period of many demonstrations by disaffected groups and supporters of reform when attacks and threats of attacks on prominent persons were commonplace. Etty's letter drafted for publication in 1840 is headed "Premiums for Crime."[13]

The deep interest I feel in all that concerns the vital and permanent interests of my country must be my excuse for troubling you with the following remarks. At the present period when it seems generally agreed that assassination, so far from being atrocious, according to the old but now exploded notion, is really deserving of encouragement, and he who attempts it on the person of our Queen and he who perpetrates it on that of a most lamented individual, are alike deserving of patronage and protection, "a comfortable asylum" for life, "retired leisure" and the protection of a grateful country, thus offering a most attractive Premium for Crime. Can we wonder at its immediate repetition? as late events so fully prove.

That insanity exists somewhere, either in the criminal or those who have sat in judgment on them I am quite ready to admit, but I shrewdly suspect less in the first man than in the last—or if not insanity, an imbecility that criminal irresoluteness of purpose, so fatally dangerous in times of peril.

What a *mistake* our forefathers made in imagining hanging was a wholesome remedy for these things or that burglars, highwaymen and murderers were not most desirable examples to be held up for the imitation of the rising generation in this our "better state of things." They are *very properly* judged to be the best heroes, for novels, romances and drama, and we are in no danger of wanting a plentiful crop—or furtherance of this most *laudable* object. I beg to suggest that not only Periodical Premiums should be offered for *Crime*, where the reward should be enlarged as the effort deepens in atrocity but that "subscriptions be immediately set on foot" for establishing a College where its principles and practice be initiated and developed to the utmost that Professors [*some words appear to be missing here*] and honors be decreed, that he who levels the death tube at a Queen idolized by her people, or a Minister on whom the destinies of his country and of Europe in some measure hang—should be eligible to

the highest honors, unless it should be proved there is "no ball" fired which shall be equivalent to a *black ball*, the other situations to be filled as candidates may offer—it is proposed to build it in a pleasant and salubrious part of the country where the amusements of hunting and *shooting* (no matter at what or whom) may be had, it being all *practice*.

The College to be adorned with effigies and busts of all the most celebrated ruffians from the earliest to the latest time, with stored library containing the Newgate Calendar, a few of our latest and most *racy* novels and romances and a Drawing School for the Study of *Design—Oxford* on being asked how he employed himself coolly replied that he *read* and *drew* occasionally. But to be serious on this momentous subject, it requires no great penetration to discover that unless something be done, if what with the twaddle of mawkish philanthropy on the one hand and that of *monomania* on the other Justice is to be defrauded of those who, in mercy to Society, ought to be her victims, *no person* however sacred, their character or office, is *safe*; murder no longer skulks in corners or shrouds itself in darkness but boldly walks out into sunshine and the "holy light" of day. The sacred person of our Lady Sovereign is judged to be a fit popinjay for a pot boy! an apothecary's errand boy, emboldened by this success of Oxford next tried his hand and with almost impunity both wretches live! Gracious heaven, what is the result, a most respected and amiable gentleman, holding a most important office, is next attacked and murdered almost at his brother's threshold! Still Justice sleeps! Beware! Englishmen! how you protect the Regicide and the Assassin! Hear what Aeschylus makes his Minerva say to the Athenians! "Let not my Citizens Riot in lawless anarchy, nor wear the chain of tyrant pow'r, *nor from their state loose all the curbs of rigour*: this removed, what mortal man, unchecked with sense of fear, would reverence Justice?"

It may come as a surprise that so normally mild mannered a man should have written such a letter but we do know from other references that he had no sympathies for anyone who flouted the law. He certainly had no sympathies for political activity of a radical nature and none at all for the Chartist movement and the Reformers. From his reaction to this and other events it must be concluded that Etty was a somewhat timid man who did not like the even tenor of life to be disturbed. Gilchrist said that Etty was very opposed to the Reform Movement.[14]

"*Reform*" was a word exciting Etty's vague aversion. His confused impression of it, was as implying simply: the future ascendancy of the "Tag-Rag and Bobtail." Towards which latter ill-deserving class, he,—as befitted one himself risen from the ranks,—cherished a just and intelligent contempt, not unallied to fear: loose old-fashioned notions, taken up on trust. The "Lower Classes" are "to be kept in their place, etc.,..."

The Painter continued charged with excited patriotism, and big with melancholy vaticination; prophesying the ruin of his Country, and of the respectable members of society.

In a letter dated 16th August 1831, writing to Mr. and Mrs. Bulmer in York, Etty said—"I am like yourself, sick of the hackneyed phrase REFORM; fear it will, like the Whigs, never do much for us." In another letter to George Bulmer of the 14th September 1831 he referred to "Reform and Cholera, the two great Evils of the Day," complaining that he was "sorry the Tories had let the Whigs" authorize the establishment of the National Gallery. So biased was Etty against the Whigs that he objected to their doing anything which he otherwise supported. As Gilchrist said[15]:

Etty shared the Tory instincts of his class. Painters mostly take their Politics—with their Commissions—from their Patrons; and are (almost) to a man, staunchly devoted to the order of things as they are, whereby they get their living,—pudding and praise; and are enabled peaceably to follow their craft.

This may have been the general view at this time but as the century wore on artists became suspected of subversive ideas. Generally artists either divided between supporting their patrons or despising the general public, with some taking no interest in politics at all, believing that Art (with a capital A) was spiritually superior to all material considerations. However, as Gilchrist continued: "in course of time, he, as others, came to find that the world still rolls on its axis,—*after* this invasion by Democracy, pretty much as before."

This was very percipient of Gilchrist and quite an unusual view at the time when the "respectable" middle-classes were terrified that "the Mob" would take over society. What we know

of Gilchrist suggests that he was more a Whig than a Tory but attracted to Etty by admiration of his art. Fear of reform stayed with Etty. Much later, on the 26th August 1842, he wrote from York to brother Walter

> There was a Chartist Meeting here last Sunday on Knavesmire but they were prepared for them and their threats of burning down the Castle and liberating the prisoners passed harmless. A hundred and fifty prisoners from the West Riding (or more) are here waiting the decision of the Law on their lawless proceedings. It is Assize time and has been Racetime so York is in a bit of a bustle....

Etty never seemed able to understand that the social upheavals of the century had condemned a large part of the population to inescapable poverty. He may well not have realized that there had been social changes since his boyhood. Of all men Etty seems to have be the most myopic when it came to understanding what was happening in contemporary society. Although the Anglican Church was rooted in Tory politics, Etty's early Methodist upbringing may also have made him sympathetic to its opposition to any expressions of social unrest, a fact which often now goes unrecognized. Jabez Bunting (1779–1858), who became President of the Wesleyan Theological Institute in 1835, had declared that "Wesleyanism is as much opposed to Democracy as it is to Sin."[16] The uneducated and illiterate poor were not regarded as capable of exercising any political judgment. The effects of the Enclosure Acts, the introduction of agricultural machinery and the change from crops to livestock farming, had compelled thousands of agricultural workers to move to the towns. Here they continued to face unemployment with the added misery of either slums to live in or no dwellings at all. Families who had been used to at least a plot of land on which to grow their own food now found themselves totally destitute. The great majority of the poor had no possibility of improving their condition. Even when they obtained employment in the factories their condition was appalling. Emigration was almost official policy as a means of relieving the number of unemployed but Etty saw no reason why through hard work everyone could not improve their lot, as he had done. Like so many who "make good" he could sometimes overlook the education and help and encouragement he had received. He believed that the poor should be grateful for whatever charity was bestowed on them, though it is probable that he disapproved of charity as encouraging idleness. Those who, even today, argue that "everyone can get to the top" do not recognize that at the top there are very few places on offer. Getting there is a highly competitive process and while this may be no bad thing there were no opportunities for the majority of the uneducated, of whom there were hundreds of thousands in the nineteenth century.

Yet Etty was not a heartless man. He merely shared the attitude towards the poor of most of his contemporaries. In a letter dated 22nd June 1848, written to Betsy from York, he recounted the following incident and its effect upon him.

> I sauntered back past the old Cottages near Holdgate Lane end. There a poor man was groping his way from door to door, his poor eyes orbless, he had a stick and a basket, he was standing at one of the doors begging—poor thing thought I, thou cant see this glorious day and by the blessing of God! I can. What reason have I to be thankful. I tapped him on the shoulder and put a penny in his poor hand. He turned his poor white eyes on me "May the Lord give you a blessing!" I felt it as worth more than a penny for I felt happy all the evening after.

This was indeed the normal attitude of most people. There was not to be any official alleviation of poverty whether by government or other institution. Alms were to be given privately and the alms givers would experience a glow of self-righteous satisfaction. It was the medieval idea that alms-giving secured merit and a surer path to paradise. The general view of the middle classes as expressed by Charity Commission inspectors in 1821 was that charities turned the poor into beggars with consequent "idleness, drunkenness, poaching and thieving. It is impossible to exaggerate the evils they produce."[17] Evidence that many charities did not fulfill their aims was enough to justify doing nothing. After all, there *were* examples of poor people improving

their lot but the fact that the social structure was pyramidal, as it still is, and no doubt must be, meant that the majority could never reach the top. That crime and prostitution increased rapidly throughout the century was not seen as the consequence of social upheavals and poverty but of a general moral laxity which was held to be the natural condition of the lower classes. It was the accepted opinion that the poor needed hardship to make them work and severe punishments to keep them law-abiding. This was the time when even petty theft could be punished by hanging or transportation for life. Social unrest was held to be the consequence of revolutionary provocation, not genuine distress.

Etty was no political Romanticist. Although he never wrote down his views on these subjects we may infer that the French Revolution and the American War of Independence were not for him victories of the free spirit of man. As we have seen, when he encountered firsthand the Paris Rising of 1830 his initial attitude was not sympathetic. There are very few occasions when Etty reveals his political opinions and it is unlikely that he thought deeply about events of his time but that he disapproved of change or any display of political dissatisfaction is very certain. We must accept Gilchrist's conclusion[18] that "for him, it (Reform) still maintained a fountain of Modern Evil, explaining many a degeneracy and mischance." Etty, like many others, carried memories of the licentious behavior of the Regency period and, again like many others, believed that mankind possessed a natural inclination towards sin which only true religion could eradicate. Throughout the Regency and earlier many, both rich and poor, had led such dissipated lives that the nation often seemed beyond redemption. Writing to Betsy from York on the 17th September 1837, a Sunday when Etty's mind was always occupied by the effects of attending religious services, he said:

> This week is Doncaster races, which makes a stir among the knowing ones even here, so the world jumps from one folly to another, till they jump into that cematary [sic] where jumping is no more. Now a bazaar, now a bible meeting, now a sermon, now a collection of the missionaries, now for the jews, now for the niggers, and now for nothing that's good

Going to the races, attending Dissenters' bible meetings, sending missionaries to Africa and offering social equality to Jews were all for him unnecessary and misapplied activities, similar to extending charity to the poor and political opportunity to the unenfranchised. Virtually the only section of society whose lot he would have improved were the Roman Catholics. Only in regard to Catholicism was Etty willing to argue for offering social equality to a minority faith.

Etty and money

There were more artists in Great Britain, certainly more in England, in the nineteenth century than ever before. In 1800 Joseph Farington remarked to a friend that in his early years in London there had been only five or six other masters, now there were hundreds. It was not only drawing masters who had increased in number, there were by now a vast number of all artists. Fawcett[19] estimated that there were four hundred exhibiting artists in London alone, to say nothing of all those who had not yet managed to get their work on any gallery wall. It was the usual story of supply and demand and as those who failed in London moved to the more promising provincial towns (and we have seen how few they were) so those who failed in the provinces moved to London. Etty himself had done so. Certainly he had not failed in York but he knew that any artist would fail there. The one or two he knew in York barely made a living. In the face of such fierce competition it was not merely ability that would find an artist a client, it was also price. It was also a matter of fashion. Any artist wishing to succeed had to be willing to supply what the public wanted. Etty had his own ideas about what art was, as we have several times seen. Fortunately, as we have also seen, there were enough clients, or patrons, wanting his kind of subject to keep him busy. But available money was not unlimited. Even in the booming economy

of the earlier eighteenth century patrons had seldom been generous. In the depressions of the early nineteenth century they were parsimonious. The good times would return but in the first decades of the nineteenth century those with money were not as affluent as their fathers had been.

Outside London there was little interest in the arts. That kept artists in the capital to compete for what was going. Fawcett has shown[20] how low were the prices paid for pictures in the provinces. Sums below £10 were commonplace. It was a lucky man whose picture reached £50. Moreover, these prices included frames. Another problem was securing payment once a sale had been agreed. Sales through exhibitions usually required the payment of a deposit while the painting was still on the wall with the full balance paid before collection, the purchaser making his own arrangements for transport. This system guaranteed that the artist was paid, after deduction of commission to the gallery. Dealers bought under similar rules. It could be altogether quite different when a work was bought directly from the artist and even more hazardous when it was commissioned with, perhaps, only a small amount paid in advance. The aristocracy were notorious for not paying their bills. Legal proceedings were costly, lengthy and often uncertain. Not for nothing did Dickens invent the Circumlocution Office (*Little Dorrit*) or Mr. Tangle (*Bleak House*). Magistrates were ill-educated in the law and tended to favor the wealthy and also their friends who were usually among those who neglected to pay their debts. In any case, it did no one, artist or tradesman, any good to be seen as litigious, even infrequently. He could be sure that no further orders would come his way, neither from the debtor nor anyone aware of the case.

Throughout most of his life and especially in his early years Etty was much troubled by money problems. He had entered upon his career seriously indebted to his uncle William. Uncle William was a generous man always willing to help other less fortunate members of his family. But the young William regarded all the help he received to be a debt and when his uncle died and his brother Walter assumed the role of paymaster and guide, his sense of indebtedness became ever more acute. Walter funded his nephew until his late middle age and though the arrangement between them was that all debts would be repaid if possible, and in due course they were, Etty always considered that he remained in debt to Walter to the very end of his life, no longer in money but in obligations. Thomas Bodley also helped but to what extent is unknown, obviously not sufficient for Etty to feel permanently indebted. All young artists begin impoverished unless there is a munificent relative or friend at hand but Etty continued for most of his life to face financial difficulties. He had no head for business. He was temperamentally unable to bargain and could be beaten down without too much trouble. There are many instances of quite wealthy patrons haggling over a few pounds with Etty finally succumbing. Even though his work often increased in value after being initially placed on the market, Etty always ignored these changes in demand and never increased his prices when a sale was subsequently negotiated. It was a matter of honor to keep to his original price. It seems that he had not examined the differences between cost, price and value. He believed that even wealthy collectors should not pay more than what he regarded to be the appropriate price, though how he arrived at it is unknown. Perhaps he was always influenced by what his more recent works had sold for without considering whether demand had changed or, more particularly, whether the prospective purchaser was eager to acquire and would pay to get it. It seems equally likely that he calculated prices by reference to cost plus a reasonable profit. He does not appear to have applied the principle of charging what the market will bear. It was certainly his view that it would be immoral to increase the price of a painting that had not sold even if subsequently a buyer showed increased interest. Gilchrist records[21]

> To the last for all but his most important works, he charged old friends at old prices. So unworldly in money matters was Etty throughout his career, whether painting in obscurity,—"for Fame and the Honour of his country"—or, in the height of his reputation or in the decline of his health,—for "Independence, and a Cottage in York."

Unlike Constable, Etty did not despise anyone for not appreciating his work and unlike Turner he was not driven by anxiety to become wealthy. Turner, of anyone, understood the art market and how to exploit it, eventually being able to ignore it altogether and dying quite rich. Turner, like Canaletto, was well-known for raising his prices overnight. Anyone showing interest in Turner's work was well advised to settle at once. Delay usually meant an increase. Etty never seemed to realize the nature of the art market, at least not sufficiently to encourage him to manipulate it. Inevitably he was unlikely at the outset of his career to obtain commissions from wealthy patrons. They always bought from established artists. He relied on sales through the Academy and the British Institution exhibitions and an artist's early sales are always determined by need to make a start in life. In these years there was not a rush of purchasers for his work. Usually a sale resulted from the coincidence of an interested collector happening to attend an exhibition. Frequently he had to reduce initial prices in order to sell. Often he took what was offered merely to secure some money because always haunting him was his indebtedness to his brother and his own strict principles that all debts must be repaid as quickly as possible. Consequently for many years he accumulated very little private wealth. As a case in point, his sale of *Judith* to the Scottish Academy in 1829 followed his usual practice of asking of them no more than the reduced figure of 300 guineas he had asked from Birmingham although Edinburgh was much more eager to acquire it and were financially somewhat better placed. When in 1841 Robert Vernon wanted to buy *Bathers Surprised by a Swan* Etty initially asked £250. Vernon offered £200 and at first Etty declined. After a meal together in Vernon's house, just as Etty was about to leave, Vernon again offered £200 and laid the money on the table. Influenced by the sight of so much ready cash and no doubt affected by Vernon's hospitality Etty accepted, as, later, Vernon said he knew he would. Vernon was a tradesman with a tradesman's ability to bargain.

A similar event had occurred in 1837 when Etty revisited Manchester and was entertained to dinner by Daniel Grant, a manufacturer whom he had first met two years earlier. Grant wanted to buy Etty's *The Sirens and Ulysses* and also his *Samson Betrayed by Delilah*. Grant already owned *Venus and Her Doves*. The *Samson and Delilah* was on exhibition in Manchester and Grant had seen it but not the *Sirens*. Grant had already prepared the ground the previous day by confiding in Etty that "trade is bad," that his fellow manufacturers were "afraid of Pictures" and that his firm had lost £100,000 that year. "Over their wine," says Gilchrist[22] "the Pictures being mentioned, his wealthy host takes it into his head to bid for them; asks 'what will he take' for both paintings." Etty, reporting this to Walter, decided to ask £300 for the two, having already refused £100 for the *Delilah* alone. According to Gilchrist, Grant had taken £300 to the races that very morning and had lost only £25, so he was well able to pay the amount asked. (How Gilchrist knew this is not revealed.) Grant offered £200—"in notes." Etty could not accept since the paintings represented "the best part of a year's work." Grant increased his offer by £50 but still Etty refused. Grant put the money back in his pocket and Etty confided to his brother that he now thought he had been too obdurate. He remembered Walter's advice—"Never refuse money, William." When he was leaving Grant that evening his host suddenly asked, "Will you take the money?" and Etty, taken by surprise, agreed. Grant obtained a bargain but this was never actually proved since on his death his brother presented *Ulysses and the Sirens* to the Royal Manchester Institution who, in due course, gave it to the Manchester City Art Gallery where it remains. Gilchrist said that in 1854 this painting was valued at £2,000, presumably for insurance but nonetheless a considerable amount for the time. In negotiations it is always necessary to know your adversary. It seems that Etty was always too trusting of another's good nature. He was probably always seeing himself in others.

It was not at all unusual for paintings to be resold within a few years at a greatly enhanced price but Etty seemed always unconcerned. It is instructive to see from Farr's Catalogue how many of his paintings increased in price over the years.

The Coral Finder which Thomas Tomkison bought direct from Etty in £30 in 1820 went through many hands until in 1849 it was bought by Agnews for 370 guineas.

Cleopatra's Arrival in Cilicia was commissioned in 1821 by Sir Francis Freeling for 200 guineas though it seems it was unlikely that he paid the agreed price. In 1880 it was sold for 500 guineas. Of course sixty years had passed and general prices had increased but nevertheless it appears to have made a considerable profit.

The Destroying Angel and Daemons of Evil, having been commissioned as early as 1822 for 60 guineas, was bought directly from Etty by Henry Payne of Newark for £130 and sold by him to Sir Joseph Whitworth in 1854 for 770 guineas.

Phaedra and Cymochles, bought directly from the artist by Wynne Ellis in 1832 for 100 guineas, was sold 1874 for 510 guineas.

Britomart Redeems Faire Amoret, bought by a "Mr. L." of Manchester in 1833 for £157, was sold to Lord Charles Townshend in 1849 for 520 guineas.

Wood Nymphs Sleeping, Satyr Bringing Flowers, bought from Etty by the dealer Colls for £50 in 1835, sold in 1851 for £500.

Mars, Venus and Cupid, bought directly from Etty in 1836 for 120 guineas, was resold in 1845 for 370 guineas.

A Family of the Forest, bought directly from Etty by his friend Harper (probably John) in 1836 for £50, was sold in 1850 for 192 guineas.

Mars, Venus and Cupid, painted 1836, exhibited 1837, sold as *The Bivouac of Cupid* for 120 guineas and again in 1845 for 370 guineas.

Pluto Carrying Off Proserpine, bought from Etty by Lord Northwick for £350 from the reduced original price of 500 guineas, was sold in 1872 for 1,000 guineas.

Diana and Endymion, bought directly from Etty for £100 in 1839, fetched 210 guineas in 1845 and 300 guineas in 1878.

The Repentant Prodigal's Return was bought directly from Etty by the Marquis of Lansdowne after exhibition in the Royal Academy in 1841 for 250 guineas, no doubt regarded as a good price, but it was sold in 1895 for 460 guineas. Of course, over fifty years general prices had increased so it is difficult to be sure that any considerable profit was made, but it is clear that Etty's work could usually at least hold its value. Etty's religious subjects were however exceptional. Most lost value severely over the century as attitudes changed.

To Arms, to Arms, Ye Brave! was bought from Etty in 1842 for £200 and resold in 1845 for 390 guineas and again in 1849 for 450 guineas.

The Dance, bought at the Birmingham Exhibition in 1842 by a Mr. Bacon for the greatly reduced price of 360 guineas, was sold by the dealer Winstanley in 1852 for 1,100 guineas.

Musidora, bought directly from Etty by George Knott in 1843 for 70 guineas, was resold in 1845 for 225 guineas. Knott was a City of London merchant and clearly experienced in doing deals

The Judgement of Paris (second version), commissioned in 1845 by Gillott for 600 guineas, sold in 1872 for 810 guineas.

The Fairy of the Fountain, commissioned by Gillott in 1845 for £300, was sold in 1872 for 470 guineas.

Andromeda, bought in 1845 for 210 guineas, rose to 300 guineas when sold a year later and to 400 guineas in 1858.

Circe and the Sirens, bought directly from Etty by Gillott in 1845 for 350 guineas, was sold in 1872 for 600 guineas.

Aaron, also bought by Gillott for 100 guineas in 1848, was sold in 1854 for £375.

The foregoing does not, of course, tell the whole story. There are many paintings whose prices we do not know and many, though apparently not so numerous, where prices fell on resale. It is true that prices of all of Etty's paintings fell considerably during the twentieth century. Anyone buying in the 1870s and 1880s with a view to future sales would have made a bad investment. It is difficult to assess the present day value of these prices and since we are dealing with

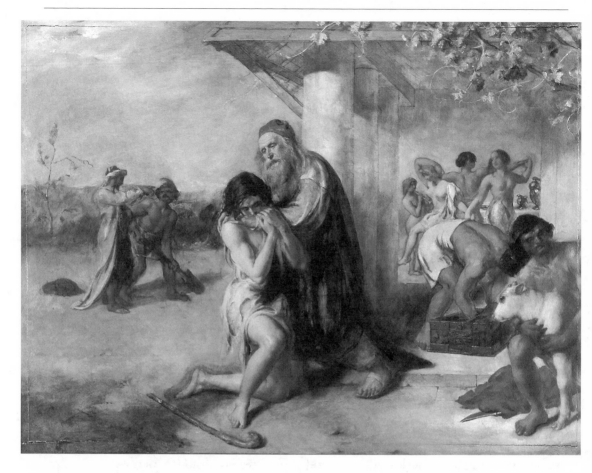

The Repentant Prodigal's Return to His Father (34 × 36 ins) (1841), Ashmolean Museum, Oxford.

a very special commodity operating in a unique market of personal tastes and fashions it is better not to attempt such comparisons. So far as Etty's own lifetime was concerned there is no doubt he did not receive the full monetary rewards that he deserved. Reliance on dealers during the latter part of his life may have guaranteed sales and relieved him from the worry of bad debts but they were not in business to act to his or any one else's advantage.

There were however occasions when Etty realized that he was being robbed of his due. One such was in the spring of 1829 when a publisher wished to engrave his painting *Cleopatra's Arrival in Cilicia* which he had sold to Frances Freeling in 1821. The intention was to include the engraving in an *Annual* for general public sale. The publisher approached Freeling who, as owner, had no objection but since under the terms of the Copyright Act of 1735 he did not own the copyright, he directed the publisher to Etty. Etty asked for a fee of thirty guineas which the publisher refused to pay, believing that Etty had no rights in the painting, having sold it, and that he should be pleased to have his work made so widely known. For once Etty stood his ground. He was now famous, this painting in particular was valuable and the law allowed him to reap the rewards of his skill. Freeling supported Etty and as Etty wrote at the time, in a draft letter discovered by Gilchrist, the addressee being the engraver: "I think I may safely say, I have as little mercenary spirit as any Artist. But there's a point beyond which indifference to money is wrong."[23]

Etty went on to claim that as he had studied some fifteen to twenty years to perfect his skills and the law recognized his continued rights in the work, he was entitled to be properly rewarded.

This was not a stance Etty often adopted. But in 1834 he stood up for his rights against no less a person than Lord Darnley. His Lordship had commissioned Etty in 1825 to paint *The Judgement of Paris* for £500. He was a considerable collector and no doubt Etty felt that receiving this commission would afford him suitable recognition by his contemporaries, but Lord Darnley showed no interest in the finished work. It remained with Etty for some time and only after repeated requests for payment did he receive £400 in four installments spread over three years. On 3rd June 1834 Etty's patience had run out and he wrote to brother Walter, "I began, yesterday week, to cogitate and afterwards write a letter to the Lord Darnley" and explained that he had said that "an illness of many weeks ... wholly prevents his exerting himself in his profession, has prevented him from completing his usual quota of Pictures for the Exhibition and has thrown him back consequently on his own resources."

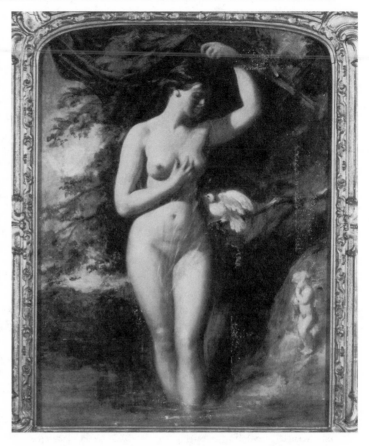

The Fairy of the Fountain (27.875 × 20 ins) (1846), Tate, London 2005.

Lord Darnley called on Etty and according to the letter to Walter had expressed the view that "the Painter had received the Picture's value by receiving £400." Etty told his Lordship that he had a different opinion and reminded him that he had "studied twenty years and spent on the picture best part of a year and gone to considerable expenses with that picture and taken the pains I did with it." So he considered he was entitled to full payment as promised.

Throughout the eighteenth century the aristocracy had regarded it almost obligatory never to pay tradesmen and, unfortunately for artists, they were too frequently regarded as being in that category. But things were changing in the nineteenth century and Etty had no intention of being treated as someone's tailor. So, as he told Walter. "I procured the necessary documents" and went to Lord Darnley's house.

> As I drove up, his Lordship was just dismounting. I laid before him one by one my powerful documents. He paused, again said he thought it was not worth five hundred guineas, or someone at the Gallery would have bought it at that price. I told him *that* did not exactly follow—many people had not room for large pictures—put it to his candour whether a man having studied twenty years, and of my standing in my profession, was not entitled to £400 a year for his exertions. He paused again. *He would settle it!*

But not entirely as it turned out. In another letter to Walter, dated 1st July, Etty tells him

> Knowing how much it would agitate and unsettle my mind to have it go to Reference—at a time, too, when I wish to have my mind easy, and to regain my health and strength,—I have made up my mind to take the £75 and have done with it. Rather than any law proceedings, I would have lost it altogether.

This was the year of Etty's serious illness and his later departure to York for convalescence. One can see that he was in no state to undertake lengthy legal proceedings which would certainly have been contested and could well have resulted in a smart lawyer's deriding Etty's abilities on the lines of the famous Whistler versus Ruskin trial in 1878. The settlement of £75 was actually offered by Lord Darnley's heir, his Lordship having in the meantime died. The new Earl sold the painting in 1838 and after other changes in ownership it sold in 1848 for £1,000. Another version painted for Joseph Gillott in 1845 was bought by him for 600 guineas and sold in 1872 for 810 guineas. At subsequent sales both paintings dropped considerably in price but by the end of the century Etty was no longer collectable. As always, fashions had changed.

Etty's affairs were increasingly in some confusion after his uncle died. Walter assisted and gave advice but apparently did not interfere. Some years before the Darnley episode, in 1831, Etty was concerned that he owed Walter £804, quite a considerable sum for the time. By 1841 all Etty's monetary debts had been discharged and he was standing, though still precariously, on his own feet. In that year Edward and John Harper took Etty's financial affairs in hand. They must have advised him that he had insufficient capital to contemplate retiring to York as it was becoming increasingly apparent this would be necessary since his health was unlikely to improve. They invested £300 for him in 3 percent Bank Stock, establishing what they called "The Etty Fund." This was a small amount for a successful artist of 54 to have put aside. It was certainly not due to profligacy; Etty always lived somewhat parsimoniously. He seems to have drunk wine only at dinner parties, and then not very much. His own favorite drink was tea which was expensive enough at that time so he limited himself to two cups per meal. As has already been reported he had originally feared that 14 Buckingham Street would be too costly—an indication of his concern not to overspend—but in the event the upkeep of the premises does not appear to have troubled him. It is believed that Walter paid his rent but this is by no means certain. He had Betsy and two servants to pay and provide for but the wages of servants were notoriously low. It is known that £9 a year was paid to one of his women servants in Buckingham Street though she would have had meals provided. C. S. Peel[24] considers that around 1830 "£12 a year was regarded as a good wage for an experienced woman servant" but this would depend on what was provided by the employer. It is known that Etty provided sugar and tea, as many servants expected, as these items were expensive. What we know of Betsy suggests that she would not waste her uncle's money. Etty would have relied upon her to run his household as economically as possible. From the few notes of expenses made in his notebooks it is clear that he had no idea how to manage his affairs.

Etty accumulated most of his wealth in his final years. His small capital of £300 in 1841 proved a wise investment and although it attracted only 3 percent a year his capital had become £5,000 by 1844 when in August of that year he wrote to Betsy telling her so. He had added to his capital whenever he could. In a letter dated 12th September 1843, Etty told Thomas Bodley: "I have added Three Hundred Guineas to my stock which adds to its *respectability* and usefulness." By 1845 it had increased to £8,500. This was the result of some worthwhile sales, his investment and a good deal of frugality. After 1845, for only the final four years of his life, purchases by Joseph Gillott brought a sense of security that he had not before experienced. But Etty never hoarded money out of any desire to own it. He had always in mind his ambition to buy a house in York for himself and Betsy to retire to. In this he was to succeed.

There were always calls upon him to subscribe to the particular causes which interested him. As a famous artist, especially one who never shrank from encouraging others to save old buildings or purchase works for public collections, he had to demonstrate that he too was ready to put up money. The causes of York Minster and the City Walls cost him various sums, but they were never large: £30 in 1829 for the Minster restoration, £50 in 1832 to save Bootham Bar and £2. 2. 0. in 1844 towards the new Minster bells. The latter was a modest sum indeed. There may have been other unrecorded sums but the general impression is that Etty was more inclined

to write letters and make speeches than put his hand very deep into his pocket. He probably did little to assist his parents since when Walter offered to pay them an annual sum they declined to accept it, saying that an occasional £2 would be sufficient. Generally his family did not need financial assistance. When in February 1837 an elderly relative, Mrs. Rachel Calverly, was reported to be in considerable financial distress,—"she has only from 2/6 to 3/- a week coming in,"— he sent a sovereign to be given to her. On another occasion he sent an impoverished distant relative a mere 2/6d. Although he had no intention of encouraging idleness in others he was not like Turner who steadfastly refused to assist his poor relatives who sent frequent begging letters from Devon. Whereas Turner had plenty to spare Etty had found the fruits of fame difficult to achieve.

Like all men known to have achieved success, Etty was often the target of others. On 16th June 1838 he received an appeal from a Robert Pattinson in Liverpool claiming old acquaintance and asking for a loan of £30 to £50 to enable him to start up a trade in Irish goods. He and his wife had fallen on hard times and were destitute. He promised to repay the loan in weekly amounts "plus a good profit." Etty sent him £5 for which Pattinson thanked him, promising repayment. Whether he did is not known.

All in all one must conclude that Etty did not charge enough for his work. Although London was full of artists, not many were painting the nude figure and in this field he was regarded as pre-eminent. Those who wanted such subjects, and there were always sufficient, could generally afford to pay more than they did. Not perhaps the lower gentry who shared his beliefs in the nature of art and life, but there were certainly enough old nobility and new rich who knew the value of what was offered.

CHAPTER FOURTEEN

A qualified tribute from one artist to another

Etty was so highly regarded by his fellow artists they seldom offered criticisms of his work and when they did they usually confined themselves to making comments on detail. Even Constable and Leslie who objected to so much bare flesh recognized his skill and asked only for more draperies. One artist who ventured to question Etty on details was Edward Calvert to whom it might be thought Etty's subjects would not appeal. In 1840 Calvert, who was then 41 years old to Etty's 53 years, wrote him at length offering tentative advice and some gentle criticism. The letter is worth quoting in full because it indicates the kind of comment that one artist would make to another at this time. It also informs us of the high regard in which Calvert held Etty.

My dear Mr. Etty

In naming the things that unpleasantly affected me in your picture of the *Ten Virgins*, I feel a confidence derived from several sources.

First—My admiration of your works is such that I can trust to the motive with which I address you. Then I think I have a kind of right to speak freely with you, seeing that with others I speak only your praises. And I have no fear of offending because I have witnessed too much of your patient, humble and victorious conflict with the giant difficulties of Art, not to trust to your greatness. You can afford to be robbed, for you must necessarily remain wealthy still.

The first thing that I did not like was the disposition of the Architecture (I am not adverting to any deviation from Authentic models). It appeared too much like a box set up for a show; and to have not space enough within it. Not even the massiveness of its style together with the largeness of the general organization of the picture seemed sufficient to prevent it from appearing to be narrow.

That which next displeased me was something in the Action of the Bridegroom that appeared too repulsive of the unadmitted five. The only things remaining that I think unsatisfactory are—the shape of a sleeve in one of the Wise—and in the figure with the beautiful face who is regarding the Bridegroom there is a coronet of flowers so large as to detract (I think) a little from the Chastity of the wearer: and to destroy that repose which might be grateful so immediately beneath the lamps.

I have now said all, unless I may be allowed to advert to the other two pictures. In the beautiful *Andromeda* the features of the face are perhaps in the *slightest degree* too small. And in the *Venus* the same features are I think in an equal degree too large, giving the least taint of grossness to her character inconsistent with the beautiful body and limbs. The flow of line in her right outer ancle [sic] appears to have overwhelmed the borders of correctness and to have become licentious. In the sway of line, on the contrary, in her left arm down to the elbow, although wonderfully free, yet the mind rejoices in the charm, and assents to the divine daring. In the picture of *Venus* I think there is something heavy in the termination of the landscape with the sky in one part. We feel fastidious concerning the landscape with the author of backgrounds to the pictures of *Proserpine, Psyche, Venus with her doves, Dancing Bacchante, Family of the Forests, Nymphs surprised by a Satyr*, etc., etc. I do not like the shape of the arch, or an arch at all, above the head of the Venus, beautiful and useful however the color may be. But it is gluttonous to want more where beauty is so largely spread.

I consider the production of the two pictures an honor to the Country. Such should be done in a great nation.

I congratulate you on the majesty and the copious largeness expressed without loading the muscles and forms. One appears to have seen life-sized figures.

I congratulate you on the musical harmonies of figure and color in both. On the exquisite bounding of the lights in the limbs, on the grace of execution. On the Dorian greatness of the largely flowing sanguine here in the Venus, and the elephantine enchantments of the daughters of Cepheus.

I have never seen whether in Ancient or Modern Art, such perfect concord between the forms and colors. The color of *Andromeda* not only belongs to the circumstance but to the delicate form that it pervades. And I never saw before such delicacy at the same time so great.

I am dear Sir with the highest respect

Your very obedient servant and faithfully your friend

Edward Calvert

14 Park Place

Paddington Green

11 April 1840

Thus, despite the perhaps surprising (to the modern mind) strictures that a coronet of flowers should suggest lack of chastity or the line of an ankle should indicate licentiousness, or that "elephantine" should be considered an appropriate adjective to apply to female enchantments, Etty is unhesitatingly praised for the harmony, grace and delicacy of his pictures. There is no doubt that Etty was regarded by his contemporaries as an outstanding artist bringing honor to his country. Whatever the newspaper critics found it expedient to write to satisfy their readers, Etty's fellow artists usually praised his work and if they found it necessary to offer criticisms they did so in restrained terms that recognized his status.

The Parable of the Wise and Foolish Virgins exhibited at the Royal Academy had not been received very kindly by the critics despite its subject. *The Times*[1] described it as "A large life-size group—not very pleasing. Who were the Models?" Was this an oblique comment on Etty's usual models? Was the critic suggesting that models who usually posed naked could hardly be regarded as virgins? In the background Etty had introduced some architectural features which another critic said reminded him of an entrance to a "modern station-house."[2] That could have been regarded as equally critical of railway architects who were raiding every architectural style in an attempt to make railways acceptable to the general public. Etty usually took more notice of his fellow artists and peers than he did of newspaper critics, rightly believing that the former were better judges of art than the latter who, for the most part, were more concerned to flatter readers who were even more ignorant of such matters.

Another important appointment—The National Gallery

Well before the overcrowding of the National Gallery in its Trafalgar Square premises was becoming a matter of urgent concern Sir Robert Peel, who had just been appointed Prime Minister for the second time, considered it desirable that someone should exercise overall direction of the national collection's future. This was typical of the government's attitude to the arts. It disapproved of undertaking any financial obligations but wished to exercise control. Had Constable lived long enough (he had died in 1837) he would have felt confirmed in his objections that the establishment of a national collection would invite government interference in the arts. From its inception the National Gallery had been directly under the Treasury and so was, technically, a Government department. In 1824 six Trustees had been appointed of whom two, the Earl of Liverpool and the future Earl of Ripon, were Prime Minister and Chancellor of the Exchequer respectively. Of the other Trustees, Sir Robert Peel was Home Secretary (later to become Prime Minister), Lord Farnborough was Paymaster-General and the Earl of Aberdeen was to become Foreign Secretary. The Government had made it certain from the outset that it would control the Gallery.

Sir Robert Peel apparently did not consider that the artists already acting as trustees could be relied on to make informed judgments without the assistance of additional artists selected by Parliament. These artists, not having been elected to the Gallery's Council, would be unlikely

to agree with its policies and forms of administration. It was one thing to break a monopoly, altogether another to introduce inevitable dissension. What he did, however, was to set up in 1841, being then Prime Minister, a consultative committee of eminent artists to advise the Trustees of the National Gallery on future purchases. The committee consisted of Charles East-lake, Augustus Callcott, Henry Howard and William Etty, three being elected members of the Academy Council, and Howard being secretary to the Academy Council and this presumably being his task with the committee. Etty was thus confirmed as an authority and one, moreover, who rubbed shoulders with the great, none other than Eastlake himself, who was friendly with the Royal Family and destined for higher honors. Etty had already shown himself to be inter-ested in the nature of acquisitions for the National Gallery, having complained in a letter to the *Morning Herald*, published 18th July 1836, "why is our Gallery of the Old Masters called the National, seeing that the pictures are not, for the most part, of our nation?" In July 1837, he had supported the movement for purchasing Constable's *Cornfield* by circulating a letter, in order, as he said, to "give our Rulers a hint that if they really wish to patronize and foster Fine Art, they must not forget entirely the flowers that spring up on our own earth." Etty also wanted the National Gallery to acquire this painting in order to afford Constable his due recognition. Whatever Constable occasionally said of Etty's paintings—usually objecting to "ladies' bums"—they each had a high regard of the other and remained good friends.

An immediate task given to the committee was to give the Gallery Trustees their opinion of a painting that had been offered to them and which was alleged to be by Raphael. Eastlake presented a report on the 3rd May 1841, stating categorically that the painting was not a Raphael but by Fra Bartolommeo, certainly good enough to purchase but a suitable price could not be suggested. Whether the report had been composed by the committee or by Eastlake alone is unclear but it was written in the first person singular and revealed that he had a detailed knowl-edge of the painting. At least one of the Trustees was reported as being astonished by the news; "We never had any doubt about that! the only question was what it was worth."[3] The Trustees took no further interest in the painting. In those days they were willing only to collect "big names" and it is unlikely that either the government or the public would have approved the acquisition of a painting by someone unknown to them. The Trustees had however become aware of the value of having a committee of informed persons to turn to.

The establishment of the National Gallery on its own site had proved highly successful with the general public. In 1835 when the Gallery was still in Pall Mall and awaiting the completion of its part of the new buildings in Trafalgar Square, the number of visitors was 130,000. In 1840, when it was sharing the Trafalgar Square building, the number of visitors was officially given as 768,244. In 1843 Eastlake was appointed Keeper of the Collection by Peel. Although the Gallery was administered by Trustees, they acted under the aegis of Parliament who exercised the pow-ers of acquisition. But Parliament and many of its ministers were quite unsuitable for the task. When in 1836 a Parliamentary Committee had recommended the purchase of some pictures by Raphael and his predecessors, Peel told Eastlake,[4] "I think we should not collect curiosities." The Trustees learned how to circumvent Parliament. This remained the position until 1855 when Lord Rosebery vested in the Trustees all powers to make acquisitions. There was not any coher-ent art theory in the country and no agreement over the desired nature of national or local col-lections, which continued to be regarded as just large "cabinets of curiosities" despite Peel's anxiety to avoid this but at the same time lacking any sensible alternative ideas of his own. At least England now had its national collection which the public could visit and which, it was hoped by philanthropists, would improve their moral virtues. As Victorians they could only sup-port such institutions if they did one good. The Gallery was fortunate to have the conscientious services of Sir Charles Eastlake as its Director from 1855 until his death in 1865. Having the final decision regarding acquisitions, his expertise and good taste ensured that the Gallery acquired some of the finest Italian pictures available, these being the most desired paintings at

this time. Etty, of course, was dead by now but he had had the advantage of knowing Eastlake firsthand and benefiting from his good advice and in some small measure influencing the Gallery's purchasing policy.

"Nature supreme and over all"

In July 1841 Etty took time off to visit Belgium for a second time. In September of the previous year he had taken Betsy with him but it had been very much a "lightning tour" since they had visited seven cities before taking a river boat back to Rotterdam. He wanted to concentrate this time on a single artist. Although he had reputedly first seen Rubens' work in the Luxembourg Palace in 1822, it is very likely that he had already seen the several works by Rubens in the Dulwich Picture Gallery. As a student of the Academy he was permitted entry to the Gallery for study purposes and without doubt the many Rubens bequeathed by Sir Francis Bourgeois in 1811 would have attracted him. Etty again studied Rubens in the Louvre in 1823 when he copied his *Sea Nymph* and he returned to Rubens yet again in 1830. Rubens was not an admired artist in early nineteenth century England, being far too "fleshy" and generally condemned as lascivious. If the nude was accepted it had to be modeled on classical examples. Etty had heard Opie's lectures as a student and Opie had always stressed the need for artists to be true to Nature. Whereas the Academy Life Class tuition had required students to correct any physical imperfections in the models, Opie preferred them to draw the figure just as it was. As we have seen this caused some students considerable problems. They were required to draw in the classical mode but no model ever possessed a classical figure. What was the purpose of drawing from the model if they were to ignore it? As a mature artist Etty was always being criticized for not making his figures sufficiently classical and impersonal. Certainly Rubens' nudes looked like real people. That was the crux of the matter, contemporary taste did not want nudes that looked like real people. When Etty had visited the Louvre in 1830 he jotted down in his notebook approving words for Correggio, Rembrandt and Rubens, adding against the latter—"Nature supreme and over all." He was, of course, referring to the human body not to landscapes.

So off he went to Belgium to immerse himself in Rubens. He had a bad crossing but in a small sailing ship in the North Sea this was only to be expected. Recounting his experiences to Betsy he said that[5]

> It was getting darkish when we got out to sea. Then began the tug of war, when out of the shelter of land. As she rolled a good deal, and a fresh wind on, there were strange and pressing calls for the Steward. I kept on deck all night, on a blanket and a mattress. Sinking into a nap, and awakened by the roaring sea, he wondered where I had got to. ... Some ladies got into their Carriages. But Old Neptune did not let the Aristocracy escape.—Basins were called for, even into *their* luxurious retreats. As morning dawned, the wind abated, and the Belgian coast appeared in the misty morning. Walcheren and Flushing, the grave of many a brave English soldier, we passed close to; and entered the wide-watered Scheldt: about eleven, anchored off the Quay, or rather hove to.

This extract indicates the custom of wealthy persons taking their carriages abroad even as today it is possible for travelers to take their motor cars, though then the carriages were lashed on deck and readily available to provide comfort for the sea-sick.

Etty stayed first in Antwerp then he went to Malines where he saw Rubens' *Miraculous Draught of Fishes* and *The Beheading of John the Baptist* and also to Ghent and Bruges. We must assume that he saw Rubens' *Raising of the Cross* and *Descent from the Cross* in Antwerp; it is quite unlikely he would not have visited the Cathedral to see these unquestioned masterpieces. He twice visited a Trappist Convent and watched printers at work causing him to reminisce on his own apprenticeship. On his second visit to the Convent he joined the monks in a meal of "new milk, eggs, beans, carrots, cherries," and "other productions of the earth." He watched everything that was going on, obtaining ideas which he hoped "will be useful" in future paintings.

He stayed there overnight, going to bed at eight and being awaked at two in the morning to attend service and then to take breakfast of brown bread and milk. He bought a monk's habit before he left and the whole experience clearly enthralled him. For at least one night he was back in the Middle Ages. He went on to Mechlin and visited the Cathedral where he saw some paintings by Rubens. Then on to Ghent and Bruges. In Bruges he went to a Capuchin Monastery and there bought a Capuchin habit. Both purchases were made with a view to using them as accessories in his proposed *St. Joan* paintings. In all, the excursion had lasted ten days and he came back from Ostend eager to give Betsy every detail. Etty was enthralled by the paintings by Rubens, unaware that he had employed a team of assistants and that only exceptionally did he paint even the majority of a picture himself. The workshop system used by many prolific artists in the past was still not generally acknowledged, though Kneller's "factory" methods had been famous in his time. The system was not used by Etty and his contemporaries. Every artist who had much work in hand employed an assistant to prepare canvases, mix colors and lay in backgrounds and many artists had contractual arrangements with other artists who painted the more specialized details for them such as costume details. They became known as "drapery painters" but Etty had always declared that he did not wish to paint materials or "stuffs" and what he did not paint himself he did not put out to another.

The importance of Etty's visits to Belgium to see firsthand the paintings of Rubens was not only to study his methods of painting luxuriant flesh but, perhaps, surprisingly, to examine Rubens' interest in Nature. Rubens is not usually the first name to spring to mind when considering the art of painting Nature. There were plenty of Dutch artists at the time to whom we now refer but Rubens frequently painted landscapes, and in his final years is believed to have painted some fifty outdoor scenes. His landscapes are luxuriant, even arcadian, and we may expect that it was these qualities that appealed to Etty. We do not usually associate landscape painting with Etty, though there are a few examples to be seen, and even less do we associate with him the authorship of Romantic Nature poetry so the following may come as a surprise. In one of the notebooks made available by Tom Etty of Nijmegen is the following, unfortunately undated.

> Deep in the vale of peace retired far,
> I trace upon the Book of Nature loved so well
> For faction's restless brood and feverish war
> My soul detests them as the gates of hell.
>
> I love the lofty crag. The mountain hoar.
> The mighty music of the forest's roar,
> Or billows darking on the rocky shore.
> The cattles' low. The eagle's cry,
> And eke the cataract white, that dashes from on high.
>
> And oh! sweet Nature, on thy face
> How much, how fondly can I gaze,
> Thy lineaments *divine* to trace
> Till lost in thy effulgent blaze!
>
> The blade of grass. The weed. The flow'r.
> The blossoms clust'ring on the tree.
> The morning breeze. The gentle show'r.
> All fill my heart with love of Thee.

It would be pleasing to know that these verses, as unskilled as poetry though they may be, were the result of looking at Rubens. It is more likely that Etty had been reading Wordsworth, to whom there is but a passing reference by Gilchrist, so we must assume that Etty might merely have read his works occasionally and felt, as so many did, intensely inspired by them. Years later Etty said that he wished to paint "a monument *a la* Rubens—a Picture from his own hand." The nearest he came was his copy of *The Rape of the Sabine Women*.

Summer excursions

After Belgium, Etty paid his usual summer visit to York and there enjoyed the company of his friend John Harper on a two days' sketching trip to Bolton Abbey. Harper was himself proficient with the pencil, preferring landscape subjects. Although he occasionally went on sketching trips with John Harper, Etty was not by inclination a landscapist. Only a dozen or so landscapes by Etty appear to have survived. Most are of views local to York, five of which are in the York Gallery collection. The earliest is probably of *The Plantation at Acomb*, then a village on the west side of York. It has been dated c. 1840. Another possible *Acomb Plantation* scene (see below) is inscribed "Etty 1842." The plantation is now the site of a sugar beet factory. Etty sometimes

The Plantation at Acomb, York (8.5 ins diameter) (c. 1842) York Museums Trust (York Art Gallery), YORAG714.

Givendale Church, Yorkshire (8.25 × 11.25) (c. 1848), York Museums Trust (York Art Gallery), YORAG78.

visited John and Rebecca Singleton at Givendale in Yorkshire and here he painted two scenes, one of *The Fishponds* and another of *Givendale Church* (see above), both possibly in 1848 after his retirement. These are also in the York Gallery collection. A very free sketch of *The Strid, Bolton Abbey* (see facing page), appears to have been painted directly from the subject and has been attributed to the occasion when Etty took his two day tour with John Harper in the summer of 1841. This reveals a spontaneity not usually found in Etty's work and suggests that he could have been a successful landscapist in the manner of Constable had his interests been in that direction. This painting was exhibited at the Society of Arts where it was dated 1843. Etty's visit to Bolton Abbey was in 1841 and the sketch must have been painted then. It seems unlikely to have been made later from a drawing. An inscription on the back of this painting reads *Mr. Wood purchased at the sale of the late Mr. W. Etty's pictures a parcel of sketches of which this is one. Lot No. 375 at Christie's.* It may be that Mr. Wood did indeed purchase this painting on the occasion of this sale but Farr comments that Lot No. 375 was a copy of a Titian painting made by Etty, not a landscape.[6]

 Since Etty's paintings of landscape are few in number and not easily dated it is convenient to refer to others here. In private ownership in Wiltshire are three seascapes. These were probably painted when Etty visited his cousin and friend Thomas Bodley at Brighton 1836. Letters from Etty to Bodley at the time indicate that he was wishing to make sea studies in connection with his proposed painting *The Sirens and Ulysses*. The minimal importance given to the sea in this painting suggests that Etty was being over-conscientious in his desire to study everything at firsthand. But Etty was always eager to do well in whatever he undertook. There is a revealing note which Etty wrote to a patron, Andrew Fountaine, indicating his pleasure in being praised for a landscape background. In 1849 Fountain enquired regarding the identity of the models

The Strid, Bolton Abbey, Yorkshire (8.25 × 11.5 ins) (1841), **York Museums Trust (York Art Gallery), YORAG723.**

Etty had used for his *Judgement of Paris*, exhibited in 1826. After replying to this enquiry Etty sent a further letter, dated 6th July 1849:

> Since I wrote the last note to you, a circumstance occurred to my memory which may be interesting. When during the Varnishing and Retouching Day previous to the opening of the Royal Academy Exhibition the year it was exhibited there—when I was retouching it, Callcott, the Landscape Painter says to me "Etty! What business have *you* to paint a *landscape* as well as that?"

Callcott must have been referring to the trees on the lefthand side of the painting (see color plate 5) since there is very little of a landscape nature elsewhere. These are exceptionally well painted for Etty, who usually treated backgrounds in a summary manner. There are also two well painted peacocks at the lower right hand corner, obviously the result of some careful studies.

Etty was also not by inclination a painter of still life. Fourteen such subjects have survived, three being in the York Gallery collection. They were probably all studies for accessories for his larger works. The earliest, *Study of a Peacock*, was probably painted in 1826. This is in the Tate Gallery collection. There is another peacock subject in the City Art Gallery, Manchester, which may have been painted at the same time. Both are probably studies for the 1826 *Judgement of Paris*, in the Lady Lever Art Gallery at Port Sunlight and used again in the 1846 version now in the Scarborough Art Gallery. The York City Art Gallery possesses an inferior version of this subject which was painted for Joseph Gillott in 1845 and finished the following year. Etty also painted five studies of pheasants, also probably originally intended for inclusion in larger works though none can be identified. It is likely that these pheasants were sent to Etty in Buckingham Street at various times by the Singleton family at Givendale as there are several letters from Etty thanking them for such gifts. There are also six studies of flowers and fruit. Only one of these is at York. These still life subjects are not paintings by which Etty's significance can be judged.

Landscape with House (probably the Rev. Isaac Spencer's house, "The Plantation," Acomb, York, c. 1840), Tom Etty, Nijmegen, The Netherlands.

A prestigious appointment—The Houses of Parliament

When in 1841 Professor Charles Cockerell, R.A., gave his series of lectures on architecture to the Academy, Etty took offence at his comments on the Gothic style and felt obliged to address a letter to the Professor to put matters right. He particularly objected to Cockerell's disparaging the Gothic style and claiming that Michangelo was more Gothic than Classical. This had also been Blake's view. While disparagement of the Gothic was heinous enough to Etty, who had done so much to preserve York Minster and York's bars and walls, he could not allow Michelangelo to

be despised. Ever since his first visit to Rome in 1822 Etty had venerated Michelangelo, though not so unreservedly as he did the Venetians and especially Titian. Etty was strongly sympathetic to the Gothic but also believed the Classical to be equally worthy. He insisted that the two be differentiated. In the course of his lecture Cockerell had also adversely criticized Cologne Cathedral and referred to the Tower of Babel, suggesting that Gothic architecture was a babel of styles. Etty had stopped in Cologne during his visit to Belgium and he felt obliged to remind Cockerell that whereas the Tower of Babel had been erected in defiance of God, Cologne Cathedral had been erected to the honor of God. Though Etty was never reluctant to argue his case with anyone he always did so with such courtesy that he never made enemies. Later, in 1849, when Etty was given a retrospective exhibition (which will be considered in its appropriate place) Cockerell sent him a kindly congratulatory letter.

Cockerell had been one who had put money down to save Lawrence's collection of drawings and again to purchase Constable's *Cornfield* for the National Gallery. So Etty wished to have a good opinion of him but justice had to be done to his heroes. Architecture was being critically reassessed at this time because so many new buildings of an official nature were either being built or planned and there was no general agreement for a preferred style. Buildings went up everywhere in various styles, usually classical for art galleries and museums, Gothic for civic buildings and churches and Renaissance Revival for almost anything that could accommodate it. The general distinctions seemed to suggest that art and science were classical subjects (though not always, the Natural History Museum first conceived in 1860 but not completed until 1881, is quite frankly ecclesiastical and Gothic with Romanesque interior details in a nave-like central hall); churches were Gothic and civic buildings could be either Classical or Gothic depending upon whether the current concepts of law and order were regarded as derived from Rome or the Middle Ages. There is thus no such thing as a Victorian Style in architecture, buildings were designed according to individual tastes. All that can be safely said of Victorian architecture is that it is determinedly eclectic. Although Etty preferred Gothic art for its religious associations he preferred Classical sculpture and Italian Renaissance and Baroque painting. Michelangelo was without question a classicist and truth had to be defended.

It was this confused attitude towards contemporary architecture that had delayed the rebuilding of the Houses of Parliament after the disastrous fire of 1834, an event which Etty surprisingly never mentions in any of his surviving correspondence. Originally Robert Smirke had been chosen to design the new buildings, because of his expedition in providing temporary buildings after the fire. When it was proposed that the new Houses of Parliament should occupy the space between the ruins and the river there was such a public outcry that Smirke was dismissed and a commission appointed to administer a competition. The design had to be either Gothic or Elizabethan (Smirke usually had a preference for the Classical) and there was public satisfaction when Charles Barry's entry was selected. His exuberant Gothic edifice was regarded by those who wished to sever all connections with ancient Rome and Greece as a defeat for the classicists. Much of the decoration was the work of his assistant Augustus Pugin whose main interest was in designing churches. Pugin had been received into the Roman Catholic Church in 1833 and was thereafter the most ardent of converts. Like Etty, with whom he became very friendly from 1837, his religious sentiments were influenced by his aesthetic ideals and also like Etty he was much attracted to medievalism. But, unlike Etty, this did not run in parallel with a love of classicism in some areas.

The appointment of the Fine Arts Commission in 1841 was the culmination of a long campaign by the government since the early 1830s to become involved in the arts. The Royal Academy had successfully escaped all attempts by governments to insinuate control but government had managed to control the National Gallery and the Schools of Design. It was now intended to control the design and decoration of the Houses of Parliament themselves, a not unnatural desire. The Prince Consort was appointed chairman and Charles Eastlake the secretary of the

Commission. Albert's appointment was a surprise since he had been in the country only a year and was still generally unpopular. It was probably thought that he would be anxious to be amenable. But Albert was well educated in the arts and anxious to play a full part in British life. In Eastlake he found a loyal colleague and eventual close friend and between them they dominated the Commission. Both were very wary of James Barry and this distrust was soon shared by most of the Commission members. In 1846 Eastlake wrote to the Treasury[7]:

> The Architect has undertaken on his own responsibility the whole of the decorative work in reference to several of the objects comprehended in the [notices to Artists issued by the Commission in 1846] with the exception of Stained Glass, though even in this branch the Artist recommended by the Commission has been instructed by the Architect to adapt his designs instead of following his own conceptions.

Although written well after the events here recorded, this letter indicates the continuing distrust that the Commission felt for Barry who, like all architects, wished to control his work in every aspect. But the Prince and the Commission were determined to be the controlling authority and it was because of this friction that the Commission announced the various events that now follow.

Barry's design allowed for a great deal of wall space so it was soon decided that the decorations should take the form of frescos illustrating important events in the nation's history. To ensure that Barry should not select the winning entries the Commission appointed a committee of artists to judge the entries and make recommendations. The committee consisted of Lord Lansdowne, Robert Peel, Samuel Rogers, Richard Westmacott, Richard Cook and William Etty, a curious company it must be admitted. Again it must be inferred that Eastlake had a hand in the selection. It is very probable that it was not only Etty's standing among his fellow artists but also his many interventions to retain all the medieval buildings that were under threat, that prompted his inclusion. To be appointed to such an important committee was a great honor.

Although the Commission had decided upon fresco for the decorations, no British painter had experience in this method so it was decided to engage the German Nazarene painters Peter von Cornelius and Johann Friedrich Overbeck. These artists had learned the technique while in Rome some 20 years earlier and they naturally appealed to the Prince as fellow compatriots. When it was suggested that they should themselves undertake the decorations they pointed out that this would be most inappropriate especially as the Commission had decided that the subjects should be episodes from British history. They agreed instead to instruct the English painters chosen.

Details of the competition for carrying out the scheme of decoration were published on the 25th April 1842 and entries were invited through the submission of cartoons. Altogether 141 entries were received.

Actually the selections were made, as had been the selection of the design of the building itself, by the Commission appointed for the purpose, though it did follow the recommendations of the artists appointed to the Committee. Each judge made his own recommendations, which were separately submitted to Charles Eastlake. On 24th June 1843 the judges reported. Three first prizes of £300 each had been allocated by the Commission and in Etty's opinion the winners of these prizes should be John Callcott Horsley with St. Augustine Preaching to Ethelbert and Bertha, Charles West Cope with The First Trial by Jury and John Zephania Bell with Cardinal Bouchier Urging the Dowager Queen of Edward IV to Give Up from Sanctuary the Duke of York. Of these Cope was finally selected by the Commission along with Edward Armitage with The Landing of Julius Caesar and George Frederick Watts with Caractacus Led in Triumph through Rome. Both of these artists Etty had nominated for second prizes. Horsley and Bell received second prizes of £200 each. So altogether Etty's judgment was not adrift. Each prize winning artist had then to submit an example of his skill with fresco and, on this being also approved, he was engaged to undertake the final work. But, as it turned out, not immediately, since a number of artists refused to undertake this further test as it interfered with their more lucrative private commissions.

The competition had attracted a large number of entries by amateur artists and initially Eastlake had commented that nearly fifty were "bad and some absurdly so"[8] but with the response and general level the Prince expressed his delight. Inevitably there were acute disappointments, the worst affected being the fifty-seven year old Benjamin Haydon who, confident of success, had written a letter to Eastlake asking to be allowed to put the first stroke of paint upon a wall in the new building in the presence of all the successful contestants in recognition of his seniority. When he was informed by Eastlake on the 27th June that he had received no prize at all poor Haydon was convinced that everyone concerned had from the beginning been intent upon destroying him. This was one of many disappointment that prompted his suicide in 1846.

The winning cartoons were placed on public display in Westminster Hall on 1st July 1843 with a private View attended by the Queen, Prince Albert and the King and Queen of the Belgians who were visiting the Queen at the time. For two weeks "the higher classes" visited the display, paying 6d entrance fee including the catalogue, this being the contemporary system for ensuring that the "lower orders" did not mix with their "betters." Their turn came later when free public admission was granted, except on Saturdays. Eastlake was astonished that the poorer members of London society came in such large numbers and that, though offered an abridged catalogue for 1d, so many chose to buy the 6d one with its greater amount of information. The occasion convinced Eastlake that ordinary men and women *were* interested in the arts but, this

being the notorious "hungry forties," *Punch* in its issue of 15th July 1843 commented that Ministers "have considerately determined that as they cannot afford to give hungry nakedness the *substance* which it covets, at least it shall have the *shadow*."

From the money raised through entrance fees and sales of catalogues the Commission awarded a further ten prizes of £100 each. Poor Haydon did not even receive one of these but it would have been patronizingly insulting to have offered him one.

Two further competitions in 1844 but no further commissions or prized were offered though three sculptors were later engaged to provide statues for St. Stephen's Hall. To meet the objections of the discontented artists, the Prince Consort offered a number of commissions for paintings for the royal collection. Albert was particularly sympathetic towards artists and with his own considerable knowledge and amateur ability he got along with them very well. The decorations of the Houses of Parliament were duly completed and may still be seen. Etty, by being chosen to make recommendations, had added to his fame.

The Three Graces (35.5 × 26.75 ins) (?1843–47), National Museums Liverpool, Lady Lever Art Gallery, LL 3593.

During the period when he was engaged on the selection of paintings for the Houses of Parliament, Etty was also busy on his own works for exhibition. In March 1843 he was painting an *Entombment of Christ* for which he arranged to visit the Dissecting Room and the Dead House at University Hospital in order to study corpses. He was also painting *The Three Graces*. There are two paintings with this title. One with that simple title (see previous page) is now in the Lady Lever Art Gallery in Port Sunlight and has obviously been composed by using one model in three different poses and may possibly have been inspired by Jean-Baptiste Regnault's painting of the same title of 1793, now in the Louvre, Paris and which Etty could very well have seen. It has already been noted that he admired Regnault's work. Regnault's painting is a typical treatment of this subject, as also found with the same subject by Rubens and others. Each figure presents a different aspect, front, back and side views so that the body can be examined "in the round." Etty's version omits the front view having a three-quarter back view instead. The use of a single model emphasizes that the painting is intended as a figure study. This painting was exhibited in 1847 at the Royal Academy with the title *Charites et Gratiae* but it is generally agreed that it is probably a work from the early 1840s.

York Art Gallery also possesses *The Graces: Psyche and Cupid as Personifications of Love, Burning the Arrows of Destruction and Trampling on the Insignia of War*, which was exhibited at the Royal Academy in 1843. This painting (reproduced below) was bought by Etty's friend John Singleton at the sale of Richard Nicholson's collection in 1849 after Nicholson's suicide following the collapse of George Hudson's railway enterprises.

Gilchrist refers to the painting of *The Graces* at the commencement of Chapter XXIII of his biography.

The Graces: Psyche and Cupid as the Personifications of Love Burning the Arrows of Destruction and Trampling on the Insignia of War (31 × 27 ins) (exh. 1843), York Museums Trust (York Art Gallery), YORAG1048.

As usual at this period of the year, Model swiftly succeeded Model, in his Studio; one of the "Graces" giving place, after her hour or two hours were up, to a "strapping Life-Guardsman" for the *Entombment*; and so on. One day, a friend sitting by, remarks on the costly nature of this kind of assistance,— "Ah!" characteristically replied Etty. "they take a deal of the gilt off the gingerbread!" A metaphor, often on the painter's lips, borrowed from early experiences under the roof of the Spice-Maker.

The year 1843 was particularly busy for Etty. He exhibited no fewer than six paintings at the British Institution and sixteen at the Royal Academy, there being then no limitation on the number of works a member might submit. From 1842 onwards Etty submitted large numbers of works every year for exhibition to the three principal institutions in London. The changing nature of the art market was making artists increasingly competitive but, as jealous as Etty was of his own reputation, he was never lacking in paying compliments to his

fellows. "I cannot resist congratulating you on your most noble Picture from Gray's *Elegy*," he wrote to Daniel Maclise in 1843. On another occasion Clarkson Stanfield wrote to Etty thanking him for his praise of one of his paintings.

A royal command

The Prince had become so attracted to fresco as a result of the competitions that he decided upon it for decorating the summer pavilion in the gardens of Buckingham Palace. This had been built on a mound of earth formed during the excavation of the lake and according to a contemporary authority[9] it was "picturesque and fantastic, without any regular style of architecture." It consisted of three rooms and a kitchen and was intended as a place for royal al fresco meals or picnics. The main room was octagonal and this, with the two rooms on either side, were to be decorated. Nobody, not even the Prince who was usually knowledgeable on such matters, seemed to realize that fresco, being a water based pigment on plaster, is suitable only for dry climates. It is rarely used in northern Europe and it was unsuitable even for the Houses of Parliament with their proximity to the River Thames. For use in a garden room where doors and windows would frequently be open it was a disastrous proposition. But the Prince favored fresco, because of its association with Italy and his native country through the Nazarenes. He decided that the octagon room was to be decorated with scenes from Milton's *Masque of Comus* and the other two by scenes based on the novels of Walter Scott, whom he admired both as a man and a writer.

Following his acquaintance with Etty on the Committee that judged the entries for decorating the Houses of Parliament, the Prince commissioned him to paint a scene for the octagon room along with Clarkson Stanfield, Thomas Uwins, C. R. Leslie, Sir William Ross, Charles Eastlake, Daniel Maclise and Sir Edwin Landseer. Although Etty was the last of the artists to be invited it was another honor for him but, as it proved, one he would wish had not been bestowed. Etty received "His Royal Highness's commands" on the 8th May 1843. Having no experience or knowledge of fresco painting, he was understandably reluctant to undertake the work and so informed the Prince. Receiving only a repeated command, he asked for instruction in the technique from William Dyce who had some, but clearly inadequate, knowledge. The artists were left to choose their own subjects and Etty chose to illustrate Milton's lines—"Circe with the Sirens three, Amidst the flowery-kirtled Naiades...." He began work in July but, as he had feared, it proceeded badly, with much repainting, and retouching. By the middle of July he had, according to his notebook, "pulled down the first Fresco figure, repainted it and cut." Taking advantage of the long daylight hours he worked "from nine till seven." Although the Queen praised his work he knew it was unsatisfactory. Etty was a painter in oils. He did not paint in watercolors as most artists did either for the preparation of studies or for relaxation. His color technique, with over-painting and use of glazes, was quite distinct from fresco. He frequently retouched previous work, as an oil painter would, but this is disastrous with fresco which depends on the absorption of the pigment by the wet plaster. Retouching dry fresco work results only in the added pigment flaking off. Etty asked Colonel Anson, the Prince's Private Secretary, if he could paint his chosen subject in his own painting room and have it fixed into position but this was not agreed. True fresco must be painted *in situ*. He also painted a sketch of a fresh composition and left it in the Palace for the Prince's approval, but to no avail.

Friends did their best to encourage Etty. Daniel Maclise suggested more attention should be given to details as this would please the Queen and Prince Albert. Lady Eastlake recorded in her diary,[10] that she had visited the gardens of Buckingham Palace in March 1844 and had thought Etty's painting the "next best in composition, and the nearest to real fresco effect. The others over-finished, and looking no better on wall than they would have done on canvas."

She had, as might be expected, placed her husband's work the best of all. The Prince did

not share her opinion of Etty's painting. To recover his reputation Etty painted a similar work (see below), *Hesperus*, in oils, which he sent to the Academy Exhibition where it was exhibited with the title *A Subject from Comus*. He depicted the three daughters of Hesperus, i.e., Hespere, Aegle and Erytheis, extended by the addition of a fourth figure probably because he was influenced by Poussin who used four figures in his dance subjects. The catalogue of the Lady Lever Art Gallery records that an old label on the stretcher to the painting quotes the following lines:

> All amidst the gardens fair
> Of Hesperus and his daughters three
> That sing about the golden tree:
> Along the crisped shades and bowers
> Revels the spruce and jocund
> Spring [*lines omitted*]

> Bells of hyacinth and roses
> Where young Adonis oft reposes
> Waxing well of his deep wound,
> In slumber soft; and on the ground
> Sadly sits the Assyrian queen,
> But far above, in spangled sheen
> Celestial Cupid, her famed son advanced
> Holds his dear Psyche sweet entranced.

In the painting the daughters dance before an apple tree and Hesperus peers over a bush, watching them. Apollo and the Assyrian Queen recline on the left and Cupid and Psyche on the right, more towards the background. *The Examiner* and *The Illustrated London News* particularly liked it but the most fulsome praise came from *The Morning Chronicle*, whose critic wrote[11]:

> the painter has exhibited the gorgeous fancy and genius which distinguish him. The picture is full of sunshine and a golden richness of voluptuous colour. The mystical notion conveyed in the lines is kept up somehow. You feel that you are looking at an enchanted ground; the colours are rich and indistinct, the figures dancing round in a haze and film, as one might see them in a dream of the enchanted place. The picture strikes us as being of the highest poetical order.

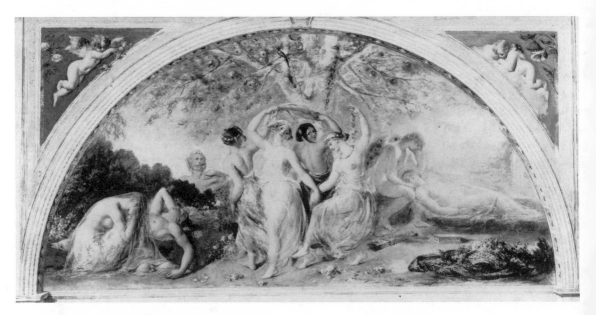

Hesperus, a Subject from Milton's Comus (35 × 68 ins) (1843), National Museums Liverpool, Lady Lever Art Gallery, LL 3592.

But the *Observer* managed to mount its usual attack. Its critic said that the painting lacked sentiment, arrangement of parts and correctness of form.[12] "Were it not for the charm of the gorgeous but truthful colouring which is shed all over this incoherence and confusion, it would be, perhaps, one of the worst pictures in the collection" and *The Spectator* dismissed it as "sensual and smeary ... with mannerism predominating."[13] *The Athenaeum*[14] admired its "luscious sweetness" and its "fullness of sweet and melancholy grace." but regretted its "meretricious slightness" and "recourse to effects and artifices of colour." The *Art Journal* did not like it either. This was an unusual reaction, for the publication was among Etty's most loyal supporters.[15]

> In considering this composition we are first struck by the extremely careless drawing everywhere prevalent, again by the total absence of grace in the Hesperides, and again by the extravagance of the entire composition. ... The proverb allowed Homer to sleep sometimes, but it must be feared that the slumbers of Mr. Etty are mesmeric dozings.

Whatever a modern viewer's opinion of such a painting might be, it must surely be regarded as unjust to say that the dancing figures lack grace. Critics frequently used their columns to exhibit their self-importance and their power (and desire) to destroy an artist's career. This has ever been an ambition of critics and remains evident to this day when it is extended beyond the confines of art to everyone who attracts their venom.

The Prince himself praised this work at the Royal Academy dinner that year, Etty being so pleased that he wrote to his friend Robert Davies in York to report the fact.[16] but this did not result in Etty's being allowed a second chance with the pavilion. What he had painted was taken down and William Dyce was appointed in Etty's place. Dyce, being a friend of Etty's, was unwilling to undertake the commission, but a royal command must be obeyed. He asked for Etty's understanding of his position, of which Etty assured him. Etty in due course received the sum of £40, the amount promised under the original contract. It must be conceded that Prince Albert had no alternative but to dismiss Etty from the work for which he clearly had no aptitude. He had been appointed because of his high reputation but a painter in fresco he was not and could never be. At least he had been paid in full. The Prince had not been ungenerous. But not everyone thought so. Many of Etty's friends and colleagues were angered by his treatment. It must be remembered that Albert was not a great favorite among the English. He was German and the English had had enough of Germans in the royal family and many in high places (and lower ones) consistently sniped at him. William Thackeray in particular wrote a long article in *Frazer's Magazine* of May 1845 in which he vented his indignation over the Prince's behavior.

> What victims have these poor fellows been of this awful patronage! Great has been the commotion in the pictorial world.... Think of august powers and principalities ordering the works of such a great man as Etty to be hacked out of the palace wall—that was a slap in the face to every artist in England.

Gilchrist calculated[17] that Etty lost nearly £400 if the value of his time was taken into account, but he failed to understand that the contract price had been £40, which included Etty's time, and Etty had agreed this. Whether Thackeray was entirely accurate to use the words "hacked out of the palace wall" is doubtful. Gilchrist recorded that Etty received £40 from the dealer Colls for the fresco which he had recovered from a shed in the grounds of the Palace. Apparently Colls obtained it from the Superintendent of the Palace Gardens so it must have been more or less in one piece. What Colls' arrangements with the Superintendent were is not recorded. Colls sold the fresco on to his fellow dealer Wethered for £400, but he had difficulty in disposing of it. In total Etty received £80, twice what he had originally expected. Colls did very well but Wethered burned his fingers. Loyal as ever, Etty referred to the episode only once in the rest of his life and then only indirectly. One day he encountered Daniel Maclise and Charles West Cope coming from the House of Lords where they had been working on their decorations. Maclise, reporting the incident, said that he had expressed his dislike of fresco as a painting method and Etty had replied that he did not envy them. "Any style of Art for him but that!"[18]

The painting *Hesperus* (*A Subject from Milton's Comus*), was bought by Edwin Bullock for an unknown sum. It was later sold in 1870 to Agnews for 1,005 guineas. However, it did not hold its value and three years later was sold for 800 guineas by John Hargreaves who had meantime acquired it. In 1920 it was bought by Viscount Leverhulme through the dealers Gooden and Fox. Farr says the price was £580 but the Lady Lever Art Gallery catalogue says it was £609. Probably Farr meant 580 guineas. Either was a considerable reduction from the first known figure. Etty painted a version in oils which is now in Perth, Western Australia, under the title *Circe and the Sirens Three*. The garden pavilion no longer exists. Neglect during the Great War left it in such disrepair that Queen Mary and the Princess Royal agreed it should be demolished and so it was in August 1928.

"Let Brotherly Love Continue"

An artist's relations with other members of his family are seldom recorded unless they seriously affect his career. Parental objection as in the case of Constable or encouragement as in the case of Turner will affect an artist's start in life just as objections by a wife, adulterous liaisons, divorces, bankruptcies, sudden deaths or unexpected success can affect later developments but an easy passage through life provides few stimuli. There are many formative influences in everyone's life and though, as we have seen, there were many occasions when Etty was affected by the actions of others, it has to be admitted that his determination to be a painter and, moreover, a painter specializing in a particular subject, seems to have been his own decision. Even so, this is not wholly true. The narrow range of cultural interests available to him in his boyhood and his training in the Academy Schools suggested that the aristocratic tradition of history painting was the only path to follow. In that respect his family seems to have had no influence upon him at all. Not even uncle William or brother Walter appears to have sought to change his ideas. They provided encouragement and practical help but there is no evidence at all that they ever gave any guidance regarding his aspirations as an artist. Nor did his mother or father influence his decisions. They were content to admire. So, too, it seems did his brothers. Even Betsy, who had close contact with him for the last twenty-five years of his life, appears never to have voiced an opinion.

It was always to Walter he appealed for advice at any time of crisis but this did not extend to seeking his opinion about art. The relationship was very much that of the younger brother deferring to the worldly wisdom of the elder. It may be significant that when writing to Walter, though addressing him as "My Dear Walter," he invariably signed himself as "Wm. Etty," as though in deference, recognizing himself not merely as junior in years (as he was, by thirteen years) but somehow detached. This was an age of formality and letters to fathers were habitually signed in such terms as "Your obedient and respectful son." An elder brother would also expect appropriate respect. Much of what we know of Etty's life is contained in these letters, most of which are in the York City Reference Library. Walter was always the example of the brother who had made good in life. Walter was ever generous and Etty was fully appreciative of his support so unstintingly given. The Ettys were not an overly ambitious family, Matthew had had little education, but many of them sought and achieved material comforts and, especially, the financial security essential at that time when failure meant starvation. Of all the family, Etty cherished most the constant help he obtained from Walter.

In his Italian notebook of 1822 in York Art Gallery, Etty drafted a letter to cousin Thomas Bodley, a curious habit since all his letters appear quite spontaneous and frequently copiously amended. This particular letter, though undated, was written just after Walter had written to Etty following the request for his opinion about cousin Mary's intentions when he was so desperately in love with her. It reveals just how much he relied on his brother.

Tell Walter I got his last kind and important letter and thank him for it. Walter, tho' always most especially dear to me yet I think he more and more endears himself every month by that noble and liberal spirit with which all his actions are characterized, by that kind and watchful solicitude for my welfare, by that tenderness for my feelings, in short by everything that can bind him closer to me, and like those benign planets, which cheer us with their light while they cherish us by their warmth, knows no shadow of a change. The communication he made to me on a certain subject, tho' it caused me some emotion at the time and a few pangs of regret, yet I thank God it has passed away like a cloud from the brow of the Apennines on a sunny morning and left me my accustomed tranquility.

As is so often the case with Etty, this is an effusive outpouring of feelings which reveals not only his affection for Walter but also for Thomas Bodley to whom he often entrusted his private emotions. When reading the letters that passed between the two brothers we have the inescapable thought that Walter believed that his younger brother lacked the strength of will that he possessed and needed a mentor to guide him through life—and that Etty himself realized this. Whenever any event brightened or darkened his life Etty wrote to his brother. Even in 1833 Walter was still providing financial assistance. A note at this time in Etty's *Cashbook*[19] reveals that Walter had paid out £3,937 on his brother's behalf and had so far received back £3,133. He was owed £804, a considerable sum for the time. Etty always repaid Walter as soon as opportunity permitted but the fact of constant indebtedness always haunted him. When in the 1840s Etty was troubled by his increasing sympathies with Roman Catholicism it was to Walter he wrote expressing his worries and assuring him that he would not convert. No doubt Wal-

ter would have disapproved had he done so for anti–Catholic feeling continued to be very strong in the country, and in such a religious family as the Ettys such a drastic change in faith would have been regarded as a very serious step. By this time all his debts to Walter had been discharged but the sense of obligation remained and it was always to his brother that he continued to turn for advice.

Etty was a punctilious letter writer and very impatient when he did not receive speedy replies. Keeping in touch with friends was a firm principle. He frequently chided Betsy, Walter and Thomas Bodley for not writing often enough. In a letter dated "Thursday Oct. 18, Nine o'clock at Night" from the Mount, York, probably 1838, he told Betsy "I was very anxious to hear from Walter, especially since I heard Jane [*Walter's wife*] has been so unwell but however I have not had a line from him tho' I have twice wrote."

Later in life when he was frequently ill he felt he had cause to

John Etty (30 × 25 ins.) (1811–12), **The Company of Merchant Adventurers of the City of York.**

complain to Walter that he had not written as often as he might have done to enquire after his health. Some have suggested that William Etty was a hypochondriac, exaggerating his ill-health, but his accounts in letters do indicate increasing attacks of bronchitis, asthma and worsening rheumatism, possibly even arthritis. Reports from Betsy confirmed his condition.

Of his other brothers it was John to whom he felt the closest ties. He clearly envied him his happy marriage and family life and whenever he was in York he paid him frequent visits. Having John's daughter as his housekeeper/companion formed an additional tie between them. John was a miller and gingerbread-maker like their father but at some stage he also became a builder and small time property developer. John appears to have had some property in Walmgate, York, and built some town cottages for letting. The city councilors wanted the area to be cleared and rebuilt in a manner more befitting the image the city was seeking to present. But such work had to be undertaken privately, there being as yet no concept of municipal enterprise. The cost of the work exceeded his estimates and Walmgate had such an evil reputation that nobody wished to live there even though the area was being "cleaned up." Over fifty years later, in 1864, Walmgate's reputation was still so bad that the Wesleyans appointed a missionary to minister to the residents in the hope of reforming them. The Anglicans also tried to reform the area but had to admit that only one woman had been persuaded to go to church. Walmgate and adjoining Fossgate was known as harboring thieves and prostitutes. An alley leading off Fossgate still bears the name "Tricksters Lane," which speaks for itself.

John eventually went bankrupt. Even so he seems to have enjoyed a happy life. At an unknown date he married Susannah Shepherd, the illegitimate daughter of Abigail Shepherd,

Tom Etty (1811), Tom Etty, Nijmegen, The Netherlands.

a somewhat brave thing to do at the time when the sins of the fathers, and especially the mothers, were frequently visited upon the children. John and his family moved to Huntington, then a separate village outside York, where he had a mill which afforded him a satisfactory living. Whenever Etty visited him, as he often did and, most suspiciously, usually unexpectedly at meal times, there was always plenty of food on the table. John's daughters, Catherine (Kitty) and Elizabeth (Betsy), were great favorites with their uncles. They appear to have been quite good looking but above all it was their charming manners that appealed. They had been well brought up. Of their three brothers nothing is known. There were also no fewer than seven other children who died in infancy. John died in 1865, aged 90.

Brother Thomas seems to have had less ability or determination than his brothers. For a time he was a sailor, according to Gilchrist "in a Whaler,"[20] and he gave Etty his first box of watercolors. His nautical life did not last long and he was content to move to Hull where he set up a baker's shop, following his father's trade. Thomas married four times, to Elizabeth (surname unknown), then to Jane Elizabeth Cook, then to Mary

(surname also unknown) and finally to another Mary (surname also unknown). One proved to be a very unhappy experience. This we know from a letter that the youngest brother Charles wrote to Betsy in 1825 describing the spouse at that time as "a wicked wife" though on what grounds he does not say. Although she is not named she must have been his first wife, Elizabeth, since Thomas would have been only 19 at the time and could not have been married before. The deaths of only the last two wives are known, 1849 and 1877 respectively. After Matthew's death, Esther went to live with Thomas in Hull where she clearly sustained the family through some difficult times. Esther was a very capable woman; she decorated Thomas' house when he first moved there as she also did for her son William when he moved to Buckingham Street. Apart from one troublesome marriage, Thomas lived an uneventful life, dying in 1854, aged 79.

In many families there is often an adventurer whom the others regard with mixed feelings. William Etty had always admired his youngest brother Charles who, born in 1793, had left home in 1812 to become a sailor and eventually, in 1831, a sugar planter in Java. There are numerous letters from Charles, some preserved

Charles Etty (original destroyed in 1944 while in storage at Arnhem) (1844–45), Tom Etty, Nijmegen, The Netherlands (photograph of copy provided by Dr. Dennis Farr, C.B.E.).

in York City Reference Library but many more in the possession of Tom Etty of Nijmegen. Charles must have received a sound education. He wrote an excellent copperplate hand and was possessed of a sound business mind. He was both literate and numerate to a high standard. Gilchrist described him[21] as having a strongly "mechanical turn" of mind which was also evident in other men in the family. Charles enjoyed an adventurous life, beginning as a merchant seaman, claiming the experience of a sea battle with a French frigate and ultimately becoming the captain of a merchant ship, settling for some time in India and then moving to Java in 1831 where he established a sugar plantation and factory. In Calcutta he had married Elizabeth Leal Pereira, she being then 32 years of age, eleven years older than Charles. Elizabeth was the daughter of a Portuguese father and a Parsee mother. She herself had been married to a Portuguese sea captain who had died leaving her with four children.

The policy of the East India Company, which then controlled India, was to encourage intermarriage and even conversion to Islam or Hinduism, if this would cement a marriage and assist the company's trade. This was already being reversed by the British government who was increasingly taking control of India and who finally did so completely after the Mutiny of 1857–59. Imperialist minded ministers and civil servants did not believe that mixed marriages and toleration of Indian faiths would gradually anglicize the subcontinent. Evangelicals, in particular, had long deplored the tolerance of the East India Company and their missionaries went in large

numbers to convert "the heathen." Although Indians were admitted to the civil service, because it was impossible to supply sufficient Englishmen, in practice this meant they were relegated to the lower ranks since they had not been educated in England. Strict divisions in public and private life were established between the British and the Indians and the mutual distrust which was eventually to result in mutiny and final independence had its origin in the intervention of the British government at this time. From what we learn of Charles' character from his subsequent letters and behavior we may conclude that it was the intolerance being introduced by the government and the missionaries that caused him to leave India for Dutch Java. The earliest surviving dated letter from Charles is that of 26th April 1834 written from Java to William telling his brother that

> As I am beginning my house which will be a decent one I hope that you will send me some of your best, I will pay you for them and not beat you down. Among them must be the portraits of you all, not forgetting Cousin Martha [*Walter's daughter*] amongst the first, a Copy of my own and Blue Ey'd Betsy, my play fellow—God bless her. Tell her to write me soon.

He goes on

> I often think of you when we have a Yorkshire pudding. By the bye we have one today. I wish you could join me. I think you would find it good, you may inquire of this Gentleman [*presumably the letter had been entrusted to someone who had traveled to England, as was customary*] perhaps he may tell you wether [sic] it was or not, for I think he likes that sort of cooking.

Although the next part of the letter does not concern the Etty family it does throw an interesting light on Dutch colonial government of the time and is worth reproducing for this reason.

> We are going to have a visit from our Governor General for he leaves Head Quarters on the 1st May. We are all very busy getting ready to receive him. In this district alone will be ready for his [*illegible word*], no less that four hundred and fifty Carriage horses, followers which will attend and follow the Carriages will not be less than fifty men on horseback at every Station. In our district I believe there are twenty Stations, besides other attendance. The whole line of roads will be watered the same as a garden and not one particle of dust will not [sic] be seen to rise during the time he will travel. How do you do for stile [sic].

Such pomp and circumstance would not have been unusual in any country's colonies at the time. The reliance of colonists upon their home countries is confirmed by Charles' next request.

> Can you send me out a little good Bacon put up in a close tin case with saw dust inside. I am sure it would arrive in good order. Mrs. Etty wishes much for some. If you do put it in cases about one foot and a half square and then put them into a wooden case.

In another letter he asks that needles should be sent to his wife as she needed replacements for those that had broken. Charles' reference to "blue ey'd Betsy my play fellow" indicates that he had known her very well before he left England and was very attracted to her. This explains an undated letter from Charles to Betsy written when he was on board ship from Java to Cape Town and which Tom Etty of Nijmegen suggests dates from the year 1825. This letter makes clear that they were regular correspondents although nothing earlier has survived. Charles recalls walking with her in York when they counted "nineteen squinting girls in one evening," a lighthearted pastime for an uncle and his niece. Yet he considered it necessary to assure her that he has never entertained any ill desire towards young women and expressed disapproval of "other young men and their bad intentions towards" their female companions. He assured her that "a Female's honor is my God." Charles was only eight years older than Betsy and as she may have realized that he found her very attractive he wished to reassure her that he never had any improper intentions, which in itself indicates how vulnerable many young women were. Indeed, there are plenty of examples of uncles seducing nieces and it was commonplace for men

with young mistresses to pass them off as nieces. Of Betsy's sister, Kitty, he expressed regret that she does not write to him and wished her "a happy marriage and fat children." In this letter Charles enquired after his "favourites" and especially of Ann—"tell her that she still reigns in my breast" but who Ann was is unknown since the only Ann in the family was the future wife of his nephew Charles, Thomas' son, and she had been born in 1824 and so was but one year old at the time. Whoever Ann was she certainly held a favored place in his memory since he named his own daughters Ann—the first born in 1821 who died in infancy and the second born in 1824 who died in 1867 after two marriages. Etty occasionally mentioned an "Ann" in his letters from London and it is unclear whether she was a member of the family or a servant.

A steady correspondence with home was maintained once Charles was established in Java. He sent glowing reports of his success, informing the family of his increasing wealth, and so attractive were his accounts that Thomas' son Charles joined him and also prospered. In a subsequent letter he complained that the Dutch Government, who contractually supplied new sugar canes every year and took delivery of the sugar at the end of the season, were very slow in sending payment, often as long as three months. But considering how long a ship took to sail between the East Indies and Europe this was surely not unreasonable for the times. However it informs us of the colonizing methods of the Dutch who did not leave everything to uncontrolled *entrepreneurs*. Charles may have found Dutch administration unsatisfactory but it is doubtful if he would have welcomed British missionaries. He was particularly pleased with the fact that there was no slavery in Java.

Charles' marriage may have presented his family at home with some problems. Being half Indian and of dark complexion his wife may not have been fully accepted. When in 1822 Etty was troubled by his apparent rejection by cousin Mary, he had written in one of his notebooks,[22] in his usual humorous manner, that he would remain faithful to his Tea Kettle since

the song of the kettle [is] sweeter to a studious man than a crying child or a scolding wife, however I must consider seriously on this matter ere I offer her my hand lest she should burn it and secondly because the world might be inclined to remark on it should a *second* of our family marry *a lady of color!*

Charles' letters are not easy to decipher. His hand-writing though very clear was very small in order to get as much as possible on a single sheet of writing paper. Because of the high cost of postage, decided not only by distance but also by the number of sheets of paper used, he frequently followed a common practice of the time of writing first across the page and then, turning the page sideways, writing across the original text at right-angles. Sometimes his handwriting is minuscule in order to cram as many lines as possible on a page. One may doubt whether Charles needed to be so parsimonious but, though by far the most blessed with money of all the family, Charles did not approve of waste. It was, in any case, an expected practice of the time. Without doubt Charles was very successful and must have appeared to his brothers John and Thomas as rich beyond their dreams. In two letters he wrote home he gave details of the size of his plantation and the value of his transactions, obviously eager to impress them that he was not languishing in poverty in a distant land. He was better off even than Walter. Charles was always concerned about his brothers and accepted obligations of financially assisting them. In a letter of 31st May 1841 to Walter he wrote:

Whatever you can do for Brothers Tom and John do and draw on me. Should you have any Cash [left] over from my last bills divide it between them and make Tom happy by getting his old furniture back. That will please him. I will send you another set of bills in the course of three months when the Eastern Ship enters [word illegible] port. I am sorry that Chas. [i.e., Tom's son] did not do more for his Father. I would sooner he had come without the wheels and my two [word obliterated] sooner than he should have left the furniture in pledge. His orders was [sic] that that should be placed in his house forthwith. On that head I was not altogether pleased but I hope you will be able to do the needful and I will repay you with pleasure.

This indicates that brothers John and Tom were experiencing some hardship and that Tom had had to raise money against his furniture. Neither had the business acumen of either Walter or Charles. Tom's son Charles had joined his uncle in Java and had brought out some machinery for him. Tom appears to have been in financial difficulty since his furniture was "in pledge," i.e., held as security against a debt.

The brothers had not seen Charles for over thirty years and then, in 1843, on the 28th May according to Etty's diary,[23] Charles arrived unexpectedly in England to buy machinery for his sugar factory. "A memorable day in our life. Dear Charles, my youngest brother, arrived from Java." On Etty's return from the Academy that evening where, most unusually, he had not stayed to attend the Life Class, he found Charles in his house. Actually Charles' decision to come to England was not in itself unexpected, only the date of his arrival. Arriving unheralded seems to have accorded with Charles' general character. Charles' visit coincided with the many events that have already been recorded in the previous chapter but it is here dealt with separately since to intersperse it with all the other problems that were then confronting his brother could result in some confusion. In the early years of the 1840s Etty was so busy that it is more convenient to record each event separately rather than to attempt to break them into strictly chronological order.

Charles stayed in England for two years and then returned to his Java plantation, never to return, dying there in 1856 aged 63 years. His wife died in 1868 aged 86 years. While he was in England Charles also arranged for a memorial to be erected in All Saints' Church, Pavement, York, where his parents were buried. This memorial still remains in the church. Etty painted his portrait, on panel, but unfortunately, like the portrait of his mother referred to earlier, it was destroyed while in store at Arnhem in 1944.

It is not clear where Charles stayed whilst in England. He seems to have spent most of his time in York and also in some occasional traveling, usually with his brother who accepted the obligation of keeping him entertained. While in England Charles bought a house in York for his retirement and named it "Java Hill." However he did not return. He does not appear to have visited London very often. Charles appears to have proved a somewhat difficult person to deal with. Etty complained, though very mildly, to Thomas Bodley that it was never possible to be certain of his plans. For example, Charles thought of visiting Brighton. So Etty asked Bodley, who had by now moved from Brighton to Cheltenham, for a suitable address in Brighton where Charles could stay. Then no more was heard of the idea and Etty was displeased that Bodley had been put to the trouble of making the enquiries.

In fact 1843 to 1845 were not the most convenient years for Etty to have to entertain a demanding visitor. He was struggling with the Garden-Pavilion fresco and making no headway. He was also anxious to proceed with a series of paintings which he hoped would prove to be the culmination of his career. These were so important to him that they will be separately considered in the next chapter. Partly to relieve his anxiety over the ill-fated fresco and partly to gather firsthand material for the intended series, he went to France in August but he could not manage to be away longer than two weeks. He had to continue his normal work to maintain his income and in the autumn he was busy painting some small works for his dealers and also for his regular clients, the Right Honorable Sir James Wigram, George Knott, Serjeant Thompson, Edwin Bullock, Charles Birch and William Roberts as well as Joseph Gillott, the latter becoming so important to Etty that he deserves separate consideration. How Charles spent these months in 1843 is not recorded. Doubtless he was busy buying machinery, the reason for his visit, but Etty does record[24] that he amused his hosts, apparently *ad nauseam*, with tales of his various exploits. It also seems that he decided to do more than buy machinery for himself but also to invest in some exports to Java. A whole year passed and still Charles remained.

In a letter of 26th June 1844 Etty told his agent Richard Colls:

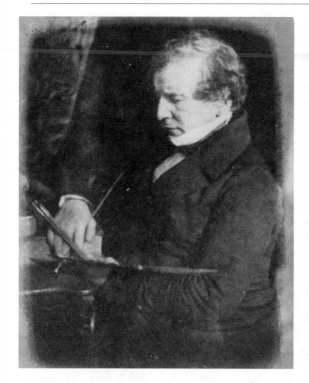 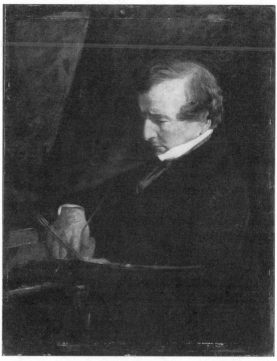

Left—Photograph of William Etty by Octavius Hill and Robert Adamson of Edinburgh (taken in Edinburgh on the occasion of Etty's visit there with Charles in the autumn of 1844); *right*—*Self Portrait* (apparently copied from the photograph) (date unknown); both are courtesy National Portrait Gallery, London.

> My Brother is still here, amusing us occasionally by "yarns" of perils by "flood and field," tiger combats, piratical encounters, drifting out to sea, etc., etc., which in one and thirty years' broiling under Oriental suns, he has seen and undergone.

Charles was probably boastful but the world was still an adventurous and mysterious place for those who stayed at home.

In October 1844 Etty took him to Edinburgh to be present at the dinner given in his honor by the Scottish Academy to thank him for *Judith and Holofernes*. Etty made a speech, a task which never came easily to him but which he was always willing to undertake, and even Charles "who is not easily pleased" was impressed, as Etty wrote to Walter on the 19th October. While in Edinburgh the two brothers were photographed by David Octavius Hill and Robert Adamson, who jointly had a studio there. On the way home they visited Manchester where Etty showed Charles *The Sirens and Ulysses* which also confirmed for him that his brother was a painter of skill and status. Altogether the journey fulfilled its purpose of demonstrating to Charles that his brother was also important and successful in his chosen career. Etty seems to have found it necessary to do this and, bearing in mind the impression that Charles apparently left on everyone, there was need to show him that other members of the family had also achieved something.

Charles also ruffled feathers by taking Betsy for a tour of North Yorkshire and then, more ambitiously, for a tour on the Rhine, returning via Paris and London, an excursion of which Etty did not approve since he knew that Charles was trying to persuade Betsy to return to Java with him. But she declined, having, as Etty noted at the time, someone in York on whom she had fixed her affections. In the event she was not to marry until after Etty's death. Etty set about

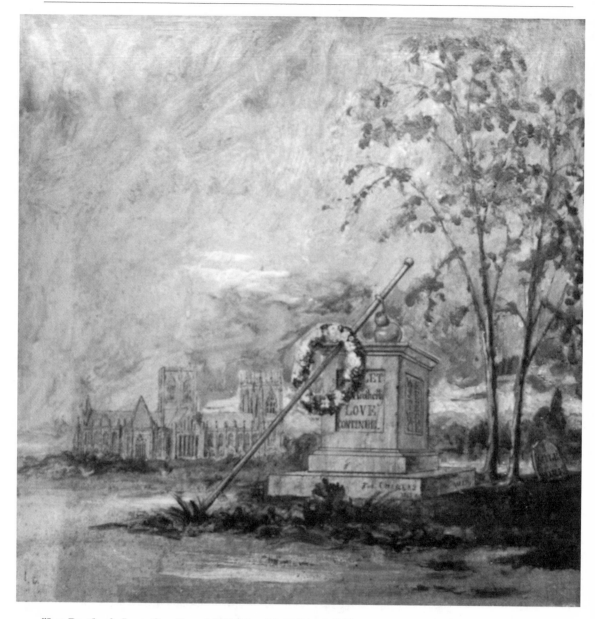

"Let Brotherly Love Continue" (20.25 × 20.125 ins) (1844), Tom Etty, Nijmegen, The Netherlands.

painting a picture for Charles to be called *Indian Alarmed*, the subject being an Indian model named Mendoo who also helped Etty in bringing all his necessary accessories to the Academy. Etty also painted a memento for Charles to take back to Java. It was a painting, just over twenty inches square, of a memorial with a garland, a pilgrim's staff, a water gourd and, in the background, York Minster. The monument bears the initials of all the brothers and the inscription "Let Brotherly Love Continue" with the words on the base, "for Charles 1845." A milestone records that York is one mile away. This painting, as simple and indeed as *naïve* as it is, tells us much of Etty's own honesty of character. Family unity and brotherly love were central to his own principles, being founded, as he saw it, in his faith. Nonetheless Charles frequently stretched his tolerance to the limit. To keep Charles amused it was necessary to arrange for the two of

them to attend balls and "gaieties" which were not Etty's usual mode of entertainment. He told another agent, William Wethered: "Not getting home this morning till about three; from the Earl de Grey's Ball. But late hours and champagne suppers don't do so well with me as tea at home and to be in bed by twelve."[25]

All five brothers met together only once, sometime in October 1844. It was their first meeting as a family for thirty years and it was to be their last. Walter seems never or very rarely to have visited York and the occasion must have been exceptional for him. We may deduce from other evidence that the brothers did not get along very well with Charles, but presumably John and Tom did not know that he had helped them financially since he did so through Walter. Charles had outstayed his welcome and even William began to wish he would leave. Writing to Thomas Bodley on the 11th May 1845 he said: "We know that he *at present* fixes his departure on the 20th June but he is so very uncertain in his movements I cannot say. He has been *talking* of going ever since November last...."

In July Etty, perhaps accompanied by Charles, traveled along the south coast, visiting Brighton, Hastings, Dover, Ramsgate, Canterbury, Winchester and Netley Abbey. Then Etty accompanied Charles to Southampton where he left for Java on the 20th July. How close the two were cannot be conjectured. Etty and Charles were very attached to each other in childhood and certainly Etty admired Charles for his enterprise in successfully establishing himself in Java but there seems little doubt that his visit to England had had a mixed reception throughout the family. While Etty himself could hold his own as a success in life, and clearly intended to do so, John and Tom seem to have felt out of place. Walter had remained in London except for the occasion of the single family gathering. However much Etty was pleased to see his younger brother there is no doubt that his presence became increasingly irksome. Etty had so much work to do and, in particular, the painting of a triptych on which he had set his heart was seriously delayed.

Of the few surviving letters from Charles after his return to Java most are to Betsy whom he invariably addressed as "My Dearest and ever Dear Niece Betsy." She certainly continued to attract him. Charles built an extension to his home in Java to serve as a picture gallery. Here he hung the portraits of all the family painted by his brother and reported in a letter that he often sat in the evenings admiring them. The building still exists as an occupied dwelling.

Chapter Fifteen

"The Judith of modern times"

It had long been Etty's ambition to paint a great work through which his fame would extend to future generations. This was not egotism, though he would have been the first to admit that he was not without more than a hint of this in his character. It is an unusual artist who does not hope to be remembered. In Etty's case he had wanted for some time to paint a great historical work dedicated to St. Joan. But it is likely that this had not been his first choice. At some time prior to September 1839 Etty began to consider painting the story of Thomas à Becket, a subject well suited to his interest in medieval martyrdom. There is in York Art Gallery a notebook with three pages of notes taken from Sharon Turner's *The History of England during the Middle Ages* relating to Becket's murder. There is also a sketch of a projected composition of the martyrdom. As is usual with Etty it is a confused scribble which can be discerned only with difficulty. He also made some sketches of medieval armor and a group of heads of three soldiers wearing helmets. But this project did not proceed. Instead he turned to Joan of Arc. Dennis Farr considered[1] that Etty thought of Joan as "the Judith of modern times," a patriotic woman willing to do anything to save her country from invaders. This work occupied him for nearly four years, (though Etty declared that from his first thoughts it was seven years) during which time he was immersed in so many other projects.

Work on the Royal Pavilion had taken up more of Etty's time than he had really wished to spend, despite the honor that would have resulted had things gone well. But already by the summer of 1843 he knew this work was a failure and he wanted a rest from it and probably also a rest from entertaining his brother Charles. He decided to visit France to see for himself the places connected with Joan of Arc. Perhaps he thought that spending some time away would allow him to overcome his frustration and return renewed to start again. So on the 16th August 1843 he set off accompanied by his friend John Wood. It was to be his last visit abroad but he put it to good use. In 1835 Etty's friend, also Wood (forename not recorded), a merchant in the City of London, had placed horses at his disposal as models for the painting *Pluto Carrying Off Proserpine*, exhibited 1839. He may have done so again for the picture of *St. Joan Riding Out from Orléans*. Whether the John Wood who accompanied him to France in 1843 was related to the City merchant is not known. He may have been his son. We know that John Wood was a minor artist, born in 1801 and destined to die in 1870. He had already studied at Sass's Academy and he exhibited in the British Institution and the Royal Academy between 1823 and 1862 though he never became an Associate. Writing from Paris, Etty reports that he gets on with him "capitally,—he is very kind and good."[2] Two years later, in 1845, a Henry Wood of Lewisham commissioned Etty to paint his three children, Emily Sarah (1837–75), Frederick William (1840–62) and Mary Ann (1820–1918). Although a delightful study of children, it seems the three figures were not posed together: Mary Ann on the right appears quite detached from the others. Again, whether Henry Wood was related to the others is unknown.

In Rouen, Etty walked on the very stones where Joan had walked and stood in the Old

Market Square where she had suffered martyrdom. He found that Rouen had been "improved" since his previous visit in 1830 so that too little remained of the medieval buildings to afford him the atmosphere or the details that he wanted. It was much the same in Orléans where he next went after first going to Paris to paint again in the Louvre. "What animals these Corporation men often are; to destroy the only existing memorials of their glory!" he wrote to Walter,[3] a complaint he so often made about the authorities in York. So much had gone but what he did find he cherished. Again he stood on the spot, if not on the actual stones, where Joan had stood and crossed the river "over which she rode triumphantly into the City." Unfortunately the original bridge was no longer standing. He found parts of the original city walls but the gates and bars had gone, which must have reminded him of the possible fate of York's medieval remains. Too much of the cathedral was modern but he found "some parts round the Choir seem the same." He was shown an old banner, though painted after Joan's death, and was given a little book on its history. He saw prints of the old city in the Town Hall and had to make do with these. In Paris Etty dined with Bishop Luscombe, went to St. Denis and Versailles and one night he went to the *Opéra Français* where he saw a ballet which he declared a superb spectacle. He was away two weeks and his exertions made him "long for a little rest." Although undoubtedly something of a valetudinarian there is also no doubt that Etty had a weak constitution and much exertion tired him. He returned from Folkestone to London by railway, not his usual means of travel; and he does not seem to have enjoyed it. Etty seems to have been unable to find either the time or the energy to begin his great work and actual painting did not begin until 1846.

After taking brother Charles to Southampton to embark for Java in July 1845 he went to York, as usual by coach but regretting that fewer coaches were "yet in the field," the railways now being more popular. He had returned to London by December when he wrote to Mrs. Bulmer (on the 1st of that month) that he was sitting at home

> reading and thinking tranquilly,—the Sun shining on my picture of York Minster Choir, and my beautiful picture of De Witt's interior of a Dutch Church,—made the morning pass speedily and happily away. I sit and think of York and Italy, scenes that are past, and friends that God has yet blessed me with; and I hope long will. Imagination and memory lend their wings to the spirit. Lands and seas are compassed, while one is sitting in one's chair. Such delights, content and a tranquil mind can give.

By January 1846 he was reporting to Walter that he was "better, decidedly, than last winter" and, as member of the new council he was going to "the Academy, at night and day, without any serious inconvenience." Nevertheless he was eager to retire to York though content to leave it God to decide whether this would be possible. His retirement home had been purchased, altered and decorated ready for occupation. All that was required was Etty's own determination to leave London and the Academy forever. Considering that he had seen this house many years earlier, when it was occupied by others, and had set his heart on it, we may wonder at his reluctance to make the move. London, the Academy and the satisfaction of being a man of importance—a very understandable attitude in a man who had struggled to carve out a career—all combined to tie him to his familiar haunts.

Throughout 1846 he worked on his *St. Joan* paintings. Although we know that Etty worked continuously against the effects of illness and pain we know very little of the details of the progress of his painting of these canvases. In this work he had changed from his customary style of smooth brushstrokes to a more broken brushwork, probably influenced by the new styles of the Romantics and perhaps also by his own increasing rheumatism. Probably in this year he painted two portraits which later served him as models for St. Joan herself—*Mrs. William Wethered*, the wife of his agent, and *The Right Honorable Mrs. Caroline Norton* (see age 333 and 331). Both, but especially the former, suggest poses suitable for a martyred saint.

In July of that year he visited Augustus Pugin in Ramsgate. By the mid–1840s, Pugin, aged

thirty-two, was already an esteemed architect and a man of national importance. His public advocacy of the Catholic cause brought both admirers and enemies. Already he was renowned for the quantity of work he could handle. In one month alone he had completed two churches and a cathedral. *Punch* in 1845 had satirized him as an architect able to supply "every article in the medieval line ... Designs for Cathedrals made in five and forty minutes."[4] Pugin was a most approachable young man, not at all the daunting genius his reputation suggested. It is said that, like Wordsworth, he attributed even to stones a moral life and some feeling, but with him they were not the stones of the Lake District but of the great cathedrals. Apparently he believed that the very walls of cathedrals had soaked up the piety of those who had worshipped there through the ages. His love of the Gothic was heavily tinged with Romanticism. Etty's visit made a great impression on him. He had known Pugin for some ten years and many of the latter's beliefs had been absorbed by the willing painter. There is no doubt that Pugin's influence encouraged Etty to produce a series of paintings that would do honor to the medieval saint he had chosen. Etty wrote to Betsy on the 11th May 1846, describing the reception he had been given. He was

Installed in the state bed-room;—state without nonsense and with real comfort; (sitting) on a beautiful, green velvet chair (at an) oak table, ... a window looking out on a beautiful bay, luxuriant corn-fields, and, in the distance, the coast of France.

On the Sunday (the 12th May) he wrote to Betsy again, a frequency that was usual when he was away from her. "This was a glorious morning. The bell rang at six. I got up about seven. At eight, is Mass in the Chapel; this morning,—to accommodate Stanfield [*Clarkson Stanfield, the painter*] who has to come some distance,—half-past."

John Harper (19.5 × 15.5 ins) (1839–41), York Museums Trust (York Art Gallery), YORAG71.

He continued by describing once more the countryside in which the house was situated. He heard a

Lark at Heaven's gate, singing, ... soaring and singing, till a mere apparent speck; its little wings flashing back the sunshine; singing over our heads the Heavenly hallelujah of Nature and ecstasy, for the best part of an hour. Herbert [*John Robert Herbert, also a Catholic*] and I watched its untiring praises till we went into the Chapel.... Oh! That dear Lark! Sure, something holy is in that breast, that *little* breast, that sang so loud and untiringly. ... The butterflies are dancing by dozens over the golden corn-fields. ... The swallows are building their nest, under the eaves; indeed, have built it, and are feeding their young; shooting silently by. All Nature looks gay. ... Pugin treats me like a prince. I am truly enjoying myself; so far as I can without thee.

Etty did not waste his time at Ramsgate. He set up his easel and painted three backgrounds of sea and landscape in preparation for pictures yet to come. We may certainly assume that Etty's stay with Pugin encouraged him in his ambition to paint a series worthy of his medieval heroine. But he was dogged by ill health and felt the

need to return to York for further recuperation. From there he wrote to Betsy (11th September 1846) that he had taken

a solitary walk on dear Knavesmire; the haunt of my boyish days, where I used to take my two poor Scotch cows;—the old Mill of Father's near, pasture all around. ... The day was lovely;—the sun warm and golden; the atmosphere and scene most pleasant. ... The swallows and swifts darted by in the sun, and seemed to welcome me, in my sweet solitary ramble. Here an old horse biting his mouthful of grass;—there a cow, crumping; all peace and pleasantness. ... I entered the sweet and solemn, natural, Gothic Cathedral of Knavesmire Wood. The last time I was there, was with poor John Harper. The sun darted in here and there, as it does in the Minster. I turned my thoughts homewards. The crows were collecting their evening council. I gathered some sweet little forget-me-nots, and brought them home.

Back in London, he spent October 1846 working on the *St. Joan* paintings. He was so far behind that he made his dealers, Wethered and Colls, promise to give him six months' freedom from any more commissions. According to Gilchrist[5] his Diary (not now known) recorded that he was "Out of bed one day by six in the morning, another by five, another as early as four." The rheumatism in his hands still plagued him and by November he was suffering from "attacks on his trachea, bronchial tubes, and throat—with cough and asthmatic accompaniments." Writing to Walter on the 16th December he told him:

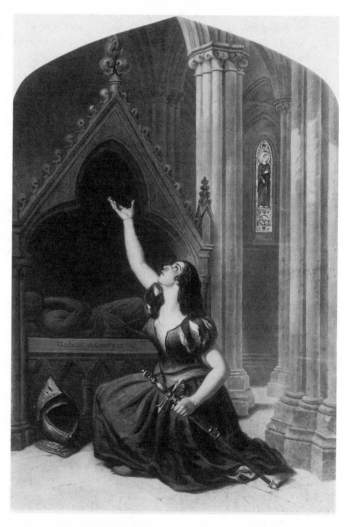

I have been for some time intending to write to you. Frequent attacks of my enemies,—cough, and shortness of breath, and engrossing attention to my dear *St. Joan* have, till now, prevented me. At times, the weather's severity has nearly floored me. But I have again rallied; and, fighting side by side by my inspiring Heroine, have—if I may believe what folks say—done wonders. Certainly, she is an inspiring subject—worthy of the Poet's pen, and Painter's pencil. If God will only grant me health and favourable weather, I hope to make my Pictures worthy of her. As yet, however, prevails cold most intense. My medical man, Mr. Cartwright, says, the thermometer at two o'clock after midnight, on Tuesday morning, was 15° below freezing point. On the previous evening I suffered much: but at *that* time I was snug in a warm room, in bed.

The three *St. Joan* paintings were completed on 5th May 1847 and exhibited in the Royal Academy and two years later in the Royal Scottish Academy. They were large canvasses, the

Joan of Arc, on Finding the Sword She Dreamt of, in the Church of St. Catherine de Fierbois, Devotes Herself and It to the Service of God and Her Country (117 × 78 ins.) (1847), **by permission of the Sisters of St. Joseph of Annecy, Llantarnam Abbewy, Cwmbran, South Wales; photograph by Roger Bell.**

central panel described as *Joan of Arc Makes a Sortie from the Gates of Orleans and Scatters the Enemies of France* measured 9 feet 9 inches by 15 feet (see color plate 11). The two flanking canvasses measured 9 feet 9 inches by 6 feet 6 inches. These were entitled (on the left) *Joan of Arc, on Finding the Sword She Had Dreamed of, in the Church of St. Catherine de Fierbois, Devotes Herself and It to the Service of God and Her Country*, and (on the right) *Joan of Arc, after Rendering the Most Signal Services to Her Prince and People, Is Suffered to Die a Martyr in Their Cause*. The three canvases were intended by Etty to illustrate the virtues of Religion, Valor, Loyalty and Patriotism, all principles that he himself held most dear. Etty wrote to Colls on the 5th May:

> Destined by the Almighty to be the instrument in the accomplishment of one of His great designs [St. Joan became] from a simple peasant girl ... a heroine, patriot, and deliverer of her country ... swayed by two powerful emotions, religious and political enthusiasm. ... she believed herself a chosen instrument in the hands of the Deity; and by the strength of this faith was supported. ... Her mind feeding on itself [had received] impressions, which the simplicity of her nature interpreted as direct messages from Heaven.
>
> I thought that as she was the Judith of modern times, her story, like my First [and] like the Epic, ought to have a beginning, a middle and an end [and] like all my large Pictures, point a great moral lesson to the mind, namely—that heroic self-devotion to her country and her Prince, which has stamped her fame.

In this letter Etty explained the various features of each canvas. He said that St. Joan's appearance "that she is not sufficiently excited" was intentional. "I conceived her in possession of superior power." In the paintings Etty had fulfilled an ambition that he had nursed over seven years, to express an idea which had first come to him in Henry VII's Chapel, Westminster Abbey. On Easter Sunday, before the paintings finally left his studio, Etty had again visited Westminster Abbey "to return thanks to Almighty God for having so mercifully dealt with me," as he wrote to Walter.[6] He attended evensong and "spent the evening in peace."

Gilchrist, who was able to see them, said that[7]

> finished pictures the *Joan of Arcs* assuredly are not. Noble as is the appearance they make by themselves, they ... suffered ... by comparisons with the *Judiths*. The day was past with Etty for careful detail. The sure hand and patient was his no longer. The very facility a Master in the Art has attained often leads him into habits of careless execution; a fact, the later stage of many a great Painter's career illustrates.

The Times welcomed the new subject and hoped there would be no more paintings concentrating on the female nude. The review by Samuel Phillips of 1st May 1847 was, on the whole, adulatory. As this is now virtually all we can know of these paintings it is worth quoting.

> On entering the great room, a picture by Etty, divided into compartments, and illustrating three epochs from the life of Joan of Arc, instantly arrests the attention. ... The character of the heroine under these different circumstances is preserved with extraordinary skill. In the church we have the single-minded enthusiasm of the inexperienced girl; in the conflict with her enemies, where she is scattering death around her, there is still the same consciousness of high purpose; so that every blow she deals seems to be the act of one by whom nothing is done in anger, and with whose will no human emotion could interfere; while, on the pile, her task completed, and the animal vigour by which she has been sustained in her career no longer needed, her entire spirit seems to be concentrated in the trance of martyrdom. This last compartment would be painful if it were more than a grand part of the whole, for the eagerness of the monk holding up a crucifix at the last moment, while yet he can venture near, the bursting up of the flame and smoke, which in another moment will remove the victim from sight, and the crowd of eager faces (among which one female head is alone discernible, and that turned away) impart an intensity of action to the scene the impression of which is not easily subdued. Amidst all these merits there are faults, and some glaring ones, although they are none of them such as to interfere with the sentiment of the work. The routed and half-naked soldiers in the sortie look more like Saracens than the people of any other country, and it is quite clear that the colossal horse upon which Joan is mounted could never have emerged from the very modest castle in the back ground.

Gilchrist says that "among lovers of Art, and brother Artists" there was praise for the work. "Turner, Landseer, Leslie, among others, warmly praised them. The last-named spoke of the con-

cluding scene as [one of] the most tearful and affecting Pictures he had ever seen."[8] Leslie, when he came to lecture on Etty's achievements after his death, was full of praise for these works. Although there were several interested collectors no one had a room large enough to accommodate all three. Etty's usual dealers, Richard Colls and William Wethered joined with the engraver Charles W. Wass to buy them for £2,500. Their intention was that Wass would engrave them and they would publish the prints and the paintings would be toured round the country to stimulate sales. The tour did not materialize. There was no public interest. The paintings soon disappeared and their whereabouts were still unknown when Farr published his biography in 1958. Since then the central canvas came unexpectedly on the market in 1982 and was bought by the Musée des Beaux Arts, Orléans, and the first has been discovered in a convent in Wales. The third painting is known only through prints. All three are reproduced in the present work for the first time.

Etty had followed the principles of history painting but the valor, patriotism and religious faith he had depicted had been displayed by a foreigner and, moreover, a citizen of France with which country England had recently been at war. One may truly say, "bad timing!"

It appeared to his critics that Etty was turning away from his usual subjects when, in the following year, he exhibited *A Group of Captives: "By the Waters of Babylon"* and a large *St. John the Baptist.* with an accompanying text "Him that crieth in the Wilderness, Repent ye!" *The Times* hoped that this meant a change at last from nude females. the critic writing again in the issue of 2nd May 1847:

The public were taken by surprise at this new production of historic art, and were curious to know, whether Etty intended to maintain the position so suddenly seized. The *St. John* of the present exhibition shows that he will keep to his post.

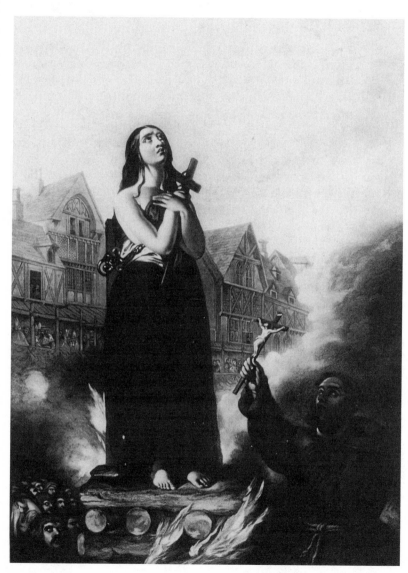

Joan of Arc, after Rendering the Most Signal Service to Her Prince and People, Is Suffered to Be a Martyr to Their Cause. From a print of the engraving by C. W. Wass, 1851; original canvas 117 × 78 inches, exhibited at the Royal Academy, 1847.

Nonetheless Etty's new style of brushwork was not well received. "The attempts and conceptions of Mr. Etty are very great, but he does not quite abandon the preparatory aspect." *St. John* was bought by his friend the Rev. Isaac Spencer at Acomb, near York, who sold it in 1861. Its present whereabouts appear to be unknown. Later, John Ruskin was to dismiss Etty's "larger subjects, more especially the St. John, as wanting in the merits peculiar to the painter; and in other respects it is alike painful and useless to allude to them."[9] The smaller works that Etty exhibited that year were singled out, after allowing for "their peculiar aim" (whatever that might have been) for "the highest praise." Ruskin was not generally approving of Etty's work, rejecting the nude figure as a suitable subject for art and certainly most unsuitable for teaching to students. Ruskin would probably have approved of Etty's "new production."

York Minster again

Throughout his life Etty found it necessary to abandon his painting to deal with other pressing events. These interruptions often lasted many months, in some cases a year or so, and although he did not give up painting altogether at these times they did interfere very seriously with his plans. Thus while he was getting over his disappointing experience with the Prince Consort and getting down to painting his major work, the *St. Joan* series, he found himself once again taken back to York to deal with threats to his beloved Minster. Four years earlier, on the 20th May 1840, a clockmaker from Leeds named William Groves had been repairing some wooden ducting in which the clock wires ran in a room beneath the bell chamber. The room was dark so he had fixed a lighted candle to a piece of wood and had apparently failed to extinguish it when he finished work at around six o'clock in the evening of that day. There was a great deal of interior timber construction in the tower and by nearly nine o'clock, when the fire was first seen, it had burned through the floor of the bell chamber and the bells above had crashed to the ground. The Nave was gutted but fortunately the stained glass windows escaped undamaged. Gilchrist recorded the event as typical of the indifference of York's citizens to the splendors of their city. "Two such Fires within ten years are no result of Chance, but of deep-seated habits of carelessness and sluggish obtuseness."[10] Such strictures were hardly fair since neither fire was caused by "the citizens" but Gilchrist had developed a hearty dislike for the people of York.

Etty is said to have burst into tears upon hearing the news of the fire. He wrote immediately,[11] urging prompt action to protect the building from the weather, and, to the Dean and Chapter, forwarding the offer made by his friend the architect Lewis Cottingham to superintend the restoration work "free of professional charge; an offer of some thousand guineas value." His offer was not even acknowledged. They were probably displeased by yet another of Etty's interventions. In any case, they had already applied to Sir Robert Smirke for help.

Early in June Etty went to York to see the damage for himself and to speak at one of the public meetings held to raise funds and subscribing himself, very liberally it was said. His speech was one of his usual grandiloquent efforts describing

> the noble Nave, that perspective of splendour, finished by the glorious West Window, resplendent like a mass of living gold ... with the gorgeous Windows of the Side Aisles ... unexampled in richness, unrivalled in any Cathedral in England; now open to the winds and rain of heaven.

And much more, designed to awaken local pride and eagerness to act. On 6th July he gave a second lecture to the York Philosophical Society, the speech being reprinted in the local newspapers. He was particularly concerned about the damage to the bells and the clock "whelmed into one mass of ruin, molten ore and rubbish." By February 1842 work was well advanced on the tower itself and an estimate of £992 had been received from the Whitechapel Bellfoundry for supplying nine bells, to which £350 8s had to be added for new timberwork and £80 10s for

re-hanging one bell that was still serviceable. It seemed unlikely that such a sum of money would be readily forthcoming but in December 1843 Dr. Stephen Beckwith died leaving the sum of £2,000 to provide "a good and sufficient peal of bells" for the Minster.[12] The Dean and Chapter speedily took advantage of this bequest and on the 3rd January 1844 they met and resolved to instruct the architect, Sir Robert Smirke, "to obtain an actual estimate of the Expense of completing a Peal of Ten Bells with the necessary framework and fixing." However, as was so usual in York, disagreement was at once introduced into the proceedings. Dr. Beckwith's will had been published in the *Yorkshire Gazette* of the 30th December 1843 and Mr. John Robinson, a music seller in Stonegate, York, also wrote a letter to the paper on the 6th January urging that

The late generous bequest gives the Dean and Chapter an ample opportunity to add to the structure bells worthy of such a Cathedral.... The number of bells to correspond with so magnificent a cathedral should be twelve, not ten ... and as this is the grandest cathedral in the Kingdom, it certainly ought to have the grandest peal of bells.

He went on to propose the desired tone of each bell ("at least in the key of B natural"— and preferably "carried down to A") requiring that the tenor bell should weigh at least 80 cwt. He also asked for a separate bell to be provided for the clock in the North-West Tower and "it ought to be a magnificent one." On the 17th January 1844 the Dean and Chapter agreed to enter into a contract for twelve bells. But not everyone agreed with the details of their decision and on the 20th January, John Robinson had another letter published in the *Yorkshire Gazette* quoting the opinion of Mr. Vincent Novello (former organist at Westminster Abbey and more lately at the Roman Catholic chapel at Moorfields), "one of the highest musical authorities in London," supporting his proposals. Several other letters were published all urging heavier bells but this was not agreed to by the Cathedral authorities, who decided to match the original tenor bell in the key of C. Even so, the full set was to be the heaviest in the country. But John Robinson's suggestion of a bell for the clock was taken seriously, though this required a separate application for a public subscription.

John Camidge, the Minster organist and friend of Etty's, reported all this to him. Camidge was of the opinion that the intention of the original builder had been for "one Tower for Bells for Festival occasion, the other for the Gt. Cathedral Bell for the Solemn Purposes of the Church." Camidge was also anxious to have trumpet pipes installed in the new organ that was necessary due to the fire. He had himself gathered subscriptions totaling £150 and asked Etty to gain the support of his London friends for further contributions. Camidge went on to say that he wanted the proposed bell for the clock to be "the Pitch of F." This would make it a fifth below the "bell which is to be purchased as the Tenor Bell of Dr. Beckwith's Peal of 12 Bells" and therefore suitable for incorporation in the peal. In February 1844 Vincent Novello, wrote to Etty from his home in Bayswater, London, urging him to enter the campaign to ensure that the bells were installed.

My fear is, that while you are hesitating whether the Rooks & carrion-Crows are worth your "powder & shot," the said "obscene birds" will have done the mischief by plundering the fields, so that your aim at them will come *too late*. Let me add my earnest entreaty to that of Mr. Robinson not to let the opportunity pass by of "firing a shot" at the flock of intended depredators, if it be only to *scare them away* from attempting to carry off any portion of the rich sheaves from the granary that Dr. Beckwith has so kindly accumulated with the intention of forming a lasting provision for the occupier of the South west Tower of York Cathedral. I am quite willing to act as a *scare-crow* on such an occasion, and I hope you will have no objection to join company with me in endeavouring to *frighten away the thieves*.

The best police, or protectors of the public, are those who think that "prevention is better than cure"—and who therefore try to *prevent* a robbery instead of waiting till it is completed & then try to *punish* the robbers.

We may pause to wonder how many townspeople today would use agricultural metaphors to emphasize their case. Such was the nature of mid–19th century society that most townspeople had some recollection of life in the country.

Etty straightaway wrote to his old friend Robert Davies in York for information. In 1821 Etty had painted the portrait of Mary Arabella, the daughter of the Rev. William Jay and Anne Davies who had married in January 1791. The relationship between Anne and Robert is not known but a connection clearly existed. Davies' reply indicates the local suspicion which attended any dealings by the Minster Dean and Chapter. Writing from York on the 13th February 1844 he said: "The Dean & Chapter, who have the disposal of Dr. Beckwith's legacy are a close body, & it is not easy to ascertain their movements." He had learned that

> A peal of Bells are ordered which are to be exactly like the old ones with two additional small bells to make up twelve, the present one to be the lowest. Many persons very much wanted to have a larger bell—one deeper in tone & power than the deepest—but the authorities will not consent.

One is drawn to the conclusion that though the Cathedral authorities had accepted John Robinson's plea for twelve bells, they objected as usual to any interference by others and instead of welcoming cooperation they had to dig in their heels over something. However the proposals for a new clock bell were taken seriously and by March 1844 the cost of casting such a bell had already been ascertained. A bell weighing ten tons was envisaged as being "much heavier than any other Bell in the Kingdom." The country's heaviest bell so far was at Oxford and it indicates the nature of the Chapter's pride in the Minster that they had such ambitions. An appeal for £2,000 was launched on the 29th March. The Minster Restoration Committee gave £350 but reclaimed it from the Beckwith Bequest when they realized this sum remained available. Etty sent two guineas to the appeal and was thanked by John Robinson who, perhaps rather pointedly, listed the subscriptions so far received. These ranged from £30 down to £5. Etty's two guineas looked somewhat meager but as the provision of a clock bell was not an act of restoration and the Minster already had Dr. Beckwith's legacy, he is not likely to have regarded the proposal as urgently important as the matter of the organ screen had been.

The peal of bells was duly installed and rung for the first time on the 7th July 1844 when the Minster reopened after the second fire. Dean Cockburn preached a sermon. As insufficient money had yet been raised for the clock bell it was decided to keep it in London and charge the public to view it. It was taken by wagon and horses to Baker Street Bazaar for this purpose and as by June the balance had been received it was then transferred to Pickford's depot in Camden Town and sent by railway to York, the station then being in Toft Green on the opposite side of the river from the Minster. At that date there was no bridge at this point, everything being transported across the river by ferry. On the 18th June it was drawn in procession to the Minster and the long task of installing it began. The Great Peter bell was not rung until the 14th August 1845, the day after final hanging. The first striking coincided with the election of George Hudson, "the Railway King," as Member of Parliament for Sunderland. It was felt that Hudson's success should be so honored since he had been Councilor, Alderman and Lord Mayor of York

In fact, the bell was rung three times that evening but the effort of thirty men was required to do so, the clapper being very heavy. This was clearly not a sensible method and it was decided to install a large hammer and lever system. But still all was not well. The tone of the bell was not as expected and the striking could not be synchronized with the clock without the considerable expense of either rebuilding the clock or replacing it altogether. In the meantime the tenor bell of the Beckwith twelve bells was used as the clock bell but the heavy hammer needed to strike it had caused it to crack. This bell had to be replaced and opportunity was taken to deal with the problem of striking the Great Peter bell. It was decided that this would require a new clock and in August 1850 a new committee was formed and an appeal for £300 was launched. The appeal was unsuccessful. It was also becoming apparent that the tone of the Beckwith Bells was too unsatisfactory to be tolerated.

The story of the Minster bells is of one problem after another. The whole subject occupied the attention of the Chapter until 1900. Eventually the bells were removed, retuned and re-installed.

They were rung on the 25th March 1914. But again the tone was unsatisfactory, especially to the bell-ringers in the ringing chamber who found them far too loud. Nothing could be done during the period of the First World War. Further work was undertaken between 1924 and 1927. It is, of course, far outside our concern with this subject to deal with it in any detail. All that needs to be said is that Etty never heard the bells as they were originally intended to sound and he seems to have withdrawn from the whole subject, no doubt in despair. At least the Minster Chapter had succeeded in installing the heaviest bell in the country, at ten tons and fifteen hundred weights, and the Great Peter bell held pride of place for eleven years until Big Ben was erected at the Houses of Parliament in 1856. The checkered history of York Minster is a sad reflection on the attitude of local people, who seemed ever unwilling to finance the edifice and its activities which were bound to be costly. Despite their attachment to the Anglican Church as an institution the citizens probably regarded the Minster as a wholly ecclesiastical responsibility.[13]

There was also the question of where to site the new organ made necessary by the fire. John Camidge and Etty favored a chamber to be specially built in the north aisle. This seemed more important to Etty than the restoration of the bells. This proposal was eventually adopted.

The attitude of the Minster authorities to the general public, or even to the congregants, was very much the consequence of the personal nature of the Dean who was always determined to have his own way in everything. As the Dean was still William Cockburn, who had caused difficulties on the occasion of the earlier fire, it was never going to be easy to obtain even a compromise solution. His motives were often of the best but he was too apt to act on his own initiative without reference to the Cathedral Chapter. He now sought to assist the Minster's financial position by selling the metal of the bells destroyed in the latest fire but as he did this without reference to anyone else he was accused by his enemies, of whom he had many, of selling Minster property for his own gain. When he had earlier ordered the demolition of the old Deanery and the building of a replacement, he had also done this without consulting the Chapter. The architect for the new Deanery overspent, claiming that he had been given inadequate instructions, and the Chapter had to meet the costs. The Dean had also ordered the removal of various commercial buildings which had long been attached to the south side of the Minster. This had resulted in the loss of valuable rents and many thought the Dean should have personally reimbursed the Minster authorities. We must today agree with the Dean's opinion that these buildings were inappropriate, but he had acted without prior approval. There were many occasions when Dean Cockburn had acted unilaterally and confused the Minster accounts with his own money and although he may not have intended dishonesty his colleagues disliked his rudeness and coldness of manner and peremptory attitude, which did nothing to attract support for his various enterprises.

Local disquiet had reached such a stage in 1841 that Archbishop Harcourt announced his intention to "visit" the Cathedral. This, of course, would be an official visit to enquire into Cathedral affairs and in constitutional terms was a very serious matter. The many conversations and letters that had passed between the two men had had no effect in curbing the Dean's notions of self-importance; so it was now to be a formal Inquiry. The last "visit" of an Archbishop had been in 1715, so it can be seen that these were not frequent occasions. The new visit began on the 18th January 1841 and on the next day Dean Cockburn and his wife walked out of the court, refusing to take part. Two days later he returned and spoke to praise the Archbishop. The court was still sitting at the end of February but the Dean had retired to Somerset, again refusing to take part in the proceedings. Now there arose the accusation of simony, that the Dean had sold livings, that is, had accepted money in exchange for appointments to parishes, an extremely serious offence. Dean Cockburn returned to York on the 23rd March, causing an uproar with counter-accusations, and nearly had to be ejected by force, which some believed he was hoping to encourage. On the 2nd April he was declared guilty of simony and the Archbishop deprived

him of his title, his deanery and all its emoluments. The Dean appealed to the court of Queen's Bench and on the 20th June the court found for him, though most thought only reluctantly. The Archbishop accepted the verdict, for otherwise he would have had to proceed under ecclesiastical law and he did not wish to divide the diocese by doing so. In the autumn of 1841 the Dean sued his agent, a Mr. Singleton, over disagreements regarding the repayment of his stipend and income from leases for the period between his dismissal and his reinstatement. The Dean lost the case but the agent had to pay his own costs. The name "Singleton" is interesting. Was he one of the Singletons of Givendale, the friends of Etty?

There is no doubt that Dean Cockburn believed he was always acting in the bests interests of the Minster. He was obviously a man of some learning and culture. He had been foremost in attracting four music festivals to York between 1823 and 1835. It may be assumed that at least he had many friends among the cultured minority. At all events, he remained in office until 1858. But Etty appears to have had either no knowledge of or interest in these matters. Considering that Cockburn was Dean of York throughout Etty's adult life and beyond and that he constantly attracted controversy and that Etty felt himself bound to the Minster, it must be assumed that he should have known of these events and have had some opinion, even concern, about them, especially if the agent Singleton was one of the Givendale family. We are driven to conclude that for Etty, York Minster was a spiritual experience and that he had no interest in its organization.

Throughout the spring and early summer of 1844 Etty was still struggling with the Prince's commission for the Garden Pavilion and could well have done without these diversions of his attention.

Planning for retirement

The 1840s were busy for Etty. It was to prove his last decade and perhaps he feared this might be so as his health continued to deteriorate. He began making plans for retirement. So much was occupying his attention that it is necessary to consider each set of events separately in order to record them in some comprehensible chronological order. As early as 1844 Etty began to look around in York for a house suitable for his retirement. He decided he wanted one within the City walls and near the Minster. Although he wrote lyrically of hanging up "his harp on the willows" and sitting on "the sunny bank to meditate," he was concerned that the fields around York, which at that time came close to the walls, would soon be built on and any house purchased in such a situation would soon be surrounded by other houses not to his liking. He decided to buy a house within York among neighbors with whom he would feel comfortable. Friends found a house in Gray's Court, near the Minster, but it was soon declared to be small and dark and damp. Other houses found for him had similar drawbacks. At that time the water-table in York was high and houses were not built with damp proof courses or cavity walls.

So he did not take up retirement immediately after all. As already recounted these were busy years for Etty. In 1843 Charles visited England and stayed until mid–1845. There was also the competition for the decoration of the new Houses of Parliament, the disastrous Royal commission, his involvement with the Schools of Design, his visit to France and the beginning of his last great work, the *St. Joan* paintings. But it was not all work that occupied his attention. In January 1845 two fires occurred in the neighborhood of Buckingham Street, both while Betsy was away with Charles. Etty reported the incidents to her by letter. The first fire was, he said in his letter of 23rd January,

> in the daytime, and trifling. Ann [presumably a servant] had been out. She saw volumes of smoke rushing out of Stafford's area, and Stafford himself coming out of his door, crying, "Good God! We are all on fire!" She despatched a boy for good engines. And soon one came, accompanied by a lot of idle boys and men, with great hurras. Happily, it proved more alarming than serious; soot from the chimney was ignited. The assistance of sweeps put it out.

The second was more serious. In the dead of night, or rather at half-past three this morning, I heard a ring at the bell. Ann went down; soon returning in the greatest alarm; "Fire! Fire!" I drew up my bedroom blind. Sure enough, there *was* a fire, *apparently* coming out of the Leeds Warehouse! With my grey coat on, and neither shoe nor stocking, I ran up the planks [*to the roof*] and was relieved to, by seeing it was the Straw at the bottom of Villiers Street; a mass of fire running all over it. *This* was sufficiently alarming. For, if the warehouse or trees had caught, or the flagstaff, we should have been in the greatest jeopardy. I put on my things, and sallied out, leaving directions with Ann, to stand by the "thatched cottage" and prevent any sparks settling on it; which injunction she obeyed till almost starved, and trembling with cold or fear. I endeavoured to get more engines into play—the fire raging, so as to threaten the house adjoining. Fortunately the tide was rising [*the river level was rising and the fire engines could pump water from it*]. And we got a second engine, at which I worked lustily for a considerable time. It sent a deluge, Walter says, which in time reduced the Fire to reason. By half-past five, the fierceness was subdued, and our fear allayed. They took down the names of those that had worked the engines, mine among the rest, and distributed money to each. Mine I divided between some poor fellow-labourers near me. I had previously sent four pots of porter. For they worked cheerfully.

In addition Etty distributed among them "all the sixpences and halfpence in my pocket. I returned home; went to bed for an hour or two. And, bless God! Our sweet, and (when thou art there), happy Home is safe, and smiling in the sun."

This account provides us today with interesting details of the operation of fire brigades at that time. After the Great Fire of 1666 insurance companies were granted charters to provide fire appliances and more and more owners insured their properties. The companies realized it would be to their benefit to hire men to extinguish fires in the buildings they insured and engines with pumps and hoses were introduced. Every policy holder was issued with a metal badge or "fire mark" to fix to his building to identify the relevant insurance company. Fire brigades would extinguish fires only in those buildings which their company had insured. This was clearly an unsatisfactory situation. Gradually the brigades were amalgamated and in 1833 the London Fire Engine Establishment was formed. The force consisted of only 80 men to cover the whole of London, clearly inadequate. The government appointed a committee to examine the problem and it was not until 1865 that the London Fire Brigade was established—another example of the unwillingness of governments to intervene and of the public's reluctance that they should do so. This was twenty years after the events recorded by Etty. In his time the insurance companies were still providing the men and equipment and clearly needing the co-operation of anyone available, paying them on the spot for their help—and, be it noted, relying on the River Thames being at high tide to supply the water! Properties distant from the Thames had to rely on the small amount of water carried in the engines and on buckets provided by local householders.

The night of the 23rd January 1845 must have been arduous for a man in such ill-health as Etty was. Yet he was back to work at once. On the 1st February he completed his reworking of the copy made by an unknown Edinburgh artist of his earlier painting *The Combat*. This was for the engraver George Doo to work from. This required so much repainting that it can be regarded now as wholly by Etty. Incidentally *The Combat* was so popular that a further copy by Etty is known (now in the U.S.) as well as one by an unknown artist (now in York). In February he was again afflicted by his usual respiratory trouble but refused to stay at home. In a further letter of the 2nd February to Betsy he told her:

Breath and cough yesterday so bad that Mr. and Mrs. Walter Etty [*then staying with him*] and Mr. Colls, all advised me not to go the Academy. But no! I will complete my duty [*as Visitor*] if I die at my post.... When I got into the warm air of the Life Academy, was right enough.

But on his return home "my cough and bad breathing returned, and I suffered severely until ten" when he was relieved again by his warm bedroom. It is ever curious that he never realized that much of his affliction was due to the London air and particularly due to his living in the damp conditions next to the Thames.

Seven paintings were sent that year to Academy exhibition though none was of outstanding merit. His work this year, as with the previous year, reveals a considerable falling off in quality, the result of ill-health, too much preoccupation with other matters and a misconceived desire to present as many works as possible for exhibition.

At last he did find a suitable house, behind St. Martin's Church in Coney Street right against the river Ouse and near the Printing House of the *Yorkshire Herald*. He had seen it some years earlier and fallen in love with it, though it was then occupied. On the 14th January 1846 he wrote to Walter that he had signed the Agreement to purchase and in April completed the transaction at a cost of £1,100, quite a considerable sum at the time. Having lived for so long near the Thames he could not live in a house which did not give him a view of a river. But he did not occupy it at once. It required some alterations and Etty had his exhibitions in London to look after. His brother Walter had thought he should choose more rural surroundings but as Etty said, in this letter, "Green fields near a city are soon laid with bricks and mortar. And I am never happy long together, away from a River: which is more difficult to build on." Moreover he feared the growth of the railways. "The Railroad rascals," as he called them, were always threatening with "wild projects." Etty's thorough disapproval of the railways, so different from Turner's enthusiastic acceptance of them, is expressed in a letter he wrote earlier to Thomas Bodley on the 1st December 1845 from Buckingham Street:

St. Martin's from the River Ouse, York, Showing William Etty's House, by James Boddy (1910). York Museums Trust (York Art Gallery), YORAG:R2696.

What an overwhelming madness, for I can call it justly by no softer name, has taken possession of the public mind—the Railway Madness—really I think they want "a keeper!" to keep them within any decent bounds of justice or propriety. All the property about here, and my dear domicile among the rest, is threatened. So is yours I hear. Really so monstrous a monopoly, so offensive a tyranny, and one so destructive of the vital moral principle, has not in my opinion, visited civilised society for centuries! This is my candid opinion of the railway monopoly as it is now attempted to be carried thro'. The Englishman's house, it was formerly our boast and pride to call his Castle is now all a farce! *Pro Bono Publico!* falsely written in letters of brass—is made a Plea for the most monstrous schemes which avarice ever dreamed of.

So Etty unburdened himself and, incidentally, proposed that such enterprises should be governed by a Regulator, an original opinion for the times and an unusual view for someone of Tory persuasions. One of

the powers granted by Parliament to railway companies to which most people objected was that, once a railway proposal had received consent through a private Act of Parliament, the company could compulsorily acquire the land and property required for the project. Etty was confident that a house in York city center would be safe from the railway promoters. The purchase of the house having been completed, he set about altering it to suit his needs. Above all he needed a painting room so that he could continue his only interest. His friend James Atkinson assisted him by supervising repairs and alterations, including the building of a bay window to give him views up and down the river. With all of these alterations Etty declared himself most pleased. Even so, he still had it in mind to make periodic visits to London to arrange exhibitions of his paintings. He wrote to brother Walter on the 14th January 1846 that the house appealed to him because it was "near all those points to which I am attached." It was detached, which he felt necessary as a precaution against fire (he had seen too many cases in London of fires spreading uncontrolled), and it had stables which "I mean to pull down, as I shan't set up my carriage (unless a wheelbarrow)—and on their site build a bath,—an Academic room over that." Already he was talking of staying in Buckingham Street until "Michaelmas, 1847, I shall have been twenty-one years in the upper set; twenty-two and a half, if not twenty-three and a half, in the building altogether." Considering that he had not wanted to move there in the first place, he had grown very attached to his house next to the Thames.

"The new Maecenas"

So Farr describes Joseph Gillott and so Etty's new patron proved to be, so much so that particular attention must be paid to him.

Joseph Gillott had been born in Sheffield in 1799, the son of a workman in the cutlery trade. He moved to Birmingham where he at first worked in "the light steel toy trade" and about 1830 began his own business making steel pens by machinery. Gillott was one of those Victorian entrepreneurs who rose from poverty by his own efforts and overcame every technical difficulty by persistent ingenuity. Birmingham was a city of small manufactures where employers usually worked on production along with their employees until the business eventually grew large enough for them to manage from a distance. Gillott began by manufacturing buckles for belts. Then he invented a steel pen nib which quickly superseded most other contemporary pens. Its novelty was its small ink reservoir which allowed longer continuous writing without constant dipping into a bottle or inkwell. This nib continued to be popular until the invention of the fountain pen some fifty years later. Beginning with one female assistant selling the pens at a shilling each to a local stationer, Gillott finally employed 450 workers. Since his production methods were cheap and his sale price, at one shilling each, was high, he quickly amassed a large fortune. Advertisements that he placed in provincial newspapers publicized his success. One such appearing in *The Yorkshire Gazette* for 1st December 1849 stated that from December 1841 to December 1842 he had manufactured 70,612,002 pens and from December 1842 to December 1843 he had manufactured 105,125,492 pens and that "The Queen has been graciously pleased to commend that [he] be appointed Steel Pen Manufacturer in Ordinary to Her Majesty, dated April 13, 1840." Gillott never forgot his own humble beginnings and became well known for his philanthropy and his considerate treatment of his employees. Having himself known poverty he had no wish to inflict it on others. "From his earliest years as an employer Gillott spared no cost or pains to benefit his workpeople to the utmost of his power."[14] It is said that he never changed his managers and never had a dispute with his employees.

In 1845 Gillott moved from his very modest home in Newall Street, Birmingham, to what has been described as a palatial house in Edgbaston, regarded as the "Belgravia" of Birmingham, an area of fashionable businessmen. He had "arrived," the ambition of every entrepreneur of the time. In 1851 he moved again to a house he had built on 500 acres also in Edgbaston, all

paid for by his flourishing business and wise investments. This house was in imitation of Lord Calthorpe's mansion and estate but Gillott never aspired to mix with aristocracy, merely to announce that he, a self-made man, was as good as they were. He was described in 1872, a year before his death,[15] as

> short, sturdy, square; his hair and beard silvery and venerable, well rounded, high; his eyes clear, humorous, and bright; his expression pleasant and assuring; his walk light, active, firm. His chief characteristics were remarkable quickness and accuracy of observation, wonderful shrewdness, common sense and frankness, boldness, and decision, and enterprise, rare mechanical skill and constructive powers, special talent for arrangement and organisation, and rapid and sound judgment on all matters which came before him.

Gillott joined the few industrialists who practiced "paternal capitalism," men such as Josiah Wedgwood, Titus Salt and Robert Owen, by establishing good working conditions and founding a benevolent society for his employees. Etty approved such self-made men and after they met in 1843 the two became firm friends. According to George Redford[16] Gillott acquired a taste for paintings through his friendship with George Dawes and Charles Birch, who were also manufacturers in Birmingham and both "great lovers of pictures." They possessed works by David Cox and Turner, and Redford asserted that Gillott was anxious to rival them. Finding that Turner at that time was unwilling to sell, having been, in his view, insulted by London art critics, Gillott decided to call upon him at his home where, having got inside the door, he engaged in some banter with the artist. On being told by Turner that he was not selling his paintings, no doubt a ploy to arouse his interest, Gillott replied that he had come to "swop pictures" with him and showed him a bundle of £1000 notes. This amused Turner and when Gillott told him that he always bought in guineas this established him as a serious collector and several paintings were bought. This story was told in Gillott's biography and recounted by Redford[17] who expressed some doubts but whether true or not it indicates something of the character of the two men. However deep his disgruntlement, Turner could not resist a good price.

Gillott was to prove an enthusiastic purchaser of Etty's work, mostly of his nude mythologies. He began seriously buying works of art in 1845, though he had started collecting some years earlier, and quickly made up for lost time. He quite openly based his first collections on Lord Northwick's own collection in Thirlestaine House near Cheltenham. Gillott was not educated in the arts but realized the importance of having a collection if he was to take his place in Birmingham society. He soon began to discern his own preferences for landscapes with a smooth paint surface and subtle luminosity. This has been described by Dianne Macleod as an "amateur taste" which also thrived among other Birmingham collectors.

In April 1845 Gillott bought from Etty "various Copies, Studies, and Works"[18] and on 1st November the same year he bought five studies. A week later Gillott paid on account for three paintings he had commissioned. By the end of 1845 Etty was referring to himself as a "partner" in Gillott & Company. This statement by Etty has led to much misunderstanding. There is no evidence that Etty actually became a partner and Farr thinks, as is most likely, this was a humorous reference to the amount of business passing between the two men. It seems that Gillott was never one to bargain over prices and it must have been very satisfying for Etty to obtain at last his asking prices without haggling, which he never enjoyed. Gillott's collection of paintings grew rapidly and when he died in 1873 they sold for £170,000. Etty never painted Gillott's portrait, his friend apparently not being interested in bequeathing his likeness to posterity.

Gillott quickly began to acquire an art collection. Five more works were bought in November for £465, followed by a payment of £1,000 on account for three pictures Gillott had commissioned—*The Choice of Paris* (now titled *The Judgement of Paris*), *Circe and the Sirens* and *Venus, Cupid and Psyche*. Dennis Farr considers[19] that Gillott "brought out certain aspects of Etty's personality which previously had laid dormant." Gillott had a boisterous humor and Etty had always had some delight in puns and parody, which his letters to Thomas Bodley often reveal. Gillott

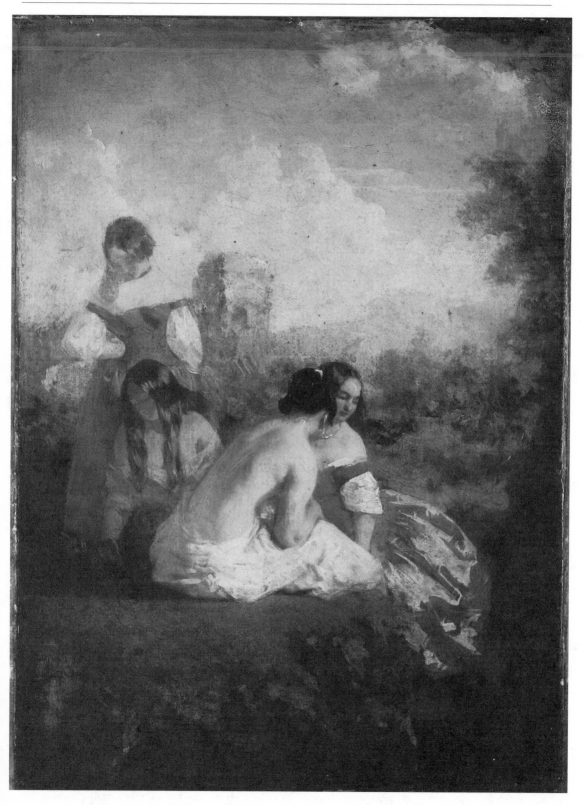

Four Girls by a Stream (43 × 31 cms) (c. 1830–35), Ashmolean Museum, Oxford.

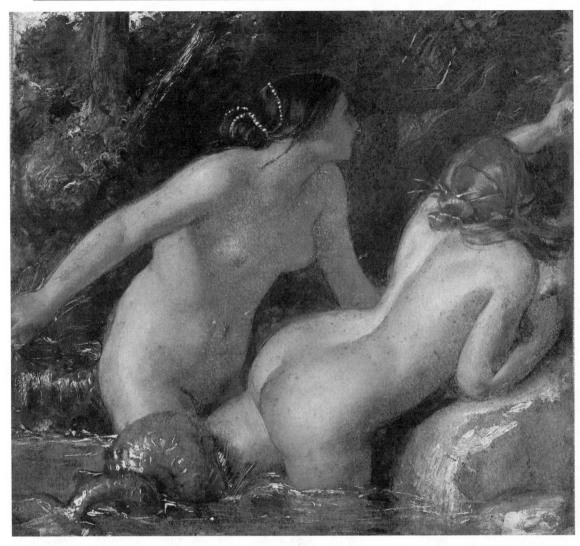

Nymphs with Sea Monster (dimensions unknown) (?late 1840s), Maas Gallery,
London/Bridgeman Art Library, London; MAA199078/78.

was prone to suddenly arriving in Buckingham Street and just as suddenly leaving so that Etty
began to nickname him "The Comet," partly after an express coach of that name. This account
confirms the *Birmingham Daily Post's* description of him (given earlier). Very soon the two men
were on such intimate terms that they were staying at each other's houses, Betsy as well and
sometimes on her own. As we shall see, Betsy fell for Gillott's lovable good-nature but she was
always careful never to compromise either of them. She was particularly well received by Gillott's
wife and children, of whom she became very fond. Etty found Gillott such good company that
he dropped his natural reserve and began to address him as "Joey." In these last years he had
found the close friend he had always needed. Up to this time Etty had confided in his brother
Walter and his cousin Thomas Bodley, the former being often called upon to advise him on
very personal matters, the latter enjoying a more restrained relationship, often humorous in a
boyish manner. Gillott was both friend and patron and, especially to Etty's taste, one who did
not drive hard bargains. Indeed, he seems never to have bargained at all. Each trusted the other
and that was what Etty valued.

Distinguished portraits

Etty continued to be reluctant to leave London and despite his failing health he continued to work hard and to receive commissions. As usual in addition to the nude studies that constituted his true interest, he received commissions for portraits which he always fulfilled, conscious as he was of his reputation and the need to ensure a steady income. These commissions came to him over a number of years and as they tended to be occasional rather than a steady stream, such as the more established portraitists enjoyed—and which he did not want—it is convenient to deal with them in groups rather than singly. His portraits often do not receive the attention they deserve. His much larger output of figure subjects have eclipsed their importance, most probably because English patrons were continuing with the national preference for portraits and there are consequently so many of them from this period that the opportunity to engage more challenging subjects is more appealing. But Etty was an accomplished portraitist and had it not been the obligation to paint so much costume that accompanied portraiture, he might have decided to pursue that course. But he was not only looking for fame and fortune, he wanted to fulfill a particular ambition, to declare the glory of God's most perfect creation. It is perhaps noteworthy, therefore, that Etty's most successful portraits are of women. Since most were commissioned by husbands and most of his subjects were renowned beauties in their day one does

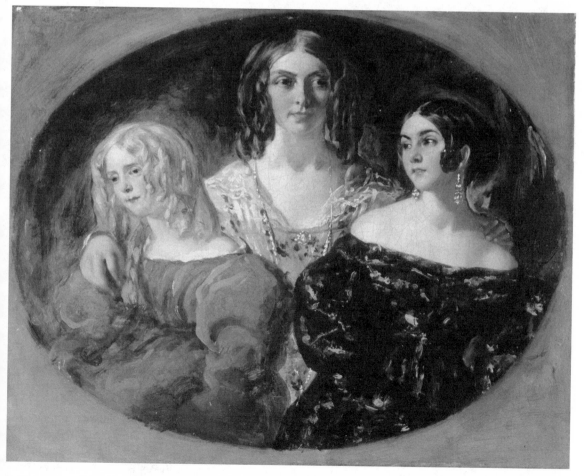

The Hon. Caroline Norton and Her Sisters (13.25 × 16.875 ins) (c. 1847), **Manchester Art Gallery.**

not find this surprising. Being needed for a particular family purpose, most have remained in the families that originally commissioned them. They are considered here in some chronological order.

The Hon. Mrs. Caroline Norton was a famous society beauty and author, whom Etty painted twice, once in 1847 with her children, the other on a date unknown. She was a granddaughter of Richard Sheridan, born in 1808, and had married the Hon. George Chapple Norton in 1827. Caroline Norton was a renowned beauty and with her sisters was known as one of the "Three Graces" of London society. Her husband proved to have no independent means so she entered upon a literary career. She had already published a satire, *The Dandies' Rout*, in 1825 when she was only seventeen years of age. Two more novels quickly followed. She also wrote a pamphlet condemning child labor. Her husband proved to be not only impecunious but also a cruel and jealous man who unjustifiably accused her of having a liaison with Lord Melbourne. His case,

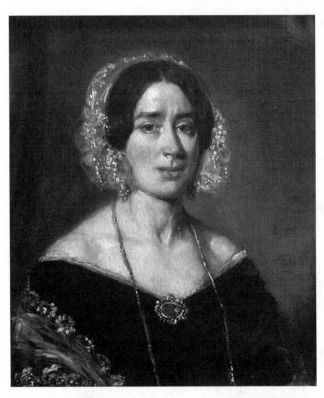

Portrait of an Unknown Lady (believed by Dennis Farr to be Jenny Lind). This painting bears a dealer's label on the back *"Portrait d'une femme par R. Bonington."* In June 1907 it was with the Galerie G. H. Sedelmeyer, Paris. When and how the Paris gallery acquired it is unknown. If it is a portrait of Jenny Lind it is unclear how it came to Paris. After his disgrace in 1849, George Hudson and his wife lived most of the remainder of their lives in poverty in France. It is a tantalizing thought that the ex–Lady Mayoress sold her portrait, whose present whereabouts is unknown, to provide much needed funds. (1846–48), York Museums Trust (York Art Gallery), YORAG696.

brought in 1836, clearly had no foundation and his action to recover damages from Melbourne failed. Caroline left her husband and suffered social ostracism in consequence, such being the antipathy towards women who defied husbands however errant. Her literary success continued but in 1853 she had to resort to the court for legal protection against her husband's behavior. He was refusing to pay her an allowance and at the same time claiming as his own the proceeds of her books. In 1855 she petitioned Queen Victoria for a change in the divorce laws. Her pamphlets on women's rights contributed towards some amelioration in the laws affecting women. George Meredith so admired her that he used her for his character Diana in *Diana of the Crossways*. Throughout her life she wrote a succession of novels and collections of poetry. Being unable to bring an action for divorce she had to await her husband's death in 1875 and in 1877, which proved to be the final year of her life, she married Sir William Stirling-Maxwell. She is recorded as the model for Etty's ambitious triptych *Joan of Arc*, having herself declared the fact to the Director of the Great Exhibition in Manchester in 1857, even admitting that Etty had rebuked her for "overacting" the distress and suffering of "the Sainted Martyr." The 1847 portrait is doubted by Farr on the grounds that the two sisters who accompany the Hon. Mrs. Norton in the portrait appear to be too young. They cannot be her children, who were boys. Whatever the facts regard-

Mrs. William Wethered (Triple Portrait) **(?1845), from the collection of Dunedin Public Art Gallery, New Zealand.**

ing these details, to have painted her was a recognized achievement for Etty. A more likely candidate for the model for St. Joan is the triple portrait of Mrs. William Wethered, as already suggested. Possibly painted about the same time it was not exhibited in the Academy until 1849, when it was catalogued as *"Three Versions of One Subject—painted in a previous year."*

Among the more notable persons who sat for Etty was the famous singer, Jenny Lind. She had been born in 1820 in Stockholm and had begun her career as a singer at the age of ten and, although called an "actress pupil," she did not make her first theatrical appearance until 1836 (at age 16). She was soon renowned throughout the major European theatres for her operatic roles. She visited London in 1847, where she appeared as Alice in Meyerbeer's *Robert le Diable* at Her Majesty's Theatre, her acclaim being pronounced "prodigious." In London she also appeared as Susanna in Mozart's *Figaro* and as Amalia in Verdi's *I Masnadieri.* While in London she sat for Etty. Farr considers that William Macready arranged the meeting. Although Jenny Lind had plain features and a broad snub nose, Etty "improved" her appearance, knowing that his task as a portraitist was to flatter the sitter. Even so, Etty could not make her a "beauty" but he does indicate the good humor for which she was known. There is a handwritten note on the back of the painting saying "This painting by W. Etty, R.A., a portrait of myself. Becomes the property of Dr. Baily [sic] at my death. 1858 Aug. signed E. Bailey Jenny Lind." Dennis Farr

identified *A Portrait of an Unknown Lady* in York Art Gallery as another portrait of Jenny Lind. A dealer's label on the back reads "Portrait d'une femme par R. Bonnington" and on the centre stretcher is inscribed "Mr. [?] Simmons [?] 35 Rue des Couteau [*sic*]." It is quite unlikely to be by Bonnington and there is indeed a likeness to the other painting, allowing for the subject's aging.

Jenny Lind toured in Manchester, Liverpool and other cities and whilst in Norwich she met the bishop, Edward Stanley, who persuaded her to give up the stage, though she did not do so at once. She was booked to sing in York on 11th September 1847 in the Festive Concert Rooms which had been built in 1824 at the rear of the Assembly Rooms. Prices were high for the provinces, one and a half guineas for a reserved seat and £1 for a gallery seat. A large number of tickets were sold but at the last minute it was announced that Jenny Lind had a cold and would not appear. The local newspapers reported that "the audience went meekly home again." However she did appear on 15th September the following year. The event was highly successful, £1,200 being received from ticket sales.

She revisited London in 1848, made some operatic appearances without action which were not well received and gave her last stage appearance on 10th May 1849. She continued to make

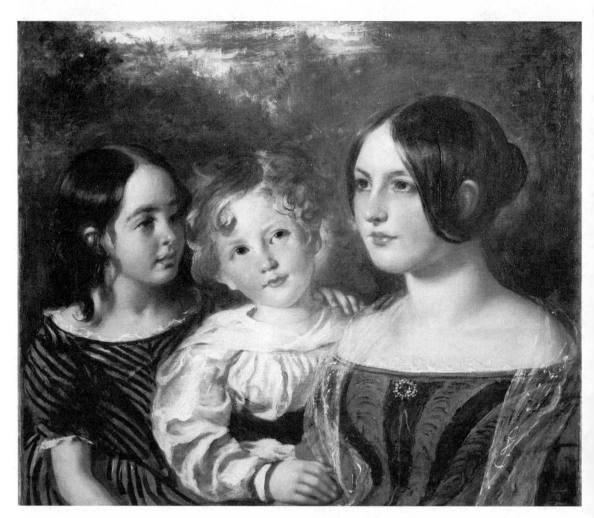

The Wood Children—Emily, Frederick and Mary (26.25 × 29.5 ins) (1845), York Museums Trust (York Art Gallery)/Bridgeman Art Library, London; YAG23586/172.

concert appearances, touring America in 1850–52. In 1852 she married Otto Gold-schmidt of Hamburg, whom she had met in Lübeck two years before. She continued to tour, again visiting York in 1856 and finally settled in England, becoming an English citizen in 1859. In 1883 she was appointed professor of singing at the Royal College of Music, in which position she remained until 1886. She died the follow-ing year on 2nd November at Malvern, her husband outliving her until 1907. The stage was not regarded as a respectable career for women in the 19th century but Jenny Lind was renowned for her rectitude and generosity The Bishop of Norwich really had nothing to fear. Jenny Lind was by far the most famous person to sit for Etty. Strangely Gilchrist does not mention her—was it because she was an actress?

Equally famous in her field was Elisa Félix, though less well-known in England than in Europe. Also born in 1820, in Switzerland the child of wandering ped-dlers, she began by singing in the streets of Paris where she was discovered by Isidore Samson. She began in *poses plas-tiques* and made her debut at the *Comédie Française*, adopting the name of Mlle. Rachel. Despite being very thin and less than five feet in height, she became a

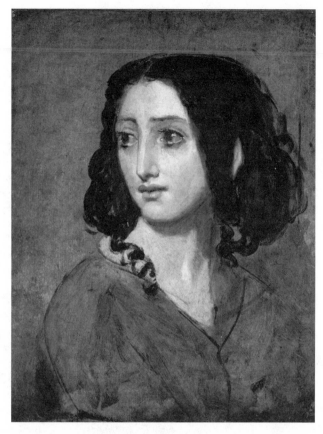

Miss Rachel (Eliza Félix) (24 × 18 ins) (?1841–42 or ?1846–47), York Museums Trust (York Art Gallery)/Bridgeman Art Library, London; YORA23589/117.

favorite of audiences. For 17 years she dictated the policy of the *Comédie Française*, herself appear-ing in plays by Racine, Hugo, Dumas *père* and De Musset. She toured widely and frequently, vis-iting England in 1841, 1842, 1846 and 1847. Her private life was notorious and in consequence her health declined. She died of tuberculosis on 3rd January 1858 in Paris. Again, Gilchrist does not mention her, no doubt another example of the biographer protecting his hero. Farr refers only to Etty's portrait in pastel on deep pink paper which depicts a young woman, almost a girl. Farr gives the date of this portrait as 1841 when she appeared at Covent Garden and Her Majesty's Theatre, when she would have been 21 years of age. Again he believes that Macready arranged the sitting. Macready described Mlle. Rachel in his diary as "a very engaging, graceful little per-son, anything but plain in person, delicate and most intelligent features." There is, however, in York Art Gallery an oil study on millboard of an older woman entitled *Mlle. Rachel*. The face is more or less finished but the shoulders are sketched in. The title of this painting has no prove-nance and its attribution is based on its similarity with other known portraits of Mlle. Rachel. However, it bears no resemblance to the pastel study.

CHAPTER SIXTEEN

Etty and his models

Most unusually for an Academician, Etty continued to attend the Life Class after he had completed his studentship and continued to do so until his final years. This habit was often remarked upon by his colleagues, who considered it to have diminished his status but Etty always maintained that his life would be robbed of much of its purpose if he did not do so. Charles Robert Leslie recorded in his *Autobiographical Recollections*[1]:

> Up to the time at which Etty was elected an associate of the Royal Academy, he had attended the Life-School with more regularity than any other student. It was supposed that, on becoming a full member, he would discontinue this habit, and some of the old Academicians thought he ought to give it up. I told him what I had heard on the subject, and he replied, "I do not mean to leave off studying in the Life-Academy. It fills up a couple of hours in the evening that I should find myself at a loss to employ otherwise. I am very fond of it, nor do I think it beneath the dignity of any rank to which my brethren may think fit to raise me. I hope I shall never disgrace the Academy by my conduct; but if my continuing to paint in the Life School is considered wrong, let them not make me an Academician, for I will not give it up."

In his letters to brother Walter and to Thomas Bodley he frequently indicated how much attendance at the Life Class meant to him. He was compelled by his nature to be forever painting the figure and always convinced that he needed constant practice. Although it had long been customary for artists to employ models it had always been difficult for artists in England to obtain reputable females who would pose unclothed. The problem lay in the word "reputable." There was little difficulty anywhere in Europe in securing the services of prostitutes and in Italy in particular such persons had supplied artists' needs from the early Renaissance onwards. By contrast male models were comparatively easy to find. Workshop assistants, fellow artists and friends were usually willing and in the last resort artists used mirrors and themselves. But most women refused unless they were already accustomed to a form of life that required them to display their bodies to men. Some wives, such as Rubens' second wife, are known to have reluctantly agreed and many artists had mistresses who also accepted modeling as part of their duties but most artists were reduced to copying from the work of other artists and, increasingly as Roman statuary was discovered, using these as examples.

Etty was unmarried and did not attract female friends, certainly none close enough to model for him, but the Academy and some private collectors possessed Italian paintings and Roman statuary. Students soon found that plaster casts and even original pieces of sculpture were inadequate. The history of the development of academies in England is not of concern but it may be briefly explained that the purpose of the many so-called academies founded from the end of the seventeenth century onwards until the establishment of the Royal Academy in 1768 was to provide artists with opportunities to study from life. In England there had been no tradition of the nude in art before the seventeenth century and probably the first English academy offering study from the living model, certainly the first with surviving documentation, was established by Peter Lely c. 1673.

Early English academies clearly had difficulty in securing the services of female models and Bignamini and Postle suggest[2] that the number of drawings of female figures by Godfrey Kneller in poses traditional to male sitters indicates that he and his contemporaries had to substitute males for females owing to the difficulty in securing the latter. This had also been a problem for earlier Italian artists who drew and painted the nude figure. Michelangelo clearly did not have access to female models. It has often been said that his female figures are males with breasts. Bignamini and Postle suggest that regular employment of female models by European academies did not become usual until the nineteenth century but that English academies began regular employment of female models between 1720 and 1724.[3] Naked female models were forbidden by the *Académie Royale de Peinture et Sculpture* until the nineteenth century and though they were engaged privately it was expensive to do so because models were scarce. In England William Hogarth introduced female models into the St. Martin's Lane Academy c. 1761 expressly "to make it more inviting to subscribers" since artists were constantly complaining that it was difficult for them to obtain models, presumably without attracting accusations that they were engaged in improper behavior. The establishment of the Royal Academy with its Life Class solved the problem for artists and students and relieved them from the problems of negotiating with models and providing accommodation for study.

Upon election to Academician status, artists were, however, expected to cease using the Life Class, though there was no written rule on the subject, and consequently those who continued to paint the nude were once more faced with the problems from which the Academy had for a time rescued them. Etty had the advantage of a brother who financed him for much of his early career but although he could afford to hire models, and did so in his own so-called academy, he was clearly concerned to spare his brother as much expense as he could. Other, more impecunious students and young artists had to resort to friends or themselves. Wilkie was sometimes found in his rooms stark naked drawing himself with the aid of mirrors. In the "Living Model Academy" which Etty set up in Soho Square in 1830 he and students could draw from the living figure, no doubt sharing expenses. These were not his students and it is unlikely he offered them any instruction. How he obtained models for this Academy is not known. Perhaps it was enough for it to be known to exist and the models came to him. It is well known that some young women were now willing to undertake such work. Many were driven to do so by poverty, modeling being preferable to prostitution. The establishment of the Living Model Academy is not mentioned by Gilchrist but in a notebook in the possession of Tom Etty of Nijmegen there is a note "Took Room in Soho Square The 18th October 1830" which is probably the same building that Etty later called the "Academy Soho-Square." There are constant references from this time onwards to the quarterly payment of rent so one may infer the connection to this establishment. His notes at this time do not mention models but Alison Smith[4] states that Etty studied from the model there. Whether this included female models is not known but knowing Etty's constant efforts to obtain female models it is very likely that this would be a primary reason for his renting the building.

Male models were comparatively easy to obtain. Soldiers and pugilists were commonly engaged by the Royal Academy, as well as their own porters who were pressed into service. Soldiers needed money to supplement their meager pay and pugilists, especially those not frequently winning their fights, were always available. Soldiers generally had a good physique and were able to remain still for long periods. Pugilists with well developed muscles were suitable for "action" poses. A drawing, now in New York, considered to have been made around 1830, of "Guardsman Higgins" is described on the label as Etty's favorite model. There is no known justification for this claim but it is very likely that Higgins did pose frequently for artists and that Etty was one of them. Gilchrist recorded[5] that in March 1843 when Etty was painting both *The Three Graces* and *The Entombment of Christ* that "Model swiftly succeeded to Model, in his Studio; one of the 'Graces' giving place, after her hour or two hours were up, to a 'strapping Life-Guardsman' for the *Entombment*; and so on."

Haydon several times referred to soldiers as models in his autobiography, in particular mentioning a "Corporal Sammons" as "a living Illisus" and another soldier, "Hodgson," as "a perfect Achilles." Samuel Strowger was a well-known soldier-model in the Royal Academy in the early years of the nineteenth century and was known to have been painted by Constable, Wilkie and Etty. He was so popular with the academicians that they negotiated his release from the army in 1802 so that he could become a full-time porter and model at the Academy Schools.

The council members of the Royal Academy were acutely conscious of the likely accusations to be leveled against them for engaging fully nude models and they drew up a long list of rules to be observed by everyone attending the Life Classes. These have been reprinted in Sidney Hutchison's *History of the Royal Academy* at pages 29 to 30. No student could attend the Classes unless he had first shown himself to be "properly qualified," that is, he must have proved capable of drawing efficiently from casts. The fee for male models of five shillings a week plus one shilling for each night's work, with each model required to sit three nights, was not an immense remuneration but the prospect of an additional eight shillings a week for a soldier would be very welcome. Female models were not engaged until February 1770 when it was agreed that one could be hired at a cost of half a guinea a sitting. This was a very satisfactory payment for the time. Although it is difficult to be certain what the wages were for those without a skilled trade there is some evidence that a female servant over eighteen years of age seldom received more than £10 a year plus board and lodgings. Lodgings may be said to have cost an employer nothing since a servant's bedroom was usually in the attic and the quality of food supplied varied according to the nature of the employer. We are dependent on reports by campaigners later in the nineteenth century. Early in that century *The Times* newspaper was agitating on behalf of the women employed as needlewomen in London. The first effective and reliable sewing machine, though still very clumsy, was invented in France in 1830. It attracted the wrath of the needlemen and women in Paris and was not introduced into England and the United States until 1845 and was not generally accepted until the Great Exhibition of 1851. The workers in the clothing trade had reason to be fearful. In London they were mostly women and as late as 1843 *The Manchester Guardian* newspaper was reporting that wages of six shillings a week were considered good and four shillings a week were usual. For this they worked from six o'clock in the morning till midnight seven days a week. They slept and ate in the workroom. Small wonder that many women sought more remunerative employment. Modeling at ten shillings and sixpence for one evening a week, with the prospect of additional private engagements, would have been a life of comparative luxury—and, of course, morally quite safe.

Modeling for the Academy was not an easy task. Models posed on a dais under a large oil lamp that gave some limited heating, surrounded by a half circle of students. The room became increasingly fetid as the sand in the hour glass measured out the passing hour of each session. Models undressed and redressed in a separate unheated room. In 1847 it was proposed to place the models near a stove while posing. While in the private *ateliers* in Paris models were posed informally, required to move about so that natural positions would be achieved, in the Academy posing was strictly formal. Models were "set" by the master before students entered the room and any movement was strictly forbidden. If, later, models entered the room with the students present they had to be robed and "set" before the robes were removed and re-robed before leaving. This was to ensure that no physical details of a private nature were revealed. The result was an inevitable stiffness in the poses which the Academy regarded as properly "classical." Although Etty in his own work usually used only a single model which he placed in different poses to achieve a group composition, sometimes in the Academy Life School, when he was appointed to teach the students, he posed several models together to produce subjects such as *The Three Graces*. He did not, of course, have to pay the models himself, which probably accounts for this practice. Etty's paintings of single models in the Life Class show him at his best, producing studies of the figure uninhibited by so-called "classical" settings.

Although Etty hired models privately what is most likely to have influenced him to continue attending the Academy Life Class is that he would have considered it to be an improper expense to hire models frequently when he was dependent on brother Walter for funds. It is interesting that Etty said he needed to attend the Life Class because he had little else to do in the evenings. He was not a gregarious man, being shy, a poor conversationalist and convivial only among his closest associates. He went to few dinners and seldom went to other similar events, disliking the hot and smoke filled rooms which aggravated his asthma. We know he went to the theatre but which plays he saw we do not know. Theatres were limited in number by the licensing laws and in London until 1843 only Drury Lane and Covent Garden had dramatic licenses. The few other theatres that existed evaded the licensing laws by presenting music and dance as accompaniment to plays which were themselves quite trivial. So his theatre-going was probably infrequent. The traditional Victorian music hall began to emerge after 1843 but before then there had been many private "song societies" or clubs, usually situated in a room over a tavern. Some were respectable clubs and it was possibly one such that Dickens was accustomed to visit. It is most unlikely that Etty ever did. His tastes were more serious and there were learned societies he could join and he probably did so though they probably met less frequently. What governed Etty's leisure activities was his determination to continue his studies and to perfect his skills.

We know he went to some of the dinner parties given by the London *literati* because the actor William Macready recorded Etty's attending a dinner given by Samuel Warren in May 1837 and also a dinner given by Macready himself in 1839, which Charles Dickens and his wife also attended.[6] In April 1840 Etty went with Dickens, who called for him, to a dinner given by Lord Northampton which was also attended by a glittering array of the famous including the Archbishop of Canterbury and several well-known artists. He and Dickens walked home together afterwards. When he visited York, Etty was in great demand as a dinner guest. Here he was among close friends. It is equally likely that there were many others in London who welcomed him to their table. So we may conclude that he did not live a lonely life even if records are sparse. But he does seem to have preferred to pursue his chosen career and not to "waste his substance" on frivolities. One problem affecting his social life was his bachelor status and his probable inability to arrange suitable dinner parties in his own house.

Whatever his reasons for continuing his visits to the Life Class he did not wholly rely on the models there. It is clear that he sometimes engaged them privately during the day. Although Etty became aware that the middle classes were objecting to his subjects it is perhaps unlikely that he was much aware of the moral campaigns against models. There is no trace in any of his correspondence of his being concerned about the matter. In fact, perhaps somewhat strangely, he never refers to the employment of models to anyone other than his Academy contemporaries. It was not something that he felt he had to justify. The use of models was a natural activity for an artist and their use by the Royal Academy obviously legitimized the practice. At all times Etty took the view that since his motives were innocent then the paintings he produced were innocent. Therefore his use of models was innocent. He had grown up accustomed to the use of models and there are many reasons for concluding that Etty did not pay much attention to contemporary attitudes and campaigns. He certainly disliked the preachings of Dissenters and looked back to the Catholic Church for its support of the arts and especially for its tolerance of Renaissance art. From what we can glean from his surviving correspondence he is unlikely to have approved of the Evangelicals. Etty had strong moral principles but vigorously objected to Puritanism.

Although there are no recorded reactions by his housekeeper, his niece Betsy, to the presence of models, especially women, posing in the house, it can be deduced from the general relationship between Etty and Betsy that she would have been quite unconcerned, regarding it as the normal state of affairs in an artist's household. We may assume that models did visit Buck-

ingham Street since he had a painting room there and his work required the use of models. At a time when the nude in art was the subject of much moral debate and when wives of artists would often forbid their husbands to employ models, it says a great deal for Betsy's liberality of mind that she could accept the presence of women whom most of society would have denounced. Etty's mother, who visited him fairly frequently, must also have been aware of models visiting his household and similarly we may suppose that his cousins, Thomas and Martha Bodley, who often stayed with him, must have known of this practice, though it is possible he did not engage in much painting while either they or his mother were there. Nonetheless they knew he painted nude subjects and would have known that he employed models. Etty did on several occasions take his mother, Betsy and Mrs. Bulmer and the Bodleys to see public exhibitions which included his work and also that of the Old Masters. For example, on the 15th June 1834 he took Jane (Walter's daughter), Cicely Bulmer and Betsy to see the paintings by Correggio which the National Gallery (then still in Pall Mall) had recently acquired for twelve hundred guineas, regarded as a large sum. Objection to the painting of nude figures was not a general reaction by women at this time.

Yet it seems somewhat strange that in all of his letters to Betsy, most of which seem to have survived, there is no mention of models, no instructions, for instance, to cancel engagements when he was going to be delayed in returning to London, though he did on many such occasions instruct her to rearrange other engagements. We may, perhaps, assume that she acted as his agent and the models' chaperone during painting sessions and knew what to do if necessary. Betsy did on occasion assist her uncle in obtaining models to pose for portraits but as this did not involve nude modeling it is possible that it was only for such purposes that he enlisted her help. Some of these occasions are considered later. It is probably more likely that Etty employed has assistant, George Franklin, to deal with the engagement of models when he was unable to do so himself. Obtaining models who posed professionally, whether male or female, would not have been difficult. Among artists they were well known but all artists using them liked to engage new models and though some were introduced by brothel keepers and the like and many actually introduced themselves, the usual method was by recommendation.

It seems that for all his many paintings of the nude figure Etty could never produce anything of this subject without a living model before him. His contemporaries often complimented him for having produced work of such verisimilitude that the figures appeared, to them at least, as almost living. In March 1837 at the last meeting of the Life School in Somerset House, Etty gave Constable a life study. The latter said in appreciation, smacking his lips, "you might eat it." There was inevitably some insinuation that Etty derived more than aesthetic satisfaction from contemplating his models, though there was never any suggestion of improper behavior. His paintings *Youth on the Prow and Pleasure at the Helm* and *Cleopatra's Arrival in Cilicia* were indecorously referred to as "Etty's bum-boats"—a *double-entendre*, "bumboats" being naval slang for boats which carry provisions to ships. On the 11th June 1828 Constable had written to his friend Archdeacon Fisher of Salisbury criticizing Etty's *World Before the Flood* as "a revel rout of Satyrs and lady bums as usual." To some these paintings of bevies of young women suggested the artist obtained improper excitements from having so many models cavorting erotically in his studio. But this was incorrect. Not only would it have been seldom possible to persuade models to pose together, though some did in the Academy Life Class, it would have been too expensive for an artist like Etty who practiced the strictest economy in everything he did. It was customary when many figures were required for one model to adopt different successive poses which is why sometimes compositions lack plausible coherence. Etty always found it difficult to present figures in groups so that they appeared to be realistically related to each other. Moreover, it is also often possible to see that all figures in a composition have a facial resemblance. Employing one model to supply group compositions was not unusual. Many of Rubens' groups are clearly composed of the same model.

Several letters retained by Etty indicate how the suitable models of either sex were passed on from one artist to another with letters of recommendation, often expressing the type of poses they were suitable for or would not undertake. Many female models would not pose unless they were modestly draped. All these letters indicate that artists required women models with full firm figures and those depicted by Etty and others artists of the subject confirm that only those meeting these requirements would be engaged. Constable told his friend C. R. Leslie that Etty had reported to him by letter that he had had a young woman brought to him to serve as a model—"She is very much like the Antigone *and all in front memorably fine.*"[7] Etty passed on this young model to Constable who told Leslie, "Next week I have a little girl aged 17. She is *procured* by Etty our grand *'curator'* and I am to have her maiden 'sitting' on Monday week." Even the usually disapproving Constable, who often remarked that Etty was too interested in "breasts and bums," could respond to the attractions of a young model and it was such reactions that alarmed the moralists.

There was an opinion among some critics that Etty was interested only in the torso and not in the head, hands or feet. It is, of course, the fact that these features are more difficult to depict. This view of Etty's interest may spring from the fact that often heads, hands and feet do not convincingly "join" the torsos to which they are attached but this is more likely to be due to their being painted from different models, a common custom and one that is known to have been used by artists as far back as classical Greece. The story of Zeuxis and "the chosen five" was well known.

In a letter dated only "Tuesday" from 14 Buckingham Street (provided by Tom Etty of Nijmegen), Etty wrote to Charles Landseer recommending a male model. Charles was the elder brother of the more famous Edwin Landseer and Keeper of the Royal Academy from 1851 to 1873. He enters Gilchrist's history in 1837 as being an admirer of Etty's work.

Dear Sir,
 The bearer is a good form and color as a Model—of a Copper color—difficult to get should you ever want such a Model he will be most happy to serve you.
 Yrs very truly,
 Wm. Etty

The envelope is addressed to "C. Landseer, Esq." Charles Landseer was made an Associate of the Royal Academy in 1837 and a full member in 1845. The letter was sent before the latter date as otherwise Etty would certainly have addressed him as "R.A." The formal address of "Dear Sir" indicates that Etty did not yet know him intimately so it is also likely that Landseer was not yet an Associate.

Landseer expressed his thanks for Etty's services in the following letter, dated only "Monday."

I am very much obliged to you for the model you have recommended to me, he has a capital head and is a most excellent sitter.
Yours very faithfully,
Chas. Landseer.

In due course Landseer reciprocated. In a letter now in York City Reference Library and dated only "3rd August" he wrote to Etty: He addressed Etty as "R. A." so it was written after February 1828 and the two are now on intimate terms so the letter was probably sent after 1837.

Dear Etty, The bearer is Miss Lawrence who is a candidate for the Academic honors of life, judging from the upper part of her figure, the only part I have seen, think you will like her, colour very good.
Yours very truly, Chas. Landseer.

The letter is endorsed in Etty's handwriting: "Miss Lawrence, No. 1, Nelson Street, City Road," presumably the model's address. The Shepherdess Walk Tea-Garden was near Nelson

Street until 1825 when it was turned into a music hall which became well-known for ballet and acrobatic performances. It may be that Miss Lawrence had some connections with both establishments.

It was not unusual for young women intending to become models to present themselves at an artist's house in the hope of being engaged. One such aspirant is the subject of the following letter. It is undated but was written from Buckingham Street so was after 1824 and the familiarity of the letter indicates that Etty was by this time an Academician, i.e., after 1828. It is addressed to "A. Cooper, Esq., R.A. at the Royal Academy, Somerset House," and therefore was written before the move to Trafalgar Square in 1837.

> Dear Cooper,
> The bearer is a Person who is desirous of sitting as a Model. I have not seen her. If you approve of her and are not engaged you can sit her, as I spoke to you of.
> Yrs.
> Wm. Etty

Abraham Cooper usually painted sporting, battle and historical subjects such as *The Battle of Waterloo*, *The Battle of Marston Moor* and *The Battle of Bosworth Field*. He is not known to have painted nude subjects so we may assume that the young woman concerned was not seeking such engagements.

By such exchanges artists knew they could rely on the models recommended. A letter (undated) in York Reference Library from a fellow artist, Edward Rippingille, also passes on a suitable model. Rippingille was a genre painter and would not himself have engaged a model for nude subjects. "Here is a very nice modest girl whom I would not send to anybody. I fancy she might be made very useful, without being *entirely* d--d which she objects to."

Rippingille is indicating that the young lady would object to unseemly poses but knows that Etty would not require her to undertake such modeling. In a letter (also undated) to another fellow artist, R. W. Pickersgill, Etty wrote: "You expressed a wish that if any model at all like Burton offered, that I would send her to you. The bearer is a fine model and when put in the posture sits like a statue."

Etty here touches on a common problem with many models, an inability to keep still. This lady, whoever she was, did not suffer from this defect and would therefore be much favored.

In 1836, one of Etty's most fervent admirers, Thomas Myers, offered to bring to Etty a young woman who had come from Wakefield to earn a living and who was prepared to pose for him provided Myers himself was not also present. Myers wrote[8]: "She is full sized, in the prime of life, of the true Yorkshire stamp—as they say of a Horse—& I believe is wanting in nothing except a little "fining in the finishing"—the case with all persons in her rank of life."

We have in this letter the proviso often applied to aspiring models. It was the opinion among artists that working girls were always coarse in appearance and manners and so, if used as models, needed "refining" by the artist. There is a great deal of difference between posing nude and standing naked. Artists would exchange models with recommendations that went into some detail regarding their physical attributes.

Writing to a fellow artist, George Patten (1801–1865), who had sent him models, Etty said, in a letter dated the 7th April 1836

> I did not know you were knocking at my door yesterday, or I should have asked you to undertake another rib:—your wife need not be alarmed, I mean a rib of lamb. You left word you wanted a fine Model. It is difficult. Mrs. S., whom I sent you, has some very good points; a short figure and a fine head. Miss R. at a cap-shop, in –– Street, (private door) is a good colour and proportion, but rather thin. I have lately made sketches in outline of several, in order to get a small figure I am going to paint as good as I can. I have found two out of the number, fine. One, her name is H., of a fine form and bright colour. I am endeavouring to persuade her to get money in a way more artistical; to sit to Artists and Academies. She would be an acquisition. She sat for me for an hour and a half, to make sketches

from; and I think she might soon be broken in. You might write a twopenny letter and try. Say, I recommended her. Another with a fine figure, *her* name is Y.; also, a fine form of torso, and nice colour. If either of them could be induced to sit, and be punctual to their engagements, they would be acquisitions.

This letter, known only through Gilchrist,[9] was censored by him to avoid embarrassment to the ladies concerned. Presumably women unused to modeling had to be "broken in" by insisting on punctuality and not moving while posing; probably also, not talking and otherwise disturbing the concentration of the artist. Patten was an artist very much in Etty's mode. He painted portraits, historical, mythological and biblical subjects. It was the general critical opinion that he aimed at Etty's manner but lacked the ability to carry out large works successfully.

There is, however, no question that Etty was highly respected by the models he employed. When he finally left London and the Life School it was reported to him that all of the models were upset and some cried. He had always treated them so well. Whatever their social standing and background, Etty respected them as women, even as *ladies*, a title to which they would certainly not have been accustomed.

In one of the notebooks in the possession of Tom Etty of Nijmegen there are the names and addresses of five women, all living in the North London area. Two are shown as married. Against one name Etty has noted "Dark hair, 27." They are clearly models he was accustomed to use. The list is adjacent to a page with an entry dated "11th Dec. 1834." This is the only such list in these notebooks and there is a surprising lack of firsthand information regarding the models Etty employed. A letter dated "Tuesday 6th" (no month or year was given but it was endorsed "1849" in a different hand) written by Etty to a patron, Andrew Fountain, reveals how he worked with his models.

Dear Sir,
 Mr. Wethered tells me you wished to know the names of the models that sat for your Picture of the *Judgment of Paris*. It is rather a puzzling question at a period so remote. [*It had been painted in 1838.*]
 The names that *do* occur will be at the same time unknown entirely to you. Warner and Clownley—two female models of the Royal Academy were among them. The latter sat a good deal for Minerva—a Mrs. Clayton, the wife of an architect sat for the *face* of Venus and Warner sat for the Cupid.
 A Mrs. Wilcox, now dead, also sat—but it is only right to say that my pictures are not the transcripts of any individual or particular model but made up by a selection and knowledge of the figure generally.
 The figures in Historic Posture or Poetic Composition are the creation of the Mind from which he seeks authority in nature for the "material."
I remain, Dear Sir,
Yours truly,
Wm. Etty

This letter bears the following on the reverse: "Letter from Mr. Etty R.A. to me respecting the persons who were his models for my large painting of the Judgment of Paris by Etty."

It is interesting to note that Etty employed the method attributed to Zeuxis. In the case of *The Judgement of Paris* it may be said the end hardly justified the means. Mrs. Clayton contributed no classical qualities to Venus but it should be noted that posing for the face of Venus did not require her to appear nude though she could have objected to her face being attached to a naked body. Just as today some film actresses have "body doubles" to appear for them in nude scenes so some models with good figures but imperfect faces posed only for the torsos. Models with finely shaped hands and feet provided these features just as they often do today for advertisement photographs and even in films

The fact was, as many reformers complained, that there were many places where men with sufficient money could gather to witness exhibitions of female immodesty that could, if so desired, culminate in private liaisons. Many such places on the other hand were carefully conducted to ensure that no such opportunities would arise. Most were private clubs, often over public houses,

but London theatres also frequently staged such spectacles, always, of course, within the strict censorship rules of the Lord Chamberlain, and always without any contact between performers and audience, though men often hung around stage doors. It is not to be suggested that Etty was of such company. It is likely that if he attended such performances they were presented as decorously as could be expected and that his main interest was probably to obtain ideas for compositions for his own works.

Most performers were private individuals contracting themselves to managers but there were also established companies that traveled the country. A well known actress-manager of such a troupe of performers was "Madame Warton" (actually Eliza Crowe.) She was said to be seriously interested in classical art, knowing many artists and often allowed access to their studios. She had begun by presenting Shakespearian characters as family entertainment, especially during the Christmas period. She advertised regularly in *The London Illustrated News*. Very soon she extended these performances to embrace classical subjects but the literary subjects also continued. Thus she advertised in *The Illustrated London News* in 1837:

> WALHALLA, late Miss Linwood's Gallery, Leicester Square,—
> MADAME WARTON'S UNEQUALLED TABLEAUX VIVANS [sic] and POSES PLASTIQUES. Madame WARTON begs to inform the Nobility, Subscribers, and Public, that it is her intention of producing, for One Night Only—MONDAY, MARCH 15th, A NIGHT WITH CANOVA AND FLAXMAN, at the suggestion of several Distinguished Patrons of the Fine Arts and ever anxious to produce novelty, has induced her to produce this Truly Classic Entertainment, regardless of expense to render it accurate, forming a selection of the most admired works of those celebrated masters of the Programme. During the week will be introduced several New and Original Tableaux, in which Madame WARTON will have the honour of appearing. Morning Performance at 3 o'Clock; Evening at Half-past 8. Stalls 3s; Reserved Seats 2s: Promenade 1s.

It will be noted that Madame Warton represented herself as having been "induced" to stage these performances (of course by "the Nobility"), thereby emphasizing the purity of purpose of herself, her troupe and the "Distinguished Patrons." The performances by Madame Warton were always presented as "artistic" events whatever might have been the interests of those attending. Other groups presenting similar performances were not always so restrained. We know that Etty engaged Madame Warton when her company appeared at York's Theatre Royal in 1849, a rather curious appearance in this city at that time. Madame Warton was better known to Etty than has hitherto been realized. We know he visited the London theatre and it is very likely that some of the productions he saw were those of Madame Warton and of others like her. It is equally likely that he engaged her and members of her company to pose for him in Buckingham Street. Etty's interest in Madame Warton's company probably accounts for the general nature of his compositions when painting mythological subjects. They have the appearance of *tableaux* especially in the female figures holding their arms aimlessly above their heads in what would then have been regarded as "artistic poses."

In his book, *My Secret Life*, the anonymous author, "Walter," claims that one of Madame Warton's performers, Sarah Mavis, with whom he had a sexual liaison, had once posed for Etty and William Frost in her youth. "Walter" was writing towards the end of the nineteenth century and Sarah Mavis was no longer a young woman. Very possibly Sarah Mavis had been in York when Madame Warton appeared there. As it is uncertain how far this book was a work of fiction it is difficult to be sure that this statement can be relied on. Nonetheless it would not have been unusual had Etty engaged a model such as Sarah Mavis. Being accustomed to posing nude or near-nude she would have been a perfect model. Incidentally, "Walter" includes a comment which would have confirmed the fears of the moralists—she said that "posing naked before me made her feel lewd and want me."

In fact the members of Madame Warton's troupe did not appear naked on stage. They all wore "fleshings" and care was taken that they did not touch each other. Tableaux were often

accompanied by "descriptive music" and every scene was carefully lit to present a suitable "atmosphere" and there must have been many in the audience disappointed that more detail was not visible. But Madame Warton had need to protect her license.

Tableaux vivants were a common form of entertainment in the eighteenth and nineteenth centuries and had developed from the various entertainments of the earlier century that were sometimes provided in the upper rooms of taverns. In Hogarth's *Rake's Progress*, Plate III illustrates Tom Rakewell's evening pleasures in such an establishment, this one being identified as "the Rose Tavern Drury Lane," an area well known for its low life. Tom and friends have been drinking hard and enjoying the attentions of prostitutes. A slovenly woman is undressing preparing to perform as a "posture woman" on the central table. This was a common form of entertainment for the young rakes of the aristocracy but more sedate entertainments were sometimes provided in the houses of "persons of quality." In the élite circles of the aristocratic town houses some of the nobility permitted, or even arranged, their more adventurous female guests to stage true *tableaux vivants*. Elizabeth Chudleigh led a scandalous life until she became the Countess of Bristol. In 1749 she appeared at a masked ball completely naked except for a strategically arranged garland of flowers around her hips, declaring herself to be Iphigenia. The famous Emily Hart (born c. 1765), who graduated through a series of liaisons to become Lady Emma Hamilton and later Horatio Nelson's mistress, was well known for appearing at evening entertainments impersonating characters in famous paintings and statues, sometimes draped and sometimes naked. Others, who advanced up the social ladder through sexual liaisons, did likewise. These events were frequently accepted as part of London's social scene and were as decorous as might be expected given the standing of those in whose houses they occurred.

Elsewhere the situation was quite different. In the Garrick Head Tavern in Bow Street, London, an area notorious for brothels as well as Covent Garden Theatre and literary clubs, Renton Nicholson delivered illustrated lectures on poetry and song with women posing, nude or semi-nude, depicting scenes from famous paintings. This device became common and, whatever the nature of the presentations, was regarded as serving "Art." Alison Smith details[10] several types of *tableaux vivants* of differing qualities which were mounted in London during the first half of the nineteenth century, some masquerading as artistic presentations and some offering no pretence of cultural value. Theatrical performances in these years were no different from those today catering for various tastes and interests.

Theatrical managers began to introduce acrobatic performers into evening entertainments. There had been male acrobats for centuries and in some countries also female performers but the latter were unusual in England. The moral objection to female acrobats was that they exposed their legs. No doubt sometimes female acrobats were scantily clad but acrobats, both male and female, always wore "fleshings" and by today's standards were always well covered. It was enough that female acrobats adopted what some regarded as provocative poses and did so with male colleagues. Probably there were some acrobatic troupes who presented salacious displays but the majority did no more than offer balancing tricks, trapeze and high-wire acts. None approached the frankness of the *tableau vivant*, which survived because it confined its appeal to the wealthier members of society who respected the unwritten rules of behavior. The companies who performed these entertainments were often sources from whom models could be engaged.

The problem with which the historian is concerned is how did artists engage models, especially female models, to pose in the nude when they did not originate from troupes of entertainers? Many artists of the nude figure did not employ living models but relied on statuary, which is to say, the classical statuary excavated mostly in Italy and which had, by some means or other, come to England as part of someone's private collection. This was clearly unsatisfactory since most artists did not enjoy access to these collections and many collectors would not allow it. This was why the Royal Academy made it a central part of its policy to acquire casts of classical statuary for members and students to copy. Models engaged privately came from various sources. Usual

sources were the prostitutes who at this time formed a sizeable proportion of London's population. How they were hired is not known and why that should consider modeling to be more lucrative is surprising. Possibly earning a little money in the warmth of a painting room on a winter's evening without risking ill treatment is one explanation. It is known that some models were hired directly from brothels and there is confirmation of this practice in John Smith's book *Nollekens and His Times.*[11] The sculptor, Joseph Nollekens, R.A. (1737–1823), and his wife were renowned for their parsimony.

> One May morning, during Mrs. Nollekens's absence from town, Ms. Lobb, an elderly lady, in a green calash, from the sign of the "Fan," in Dyot-street, St. Giles's, was announced by Kit Finney, the mason's son, as wishing to see Mr. Nollekens. "Tell her to come in," said Nollekens, concluding that she had brought him a fresh subject to model, just arrived from the country; but upon that lady's entering the studio, she vociferated before all his people, "I am determined to expose you! I am, you little grub!"—"Kit!" cried Nollekens, "call the yard-bitch;" adding, with a clenched and extended fist, that "if she kicked up any *bobbery* there, he would send Lloyd for Lefuse, the constable."—"Ay, ay, honey!" exclaimed the dame, that won't do. It's all mighty fine talking in your own shop. I'll tell his worship Collins, in another place, what a scurvy way you behaved to young Bet Balmanno yesterday! Why the young girl is hardly able to a move a limb to-day. To think of keeping a young creature eight hours in that room, without a thread upon her, or a morsel of any thing to eat or a drop to drink, and then give her only two shillings to bring home! Neither Mr. Fuseli nor Mr. Trensham would have served me so. How do you think I can live and pay the income-tax? Never let me catch you or your dog beating our rounds again; if you do, I'll have you both skinned and hung up in Rats' Castle.
>
> [*Mrs. Lobb continued in this manner until...*]
>
> Nollekens perceiving Mrs. Lobb's rage to increase, for the first time, perhaps, drew his purse-strings willingly; putting shilling after shilling into her hand, counted four and then stopped. "No, no," said she, "if you don't give t'other shilling, believe me, I don't budge an inch!" This he did; and Kit, after closing the gates, received peremptory orders from his master to keep them locked for three or four days, at least, for fear of a second attack.

(According to John Smith "Rats Castle" was a shattered house then standing on the east side of Dyot Street, and so-called from the rat-catchers and canine snackers who inhabited it, where they cleaned the skins of those unfortunate stray dogs who had suffered death the previous night.)

This detailed account is very revealing, telling us a great deal about many aspects of London life at the end of the eighteenth and beginning of the nineteenth centuries.

It seems unlikely that Etty resorted to brothel keepers or prostitutes for his models. Although his niece Betsy appears to have been a very broad minded woman it would also seem that she was wholly decorous in her behavior. She was certainly a regular churchgoer although apparently not as pious by nature as Etty himself. All the surviving records indicate that his models regarded themselves as professionals at a time when their form of employment was not yet regarded as a profession. Male models were easy to obtain as has already been suggested but female models had to persuade themselves that appearing naked before another person was not immoral. They also had to be assured that it was not dangerous. The traditional explanation is that women resorted to modeling as a last resort to escape starvation and it was this tradition that later Victorians exploited in their campaigns. Certainly young women, coming to London in search of work after the extreme poverty of unemployment elsewhere, were easy prey and coaches from the country bringing such girls were always met by brothel "madams" promising lucrative employment. If they resisted these approaches it was likely that nevertheless many succumbed to street prostitution in desperation. Later, with the invention of photography, it was quite usual for young women, even when employed as servants or shop assistants, to call at studios offering to pose naked or "with their skirts up" in return for as little as sixpence or a shilling. Photography introduced an entirely new problem.

Letters reveal, as we have seen, that Etty and his contemporaries passed models between them, thereby ensuring that only suitable women were engaged—suitable, that is, not only physically

but morally also. Later records show that many artist's wives strongly objected to the use of live models, fearing that their husbands would be tempted. Artists wishing to paint from the model and anxious about maintaining their position in society were careful to engage only those of known moral rectitude. The problem for women wishing to establish themselves as artists' models was the certainty that they would not be required to pose indecorously. Leonardo da Vinci had insisted that women in painting and sculpture should always be presented with their legs together, partly to protect them from embarrassment but mostly for aesthetic reasons. Similarly Michelangelo instructed his assistants to fashion the male parts as small as possible. Italian Renaissance artists were expected to abide by the code of *decoro*. Some artists, especially in eighteenth century England and France, ignored this advice. Thomas Rowlandson was notorious and even Joseph Turner could not resist curiosity. To avoid being drawn into inappropriate relationships with artists, models were frequently cautioned, as by William Mulready,[12] not to permit conversations or other approaches of a familiar nature "that everybody knows should take place only between man and wife."

Ever since the Italian Renaissance concern had been expressed among artists as to whether they needed to study anatomy in order to paint and draw the human figure more accurately. It had become accepted that surgeons needed to study the subject and they had done so since Versalius in 1533 confronted his professor with evidence that the great Galen had been wrong. There is no need to discuss the long line of illustrious anatomists but to bring the subject into Etty's own time. George Stubbs (1724–1806), the well-known animal painter, studied anatomy in York under Charles Atkinson. Although he concentrated on horses he began an ambitious work, *A Comparative Anatomical Exposition of the Human Body with That of a Tiger and a Common Fowl*, which was still incomplete when he died. His engravings were published in 1817. Etty was well aware of the interest in anatomy among his contemporaries. There is however nothing to tell us whether Etty dissected bodies, though a number of his contemporaries did. He certainly studied some cadavers. Farr states that Etty "sought the aid of Robert Liston the surgeon while painting the *Entombment of Christ* in 1843."[13] A letter dated 29th March 1843 in York Reference Library probably relates to this request.

> Dear Merton,
> Mr. Etty the celebrated artist brings this. He is anxious to see Dead Bodies. Give him admission if you please to the Deputy [illegible] & to the Dead House of the Hospital if there are any bodies there.
> Faithfully [signature illegible]

This was rather late in Etty's career, he was then 56 years of age, but he may only have been doing something that he had been doing for some time. The bodies of paupers, as well as hanged criminals, could legitimately be used for study and dissection and the hospital must have been able to provide the corpses of paupers. Gilchrist is silent on the matter, probably because he shared the general disapproval of such a practice. It is certain that Etty drew from corpses on earlier occasions since he recorded in his notebooks that he had done so after his student years.

It is quite certain that posing nude was a greater problem for women than for men. It is always obvious to women that men have a prurient interest in the female body. This is a biological necessity but it is increased by the custom of the female concealing her body in clothing and also by the ability to conceal their genitals when naked. The female, unlike the male, must deliberately expose herself in order to reveal herself and all cultures regard such behavior as immodest and often as reprehensible. Girls are usually reared to be modest. As Germaine Greer has said in *The Female Eunuch*, most women regard their genitals as distasteful and in all ages most have been rightly suspicious of male curiosity. Nonetheless it is surprising how readily many women have willingly exploited this curiosity and the male need for sexual satisfaction.

In the nineteenth century it was the accepted opinion that women who modeled in the nude were either of low morals or compelled unwillingly by adverse circumstances. William Frith

in his book *My Autobiography and Reminiscences*[14] recorded the case of a young model who posed for the Royal Academy to prevent her father from going to prison. "He owed three pounds ten, and if he couldn't have paid it by that Saturday night he was to be arrested. The Academy paid me three guineas for the week and that saved him. I never sat in that way before and never would again."

Joshua Reynolds also reported seeing a young model in tears with shame who was posing nude for a similar reason. If a woman outside the world of prostitution was known to pose nude for artists she was regarded as a social outcast. It is surprising that so many did. Because so many artists did engage models for nude posing they themselves were frequently regarded as outcasts and in the later nineteenth century artists were generally regarded with suspicion. Even those specializing only in landscape could not escape censure. By this time the campaign against nude modeling was in full swing. Etty died before this really took off in the 1860s.

Etty, like all his contemporaries, did not require models only for his paintings of the nude figure. All artists at this time who painted the figure in whatever setting depended on live models. As distinct from portraits where the subjects presented themselves, other figure paintings required the seeking of models suitable for the subject. Many models came to artists' studios seeking work sure in the knowledge that they would pose fully clothed or draped. Sometimes artists would seek to engage persons fortuitously encountered in the street or elsewhere. Beggars were often asked to pose for such subjects as Old Testament prophets since they usually possessed flowing beards. Servant girls were usually willing because they were so poorly paid by their regular employers. Frith frequently resorted to employing working girls in his early years. His *Sleeping Model*, which he presented as his Diploma Painting on his election to the Royal Academy, illustrated a common problem. Frith had hired a girl earning her living selling goods on the street. He intended to paint her in a laughing happy mood but, so tired was she from tramping around the streets, that she fell fast asleep and could not be roused. So the subject became a sleeping girl instead. This incident also illustrates how dependent artists were on models.

It may appear out of character that so reserved a man as Etty should be willing to ask a stranger to pose for him but according to Gilchrist this was not unusual, or not unusual now when he had reached the age of fifty or more years. How Gilchrist became aware of this new tendency—for it certainly seems to be new, not having been mentioned by him before 1845— we cannot say. Perhaps he was told by Betsy whom he must have interviewed for his biography though he does not say so. Gilchrist's first reference is to a letter Etty sent to his dealer William Wethered.[15] This letter of the 23rd November 1845 refers to "the young lady who so kindly sat" for the head of Joan of Arc. Gilchrist says that this young lady had first been seen in Westminster Abbey and had there struck his fancy as suitable for the head of his chosen heroine. "He set his niece on the stranger's track, who traced her to Kensington. By dint of management— applications to Verger, and Kensington tradesmen, the skilful envoy extracted from them, first, the calling, then the name, of the lady's father, finally for the celebrated Artist,' obtained (a delicate business), his and the lady's consent to her sitting." This, says Gilchrist, cost him "no small pain and embarrassment." The young lady sat for him many times and was remembered for her remarkable "spirit, colour and force." Considering that Etty was well known for painting the nude figure it is surprising that any father would consent to his daughter's posing for him but presumably Etty was able to assure him that his daughter would not be required to pose without clothing.

It would seem that it was Betsy who was used as the means for tracking down such suitable models, no doubt on the principle that young ladies accosted by her would not take fright. "Sometimes, at the Theatre, the Painter's eye would be taken with a picturesque face in the boxes; and he, issue the injunction to his Niece to 'keep her eyes about her.'"[16]

Gilchrist records an occasion[17] when Etty and Betsy disagreed over which cab their quarry

had taken on leaving the theatre. Etty ran after the cab of his choice (no mean feat for him) only to find that the lady was elderly and not beautiful.

It was very usual for Etty to use his friends as models for paintings not involving the nude or, sometimes, to provide only the head for such a figure. Mrs. Bulmer posed more than once for such paintings and seemed not to be embarrassed by the fact that her head would be attached to a naked Venus. There is no evidence whatsoever that Betsy ever posed for her uncle except for two portraits, one in 1811 and another perhaps c. 1840.

However, it was not so much the posing by models fully clothed that concerned those who objected to the practice. They were convinced that posing in the nude was deeply offensive because it corrupted both the model and the artist, especially if the artist was a student. At the beginning of the nineteenth century it was seldom, if ever, the custom for women artists to use models in this way though some attempted to attach scandal to the name of Angelica Kauffman by suggesting that she did. When towards the end of the century women artists and students insisted on studying from the nude model there was, as might be expected, an uproar of disapproval. The principal claim that study from the actual figure was essential was that without it figures in paintings were usually stiff and lifeless. It was regarded as a necessary study if the fall of clothing was to suggest the existence of a live body beneath. Even cursory examination of early full length figures demonstrate that they seem to have been painted from what are known as lay figures, and indeed this was often the case. The carefully draped figures of Angelica Kauffman are limp and lacking naturalism because she was unable to study the human body anatomically. Students spending their formative years at the Academy Schools studying from casts invariably produced lifeless images.

During the 1830s Wilkie, Mulready and Etty had sought a more empirical approach by studying directly from the model whom they hired privately, presumably in Etty's Soho Square studio. But generally the Academy was content to pose models in sculpturesque poses on the grounds that this was classical art and this was what contemporary patrons wanted. It was probably Constable who was the first, or one of the first, to pose groups naturally for students when he became a Visitor. Etty always seems to have difficulty in posing groups naturalistically, though he became more skilled as he grew older. Despite his continued attendance at the Life Classes he gained much of his experience from copying the work of the Old Masters but each form of study was directed towards different ends. From the Old Masters he gained mastery of color, from the Life Classes he gained mastery of naturalism. The latter may not always be apparent in his group compositions, but it is certainly to be seen in his single figures.

"Never to marry!"

If, as Jean-Jacques Mayoux says,[18] Etty "repeatedly fell in love with his models and offered them marriage," we must ask, what did Etty expect from marriage? what in fact did he expect from a wife? and, why did he never marry? Mayoux considers that Etty "lived in a state of mental confusion, of shifting and undefined aims." He blames this on Etty's single-minded obsession with the theme of the nude female which isolated him from the wider world of men and their interests. This may well be so. We certainly find that Etty was a "poor mixer," always ill at ease in the company of those with whom he was not wholly familiar. But it was not his obsession with the nude female that made him uncomfortable in unfamiliar social groups. It was a natural shyness that afflicted him from youth. If it is true that he frequently proposed to his models then the fact that most of them came from a class with which he was not familiar must make us wonder how he thought he could have accommodated their behavior, their lack of social graces, had they accepted him. Of course, not all his models posed in the nude and it may have been that he proposed only to those who did not since they would have been of a socially higher class, more likely assistants in shops of a superior nature, such as hat shops and florists, young

women aspiring to a more "genteel" life. The situation is confused and uncertain since even shop assistants and domestic servants would sometimes pose in the nude, so desperate were they to earn extra money.

It was not unusual for artists to marry their models or at least to enter into permanent relationships with them but this tended to become more usual later in the century. Some of the second generation Pre-Raphaelites were well known for making mistresses of their models and then marrying them. The "Bohemian life," as it was then termed, was very attractive to young men and women eager to escape the restraints of the Victorian family. But this was well after Etty's death.

The matter of Etty's lifelong bachelor status has concerned some people, especially having regard to his interest in the female nude and his employment of models throughout his life. In the second half of the twentieth century there developed a pseudo-scientific interest in the lives of celebrities and especially in the details of their sexual orientations and proclivities. There is a press which depends on such "exposures," the kind of tabloid newspapers which pretend to be shocked by what they "expose" but know their readers delight in it because they encourage them to be so. Today, if Etty became a popular artist once more and attracted sufficient attention, he would undoubtedly be the subject of much amateur psycho-analysis and, of course, feminist outrage. His fondness for the nude, always painted from actual models, would be analyzed as the consequence of frustrated sexual longings, of a bachelor condition forced on him by sexual impotence, of a pathological shyness bordering upon paranoia, of deep-seated psychological disturbances, a possible "mother fixation," even unsavory perversions. Very few men do not desire sexual experience and we have no reason to believe that Etty was abnormal. He probably had little contact with girls and young women in his own youth and had not mastered the necessary arts for making himself attractive to the opposite sex. It is possible to surmise that during his years at Mr. Hall's Academy at Pocklington, where he had been a weekly boarder, he experienced the usual temptations of boys brought together but isolated from the opposite sex. If he visited his uncle Calverley at weekends and met an attractive cousin, as seems likely, he could well have experienced conflicting feelings, secretly adoring her but forever tongue-tied. Being tongue-tied was a constant problem for Etty when in unfamiliar company.

It is clearly the case that all his life Etty *was* afflicted with acute shyness and he would frequently sit silent throughout an entire dinner party unable to participate in the conversation. C. R. Leslie said in his autobiography,[19]

> At our meetings [i.e., of the Council of the Royal Academy] he never spoke without a great effort, yet he was never silent on any question in which he thought he could serve the Academy. The first speech he made at a general meeting was to propose a very useful measure, which he carried; but he was so nervous that he could scarcely articulate, and it was painful to witness how much the effort cost him. He was warmly thanked by the President.

Yet he was a popular man among his contemporaries, largely for his modesty and obvious natural honesty. He could be a cheerful host when he entertained friends and he was amiable to students. It seems that he had to be among friends well known to him to be comfortable. He did regret not having married but he does not appear to have had any recourse to female company other than for normal friendship and conversation. Almost all his female contacts were wives of his friends. He lived quite happily with his niece Betsy as his housekeeper and in his extensive correspondence with his cousin Thomas Bodley there are only occasional hints of dissatisfaction with his bachelor state. Indeed one concludes that, in the last two decades of his life, it suited him very well, enabling him to concentrate on his painting. There have been the usual conjectures that he and Betsy were united in a relationship that could not be revealed. Later this relationship is more closely examined. It seems quite clear that such conjectures are unfounded. Gilchrist devotes a whole chapter[20] to the subject of Etty in love. He describes him as

slovenly in attire, short and awkward in body; large head, large hands, large feet:—a face marked with small-pox, made still more noticeable by length of jaw, and a quantity of sandy hair, long and wild;—all conspired to make him "one of the oddest looking creatures," in a Young Lady's eyes,—what she would call "a Sight."

Ernest Villiers Rippingille, R.A., writing an appreciation of Etty in *The Art Journal* of 1859, remembered him as

a short, stout man, with shoulders low, and rather narrow, surmounted by a large, heavy head. He had a shambling gait, stout limbs, large feet, with toes less diverging than is usual. ... [H]e was strongly marked with small-pox ... a large mass of an unmeaning face, with wrinkled forehead, and thin, grey, straight, and straggling hair.

This was Etty in his last years. In 1830 "A Young Lady" writing in *The Dublin Literary Gazette* (15th May), wishing to describe Turner, said:

What an odd little mortal he is, wizened, and not even so good looking as Etty, who would be the ugliest man in London but for one simple cause—his pure unaffected good-nature that renders him the darling of all the students of the Royal Academy, and irradiates his countenance until you wonder you ever thought him less than beautiful.

William Camidge of York, son of the organist at the Minster and a friend of the artist's, wrote a personal memoir of Etty in 1899.[21] He described his appearance thus:

Mr. Etty's personal appearance could scarcely be called attractive. He was short in stature and somewhat awkward in gait. He had a large head, large hands, large jaw, and large feet—all out of proportion to his size. His face bore slight evidence of that scourge once so prevalent in this country [*small pox*]. His hair was thick and sandy; it showed that great attention was not paid to it and it was frequently long and unkempt; but his massive forehead gave character not only to his face, but to the man, and redeemed his personal appearance; it evidenced marked indications of energy, power and skill. He was ever too busy, both as student and artist, to pay much attention to personal appearance, with the consequence that to the casual observer he gave very little indication of a refined and imaginative mind.

Jean-Jacques Mayoux describes Etty[22] as "small and ugly" which he mentions in the same sentence as "he resolved never to marry," suggesting that the two were connected. But Mayoux had no personal knowledge of Etty and relied on the testimony of others, as we all must now. All these descriptions may be true and may account for why Etty was never able to attract women to consider him as husband. Untidy and shambling he undoubtedly was, but Rippingille's description of "an unmeaning face," suggesting someone who had no power of serious thought, is surely unjust. His friendships with men of intellect would not have been possible had he not been able to match them in conversation when he came to know them well.

We know that many men of apparently unattractive physical condition nonetheless find conventional satisfaction for their emotional needs. Turner, with the example of his parents to warn him, avoided marriage but had mistresses and some passing liaisons during his tours abroad. History is full of young women giving comfort to unhappy men. Marriage was not every woman's expectation though it was usually her hope. In addition to those honest women who love for love alone there have always been those who assume a fidelity through the need for financial security. Etty's inability to secure a wife must have been more due to his shyness and difficulty in articulating his hopes than his physical appearance. If it is true that men choose women for their beauty and women choose men for their good character, Etty should have had no difficulty in attracting a suitable companion, if not a wife, for he was held in high esteem by everyone who knew him. In any case, the drawings made of Etty in the last decade of his life do not suggest an unattractive person. Though short and of a thick-set stature his sensitive mouth suggests the amiability for which he was renowned. Matthew Noble's marble bust (see the title page) was made in 1850 and probably based on these drawings. It portrays a pleasant looking man who, one would expect, would not have lacked appeal. The National Portrait Gallery, who now owns this bust,

suggests it was based "chiefly on photographs" made by David Octavius Hill and Robert Adamson when Etty visited Edinburgh with Charles in 1844. These photographs of Etty present such a different image—the mouth is drawn down severely and there are other differences—that it is difficult to reconcile them with the drawings or the bust. More consistent with Matthew Noble's bust and with Etty's self-portraits is a pencil drawing by Abraham Cooper (1787–1868) now in the Royal Academy library. This shows a sensitive mouth, large nose and tousled hair and the face of a man immersed in his painting, not at all likely to be unappealing to a perceptive young lady. Camidge said of him[23] that "he had a kind heart, which led him into sympathy with all that were troubled."

Gilchrist, in his chapter on the subject, suggests that at first it would have been Etty's poor financial prospects that would have deterred women from accepting him. Artists were not regarded as desirable husbands. Young women were counseled by parents and others to seek money before love, the times being what they were. Etty certainly wished to marry and even to raise a family. In a letter to Walter dated the 20th October 1822 from Rome, he laid his soul bare as he often did to his sympathetic brother.

> To calm me, let me quote a beautiful thing I met with the other day, translated, I believe, from the Persian, by your Indian friend, Sir William Jones. It is a poetic gem, so polished in execution, so exquisite in sentiment:
>
> > On parent knees, a naked, new-born child,
> > Weeping, thou sat'st, while all around thee smiled,
> > So live, that, sinking in thy last long sleep,
> > Calm thou may'st smile, when all around thee weep.
>
> Isn't it beautiful?

This was when he was waiting in vain for a letter from his cousin Mary saying she looked favorably on him, encouraging his hopes that she would marry him.

It must certainly seem strange today that any young man exposed to the company of attractive young women should not have displayed some feelings towards them. It is hardly to be expected that a young man who openly declared a desire to marry should not be attracted to young models. We must assume that some of them at least could hold an intelligent conversation. A young man raised in a strict Methodist family, conservative and orthodox by upbringing and by nature, wholly conditioned by a social *mores* which condemned any sexual activity outside marriage as the worst of sins, such a man would either feel compelled to offer marriage to satisfy his needs or make a very conscious decision to rebel against his upbringing. Etty was not a rebel. He had been brought up in a provincial backwater, accustomed to the close proximity and interference of neighbors, concerned for his good name and that of his family which could easily be forfeited. Above all, Etty conformed to the Victorian *ethos* of respectability. He adored his parents and even if he had suspected that their marriage, though willing, had been hastened by circumstances, he would have approved his father's honorable conduct. Without doubt he had been brought up to respect women. He always treated them with utmost consideration and it was probably impossible for him ever to regard a woman merely as an opportunity for temporary gratification. Camidge again said of him: "Gentle, tender and affectionate, he would have made any home happy and any wife joyous." But, we must surely conclude, she would have had to be content with a life of near, if not total, celibacy.

Yet it is clear that at least in his early years Etty was not naturally a celibate. It is part of the family tradition, told to the author by Tom Etty of Nijmegen, that young William was very fond of his niece, Catherine, known as "Kitty," the daughter of brother John. Kitty was nine years younger than her uncle and in due course she married Robert Purdom. Much later Etty became equally fond of Elizabeth, known as "Betsy," another daughter of brother John and fourteen years younger than her uncle. Etty seems to have had a preference for younger women as

we shall see, probably because he was too shy and awkward in manner to feel at ease with women of his own age. There seems to have been a tendency in the nineteenth century for shy men to turn to young women or girls: we have the examples of Charles Dodgson (Lewis Carroll) and John Ruskin. Probably the avuncular role they could adopt protected them. In July 1816 (endorsed by Walter as received the 24th July) Etty wrote to his brother Walter, in whom he frequently confided, that before he left for Italy he wanted to settle one question—

> Whether you think it would be advisable (supposing for a moment I could meet with an amiable girl with some property of her own) to take her with me as a wife, to be the companion of my bosom in a foreign land, to soothe my lonely hours, and by making me enamoured of home, preserve me from the effects of vice, and the contagion of example?

It may seem that Etty was looking only for someone to protect him against the temptations of foreign women. If he disapproved of temporary liaisons, as is most likely, he would not wish to risk casual encounters while he was away. It was generally supposed that a young man let loose on the continent was seldom able to resist the temptation of brothels. His requirement that a wife should have some property of her own was probably no more than a safeguard that he would not attract someone seeking a husband for his money and prospects, a common enough risk at the time. He seems to have realized that at 28 years of age he was not only leaving marriage until somewhat late in life but that he was very likely to prove unable to resist easy temptations.

We have already seen that in 1821 Etty was deeply in love with a cousin named Mary who did not respond to his expressions of interest. The fact that this young woman was a cousin and that Kitty and Betsy were nieces indicates that his circle of intimate female friends was probably limited to the family. Cousins frequently marry and the reason may well be that they are associated with each other from any early age, become friends and develop into lovers largely through constant contact. There are no initial problems of expressing interest to overcome. There is plenty of evidence that in rural England at this time cousins frequently married. Various married friends had young daughters but, if what we know of some of them is typical, none seems to have come close to him in affection. George Bulmer's daughter always addressed him as "Mr. Etty." One can see that for a shy man like Etty it would be difficult to approach a young woman with any display of interest that she might not welcome.

Nevertheless his disappointment with cousin Mary in 1821 seems to have emboldened him. In 1822 he wrote from Italy to Thomas Bodley that he had come to know "a fair Venetian of respectable family ... who is, besides, a very fine girl." Apparently he had not declared his attraction and decided not to take the matter further. Yet, strangely, he wrote in a later letter to Bodley: "I have so often and unprofitably been in love...." What these other previous occasions were we do not know. Not again until 1830 when he was in Paris did he again feel the stirrings of love. Once again we are indebted to Gilchrist for an account of this.[24] "He had insensibly become enamoured of a beautiful and accomplished young friend, some twenty years younger than himself, who had barely ceased to be a school-girl:—an Englishwoman, but not this time in England."

Etty was now 43 years old, the young woman was therefore a little over 20 years, hardly still a school-girl, but such an age difference was often ignored when wealth and titles were at stake. The young lady preferred a younger man. Etty declared his love but she, while promising to "feel great esteem and affection" decided against him on the grounds of "disparity of years." Gilchrist describes "the love-storm" to be as "vehement as the last, while it continued, and he was vehemently unhappy." We see the reason for Etty's recurring failures in love, he was always attracted to young women, indeed to adolescent girls, probably because his feelings were more protective than sexual and also because of a natural inability to deal on equal terms with women of his own age. He subsequently recorded in his notebook (in the possession of Tom Etty of Nijmegen) "that it is best I have not married because I have not noisy Children and can have nice Books,

and Pictures, etc." He also now had the services of his niece Betsy, who managed his domestic affairs very efficiently and came as close to his heart as any woman.

In 1840 Etty again noted: "Never to Marry—Virago of Wife!" and three years later, also in a notebook: "this day being in sound Mind and Body I declare it to be my *Firm Intention NEVER TO MARRY.* In which resolution I pray GOD to help me that I may devote myself more purely to my Art, my Country and my GOD!"

Why Etty should have decided that a wife would prove to be a virago we do not know but he would certainly have been aware of the breakdown of the marriage of his friend William Mulready. Although details of the marital breakdown were never fully made known, each side accused the other of cruelty and infidelity with the most disturbing accusations coming from Mulready's wife, Elizabeth. Mulready himself said very little, no doubt feeling that since his Roman Catholicism forbade divorce it was more prudent merely to separate and hope to draw a veil of silence over the whole affair. Even so he did accuse his wife of "bad conduct" though never specifying its nature. Elizabeth Mulready wrote a letter to her husband some twenty years later, around 1828–30, in which she blamed him entirely, suggesting cruelty, homosexual behavior and adultery. It is not necessary to examine the break-up of the Mulready marriage here, which can be examined in papers in the library of the Victoria and Albert Museum and in paraphrased form in Kathryn Heleniak's account,[25] but it must be presumed that Etty at least heard as much about it as Mulready wished to divulge and equally we may presume that Etty believed his friend's account.

There were at the time too many cases of marriages turning out badly. Yet it would seem that Etty was surrounded by friends and family whose marriages were as happy as they could expect, though his brother Tom had been particularly unfortunate. Not having been able to marry his cousin Mary, Etty found solace in believing it was for the best. We can at least be certain that Etty was content with the arrangement with Betsy, who developed from housekeeper to confidant and for whom he had an increasing affection. Whatever Etty's condition that caused him so much difficulty in expressing his feelings, he settled apparently quite comfortably into bachelorhood for the rest of his life.

Etty's religious and personal lives were so interwoven that our knowledge of the former can be claimed to give information on the latter. Camidge wrote very feelingly of Etty's pious nature.[26]

He was pre-eminently a religious man. The son of good Methodist parents, at a time when Methodism was Christianity in earnest, with the consequence that he received a training which influenced him all his days. He frequently expressed his religious sentiments as "My soul pours itself out in grateful adoration to Him, the bountiful giver, that he has given me so much when I deserve so little. ...

"Teach me, I pray thee, O God, ever to conquer and command those passions which war against our peace and corrupt the purity and innocence of the soul."

Camidge continued:

He was not devoid of admiration for the opposite sex, but failing in one or two efforts to secure the objects of his choice, he abandoned the purpose and lived out his days unmarried. Gentle, tender, and affectionate he would have made any home happy and any wife joyous, but he failed capacity to select the right person to go about the business in the right way. He wooed but never won. ... His love was always a fever, and perhaps its very strength destroyed its success.

Of all men he was concerned to live a virtuous life and this would not allow him to enter into loose sexual relationships. The correct relationship between man and woman, if it could not be one of pure friendship and had to be amatory, should be marriage. It was no doubt fortunate that he was refused. Many artists have married models and enjoyed happy lives together but for the most part the models that came to Etty were chosen for their physical attributes and not for intellectual qualities that would have guaranteed social acceptance. Very few models could claim the graces of the future Lady Hamilton. In a notebook in possession of Tom

Etty of Nijmegen, which also contains an entry at this point dated "18th October 1830," Etty wrote the following poem, presumably composed by himself.

Temple of Virtue–Lambeth

How smoothly flow his days and nights,
As sweetly as some limpid stream,
Of him whom *Virtue* fair delights,
Whose soul absorbs her cheering beam.

But turbid as some mountain flow
When swoln with dark autumnal rains
Is when forgetting life's chief good
Wild throbbing passion fires the veins.

Then, O my Soul, awake from Sin!
And throw thyself at Jesus's feet
And let us our new course begin
For surely Virtue's ways are sweet.

And O my God! to Thee I pray
That thou direct my wav'ring heart
To seek to do Thy Will alway
Nor from Thy holy paths depart.

Then, I may hope when life is past
And all its fev'rish visions fled,
We may repose with Thee at last
And Friends now numb'red with the dead.

This poem is directed not towards the general temptations of sin but specifically towards "throbbing passion," suggesting that poor Etty was frequently almost overcome with desire, as any normal young man would be. That it was a recurrent problem for him is also suggested by another entry in this notebook "To be Virtuous is the best proof of Faith—as well as of good Policy, like Honesty—for the Virtuous Man has more real good and enjoyment than the Sensualist—because he has the mind's calm disposition and the heartfelt ease."

Etty was constantly jotting down thoughts in his notebooks, not in any orderly manner but as they occurred, often in the middle of other notes referring to quite distinct matters. Thus suddenly occurs the following:

Stand Firm
Never bind yourself again—Get within sound of Minster Clock and sight of the Tower. Tis Soberly! [*Sobriety?*] alone which gives the flower of fleeting life its lustre and perfume and we are weeds without purity of mind and body for ever.—

The command "Never bind yourself again" suggests a commitment from which he was glad to escape but what it was we cannot know.

That the question constantly worried him is again indicated by a short entry in the same notebook, but undated,—"Not to Marry—Go on!—Go on!—Go on!" This is set down among notes regarding the materials he needed for painting. As is another note written after some self-instructions regarding the use of primary colors. "Enter not into Enjoyments or Promises—I do not like Bonds or Restraint—Chains are Chains if of Gold—Memo Never to Marry—Crying Children."

Elsewhere in the same notebook Etty declared, "For though to Love I now am dead." Was the desire for female companionship so incessant that it was never out of his mind? He seemed so anxious so often to deny the need. But over and over again he writes of "Virtue" and it is clear he means not only the spiritual principle but also, perhaps above all, chastity for he so frequently condemns "sensuality."

It was common knowledge, or so it was alleged by those of a moralizing nature, that travelers

abroad were constantly subjected to temptations. Certainly in the preceding century many young men of means went to the continent in the expectation of indulging themselves safe from the eyes of their friends and families. Sowing wild oats was a recognized necessity for young men and, so long as they sowed them far from home, parents usually turned a blind eye. Etty himself knew this and recorded in a notebook Reynolds' advice to artists abroad—"Avoid, above everything, the loose habits and vicious manners of Italians." It does appear likely that Etty may have succumbed to such temptations, though this is by no means clear. This particular event, or possibly *events*, have already been referred to earlier.

There is a further enigmatic reference to these matters in an undated letter which Etty wrote to Betsy from Brighton. It was sent from 13 Brunswick Terrace, the home of Thomas Bodley. By 1844 the Bodleys had moved to Cheltenham so this visit was before then. There is no doubt that it was still the Bodley's home since Etty mentions "Aunty Bodley" entering the room as he is writing. He tells Betsy that he is intending to return to London on the following Wednesday (the letter is dated only "Sunday morning"). Etty is known to have visited the Bodleys at Brighton in August 1816, September 1827, August 1831, and January 1834. Since he was a frequent letter writer and virtually all his letters appear to have survived, it is unlikely that there were other unrecorded visits. The weather as described in the remainder of the letter following suggests that it was either autumn or winter and it might therefore be the occasion of his 1834 visit. Other details confirm that it was certainly after 1824. The tone of the letter is so intimate that his relationship with Betsy was well established and the letter must have been written some time after 1824. The part of the problematic letter that is significant here reads as follows:

> Oh my darling, I like to be ever near thee. Love, such as angels might feel, for purity is mine for thee unmixed with base matter—that is the love I love the best. I wish for, I look for no other on earth or in Heaven—let others take all the rest for me. I have done with the rest I trust for ever. It is indeed Vanity, all is Vanity save that holy flame of sacred Love which lights us alone for happiness and peace and leaves no stain, no sting behind and like the last gold rays of the setting sun on a cheerful hillside on which the sheep and lambs of the fold of Christ are feeding, inspires nothing but sweetness, gentleness and love towards Him who made and blesses us.

These words surely confirm that Etty's deep affection for Betsy was the closest he ever came to loving a woman who accepted the warmth of his feelings, but these were by now unalloyed with any sexual desires. But what however must be significant is his declaration "I have done with the rest I trust for ever." Did he mean that he had had sexual experiences or only that he had had sexual desires or was he merely renouncing any fond memories for women he had loved earlier? The proprieties of the time would not have allowed him to say more but we may justifiably read the words in this letter alongside his "confession" and the anecdotal evidence that he had asked models to marry him and conclude that Etty had at some time most probably had experienced the desires, if not the satisfactions, that we would expect. Whatever the meaning of these words it must be clear that Betsy knew what they meant. This letter is curious in many ways since it confirms that Etty and Betsy were on very intimate terms but that they were not physically intimate. The relationship was so close that, for some reason or other, he felt obligated to assure her that his love for her was not sexual and that he expected no intimacy. Why should he have felt it necessary to reassure her? Had she expressed concern that he might be expecting intimacies she was unable to grant? They were undoubtedly very closely attached to each other. Their relationship must wait later consideration.

What is clear is that Etty's interest in women with a view to marriage was expressed in the years between 1820 and 1830, and that thereafter he decided that he was destined to a bachelor life. By then he was approaching 50 years of age.

CHAPTER SEVENTEEN

The York School of Design

The final decade of Etty's life was so busy that it has often been convenient to consider his different activities separately. His involvement with the York School of Design is such a case. Etty had been an early enthusiast for the establishment of a School in York, beginning in October 1838 when he had read a paper to the Yorkshire Philosophical Society. He was subsequently invited to repeat the paper as a public lecture. This event has already been recorded as has his earlier appointment to the Committee of the parent body, the London School, in December 1836 but we now come to the principal reason why he engaged in this task. As much as he wanted these Schools to be set up all over the country, he particularly wished that one should be established in York. York could make few claims to be a cultural center and this always rankled with Etty. He particularly wanted York to have a School of Art. But the government project was confined to Schools of *Design* intended to train young men and women in industry. York was not an industrial city. It had scarcely any workshop that could claim to be industrial and it was far from the nearest industrial city, Leeds. But this did not deter Etty. His first determination was to make it possible for all students in the Schools to study the living model. This he insisted was the basic training that any artist needed and since the Schools were not intended to teach art he argued that the study was also essential training for a career in design. Many industrial designs and especially those in the pottery trade depicted human figures and while they were always clothed—usually draped—it was necessary for the underlying anatomy to be well understood if the figures were to be plausible. He did not have to say so but the paintings of women artists clearly suffered from their lack of training in human anatomy. Etty would undoubtedly not have agreed to have women share a Life Class with men but we can be equally assured that he would have allowed them their own classes. He undoubtedly applauded Haydon's actions when he sent plaster casts to every School in an effort to circumvent the existing restrictions.

It is not proposed to recount the story of the establishment of the Schools, which has been dealt with in great detail by Quentin Bell in his book, but to do justice to Etty's single minded determination to have such a school in York. As Bell says,[1]

> The fact of the matter was that Etty ... had set his heart on having a school in his native town. The citizens were proud of Etty, had raised a subscription for a school; but there was not enough support and so the painter, in his quiet, obstinate way, insisted that the Government should provide the money.

Etty attended every meeting of the Council of the London School, always pressing for a branch school in York, a conscientiousness which eventually was rewarded. He later declared,[2] "I served as many years in that Council, as Jacob served to obtain a wife: without fee or reward; at a great expense of time and feeling,—which I could ill spare."

Etty's method was not to attack frontally but to burrow away quietly until he had undermined the opposition. He was also sufficiently aware of the changing fortunes of the scheme to

move his support from Haydon to Dyce when it was becoming obvious that Dyce's views would prevail. As we have already seen, Haydon was proposing that students in the Schools should have frequent access to living models whereas Dyce believed that, as design was an ornamental art requiring a different form of training from "High Art," students had no need to study the human figure. Moreover, he knew that students, who would always be boys, would come to the Schools comparatively uneducated and their progress towards desired aims would be slow. Only later did he concede that models could be made available at the end of the period of training and then only to those students showing sufficient aptitude. Etty rightly saw that it was better for students to have conditional access to the model than no access at all. He had always been a supporter of the Royal Academy Schools and particularly of the Life Classes but if the provinces had to wait a while, then so be it. Etty was mindful that he had been fortunate to receive support from an uncle able and willing to assist him. He was concerned for others less well connected and especially those who were destined to remain in the provinces. He rightly saw no reason why all talent should have to emigrate to the capital. London was expensive and students would have difficulty finding suitable lodgings. He obviously feared that a young boy cast out in London could well end up in crime. In any case, designers had to find employment in local factories wherever they were and for the most part that meant outside London. So they should begin where the work was—and if they decided to become artists instead of designers, so well and good.

Etty was always persistent in any cause he espoused. Alongside his duties on the Council of the Normal School in London he pursued his interests in a school for York. How he managed this success is not known but clearly this quiet man won through by sheer persistence and, despite his initial disappointment in 1838, he was able in 1842 to preside over the opening of a School of Design in York. Bell, in his book, is also unable to explain Etty's success. All that can be said is that Dyce supported Etty and Etty supported Dyce and without any deal between them being struck so far as we know Etty got his school. In accordance with the laid down requirements the York School was constituted as a branch of the London Normal School and was by this arrangement centrally funded though some obligations also rested on the city of York itself. Rooms were rented in the Freemasons' Hall and in an adjacent public house in Lop Lane, which was then an extension of the road leading from the Lendal Ferry to the Minster. Lop Lane was given the name Little Blake Street in 1846 and then transformed into a widened Duncombe Place between 1859 and 1862 to provide a more imposing approach to the Minster. Provincial schools were supposed to be funded partly from Government sources and partly from local subscriptions but, as Etty should have expected, insufficient money was forthcoming from York citizens and he had to persuade the City Council to provide the balance. In March 1842 he assured them that if they would guarantee £150 per annum for three years and provide a suitable room for the School he would arrange for the Council of the Government School of Design in London to give "an outfit of valuable casts for drawing from to the amount of £500 and add to the £150 per annum, £150 more." This was a most generous offer and indicates Etty's strong feelings. On 7th April 1842 the City Council appointed the School Committee with Mr. Edward Harper and Mr. Dodsworth as joint Secretaries and Mr. John Brook as Treasurer. These gentlemen and several others on the Committee were friends of Etty and he must have been well pleased with his labors. In September 1842 a public meeting was held which William Dyce attended.

In the later stages of the campaign Etty had gone out of his way to support William Dyce in his proposals for running the provincial schools even though he disapproved of many of Dyce's ideas. When Dyce came to York to deliver his inaugural address he found it necessary to explain as best he could why York had been granted a school. He admitted, as was obvious, that York was not a manufacturing town as required by the Government for a school to be established, but claimed it was "the centre of a manufacturing district."[3] This, of course, was quite untrue. York was the center of an agricultural area and its industry was insignificant but nobody

challenged Dyce on this point. The citizenry, assuming they were at all interested, were probably pleased to have their city regarded as the center of something and accepted what they were being offered. Dyce decided that York was "a nursery for national taste."[4] It certainly looks as though something was afoot between Dyce and Etty because some other cities had had their applications refused for not being industrial enough.

The London School had appointed a Mr. Lambert as the first Master. On 10th October 1842 Etty wrote to Mr. Lambert at 18 Clarence Street, Gillygate, offering him advice. He welcomed him as a stranger to the city and wished for his success. He particularly supported Lambert's previously declared "determination to take no other pupils than those of your School." Etty was apparently suggesting that, as a newcomer who was moreover to be paid a good salary, Lambert was likely to encounter opposition. What particularly concerned him was that Lambert should not seek to attract pupils from private tutors since this would deprive them of their living. Etty always acted and counseled others to act on the principle of living in harmony with one's fellow men. At all times his natural amiability determined his course of action. His advice, however, sadly proved unnecessary. Lambert died of typhus shortly after his appointment and a replacement had to be appointed.

In the meantime matters were not proceeding smoothly in London. The central Council was critical of the amount of time that William Dyce was devoting to teaching the students. Dyce felt that he not only had to visit provincial Schools but, as he was a professional artist, he should be allowed adequate time to pursue his career. He could not also give much time to actual teaching. The dispute could not be resolved and Dyce, expecting to be dismissed, resigned from his directorship in May 1843. Just before Dyce's resignation Etty prepared a letter to be sent to William Gladstone, then President of the Board of Trade, protesting against dismissal and urging that, as a practicing artist, Dyce needed periods of re-inspiration. He also insisted that it would be impossible to replace Dyce with anyone so well qualified. The letter is in draft form and incomplete in York Reference Library and whether it was ever sent to Gladstone is unknown. Etty did not present his case to the Council directly and Farr believes that he did not attend meetings of the Council at this time because he was too busy completing paintings for the Academy exhibition.

There had, in fact, been more to the matter than the question of inadequate teaching of students. As so often happens in institutions of this kind, factions began to emerge. The Manchester School had opened in 1838 and its first master, Zephaniah Bell, was a firm believer in study from the living model but the Council reiterated its policy that the schools were to teach *design*. Bell would not give way and when Dyce resigned in 1843 he decided he had won his point. Etty wrote to Bell reminding him that Dyce had been reappointed as Provincial Director (to give him more time for following his own career) and that Bell would still have to reckon with him. Bell replied to Etty[5] that he had no intention of giving way as much as he was grateful to Etty for his advice. Etty's advice had, of course, been "to go carefully" but Bell was too confident. He certainly had local friends but he also had local enemies. Throughout the country the manufacturers did not want their employees becoming artists. When a new Secretary was appointed to the Manchester School the life class was abolished. The Council had demonstrated that it would always get its way. Etty was well aware of this and proceeded cautiously.

After Mr. Lambert's untimely death in York the London School appointed Mr. John Patterson to the York School. Patterson does not appear to have been a popular Master. In his unpublished account of the formation and history of the York School of Design, held in manuscript by the York Reference Library, the architect J. W. Knowles, announcing himself as a former pupil, described the School's Master as follows:

> Mr. Patterson was a man of morose disposition and used to sit near a table in the School in an attitude of absorption of thought during most of the time the students were at work. Occasionally he would rouse himself and walk round and overlook the work of the students and often cause much irritation by his habit of making an extra black line with the Black Chalk to show where an error in drawing had

been made, sometimes spoiling a good drawing which had taken a long time to execute. On one occasion he committed this act of pure brutality upon a highly finished drawing by Maddison a very clever student with the result that Maddison jumped up from his seat and threatened the Master with fisticuffs. As an Art Master he was possessed of but little ability. His studies from the life in oil and in Crayon are weak in drawing but the oil studies had a certain character in the painting that he had gained by his previous experience as a house painter. With the [*words illegible*] he adopted a summary mode of showing his displeasure by seizing the delinquent by the shoulder and ejecting him out of the school door. [*Words illegible*] of these exhibitions he ejected six of the students, the writer being one of them. He was a tall broad set man and strong.

Knowles also records that Patterson had a brother who set up a boys' school in Wood's Passage, Pavement, in York, later removing it to St. Andrewgate. "He had to give it up on account of his intemperate habits and I believe ultimately committed suicide."

In 1843 Charles Heath Wilson was appointed by the Council of the London School to replace William Dyce as Director. Wilson was appointed in his place and Dyce was made Inspector to visit and report on the provincial Schools. The unpleasant campaign waged against Dyce and his own intractability is given in detail by Bell. In or around 1844 Wilson wanted to move Patterson from York to another School. For some reason Etty opposed the idea. Wilson wrote to Etty to explain his proposals—the letter in York City Library Archives is undated but has been endorsed by another hand "Probably 1844."

My Dear Sir

The proposition I made with regard to Mr. Paterson [*sic*] was this That he should have another School at £150. I did not think for a moment of dismissing so praiseworthy a person. But I think that York especially should have a superior Master in points of Manners & position. It is a great city. The School is much seen by people of consequence & a great number of people get the idea of a School of Design from that at York, this is a sort of show School, now I thought that if Mr. Paterson could have been provided for in a *proper manner*, a superior person could be sent to York. I feel very anxious that you should understand my real sentiments & not suppose that I was about to advocate a sweeping away of Masters, with the exception of Thomson of Nottingham & Evans of Coventry who are utterly unfit, & of course it becomes my duty to say I believe that to be the fact, although it is very painful to myself. I have today put my opinion on record & if there is an inquiry into the subject at any time I can say that if there are to be any bad Masters in any of the Schools it is not my fault.

I remain

My Dear Sir,

Truly Yours

C. H. Wilson

Wilson did not get his way. Etty would have been well-advised to have accepted Patterson's removal. Patterson remained in office until 1853 when he died suddenly of apoplexy in the street near St. George's Field in York.

Wilson himself was not a generally popular man and doubts had been expressed from the outset by some who doubted his competence. Matters came to a head in 1845. Between the 2nd and 3rd of April that year a notice appeared on the door of the Life Class room in the London School complaining that certain students had been punished for "inattention." The students felt that this was inappropriate for adult persons of their age and the Master, John Rogers Herbert, feeling that the action was personally insulting, went to the Director where the students joined him. "An altercation" took place and the class was suspended and this was followed by a letter to the Commissioners of the Board of Trade (i.e., the over-seeing Government authority) signed by thirty-three students. In this letter the students described Wilson as "utterly incompetent as an Artist and Teacher of Ornamental Design," praised Herbert and asked for "this portion of the School" to be placed "under a more efficient system of management."[6] If the authorities at any level had thought they were dealing with school children they now learned otherwise. These were young men, one at least was only eight years younger than the Director himself, and they were intent upon pursuing a worthwhile career.

The Council of the School sought to arbitrate in the matter and appointed a sub-committee to inquire into the future of the Figure School, i.e., the Life Class of the London School, of which Wilson particularly disapproved and which the students were anxious should continue. One of the members of the sub-committee was Etty along with Charles Cockerell and Richard Westmacott and six others whose names are today barely known. Etty, Westmacott and another member did not attend the first meeting and neither they nor yet another attend the next meeting. It was Christmas Eve and this may account for their absence but at that time the Christmas festival was barely celebrated. The usual disputes arose with witnesses disputing the terms of inquiry. Etty was not present at any of these meetings, in fact he never attended a single meeting. It seems that he had been appointed against his better judgment and in June 1847 he resigned. Bell suggests[7] that Etty resigned as a gesture of his friendship for Wilson after the sub-committee had produced a report whose recommendations would have required Wilson's removal from the School. If correct, it suggests a curious ambivalence on Etty's part since Wilson had sought to close down the Life Class and Etty was a strong campaigner for life studies in all schools. It is more likely that Etty, ever kindly, did not want to be involved in another man's losing his livelihood.

The London School was more concerned with the pupils of the York School than with its Master. In evidence before the Select Committee of 1849 its representative complained that of the female students there were seven whose social status was such that they should not be there. One in particular was "the wife of the highest church dignitary in York," three were "daughters of another high and well beneficed dignitary" and a further three were "daughters of the principal physician of the place."[8] It was not such persons that Schools of Design had been established to assist. They certainly had no intention of earning their living as industrial designers. As usual, the middle classes knew how to exploit the system. However Wilson decided, after visiting York, that "the school should be opened to all classes, provided the pupils conform to the regulations of the school, without distinction of rank...."[9] He may have realized that there was very little demand for *industrial* designers in York and had he required the school to be so limited in its intake it would have to close.

Knowles, in his history of the York School, indicates the problems such ladies could bring to a school of art at that time.[10]

> About this time [c. 1847] a lady attended the afternoon class of particularly modest feelings and could not conscientiously attend the school so long as the statuary stood in unabashed nakedness. And being a lady of somewhat higher grade in society than her fellow students she sent a request to the committee that those of the male figures which were so shocking to behold should be covered, therefore to conciliate the lady student the master was requested to have the penis of each of the offending statues cut off and one of the students was set to model a leaf to cover the demolished parts—a proceeding that called forth the indignation of the male students and the remonstrances of even the lady students.

The 1846 Report of the Council of the School of Design had noted that "This difficulty [i.e., *objection to nude statuary*] is experienced wherever classes have been formed for females in the Branch Schools of provincial towns." Women also often expressed their objections at public exhibitions. Alison Smith cites[11] the case of Susan Flood, a member of the Plymouth Brethren from Devonshire who, on a visit to the Crystal Palace when it was removed to Sydenham, "ran amok among the statuary" and knocked off offending parts with the handle of her parasol. She was arrested—"to the intense chagrin of her uncle and aunt." The magistrate decided she should be sent back home and "looked after." It was reported in the local press that her "return to us ... was a triumph."

There were other problems attending the enrollment of women students in Schools of Art and Design. There were complaints that many female students enrolled merely to come into the company of young men of better social standing with a view to marriage. They were consequently a distraction to the men. Some masters attempted to overcome this by enrolling only less attractive looking women but, apparently, to no avail. The men were also looking for suitable matrimonial

partners.[12] Not all female students were husband-hunting. Many seriously wished to study art. When the Female School was opened in London in 1843, there were forty-five students immediately and a long waiting list. Except for those towns where women were predominantly employed on design work, as for instance the Potteries, most women students were preparing themselves for employment, for example as governesses where they would be expected to teach drawing and painting in watercolors. Parliament had not expected this and in many cases, as in the London Female School itself, steps were taken to discourage women students, often by moving them to ill-lit corners of the studio or even to separate rooms, dark, cold and damp. This was not the case in York. It is clear that from the first Etty was eager to have a School of Art in York. He knew that in York there was no demand for training in industrial design and he did everything he could to encourage tuition in art rather than in design. He was clearly motivated to place before young men and women facilities which had not been available to him in his youth.

An example of Etty's quiet generosity is provided by the gift he gave to the School of Design. In December 1847 a plaster cast of Flaxman's bas-relief *The Shield of Achilles* was specially made for Etty by permission of Flaxman's patron Joseph Neeld, who owned either a bronze version or a plaster cast of the original. Among those who had been given bronze versions of the relief were the King, the Duke of York and the Duke of Northumberland. Etty was therefore privileged to be given this cast. He presented it to the School of Design to provide them with a suitable work for students to copy in accordance with the established system of art education. When he retired to York in his final year and was having some difficulty in obtaining models, Etty was successful in having a male model introduced into the York School. He does not appear to have attempted to introduce a female model and there is no doubt this would have been strenuously resisted by the Corporation and the citizens. In any case, he himself had great difficulty in finding a female model for his own use. In a small provincial town the identity of such a person would not have been a secret for long. He also attended occasionally to give instruction though he restricted his tuition of the female students to the drawing of flowers and similar objects. However, after Etty's death, it was resolved by the Committee of Governors on 11th March 1850, that "the Life Class be discontinued for the present on account of expense."

By 1848 the School buildings were recognized as inadequate and in that year the former St. Peter's School in the Minster Yard was acquired and the School moved to new premises. According to local newspaper reports the School gradually lost support, partly as a result of a decrease in the grant from London which required increases in local fees. Nonetheless attendances at York rose in subsequent years. According to Knowles,[13] in 1851 the number of enrolments were—mornings 9, afternoons 35, nights 37. One may conclude that the afternoon numbers were swollen by young ladies and the night (evening) attendances were of young people after their daily employment. By 1890 there were 76 students enrolling for day classes and 124 for evening classes, which one might have thought reasonable enough for a city the size of York which has never had a large population. In that year the Government Inspector described the School buildings as unsuitable for teaching. Available photographs confirm this was so. It was therefore transferred to the North Gallery of the City Art Gallery, which was purchased by the Corporation in 1891 from the Association of Citizens who had administered these former Exhibition Buildings since their foundation in 1879. The School began to flourish from 1905 onwards. In that year 222 students enrolled and, together with those who had enrolled in the art school connected with the Technical Institute in Clifford Street, i.e., 215 students, it can be said that Etty's high hopes had been realized. The School was eventually moved to the York College where it joined other departments of Further Education.

Schools of art and design owe much to William Dyce. His ideas were crucial to their original establishment and to their continued existence despite much opposition. After resigning from the directorship in 1843 he accepted the post of inspector of provincial schools but resigned from this on the 10th June 1845, again because of its interference with his career as a professional

artist. In 1847 he was given another appointment, as one of three head masters, sharing responsibility for instructing students. But being a man of forthright views he found it difficult to compromise and collaborate with others. He resigned from this post in 1849. Thereafter he confined himself to fresco painting in which he was the country's almost sole exponent. Perhaps surprisingly Dyce was not an associate of the Academy when he took up his original position with the London School. He was elected associate in 1844 and full member in 1848. His skill in fresco painting attracted him to the Royal Family and he was engaged in decorating the Queen's apartments when he died on 14th February 1864.

The work of William Dyce and others concerned with the establishment of Schools of Art and Design has been overshadowed by that of Sir Henry Cole (1808–1882), who is today frequently represented as being the founder of these schools. This was not so. His role was to reform them. His association with art and design education began in 1845 when the Society of Arts announced a competition for the design of tea services and beers mugs as part of a campaign to improve the taste of the public in domestic wares. Cole's design for "Summerly's" tea service, manufactured by Minton's pottery works, won a silver medal and was soon being sold in large numbers. In 1849 Cole suggested the holding of a national industrial exhibition to promote British manufactures and Prince Albert, who was the Society of Arts' patron, took up this idea and became the driving force behind it. At the Great Exhibition of the Industry of All Nations of 1851 it was a huge success and put Great Britain on the world stage as a leading manufacturing nation. Incidentally, it was not originally planned as embracing "All Nations." Other countries had to be included when it was realized that the design of British manufacturers was so inferior to their continental rivals. The exhibition had the desired effect of stimulating British manufacturers to improve.

In the meantime Cole had, with Richard Redgrave, founded the *Journal of Design and Manufacture* in 1849 "to establish recognized principles." Cole used this journal to press his ideas upon the government and being a man, as Bell says,[14] never afraid to make enemies, he renewed his attacks so often that ultimately he was admitted to office in the hope of silencing him. He at once began to put into operation his plan to establish a separate system of Schools of Design fashioned on his own theories that learning to copy was sufficient for any designer. Despite attacks upon him by the *Art Union Journal* he succeeded in persuading the Prince Consort to support the establishment of a College of Applied Art in South Kensington, London, for the purpose of spreading such colleges throughout the country. The *Art Union Journal* launched a furious attack on Cole,[15] declaring him "not to be a person to be intrusted with a duty of great difficulty and delicacy" and that "This is the beginning of the end." In 1852 the Board of Trade established a department of practical art with Cole as secretary. He soon had complete control and along with the artist Richard Redgrave, who had supported him throughout, he was able to transform the whole system of art education and take steps that led to the formation of the Royal College of Art and the Victoria and Albert Museum. Not everything Cole did was detrimental to the cause of art education. He accepted the entry of children of the gentry into the schools as a means of making them more acceptable to employers and also as a source of income. He supported, or did not object to, the enrolment of women students. Those who wished to use the schools to study art as distinct from design could do so at a special rate and through this the schools developed into Schools of Art as Etty had always wished. Cole's administration ended in 1873 and in 1875 he was knighted and ever since Cole had been credited in the minds of those who take an interest in the subject with being the originator of the Schools of Art and Design.

Without doubt a firm administration was necessary and someone like Cole would sooner or later have to impose it. Nobody could possibly believe that an easy-going man like Etty might manage it or even understand that for any organization to succeed there must be sound management. But Cole wanted more than good management, he wanted a new doctrine of principles.

He did what all men like him do who are determined to achieve their ends, he made sure that he did not have round him anyone who would disagree. He also recruited a willing mouthpiece. Redgrave had achieved by 1846 some reputation as a painter of sentimental genre but his comments on the exhibits at the Great Exhibition of 1851 were remarkably revolutionary. He objected to over-decoration and proffered the very modern view that the intended use of an object should determine the nature of its ornamentation. In practice, however, he was conventional and when, later, he became master of an art school he failed to follow his own theories. Redgrave was a Catholic and very supportive of decorative forms in liturgical objects. Giving evidence before the Parliamentary Special Committee of 1847 he said that he made no distinction between art and design and adopted a conciliatory manner but before the Select Committee of 1849 he objected to the influence in the schools of the "artist members" of the Committee of Management. Etty had already resigned his position on the management of the schools but presumably Redgrave's objections were also retrospective. By 1852 Redgrave was Cole's closest ally and their joint plan, drawn up by the 10th March of that year, was ready to be implemented. In parts the plan was praiseworthy. More art teachers must be trained, but a high standard was not demanded; manual dexterity was sufficient. Teaching ornamentation would follow but it was accepted that the application of art to design was unlikely to be attained. The *Art Union Journal* complained[16] "Mr. Redgrave has lent himself to Mr. Cole." This was, of course, long after Etty's death but he had at least secured what he wanted—a York School of *Art* and Design.

Failing powers

Holman Hunt described meeting Etty on the staircase to the Academy Life School in the winter of 1847.[17] Hunt, still a student, overtook the "veteran master" who was "labouring to reach the top" and drew back in order not to pass him.

> He could scarcely speak, but stood aside and made signs for me to pass. I apologized, with assurance that I would follow. Beckoning me close to him he said, as he put his hand on my shoulder: "Go. I insist! Your time is more precious than mine."

Etty would have been well advised not to have attended the Life Class in winter evenings. He was so afflicted with asthma that frequently he could scarcely breath. Many of his contemporaries recounted that he was often to be seen at night in the street going home clinging to a lamp-post struggling for breath. Betsy recounted[18] that on one occasion (no date was given), having been told that "a drunken man" was outside in the street, found him to be her uncle being brought home by two men. This, it proved, became a frequent accusation by passers-by. Etty still kept his "Academy," a somewhat mysterious establishment since we have no reliable firsthand details of it. An entry in a Notebook dated "18th October, 1830" states "Took Room in Soho Square" with details of rent paid to a landlord named Hookham. This room is sometimes referred to later as "Academy Soho Square." It would appear that he retained this room so that he could paint from models without introducing them into his home, but of this we cannot be certain. It was often said that after leaving the Academy Life Class at eight o'clock in the evening he went on to Soho Square and stayed there till ten o'clock, presumably with students. This meant he did not get home to Buckingham Street until late and with London invariably shrouded in dense fog during winter nights this was disastrous for his health.

The effects of the winter evenings on his respiratory problems was such that often even in previous years he had had to decline evening invitations. In June 1844 he found it necessary to decline an invitation to dinner from Sir Robert Inglis because, as he wrote,

> excepting to the Academy, which I consider an imperious duty I do not go out at night now—a severe chronic cough, from which at times I suffer dreadfully more especially when there is the least frost or foggy vapour in the atmosphere, prevents me.

Unfortunately his career had required him to live in London and his obsession with the Life Class condemned him to remain there. Living near the Thames exacerbated his condition. He had ample evidence from his visits to York that his health suffered from staying in London and improved when he went into the country but to have returned permanently to his home city would have meant returning to anonymity and poverty. London has ever been the magnet for ambitious men and women and it was even more so then than now.

During the last decade of his life Etty also suffered increasingly from arthritis and rheumatism, particularly in his hands. This made it difficult for him to hold a brush for any length of time and undoubtedly restricted the movements of his fingers and wrists. We have already seen that Gilchrist did not consider the *St. Joan* series to be finished paintings though he may have been criticizing Etty's new loose brushwork, having been accustomed to and preferring the conventional smooth brushstrokes of previous works. Farr also draws attention[19] to a falling off in the quality of Etty's work from around 1838. He cites *A Bivouac of Cupid and His Company, Somnolency* and *Il Duetto*. "In 1838, Etty's work already begins to show signs of unevenness and, although the average number of pictures sent to each Academy exhibition now increases, one may detect an almost proportionate deterioration in quality."

Farr regards *The Bivouac of Cupid* as "executed in a rather slipshod, facile manner and much of the flesh modelling appears flaccid as well as damaged by bitumen," an increasingly common fault in these latter years as Etty succumbed to the new fashion of using bitumen.

Farr also refers to Etty's *Fairy of the Fountain*, completed in late 1846, as particularly illustrating his decline in health. He complains that it lacks the firm modeling, clear color and strong composition of his earlier work. It must be admitted it is no more than a studio nude placed in a river setting with a dove, a wisp of incongruous drapery, and a minute cupid on the river bank, a work, it must be said, more suited to an amateur talent. It was commissioned by Joseph Gillott for £300. Etty had labeled it "Woman with Dove and Cupid/Etty." Perhaps that is what Gillott would have wanted but equally perhaps it was a tongue-in-cheek piece of humor that would also have appealed to him. The cupid looks so like a statuette that possibly this is just what it was and the painting is really of a young woman playing at being Venus having brought with her to the river a stuffed bird and a garden ornament. Courbet was to play such a joke, parodying contemporary paintings of the nude, with his *Women Bathing* of 1853 and perhaps, just perhaps, Etty and Gillott were conspiring to produce something similar. As Farr says,[20] this cannot be compared to his *Musidora* of 1844 but whereas *Musidora* was intended to be just what the title said it was and it certainly holds it own against any other representation of the same subject, Etty's own label on the back of *Fairy of the Fountain* tells us that this painting is really something else. Etty was not without a sense of humor and as this painting was commissioned by a friend he may have indulged himself, though it would have been unlike him not to treat his art seriously. Be this as it may, the workmanship certainly shows signs of falling off.

Critics called attention to this, sometimes condemning him for laziness or indifference to his obligations. Consequently direct commissions began to diminish but, as Farr says, the dealers were demanding more and he thinks that it was as much these demands as his ill-health that contributed to the effects on his work. From 1840 onwards, though making many studies to fulfill his great ambition to paint the three *Joan of Arc* pictures, he found difficulty in finishing whatever he began. During the time he was painting *Joan of Arc*, especially in the winter of 1846, he became so obsessed with the task that he took to rising at five or six o'clock each morning in order to put in as many hours' work as possible. He was all this time reporting increasing affliction by attacks on his "trachea, bronchial tubes, and throat—with cough and asthmatic accompaniments" and also rheumatism.[21]

An entry in William Macready's diary[22] of 7th April 1846 tells a sorry story. "Went to Etty, who is very thin, very asthmatic—will not, I fear, last very long:" But he did last. In a letter of the 26th April he wrote to Mr. and Mrs. Bulmer in York that "These east winds and fogs wither

me, as I were a plant," and much aggravate his difficult breathing and coughs and as "last night almost [wore] me out, I with difficulty got home." Actually he had been *sent* home in a cab. Etty very seldom willingly used cabs. It was partly natural frugality and partly obstinacy. In this letter he looked forward to more congenial times and sunshine and in the summer he had his wish, visiting York as usual where he made final arrangements in the purchase of a house for his retirement.

In May 1847 he took an unusually early holiday in York in an attempt to recover from his winter illnesses. Since his last visit the previous year the Corporation had been busy "improving" the city. Feasegate was "a heap of rubbish" but his birthplace there still stood and he hoped it would be spared. It was, at least until after the end of the Second World War. As much as Etty might regret these changes, and certainly many of them were destructive, some work was necessary. Old York was a city of narrow streets with unsanitary houses. The "improvements" continued into 1848, mostly street widening. Gilchrist complained that most provincial cities embarked on street widening just when stagecoaches ceased to operate but it was not a matter of improving traffic conditions, the various councils wished to attract a superior middle class to live in the towns. Etty accepted what was happening with a heavy heart but he was more concerned in that holiday to visit the countryside around York. He went to Beverley and Hull, visiting his brother and his family, and to Pocklington and Givendale and Kirkham.

At Kirkham Etty visited the Abbey and described his time among the ruins in an undated letter to Betsy:

> ... beautiful though in ruins; the Nave nearly perfect, except the roof,—noble trees growing round it. A beautiful river runs by. Apple-trees blossom and shed their sweets, while bees are feeding on these. A sadly sweet and solemn sight. We heard not the choral anthem, nor the organ, but the wind sighing among the noble trees, and the distant railway shriek; that told the dread tale too true, that the days of the glory of God's house were passed away.

Etty was always lost in nostalgic longing whenever he visited a Gothic ruin and fancied the ghosts of monks at their devotions. This was more than a Romantic vision of the past but a genuine sense of loss of better times that had been swept away by intolerance and repression. He never seriously studied the times for whose return he longed but viewed everything through eyes misted with religious sentiment. In this case the experience was given a sadder tone by the sound of the nearby trains. The Modern Age was here to stay. After this visit Etty returned via Beverley and Hull "to see the folks." In Beverley he "visited dear Uncle's monument in the Churchyard, carved by himself." This was John Calverley, the joiner, his mother's other brother and very probably the father of "Mary" with whom Etty had fallen in love when a young man.

He also had the sad task of seeing a friend (unnamed) in Leeds whose wife had recently died leaving "four little motherless children," a task made all the more poignant by the youngest child's reaction to her mother's death. He heard "her little daughter's inquiries why Mother does not come back. When she is told she has gone to Heaven, she says, Why does she not write then?"[23] Death was a constant experience in those days when life expectancy was so short and Etty frequently alluded to his own eventual demise, not as something he feared but something he wished to delay so that he could complete yet one more painting. Incidentally, Leeds was not a city he enjoyed visiting because there were too many factories pouring out smoke, but he had much support there from the Northern Society for the Encouragement of the Fine Arts, who sometimes asked him to exhibit and to speak to them. The coach from Manchester to York passed through Leeds and he was always glad to be past the city, usually at night, with the prospect of clean countryside beyond. Spending time visiting old friends and old haunts may not have enlivened his spirits.

Brother Walter was now living in Scarborough where he had gone for his health. He was seventy-five years old, a creditable age for the time, and suffering from some physical debility

which made it impossible for him to travel. He had moved to Scarborough for the sea air and probably for the benefit of the spa (called locally "the spaw") whose waters were supposed to restore health. It is unlikely that Walter would actually have bathed in the sea, which was regarded by doctors as a universal remedy for almost every ailment afflicting the English.

While we notice in Etty during these last years an increasing melancholy there is no doubt that a contributory cause to his deterioration was the demand placed on him by dealers. As he himself said, they could sell all he could produce but they were unconcerned about restricting his work to serious collectors. They were commercial enterprises anxious to turn over pictures at a profit and, though they spared Etty a considerable amount of trouble in finding purchasers, they did not enhance his reputation among those who could still claim to be connoisseurs. There was also the nature of the new collectors who were entering the market. They no longer wanted large "history" subjects but small canvases that fitted the smaller rooms of their houses. They made no pretence to classical learning and an anonymous subject, a single figure or a group of nymphs suited them very well. Consequently we find Etty more and more painting "fancy pictures" of this kind. However, these must not be confused with earlier studies of single figures which were made to be incorporated into large compositions and which were released on to the market after Etty's death. More to the point was his move away from works that had a recognizable subject to what has been called "subjectless paintings." These were not only paintings of single figures but also of pairs or groups that might be given titles such as *Gather the Rose of Love*

While Yet 'Tis Time or *Venus and Her Doves* or *Nymph and Faun Dancing* or even his various paintings of *The Three Graces* which were no more than the figure presented in three different positions. Some of these paintings were produced at the request of his dealers and some, it must be said, to please Joseph Gillott. We can certainly say that his dealers, as useful they were, were not always a beneficial influence and the same might be said about Gillott. But equally it must be said that the dealers knew the market and they were in touch with the new middle class purchasers—they cannot be called collectors because many of them bought only one or two paintings. As much as there was a falling off in Etty's powers, there was also a falling off in the discernment of those who now chiefly comprised the market for art.

Gather the Rose of Love While Yet 'Tis Time (based on Robert Herrick's poem—"Gather ye rose-buds while ye may") (circular: 19.625 ins diameter) (1849), Birmingham Museums & Art Gallery.

Excursions and alarums

Etty was frequently asked by established collectors, and especially of Italian "Old Masters," to give an expert opinion of their worth. His renown was quite wide and the fact that he had been appointed to several committees made him something of an expert. We are fortunate to have in York City Reference Library a letter from such a collector written for such a purpose.

Early in 1847 Etty received a request from Sir William Worsley of Hovingham Hall in Yorkshire to advise him regarding the value of some paintings and drawings. The letter was written on the 16th February to Etty at Buckingham Street.

> Sir,
> You were kind enough to write to me in the year 1835 at the suggestion of Mr. Bonomi relative to my collection of ancient pictures here, which were collected about the middle of last century at a great expense by my God Father (the then Surveyor Genl. of the Board of Works & a great patron of the Arts) together with many hundred Original Drawings of most of the Old Masters from the collections of Sir P. Lely Snr and about 2000 ancient Prints & Etchings from & by them....
> The pictures are from the hands of Raphael, Guido, Guercino, Titian, Giorgione, Palma. Rubens, N. Poussin, Caravaggio, etc., etc., and are many of them of a suitable gallery size;—a great number of the drawings are I believe equally genuine, from Raphael & most of the other old painters, and it is the pictures and drawings that I should very much like you to see—and as traveling is now so expeditious that it would take you no more than 3 or 4 days to come here & return I venture to ask whether there wd. be any chance of your being able & willing to make such a trip. I know I have no claim to prefer the invitation & I should of course insist on paying your expenses. You could (by my carriage meeting you at Barton Hill Station close to Castle Howard) be here the same day you left London & by my sending you to the station you might be back the 3rd day in London. Should such a visit be compatible with your time & inclination it would give Lady Worsley & myself much pleasure to see you and if your avocations on the contrary do not permit you to leave Town at this season of the year I will at any rate venture to hope you will give me an hour or so some day in London to inspect the drawings, ...
> With all due apologies
> I am Sir
> Yr. Obt. Servt.
> Wm. Worsley
> P.S. Should you be unable to pay us a visit now I shall hope that we may have the pleasure of seeing you here some time in the summer when you may be down in York.

This letter not only confirms the high regard in which Etty was held as a connoisseur of the arts, it also indicates how relationships between patrons and artists had changed over the preceding century. This is not a letter from a member of the aristocracy or the gentry *expecting* compliance but one that actually begs the artist to spare a few days to visit him. Worsley does not go so far as to suggest that he would be honored by a visit from Etty but he does say that such a visit would "give Lady Worsley & myself much pleasure" and he admits that he has no right to expect compliance. Then he offers an alternative, possibly more suitable to Etty; that he will come to Etty in London if he prefers. This is not a letter that any of William Worsley's ancestors, nor indeed any member of the aristocracy of a former generation, would have written. The aristocracy of the eighteenth century would have made little distinction between an artist and a craftsman. They would never have apologized for asking an artist to call upon them and certainly would *never* have regarded themselves as an artist's "obedient servant." They would have been more likely to issue a command, or at least to phrase the request in such a way as to leave little opportunity for noncompliance. This letter is confirmation both of the artist's improved social status and of William Etty's personal standing.

Unfortunately we do not know the outcome of this invitation but can only assume that the visit was duly made, the advice duly given and suitable reimbursement duly paid.

This summer visit to York was the occasion when Etty renewed his acquaintance with George Hudson, "The Railway King." He told Betsy by letter on the 22nd September 1847:

I met Mr. Hudson on Tuesday. He, with his usual frankness and good feeling, instantly asked me down to Newby Hall. I could not go that day:—went yesterday. He took me by the rail eighteen miles, and then in his carriage and four. A fine old mansion house;—fine old oaks, by the river Swale. He brought me and Mr. Nicholson back this morning. Sir Robert Peel came through York at the time. The Lord Mayor introduced me to him. He shook hands with me cordially; seemed glad to see me. They cheered him much at the station.

Etty had no idea at all of what was going on in the matter of Hudson's handling of railway affairs but was completely taken in by his apparently honest nature. Of course, he enjoyed meeting the great and the famous, especially on equal terms, for this confirmed his own social status and his own achievements. A man who has reached the top of his chosen career from humble beginnings cannot be denied moments of self-satisfaction. Etty had gained his fame through wholly honest dealings and, being the man he was, was ready to believe that everyone else had done so likewise. The friendliness between Hudson and Etty can be explained not only by Etty's having painted the portrait of Hudson's wife but also by the distant relationship between them, which never seems to have been mentioned at the time but is now apparent. Hudson's wife's brother John Nicholson was Hudson's business associate and John Singleton of Givendale's wife Rebecca was John's sister. Etty's Uncle William's daughter Elizabeth had married John Singleton Clark and though the precise relationship is not known it is quite clear that a connection through marriages did exist between the families. The middle name Singleton suggests that a daughter of the Singleton family had married into the Clark family and the name had been retained. A member of this family (John Singleton Clark) had in turn married Elizabeth ("Kitty") Etty.

While in York that year Etty revisited Feasegate, the street of his birth, and was horrified to see how ruinous it had become. Learning of the current plans to "improve" the area, he wrote to the Corporation asking "as a boon" that they would "spare what remains of Feasegate, and with it, the House I was born in." But as Gilchrist records, "1848 was a year in which 'Street improvement,'—architectural jobbing, that is,—was very rampant" and the work went on regardless of Etty's pleas. York could not provide him with what he wanted and he was back again to London and the Academy Life Class for the winter. He went via Birmingham, where he called upon his friend and patron, Joseph Gillott in Edgbaston. Writing to Betsy of this visit he said[24]:

spent Wednesday there pleasantly. After breakfast, went to the Catholic College at Oscott, by invitation of the Bishop,—the festival of Corpus Christi: a grand ceremony;—high mass and processions. Stanfield and Herbert were there. We then dined. The Bishop showed us his curiosities in the Museum; splendid chalices, and vestments;—and was very kind. A gentleman,—Mr. Hardman, gave me a seat in his carriage to Birmingham; showed me the Convent, built by Pugin, and endowed by his father, for the Sisters of Mercy, whose avocation is to visit the poor, the sick, etc.,—the order, economy, ventilation, and cleanliness, admirable.

St. Mary's College at Oscott had been begun by Pugin in 1837 to house the school and seminary which had been established in 1794 and had moved to the site in 1834, occupying a new building designed in a Tudor style by the architect Joseph Potter. When Pugin was called in he gradually took over and began his first great work in medieval Gothic. This was to provide him with introductions to wealthy Roman Catholic patrons, including the sixteenth Earl of Shrewsbury. The influence of the Earl was of considerable importance to Pugin's career and he became known throughout the country as the foremost architect and designer in the Gothic manner and a major force in the century's Gothic Revival. Etty's friendship with Pugin was of considerable importance to the painter. Pugin had recorded meeting Etty, apparently for the first time, in his Diary on the 15th August 1837. There is a further note in the Diary for the 28th April 1839[25] that he had met Etty again and another on the 9th November 1841 that he "went to Mr. Etty's." At this time Etty had written to his friend John Harper that "Architecture, Painting, Music, Sculpture, all owe their second existence to the Catholic Faith."[26] Harper, himself an architect in York, had hoped to secure a commission from Pugin but Pugin's patron had other preferences.

On the 23rd May 1848, still in London, Etty experienced a shock which convinced him he was no longer strong enough in health to stay in London. He described everything to his friend Thomas Bodley in his own dramatic manner though, no doubt due to his desire to unburden himself as quickly as possible, his account lacked much of its usual embellishment.

> Buckingham Street Strand
> London
> Wednesday 24th May 1848
>
> To be Awakened my Dear Thomas from a pleasant dream to a frightful reality, is one of those star-tling situations in this changeful life (which passeth as a dream) that sometime occurs *and did so last night to me!*
>
> I had passed a pleasant day and after a tranquil and happy tea with my dear Betsy (whose dear com-pany, always dear, was renewed still more so by a recent absence of a week in Yorkshire) I had gone to bed about ten by twilight, and was sinking into dreams quietly, when Miss Etty and the servant burst into my room hurriedly and almost frantic with fear, told me of the awful fire which glared upon us in the most vivid light evidently close at hand, crackling, of Flame and volumes of fiery smoke & sparks, seemed on the other side of the wall. What is it? the wild ringing—it is the Straw Warehouse! I hurried on a few of my clothing, got on the adjoining roof to see! Such an awful sight as I never wish to see again, and I confess I expected that ere the morning light my own dear dwelling and works of art would be in ashes, fortunately the wind took the sparks the other way and we were saved, or oil warehouses, seed warehouses and Painting Rooms must have gone! After an hour's anxiety the praiseworthy exertions of people and fire-men got it under [*control*] and the moon rose in silent majesty on the scene! and the Market was saved!

Yet another fire! But they were very frequent in London and elsewhere in cities and Etty was really quite accustomed to them. But he proceeded to make the most of the experience and to recall his experience of "The Chartist Day" in July 1830 when troops were brought out to control the demonstrators and he had feared a riot. Etty was always fearful of "the Mob" and any kind of disturbance. He occasionally wrote letters to the newspapers deploring all kinds of lawbreaking and civil disobedience and urging the severest punishments for those responsible. In this case he concluded his letter to Thomas Bodley by comparing England and Europe and praising "His Good Providence" for the superiority of his native land, though why an acciden-tal fire should be regarded as a threat to civil peace is quite unclear. But Etty saw the protective hand of God in every event and just as he believed he had been saved by Divine intervention during the Paris riots in 1830 so even in a commonplace fire in London it was the Almighty who had decided that though other properties could be destroyed, his must be spared.

A reluctant departure

Etty had been hesitating over leaving London for over two years and many of his colleagues knew that he was planning to go to York if only he could make a final decision. Two years before, Turner, hearing that he was thinking of vacating his apartments in Buckingham Street, went along to see him. Etty recorded[27] that on the 3rd September 1846 he was just leaving his front door when he encountered Turner in the street.

> I made him turn back; as he was coming to see me. He had heard that I was going to establish a School in York! and wanted to know what apartments I had. I thought he meant in York. Not so! *here*. He liked my view; and seemed a little disappointed I was not going sooner. However, he was very good, drank a glass of wine; and, I believe, *sincerely* wished me well, wherever I went. Said he would be sorry.

Etty and Turner were quiet rivals despite their different subjects and painting styles. Turner would have envied Etty his view along the Thames and although he was living at Chelsea with an equally good view of the river, Buckingham Street was closer to the Academy and the exhi-bitions. But Etty did not dispose of the lease of the top floor rooms at Buckingham Street. He still owned them when he died, always wishing to keep a foothold in London.

On the 4th September 1847 during his summer visit to York he wrote to Betsy, who still remained in Buckingham Street, to tell her how he pleased he was with his house in Coney Street, although he had not moved in.

> I have got fires lighted; and sit looking at a very pretty view;—green fields, trees and rippling river. How I love it!—only want my dear Bairn here to enjoy it. Here are no steam-boats in sight. ... A place after my own heart. ... This is the place, and the only.

The next day he wrote to Betsy again.

> Have just returned from Minster Prayers, after a walk from Huntington.—a nice walk;—now and then stopping, and leaning over a gate, to see the cows chewing the cud. The sun is setting golden, shedding his parting beams in my chamber. The trees are gently moving. And all is peace. ... The Italians say, of a house or room, in which the sun never enters—there the physician must. This one is like a palace in the Sun. The morning and the evening sun peeps in.

On the 22nd September he again wrote to Betsy from his lodgings in Gillygate to tell her that he had visited the new house and that it surpassed all his expectations. He was particularly pleased with the bow window that James Atkinson had had built to his future painting room. The outbuildings and the garden also pleased him. He only regretted that it was not yet ready for their occupation though he had been sitting in his armchair in the painting room, looking up the river and wishing that she had been present. He stayed in York and this time with some reluctance returned to London. Winter in London meant the resumption of painting and regular evening attendances at the Life Class. He sent pictures to the Academy exhibition that year, including his *St. Joan* series, with one or two minor nude studies, some Biblical subjects and a single landscape. Gilchrist reported Daniel Maclise's rememberance of Etty making his last painting in the School from the model[28]:

> I saw him with pain, how more that usually distressed he was; when he arrived at the top of the staircase, labouring for breath. I sat near him while he was making his Study. And we talked in whispers together. It so happened that he spoke of his residence in Venice, where he spent exactly, he said, a year; and with a smile he added,—alluding to his copies and Studies from Titian,—"sucking the Sweets." He made on that very evening, a most splendid and glowing splash of colour, from the Figure, that quite rivalled the original before us, in all the splendour of lamp-light.

Etty exchanged studies with a student in the class—a customary kindness which the fortunate student always regarded as a great honor.

In December 1847 Etty resigned his seat on the Council of the Royal Academy. Slowly he was deciding that he had to go. In June 1848 he left the capital and came home to his birthplace, bringing all his possessions with him. He was as unwilling as ever to leave what he regarded as "the dear banks of the Thames," though why that river could appeal to anyone except as a wide vista is difficult to imagine. Its banks ands environs were filthy and one wonders how he could have ignored the stench that must have permeated Number 14 Buckingham Street. Although also a sewer, York's river Ouse must have been sweet by comparison. He was sad to leave Buckingham Street for it had been the scene of so many paintings prepared for so many successful exhibitions and satisfied patrons but soon he was settled in York, in his house on the river just behind St. Martin's Church in Coney Street. He claimed that it required forty packing cases—"some almost as big as a house" (an exaggeration, of course)—to convey all his possessions to his new home. "I have returned," he wrote from York on the 14th of June 1848, "bless God! With Fame, an unblemished reputation, and a fortune large enough, or small enough, for all my modest wants." He had achieved all he wanted, above all the fame which today is denied him. He had installed a painting room in his new house and here he hung his principal paintings including his copies of Titian and the other Italian Masters whom he revered. Betsy had returned with him and was living in Coney Street, continuing to act as his housekeeper. He

spent his first weeks just looking around the city and attending services at the Minster having no immediate ambitions other than to spend his life quietly. His father's old mill on The Mount had recently been demolished—another link with his childhood gone—but he managed to recover some of the timbers and to have furniture made from them. Writing to brother Walter on the 1st July he had apologized for not having visited him in Scarborough the previous week but it had rained too heavily for him to venture out of doors. Also he did not like the idea of another train journey.

> I confess I have a lurking desire to travel no more by rail-road than I can possibly help—as Sergeant Mirehouse the City Judge says—"I never get off a rail-road that I don't thank God!" I have the same feeling I confess—however silly it might be.

Etty's submissions to the Academy Exhibition that year were something of an anticlimax to a great career. "*Gather the Rose of Love While Yet 'Tis Time*"—a title taken from Robert Herrick's poem "Gather ye rose-buds while ye may"—was a slight thing of a young couple, he imploring her while she picks flowers from a shrub. It is circular in form, only just under twenty inches in diameter, now in Birmingham City Art Gallery but, according to a label on the back, had been "Painted by William Etty, R.A. for his friend James Coles, Esq., Aug. 1848." *The Crochet Worker*, also known as *Miss Mary Purdon* (i.e., "Kitty" Etty, brother John's daughter who had married Robert Purdon), was one of three versions, this one being painted especially for the 1849 Exhibition Another version had been painted for John Harper, Kitty being a great favorite in the family and among their friends. *Amoret Chained*, of which nothing is known, was exhibited together with a portrait of an unknown lady which had been painted in a previous year and brought out now to make up the number. Circumstances had been against him but, as ever, Etty had felt obligated to make his annual submissions as before. The closing of the Academy Summer Exhibition required a visit to London to supervise the packing and transport of his paintings. In September he returned to York and resumed painting but without any ambition to exhibit again, merely to pass his time in the only way that satisfied him. In London the female models employed by the Academy Life Classes were reported to be seriously upset by his departure. He was renowned for the respect with which he had always treated them, so much so that many were reduced to tears when they realized they would never see him again. It now became known that he had frequently assisted those who needed aid, either because of illness or irregular employment.

For his part, Etty soon missed his old haunts and companions. He needed his constant attendances at the Life Class. He needed to continue painting from the model. He was in due course able to introduce the use

A *Girl Reading* (14.5 × 12.75 ins) (c. 1847), York Museums Trust (York Art Gallery), YORAG91.

of male models in the York School of Design though not without some objection from those who feared for the students' morals. Etty was able to attend these classes but his principal subject had always been the female nude and this presented difficulties. He feared he would not be able to find anyone willing to pose for him and, if he did, that he would attract condemnation from the worthy citizens of York. The visit of Madame Warton to York with her theatrical *Poses Plastiques* provided him with at least one female model, Madame Warton herself, probably also one or two of her company. The appearance of this company in the theatre in York is surprising. Etty's old friend, John Harper, an amateur artist with whom Etty had sometimes gone on sketching trips, joined him in his painting room in Coney Street and tried his skill at painting the figure. We must assume that these models were probably either Madame Warton herself or one of her company who were used to modeling since it was most unusual for women unaccustomed to the task to agree to pose for more than one artist at a time. Gradually it became possible for models to be found more regularly so that he could continue his painting but it is unlikely that they were many and they were never made known. Gilchrist suggested[29] that "Other models followed," but does not say whether male or female, and that it was only due to a regular supply of models that Etty was able to settle in York. There would have been some young women so impoverished that they would been willing to undertake the work and presumably some of these were prostitutes willing to add a few shillings to their meager living.

At the York School of Design the women students were confined to painting still life and flower pieces. Etty attended these classes, giving the students advice—"paint from Nature." In the male classes subjects were more adventurous, drawing from casts and eventually from models. On the 13th December 1848 Etty wrote to Wethered, "We have made a start with the *Life* class here and have had Models of both sexes," but not, of course, *for* both sexes. He had arranged that he could bring his easel into the male class and there he continued to paint alongside the students without any concern for the differences in their status. Letters came to him from various admirers throughout the country, praising his work and asking advice so that they could better pursue their own amateur interest in painting. His frequent visits to the York School enabled him to take a close interest in its affairs. He provided some of the prizes for the students and at the end-of-year meeting in December 1848 he gave a speech. He always regarded it an honor to be asked to make a speech, not a natural accomplishment for so retiring a man.

Generally life in York was very much what would be expected for a famous painter retired from London. He visited old friends, though he drastically reduced his dinner engagements, as they tired him, took walks with Betsy along the banks of the river Ouse, especially New Walk which he had always enjoyed, and frequently attended services in the Minster. He visited the adjacent Printing Office of the *York Herald*, telling the printers of his own apprenticeship and engaging in reminiscences, leaving them "five shillings to drink his health." A surprise had awaited him in the *York Herald*. The head printer had also served his apprenticeship with Mr. Peck of the *Hull Packet*. Gilchrist records that all his life Etty had made his annual contribution to a Printers' Chapel, strangely so given how vehemently he had disliked his time as a printer. Perhaps he deemed it prudent to have a trade to fall back on in the event of need. The winter of 1848-49 in York was far more pleasant than the winters he had endured in London. "Little or no fog" he reported in a letter to his old friend, George Jones, Academician and Keeper, "which I like to escape. *You* have witnessed its effect on me." Even so, winter was the period of "cold dark days" and his continued difficulty with breathing did not allow him to accomplish much. He kept to his house where he maintained two comfortable rooms—"at a sort of Madeira climate"[30]—so that he could remain warm. Today with various forms of heating it is possible to keep a whole house warm but then it required fires in every room with the consequent work of carrying coals and ashes up and down stairs. In London he had experienced the dangers of moving from "stove-warmed rooms" in the Academy Schools to "a cold and damp journey home on foot." Now he remained at home but even so his coughs and breathing difficulties were still troublesome.

Etty comforted himself with the thought that all his family had lived to advanced years and that he should do likewise. But they had been country people, not exposed to treacherous London winters nor driven by his determination to go out night after night despite his asthma and tendency to bronchitis. There had also been a certain carefulness with money which did not assist his health. All his life he had insisted on walking when it would have been more prudent to have taken a hackney carriage. It was too late to remedy all his ills though he took more care than had been his custom.

George Jones wrote to him from the Academy late in 1848 telling him that "The Life School hardly looks right without you."[31] There were many instances relayed to him by friends that he was greatly missed, not only by his artist colleagues but by the staff and models of the Academy. *That* is a mark of a man's good character, that affection reaches out from everyone he meets.

CHAPTER EIGHTEEN

Who bought Etty's paintings?

It has already been indicated in the Introduction that the initial development of the arts in England depended, as elsewhere, on the patronage of a wealthy aristocracy. As a cultural phenomenon in English society, art cannot be said to have had any real existence before the Tudors and did not develop beyond simple decoration and become an essential element in society until the late seventeenth century. Its emergence coincided with the rise of the aristocracy as an influential force in its own right. This class, which hitherto had been subservient to the monarchy, now began to exercise independent political power. At the same time it expressed its own class *ethos* distinguishing it from the rest of society as a people fit to rule, indeed destined to rule, not only through its natural position as a class of great landowners and therefore originators and controllers of the nation's wealth, but also as a class privileged by a special education.

The aristocratic interest in education had not existed before the mid–sixteenth century. Then it became increasingly apparent that new opportunities were opening as foreign ambassadors, trusted emissaries and statesmen and that more than a merely noble presence was necessary. Education was already being provided by the two universities for those with ambitions in the Church or professions connected with the Church. In practice many graduates entered neither and some, such as Christopher Marlowe, eventually settled for the theatre, although it is likely he had had secret commissions abroad before sinking so low—as it would then have been perceived. Theology and the classics were the basic subjects taught at the universities and the sons of the aristocracy found themselves having to learn Latin and Greek, compile verses in the classical mode and become acquainted with ancient history and the myths. Not a necessarily useful education but the only one available and the one that made them acceptable in the society they were now inhabiting.

Most of the sons did not enter the world of diplomacy but carried on as their fathers had done, idling their time on their country estates and spending the rents on amusements. But, having for the most part received a classical, or pseudo-classical, education, those that thought about such matters, and not all did by any means, equated Good Taste with what they had absorbed as the proper attributes of men of property and influence. They had the money and they dominated the country. It was they who now decided what art was and what it should be. The artist-critic P. G. Hamerton (a man otherwise little known) wrote in 1871[1]:

> The simple truth is, that capital is the nurse and governess of the arts, not always a very wise or judicious nurse, but an exceedingly powerful one. And in the relation of money to art, the man who has money will rule the man who has the art, unless the artist has money enough to enable him to resist the money of the buyer.

Hamerton was writing principally about the century in which he lived but what he said was true for all times. We have seen in the preceding pages that artists frequently complained that they were treated as craftsmen, often no higher in status that carpenters or house painters,

regarded as contaminated by trade and therefore inevitably inferior. As early as the late seventeenth century John Evelyn was referring to artists, and especially engravers, as money-grubbers because they had to earn a living from their skill. He took particular care to withhold from them a new system of engraving he had discovered because he believed that they would use it to earn money. After the Restoration there began to develop the first signs of an art market in England. Works were imported from the continent to be sold like articles of furniture. Art as objects of trade was a new activity and many did not approve. English artists and engravers persuaded the government to forbid such imports as unfair competition but the changes in the nature of aristocratic households, particularly the building of large country mansions, needed an unhindered supply of artifacts. They constituted the art market and for the whole of the eighteenth century the aristocracy and the landed gentry controlled the art world throughout Europe.

At the beginning of the eighteenth century art was invariably produced on demand or, as is preferred to be said, it was commissioned, usually by a patron who was sufficiently well informed to know what he wanted before seeing the finished product, especially if he had been on the Grand Tour. If not directly commissioned, a work of art would be bought from an artist's studio but this also required the patron to have enough self-confidence in his own taste. This was still patronage in the accepted sense but it was moving towards the artist's producing for a general market. However assiduously arbiters of taste, such as those briefly considered in the Introduction, tried to educate the upper classes to make informed judgments of the arts, most of them never gained sufficient confidence and had to rely on advisers and increasingly on dealers to guide them in their purchases. Consequently a reinforcement of taste occurred whereby advice was given, especially by dealers who depended on a reliable market, that conformed to prevailing Good Taste, and Good Taste was confirmed as that which was generally approved. It was a self-pollinating system ensuring that change did not occur. But changes were occurring and principally in the methods by which works of art were bought and sold.

Etty was born as one world was languishing and another beginning to flourish. When he was growing up the old system of patronage by commission was still operating but by the time he was a student it was giving way to a new system of selling through exhibitions so that the market for art works was a mixture of private patronage and what might be called "commercial retailing." Exhibitions of work had been increasingly held by artists and, as has already been described, the Royal Academy provided a very necessary "shop window" for artists and patrons alike. As a boy wishing to become an artist Etty would have known only of art being bought by the gentry and that meant art of a traditional kind. It was an art of portraits and classical subjects. When he began to seek purchasers himself the old order was well on its way out. Although some patrons of the old school still ordered their art in advance, it was now increasingly unusual for anyone to do so. Instead of patron and artist negotiating before a work's was started, collector and artist negotiated afterwards, usually as a result of the work's having been first publicly exhibited. The chief exception was portraiture, for obvious reasons.

Although Etty was occasionally commissioned to paint something after the style of another picture he had already exhibited and sold, it was more usual for him to produce works for exhibition and sell from there. Public exhibitions were now well established as the accepted method of marketing art. The Royal Academy, the British Institution and the new provincial art societies mounted annual exhibitions of their members' work. Exhibitions were superior to the galleries owned by dealers since there was no pressure to purchase but they were shops nonetheless, and would-be collectors visited them to see what was on offer in the hope that something would attract. Visiting exhibitions was a means of extending one's knowledge of the arts and, as the art market changed, learning of the latest fashions. The institutions received the prices on behalf of the artist and took a commission and the artist was sure of his money. It was a secure system, a great improvement over previous arrangements when an artist might wait months and years for his money and might never be paid, being regarded by his patron as little better than his tailor.

The collector saw before he bought and was thereby certain to be satisfied. The system also brought other advantages. A work might not attract a private purchaser but dealers would buy whatever seemed to them to be marketable. They paid the artist, usually less than the original asking price, and they had the task of finding a buyer. Many traveled the country re-exhibiting their purchases, a process artists could not usually undertake though some did exhibit in the larger provincial centers.

Nonetheless some artists were so attractive to particular collectors that they frequently offered their work first to them and were usually sure of regular sales. In the final years of the eighteenth century the young Turner declared that he had "more commissions than he could execute." This usually meant that certain collectors would buy almost anything that he produced. Within ten years Walter Fawkes of Fawley Hall in Yorkshire had become his principal patron, so enthusiastic that Turner would arrive with a roll of watercolors and Fawkes would buy them all, virtually unseen. Generally, however, collectors preferred to see what was offered before they bought. Buying en masse was more usual later in the century after an artist had proved his worth, which meant that a collector could be sure not only of his current standing in the opinion of others but also that his works would resell at a profit. This became the customary procedure of dealers and soon this method of selling was much preferred by artists. Most complained of the unreasonable demands of private patrons, particularly of their expectations that an artist should be obsequious. It was so commonplace that William Thackeray, who had earned his living as an art critic, wrote in his novel Newcomes of 1854,[2]

> I have watched—Smee, Esq., R.A., flattering and fawning, and at the same time boasting and swaggering, poor fellow, in order to secure a sitter. ... I have seen poor Tomkins bowing a rich amateur through a private view, and noted the eager smile on Tomkins' face at the amateur's slightest joke, the sickly twinkle of hope in his eyes as Amateur stopped before his own picture.

Constable complained to his friend, C. R. Leslie,[3] "Still, it is a bad thing to refuse the 'Great.' They are always angered ... they have no other idea of a refusal than it is telling them to kiss your bottom."

An aristocratic patron required his protégé to produce just what he wished but in return he would introduce the artist to his friends, bestow special favors and offer personal advancements. Close relationships could be established but artists must never forget their social differences. Artists, like all those in the lower classes, had to be deferential. He remained a servant. Sir George Beaumont was well-known for his encouragement of young artists but equally well-known for advising them on correct behavior so that they would satisfy their aristocratic patrons. His letter of encouragement to David Wilkie[4] brought a suitably decorous reply from the artist who, at this early stage in his career and being himself of lowly birth, knew how much he depended on Sir George's patronage: "I am sensible of having a great deal to learn."[5]

Constable was always grateful to the Royal Academy for assuring artists a higher position in society than they had hitherto enjoyed. Whilst a few artists were determined to break away from the constraints placed upon them by aristocratic taste, the majority knew who buttered their bread and conformed to the wishes of the patrons on whom they depended. Few broke the rules as Richard Wilson had done by abusing patrons for their lack of artistic sensibility. By the end of the eighteenth century there was less direct patronage than there had been earlier, but whatever the relationship between artist and collector it remained patronage and artists had be careful. If an artist exhibiting at the Royal Academy Summer Exhibition did not display paintings that appealed to those with money, he did not sell. Of course, this still remains the case but today the purchasing public is not limited to the upper classes. Now there are no generally agreed limits to Good Taste and no longer a body of people acting as self-appointed arbiters accepted as well equipped to distinguish between good and bad art on whom collectors rely. It was not so in Etty's lifetime.

But all the time other changes were taking place which would eventually alter the art world forever. In river valleys in the north, buildings were being erected in which men and women who had previously worked at home on looms with their own hands, were now being gathered together to tend machines powered by water wheels. As the cotton trade with America increased more such buildings were erected and soon almost every valley had its mill. Then came the harnessing of the power of steam and, thanks to apparently unlimited supplies of coal, these buildings no longer had to be sited close to water supplies but could be built anywhere. Other forms of production were transferred into such buildings and soon northern England had factories as well as mills. These changes occurred in the north of England because coal was more plentiful there and Liverpool was the principal port engaged in the American trade. The industrial age had arrived. A new class of men totally unfamiliar to England, or indeed the rest of the world, had entered society. These were the world's future capitalists. A new economic system was being shaped.

These men soon accumulated considerable wealth. They built large houses with estates and, like the aristocrats who had done this a century before, they needed to furnish them in a manner that befitted their wealth. But they lacked the status in society that they believed they deserved. They were "in trade" and most of them were Dissenters. So far as the traditional gentry were concerned, they were social outcasts. But the newcomers knew, and openly declared, that "they were as good as anyone else" and they meant to prove it. They wanted respect. If they were as good as the gentry then they must demonstrate it by adopting the tastes and manners of the gentry. One way was through furnishing their houses with works of art.

Almost none of this entrepreneurial class had received a classical education. They were at a disadvantage when it came to acquiring works of art. They depended on the advice of those better informed than they were. They could, and did, go to dealers but, being themselves men of business, they knew how easy it was to be cheated. Some of them set out to acquire knowledge and visiting exhibitions was as good a method as any. They needed to simulate knowledge even though they did not have it. Some appointed agents, some relied on particular dealers but all could read the art criticisms in their newspapers. The rise of the art critics is wholly due to the needs of this new class. Having themselves absorbed the accepted opinions of the aristocracy the critics saw it as their duty to pass them on to those in need. Very few critics troubled themselves with the intellectual effort of re-examining the accepted opinions but, since many were often impoverished clergy or men who had failed to reach the positions expected of expensively educated sons, they sought to foster a taste for the classics but with strictures against what they and the class they were serving regarded as "improprieties." The new class were family men as the aristocrats had never been. What they bought had to please their wives and it had to be a good influence on their sons and daughters. It had to conform to the demands of their religion.

The early years of the nineteenth century were years of change, change in the nation's social and economic system, change in the operation of the market, which included the art market, and change in the very nature of art itself. It was a period requiring constant re-adjustment of men's attitudes. For a whole century those who regarded themselves as men of authority had lived with the belief that, after a previous century of disorder, the nation had settled down to comparative tranquility. Even today the eighteenth century is often still seen as the age of John Bull standing happily amid his fields, of stage coaches rattling merrily along surprisingly well made roads and happy laborers in well maintained cottages content with their lot. Of course, it never was so. The state of agriculture was economically disastrous, roads were seldom repaired and the rural poor lived in hovels. Factories and mills were already being built, towns were becoming over-crowded with the unemployed from the countryside, there was an increasing problem of widespread poverty and, with it, working class crime. England was on its way to becoming a predominantly urban nation and a new class of *nouveaux riches* was taking over.

The aristocracy had made their wealth from their country estates and many had put their money into "the Funds" and often, usually without their knowing, into financing the "triangular trade" of cotton, sugar and slaves. Now a new class was growing rich, with cotton and steel and also slaves, but the slavery of those they employed to work for fourteen to eighteen hours a day for a few shillings a week. They were building large family houses and often attending the London "season" and generally showing the aristocracy that they were people to be reckoned with. Good Taste gave way to Display. The culture of an aloof class was being superseded by that of persons who sought to mold society to their needs, not by writing treatises on aesthetics but by active engagement in all its activities. One feature stands out as the nineteenth century proceeds. This new class contained men with enormous civic pride. They built lavish town halls, chambers of commerce, libraries, chapels, institutions of all kinds. The aristocracy had never done any such thing because their society had not needed them. The municipalities controlled by the new class were fashioned to serve not only their needs but the needs of the inhabitants in general. True, very little seeped down to the lower classes but the middle class benefited enormously. It was mainly through public architecture that they revealed their taste. It proved to be an eclectic taste and one that informed their private art. The had not been schooled to conform. Their religious faith was nonconformist and so was their art.

As John Steegman said[6]:

> [The] Rule of Taste was established and sustained almost entirely by the oligarchic control of wealth and by the extent to which aristocratic requirements and standards influenced society as a whole. The Rule was showing signs of breaking down before the death of George IV in 1830, and during the reign of William IV it may be said to have collapsed. ...
>
> Whatever be the truth here about cause and effect, it is clearly evident that Taste, about the year 1830, underwent a change more violent than any it had undergone for a hundred and fifty years previously. The change was not merely one of direction. It lay rather in abandoning the signposts of authority for the fancies of the individual.

He went on to say[7]:

> It is hardly ever possible to assign definite dates to changes in taste. All that can be said here is that the standards that prevailed among collectors during the eighteenth century were still applicable in the 1820s; and that during the 1830s a very marked change took place. This change was the combining of patronage with collecting. It was no longer necessary to claim connoisseurship in the field of Old Masters in order to form a collection that should be highly esteemed even by quite exacting critics.

He continued "...this new phenomenon of the patron-collector was a result of the rise to power of the middle-class." Lady Eastlake, whose *Memoir* was published in 1870, looked back on the years 1830–1840 and commented on the "change which has proved of great importance to British art [which] dates from these years." It was, she said,[8] that patronage of the arts which hitherto "had been almost exclusively the privilege of the nobility and the higher gentry, was now shared (to be subsequently almost engrossed) by a wealthy and intelligent class, chiefly enriched by commerce and trade."

She went on to say that this change was of great advantage to the artist since the new class assembled collections "entirely of modern and sometimes only of living artists." No doubt Lady Eastlake, ever an astute observer of the art world, had been aware of this change as it was happening but the full consequences of it did not become apparent until later in the century. It was still going on when Lady Eastlake died in 1893. The changes which she noted have been symptomatic of European society throughout its history and brief references have been made to them in earlier chapters but they were of particular importance in the nineteenth century in England because they sprang from, and in turn encouraged, changes in the country's social structure such as had never before been seen.

In the nineteenth century England became a modern state, by which is meant that it became industrialized on an unprecedented scale and continued to industrialize at an ever increasing

rate. The chief consequence was the movement of whole populations from the country to the town. In 1800 about 20 per cent of the population lived in towns, in 1900 it was nearer 80 per cent. There was an enormous increase in poverty. Not that the laboring classes in the country-side had not been poor before but now those in the towns had no allotment gardens to feed themselves and no final recourse to an employer, or more usually his wife and daughters, who might well assist with charitable acts. The new wealthy became excessively rich and looked for more and more luxuries on which to spend their riches. Unlike many American entrepreneurs, very few remembered their roots or sought to use their wealth charitably. They were self-made men and they saw it as only right that they should reap what they had sown. Many of them were Dissenters following Calvinist principles that wealth was a sign that God looked approvingly upon them. Their debt to God was paid through building chapels. They wielded political power not through parliament but through local municipalities. Their entry into central government came a little later.

The first necessity of these men was to send their sons to the schools to which the aristocratic families sent theirs. These public schools, as they are erroneously known in England, continued to teach a curriculum based on the requirements of the universities together with the expectation that those pupils who did not proceed to university would enter the public service or the law. The universities provided the future prelates. Both systems required a great deal of time to be spent studying the classics, a fact of which the Rev. Sydney Smith was already complaining when he published his collected writings in 1839.[9] What they did not teach and resolutely refused to teach, was science. For the headmasters of these schools "science" meant "technology" and that meant working with one's hands. In fact, very few of the English entrepreneurs had actually worked in their own mills and factories (Birmingham was an exception). Their sons did not intend to either. But while their fathers went every day to manage their factories, the sons saw themselves as destined to rub shoulders with the landed families, acquiring their own estates and riding to hounds alongside the aristocracy. And so most of them did. Those sons who remained loyal to their fathers' enterprises studied science and engineering at the new Dissenters' colleges which their fathers, and often their grandfathers, had established.

But the industrialists were not the only new class to emerge. There were also the bankers and financiers of the City of London, the class to which, as we have seen, Etty's uncle belonged. The bankers and financiers were regarded as more acceptable since they were not engaged "in trade." But both the financiers and the industrialists had to be gentrified and soon there were so many of them with so much wealth, with such grand town and country houses and lands, that very quickly they constituted an altogether new class between the aristocracy and the middle class. These men and their families are usually regarded as a new middle class, or a new category of the middle class, but in truth they were neither. They never had been "middle class" as the term is understood today. They were a new class altogether, better described as "capitalists." Some moved up into the aristocracy as, later in the nineteenth century, they acquired titles, but most remained as a separate class of commercial magnates, the most powerful in society. A class so powerful that aristocratic sons and daughters were eventually glad to marry into it.

The country's political parties had to change to accommodate the new circumstances. As ever when politicians are in crisis, they forsook their principles and embraced any ideas that would keep them in power. But it must be said that the old Tory party was cautious. It was the Whigs who became the party of the free market that the industrialists needed. There was a North/South split with the Tories concentrating on the south and the Whigs finding a natural homeland in the north. In the second half of the nineteenth century the Tories established themselves in Birmingham. The preference of the Tories for traditional values of the English countryside satisfied Etty's natural support for everything traditional. As much as he came to depend on the patronage of the industrialists he loathed their factories. But what could he do? He needed to sell and they bought. He could find some crumbs of comfort in his situation. It

was because many of his new patrons realized their lack of an approved culture that they bought his works, just as some of them read the ancient writers and philosophers, a bridging of old and new values that Elizabeth Gaskell recognized in John Thornton in her novel *North and South*.

Gilchrist noted the changes afoot and recorded that Etty sold most of his work to what he called "the middle classes" and not, as he had originally expected, to the aristocracy and landed gentry. In his biography, writing of events in 1844, Gilchrist commented[10]:

> Etty had, in the course of his career, small cause to be grateful to the "higher circles" for patronage. Throughout, the buyers of his Pictures were nearly all of the Middle class: not fashionable collectors, who acquire a reputation for Taste by deputing to Dealers the formation of their splendid collections; nor aristocratic Dilletants [sic] who make "Patronage" their peculiar mission in life.

Matters were not quite so clear-cut as Gilchrist suggested. Etty *did* sell to the "higher circles," particularly in his early years, but, as time went on, his market changed. The new industrialists and financiers became his most important patrons but he was always selling to the professional classes such as the clergy and doctors, many of whom were, or became, his friends. Later Gilchrist referred to Etty's relying on the middle class, who employed dealers. Writing of the year 1844, he claimed[11] that Etty

> sold little henceforward to private hands; not even to personal friends—unless buyers of old standing. He preferred disposing of his works as they were painted, to a few dealers (and *quasi* dealers) in London and the Provinces.

Etty began selling through dealers well before 1844 because, as he said,[12] "I have half a dozen who will take all I can paint." He found dealers preferable because they saved him from negotiating prices, a task he always found distasteful and at which he was seldom successful. Even so, he continued to sell directly to his professional friends who knew what they and their wives liked.

It was a popular myth in Victorian times that the members of the entrepreneurial middle class had all risen from the poor. Certainly some did and it suited exponents of so-called "Victorian values" exemplifying the virtues of hard work for all of them to be "self-made men." "From rags to riches" became almost a popular slogan—taken up by Samuel Smiles in his books *Self-Help* (1859), *Character* (1871), *Thrift* (1875) and *Duty* (1880). Smiles presented the examples of self-made and self-educated men, especially engineers like George Stephenson whose *Life* he wrote in 1857. In *Self-Help* Smiles gave a short account of Etty's life to illustrate the value of self-discipline and determination to succeed. Smiles believed in "genius aided by industry," a description which Etty would no doubt have been pleased to have been applied to himself. Most "self-made men" had the benefit of patronage, someone with money to start them on their enterprises. This, Etty himself had had with the support of his uncle and, moreover, a standard of education which at least enabled him to appreciate the advantages of a cultural background which he knew he lacked. But it is incorrect that all mill owners and factory owners began as poor men with a keen eye for opportunities. Many, and especially those in the Manchester area, came from affluent families.

Building and equipping mills and large factories needed considerable capital. Some had had an education based on engineering and the sciences, this being the preference of the Dissenters and Puritans who believed it to be their life's purpose to improve the world about them. Such men were more inclined to hold out against acquiring works of art and pursuing similar cultural attributes, but, thanks to the education they had been given, their sons frequently did not follow their fathers' faiths. Many asserted an agnosticism born of distaste for Church and Dissent alike. Dianne Macleod has traced the social origins of many of these men and found that they varied between those operating in Manchester, Liverpool, Leeds and Birmingham, with those in Birmingham having more usually sprung directly from lowly origins. This was because, as we shall see, Birmingham was more directed to small workshops and factories which

did not require much initial capital, with employers being personally engaged in day to day production alongside small teams of workers. Many of these workshops flourished and expanded but they did not require the initial sizeable expenditure on large buildings and machines that was essential for cotton spinning. Manchester collectors were generally better educated and more inclined to regard familiarity with the arts as culturally necessary.

It was probably the fact that most of these men came from the Midlands and the North and spoke with local accents and used a more direct form of speech that condemned them in London society. When eventually these men accumulated sufficient money for them to feel no guilt in spending some of it on luxuries and leisure pursuits, many turned to art. It was also a contributory factor to the changes in fashions in art that a good proportion of these provincial entrepreneurs stayed in or near the towns of their upbringing. By not moving to London they felt no pressure to aspire to London tastes. It has been consistently noted in more recent years that the principal collectors of the Pre-Raphaelites lived in the north, with some in Birmingham. Lancashire provided the largest number of Pre-Raphaelite collectors. Of 144 prominent Victorian collectors listed by Dianne Macleod, 61 never resided in London. Of the others some moved to London only later in life. Many of the remainder were Londoners by birth but not all of these thought it necessary to acquire a fashionable address. The movement of these people and their different domiciles reflect their changes in social attitudes as they prospered.

A new art market was arising and artists had to respond. So it is relevant to ask, why did Etty continue to paint his mythologies and nude studies? Since the popular view of the Victorians is of a religious and censorious people who placed moral propriety very high in their standards of personal behavior, they do not seem likely to have approved the public exhibition of such works as Etty produced, far less purchasing them and bringing them into their homes. In general terms this is true. Although more visitors to exhibitions were registering their disapproval of his subjects there was an equal number applauding them. This was largely because more people were visiting exhibitions. The Academy moved from Pall Mall to Somerset House in 1779 because it was necessary to mount larger exhibitions and to cater for more visitors. It moved to Trafalgar Square in 1837 for the same reason and so again to Burlington House in 1869. But the attendances at exhibitions came chiefly from London and the Home Counties since coach travel was slow and uncomfortable. Some came from the Midlands, incorporating attendance into other metropolitan pleasures to which they had brought their families for a week's stay in London. Most northerners bought through dealers.

When Etty began seeking purchasers from about 1820 onwards, the new class of collectors of that time still thought it necessary to emulate aristocratic taste. Other subjects became preferred but Steegman believed that the collecting of Old Masters in England would have died out by the end of the eighteenth century through lack of supply had it not been for the releasing of so many works to the market by the Revolutionaries of French aristocratic collections. London dealers were quick to move in to assist both established and new collectors. Gustav Waagen writing in his *Works of Art and Artists in England*, published in 1838, listed forty-seven names of those who, he said, were the most distinguished collectors in England since 1792. Twenty-four of these were members of the aristocracy. Surprisingly Waagen's list excluded George IV, who was a great collector. However, by the time Waagen was writing he had to report that about one-third of these collections had been already dispersed either to public institutions or to private buyers, probably to meet debts. Debt became the principal reason why aristocratic families no longer collected and why they disposed of what they had. By the 1830s collecting was mainly in the hands of the new industrialists and many of them were buying from dealers who would have assured them that history painting was still fashionable.

The role of the dealers is of particular importance in the development of art collecting in England. Art dealing had first become popular through the auction rooms established in the eighteenth century in London. Early auctioneers had little or no knowledge of the arts and frequently

offered works purely by description without naming the artist, who was in any case often not known. Paintings were offered along with other objects as furnishings. Christopher Cock was active in the 1720s but soon gained a reputation of being untrustworthy. Another auctioneer, John Cock, who died in 1714, may have been related as may have been James Cock who conducted art auctions in Covent Garden. He joined forces with the Society of Artists in 1761, selling their exhibited works. Auctions were another method of selling, having the benefit to the vendors of encouraging competition. Some artists, such as William Hogarth, sold their own work by auction from their studios but in his case it was to control their disposal as well as to obtain the best prices. It enhances an artist's reputation if his work is collected by a renowned connoisseur. To this day many agents will not sell an artist's work to an unknown purchaser. There is, of course, a serious distinction between an agent and a dealer. The former is a comparatively recent addition to the operation of the art market.

The state of the art market in the early decades of the eighteenth century was so uncertain that artists were often forced to become small time dealers to augment their earnings. There was insufficient interest to provide a steady income for either activity separately. One who combined both roles was Arthur Pond, who began, after two years' study in Italy, to seek patronage and, being unsuccessful, began to deal in works of art from his own home in the late 1720s.

Auctions vied with exhibitions for attracting the wealthier members of society who aspired to establishing themselves as men and women of culture. At auctions they could learn which subjects were in general favor and the "going prices," which enabled them to make their own choices. The market for paintings was ever growing. Herrmann records[13] that "from about 1730 onwards it was the auction houses through whom the highest proportion of every form of work of art passed." After 1770 the number of picture dealers in London increased considerably and in one named dealer's sale rooms ("Goodall of Marsham Street, Westminster") there were more than a thousand pictures "lately consigned from abroad." All this was in addition to sales of sculpture, small bronzes and carvings, miniatures and drawings as well as the huge trade in prints and engravings where the dealers far outnumbered those specializing in paintings. London was the art capital of Europe.

Of the well known auctioneers it was John Sotheby (1740–1807), partner and nephew of Samuel Baker, who established in Covent Garden, London, in 1744, the first saleroom in the country for the exclusive sale of books, manuscripts and prints. The firm went through a number of changes of partnerships and titles until in 1815 Samuel Sotheby (1771–1842) took over the business and moved to Waterloo Street, Strand. The Sothebys were a Yorkshire family originally from Pocklington and Birdsall. James Christie (1730–1803) resigned a commission in the navy to take up employment as an auctioneer. In 1766 he opened his own auction rooms in Pall Mall, London, concentrating on works of art. There were already by that time some 60 other auction rooms. Christie later moved next door to Gainsborough. By the time of his death he was well known in London art circles and according to the *Dictionary of National Biography* was on friendly terms with Reynolds, Garrick, Gainsborough and other men of distinction.

Paul Colnaghi (1751–1833) was born in Milan and became an agent in Paris for the print dealer Giovanni Battista Torre, for whom he moved to London. The Colnaghis had been a wealthy Italian family but his father's heavy debts required Paul to earn his own living. He was soon known as a man of high intelligence and "unassailable integrity" on whom all could rely. He established his own art dealing business which passed to his sons Dominic and Martin but after a quarrel the business was continued by Dominic alone. Another "economic immigrant" was Rudolph Ackerman (1764–1834) who came to London from Germany as a coach-builder but soon opened a print shop in the Strand. In 1817 he established lithography in this country. He may have engaged in some art dealing but he is better known for publishing illustrated books. Several dealers, among them both Colnaghi and Agnew, established genuine friendships with their regular clients who could rely on them for advice.

Although men acting as dealers had been available for some time the real serious business of dealing, as distinct from conducting auction sales, began in London in the 1820s. The timing is significant. Anyone without knowledge of the market cannot confidently bid at an auction. The new collectors had to employ agents to do so. Now as the number of new collectors increased there was greater scope for dealers. John Allnutt was typical of the early type of art dealer. He had been a wine merchant and, being accustomed to buying and selling and using his judgment, he opened a commercial gallery in Pall Mall sometime before 1823. Another was Benjamin Windus, originally a carriage maker in Bishopsgate, London. He bought up all the works that he could by selected artists and then sold them on at a handsome profit, behavior that artists deplored since it reduced their work to mere commodities. Allnut held exhibitions for artists and sold works on commission, gaining the reputation of being a hard bargainer. In Allnutt and Windus we have the two main types of dealers. William Wethered, a tailor in Conduit Street, London, also turned to art dealing and bought from Etty, becoming one of his principal dealers and a friend. Others who turned dealers and bought from Etty were Thomas Rought and Henry Wallis. Some artists decided their fortunes would be better served by becoming dealers themselves. One such was Charles Wentworth Wass, a London engraver, who was among those who occasionally bought from Etty. But Etty's preferred dealer for many years was Richard Colls, who sold widely throughout the country. Colls also became a friend. Etty sold almost all his works for several years after 1830 through Colls.

These changes in the English art market worried many artists of the time. Etty had originally depended on exhibitions at the Royal Academy and the British Institution until changes in the market forced him to use dealers. Some years later, in 1850, Thomas Uwins, R.A., wrote to his friend John Townshend,[14]

> The dealers can no longer get a market for their Raphaels, Correggios and stuff, manufactured in their backshops, and smoked into the appearance of antiquity; to do any business at all, they must go to living painters, and the man they take up becomes popular.

Uwins (1782–1857) was the son of a bank clerk and had shown artistic tendencies at an early age. His father had put him as an apprentice to an engraver but he left before completing his time and entered the Royal Academy schools. He was a competent but not very adventurous artist, becoming an associate in 1833 and a full academician in 1838. He devoted himself single-mindedly to his art, traveling both in Britain and on the continent, and did not marry until 1851 when he was sixty-nine years of age. In his letter to Townshend, Uwins was condemning the fraudulent practices of many dealers who sold counterfeit paintings and notoriously smoked them to make them appear old. Hogarth had around 1759 produced a print exposing this practice. Uwins also regretted the passing of the old class of patrons. He particularly disliked all paintings of the nude figure. In the same letter to Townshend he said:

> The old nobility and land proprietors are gone out. Their place is supplied by railroad speculators, iron mine men, and grinders from Sheffield, etc., Liverpool and Manchester merchants and traders. This class of men are as much in the hands of dealers as the old black collectors were formerly. But they do not love darkness, and therefore will only deal with their contemporaries.

Uwins had personal reasons for regretting the passing of aristocratic patronage. Although elected to the Academy his career as an artist was not wholly successful. Now that genuine Old Masters were almost unobtainable in England, most reputed Old Masters that came on the market were copies and imitations. Originally these were made abroad but gradually the dealers employed minor English artists and students to produce copies which they "aged" by various devices—tobacco smoke was a favorite method. As discerning collectors became alerted to these "tricks of the trade" they moved over to buying works of contemporary English artists, often engaging reputable dealers to buy for them. Uwins had a low opinion of the new class of collectors and was particularly scathing in his dislike of Etty's paintings: Etty "was taken up by the

dealers and they can make a man's fortune.... The voluptuous character of Etty's works suits the degree of moral and mental intelligence of these people, and therefore his success![15]"

It was true that when a collector bought an Etty he was getting the best imitation of an Old Master that was available. He was also sure the painting was genuine. These buyers were self-made businessmen and they expected value for money. It was a philosophy that Etty understood and lived by. However it did not operate to Etty's advantage. He was not a wise bargainer and it is very apparent that many of his paintings were sold for less than their true current value. But Etty did not regard himself as a hack turning out *pastiche* work to satisfy an undiscerning market. He always painted primarily to please himself, though naturally always in the hope that he would find a purchaser. In this respect he was among the new class of artists in London. He exhibited each year at the Royal Academy and British Institution. It was preferable to find a purchaser through exhibitions since they were more usually men of discernment and this confirmed his faith in his abilities. We see this in a letter of 3rd May 1841 to Thomas Bodley.

"Joy steals upon me and calls forth a tear" as Eschylus [sic] says. My Dear Thomas Bodley and then says what I have frequently thought applies to you. "The glittering eye bespeaks the honest heart."

The Marquis of Landsdowne has bought my *Repentant Prodigal*. Mr. Vernon has bought my *Bathers Surprised by a Swan*. Mr. Knott has bought my *Still Life*. The Exhibition has opened with *éclat*—and these were sold last week. I take then this opportunity of telling you so knowing that it would please you, and my Pictures generally seem to please the *cognoscenti*—& Artists.

These sales had been satisfactory though small in value—two hundred and fifty guineas from the Marquis of Landsdowne, two hundred guineas from Mr. Vernon and thirty guineas from Mr. Knott. However Etty's work was not always favorably received in the provinces. Later, on June 21st, Etty recorded[16] a "diabolical injury" inflicted on *Bathers Surprised by a Swan* while on the Exhibition wall, inflicted he thought by some "Father of a Family" indicating his disapproval. Gilchrist reported[17] that in the following year Thomas Wright, of Upton Hall, near Newark, who bought *To Arms, to Arms, Ye Brave!* for £200, later became concerned about the extent of the "fair lady's" nudity, "almost to wish she had a little more covering"—and was disconcerted by its reception among his friends and family. "The ladies look grave" and "the men laugh!" Draperies were added in watercolor. This was a problem facing middle class collectors who introduced an Etty mythology into their homes. Having no separate gallery they had to hang the pictures in their domestic rooms and this caused embarrassment. Many of Etty's nude female subjects broke with convention by indicating, though very slightly, the presence of body hair. Even when over-painted with draperies these were often insufficient to obscure such details. Women particularly objected to these revelations. Studies of the role of women in the Victorian period frequently overlook their powerful influence in the home and in forming the moral *ethos* of the family. Though a painting bought through a dealer had the advantage that it came with an allegedly impartial recommendation and could be said to confirm the collector's taste, it still had to meet the approval of the women in the family. They generally preferred something sentimental and domestic.

Since one of the main functions of the Royal Academy and the British Institution and similar societies that had sprung up was to provide an annual exhibition as a showcase for the work of members, these events were attended by those seeking to purchase what appealed to their eye, as distinct from the patrons of former times who commissioned what they wanted. It took some time for the newly rich to feel sufficiently confident to make purchases direct from artists. The fact that a painting had been accepted for exhibition provided it with satisfactory credentials but most purchasers still needed the impartial advice (as they thought) of a dealer. *The Coral Finder*, though bought from Etty directly, had previously been exhibited in the 1820 Academy Exhibition. The purchaser, Thomas Tomkison, was pianoforte maker to the Prince Regent and we may assume that he was influenced in his taste by his own reliance on royal patronage. Francis Freeling, a senior public servant who was later knighted, who had also wanted this painting,

commissioned *Cleopatra's Arrival in Cilicia*. Though not itself purchased from an exhibition its commission was the consequence of an exhibition. Freeling was however a man of known taste who frequently bought exhibited works. The market was a mixture of patronage and exhibition, a stage in the gradual decline of patronage. Freeling also commissioned *Cupid and Psyche Descending*. In 1831 he purchased *Sabrina* direct from Etty for one hundred guineas.

Unfortunately we do not know the purchasers of Etty's earliest paintings and, in fact, do not know whether some of these paintings have survived. We do know, however, from their titles that many of them were of classical subjects which indicates at least an expectation that they would appeal to an aristocratic collector or someone anxious to acquire aristocratic tastes. Apart from portraits which were, of course, commissioned, Etty painted several genre subjects. Some of these have remained in the Etty family but most are apparently lost. It is not until 1819 that we can trace the purchaser of a particular painting by Etty. *Manlius Hurled from the Rock* was bought by George Franklin, who was probably the same George Franklin who became Etty's studio assistant. If so, this was a transaction activated by friendship. *Prometheus* (probably an incorrect title) which also appears to be a life study and painted in the early 1820s, did not sell until 1850, after Etty's death. What early collectors wanted were pictures with well defined subjects with more than a single figure. *Pandora Formed by Vulcan and Crowned by the Seasons* of 1820 was bought by Sir Thomas Lawrence for about 300 guineas which, although probably intended to encourage his former pupil, was clearly a genuine purchase at that price.

The Judgement of Paris, of 1826, was one painting actually commissioned. Lord Darnley was following the aristocratic tradition when, in the previous year, he had agreed to the subject and price in advance, stating his "conviction" that Etty possessed "power very superior to most of his competitors."[18] As has already been recorded, his Lordship was apparently not wholly satisfied with the finished work and despite favorable reviews did not pay the £500 that Etty expected. but only £400 and then in four installments and only after repeated applications. This was always the risk that any artist took when accepting commissions from the aristocracy. They were so accustomed to not paying their debts and of their creditors being too frightened of the consequences if they took legal action for recovery, that they treated artists as the tradesmen they regarded them to be. But times were changing and Etty was not to be denied. He pursued Darnley until only his Lordship's death relieved him of the obligation to pay the final £100. There is little doubt Darnley had a good bargain. In 1843 his heirs sold it to Andrew Fountaine for £1500.

In the 1820s Etty's patrons were still predominantly among the nobility. In 1828 the Marquis of Stafford paid 500 guineas for *The World Before the Flood*. At unknown dates but during these early years, Lord Lawrence of Kingsgate bought a *Venus and Cupid* and the second Earl of Normanton bought another painting of the same title. In 1827 Lord Northwick secured *The Parting of Hero and Leander* by exchanging it for a copy of Titian's *Ariadne on Naxos*, which Etty wanted. Northwick later sold *Hero and Leander* on to Joseph Need, M.P., for 150 guineas and in 1839 he paid £350, though £500 had been the original price, for *Pluto Carrying Off Proserpine*.

Perhaps surprisingly, Etty also had a few purchasers of his mythologies among the clergy, no doubt men who had received a classical education at Oxford. These purchases were made from 1835 onwards when private individuals with collecting aspirations but limited funds began to trust their taste and make purchases themselves, very often the only purchase they ever made. *Venus and Her Satellites*, now at York, was bought by the Rev. E. P. Owen in 1835 for "just under 300 guineas,"[19] this being, as Gilchrist reported,[20] less than the price asked. An oil study on millboard, *Woman at a Fountain*, was bought by the Rev. Alexander Dyce sometime between 1840 and 1845. In 1842 the Rev. Isaac Spencer commissioned *The Magdalen*, which though apparently a religious subject was in fact a nude figure of the penitent and probably originally just a nude female figure to which a religious title was appended to assist a sale. This became a popular subject. Etty painted several versions, so many that some can no longer be identified with original

purchasers. Many collectors, especially among the clergy, felt more comfortable with a nude subject if it was titled *Eve* or *Magdalen*. Less plausible was a reclining nude retitled *The Deluge*.

Alongside these patrons the wealthier middle class collectors were beginning to buy directly from artists, usually through the exhibitions. Dianne Macleod has made a very detailed study of the middle class art market in the nineteenth century and the author acknowledges his indebtedness to her work (see Bibliography). Other sources are Frank Herrmann (see Bibliography), the Catalogue in Dennis Farr's biography of Etty and also the *Dictionary of National Biography* as well as many purchasers recorded by Gilchrist. Several of the collectors who are considered below also bought through dealers but some preferred to buy directly from the artist after seeing a work exhibited. Many of these men were used to bargaining in the conduct of their businesses but others felt too inexperienced or uncomfortable when dealing with artists whom many still regarded as a different kind of people inhabiting a cultural world as yet unknown to them. We shall see how quickly many collectors learned that money opened every door. Even artists like Turner, who frequently raised his price as soon as he saw a collector was interested, could be brought to heel. Etty was a very poor bargainer and could be relied on to give way as soon as hard cash was placed before him.

There were a number of collectors who made either a single or an occasional purchase from Etty and who do not therefore feature in any list of notable patrons of his work. The following details of collectors are of those known to have acquired works by Etty at some time though not necessarily as initial purchases directly from the artist.

William Wells (1768–1847) was a partner in a London shipbuilding firm who had inherited money from his father. He lived originally in Chiselhurst but moved to Harley Street and then, having prudently sold his shipbuilding interests, moved to Penshurst in Kent where his family had established themselves as landed gentry. This is a typical story of Victorian *nouveaux riches* moving up the social ladder. His art collection was large and wide-ranging, extending from landscape to genre to mythologies and minor Old Masters, mostly Dutch and Flemish. Wells bought both directly from artists and also through dealers.

George Young (1798–1880s; exact date of death unknown) was a merchant in London who originally came from Scotland though his birthplace is unknown. He retired to Ryde, Isle of Wight, where he bought a mansion, Appleby Tower, about the year 1847. He was sometimes confused with a surgeon of the same name who also had an interest in painting but it was George Young the merchant who assembled a collection of works by Stanfield, Webster and Constable, and became a friend of Wilkie's from whom he acquired some early drawings. Young bought Etty's *Venus and Cupid Descending* apparently at the British Institution Exhibition in 1822. He was known for entertaining artists to dinner and enjoying conversing with them, having the reputation of treating them as equals, which previous patrons, especially aristocrats, would never do.

A similar collector was Wynne Ellis (1790–1875), a silk merchant referred to in the *Dictionary of National Biography* as Liberal Member of Parliament for Leicester between 1831 to 1834 and again from 1839 to 1847 and then as a Justice of the Peace for Hertfordshire and Kent. He left 402 paintings to the nation of which forty-four were selected for the National Gallery and also £50,000 to the trustees of the Simeon Fund. Ellis was enormously rich, his estate being valued at six million pounds at his death. His collection was mainly of Old Masters and contemporary English paintings although many were subsequently declared to be copies. He bought *Phaedria and Cymochles on the Idle Lake* directly from Etty for 100 guineas in 1832 (entered in Etty's "Cash Book" for the 30th August.)

The most important of all early Victorian collectors was Robert Vernon (1774–1849). He was fond of describing himself as from humble origins but in fact he was the son of a successful owner of a carriage rental business in London, the equivalent of a modern rental car firm. Robert Vernon continued his father's business. The *Dictionary of National Biography* states that

he amassed a large fortune as an army contractor supplying horses during the Napoleonic Wars. He was able to live in Berkeley Square and then in Grosvenor Place. In the 1830s he moved successively to Hampshire and Twickenham, then to Pall Mall and finally to Berkshire. He admired the Duke of Wellington and reputedly imitated his hero in dress and demeanor. He inherited a collection of minor Old Masters from his father. By the 1820s he was collecting contemporary English artists, spending what was then the enormous sum of £150,000 and, again according to the *Dictionary of National Biography*, between 1820 and 1847 he had collected some 200 works by living English masters as well as some by continental artists. All these, it is said, he bought without employing dealers, relying on his own judgment. But in his early years of collecting he often turned for advice to George Jones, Keeper of the Royal Academy from 1840 to 1851. Vernon was an early collector of Turner and, along with others such as Elhanan Bicknell and John Sheepshanks, his interest in contemporary artists helped to raise their prices and ensure them a livelihood. Among Etty's works that he owned were *Christ Appearing to Mary Magdalen, The Disciple*, a version of *The Magdalen, Candaleus Showing His Wife by Stealth to Gyges as She Goes to Bed, The Warrior Arming, Bathers Surprised by a Swan, Dangerous Playmate, The Duet, The Lute Player, The Persian, Window in Venice* and *Youth on the Prow and Pleasure at the Helm*. Vernon was generous in lending his paintings to exhibitions and intended to endow a school of art. He finally decided to donate 157 pictures from his collection of British art to the National Gallery but his hopes of being granted a knighthood in return were not realized. Vernon was not universally liked by artists. He adopted the traditional attitude of patronage, often addressing to artists criticisms of their work and requiring discounted prices. He objected to paying in guineas. In consequence he earned the reputation of still being a tradesman but he was such an extensive purchaser that his support was invaluable.

Vernon was not the only collector who tried to persuade artists to accept payment in pounds. Elhanan Bicknell (1788 to 1861) was the son of a serge manufacturer who had received a good education and had been friendly with John Wesley and other divines. Elhanan's father had established a school at Ponder's End in 1789 (later removed to Tooting Common) and Elhanan himself received his education at this school. It was apparently a school of some repute, one pupil going on to become Lord Chancellor. Elhanan eventually joined a firm that traded in sperm oil, then an essential lubricant for machinery before the discovery of modern oil deposits. He was a social reformer by instinct and although legislation to improve the welfare of seamen seriously affected the profits of ship owners he supported the movement and withdrew from the trade. In 1819 he had moved to Surrey and in 1838 began collecting modern British paintings. By 1850 Bicknell had acquired a magnificent collection of all the well-known British masters. He made a point of entertaining artists in his home and is reputed to have treated them generously. As a "modern man" he preferred transactions to be conducted in pounds sterling and wrote to Etty on 28th October 1845 complaining that he was expected to pay in guineas. He was a friend of John Ruskin's parents, with two of his children marrying into artists' families (*Dictionary of National Biography*). An undated letter in York Reference Library, but presumed to be 1846, invites Etty to dinner with two or three other R.A.s, including Turner. Dianne Macleod records[21] Bicknell as spending over £25,000 on his collection, a not inconsiderable sum for the time. The sale of his collection in 1863 attracted much interest.

Also a notable collector of this period was John Sheepshanks (1787–1863), though it is doubtful whether he bought much of Etty's work. It can certainly be said that Sheepshanks was sufficiently friendly with Etty as to suggest a degree of support. Only two works by Etty can be identified in his collection, *The Cardinal* and *Cupid Sheltering His Darling*. Sheepshanks was a typical northern businessman of the period. His father had been a wealthy clothing manufacturer in Leeds and until middle age he was a partner in his father's firm. He quickly developed an interest in collecting pictures, mostly Italian masters, but, apparently because the supply of authenticated works diminished, he turned to collecting British artists. In 1827 he left Leeds to

live in New Bond Street, London. Later he retired to Hastings, then to Brighton and finally back to London at Blackheath where he eventually died.

Sheepshanks never married, was a keen horticulturist, lived modestly and treated his servants with unusual generosity, though he appears to have had certain private interests unmentionable at the time. He commissioned Henry Hunt to paint pictures of young boys, though none of an improper nature, but his interest would doubtless be sufficient to bring him to the attention of the popular press today. Unlike Vernon, Sheepshanks had no desire to enter the ranks of the nobility. When, in 1857, he bequeathed his art collection of 233 paintings and 289 drawings to the South Kensington Museum (now the Victoria and Albert), he specified that his name should not be associated with it but insisted that the collection should be open on Sunday afternoons for working people to visit. However it was not until 1896 that this condition was first observed. The degree of Sheepshanks' association with Etty is not known but there is evidence that he invited Etty to stay with him on at least one occasion. Gilchrist mentions him only once, as purchasing *Cupid Sheltering His Darling*.[22] Robert Vernon, on the other hand, is referred to by Gilchrist five times.

There were many professional men who bought paintings to assemble small collections to satisfy their interest in the arts. Their patronage, though not large, taken together afforded artists with a living and a general acceptance in society. One such was Thomas Joseph Pettigrew (1791–1865), a surgeon and antiquary who became secretary of the Medical Society of London in 1811. He was sufficiently renowned to be appointed surgeon to the Duke and Duchess of Kent and in addition to publishing books on medical history he also contributed to archaeological journals. He was a typical educated and cultured professional man of his time. He included Samuel Taylor Coleridge, Samuel Rogers, Charles Eastlake, Michael Faraday and Etty among his friends and his circle was so highly regarded that John Taylor, the newspaper proprietor and editor (1757–1832), wrote in his *Poems on Various Subjects* (1827),

> At Pettigrew's no need of dice or cards
> Or any acts that human kind debase.
> There men of science, artists, wits and bards
> In social union dignify the place.

Another such was Francis Graham Moon (1796–1871), print-seller and publisher, who entertained all the notable writers and artists of his day. Turner, Stothard, Clarkson Stanfield, Wilkie, Landseer and Etty were among his regular visitors whose works he purchased. Moon became Lord Mayor of London in 1854 and was created baronet in 1855. There were many more notable people who supported artists with their entertainment and occasional purchases and Etty was among them but the absence of a systematic diary and of references to them in his letters make it very difficult to trace them all or to be sure that they made purchases.

By no means were all of Etty's paintings sold to London collectors. Both through the dealers and through his own practice of exhibiting in provincial institutions, Etty became known to the increasing number of collectors in the Midlands and the North. As early as 1819 he was the house guest in Liverpool of the Rev. Richard Bolton, who commissioned portraits of himself and his wife and their children. The Boltons emigrated to America in 1822 and the paintings are now in New York. Bolton's recommendations had some small effect among his friends but Liverpool did not figure among Etty's patrons until later. Since most midland and northern businessmen lived in their familiar surroundings it was necessary for art to go to them if sales were to be made. Although not among the wealthiest of the northern cities it was Leeds that was praised by the art critic William Carey (author of *Ridolfi's Critical Letters*) for being the first[23]

to form a Provincial Society, upon the patriotic principle of patronising the British School. Artists of England owe much to Leeds; and Leeds owes much to you; for, to my knowledge, you, your Brothers and another resident Gentleman [*i.e.*, *T. F. Billam*], eleven years ago, were the only Amateurs in its circle.

A prospectus was issued in 1808 announcing the formation of the Society with plans for an exhibition in the following year. This duly opened in April 1809, ran for two months and was regarded by everyone as exceeding the organizer's highest hopes. London artists submitted works to this and the two subsequent exhibitions until 1811, when for some unrecorded reason there was not another until 1822. After this, exhibitions were almost an annual event. Fawcett states[24] that "of all the provincial exhibitions, that of the Northern Society at Leeds had the best reputation for sales." Prices exceeding in total £1,000 were regularly paid during the three weeks of an exhibition. The fall of sales after 1830 is attributable to the economic depression of the times. Etty and Gilchrist give very little information about Leeds except his dislike of the place due to the number of its factories which filled the air with smoke at all times. Nevertheless he seems to have visited Leeds fairly frequently and it is known he was well regarded by the committee of the Northern Society who sometimes asked him to submit paintings for special events and occasionally to address them when he was in nearby York.

There were also occasional exhibitions in Bradford and Hull from the mid–1820s and we know that Etty also exhibited at some of these but he does not appear to have pinned much hope on sales that would increase his reputation.

Of all provincial cities, Manchester was the wealthiest in the early years of the century. That city's riches among its rising entrepreneurial class relied on cotton. It was the most culturally developed city in England, having seen the founding of the Literary and Philosophical Society in 1781, the Natural History Society in 1821, the Royal Manchester Institution in 1823, the Botanical Society in 1827, the Statistical Society in 1833, the Medical Society in 1834 and the Geological Society in 1838. Of these the Royal Manchester Institution played an important role in Etty's success in this city. Trevor Fawcett expresses surprise that it did not come into being much earlier, considering the town's intellectual record.[25] Manchester was also another place accused of being "engrossed by the spirit of commerce."

William Carey, in 1809, held out little hope that the arts would flourish in Manchester but when the Manchester Institution was founded in 1823 by Sir John Fleming Leicester (1762–1827), a Cheshire landowner with houses in London and Manchester, Carey was among those to lend support. Leicester held the conviction that the arts were important to man's fuller life. His father was a collector, particularly of Richard Wilson, who had ensured that his son received tuition in the arts. Leicester went on the Grand Tour, making his own sketches, and on his return decided to promote an English school of painting and sculpture. Originally he had canvassed a number of his fellow aristocratic collectors for support in founding an institution to promote the arts. Most declined to support him. For their class, art was for private pleasure and, along with the leading political figures of the day, they had no interest in making art available to ordinary citizens. To his credit Leicester persisted and raised support among the wealthier factory owners. Eventually in 1805 he and Sir Thomas Bernard founded the British Institution for the Encouragement of British Art. Fleming had other interests in music, ornithology, and politics, becoming a Member of Parliament from 1791 for various constituencies. He was a friend of the Prince Regent and at the age of 58 offered his services and became colonel of a cavalry regiment for home defense in the French Wars. Altogether he was a public spirited man of the type who regarded his privileged position as conferring social obligations.[26]

In the summer of 1823 three friends of Leicester went to Leeds to see how the Northern Society arranged their exhibitions. The Manchester Institution was formed after a public meeting in October that year but it was not until the spring of 1827 that it held its first exhibition with 74 artists showing 157 oils and eight pieces of sculpture. The following year an exhibition of 250 watercolors was held, mostly by local artists. Throughout the years the Institution's exhibitions were very successful.

Manchester also had the benefit of the dealers Thomas Agnew and Sons. Thomas Agnew (1794–1871) had been taken into partnership by the dealer Vittore Zanetti in September 1817

after serving seven years' apprenticeship with Zanetti. Zanetti himself had been an art dealer in Manchester since about 1797. He was not the first art dealer in Manchester but the firm he founded became the most important. In 1817 Zanetti was considering retirement and looking for a successor. The Agnews were originally a Scottish family from Wigtownshire and apparently of only modest means. Thomas Agnew was soon virtually running the business and in 1828 Zanetti bought property in Italy to which he eventually retired. By 1840 Agnew's occupied a most prestigious gallery in Exchange Street where customers were assured by the elegant decorations and polite deference of the salesmen that by purchasing a work of art they were achieving the status of persons of cultured refinement. All Manchester's intellectuals gathered there, sometimes to buy, sometimes to browse and often merely to meet in surroundings that confirmed their importance. Agnew's were the accepted arbiters of aesthetic taste. The firm's stock books begin in 1852 but it is known that Agnew's were buying Constables, Turners and Ettys before 1850,[27] though for how long before then is not known. Although Agnew's dealt in works by Etty their policy was directed more to promoting paintings with spiritual meaning and moral messages, more suited to the social consciences of Manchester liberal reformers. But they did not seek to initiate taste. They claimed that their contribution was to anticipate changes in taste and to accelerate those changes.[28]

Henry McConnell (1801–1871), partner in the cotton spinning firm of McConnell & Kennedy, was among the first Manchester businessmen to purchase works by Etty. Beginning collecting in the 1830s he bought directly from Turner, Wilkie, Landseer and Etty but later relied more on Agnew's. When he was interviewed on behalf of the *Art Journal* in 1839 he was declared to possess a "collection of modern art ... unrivalled out of London." McConnell did not come to the art market uninstructed. His father had been a leading figure in Manchester's cultural life, assisting in the founding of the Royal Manchester Institution. McConnell did not merely collect what was available but initiated new styles and subjects through commissions. He was not wholly typical of Manchester mill owners. He was one of the largest employers in Manchester, having some 1,500 workers, mostly women and children in his factory, but he can be reckoned as a good employer according to the standards of his time. When riots were threatened in the 1830s and 1840s in protest against rising unemployment and rising prices, he was one of a small group of mill owners who erected houses and schools for their workers. Their actions did not escape the censure of social reformers who accused them of undertaking only those improvements which would keep their workforce docile. This criticism was also made by other employers who accused him of disaffecting their employees. Alexis de Tocqueville, during a visit to Manchester in 1835, was not impressed by McConnell's philanthropy, heavily criticizing the conditions in his factory.[29]

Thomas Miller (1811–1865), partner in Horrocks, Miller & Co., cotton manufacturers of Preston, owned an extensive art collection at the time of his death, including works by Turner, Constable and Etty. His method of acquisition varied between direct commissions and purchases from artists as well as from Agnew's. Miller was another of those mill owners who responded to the dissatisfactions of employees by erecting houses and schools. John Pender (1815–1896), a cotton merchant but principally engaged in submarine telegraphy, became an extremely active political figure, being knighted in 1888 and made a baronet in 1892. A rich man, he collected extensively, including works by Etty. He mainly bought through Agnew's and Christie's but also commissioned directly from artists. His taste tended towards genre and landscapes but he seems to have been willing also to buy according to fashionable taste.

Etty achieved more recognition through the exhibitions of the Royal Manchester Institution where he sold to a variety of less wealthy collectors. When in 1835 he paid one of his frequent visits to the exhibition he was immediately recognized and made much of. He recounted that within five minutes of entering the room he had obtained a commission worth 100 guineas from Daniel Grant.[30] He was taken to visit a cotton mill where the machinery greatly impressed

him and he was also taken to see a railway engine. But he was glad to get back to "the pure clean air of dear Old York." Etty exhibited in Manchester again in 1837—this was the occasion which Gilchrist curiously records as disappointing though Etty expressed himself as well-pleased. Gilchrist describes how Grant brought Etty down from £300 for *The Sirens and Ulysses* by requiring him to include *Delilah* for the same figure.[31] Etty had less success in 1838 but in 1844 he took brother Charles, during his visit home from Java, to see his *Sirens and Ulysses* which Grant had presented to the Royal Manchester Institution in 1839. Charles was, fortunately, much impressed. In 1847 the Royal Manchester Institution wanted to buy his *St. Joan* series but was unable to raise the money, so many local businessmen having "lost their money in Railway bubbles."

It was in Manchester that Etty had the disagreement over the hanging of *Sirens and Ulysses*. In 1849 the Institution's exhibition was to be held in the room occupied by this painting. The Council of the Institution wished to move the painting to another room but in 1840, during an earlier visit to Manchester, Etty had asked that it should never again be moved, since it had suffered damage on numerous occasions from staff unused to handling paintings. Etty stuck to his demands and it required a personal visit to Manchester by his friend, Edward Harper, to settle the matter. By then Etty was too ill to travel.

Birmingham offered artists an entirely different kind of collector. As already mentioned, the cotton trade of Manchester and the wool trade of Yorkshire required entrepreneurs who already possessed sufficient capital to construct large mills and install machinery. In Birmingham manufacture was largely conducted through small workshops and thrifty men could accumulate sufficient capital to open their own businesses. Birmingham was not predominantly the realm of the ironmasters that Uwins deplored. Mostly it was concerned with producing small consumer goods for sale in the nation's shops. Employers were not usually distant task-masters but put in their day's work along with their employees. Contemporary commentators compared Birmingham favorably with Manchester, referring to the number of churches, schools, libraries and hospitals provided by the cooperative efforts of employers. Even so, the economic troubles of the 1830s struck Birmingham as hard as elsewhere with Chartist riots in 1839. Birmingham in the eighteenth century had seen such local luminaries as Matthew Boulton, James Watt, Joseph Priestley, Erasmus Darwin, Josiah Wedgwood, William Herschel, and Samuel Galton, many of whom were members of the Lunar Society where philosophical and scientific subjects were discussed. Birmingham was not a politically active city but in the 1830s meetings began to be held calling for parliamentary reform to extend representation to "the lower and middle classes of the people." This, in itself, is an indication of the more integrated nature of Birmingham society. In other parts of the country the classes were more distinctly separated.

Although art collecting was less common among the Birmingham businessmen than in Manchester, some local artists formed a Life Class (male models only) in 1809 and after five years established the Birmingham Academy of Arts.[32] An exhibition was held in 1814 with a number of London Royal Academicians participating, including West, Turner, Flaxman and Westmacott. Etty was not among them, not yet having been elected to the Academy. From the 118 exhibits shown only £40 was taken in admissions, a very modest amount which did not encourage the self-appointed committee. No further exhibitions were held. In 1821 the Birmingham Society of Arts was formed but it held no exhibitions until 1826 and then only after a petition by local artists which was at first rejected. The petition was repeated later in the same year and this time was successful. It was originally thought that the standard of local artists was insufficient to justify an exhibition but support from artists elsewhere in the Midlands and from London secured a surprising success. So successful indeed that the artists felt encouraged to complain that the Society's management committee consisted only of local businessmen and asked for representation. At the 1826 exhibition, 250 works were shown, the bulk coming from Birmingham and the Midlands but enough from London to justify hopes for the future. Receipts exceeded £300.

In 1828 it was decided to hold an exhibition of Old Masters. In protest local artists formed the Birmingham Institution for Promoting the Fine Arts, building at their own expense a specially commissioned exhibition hall. The Birmingham Society thereupon debarred all members of the Institution from again exhibiting with them. They were much concerned when the Institution's first exhibition attracted 141 oils, 82 watercolors and 19 pieces of sculpture from 101 contributors both local and from London and Manchester, Liverpool, Newcastle and elsewhere. The Society realized it had lost the day and sought to negotiate a union of the two bodies but its terms were too harsh. Eventually it was agreed to retain the name of the Society, to appoint two committees, one consisting of layman, the other of artists, with everything having to be agreed by both. Henceforth exhibitions were to be held triennially. The first one, in 1830, attracted 469 exhibits, apparently successful, but the two rival exhibitions in 1829 had attracted between them 862 exhibits, so clearly the new body had to do better.[33]

Among local connoisseurs Lord Northwick was a keen supporter of contemporary art and was, exceptionally for a member of his class at this time, very eager to promote English painters. Northwick acquired a painting from Etty, probably *The Parting of Hero and Leander*, in 1828 and in 1839 Etty visited Lord Northwick, who then purchased *Pluto and Proserpine*. Robert Huskisson's painting of *Lord Northwick's Picture Gallery at Thirlestaine House* at Cheltenham (c. 1846) reveals the varied nature of his interests. Lord Northwick had some influence over local collectors who were coming to the fore especially, as we shall see, on Joseph Gillott.

Charles Birch (known between 1825 and 1872) was a coalmine owner and ironmaster who seems to have made his way from rags to riches in the legendary manner of Victorian businessmen. His ancestry is uncertain, his date of birth unknown and how he began his collecting is also not known. By the 1840s he was well established in the cultural life of Birmingham and in the next decade had sufficient pictures of merit to lend to the *Exposition Universelle* in Paris in 1855. He had a picture gallery in his home at Metchley Abbey which he acquired sometime before 1842 and he was soon recognized as an art authority by others in the field. Birch owned a wide selection of contemporary works, including some by Constable, Turner and Etty. He was also a dealer. When he thought he had owned paintings, drawings or prints long enough for their value to have risen sufficiently he put them up for sale and bought others at lower prices. He published advertisements and produced illustrated catalogues and altogether went in for art dealing in a most accomplished manner. This practice he did not begin until the 1850s when speculation in art works began to take over from other forms of investment. By the end of the decade so many dealers were following his lead that he could no longer be sure of securing his prices. Birch understood the device of "buying in" when pictures did not sell, in order to keep prices high. But complaints were soon being made that works which had reputedly been sold in earlier sales suddenly reappeared at later sales and that his prices were "outrageous."[34]

Among other Birmingham collectors who acquired works by Etty was Edwin Bullock (known between 1830 and 1870), an ironmaster of unknown antecedents. He lived in Handsworth House, Handsworth, where he had a considerable collection which he began to assemble about 1830 when he first becomes known. He liked to entertain artists, and Etty, as well as other contemporaries such as Cox and Turner, often stayed with him. Bullock's collection began with Old Masters but as these proved ever more difficult to obtain he moved over to modern British work. He had paintings by Eastlake, Wilkie, Leslie, Pickersgill, Mulready, Roberts, Callcott, Clarkson Stanfield, Maclise, Bonnington and Collins as well as Etty. He was particularly fond of the paintings of David Cox, at one time owning more than 100 of his works. He gave many direct commissions but otherwise bought from exhibitions and from Christie. Among works by Etty that he purchased were *Hesperus* and *A Pirate Carrying Off a Captive*.

But the most valued of Etty's patrons in his later years was Joseph Gillott (1799–1872). Gillott began by casually collecting works by Etty and ended by becoming a very close friend on whom Etty relied for many of his final sales. Born in Sheffield, the son of a workman in the cutlery

trade, Gillott had moved to Birmingham, where eventually he established himself as a manufacturer of steel pens, which proved to be a very lucrative business. Gillott was an example of the man who rose from rags to riches beloved by the Victorians who extolled the virtues of hard work and enterprise. He was also an example of the very few successful men who regarded wealth as bestowing both the opportunity and the obligation to do good to others. These few, and they were few, did not question the *ethos* of the new industrial system they were creating but believed it was necessary to build a new social system that would bring well-being to all. Not equality of wealth but equality of opportunity and equality of happiness despite the differences in social status. They believed in class divisions as part of the natural order and when in due course Charles Darwin published his *Origin of the Species* they saw these divisions as evidence of the survival of the fittest. Their concept of the ideal society was a series of Garden Cities where working men and women had sufficient land, income and leisure to continue their rural crafts and indulge new found interests in the arts. Very few employers followed their example and the condition of working people deteriorated until a new class of reformers arose demanding parliamentary action.

Gillott became well known for his philanthropy and his considerate treatment of his employees. Having himself known poverty he had no wish to inflict it on others. "From his earliest years as an employer Gillott spared no cost or pains to benefit his workpeople to the utmost of his power" (*Dictionary of National Biography*). Gillott joined the few industrialists who practiced "paternal capitalism," men such as Josiah Wedgwood, Titus Salt and Robert Owen, by establishing good working conditions and founding a benevolent society for his employees and building a chapel and a school. Etty approved such self-made men and after they met in 1843 the two became firm friends.

According to Macleod[35] Gillott acquired a taste for paintings through his friendship with Charles Birch, who was also a manufacturer in Birmingham and a great lover of pictures. He possessed works by David Cox and Turner and Macleod believes that Gillott was anxious to learn from him his skill in manipulating the art market. Gillott was to prove an enthusiastic purchaser of Etty's work, mostly of his nude mythologies. He began buying works of art in 1845 and quickly made up for lost time. He quite openly based his first collections on Lord Northwick's taste. Gillott visited Northwick at Cheltenham and saw for himself the huge collection his Lordship had amassed. Northwick supported modern artists and, like many of Gillott's Birmingham contemporaries such as the ironmaster John Gibbons, he valued color, good brushwork and strong composition rather than subject matter. He was not interested in domestic narrative but, perhaps already, "art for art's sake."

Gillott was not educated in the arts but realized the importance of having a collection if he was to take his place in Birmingham society. He soon began to discern his own preferences for landscapes with a smooth paint surface and subtle luminosity. This has been described by Dianne Macleod as an "amateur taste" which also thrived among other Birmingham collectors.[36] In April 1845 Gillott bought from Etty "various Copies, Studies, and Works"[37] and on 1st November the same year he bought five studies. A week later Gillott paid on account for three paintings he had commissioned. By the end of 1845 Etty was referring to himself as a "partner" in Gillott & Company. This statement by Etty has led to much misunderstanding. There is no evidence that Etty actually became a partner and Farr thinks, as is most likely, this was a humorous reference to the amount of business passing between the two men. It seems that Gillott was never one to bargain over prices and it must have been very satisfying for Etty to obtain at last his asking prices without haggling, which he almost never enjoyed. Gillott's collection of paintings grew rapidly and when he died in 1873 they sold for £170,000. Etty never painted Gillott's portrait, his friend apparently not being interested in bequeathing his likeness to posterity.

Joseph Gillott provides us with a "case study" of the more usual type of collector among the industrial *nouveaux riches* on whom artists increasingly depended. Having begun life in poor circumstances in Sheffield he was determined, like so many others with the initiative to exploit opportunities, to rise in the world. When eventually he bought an estate in Edgbaston, Birmingham,

and built a house deliberately in imitation of one owned by Lord Calthorpe, whose family had originated the Edgbaston estate, he was declaring as publicly as he could not only that he had "arrived" but that he was as good as they were. Such attitudes among the rising industrialists reveal the social changes that were now occurring. They may not be able to join the aristocracy but they could at least join the ranks of the landed gentry. To the end Gillott was a shrewd businessman and, to his credit, always a good employer.

Gillott's appreciation of works of art appears to have been influenced by their monetary value. In this he was not unusual. These were all men whose end in life was to acquire wealth and aesthetic standards were confirmed by market value. If a work was of proper quality it would be desired by others and therefore its price would rise. These men owned little of small value. A work of art was not judged by aesthetic principles but by the amount of obvious skill and labor that had gone into its production. It had to look good. It was above everything else an object that others would desire and would pay much to acquire. Art was a commodity and the only test of its value was the market. Macleod relates[38] that Gillott frequently employed John du Jardin, a restorer, to "touch up" paintings before he resold them and quotes Catherine Coan that "an unflattering picture of Gillott emerges, as a man of fluctuating, if not fickle taste, who tomorrow for a new prize, would trade yesterday's trophy." Maybe so, but this was the new patronage that was asserting itself and, after all, had not eighteenth century collectors often behaved in the same way? Taste in art was often ephemeral; and is certainly so today. It is mainly only public galleries that retain works for their historic value.

Macleod also suggests[39] that it was possibly Gillott's secretary, Charles Hawker, who influenced his choice of paintings. Hawker had some local renown for his good taste. But others noted Gillott's personal ability to choose well, his concern for good brushwork and composition deciding his selections. It must be concluded that Gillott had a natural "good eye" and he learned quickly what his fellow collectors prized. As useful as Gillott was to Etty it could be said that his influence was not the best that an artist could wish to have. He was under obligation to produce so many paintings for his patron that it may be said that often there was a falling off in quality. Gilchrist reports Etty stating in the autumn of 1847[40] that he was hard pressed having 'nine paintings to complete, pack up, and take with him, to Mr. Gillott's,' on his way to York. True, a deterioration in quality had first been noticed in 1838 and by 1845 Etty was constantly suffering ill health but it could not have improved matters that he was now obliged to keep producing paintings virtually in the manner of a commercial workshop.

We need to retrace our steps to consider other centers of patronage. Liverpool provided another source of purchasers for Etty. Edward Morris and Emma Roberts have written and compiled a history of the *Liverpool Academy and Other Art Exhibitions in Liverpool 1774 to 1867*, to which reference has been made for the following account. In 1773 a small group of Liverpool collectors met to establish a society "for the Encouragement of Designing, Drawings, Paintings, etc."[41] William Roscoe (1753–1831) was originally a market-gardener, then an attorney, an historian and student of literature, Whig Member of Parliament for Liverpool, and finally partner and manager in a banking business but eventually declared bankrupt. He seems to have been active in all that interested an educated man of the time. Roscoe was passionately interested in the arts and in 1817 was the promoter and first president of the Liverpool Royal Institution. A society had been first established in 1783 but it does not appear to have lasted very long. After exhibitions in 1784 and 1787 it ceased to be active but in 1810 a group, with Roscoe acting as treasurer, established the Liverpool Academy and held the first of several annual exhibitions (*Dictionary of National Biography*). The Liverpool Royal Institution was formed from the ruins of these earlier attempts and assisted the Academy with exhibitions. Etty had early connections with the Academy and through its exhibitions was able to make sales to local collectors.

The eighteenth century art societies in that city were "primarily concerned with improving the technical skill and aesthetic education of their members, small groups of students, amateur

and professional artists." This was the usual origin of most art societies throughout the country. The failures of the societies were attributed to various causes. One view was that "arts and sciences are inimical to the spot, absorbed in the nautical vortex, the only pursuit of the inhabitants is Commerce."[42] By 1810 there appeared to be more interest and in 1814 a society "for promoting the increase and diffusion of Literature, Science and the Arts" was established on the model of the Royal Institution in London. It should be noted that it did not seek to imitate the Royal Academy, no doubt because its purposes were not confined to the fine arts. Its opening exhibition was surprisingly large, with 348 items submitted by an array of well known artists such as West, Turner, Stothard and Westall. For some years exhibitions continued to be of this standard and then between 1817 and 1820 the Academy lapsed and had to be restarted. It never recovered its first glory, it just managed to survive through the 1850s becoming increasingly in debt and in 1867 it closed, joining all the other Liverpool art societies which had closed over the years. In 1871 the Town Council financed and managed a successful Autumn Exhibition and a new era began. It seemed that the commentator reported above was correct. A critic writing in 1865 blamed the Academy itself.[43]

> The Academy in question was not an extremely active or noisy institution, even in its best days. No one knew, until the private view day, of what the collection would consist.... It was a lotos-eating sort of institution, and did not strive, or push, or bellow itself into the public favour.

The competing Liverpool Society of Fine Arts, launched in 1858, also attracted criticism.[44]

> There was a vulgar, flashy pretentiousness ... which was peculiarly repulsive. It somehow reminded us occasionally of a mock-auction shop; and occasionally, too, of one of that description of photographic institutions which may be seen in Paradise Street. ... No doubt there were good pictures sometimes in the Bold-street Institute; but the appearance of the place was such that they seemed to have got there by mistake.

Another view was that local taste preferred the new Pre-Raphaelites who were proving very popular in northern exhibitions because, critics maintained, the local industrialists had no understanding of art. This last critic blamed Ruskin for championing the Pre-Raphaelites.[45]

> Mr. Ruskin has committed great absurdities; but to prove a comprehension of true art it requires something more than a simple determination to oppose everything which comes from Mr. Ruskin. The Liverpool Academy regarded art too often with the eyes of pedants; but the Bold-street Institute treated it as it might be treated by Mosaic picture-brokers and Whitechapel auctioneers. [These final remarks were nothing but gratuitous anti–Semitism. It would have been sufficient to accuse the Institution exhibitions of looking like auction rooms.]

Edward Morris and Emma Roberts regard the Liverpool Academy as being "a provincial nursery of metropolitan talent." Artists unable to obtain recognition elsewhere would move to Liverpool purely to benefit from the opportunities offered. The same could be said of provincial societies elsewhere but Liverpool's exhibitions attracted entries from all over the country including London, such was the increasing need for artists to find purchasers among industrialists, bankers and merchants. Unfortunately there were insufficient of them. Etty exhibited in Liverpool, from 1812 until 1814 and then from 1838 until 1850, a total over the years of twenty-seven items. The subjects were varied, some domestic genre pieces in 1813, nude subjects in 1812, 1813 and 1838 and religious subjects and portraits in other years. The absence of nude subjects after 1838 may well have been due to the nature of their reception in earlier years. Although this city's real buying power in the arts was to emerge later in the century, along with Leeds and Newcastle, with the Pre-Raphaelites, there was a number of collectors before 1800, Fawcett lists seven, who were worth cultivating. Generally, however, the Liverpool merchants did not show much interest in the arts in the early part of the century. But one could say this of any city, both in the nineteenth century and in the twentieth. Throughout the country at the beginning of the nineteenth century the mercantile community was interested only in personal financial gain.

Among these collectors who purchased occasional paintings by Etty, sometimes directly, sometimes through exhibitions, was John Miller (1798–1876), a tobacco, cotton and timber merchant as well as ship-owner. He was born in Scotland but otherwise his origins are unknown. He became a partner in Miller, Houghton & Co., but when or how is not known. Art collecting was undertaken by the whole family including the husbands of his daughters. He bought directly from artists, gave commissions and also bought through Agnew's. He also went in for a little dealing himself, mainly by trading works with other collectors, among whom was Joseph Gillott. Inevitably one finds many such connections. The number of serious collectors was relatively small and they usually knew each other and mostly kept in contact. Joshua Dixon (1810–1885), a cotton merchant, was born in London though his father came from Whitehaven. Like Gillott, he was a "rags to riches" entrepreneur of Victorian legend. Dixon had had only one year's schooling in Leeds and then had to find work since his parents could no longer afford the fees. He and his brother emigrated to New York and then moved to New Orleans where they made rapid progress in the cotton trade. He returned to Liverpool where he soon achieved his place in local society. He occasionally employed the dealer Richard Colls and it was no doubt through him that Dixon acquired paintings by Etty.

Another Liverpool collector, Peter Stuart (1814–1888) traded with West Africa. His family had lived in Italy and he regularly returned there. He was closely concerned with the *Risorgimento,* assisting Italian political refugees to escape to America. His collection of works of art reflected his wide taste acquired through European travel. Stuart was interested in scientific theories of an unconventional kind, phrenology and homeopathy, which led him to collect casts of the heads of famous people in the hope of discovering common features in their skulls to account for their intellectual eminence.[46] Etty only occasionally visited Liverpool, usually when he also visited Manchester. In 1838 he personally sold *Somnolency* there for £45, an insulting sum especially when it is recalled that this painting sold for 205 guineas in 1851 to an Aberdeenshire collector. Etty had to accept that these businessmen knew how to drive hard bargains.

Edinburgh also offered Etty substantial support, which may appear surprising given its distance from London and its historical disdain for things English. The city had supported the Stuarts against Cromwell and still did against the Hanoverians. Its religious sympathies would not appear to have been favorable to Etty's subjects. But in the second half of the eighteenth century Edinburgh became the centre of the Scottish Enlightenment with such prominent figures as Henry Raeburn, Allan Ramsay, Robert Adam, David Hume and Adam Smith enriching an already flourishing Scottish culture, so much so that their influence was felt in London. The city's intellectual pre-eminence coupled with the rebuilding in that period earned Edinburgh the title "the Athens of the North." It was therefore not really surprising that a city newly devoted to classical ideals should welcome the work of Etty as promoting those principles.

The Scottish Academy was founded in Edinburgh in 1826 when it broke away from the Royal Scottish Institution, which had existed since 1819. The Institution had been accused of "oppressing and causing injustice to artists and injury to their profession" because of its preference for Old Masters. Although earlier, possibly because of the policy of the Institution, there were few local artists exhibiting, this soon changed. Edinburgh artists began to exhibit not only in local exhibitions but also in England. In 1827, for example, twenty Edinburgh artists showed forty-seven works in the annual exhibition of the Northumberland Institution in Newcastle. It was customary for artists to move their works from one exhibition to another, thereby widening their reputation and increasing the likelihood of sales. Edinburgh was distant from London and the conveyance of works by cart could take a week or more and subject paintings to risk of damage, which was quite commonplace, particularly if works were unloaded and reloaded several times and not always by the same carrier as they circulated the various towns. There were no specialist carriers and the carriers themselves were rough and ready, more used to handling sacks of agricultural produce or machines. Artists frequently had to travel to exhibitions to repair

works before they could be shown. Etty constantly experienced this problem and was always loath to use unfamiliar carriers.

Although the annual exhibitions of the Scottish Academy were successful—annual receipts from admissions and sales averaged just over £2,000—they had little to spare for acquiring works for permanent exhibition. Nevertheless it was soon interested in acquiring works by Etty. Its first attempt at acquisition—*Judith*—in 1827 was unsuccessful. When *Judith* was exhibited for a second time in the British Institution in 1828 the Scottish Academy applied to exhibit it but was refused as Etty was concerned that it would be damaged in transport. The Academy offered to purchase the painting if at the close of the exhibition it remained unsold. Etty's original price had been £500 but he offered it to the Academy for three hundred guineas, without the frame. This was the price to which he had reduced it for the Birmingham Society, who also could not afford it. By January 1829 the Scottish Academy had raised this sum and the painting moved into their hands where it remained until 1910 when it passed to the National Gallery of Scotland. Well pleased with their success, the Academy immediately commissioned the two companion paintings. In 1831 Etty sent *Benaiah* and *The Combat: Woman Pleading for the Vanquished* to the Scottish Academy's exhibition. The Academy purchased the former and the artist John Martin purchased the latter but sold it to the Academy when he found it was too large for his house.

For the Edinburgh exhibition Etty also borrowed three paintings from other owners. These sales were all that Etty was able to conclude in Edinburgh but he had established himself in the Scottish capital. Etty visited the city only twice. Coach journeys over such distances were too tiring for him. He went there in August 1831 as part of his tour of the north and visited the exhibition to see for the first time all three *Judith* paintings hanging together. He went again in October 1844, surely a bad time of the year for him to travel so far, this time to attend a dinner in his honor at which he made a speech. This was the occasion when brother Charles accompanied him, an opportunity for Etty to demonstrate that he was famous.

It was probably through the Scottish Academy that Etty attracted a small but useful patronage among the gentry in Scotland. In the first years of the nineteenth century exhibitions were held by local artists in various Scottish towns, Dumfries, Glasgow, Greenock and Aberdeen as well as just over the border in Carlisle. These would have encouraged an interest in art which would have been met to some extent by visits to Edinburgh. H. A. J. Munro of Novar House in Ross and Cromarty bought a total of ten paintings by Etty. Alex Kidson suggests that Munro bought from Charles T. Maud who, he considers, may have been Munro's agent. In 1845 Etty painted *Aurora and Zephyr* based on paintings by Titian and Stothard. It is a fancy work with much more spontaneity than is usual with Etty. Although not a common subject in art, Zephyr was a figure that was popular in ballet in the early nineteenth century. Munro commissioned a work from Etty to hang alongside a painting of Venice by Turner which he owned and it is possible that this is the work Etty produced. When it was exhibited by the Royal Academy in the summer of 1845 the *Literary Gazette* of 1845 praised it, comparing it favorably with the Turner landscape. The *Examiner* of 10th May 1845 decided that a distant view of the work was preferable since then its deficiencies would be less apparent. The *Observer*, which frequently deplored Etty's choice of subjects, decided in its issue of 10th May 1845 that of Etty's seven exhibits this painting was "the least objectionable on the score of coarseness of feeling." Nonetheless the *Observer* critic, never willing to praise Etty and ever ready to discover impropriety, was able to detect an "animal grossness of expression."

There were numerous small art societies throughout England, notably at Bath, Bristol, Southampton, Brighton, Norwich and Carlisle but Etty does not appear ever to have sent works for exhibition, probably rightly realizing that the appearance of his works in such places would neither enhance his reputation nor result in sales. The cost of transport would have fallen on him with no reward. Neither did Etty hold one-man exhibitions as did sometimes Turner and a few others. At this time one-man exhibitions—retrospectives—in the modern sense were extremely

rare. Etty was to be honored with one at the end of his career in London (to be considered later) but the public and the societies preferred mixed exhibitions. However, many artists kept some works on permanent display in their homes where prospective purchasers could view them. In 1824 there were recorded to be over seventy eminent artists in London who had paintings available to be "viewed at proper times, by a fee to the servant." Some provincial artists also did this. No artist could afford to wait for an annual exhibition at which he would be restricted to showing only a few works. Obviously Etty also had paintings available for inspection but it does not appear to have been conducted as a regular selling method. There are occasional references to purchasers' visiting him to view a work but it does not appear to have been usual. It was customary for a deceased artist in the provinces to have a retrospective exhibition—sometimes the local society would arrange this and provide rooms—but this was to provide the widow and family with some immediate income.

Bath having already been mentioned, it is worthwhile to note its position in the provincial art world. As might be expected the town's reputation attracted a large number of artists hoping to make a good living from the many visitors but, as was not expected, they did not flourish. Earlier in the century Gainsborough had found it necessary to move to London. Exhibitions were held in 1807 and 1808 but virtually nothing is known of the response to either. In March 1809 the Bath Institution for Promoting the Fine Arts was founded by the Duke of Beaufort and the Marquis of Bath as principal patrons. A committee of twelve was appointed but no member was an artist, though Benjamin West, as President of the Royal Academy, was made an honorary member. Exhibitions were held in 1809 and 1810, 290 works shown at the former and 216 at the latter. Although some works came from London most were by local artists but this did not mean that they were amateurs. Many of them had moved in from elsewhere. Few visitors were attracted to either exhibition and no more were arranged until 1836.[47] Why Bath was so unresponsive remains a mystery.

Those seeking to mount exhibitions in places around Bath also complained that no residents of that town ever showed any interest. This seems to have been the experience of most other local towns but Bath must need a special explanation. Those visiting the town were the aristocracy and the gentry, originally wealthy and affluent but now much less so, but many of the residents did very well out of them. It can only be assumed that the visitors did not come to take home souvenirs, just improved health. Many, of course, still came for the gaming and the opportunities for meeting a prospective wife or husband. The persons visiting Bath as described by Jane Austen do not appear to have been the kind to be interested in the arts—music and dancing, yes, but not paintings. The town gradually declined as the wealthier members of society began to travel more often abroad.

Bristol might be expected to have been another Liverpool. It had been an important seaport since the fifteenth century. In the seventeenth and eighteenth centuries it became England's foremost trading center importing tobacco and sugar and exporting a diversity of goods mostly of local manufacture. Bristol played a leading role in the African slave trade, ignoring the opposition of the Quakers and Methodists who concentrated there in their campaigns. There were plenty of the rich and the affluent living in Bristol and its environs. By the end of the eighteenth century Bristol was losing importance but was still nevertheless sufficiently flourishing to attract traders and investors. However Bristol citizens, like those in so many other towns, were renowned for their sole interest in money. The *Bristol Mercury* of 26th July 1824 complained of "the reproach to which Bristol has long been obnoxious, of apathy in elegant and refined pursuits." A minority of well educated men also complained that Bristol traders had a reputation for meanness and general disregard for the arts.

A group of enthusiastic amateurs and collectors decided in 1824 that Bristol should have its own Institution devoted to the arts and arranged an exhibition in a room specially designed for the purpose. Ninety-six Old Masters were exhibited but the response was inadequate and

not a single painting was sold. In the following year they tried again, this time more success-fully, with 700 visitors. In 1826 an exhibition of Bristol artists was arranged. This was not suc-cessful, so in 1827 it was Old Masters again. There was no exhibition in 1828, only Bristol artists in 1829, again nothing in 1830 and Old Masters in 1831. The policy of biennial exhibitions with Old Masters and local artists alternating did not prove sufficiently appealing despite free admis-sions. The *Bristol Mercury* of 25th February 1825 said they had intended to report on the exhi-bition of modern paintings but as it had excited little interest, with not a single picture being sold, they would leave it to others to "comment on the boasted liberality, the improved patron-age, and the growing taste of the citizens of Bristol."

Bristol was not the only provincial town to show no interest in the arts. This could be said of almost everywhere. All artists complained of the lack of interest wherever they lived. Only London and Liverpool, Manchester and Birmingham offered any hope of reasonable patronage. Etty was wise to concentrate on these towns and, in due course, Edinburgh.

Successful exhibitions did not only attract direct purchasers. Exhibitions attracted dealers and more often purchases were made by dealers who saw ready opportunities for buying at as low a price as possible and selling on at a high price. Exhibitors obtained a quick sale which many of them, being poor men, were eager to secure and they had some assurance that in due course their name would spread elsewhere. Etty was not dependent on such sales, having his own preferred dealers in London. Provincial dealers were less reliable. Dealers frequently prac-ticed other trades—engravers, print sellers, carvers and gilders, book-sellers, are all known to have entered the business. They usually attended any exhibition available much as modern deal-ers attend any house sale, just to pick up whatever caught their eye. Some of them published details of works for sale that included almost everything that would furnish a middle class house as well as appealing to a family's fancies. A representative but more honest dealer referred to by Trevor Fawcett[48] was Thomas Winstanley of Liverpool who traveled all over Lancashire picking up whatever he could. "People buy pictures," he said, "out of caprice, in the hope of making a profit, or because they have taste." But he cautioned that usually paintings were sold above their value and that many offered as Old Masters were fakes. His advice was to find a dealer of trust-worthy character and stay with him, as Etty did with Wethered and Colls.

Thomas Winstanley obviously enjoyed such a reputation. He acted for many well known collectors and for the Liverpool and Manchester Institutions. Other dealers have been mentioned elsewhere and it will be clear that untrustworthy dealers (whom Winstanley called "traffickers") were quickly recognized. Local dealers of good reputation were constantly worried by itinerant dealers just as reputable local auctioneers are today. Exhibitions by dealers of works for sale often prompted the formation of local art societies. The Glasgow Society founded in 1821 owed its origin to the assistance of the dealer Alexander Finlay. At other places successful exhibitions by dealers resulted in local societies not holding their own. Fawcett believes that the failure of the Birmingham Academy to hold another exhibition after 1814 was that the dealers Allen and Edward Everitt were providing exhibition space.

For the most part Etty's patrons resided in London or the Home Counties. Macleod lists ten principal collectors from this area but there were many more individuals who bought per-haps one painting to grace their homes. There were also a few such individuals living in more distant places. All of them visited London from time to time, usually with their families during "The Season," to take in the major events of the capital, including the exhibitions of the British Institution and the Royal Academy. It was here that they saw something that appealed to them and which they could afford. Alongside these occasional purchasers there was also a small band of devoted friends who from time to time bought works. Such small purchases by unknown col-lectors do not make an artist's reputation but they do confirm his general appeal.

Like all artists, Etty had to accept the changing art market. Although he did not depart from his preferred subjects he did recognize that his patrons no longer came from that class

which had large rooms and galleries at their disposal. He accepted the need to paint smaller works that could be hung alongside other paintings in domestic surroundings. He had also to recognize that his new patrons did not usually understand the ancient myths. Increasingly he painted "subjectless" pictures, reverting to single figures, either interior studio poses or "figures in landscapes." But they always had some fanciful title to suggest they were nymphs or of classical importance. He could not bring himself to paint just naked figures and, unlike Courbet, he could not paint country girls bathing in a stream and playing a game of being nymphs. He did not wholly accept the changes in taste that were occurring. He continued to rely on patrons with a preference for the female nude because they not only met his own desire to paint such subjects but were also in his eyes patrons with Good Taste, those who understood the true nature of the Classical tradition. Most fortunately the supply of such purchasers did not dry up completely and his most appreciative patron, Joseph Gillott, stayed with him to the end.

Chapter Nineteen

"A piece of egotism"

By the end of 1848 friends were becoming concerned that Etty was leaving no written record of his life and career. Most Royal Academicians have been anxious to leave at least "recollections" or diaries and many have published them, or their wives have done so after their deaths. Etty was showing no inclination to publish anything and, since he had no wife, there was no hope of a posthumous publication. If making speeches had always been difficult, writing memoirs was even more so. Etty was ever a modest man and he was not the kind to use memoirs to settle old scores, which is so common a practice now. Not that Etty had any old scores to settle. His relationships with all his colleagues had always been amiable.

A letter in York Reference Library dated 10th October 1848 from the *Art-Journal Office* at Marlborough Chambers, 49 Pall Mall, London, suggests that at least one member of Etty's family thought that his life should be recorded for posterity.

My dear Cousin,

There is to be a memoir of you in our Jany or Feby No. I believe it will be the former of the two months there will be therefore but little spare time to "get it up." I am commissioned to procure the foundation material in a letter from my Aunt. She says "I should [*two words illegible*] This memoir when written by Mr. Hall (or otherwise as the case may be) will be forwarded for your *perusal* and *approval* & should there be any matter not congenial or untrue such will be erased. Will you oblige me *again &* *again* my dear Cousin by giving me such particulars as are first of moment such as period of birth & the locality, the time of apprenticeship & to whom apprenticed, date of & circumstances attending early Study; *note* period of your Italian Tour, secondly [*word illegible*] of illustration—it will be too much to ask of you to do all this, let one of your nephews or nieces write to me. It gives me much heartfelt pleasure to hear the name of one of my kin so honored & so universally respected. May you enjoy many years of health n the country nay city wherein the remains of our ancestry reside & on the poor testimony of the love of your fellow men & their just appreciation of your qualities moral & intellectual.

You will be pleased to hear that I am progressing satisfactorily to myself & I trust equally so to others. My kind regards to àll who know me & blessing to those whom I should wish to know.
I am my dear Cousin
Yours very respectly [*sic*] & truly
John Clark
You were called in Italy *il diavolo*. You & I remember some little matters & the why *I know*. J.C.

The "Mr. Hall" referred to is Samuel Carter Hall the editor of the *Art Journal*. This letter is not referred to by either Gilchrist or Farr and both accept Etty's own statement that he had himself decided to write his *Autobiography* fearing that sooner or later someone would write his life story and "make it up by conjecture." There is no previous suggestion that a member of his family or the *Art Journal* had approached him or that a member of his family was employed by the *Journal*. The signature to this letter is not as clear as one would wish but there seems no reason to disbelieve that the signatory was indeed Etty's "cousin" John Clark though not Uncle William's son-in-law (Elizabeth Etty's husband). Elizabeth had married John Singleton Clark in

1797 and, assuming he was then in his early 20s, in 1848 he would have been at least 70 years old. Elizabeth and John had a son, also John, and the signatory is undoubtedly him. In which case the aunt referred to could well have been Martha Etty, i.e., Thomas Bodley's wife.

The post-script to Clark's letter suggests some secret between him and Etty, perhaps some reference that Etty did not wish to have made known. "Diavolo" was the nick-name given to Etty by the students of the Venice Academy due to the speed with which he painted. Somehow John Clark knew this. Only Etty could have made this fact known in England but whether directly to John Clark is beyond discovery. However, the guarded nature of the reference suggests a hidden secret and perhaps John Clark knew of Etty's life style in Venice. Perhaps there is a veiled threat here. What is of immediate interest to us is that Walter's daughter had married "John Singleton Clark" which suggests that he was the son of a female member of the Singleton family of Givendale whom Etty frequently visited and whom Gilchrist always described as "friends." It is apparent that the Singletons and the Ettys were related and that William Etty regarded them as more than friends. Throughout his adult life he had been closely attached to the Singletons. He had visited them in their home in Givendale in the East Riding of Yorkshire, just north of Pocklington, whenever possible and they had regularly sent gifts of pheasants to him in London.

Etty wrote to George Jones, the Keeper of the Royal Academy, "I have been induced to be guilty of a piece of egotism, I never intended. But thought I had better write what I knew to be the truth, than leave them to make it up by conjecture."

He wrote his *Autobiography* in the form of a letter to a "cousin," though which one is not clear. We must assume it was to John Clark. The "letter" is dated "York, November, 1848." Though sufficiently fluent with words, Etty was not by nature a literary man. Even Gilchrist[1] regarded his *Autobiography* "imperfect as a narrative" and incoherent, although "a vivid and graphic piece of writing." It bears all the marks of being written "straight out of his head" with no editing, as a letter would be. Much that we would like to know is omitted, a disproportionate amount of space is given to his time in Rome and Naples in 1822 and far too much to recounting a minor episode when he lost and found his sketch-book during the journey between those two cities. Etty also recounted at some length his reactions to the three-day uprising in Paris in July 1830. The *Autobiography* was duly published early in 1849 by *The Art Journal* in two installments (Volume XI, pages 13 and 37–40), sharing the pages, much to his embarrassment, with a Memoir of Sir Martin Shee who had become President of the Royal Academy after the death of Sir Thomas Lawrence. Ever modest, Etty thought it prudent to write to Sir Martin explaining how this had come about. "I found myself, to my surprise, in juxtaposition with a Memoir of *you*." He anxiously pointed out that he had not thought it sufficient merely to supply some "heads and points myself," leaving "the intervening parts to be filled up by one who knew nothing of me."

The general tone of the *Autobiography* is one of thanksgiving to God that he had been granted the opportunity to pursue his ambitions as a painter.

> ... my life has been, since I was free of bondage, and pursuing the retreating phantom of Fame, like the boy running after the rainbow; my life has been, I say, (with the exception of some dark thunderclouds of sorrow, disappointment and deprivation) one long summer's day; spent in exertions to excel, struggles with difficulty, sometimes Herculean exertions, both in mind and body; mixed with poetic day-dreams, and reveries, by imaginary enchanted streams. I have passed sweetly and pleasantly along, now chewing the cud of sweet and bitter fancies, and regretting my inability to do greater and better things; but God is good, and I desire in all my thoughts to give Him glory in the highest, that He has blest me and mine with a fair reputation and the solid comforts of life in a degree beyond my deserts.[2]

Etty had only warm words for everybody, which was typical of the man.

> And not only to my brethren the artists, but to all classes in that noblest of all European cities, London! my gratitude is due, from [*he surely meant "to"*] my generous patrons, to my respected tradesmen, my good, well-disposed and attentive models, and to others my best recollections are due and *cheerfully* paid.

He concluded with some advice to the new generation of artists—"amongst whom I well know are many amiable and promising young men." He urged them, using upper case text, to imprint on their minds

AN INVINCIBLE DESIRE TO EXCEL IN THEIR NOBLE ART; to be an honour to their country, a credit to their friends and themselves and THE FAITHFUL SERVANTS OF GOD. To be always attentive to His public worship, and *ordinances and strictly to respect His Sabbath of rest to the soul.*

The *Autobiography* is notable for the defense Etty made of his life-long interest in the nude figure which the Editor, as a supporter of such forms of art, was undoubtedly pleased to print. The important features of the *Autobiography* are not the details of his career, which are sparse, but the statement of his moral position. Always he asserted that the human body was the work of God and could not be sinful and that of all beings woman was the most beautiful and, if viewed correctly, the most pure.

A curious intervention

The year 1849 was a momentous one for the business community in England and particularly for many in York. In the preceding decade an opportunity for gaining exceptional financial gains had been introduced by the new railways which had spread across so much of the country. The principal figure behind these schemes had been George Hudson, known by all as "The Railway King," a man who hailed from York where he had been Lord Mayor, chairman of various railway companies and much else. Hudson's story is well known and the details of his life will not concern us, they have been fully recorded in Brian Bailey's biography.[3] The advent of the railways made many fortunes in the first ten years of their growth. This has often been likened to the famous "South Sea Bubble," not only because of the fast inflation of wealth followed by sudden collapse but also because of the dubious business methods that had been employed in the conduct of the railway companies' affairs. Our interest in George Hudson arises from a curious letter which Etty wrote to the *Yorkshire Gazette* in April, 1849, when Hudson was finally exposed for misleading investors. Etty had had only occasional encounters with Hudson, principally through Hudson's wife whose portrait he had painted in 1839, but he apparently felt bound to defend him, being satisfied that a man who had impressed him as honorable must truly be so.

There was also their hitherto unnoticed relationship that undoubtedly influenced him. George Hudson had been born in Howsham, a village between York and Malton on the 10th March 1800 and at an early age, in 1813, he had been taken on as an assistant in William Bell's draper's shop in College Street, York, probably by Bell himself, the precise date being unknown. Bell died at the end of 1813 leaving a widow, Rebecca, *née* Nicholson, who eventually married John Singleton of Great Givendale, often referred to as "Lord of the Manor." Singleton's first wife, Ann, had died in September 1811, aged 31 years, leaving him with a young family requiring a mother. Rebecca's brother Richard made George Hudson a partner in the York firm in February 1821 and on the 17th July of that year Hudson married Richard's sister, Elizabeth. She was five years older than he was and quite uneducated but the opportunity for advancement could not be resisted. What is of importance to us is that Rebecca and Elizabeth were sisters and therefore John Singleton and George Hudson were now brothers-in-law. As we have already seen, in 1797 Uncle William's daughter, Elizabeth, had married John Singleton Clark, obviously the son of a Singleton daughter though whether a daughter of our John Singleton is not known. The name "John" was a family name handed down through all first sons in the Singletons and it is not always clear which branch of the family is recorded in local parish registers which are tantalizingly sparse. Nevertheless there was a link between the Ettys, the Singletons, the Nicholsons and Hudson. Ever mindful of families "sticking together," Etty had felt obliged to defend

George Hudson even if his support was based only on one or two brief encounters and a relationship so distant that probably Hudson himself was unaware of it.

Etty was naturally drawn to fellow citizens of York who had risen above their lowly origins to achieve some fame and fortune in the greater world. Hudson was certainly a "poor boy who made good" but one as wholly different from Etty as it is possible to imagine. Two more different personalities could hardly have come together. Hudson very early displayed his natural gifts for seizing the right opportunities for advancement, relying on his own business acumen. He was forceful and ambitious and, it must be said, not always scrupulous in his dealings with others. He soon entered local politics with the Tories and became involved in establishing the York Union Bank. From this he progressed to being appointed treasurer of the company that proposed extending the Leeds and Selby railway to York. Thereafter his way ahead was clear. Local councilor, alderman, Lord Mayor of York, Member of Parliament and chairman of several railway companies all followed until the eventual discovery of financial misdemeanors, misrepresentation and even outright fraud with consequent public disgrace required him to live in France. Here he existed by cadging money from English travelers, being driven so far in his extremity as to waylay them as they embarked or disembarked at ports. It was in such a manner that Dickens once encountered him.

Hudson's position in London social's life was assured by the fact that he promised extraordinary financial gains to anyone who invested in his projects. At first he did not merely promise gains, he actually paid them, but as his enterprises extended he resorted to dubious and then illegal methods to keep the money flowing. The greed of investors was such that despite being exposed he was welcomed back when he promised further benefits. Although eventually he returned to England and with typical self-assurance stood for the parliamentary seat of Whitby, further arrest and imprisonment frustrated these ambitions to reassert himself in political life. After another period of hardship he again entered society in York but died suddenly in London on the 14th December 1871. By then he was no longer known to the general public, prompting *The Times* to comment that many would be surprised to learn that he had lived so long. Without doubt Hudson contributed to the economic development of the country, it might even be said that for a time he guided it. Certainly the invention and growth of railways were major factors in the success of the English industrial revolution and George Hudson was the archetypal entrepreneur.

Etty had little ability in money matters and seems to have been genuinely unconcerned to make a personal fortune, so he was fortunately not afflicted by the obsession to get rich quick which dominated so many of his contemporaries. Etty always disliked railways and he deplored the "railway mania" that was sweeping the country. He knew nothing of the tricks that were being employed to persuade people to invest in what were often non-existent shares. Hudson's principal method was to keep issuing shares and out of the proceeds to pay high dividends on previously issued shares without actually investing in new shares. To succeed this system required the constant supply of shareholders, a system of relying on perpetual expansion that dooms any enterprise to failure. Hudson subsequently claimed that his methods were not illegal. It was true that at the time there was no law forbidding the practice simply because there had been no reason hitherto to expect that it would be employed on such a scale. It was none-the-less dishonest and was, as a result of Hudson's operations, made illegal. Etty disliked railways largely for the reason that they represented the advance of industrialization. Why he allowed himself to have such personal contact with one of "the rogues," as he called them, is difficult to understand.

Etty probably first met George Hudson in 1839 when Mrs. Hudson wished to have her portrait painted now that she was Lady Mayoress of York but there is no record that the two men actually met on this occasion. Neither do we know whether they met in the following year when Hudson asked the shareholders of the Midland Railway to subscribe to a testimonial and the erection of a statue in Newcastle to George Stephenson. Etty was certainly not a shareholder

but Hudson had circulated a list inviting those whom he wished to subscribe, even including the amounts he thought they should give. Etty's name appeared and he subscribed five pounds, a large amount in the circumstances but he must have felt himself obliged to do so. Perhaps already both men were aware of their relationship. Their first recorded meeting was in September 1847 when Hudson invited Etty to Newby Hall where he was then living. Why he was invited is not known. It is likely that they already knew each other. Either Hudson wished to impress his other guests by parading notable people whom he knew, or he thought that Etty was a good example of local talent to grace the occasion or he was being courteous to a relation whose recognition would do him no harm. One always suspects Hudson of ulterior motives. At Newby Hall Etty met Sir Robert Peel and the whole occasion left a very satisfactory impression on him. Etty was not a vain man but he always enjoyed being recognized as an artist of reputation. He was also a man who valued friendships and was never able to discard friends or those who had been friendly towards him. He was ever unwilling to see ill in anyone.

When in 1849, Hudson's fraudulent share dealings were exposed, Etty did not join in the general condemnation. Being himself by nature a transparently honest man he could not be persuaded that Hudson was by nature dishonest. There must be mitigating circumstances. Etty was mindful that Hudson had been popular when everything had been going well, dividends increasing and the railways apparently ever expanding. He was not himself the kind of man to turn on someone when things went badly and he had no sympathy for those who, now matters had turned out to their disadvantage, were eager to vent their wrath upon him. No doubt Etty did not understand all that had happened, that it was not that "the market" was in depression (as it frequently was and ever has been) but that Hudson had deliberately misrepresented his financial dealings and had cheated his shareholders. At least, thought Etty, give the man a fair hearing. He went so far as to defend Hudson in the local York press, saying that "even if he were guilty ... he is still deserving of that Charity which thinketh no evil...." In the course of this long letter Etty said:

> I feel I should be safe were I to risk my existence on the honour and honesty of George Hudson. That he may not at *all* times have had that *amenity* which wins, I am willing to allow. He was made for carrying this mighty Change. ... And none but a man of his power and energy could have done it. But if I ever set eyes on a man—and I have some experience—whose manly port, physiognomy, and whole bearing characterised an *Honest man*,—man superior to all meanness,—it is George Hudson! a man I am proud to call my friend! because I know him to be kind-hearted, generous and public spirited to the last degree. I was only twice in my life in a Railway carriage with him. And on one of those occasions ... Mr. Hudson gave £400 or £500 to a Church at Darlington, for the Railwaymen, without hesitation.

By any standards this was a strange letter. By his own admission Etty had met Hudson only twice (so there *was* another occasion); how then could he claim him to be a friend? Hudson's generosity to charitable causes was not unusual but he generally allowed his gifts to be known. On one occasion he explained his late arrival at a meeting by explaining that he had had to retrace his steps to undo a wrong he had unintentionally done one of his employees. Perhaps significantly, he wanted his audience to know what he had done. Of course, Hudson was a mixture of good and bad, as many people are, but Etty seems to have had firsthand knowledge only of his occasional good points. Yet Hudson's bad character was being declared throughout the land at this time and Etty must have been aware of the weight of evidence against him.

Hudson had appointed his brother-in-law, Richard Nicholson, as Treasurer of the York, Newcastle and Berwick Railway Company, always wishing to reward relations and friends and to keep control through these personal contacts. While all was going well Nicholson enjoyed considerable wealth, so much so that by 1848 he had accumulated no fewer than sixty paintings by Etty, which pleased him enormously because it seemed that "his children"—as he always called them—had "come home." Nicholson was a man of considerable local status but suddenly the bottom fell out of his world. The news of his suicide was conveyed to Etty by letter from a Mr. John Russell

of Scarborough on May 20th 1849. Who Russell was we do not know but as he wrote from Scarborough he was presumably well known to Walter Etty. It is not a well written letter, full of grammatical and spelling mistakes, but it tells a sorry tale of a man who was overdrawn at the bank by £11,000 (equivalent probably to a million pounds today) and who also owed £20,000 for railway shares in respect of the York, Newcastle and Berwick Railway Company of which he was Treasurer. His debts were enormous. Nicholson was obviously an honorable man who had been misled and caught up in events beyond his control. According to Russell he had been seen late in the evening in a very distressed state on the banks of the River Ouse in York and had later been found drowned. A month later Etty wrote to Mrs. Bulmer, Nicholson being well known among a large number of affluent York citizens, expressing his extreme sorrow and recalling how "all seemed sunny at Clifton" when he had last called on his departed friend.

Nicholson disappears from our story except for the sale of his paintings at Christie's in July 1849. Etty attended the sale to see how things were going and was well pleased with the prices. He was reputed to "sell for more than Raphael!"[4] One is bound to ask, did Etty attend the sale to satisfy himself that Nicholson's heirs would be financially safeguarded or to satisfy himself that he was still selling well? Either way, all parties were reasonably satisfied.

Although Etty had felt constrained to support George Hudson and had reported of his kind treatment when they had met he did not approve of his development of the railway system. Etty's objections to railways were those of the traditionalists. Railways were part of the onward march of industry across the land. They introduced smoke and dirt into the country air and their stations, goods yards and other installations in towns were obnoxious. They bought up houses, farms and other property, often with unseemly pressure. To Etty the improved roads, though not always evident, and the network of coaches made railways unnecessary. Besides, to a traditionalist like Etty, coach travel was Romantic. But as much as he deplored the tactics of the railway promoters he obviously knew nothing of their frequent fraudulent behavior. Yet, though Etty always expressed his dislike of railways in the strongest terms, he was increasingly willing to use them, especially as he grew older and weaker in health. Two letters to his assistant, George Franklin, now in the York Art Gallery, confirm that he did use railways, if only occasionally. On the 25th September 1841 he wrote to Franklin from York asking him to be at Euston Station "on Tuesday Evening next, a little before seven—as we hope to arrive in London by the York train that night." Again on the 25th September 1848 he wrote to Franklin: "The train literally *flew* to York in 6 hours." This was from Euston station, that being then the London terminus for all north of England trains. Even Etty had to admit that six hours by train was preferable to traveling outside by coach for a whole day—or night, as he usually traveled. In his final years Etty seems to have resorted more and more to the railways. Etty's association with Hudson was wholly peripheral and fortuitous. Painting the portrait of the Lady Mayoress of York was a natural enough commission and if Etty had not written his letter appealing for what he regarded as "fair play" no one would have known he had ever met the man, and even then no one realized that they were distantly related.

Recognition by fellow artists

The year 1849 held another momentous event for Etty. The Society of Arts proposed to mount a retrospective exhibition of Etty's work to pay tribute to one whom they regarded as among the greatest artists of the age. The Society had held such an exhibition only once before, in the previous year, devoted to the paintings of William Mulready. Those who now despise Etty's work fail to understand his significance in his life-time. It may be that mid–nineteenth century English painting was not of the high standards of the Italian Renaissance but no art elsewhere was. Certainly it had taken the English a long time to accept art as a valuable feature of the national culture and there was a considerable contemporary objection to art, music, literature

or indeed any form of intellectual pleasure being seriously regarded as worthwhile interests, but royalty was a notable supporter of all the arts and many great names that have survived to us today were listed among the leading intellects of Europe. Not that that impressed the Puritans, Dissenters and Evangelicals. In the arts the country was divided but among those with social authority the arts were now accepted as essential signs of a nation's quality. Many regarded art not merely as a pleasurable pastime but as a means to elevate the human spirit. Reflecting Plato, though not necessarily aware of the fact, they claimed that constant contact with things of beauty would ennoble the soul. Art had a social and religious purpose and even the nude figure, properly regarded, demonstrated the glory of God.

As might be expected, Etty approved the Society's proposal. This was the ultimate recognition of his worth. He made it a condition that the exhibition should include what he regarded as his "Nine Great Works." One of these, *The Sirens and Ulysses,* was installed in Royal Manchester Institution and that body refused to release it. They quoted Etty's original fears of damage if ever the work was moved. He had to plead with the Institution to allow the work to go to London and to call on help from various influential friends to persuade them. Edward Harper went to Manchester, persuaded the Institution that they owed it to Etty to allow the work to be seen by a larger public and so won them over. The Royal Scottish Academy willingly loaned the five paintings in their possession but some private owners demurred. Altogether one hundred and thirty-three paintings were assembled in the Adelphi and, though the selection was generally representative, Dennis Farr has commented that nothing was exhibited for the years 1810 to 1819, an omission which went unexplained. Perhaps the omission was Etty's own decision, wishing only his more mature works to be chosen. The Exhibition was organized by Etty's friend and patron Henry Cole, who was later to assume control of the Schools of Art, and was presented as a tribute to the painter by both the Society and Cole. It is worth reminding ourselves that at this time Cole was just beginning to believe that the Schools needed reform and, it has to be admitted, there was need for a strong hand to take control. Etty could not know that Cole would eventually take them over completely.

Ever ready, as he himself admitted, to bask in his fame, Etty threw himself wholeheartedly into the arrangements and insisted that, if the exhibition was to be held, all available paintings should be shown, or at least, those within the years he felt did him justice. The proceeds from the sale of the catalogue were to be "in aid of the Formation of a National Gallery of British Art," the National Gallery in Trafalgar Square not being regarded as a British collection. During the course of the arrangements Etty declared,[5] "Prince Albert is coming, and we must get all the strength possible." Later, on the 7th June 1849, he wrote to his friend, the Rev. Isaac Spenser, "Very busy. We shall have a glorious show. ... I know you will be pleased. Please God I give them a taste of my quality." It was as though he knew this was the last exhibition of his work he would ever see.

The exhibition opened on Saturday 9th June and closed on 25th August. Etty attended everyday and sat there quietly pleased with the appreciative comments he received. Prince Albert attended and congratulated Etty though this was, perhaps, a formality due from the Prince as President of the Society. Etty was suitably pleased. "Prince Albert paid the Exhibition a visit yesterday," he recorded on the 15th June, "and paid me a high compliment from the chair." Gilchrist thought[6] the royal compliment "a faint one" and difficult to have escaped rendering adding, "By Royalty, Etty's Works were not visited," presumably meaning that the Queen did not attend. Gilchrist had never forgiven the Prince for rejecting Etty's fresco for the Garden Pavilion. On the whole the London press was lukewarm. *The Times* ignored it. *The Observer*[7] praised it and *The Morning Post,*[8] in a review of one and a half columns, was highly critical. In his account Gilchrist ignored the comments of the newspapers and reported that "the prevailing feeling was one of admiration." Things got off to a slow start and although later well attended the exhibition was not a financial success. By comparison Mulready's had been an outstanding success but

he was a genre painter and very popular with the public. Mounting an exhibition of mainly nude subjects was somewhat optimistic but Etty was still regarded as a major English artist and worthy of such recognition. In his *Biography* Gilchrist reported the exhibition in congratulatory terms. Writing of the Private View he said[9]—

> The one prevailing feeling was of admiration. None had seen an Exhibition to parallel it. For the Author of it, it proved a great day, unique in his life; a peaceful triumph, fit sequel to a career of unfaltering labour and aspiration. ... The old man sat quietly happy, surrounded by "his children".... He watched the progress of his ovation, received the congratulations of brother Artists and friends; himself content with his life's achievement.

Of the public reaction Gilchrist wrote[10]:

> Throughout the continuance of the Exhibition, spontaneous expressions of admiration and gratitude greeted Etty, from stranger and friend. Fellow-Artists were not backward in such demonstrations; though among the more pedantic of the "New School," depreciatory whispers may have been heard. Speaking generally, the younger Artists were stimulated:—those of his own standing, roused with candid recognition. Among other instances I may mention a Letter from Mr. Cockerell, the Architect,—of cordial congratulations, on the "good fight" the Painter had fought; rejoicing in his achievements;

Etty had the idea that an English translation of Homer's *Sirens' Song* should be set to music and be played in the room in which his *Sirens and Ulysses* was hanging. This was tried during the exhibition but does not appear to have been successful. It was at least an attempt to combine the arts and demonstrate their interdependence. Perhaps this was far too advanced for the time. A few months later Sir Charles Eastlake wrote to Etty approving of the experiment.

Gilchrist, himself a published critic at the time, wrote an anonymous essay in the September 1849 issue of the *Eclectic Review* praising the exhibition. It was on the strength of this that he was later engaged to write his *Life of William Etty R.A.* Otherwise he does not appear to have been known to Etty or to have featured in his life at any stage. Gilchrist's praise of Etty in his article was fulsome. "Few painters, ancient or modern, would form a more imposing or splendid manifestation, in their collective works, than William Etty." He goes on to admit that Etty's works displayed many shortcomings—"a more varied and dramatic range" could have been desired as well as "a fuller realization of essential creative power, or more exalted manner of feeling, ... a fuller manifestation of depth and truth of expression" but despite these criticisms Gilchrist regarded Etty as the next greatest painter after Titian "with the other great Venetians" and Rubens. He necessarily had to deal with the common objection that Etty painted the nude form, especially the female form, but here he blamed those who registered these objections for their "unhealthiness of feeling" and "deficiency of culture." For him "Etty is a *poet*" and a very great one. His article ran to twelve pages and concluded, "There is no man of whom the English school has greater reason to be proud, than William Etty."

The Art Journal[11] most exceptionally gave a whole page to a review of the exhibition. Their critic wrote:

> In no country and at no period, could such a glorious mass of pictures be assembled together. ... If Mr. Etty, when the hanging was completed, and he looked around on the labour of his own hands and the inspiration of his genius, did not feel a proud man, he must be utterly insensible to this weakness of human nature; at any rate, his countrymen ought to be proud of him, and to pay him that homage which greatness of intellect has a right to claim from others.
>
> The two grand qualifications of Mr. Etty's style are poetical conception and colour; in these he has never been surpassed by any other painter, ancient or modern....
>
> We might devote pages of our Journal to a notice of this exhibition, without exhausting the subject, so high is our opinion of the matter it contains. That the claims of Mr. Etty to the highest position in the annals of Art have been underrated, what we now see collectively forces us to admit.

The writer went on to regret that the general public has neglected Etty's work because of its subject. "Puerile and fastidious criticism has detected nothing in his works but that which is

sensual and objectionable." Later in the article the writer expresses his certainty that one day Etty's greatness will be generally recognized. "The hour of Mr. Etty's final triumph over prejudice and narrowness of mind is yet to come, but it assuredly is not far off." All this was high praise indeed and cynics may wish to remember that a family relation worked in the offices of the *Art Journal* but this would be an injustice to the proprietor Samuel Carter Hall who had always supported Etty and especially his insistence on the nude figure.

Although the exhibition may not have afforded Etty the public endorsement that he would have wished, it did guarantee him the support and appreciation of his peers. He regarded the exhibition as the successful culmination of a life dedicated to art and the personal triumph of a boy from humble origins who had reached the pinnacle of fame. His only regret, expressed to his friend and fellow Academician, Daniel Maclise, was that so many works were missing. He had hoped the public would see at least "as many more." Later Maclise was to write[12]:

> The last time I saw Etty he was sitting in the centre of his pictures in the Society of Arts' rooms. He confessed some complacency in finding himself surrounded by his Works, and receiving such friendly congratulations; but expressed his regret that some of his finest were not there; and said there were as many more would fill a room.

C. R. Leslie, a great admirer of Etty as a man and accomplished artist, though not always of his subjects, wrote in his *Autobiographical Recollections*[13]:

> *June 9th, 1849:*—Today I had the gratification of seeing the principal works of my old friend and fellow-student, William Etty, collected in the great room of the Society of Arts, in the Adelphi.
>
> Etty was in the room, and on my saying that I was delighted to see him so surrounded, he said, "by my children." I might have congratulated him on having so large and fine a family of daughters. There can be no doubt but that to these daughters, and to the unreserved manner in which their charms are displayed, much of his popularity may be attributed....
>
> ... The impression made on me by this exhibition, and which, from all I heard in the room, was the general impression of my brother painters, was that the pictures that had pleased formerly, now pleased still more, and those we had least liked gained on us.

Whatever the press said, there is little doubt that Etty's contemporaries and colleagues were well pleased. The appreciation of a fellow artist is always more valuable than that of the public and far more worthwhile than that of professional critics who, for the most part, are more anxious to impress their fellow critics and their editors. Sir Charles Eastlake, himself a very capable artist and future President of the Royal Academy, told Etty later that he was very sorry when the exhibition closed because he had greatly wished to visit it again.

Etty had planned to visit Thomas and Martha Bodley at their home in Cheltenham whither they had moved some years previously from Brighton but ill health prevented him taking the long route back to York via Cheltenham. At the beginning of August he had written from Buckingham Street to Cheltenham (the letter is undated but endorsed "August 7 1849 TB")—

> My Dear Thomas Bodley,
>
> I am truly sorry and ashamed again to disappoint you but I really do not feel equal to the task I had set myself or rather my dear Friends had chalked out for me. I hope you will in this instance pardon my weakness and I will not offend again. I *could not stay* so long as you kindly wish me, therefore I think it hardly worth coming so far for a day or so. My aches and rheumatic tendencies make me very helpless but hope I shall gradually lose them.
>
> Deeply regretting I should disappoint you
>
> My Dear Thomas
>
> I remain ever Affectionately
>
> Yours
>
> Wm. Etty

A few days later he wrote another letter from Buckingham Street to Thomas Bodley, again undated but endorsed "11th August 1849 TB."

My Dearest Thomas Bodley,

It gives me great pleasure that I am enabled to give you a better account of myself and to acknowledge with thankfulness and gratitude the goodness of Almighty God to me! I am much better. I think I never was more so ill—burnt up with fever and thirst—and agonized with pain—I knew no rest night and day. The attack was most severe and required the strongest remedies which have happily proved successful and I feel something of myself once more! My Dearest Betsy has been most exemplary and attentive. Her heart and head are worth a diadem! The weather here has been most sultry and oppressive; a more agreeable change has taken place.

A pleasant breeze blows—tho it is still hot. The baleful and oppressive influence of *Sirius* or the Dog Star happily ceases today! I am always glad when that's the case. Tell Martha and the rest of the dear circle round I feel obliged by their kind interest about me! The Adelphi exhibition keeps open 2 weeks after today. The visitors increasing but town is very thin, a sort of Deserted Village. I also long to expatiate in green fields by rivers of fresh water, amongst green trees and other attractions of country life.

May you my Dear Thomas long possess the power of enjoying and appreciating these and other blessings we so largely enjoy.

Yours ever affectionately

Wm. Etty

Unfortunately it cannot be claimed that the exhibition was an outstanding success though Etty himself, unaware of the financial results, thought it was. Not only were the paintings unlikely to appeal as an occasion for a family outing, but the exhibition had been held in the wrong months. July and August were months when the wealthy and more affluent families left town and the middle classes left in London were more inclined towards genre and the comical. The heavy loss incurred had to be met by diverting £500 from a donation given in 1837 for the purpose of providing prizes for architectural work, a decidedly improper procedure though one with which Etty was not personally connected. Etty regarded the whole event as "triumphant."

In the final weeks of the exhibition the Society wished to reduce the entrance fee in order to attract the less affluent members of the public, a policy which they were to adopt a few years later. But Etty would not agree. He did not trust the general public and feared that they would come to scoff or to indulge their prurient tastes. Etty's attitude to working people was probably encouraged by the small recognition he enjoyed in York outside his small group of friends. But he always distrusted the lower classes and took no part in the various charitable enterprises to improve their condition. It may seem strange that with the example of Joseph Gillott before him, who did so much for his own employees, that Etty should appear unmoved by the condition of the poor, but so far as can be ascertained Etty accepted the general attitude of the middle classes that poverty was the consequence of idleness and moral laxity. In this he contrasted strongly with that of many of his patrons who were among the pioneers in labor relations.

There was an important instance of these principles in action a few years after Etty's death which it may not be inappropriate to refer to here. In August 1856, a group of local businessmen mounted the Manchester Art Treasures Exhibition to encourage the arts in this country and especially in the provinces. It was decided to make this exhibition available to working men and women so that they could benefit from the examples of great art, refine their feelings and manners, acquire the habits of thinking and acting for themselves and "take their proper rank in the great human family."[14] We are told "that employers from all over the North and the Midlands arranged excursions for their workers" so that they could attend. "Thousands of additional workers" came from Birmingham, Liverpool, Macclesfield, Bradford and Halifax. The largest contingent came from Saltaire, 2,500 workers from the textile factory owned by Titus Salt. They came in three special trains accompanied by three bands to entertain them on the journey. Salt paid for everything and at the conclusion of the visit provided a dinner for everyone. As Macleod points out, it is doubtful what benefits the visitors really obtained since the paintings were unlabelled and without explanations, and there were no guides. Information was available only in catalogues which they could not afford and which, in any case, were only lists of artists and titles,

a device continued into the next century. But it was noted by many at the time that the visitors tried earnestly to appreciate the pictures. Charles Dickens complained that the exhibition was "too still" for working people who were used to the constant noise of machinery, but Titus Salt dealt with that matter, he had one of his bands playing in the rooms while his workpeople were there.

Although most of the paintings at the Manchester Exhibition had been chosen for their moral messages there was a fair sprinkling of other subjects. Etty's *St. John* and *The Combat* were included, no doubt because of their appeal to the virtuous principles of religion and valor. Although the extent of Titus Salt's philanthropy is legendary, he was not the only industrial employer to care for his employees. But generally, employers like Salt were few and none approached his level of concern for his fellow beings. Titus Salt's interest in art was typical of the philanthropists. Art was semi-religious and morally enlightening and working people should be brought into contact with it for their good. It does not appear that he had any interest in collecting works of art for himself and Etty apparently did not know him.

Etty's attitude towards the proposal that working people should be assisted to attend exhibitions, especially of his paintings, was not unusual. It was generally believed that the appreciation of art required a special education and the attitude of the middle and upper classes towards the poor had not developed since Shakespeare, who regarded them as simple rustics unable even to mount a play for the entertainment of their betters (*e.g.*, *A Midsummer Night's Dream*). The poor made amusing clowns but not heroes. The history of social change has been that of a system applied from the top downwards, with the lower classes being only gradually and reluctantly included. Only in the twentieth century has change been applied upwards and then with considerable resistance. As the nineteenth century developed, more and more working people read books and visited museums and galleries on their Sunday afternoons off work, sometimes even having their entrance fees paid by enlightened employers. It may be that museums and galleries were at first regarded as somewhere to go on a wet afternoon but for many the experience soon became an eagerly anticipated pleasure and an insight into wider worlds. What began as mere curiosity became in time the eager pursuit of knowledge.

Praise from a famous poet

One letter of appreciation came from an unexpected source. Robert Browning, writing from Italy, referred to Etty's recent call at his house in Hatcham (which information had been conveyed to him by his sister) and assured him that had he then been in England he would certainly have invited him. He wrote:

Bagui di Lucca, Sept., 21st, 1849

My Dear Mr. Etty,

I was duly informed, by my Sister, of your very kind call of inquiry, at Hatcham. Yet, surely, you must have divined I could not be in England these three years past, or I should not have been so neglectful of my privilege, as to leave you uninvited so long.

It was always too great a delight to me, when near your quarters, to knock at your door and convince myself that a great Painter and Poet could realize his conceptions, as exquisitely in London, at this latter day, as in Venice, when the Doges were there. I see noble pictures often now. But a noble Painter I do not hope to see, again, before I return to England; as I shall probably do next year: when it will be indeed an honour and a pleasure to shake his hand, instead of being forced to content myself, as at the present, with saying simply, that

I am, dear Mr. Etty,

Yours very faithfully, as admiringly as ever,

Robert Browning.

May I venture to send my wife's homage along with mine? We have often remembered your grand *Sirens*.

This is an intriguing letter because it suggests that Etty and Browning knew each other very well. At this date Browning was thirty-seven years of age and for the last three years had been living in Italy following his elopement with Elizabeth Barrett. The couple lived mainly in Florence and Etty had not been there since 1823, long before Browning's self-imposed exile. Etty must have met Browning before his departure and probably more than once but, as is so common with Etty, this is the only reference to the fact that the two men knew each other. Browning's reference to him and his wife remembering the *Sirens and Ulysses* introduces some questions. *Sirens* was first exhibited at the Royal Academy in 1837 and bought directly from Etty by Daniel Grant whose brother gave it to the Royal Manchester Institution in 1839. Browning first met Elizabeth Barrett in 1845. It seems unlikely that they saw the painting in Manchester since Elizabeth was an invalid and found traveling difficult, though Browning would certainly have encouraged her since he rightly perceived that much of her illness was psychosomatic. Her recovery really began in Italy. Somehow they had see *Sirens* somewhere else but however they had encountered it, the painting had obviously impressed them.

Increasing ill-health and other worries

Etty's reputation was such that his name was worth forging. As might be expected on several occasions he was asked to recommend young men to be appointed as drawing masters to wealthy families. Sometimes he later found that, notwithstanding he had refused to do so on the grounds that the applicants were unknown to him, these young men had copied his signature and submitted false references. In 1849 Etty became aware of other forms of forgery. Daniel Maclise discovered, during searches for some of his own stolen paintings, that a dealer was selling what appeared to be a copy of one of Etty's smaller works. He told William Wethered and as a result Richard Colls, Etty's usual dealer, became interested. It was always difficult to confirm whether an Etty "Study" was a copy since he painted so many and often repeated subjects. In the case in point Etty kept the "Study" for several days, discovered that what he knew to be an original was still with the original purchaser and so was able to confirm that the work was indeed a forgery. It was known that there were many "pseudo Ettys" in circulation. This fact alone should be sufficient to confirm the status that Etty had acquired. It has never been worthwhile to forge the unwanted. As gratifying as it might have been for Etty to know that his name was valuable it worried him, as it worries all artists and writers, to discover that forgeries were being issued in his name. In this particular case Etty called at the print shop and was able to declare the "Study" to be a fake.

Etty had always been fearful that the rooms exhibiting his paintings at the Adelphi were not fire proof and having witnessed fires near his London house he was worried that all his paintings there would go up in flames at any time. He was not content until his exhibition, as much as he had wanted it and still wanted it, was closed and all the paintings returned to their owners. Only then could he feel able to return to York.

During this stay in London he had painted a little from the model and on leaving had asked her to be available to resume when he returned next spring, so sure was he that he would continue to return. He still entertained ideas that he would visit London as opportunity offered and use his painting room. Although he would no longer attend the Academy Life Class he would still be able to prepare paintings for exhibition. These were his plans. For this reason he retained his lease on the apartments in Buckingham Street. But in 1849 he did not return to York until 29th September. He began to move about the city once again and to attend the Minster services and even to visit friends. He seems to have slowly recovered and to feel that his health was improving. On 5th October he wrote to Thomas Bodley.

My Dearest Thomas Bodley,

A little neater penmanship may characterize this letter to you than my two last for that the chronic rheumatism yet remains in my hands. Yet I have much more concern of them than I then had—but still it hangs about me in all my joints (but I think in my general health I hope I am progressing—but these wintry peaks in the weather gives me an astmatic [sic] spasm now and then, but I am thankful I am no worse when death and disease has been so fearfully busy around us) and I trust He will of his [illegible word] mercy bless and protect you Dear Martha and family. Betsy has been rather anxiously fearful in London of the prevailing epidemic, and I thought it to change the scene for her and we went for two or three days to Oxford, which had the desired effect; we have had an arduous and anxious five months campaign in London. The exhibition has been eminently successful, and the great and small works are now returned to their respective places—I think it will give you some little pleasure to learn that I have not given up possession of my London chambers as yet but have left my painting room in *status quo*—so that when I return I can have a fire let boil the kettle and mix the colors and paint at once, without the trouble of seeking a furnished lodging. We arrived here late on Saturday night—had a fine morning to travel in, sunny and sweetly looked the face of fair nature. A detention at Derby made us late, and a thick fog arose, and rain, which yet hangs more or less around us, gives token of winter coming.

I was pleased to hear ere I left town of the favorable impression our young friend your nephew is making in his new curacy at St. Martin's. I called on him on Tuesday and he on me, but both missed. By the way, one of the best reviews of my Exhibition is in a number of the *Eclectic Review*. We have had letters from India yesterday. Le Roi d'L'Isle de Java and his subjects are all well and flourishing. [*This is a reference to his brother Charles who had returned to his sugar plantation in Java.*]

Adieu my dear Thomas, Betsy and myself unite in love to you Dear Martha

Yrs ever Affecy

Wm. Etty

This letter has a sad endorsement: "This is the *last* letter I received from dear William previous to his death. T.B. Nov. 15th 1849." We may properly pause and consider what this letter must have meant to Thomas Bodley; the two men had been not only cousins but very affectionate friends.

A final imprudence

In such times when communications were slow even the closest of friends could not keep in close contact. Etty's letter of the 5th October remained with Thomas Bodley until he learned of his friend's death six weeks later and he knew nothing of the events that had meantime unfolded.

In York during October 1849 Etty thought he was feeling in better health. Writing to William Wethered on the 7th October he said that he was

as happy as a prince,—nay, happier. Betsy and I toddled about yesterday, we had a delightful walk and both wished you were there. Within five minutes' walk of our house, are the grounds of the Museum: where, a band of military music was playing soft airs,—the air balmy, the sky serene. Relics of ancient times—of Old Rome, and the glorious Minster were in the background. A river rolled by in front;—trees gracefully waving, tinged with hues autumnal.

He resumed his customary letter writing to all his friends. He wrote on the 9th October to Mrs. Bulmer, who now lived in London, that he had walked past her former home and remembered her. He had been to the Plantations at Acomb where his friend, a miller, had insisted upon giving him "a basket of nice apples, according to custom." This was how he intended his retirement in York to be. There was much to remember, old familiar places to visit, childhood memories to recall and recent changes to assess and pass judgment on. When not walking about his native city, remembering old friends and visiting those still remaining, he would put in an hour or so painting. Gilchrist refers to his "gouty hand" and to numerous still life subjects in progress but, above all, the twelve and a half feet by seven and a half feet canvas on which he was preparing what he expected to be his final work, *The Grecian Bridal Procession*, a subject taken

from Homer. On the 23rd October, again writing to Wethered, he indulged in some nostalgia, recalling that it was on this date in 1798 that he had begun his apprenticeship in Hull "bound in fetters." But now "his old enemies—short breathing, rheumatism, and helplessness"—were attacking him. Writing to Wethered yet again on the 30th October he declared

I am better, my dear boy. So don't be downhearted! Bye and bye, I hope to be better still. My complaint is a painful one. Yet I am mercifully dealt with; and I hope turning the corner toward a better state of things. I have been able to get a walk today.

But his health was rapidly deteriorating. All who knew him agreed that he was unlikely to survive the winter. So it was to prove but it was to be an act of kindness, an act of imprudence, that was to strike the final blow. His maid-servant was proposing to marry a local York man whom Etty believed was not a person of good character. He went out in bad weather to make inquiries, intending that if his fears were proved well-founded he would do his best to persuade the young lady to end the association. He felt a father-like care for her and did not want her to "throw herself away." Unhappy marriages were easy to contract but, once made, impossible to end. What opinion he formed of the young man we do not know but he caught cold and took bad advice. Being told by a young man of his acquaintance of the virtues of wearing only light clothing and taking cold baths Etty decided to try these remedies and began by leaving off his customary flannel night shirt. He did this on the night of Saturday 2nd November, having deceived Betsy who had attempted to dissuade him. He decided next day that he felt the better for it and went to the Minster service as usual. That Sunday evening however he had an attack of asthma and needed medical attention. By the Tuesday he declared himself better and tried to continue painting his *Grecian Bridal Procession*. He could soon do no more than sit and contemplate the unfinished canvas. He called in Dr. Simpson and felt "quite happy" about his condition but a further attack of asthma persuaded him to take to his bed. We have to remember that asthma could not then be treated beyond taking "vapor baths," which meant no more than breathing steam with camphor, only a temporary assistance.

Etty wrote a short note to Wethered on the 5th November assuring him that he was better. "Let me hear of your welfare," he wrote. "It rejoices my heart." Next day in a letter to brother Walter he said that he was convalescing and expressed pleasure that Walter was able to write, for his brother was again ill. On both the 5th and 6th he had gone into his painting room and tried to paint but in the evening of the 6th he felt worse and all next day he remained in his bedroom from where he could look out over the River Ouse. Such a situation could have only worsened his condition. The cold damp air rising from the river, probably a mist because York at that time was still undrained and liable to fogs, would have exacerbated his asthma. He had his unfinished painting brought into the room but could do little work. On the Saturday (9th November) he agreed he must remain in bed. Dr. Simpson came again to see him. Etty told him—"I don't know! but I have never felt so in all my life!—never! *never!*" Then his friend the Rev. Spencer visited him. Presumably it was Betsy who gave this account of Etty's final days, how he constantly rallied, saw his doctor and his friends, kept saying that he felt better but also admitting he was unwell.

He rapidly declined. At a quarter to eight in the evening of Wednesday 13th November 1849, William Etty died. The end was comparatively sudden and the medical certificate stated "congestion of the lungs," such was the inadequate state of medical knowledge at the time. From the reported accounts Etty did not find the prospect of death alarming. He had his strong faith to sustain him and he said to a servant at the end that death was "a great mystery. Wonderful! wonderful! this death!"

He died clearly believing he was joining his beloved parents in heaven.

CHAPTER TWENTY

Final wishes unfulfilled

It had always been Etty's hope that he would be buried in York Minster. He had said many years earlier that this hope sprang not from any belief in his virtues as an artist but from "the true love I bear that holy, that glorious work, that splendid monument of the piety and power of the Past Ages, when the House of God was thought worthy of all the perfection that man could give it."

Perhaps he did hope that his native city would honor him as one of its illustrious sons, but that was not the way of the citizens of York. Nor was it the way of the Minster authorities. Gilchrist, censorious of York and all its inhabitants to the last, declared that[1]

York Minster boasts no "Poets' Corner." The sanctuary reserved for Archbishops, Residentiaries, and the like ephemeral persons, is unavailable for a Genius, unless it disburse some £500 in fees, as a peace offering to the harpies which infest such places.

Since Etty had not made provision in his Will for such payment it could not be made and no special arrangements were offered by the authorities. Gilchrist apparently did not realize that it was not customary for laymen to be buried in the Minster and that the special dispensation required to inter Etty there would have required a cumbersome and lengthy process which could not have been concluded in time. However there was no thought of this happening and Gilchrist was bitter over York's treatment of its famous artist.

No idea seems to have been entertained by the Authorities or the Town of waiving such provision [i.e., *the payment of a fee*] and burying their great Painter in York's famous Church, of their own accord; as a fitting honour to the man, and graceful fulfillment of his known wish. A lasting discredit to York, this stolid and mercenary indifference to the cherished desires of the Painter who had effected so much for the honour of his native city; and for whom *it* had done simply nothing.

Etty could not be buried next to his mother and father in All Saints' Church Graveyard in Pavement, York, since recent regulations no longer permitted burials within the city. St. Mary's Abbey was a favored spot but, since this was also unavailable for burials, it was decided to inter Etty in the nearby St. Olave's Churchyard at a place where his grave could be seen through a ruined arch of the Abbey fabric so that he could lie in view, if not of the Minster itself, at least of an ecclesiastical building as old as the Minster.

An account of the funeral arrangements was given by Thomas Bodley in letters he sent to Walter Etty at the time. Both men were executors of Etty's Will but Walter, who was then 75 years of age and living in Scarborough, was too infirm to travel to York so everything was left to Bodley. Bodley's first letter to Walter after Etty's death reveals how deeply affected he was. It is dated six days after Etty's death, probably because Bodley had to travel from Cheltenham and then spend time attending to the funeral arrangements.

York
November 19th 1849

My Dear Walter,

Little did I expect, when I last wrote to you, that my next would be from York & as little the distressing occasion that has brought me here. Our dear William has at length closed his mortal career. I looked with some dread at this winter but trusted the change to his native air—the quiet & above all the cessation from his unwearied exertions at the Academy during so unpropitious a season would enable him to overcome his inveterate cough & pass it tranquilly—but an all wise & merciful God has ordained it otherwise & recalled his sweet spirit to Himself—to Life eternal—to happiness unalloyed. His last words were remarkable—"wonderful"—"wonderful"—as if he had already obtained an insight into those mansions of bliss to which he was so justly approaching. He is gone but has left a great example for those who will follow him in his profession of which he has been so brilliant an ornament. He has left in his endurably lasting works a monument that can never be broken down & with these works he has associated with all who really know him a high moral standard of excellence & worth & not only of devotion to his art but an earnest desire that future generations may excel like himself, proud of his own nobly acquired fame but not jealous of theirs & devoting to the last all his energies to promote it. You & I & many others all know these points of excellence in him & never shall forget the sweetness but decision of his character, the true elevation of his mind—his genuine kindness & the suavity of his manners—but I must stop—my feelings are & have been much tried. It is the first opportunity I have had to write to you.

Deeply regretting your inability to attend to it I can only say that I trust the interesting duties of our Executorship are in every respect proceeding properly. I have consulted dear Elizabeth, who has been so much our lamented William's confidant, & know so well all his views & wishes & I feel assured you will approve all that has been done—as she told me she was going to write to you & most probably mention the names of the parties invited. I will just mention two others I have added this morning, which had escaped both her & myself—that is John Bulmer (I had at first thought of him but considered him absent) who has intimated his wish to come on purpose if invited—& his brother the Revd. William B who Mr. Smithson thinks should not be omitted.

Clearly Betsy (Elizabeth), had already written to Walter before Bodley's arrival at York and, learning he could not come to York, had told him of her uncle's wishes. A further letter to Walter gives some details of the funeral arrangements:

Arrangements for the funeral at 11 0 am on Thursday 23rd November 1849. The Corporation have decided to join the ceremony at the Church. They move from the Mansion House & pass through the Museum Gardens to the Church. The grave which is close by the Walls of St. Mary is nearly ready & the ground has proved to be remarkably dry—it is 10 feet deep. The School of Design agreed to join "the mournful party." Many private individuals intend to do the same. There will be four mourning coaches (probably five). The declaration of feeling is *strong* & *universal*.

Elizabeth is still much overcome.

Originally the funeral had been proposed for the Wednesday but as the Corporation could not attend on that day it was put back to the Thursday. Gilchrist said that it was John Brook who had selected the site of Etty's grave. He was himself to die a year later and be buried next to his friend. Gilchrist also reported[2] a Professor Phillips had informed him that Etty's grave was dug through several previous graves and that he was laid to rest in a Roman grave containing "a small earthenware vessel"—which Professor Phillips had kept. It has always proved to be the case in York that no excavation can be made without revealing some evidence of earlier occupation. It may be regarded as very fitting that Etty should be buried among Roman artifacts. The funeral followed the custom of the time of all those attending the service being only male. Thirty-five members of the family and friends attended with the Lord Mayor and members of the Corporation, and presumably the chief officers, as well as many persons attending in a private capacity. Thomas Bodley reported to Walter, who did not attend, that "not one of those invited was absent."

Gilchrist records[3] shops shut and "the streets filled." But from the Royal Academy "no mark of respect was forthcoming." But, as Gilchrist also takes pains to record, it was the usual

habit of the Academy "of honouring only Itself in the person of the President." By this he presumably meant that only the funeral of a President was officially attended by the Council of the Academy. Had Etty died and been buried in London his friends and contemporaries would certainly have honored him but York was too far from London, and the journey too expensive, for them to attend. In any case, they do not appear to have been invited.

Strangely there does not appear to have been any account of the funeral in any of the York newspapers but *The Yorkshire Gazette* of the 17th November 1849, a week before the funeral, published a full column appreciation of Etty's life. This owed a great deal to Etty's own *Autobiography*, much of it being direct quotations. A long list of his paintings was given. The writer defended Etty against the usual criticisms of his art and, by implication, his character. His sobriety and high religious principles were emphasized. At the time of publication the newspaper claimed that neither the date nor place of interment was known. It urged that he must be buried within the city walls and that a public monument be erected in his memory. The same edition contained a long poetic tribute from someone using the pseudonym *Dolor*. On 1st December *The Yorkshire Gazette* published a letter from a correspondent signing himself *Civis* urging the formation of a committee for raising a subscription for a public memorial. The writer said he had already seen "the model of a bust now preparing by Mr. Noble, from a *daguerrotype* taken by Mr. Walker, last year. Both are perfect." We may conclude that both *Dolor* and *Civis* were friends of Etty, possibly the same person. The sculptor, Matthew Noble (1817–1876), was one of the most prolific carvers of monumental figures and busts of the century. At his death on the 23rd June 1876, *The Art Journal* of that month (page 275) declared that

> Few men have been more esteemed and regarded, not alone for his great ability, the manifestations of talent that very closely approximate to genius, but for rare qualities of mind and heart. ... He was a gentleman of high rectitude, irreproachable in all the relations of life

There are forty works by him in public places including three of Queen Victoria (one is the famous statue in Bombay), four of Prince Albert and three of the Duke of Wellington, and twenty-six monuments (including two in Westminster Abbey, three in St. Paul's Cathedral and one in York Minster) as well as forty-six memorial busts in various collections. Noble frequently exhibited in the Royal Academy but was never elected to membership, presumably his own wish. His bust of Etty was carved in 1850 and is now in the collection of the National Portrait Gallery, London. (See the title page of the present work.) Apart from this, Etty's death seems to have aroused little local interest. Neither the commemorative bust nor the public memorial materialized but Noble's bust has for some time been on loan to the York Art Gallery.

The churchyard of St. Olave's in Marygate would no doubt have appealed to William Etty for his final resting place. The original church had been built on a site that had been given and dedicated before 1066. In 1089, William II gave the monks a large area of adjacent land on which they founded St. Mary's Abbey. The Church of St. Olave at that time was quite small. It was rebuilt in 1466 but only gradually assumed its present form, mostly after Etty's death. The chancel was added in 1887 and enlarged early in the twentieth century. Such an ancient building would have been attractive to Etty and the proximity of the noble ruins of St. Mary's Abbey, connected to the church's graveyard by an opening in the Abbey walls where Etty's tomb is sited, would doubtless have been almost sufficient alternative to burial in the Minster itself.

Inscribed on the tomb in Roman capitals is the following dedication:

WILLIAM ETTY, ROYAL ACADEMICIAN
WHO IN HIS BRILLIANT WORKS HAS LEFT
AN ENDURING MONUMENT OF HIS EXALTED GENIUS,
EARNESTLY AIMING TO ATTAIN THAT LOFTY POSITION ON WHICH
HIS HIGHLY GIFTED TALENTS HAVE PLACED HIM. HE THROUGHOUT HIS LIFE
EXHIBITED UNABATED PERSEVERANCE IN HIS PROFESSION
TO PROMOTE ITS ADVANCEMENT IN HIS BELOVED COUNTRY.

HE WATCHED THE PROGRESS
OF THOSE ENGAGED IN ITS STUDY WITH THE MOST DISINTERESTED KINDNESS.
TO HIS ELEVATED AND HIGHLY POETICAL MIND
WERE UNITED A CHEERFULNESS AND SWEETNESS OF DISPOSITION
WITH GREAT SIMPLICITY AND URBANITY OF MANNERS.
HE WAS RICHLY ENDEARED TO ALL WHO KNEW HIM.
HIS PIETY WAS UNAFFECTED, HIS FAITH IN CHRIST SINCERE
AND HIS DEVOTION TO GOD EXEMPLARY.
HE WAS BORN AT YORK MARCH 10th 1787
AND DIED IN HIS NATIVE CITY NOV. 13th 1849
Why seek ye the living among the dead?
Luke XXIV. V.

Beside the tomb is a small stone laid flush with the ground on which is inscribed

WALTER ETTY
Late of 31 Lombard Street, London.
He was the eldest and best loved brother of William Etty, R.A.
and died February 23rd 1850

This proximity in death would have pleased William, for no man did he hold in greater affection.

"A Sordid Topic"

So Gilchrist referred[4] to the subject which he said occupied the minds of the citizens of York after Etty's death. Gilchrist had no sympathy for York or its inhabitants whom he regarded as small minded, self-righteous and altogether too censorious of those who, in his view, were by far their intellectual and moral superiors. He castigated them for not raising some form of memorial to Etty, for not recognizing his worth and for judging ill of a man who did not deserve their disapproval. It was not only that York citizens condemned his choice of subject—it was not to be expected that a provincial town would accept the nude figure as art—of more concern immediately after his death were the provisions of Etty's Will. Etty had accumulated a fairly substantial amount of capital from the sale of his paintings, which

Etty's tomb, St. Olave's churchyard, overlooking St. Mary's Abbey, York (photograph by John Rhodes).

monies he had, with the advice of friends, invested in Government stock. At the time of his death these investments amounted to £17,000, a very considerable amount. Gilchrist condemned the citizens of York for exhibiting the usual reactions of those who have failed in life towards those who have succeeded. Etty's success was resented. Gilchrist complained[5] that they preferred the "mud idol" George Hudson rather than the man who had brought honor on the city. So the citizens turned their attention to Etty's private affairs.

Etty had made his last Will in September 1845 with a Codicil added a year later on the occasion of the purchase of the house in Coney Street, York. This house he left, for her lifetime, to his niece Elizabeth Etty (Betsy) together with an annuity of £200. Everything else was left to his brother Walter. The disparity in the treatment of the two beneficiaries was picked on by the York citizens as evidence of serious shortcomings in Etty's character. Walter was reasonably affluent, having been engaged in the gold lace trade in London, and the general view was that he did not need the inheritance as much as Betsy or other members of his family did, nor, again in the view of local opinion, did he even deserve it. After all, he also had been successful. But local opinion did not know that William Etty had lived his life with a sense of constant indebtedness to his brother who had so assisted him in his early years and for some time afterwards. Etty had owed much to many people but more to Walter than anyone. He no doubt felt that a life tenancy of a substantial house and £200 a year for life would amply repay Betsy who had after all been paid and housed all the years she had served him. It also seems that in conferring on her the life interest in the Coney Street house he believed he had included the contents, but in the absence of express words this had not been legally granted. Although this does not appear to have occasioned Betsy any difficulties, some local citizens apparently picked up the defect. It may be that Etty also had apprehensions that had he rewarded Betsy more liberally such generosity would have encouraged suspicion that she had been more than a housekeeper. Artists were usually regarded as less morally rigorous than their fellow men and Etty's paintings would probably have suggested that Betsy had at least been a frequent model. Some would have suggested that their relationship had been more intimate. Gossip would have made her life unbearable in a small country town whose inhabitants were already interfering in her affairs. Etty was also well aware that Betsy intended to marry as soon she could and he may well have thought that any lavish provision would have more likely benefited her husband, and indeed attracted much interest in her, since at the time women surrendered their property on marriage. As it was, she had a life interest in the Coney Street house and that would certainly have sufficiently enhanced her marriage prospects and safeguarded her.

There were also other relatives in humble social positions whom local opinion thought deserving. Etty obviously did not regard it as his duty to provide for them for the remainder of their lives. He had anticipated a long life in York with Betsy continuing to look after him, not because he was selfish but because he felt they were bonded in true friendship, which indeed they were. It may be thought that Etty had labored too heavily under his sense of debt to Walter but he certainly believed that all he had accomplished was due to Walter's unwavering support.

After Etty's funeral Thomas Bodley wrote Walter at length regarding the discovery of an earlier Will. This Will had been made on 2nd October 1841, the year when Etty's friends had established the "Etty Fund." At that time his personal wealth amounted to no more than £300, though with a number of paintings in hand. Betsy was able to reveal that this Will had been drawn up by John Harper who told Bodley that Etty had said at the time, "I wish I could do more but I have done all I thought right." Thomas Bodley regarded himself obliged to read the earlier Will to the family and to make its contents known to Walter. This Will had bequeathed an annuity of £50 to Betsy, with the principle being divided equally on her death between Etty's four brothers. He had also bequeathed £500 to Walter and £50 to George Franklin, his assistant, and the division of any remaining estate between the four brothers. He clearly had not

expected to leave very much when he died. But when his financial position dramatically improved he had made a new and altogether different Will. One aspect of Etty's final Will has aroused subsequent curiosity. George Franklin is no longer left anything. There is evidence that in 1848 they were still friends but Farr considers[6] that some estrangement occurred to cause Etty to ignore him. There is the possibility that Franklin, who had some ambitions to be a painter himself, may have taken some of Etty's "studies" from his studio without consent.

It is very likely that Thomas Bodley made known the terms of the earlier Will in order to persuade Walter to be generous to his brothers who were not otherwise to receive anything. After a while Walter agreed to give his brothers Thomas and John £25 each but he demanded that Thomas return to him Etty's painting of their father which Thomas had had for many years but which Walter claimed was part of William's estate bequeathed to him. Charles was not given any money since he was apparently thought to have made enough in Java but he was reimbursed the sum of £82 15 00 for "The Monument"—presumably the tablet in All Saints' Church, Pavement, York, which he had had erected to his parents' memory when he was last in England. This may seem a curious provision since Charles had quite freely paid for the tablet but probably it was considered that the memorial should be an expense born by the family. Thomas Bodley also reported to Walter that he had divided William's clothing ("really good & a fair stock") between Thomas and John.[7] So, although the brothers did eventually get something, it was not much. Although Walter does not come out of this very well he was ill and dying and probably giving little rational thought to what was happening. Yet for all the allowances that can be made for Walter's state of mind at the time it has to be admitted that there is little evidence that he had ever done much to assist his less fortunate brothers. It was Charles who had occasionally provided Walter with funds to assist them. Only four months later, on 23rd February 1850, Walter, aged seventy-six, was also buried in St. Olave's Churchyard.

Among the letters acquired by the York City Art Gallery there are two which throw further light on Walter's character. In a letter dated 14th May 1851 Thomas Etty wrote from Hull to George Franklin in London asking if he could accommodate himself and his daughter so that they could visit the Great Exhibition. Franklin appears now to have established a lodging house. Franklin replied (in an undated letter) that he was "overfull" and knew of no lodgings which could take them. He then went on to advise Thomas that since he (Thomas) had received his house in Hull as a gift from his father he should not have said that he paid a nominal rent for it. Apparently this had resulted in Thomas losing the freehold but no explanation is given as, of course, none would have been necessary since both Franklin and Thomas knew the circumstances. It is likely that Thomas' house had been claimed as part of the bequest to Walter. Franklin continued that he presumed "they" would try to get the house in Feasegate and the cottage in Walmgate "that was your Mother's." He wrote—"It was sold contrary to the wish of my late friend Wm. Etty who often deplored the loss of it." Following this, Thomas Etty wrote to a Mr. Hobden, probably a solicitor, (this letter is also undated) complaining that "they" had persuaded his mother to make a Will which deprived him and John of the property and of which they knew nothing. "Jane Etty aided by Smithsons of York Solicitors have raked up everything to assert their claims amongst the rest. ... Mother's Will gave the property to Walter & £200 to Wm. Etty."

These letters appear to suggest that Walter had persuaded their mother to bequeath to him the house in Hull which Tom occupied and so disinherit her other sons and that now his daughter Jane Elizabeth with the assistance of her husband, the solicitor Robert Edward Smithson, was endeavoring to secure the property. Regrettably it must be concluded that Walter and his daughter were at least "acquisitive," and they could have afforded to be more generous to John and Tom Etty. There does not seem to have been much affection between Walter on one side and John and Tom on the other. It will be remembered that when Charles visited England in 1845 the brothers met all together only once. Walter does not appear to have engaged in family

reunions. It was Charles who sent money to Walter with instructions to assist his less fortunate brothers, John and Tom. Although facts are sparse it seems that while Walter may have begun the proceedings to secure Tom's house in Hull it was his daughter Jane Elizabeth and her husband who pursued matters to a conclusion.

In all this Betsy appears to have remained silent. That she was greatly distressed by her uncle's death was reported by Thomas Bodley but at no time is there any indication of her feelings regarding the provisions of Etty's Will. She appears to have been content with what her uncle had left her, the Coney Street house, the use of its contents and an annuity. Had Etty been a married man there would have been no criticism if he had left everything to his wife but being a bachelor with assets amounting at the time to a small fortune his will was subject to unjustified scrutiny by those who always feel they have a duty to stand in judgment on others. Usually it is aggrieved members of the family who complain but there is no evidence that either John or Tom felt disappointed. They may have been surprised that wealthy Walter was left so much and they were left nothing but if so they must have kept their feeling muted. William had lived with a constant sense of indebtedness, even dependency. All he had achieved had been due to Walter. When Walter was eventually persuaded to make a small gift of a mere £25 to each of them they must have felt patronized, even insulted, and then to be given second-hand clothes—though this was often then the custom—must have emphasized their inferiority. We must assume that Etty intended none of this and had acted without due thought of the consequences. Gilchrist did his best to defend his hero but was hard put to it. He was not aware of the terms of the earlier will nor of Thomas Bodley's efforts to remedy the obvious injustices. He took refuge in disapproving the interference of York's citizens. He thought Walter's financial investments might have declined over the years and that William considered it his duty to make good some of this loss. But this is purely surmise. All we can safely conclude is that the painter was unversed in money matters, he acted impetuously and was quite unintentionally guilty of injustices towards other members of his family. Yet, as we have sometimes seen, he was not by nature given to helping those worse off than himself. For him life was a matter of "as a man sows, so shall he reap."

A hurried sale

Six months after Etty's death, on Monday 6th May 1850, all works remaining in Etty's hands at the time of his death, his studies and unfinished paintings, his books, painting materials and studio effects, were put on sale by Christie and Manson (as the firm was then known). The sale lasted a total of seven days which indicates both the amount of sale material available and the degree of public interest. 1,034 separate lots were auctioned, realizing a total of £5,186 16s 6d, an amount which Gilchrist regarded as inadequate due to the fact that everything was put on the market at once. He complained that[8]

> a collection of Studies from Nature were scattered at random—into any but suitable hands often— which, judiciously allotted, would have been valuable as example to every town in the kingdom where Painting is cared for: to every School of Art, to every Artist, every cultivated lover of Art.

The items sold included sixty copies of paintings by other masters of which one, *Venus of the Tribune* after Titian, was bought by George Franklin for seventy guineas. Considering that the *average* figure realized for each item was only around £5, the fact that one item alone brought seventy guineas indicates that most items sold for but a few shillings. A contemporary, J. H. Anderton, wrote[9] that "This was a wonderful sale to see—Christie's 2 Rooms encumbered by Millboards and Sketches of canvas each displaying forms of man and womankind—heaps." But, said Gilchrist,[10] many of the studies and unfinished paintings suffered mutilation at the hands of others. The dealers who bought them arranged for other artists to "finish" them and so false "Ettys" were then put on the market at increased prices. Gilchrist complained[11]: "Many of the Studies

have fallen into hands still less scrupulous and intelligent: have been painted over by inferior men, and hopelessly ruined: a sacrilege unhappily, beyond the reach of law."

The treatment of Etty's last works and studies has been a constant problem for researchers who cannot trust any attribution made on their behalf. It has even been suggested that George Franklin himself passed off some of Etty's works as his own and some of his own as Etty's.

Posthumous appreciations

The Art Journal[12] reported the death of Etty in an obituary which opened with the words— "Art has lost its greatest ornament in William Etty." The writer went on:

> If the great masters of antiquity challenge the admiration of mankind by the unqualified excellence of their productions, then the modern painter who approaches the nearest to these in beauty of expression and grandeur of design, merits at our hands scarcely less of enconium than is awarded to them. This did Etty to a degree beyond that of any other artist of our school, past or present.

Because the Journal had so recently applauded Etty's exhibition earlier in the year it considered it "unnecessary for us to reopen the subject," the writer therefore concentrated on Etty's high moral character and natural modesty.

> Of a reserved and retiring disposition by nature, by no means a recluse, but a social being, yet in a quiet unostentatious way. To a mind more than ordinarily well-informed, were added a fund of genuine humour, which made his companionship a source of real enjoyment, and an imagination that clothed his words with the graces of poetry. Except perhaps, a high, broad forehead, and an expression of countenance that bespoke intellectuality, there was little in his personal appearance to indicate the extent or the direction of his genius;

So this writer, whoever he was, concluded that Etty was "the most poetical painter of modern times,—the disciple of Titian and Correggio, and Giorgione, and Rubens" and that fortunately "he lived just long enough to witness the triumph of his genius over prejudice and narrowness of mind." But this was wishful thinking. In 1849 the middle classes in England were establishing themselves as the nation's moral force and the driving power was Puritanism, a moral force which had been at work in this country since the seventeenth century, but was now associated with Methodism and Evangelism and many minor sects founded in religious fundamentalism, all often referred to generally as Revivalist. Prejudice and bigotry always dogged Etty and continued to cloud his name for the following hundred and fifty years.

The Penny Illustrated News[13] reported Etty's death with a biographical account of his achievements. "The loss of a distinguished painter will be severely felt by all lovers of British art; and that of a most estimable man by a large circle of friends beyond the limits of the profession."

The obituary was accompanied by engravings of Etty and of his painting The Death of Joan of Arc, both provided by "the eminent engraver" C. W. Wass. One imagines that the St. Joan engraving as reproduced did not do justice to Etty's painting though it afforded some idea of its composition. As the St. Joan triptych was reported as "now being engraved by him [Wass] in the highest style of line and mezzotint," we must assume that he provided the magazine with a preliminary print. Certainly The Penny Illustrated News thought very highly of Etty and his life's work, saying little specifically about his paintings but emphasizing that he was "a strictly religious man." The journal catered for general interests and at the foot of the first page of the obituary is an engraving "Sprat Fishing off Purfleet" illustrating an article on the subject which was printed later in that issue. One can only conclude that Etty's death was regarded as sufficiently important for even such a periodical as The Penny Illustrated News to report.

In its issue of the 30th March 1850 The Athenaeum reprinted a Lecture on the Works of the late W. Etty, R.A., by Professor Leslie. Charles Robert Leslie (1794–1859) was a painter of historical and humorous genre in the manner of Wilkie and Mulready. He was also a painter of

landscapes which in his lifetime were held in high regard by collectors. Leslie had been raised in Philadelphia where his parents had emigrated in 1800. He came to London to study in the Academy Schools and was elected an Associate in 1825 and a full Academician in 1826. A close friend of John Constable, Leslie edited his letters after Constable's death and in 1843 published *Memoirs of the Life of John Constable* which remain a principal source of information for that painter's life and character and reveals a considerable degree of friendliness between Constable and Etty. From 1847 to 1852 Leslie was Professor at the Academy and it was in this capacity that he delivered the lecture which *The Athenaeum* printed. In his lecture Leslie was principally concerned to discuss color in painting and to use Etty's works as examples of the best use of color. "It would be very unjust to Etty" he said, "to consider him only as a colourist, yet certainly this is the one thing in which he is always excellent, and with an equality very uncommon." Leslie gave a great deal of attention to this subject and praised Etty for the consistency of his development as a colorist and for attaining an excellence in execution from which thereafter he never declined. "In Etty, after his powers were fully developed, we scarcely observe any change; certainly no change of principle, for from the first he was right."

Leslie had no doubts about the pre-eminence of Etty as a colorist:

> It has been truly said, by the critic I have quoted, the writer of an article in the *Eclectic Review*, of September last [*i.e., Alexander Gilchrist, writing anonymously*], that "Etty must rank, hereafter, among the greatest true colourists the world has yet seen—often rivalling Rubens and the great Venetians on their ground, and having moreover, developed power peculiar to himself." And is it not a proud thing for English Art to be able to say of a son of England, so lately among us, *this*, which cannot be said of any painter out of England, since the death of Watteau?

Leslie recognized, as so many others had, that Etty was more concerned with his foreground figures than any other part of his painting, but, he said, "Slight and general as are his backgrounds, yet he is invariably happy in expressing the most charming characteristics of landscape." He remarked how the landscapes in which his figures besported themselves were always "inviting" and "congenial."

> There is one expression which pervades the whole of his Art, excepting in a few instances in which the subjects preclude it, an expression of great value, namely, that of *happiness*,—a charm that he studied not to give. Perhaps he might be unconscious of it, for it came naturally from his own constitutionally serene mind upon his canvasses.

Leslie saw in Etty's paintings the expression of the painter's own state of mind. This cannot be gainsaid for, as Etty himself said, he was concerned only to paint "God's most wonderful creation," and to do so without any base thought. Leslie was not a wholly uncritical admirer of Etty. He referred to his "occasional inaccuracies of form" and to his "want of attention to proportion." The latter was a recurring fault to which attention has often been drawn in the preceding pages. Leslie also deplored "something of the mannerism, in forms and attitudes, of the Lawrence and Westall schools, which in sentiment were the same, as may be seen in Etty's Art." Leslie blamed this shortcoming on his training under Lawrence, "something ... which he might better have been without." Disapproval of Lawrence's style as facile and too concerned to flatter his sitters had continued since his death and was to be leveled against him for the rest of the century, as though a portrait painter would earn a living if he did not flatter. But inevitably Leslie had to refer to the most troublesome question of Etty's choice of subjects.

> There is a question on which it may not appear to be my province to enter; but it is one which Etty's peculiar treatment of, and choice of subjects must present to most minds;—I mean the question of how far his frequent reference of the nude may or may not be proper.

He admitted that he had never seen a "female face by Etty in which the expression is impure" and he knew "no painter's work in which he could more readily find the personification of

innocence." But, having discussed the question, Leslie concluded "on the score of taste alone, I think Etty's indiscriminate partiality for the nude is objectionable." Nevertheless he wished to be classed as one of Etty's greatest admirers. He quoted Homer and Plato (it was always safe to refer to the classical Greeks for authority): "Man must not be honoured in preference to truth" and "To betray what appears to be truth were an unholy thing." Etty unwaveringly pursued what he saw as truth but Leslie warned his young listeners not to be "blinded by high poetic authority and the fascinations of the many fables of antiquity, as subjects of Art." Therefore Etty's diploma painting, *Sleeping Nymph and Satyrs*, sanctioned though it was by such painters as Titian, Correggio, Poussin and Reynolds, was among those which should never have been painted. The objection here, of course, was not the nudity but the subject, as Leslie stated in a note to the printed version of his lecture. As the reader will know from the analysis of this painting earlier herein, the author is of the opinion that this painting has been generally misinterpreted and Leslie, along with all his contemporaries and many later writers, wrongly believed it to depict imminent seduction or rape. Leslie feared that much of the admiration for Etty's art proceeded from "the voluptuous treatment of his subjects" rather than "from a pure love and true appreciation of what is excellent in painting." Having disposed of this vexed question, Leslie concluded his lecture by praising Etty's simplicity and sincerity of manner, his lack of any jealousy or envy or other unworthy feeling towards any of his brother artists. Leslie's assessment of Etty was that he was one of the nation's greatest painters, certainly its most proficient colorist and a man possessing a noble mind and character. It was just unfortunate that he painted so many nude females.

When later, in 1860, Leslie published his *Autobiographical Recollections* he recalled meeting Etty at his 1849 retrospective exhibition, saying how delighted he was to see him. Alluding once again to the general objections taken to Etty's subjects, he wrote[14]: "Still there is often far more that is objectionable indicated in a single face by Greuze, where the figure is entirely draped, than in all the nudities of Etty, whose mind was anything but a gross one."

Bearing in mind that many of Greuze's subjects were under-age girls posed to suggest their sexual availability we can only conclude that Leslie was being obtuse. He found it necessary to add, "Not that his choice of subject, in many instances, is in any degree more defensible than that of Titian, of Correggio, or of Rubens." He continued: "As a member of the Academy, his conduct was invariably marked by the most unremitting and disinterested zeal for its welfare and honour, which he always considered identical with the general well-being of British art."

Of Etty's personal character he wrote: "There was a simplicity and sincerity in the manner of Etty that attached friends firmly to him, and I never heard that he had an enemy."[15] Indeed, it may said as a criticism of Etty, that he was careful to please everyone and offend no one so that it always difficult to discover his true feelings about anyone. He seems to have followed the conventional countryman's philosophy of never speaking ill of anyone. Leslie numbered him among the best of men. Writing of his contemporaries he said,[16] "...men whom many of us living have had the happiness of knowing personally, as Fuseli, Stothard, Turner, Constable, Wilkie, Etty...."

The passing of so famous an artist as William Etty could not be allowed to go unnoticed by publishers. The book trade at the time was still conducted by individuals. There was not a large enough reading public to justify the modern habit of saturating the market with biographies of so-called "celebrities" before they have achieved anything. So the first in the field had it all to himself. David Bogue, a London publisher, was impressed by Gilchrist's article in the *Eclectic Review* and invited him to undertake the task of writing Etty's life story. Gilchrist had been a regular contributor to the *Review* and his unqualified admiration for the painter made him the most suitable author. Bogue thereupon commissioned Gilchrist and the *Life of William Etty, R.A.* was duly published in two volumes in 1855. Gilchrist had not personally known Etty so he had to gather all his material from his own memory of the paintings and from the ready assistance of Etty's friends and relations, of whom Thomas Bodley was the principal source. Some

of his material Gilchrist clearly obtained from Elizabeth (Betsy) Etty though he does not cite her as a source. Much of Gilchrist's material—especially that relating to Etty's early years—is available from no other source and all subsequent writers on the subject are wholly dependent upon him. In the final chapter of the second volume Gilchrist paid his personal respects to a man whom he admired to the point of adoration and to his art, which he believed to be beyond criticism. In this chapter we have fulsome praise, but it is genuine praise not bestowed by one who has any obligations of friendship.

Gilchrist first eulogized Etty's life[17] as "noble ... resolute, steadfast, loyal.... No touch of baseness, even approximate, have I been able to decry in Etty." He went on to quote the architect, Charles Cockerell: "I have never known any Artist, excepting always the immortal Flaxman, altogether so devout and pious in adoration of beauty, for its spirituality." Gilchrist believed that

> ... few men would have been less at home in "subjects of our own day" than Etty. Devotion to the undraped human form, new sights of *its* beauties, formed a leading and characteristic feature of his originality as an Artist. This tendency naturally carried him into the world of fable. For the actual world of our day ... does not move about without clothes.

This usual claim by objectors to the nude was met by Gilchrist who maintained that the unclothed human body was what God had originally created and that it was man's sinfulness that found the naked form obscene. This had been Etty's defense for his preference for this subject. He maintained, and Gilchrist approved, that he painted not stuffs and materials, not clothing but "God's most wonderful creation." Gilchrist was unwavering in his defense of Etty's choice of subject matter. "Admiration of Woman's form amounted in Etty to devotion." "To the pure all things are pure" and "the purity of the nude when rendered in purity of heart" are sentiments which constantly occur in Gilchrist's final chapter.

> The "notions of propriety" Etty's Pictures shock are, it must be remembered merely conventional. In departing from merely conventional propriety, he did no wrong. Art has a nobler morality. Conventional modesty is arbitrary: here means one thing, there another. In one nation, a woman's face becomes "improper";—in another, her eyes....[18]

We have seen in the preceding pages that a fellow artist (Edward Calvert) could find some impropriety in the arching of an ankle and we must suppose that others could also find immodesty in a look in an eye, a beckoning of a finger or a toss of a head. The Victorians had a fertile imagination when it came to immorality. But Gilchrist ignored the usual objection, still often voiced today, that total nudity is not the usual state in which people display themselves to each other and when they do it is justified by a special relationship. Gilchrist condemned those who added draperies or placed leaves on statues—especially on "the Antique"—and remarked with some disdain on "their purity of mind" which finds impurities in God's creation.

> A veneer modesty it is, covering one knows not what: the fit attendant of a specious morality, hollow and dishonest. Are Clothes then the Palladium of morality? modesty and mere decorum convertible terms? morality itself an artificial habit, secured by the frail fence of etiquette; not a growth rooted in the conscience and the heart?[19]

Gilchrist gave so much space to defending Etty's choice of subject that he scarcely assessed him as a painter. He referred to Etty's "glorious Colour and wondrous powers of rendering (because of seeing) Nature."

> Colour so far from being "sensual," as the modern notion runs,—a blunder against which Mr. Ruskin is almost the only writer on Art, adequately to protest,—is in reality a spiritual and ennobling influence: one however, addressing itself, in its full eloquence, to relatively few.[20]

Gilchrist implied, but did not bring his remarks to a conclusion, that Etty used color to present the spirituality of the feminine.

The current assumption that the human form is only capable of exciting one class of sensations; that Nature endowed it with so much grace and so much beauty, only to elicit *them*, none others: whether this or Etty's manner of thinking be the more ennobling. I leave it to the reader to determine.[21]

Gilchrist was satisfied that those who found the human form degrading were guilty of "blasphemy against Nature,—against God...." He was impressed by Etty's condition placed on a purchaser that he must keep the pictures he had bought for as long as he lived because "I don't want them in the possession of young men, merely to show about to each other. If *you* want them for such a purpose, you shall not have them!" Gilchrist deplored the

fast young men or fat old men, lewd livers and lewd talkers; men fresh, in fact, from impropriety of *conduct*, [*who*] will in "mixed society" fearlessly denounce the works of an Etty as improper and think they are acquitting themselves of a public duty in so doing.[22]

Gilchrist's defense of Etty ran to twenty-four pages and deserves to be read in full. In the main he appealed to the nobler sentiments of women. Though women were necessarily and desirably modest they did not believe that their bodies were indecent. It is a blasphemy against God to suggest that His creation is sinful. "Let them be assured, that as *they* are concerned, at all events, there is no harm in Etty's Pictures: in inspired portraiture of the female form, painted with reverent, almost devout delight and worship of Nature, of God in his works."[23]

Gilchrist saw little hope of convincing the men. "As to the men, all depends on the eyes they bring with them. They see 'what they bring with them in the power of seeing.' The indecency, if it exists, is in their eyes and hearts. For which, surely, no Painter is responsible."

But in focusing his appeal upon women Gilchrist was appealing to that section of society which was ill-educated and conditioned to subordination. Women had not yet the power to determine their own moral standards, opinions and social relationships. As Lawrence Stone comments,[24]

Young ladies ... [*were*] ready to swoon at the first suggestion of a coarse word or gesture from an impatient male. ... Girls were taught by their culture to assume that they were frail and sickly, and as a result they seriously believed that they were, and in fact became so.

This attitude protected them from the unwanted attentions of males and the fearful shame of unmarried pregnancy. Although such behavior was largely affected by the middle and upper classes, the "respectable poor" aspired to the *mores* of their social superiors. Working women could not pretend to be frail, they would starve if they did, but they could affect a decorum in speech and behavior that had hitherto been unknown in their class. Young women in domestic service and the new factories were at considerable risk from the attention of employers and overseers. This had been increasingly so throughout the eighteenth century and continued right to the end of the nineteenth. As Sabbatarians increased their campaigns more working people attended places of worship and, urged to conform to new approved modes of behavior, began to adopt the prudery of the middle classes. Even countrywomen were now affecting refined feelings. William Cobbett in 1829 complained[25] that "farmers' wives, daughters and maids cannot now allude to, or hear named without blushing, those affairs of the homestead which they, within my memory, used to talk about as freely as of milking or of spinning."

Gilchrist's appeal to his women readers to accept the art of Etty as adoration of their femininity had no chance of success. Middle class women feared that to accept the nude as a proper subject for art and intellectual discussion would open them to improper masculine advances. Their menfolk displayed almost animal ferocity in the protection of women, and women, so dependent on marriage and the money and power of men, had to conform if they were to avoid censure, ostracism, disgrace and poverty. Augustus Egg (*Past and Present*) made that clear enough. Gilchrist's final chapter was not so much a praise as a defense of Etty. But it was useless to argue that any prurience arose not from the subjects but from the minds of the viewers. They knew

very well that Plumtree and Bowdler had purified Shakespeare to protect the innocence of their womenfolk who must never know what the world was really like. Young ladies could not even be reminded that they had breasts.

Gilchrist's biography kept Etty's name alive for several years. Sarah Uwins, widow of the painter Thomas Uwins, R.A., published *A Memoir* of her husband's life in 1858 in which she recorded his opinion of Etty. Uwins had resented Etty's fame which he attributed solely to "the voluptuous character of [his] works" which suited "the degree of moral and mental intelligence" of his patrons.[26] When Uwins referred in a letter (probably to Daniel Maclise) to Etty's success at an exhibition in 1830, he said,[27] "With all Etty's powers as a painter, and they are very great, he has a radically bad taste about him, which is forever thrusting out its cloven foot. There are but few of his pictures I should ever care to possess."

Uwins confined his strictures to Etty's subjects. Frequently he wrote approvingly of Etty's generosity of mind and when he himself was abroad ensured that Etty was always among those to whom he addressed letters home. But even Uwins objected to the hypocrisy of the times. Writing to Joshua Severn in 1828 he commented wryly,[28]

> Etty's picture, for which he was paid five hundred guineas, is found guilty of having a lady's thigh almost, if not quite, naked, which prevents the moral part of the visitors from turning their eyes towards it. I expect the squeamishness of the English public will soon make it necessary to advertise in the catalogue that no picture will be admitted unless the figures be covered with drapery an inch thick.

The painting referred to was presumably *Judith* which was exhibited at the British Institution that year and for which Etty was asking five hundred pounds. The oil study (now in a private collection) shows Judith with one leg uncovered.

In 1859 *The Art Journal* published No. 5 in its series of *Personal Recollections of Great Artists*. The author was the late Edward Villiers Rippingille and his subject was William Etty. Rippingille (1798–1859) was a genre painter from Norfolk who first went to Bristol and exhibited in the Royal Academy, Society of British Artists and British Institution from 1813 until 1857. He twice visited Italy. He won a prize for his cartoon submitted for the decoration of the new Houses of Parliament, though was not selected to produce a finished work. Rippingille claimed to be the first to advocate the formation of local Schools of Design, though this is unlikely. He was an admirer of Etty's work—though with some reservations as we shall see—and, although Gilchrist did not mention him, he claimed to have known Etty well. He died suddenly at Swan Village railway station, Staffordshire.

Rippingille began his article with a physical description of Etty as "a short, stout man, with shoulders low, and rather narrow, surmounted by a large, heavy head." He described his "shambling gait, stout limbs, large feet, with toes less diverging than usual." One must ask, how was he aware of this feature?

> There was a good-natured, half-smiling look about his face; he was strongly marked with small-pox; his mouth large; his eyes light, and rather bright, with a cheerful expression,—[*then follows a very revealing remark*]—but with no character of thought in them: it was a large mass of unmeaning face with wrinkled forehead, and thin, grey, straight, and straggling hair.

This assessment of Etty as a pleasing character but with no depth of thought is one which is frequently borne out in his letters. He always wrote of ordinary everyday events, usually of the progress of his own paintings, his successes or failures and generally with no regard to the concerns of the larger outside world. Even when he wrote his three letters to Thomas Bodley recounting his experiences in Paris in July 1830 there was no comprehension of the historic events that were being played out around him. But of Etty's moral propriety Rippingille had no doubt. He referred to "the real innocence and purity of his mind" and asserted that the actual subjects of Etty's pictures came to him at a late stage in his painting.

A picturesque attitude, or combination of forms, if naked, were nymphs bathing. ... [A]n old head with a beard black or grey was a Jew.... [A] naked beauty was a Venus; clothed and wreathed, a Sappho; with dishevelled hair, a Magdalen.

The subjects came to him "in the course of his practice." So we are told that Etty painted whatever single figure or group of figures appealed to him at the time and then attached a title later. But "Etty was, in person, the last man you would suspect of an idea soaring into the regions of Fancy, and conversant with poetical and etherial creatures." We know that much of this is incorrect. Etty frequently decided upon his subject before beginning work. It is certainly likely that some of his more fanciful titles were added afterwards but this does not mean that the subject itself was not pre-conceived.

As was usual with most commentators, it was Etty's use of color that Rippingille emphasized. "In this it is to be questioned whether any painter, ancient or modern, has ever equalled him." But,

it is greatly to be regretted that in the later part of his career Etty fell into some mannerism, both in respect to treatment and drawing, prejudicial to his works. His female forms lost much of their true natural character, and became fashionable and small-waisted, like women who have for their lives been pinched up into stays and bandages.

This was a common complaint. Rippingille regretted that he could say little about Etty's painting methods.

There is no artist upon the principles of whose style and practice so little can be said, because there was but one idea pursued in them; this was, in a word, to produce *flesh*, with its peculiar charms of colour, transparency and softness; everything else in the picture was subsidiary to this.

He pointed out that the paintings were no more than studio compositions. "Of action, character, and expression there was nothing. all was listlessness and indifference. Whole groups of figures were assembled doing nothing."

Rippingille attributed this lack of action to the fact that Etty composed his pictures from models who had to hold their poses for long periods. Resting, reclining and reposing were the easiest attitudes for them to adopt. Little time was spent defending Etty's choice of the nude as his favorite subject. The nude presented no problems for Rippingille though he himself did not paint such subjects. He was more concerned with regretting that Etty did not "fit into the niche for which nature intended him, and the true genius of Art assigns him."

Etty's powers were not intellectual, and required neither high intellect in their excercise, nor in the appreciation of what they produced; [*but*] Etty worked by a power more rare among men than intellect, and altogether beyond the scope of acquirement, the nature and rarity of which must be combined in the estimate of its value, whatever price is set upon it.

Unfortunately, having assured his readers that Etty possessed a rare power, Rippingille did not venture to suggest what it was. But he did conclude with strong qualifications to his final assessment of Etty's abilities.

His Academic studies had furnished him with some portion of the necessary knowledge of form and development, but it did not extend beyond the Academic in force and truth, and has none of the vitality which distinguishes intelligence, life, and nature.

Rippingille's account was more concerned to honor the man than the artist. We are left to conclude his unspoken thought that had Etty painted subjects other than models posed in the studio, he would have produced a far superior art, an opinion shared by many at the time. The public do not, because they cannot, judge an artist by his art but by his subjects.

The ambitious account of British painting published by the brothers Richard and Samuel Redgrave in 1866 gave considerable space to William Etty. Like all writers on Etty they relied on Gilchrist's biography for the facts of his life but their generally sympathetic sentiments were

their own. After a brief summary of his early life the Redgraves described Etty's method of paint-
ing and then proceeded to discuss his choice of subjects. "The subjects which he adopted were
of a voluptuous character."[29] "Above all, he delighted in the beauty of women." They mentioned
his deficiencies, his lack of proportion in his figures, but chiefly they admired his mastery of
color. The Redgraves necessarily dealt with the problem of Etty's choice of subjects.[30]

> Though himself a particularly pure-minded man, with a most chivalrous respect for women, it must be
> allowed that many of his pictures were of a very voluptuous character, and clashed with the somewhat
> prudish temper of the age.

They went on to say that whereas collectors would place upon their walls similar paintings
by Italian artists, they "could not tolerate the nude from a native painter, even when the sub-
ject itself was unobjectionable." The Redgraves dealt with Etty wholly within the context of the
history of British art which they were compiling. It is clear they had a high regard for him and
his work and attributed his decline in favor to the increasing prudishness and hypocrisy of the
public. In their Introduction they deplored the fact that after Etty's death his final studies were
eagerly bought up by dealers, "fitted with backgrounds and dressed up pictorially for the mar-
ket"[31] and sold on as though wholly by Etty's hand. Dealers they included among "the enemies
of art."

In 1869 Francis Palgrave included Etty in his *Gems of English Art*. In the same year the poet
and critic W. Cosmo Monkhouse included Etty in his book *Masterpieces of English Art* He also
made him the subject of a single volume, *Pictures by William Etty, R.A.*, in 1874 and wrote the
entry for Etty in the *Dictionary of National Biography.*. This was both a factual and an admiring
account of Etty's life and work. with an expression of regret that "we have none of his greatest
pictures in our national collections in London." An inaccurate statement since several private
collectors had bequeathed their paintings to the National Gallery in the second half of the nine-
teenth century (subsequently transferred to the Tate Gallery.) The reason for Monkhouse's igno-
rance of these bequests is that the National Gallery did not publicly display Etty's paintings.
The late Victorians were eclectic in their tastes but on the whole preferring the easily under-
stood and the generally approved. A taste for narrative, encouraged by the increasing popular-
ity of the novel, ensured the production of genre subjects but there was also a revival in the final
decades of a new style of subjects which claimed to have classical justifications. They appealed
to a new patronage which wanted its art and everything else it possessed to display exceptional
wealth.

It says much about the commentators in Etty's art that they concentrated on his nude sub-
jects and nothing of his religious subjects and his portraits.

CHAPTER TWENTY-ONE

Etty's successors

The importance of an artist is frequently measured by the number and the quality of those who followed his example and can be regarded as his successors. In Etty's own lifetime there were a number of British artists who from time to time painted the nude but none concentrated on the subject as Etty did except, possibly, his older contemporary Thomas Stothard, who died in 1834. They were more aware than he was that tastes were changing. In his lifetime Etty occupied the predominant place in painting the nude and few were willing to compete with him. Most artists realized that the new class of collectors was not so willing to display nude figures on the walls of their houses, for reasons that have already been examined, and since artists, like anyone else, must earn a living they set about satisfying the market. But a minority saw that a small sector of the market still preferred the nude subject and being more interested in painting the figure than illustrating popular novels they contentedly followed Etty's example.

Nonetheless we begin with a painter whose name is constantly mentioned by Gilchrist and who was a great admirer of Etty's work and endeavored on at least one occasion to emulate him but is now known exclusively as a typical Victorian history painter. Daniel Maclise (1806–1870) was a student when Etty was visitor to the Academy Life Class and remembered him in 1837 making "a beautiful study once from a female figure Constable had arranged as Eve; with a laurel-tree behind her from which were pendent members of the kind of orange called 'a forbidden fruit.'"[1]

Maclise frequently complimented Etty on his exhibited works but his own preference was for the subjects that the conventional public wanted. Apparently once only did he paint a nude subject, *The Origin of the Harp*, which he exhibited at the Academy in 1842. The subject was taken from Tom Moore's poem of that title in which the personification of Ireland, a sea siren weeping for her lover, is transformed into a harp that will accompany all future Irish laments. It was a poem that appealed to all exiled Irishman recalling, as it claimed, the traditional folklore of their Celtic origins. The verse to which Maclise's painting refers is:

> Still her bosom rose fair—still her cheek smiled the same,
> While her sea beauties curl'd round the frame;
> And her hair, shedding tear drops from all its bright rings,
> Fell over her white arms to make the gold strings.

This became a popular picture, reproduced as an engraving in *Art Journal* in 1862, a magazine that always encouraged interest in the nude. Maclise's other nude subjects are restricted to Life Class studies which reveal a remarkable ability and fluidity of line that would have served him well had he chosen to follow this path.

William Mulready (1786–1863), also an Irishman who came to England about 1800 when he entered the Academy Schools, showed remarkable talent for a boy of 14. He painted both history and genre subjects, was elected to Associateship of the Academy in 1815 and a full Academician

the following year, twelve years ahead of Etty. He attracted considerable public attention and although today he is always remembered for his domestic scenes, he was a most proficient painter of the nude, continuing until his death. His drawings of life studies derive from the painstaking systems of the Academy Life Class. Mulready looked around him at other exponents of the nude and willingly followed their example. His *Bathers* of 1849 (Dublin) is based upon Ingres and his *Bathers Surprised* (1853) on Titian but also on Etty. (See Etty's *Bather* at Leeds.) Mulready was a most accomplished draughtsman and his drawings of the figure are far superior to his paintings which seek to depict the ideal rather than the actual..

Ruskin particularly disliked Mulready's nude studies, describing them as "vulgar and abominable"[2] no doubt because they were more realistic than his painted idealisms, although always meeting the requirements of nineteenth century decorum. But Ruskin had a lifelong problem of reconciling his love of the Renaissance classical nude, Venetian artists, especially Titian, and his own Puritanism. For him the nude figure was acceptable in art but not in life and more acceptable in the art of the past than in the art of the present. He had no firsthand knowledge of the naked female and believed that the smooth hairless pudenda of classical sculpture was accurate. To his horror he discovered on his wedding night that this was not so and from that moment rejected his wife as a "freak of nature." Had Ruskin studied contemporary nude paintings and drawings more carefully he would have seen that already many artists were beginning to depict facts. Unlike Ruskin, Queen Victoria had great admiration for Mulready and when she wished to buy an example of his work Mulready was so flattered he gave it to her as a gift. Victoria and Albert had a particular liking for paintings of the nude and of female subjects in general, especially those of Winterhalter. This, together with their admiration of Edwin Landseer, and their collection of sculpture in Osborne House on the Isle of Wight, suggests a royal taste that was based on the principle that purity of mind could not admit improper intentions.

Edward Calvert (1799–1883) is more usually associated with William Blake and Samuel Palmer of whom he was a close friend, but just as Blake painted the nude to express his personal visions, so too did Calvert. He trained in the Academy Schools, of which Blake would not have approved, and after a period under Palmer's influence, he painted mythological subjects from 1831 onwards. He was interested in Greek antiquity, visited Greece and took his subjects from mythology. He admired Etty and

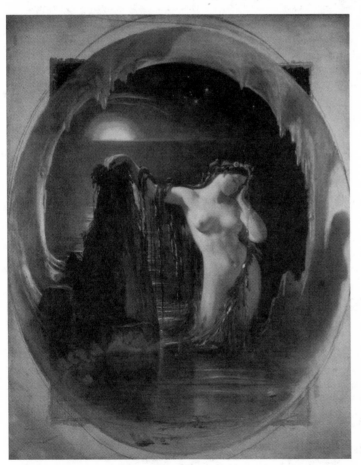

The Origin of the Harp, by Daniel Maclise (44 × 34 ins) (c. 1842), Manchester Art Gallery.

wrote him at least one sympatheti-
cally critical letter (which has been
quoted earlier). Alfred Joseph
Woolmer (1805–1892), though usu-
ally regarded as a painter of subjects
obviously derived from Watteau,
also produced a number of nudes.

The most important immedi-
ate follower of Etty was William
Edward Frost (1810–1877). In 1832
Etty had recommended him to
Bodley, describing him as Mr. Potts'
protégé. Gilchrist refers to "William
Bodley" but either he or his indexer
confused father and son and it is
not always possible to distinguish
who is meant. It was Thomas Potts
who had commissioned Etty to
paint his daughter's portrait. Frost
was consequently commissioned to
paint a portrait for Bodley. In his
letter of 19th December 1832 Etty
described Frost as "a very clever
modest lad" who "would be very
likely to do it well and reasonable."
Etty had known Frost since 1825,
the latter being then only fifteen
years old, and he had advised the
youth to study at Sass's School in
Bloomsbury. He later helped Frost
to obtain a post in the British
Museum. In due course Frost
entered the Academy Schools, was

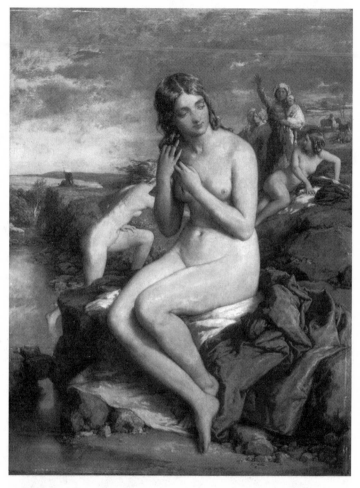

Bathers Surprised, by William Mulready (23.25 × 17.25
ins) (1852–3), National Gallery of Ireland, Dublin.

awarded a gold medal in 1839 for his *Prometheus Bound by Force and Strength* and won a £200 prize
in 1843 in the Houses of Parliament competition for *Una Alarmed by the Fauns and Satyrs*. This
success encouraged to concentrate on subjects featuring the nude drawn mainly from Spenser
and Milton. His painting *Diana and Actaeon* led to his election as an associate of the Academy
in 1846. He became an R.A. in 1870, a somewhat lengthy gap. His diploma work was a *Nymph
and Cupid.*

Frost had a successful career imitating Etty. In 1845 his *Sabrina* was engraved for members
of the London Art Union. Lord Northwick (also a patron of Etty's) bought his *Diana and Actaeon*
in 1846. This was Frost's most elaborate composition with movement from one side of the pic-
ture to the other as the nymphs begin to flee from the intruding Actaeon. All the poses are based
on the studio model, Diana's pose obviously held for too long by the model, with her left arm
unnaturally raised to simulate alarm. The subject is no more than an opportunity to depict the
nude female in various poses, always chaste, decorous and with due respect to the delicate feel-
ings of the public. No doubt encouraged by the appeal of *Diana and Actaeon*, Queen Victoria
and Prince Albert bought his *Una and the Wood Nymphs* in 1847. The Queen was so pleased with
their purchase that she commissioned *Euphrosyne* in 1848 as a gift for Albert and he in turn in
1850 commissioned from Frost *The Disarming of Cupid* as a gift for her. It was his *Sabrina* of 1845

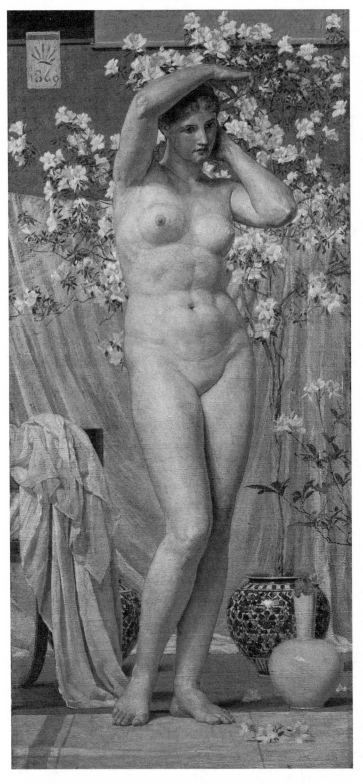

A *Venus,* by Albert Moore (63 × 30 ins) (1869), York Museums Trust (York Art Gallery), YORAG698.

that had originally brought Frost to the attention of the Royal couple. *Sabrina* is a "fancy picture" depicting the contemporary notion of ideal maidenhood. All the figures are modestly draped, most revealing no more than small rounded breasts. The naiad floats on the surface of her river borne by attendants. It has all the features of the fairy paintings which became the vogue in the 1850s. At the time the painting was praised for its "charm"; it could hardly have been adversely criticized when the Royal family was so impressed.

Frost's *The Sirens* of 1849 is another "fancy picture" of three alluring nymphets suitably draped from the waist, offering their charms, not merely to unsuspecting sailors "off stage" but also to the male spectators in the exhibition gallery. *Aurora and Zephyr* (1852) is almost a reversed version of Etty's painting of the same title of 1845. Frost's nudes always have smooth polished surfaces suggesting youth and virginity, but not necessarily innocence. Hands and feet are always too small, reminding us of a fault common with Etty. Frost's *Sirens* are calculating young ladies, pleasantly surprised after a bathe in a river backwater, sending out signals of appropriate body language to the unseen young men on the opposite bank. Alison Smith says[3] that "the subjects themselves are slight and modest." Slight, no doubt, but these Sirens are hardly modest. Their intentions are all too plain.

The Graces of 1856 repeated Etty's standard poses of females with arms raised above their heads to present graceful attitudes suggestive of *poses plastiques* rather than meaningful activity. The central figure has a particularly pinched

waist and wide hips causing the *Art Journal*[4] to complain that her body looked "as if it had been compressed by the stay." *The Graces* has some features in common with Etty's *Venus and Her Satellites*. In both paintings the figures are engaged in a dance, there being no other justification for depicting the nude female form in such positions. The general complaint against Frost's nudes was that they were "mere pieces of tinted flesh."[5] His *Bacchantes* of c. 1850 are intentionally dancing figures but also enticing. Most of Frost's paintings continued the *tableau* composition that Etty had favored, being groups of females in what convention accepted as "classical poses." In his single figure studies he reveals his indebtedness to Etty. They are often indistinguishable and have often been confused with those of Etty but this is unsurprising since so many of Etty's own studies were passed off as the work of others after his death.

The public grew weary of Frost's repetition of arch young women. By 1867 the *Illustrated London News* was commenting,[6] "There is little new to say in defence of Mr. Frost's nymphs and fairies," and when he died in 1877 the *Academy* obituary (*16th June 1877*) said that he had painted

Portrait of William Etty, R.A., by R. Gale (1861), published by Day and Son, Lithographers to the Queen (collection of the Author).

> works of the "nymph" ideal, in which every leg, every finger, and every curve of impossible drapery—not to speak of every face and every "bosom"—had to be "graceful," "classical" and, of course, also "chaste" and proper for the eyes of the British matron in her dining room.

It will be noted that the writer could not bring himself to use the dread word "breast" but had to surround "bosom" with quotation marks to assure the reader of his own delicate feelings. Frost had outstayed his welcome. Collectors no longer wanted nymphs that gazed out at them with undisguised invitation. Whereas Etty had sought to continue the informed aristocratic taste in art, Frost was incapable of perceiving the intention to raise cultural standards by reference to classical iconography. He diverted the nude subject into sheer titillation, the appeal that the nude had had for the unenlightened collectors of the previous century and still had for those of his own time, but their families were no longer willing to accept such works on their walls. Artists were presenting a new version of Venus, derived from actual classical sculpture, not from the flesh and blood of actual models but beings detached from human contact, impersonal and mute in every sense. No painting can more clearly illustrate this than Albert Moore's *Venus* of 1869 in the York Art Gallery which can just as easily be seen as a painting of Greek sculpture as of a living model. Said Sidney Colvin in that year[7] "the excellence consists in pure art, and not in historic or dramatic interest." Not all artists adopted the new ideal of the nude and there were certainly those who continued to surround the nude figure with incident but from the 1860s onwards the increasing fashion was to concentrate less on the anatomical and more on the poetic features of the subject.

Frost disappeared from public recognition and, as Dennis Farr recorded,[8] in November 1938 an album of Frost's pen and watercolor drawings was actually exhibited as being by Etty despite the decorative frontispiece which was signed: "April 13, 1835, W. E. Frost." The drawings had been separated from their binding which is a usual fate especially when it is desired to "upgrade" works for sale. Etty is still a name to cry in aid when an unknown nude painting comes on the market, as witness the seated nude offered by Christie's in March 2001.[9] It was published in the local press as a possible, even a probable, work by Etty despite its obvious failings.

Frost was the only contemporary artist who continued single-mindedly to follow Etty's interests. Other artists who have been identified as followers of Etty very soon abandoned the nude for semi-mythological or historical subjects which could be presented with draped figures. George Patten (1801–1865) entered the Academy Schools in 1816 and at first painted miniatures. He returned to the Schools in 1828 to study life drawing, went to Italy in 1837 and was elected to Associateship in the same year. He was appointed Painter-in-Ordinary by Prince Albert in 1840. His early mythological paintings attracted the criticism of the *Art Journal* whose contributor wrote of his exhibited works.[10]

Several of these are painted on a scale too large for the artist's powers to carry out successfully. Mr. Patten evidently aimed at Mr. Etty's manner, and though his flesh painting of the nude, or semi-nude figure, was fairly good, it cannot for an instant be brought into comparison with that of Etty.

Patten was never elected to full membership of the Royal Academy.

At the beginning of his career Frederick Richard Pickersgill (1820–1900) could have been regarded as a follower of Etty but by the 1850s, when he was in his thirties, he responded to the decline in demand and moved to portraits, draped history subjects and semi-mythological figures. He was the pupil of his uncle, William Frederick Witherington, a full member of the Academy, and from him and his father, Richard, a marine and landscape painter, he learned the advantages of painting literary subjects. In its issue of 3rd July 1852 *The Athenaeum* fired a warning shot, advising Pickersgill that "some of these Ettyian female nudities partake of the academical model and the pose à la Madame Warton." This was suggesting that his subjects, along with Etty's, owed too much to theatrical tableaux. There was probably also a suggestion that the women who formed Madam Warton's troupe were known to be less than virtuous and that there was a hint of guilt by association. The tide was turning as now the religious moralists were actively campaigning against the nude in art and the use of models. William Denholm Kennedy (1813–1865) is said by Christopher Wood[11] to have been a friend and pupil of Etty's. The claim to pupilage is unlikely. Etty had only one pupil, James Matthew Leigh. He may have attended the Soho Academy and so became associated with Etty. Kennedy is not mentioned by Gilchrist nor by Farr and does not appear in any of Etty's letters that have been seen. Born in Dumfries, Kennedy came to London in 1830, entered the Academy Schools in 1833 and won a Gold Medal for history painting in 1835. He specialized in history paintings but after visiting Italy in 1840 to 1842 he changed to Italian genre and historical subjects. He was never elected to Associateship.

Another little known name is Charles Brocky (1807–1855). He was Hungarian by birth and had lived in Vienna and Paris in considerable poverty before being brought to London by a collector who encouraged him in this country. He exhibited in the Academy from 1839, mostly portraits but also such subjects as *Psyche* and *Music and Art Crowned by Poetry*. His work attracted the attention of Queen Victoria. He was never elected to Associateship. William Salter (from 1804–1875) studied under James Northcote (1714–1831), a painter of portraits, histories, animals and "fancies." Northcote had been a pupil and assistant to Reynolds. Northcote's own work has been described as "turgid."[12] His genre works are decidedly amateurish but, apart from Hogarth, British 18th century painting was not generally outstanding. Northcote could not have been the best of teachers for a pupil to emulate and the young William Salter must have got off to a

poor start. Farr likens Etty's experience with Lawrence with that of Northcote under Reynolds.[13] It is likely that Salter's experience under Northcote was similar since the general level of art teaching was lamentable. Salter went to Italy, spending several years in Florence. On his return he exhibited at the Academy but mostly in the Society of British Artists. Christopher Wood states that altogether he exhibited 101 works there.[14] He painted portraits, histories, genre and mythological subjects. The latter subjects must have been early works as they do not now appear to be known. He was never elected to Associateship.

The foregoing may tell a sorry story of Etty's influence over his successors. But times had changed after his death in 1849. In particular the Pre-Raphaelites had stormed the Royal Academy, declared war on "Sir Sloshua Reynolds" and attracted enormous public attention by their skilful marketing. There is such a vast literature on the Pre-Raphaelites that it is unnecessary to record their history here. But their origin as a new aesthetic in British art was not as straightforward as the members wished everyone to believe. Before revolting against the Academy most of them had tried unsuccessfully to gain entry to the exhibitions. John Everett Millais (1829–1896), self-styled founder of the Brotherhood, had every reason later to be embarrassed by his *Cymon and Iphigenia* of 1848, certainly painted under the influence of William Etty's successes. When he called together a number of his contemporaries to inaugurate a new movement, later to be called "the Pre-Raphaelite Brotherhood," he astutely recognized that the increasing number of middle class patrons did not want pictures that their womenfolk could not feel comfortable with. The Gothic Revival was already in full swing, Etty having been a contributory figure, and Millais was probably also aware that some of the more selective collectors were looking back to the Italian fourteenth century painters, that is to say to the true Pre-Raphaelites, as Lady Eastlake was to report in her *Journals and Correspondence*. The result was a curious mixture of Italian "Primitives" and "Merrie England" which northern factory owners in particular found comforting. It will be remembered that they had also been among Etty's principal patrons. They were always anxious to demonstrate their new-found culture and their interest in innovation of all kinds.

But Millais' interest in the nude did not end in 1848. In 1870 he exhibited *Knight Errant*, a medieval invention of a naked woman tied to a tree being rescued by a knight in full armor. It was a curious reversion to a subject that was reminiscent of Etty, such as his *Perseus Coming to the Rescue of Andromeda*, and a surprising lapse for an artist who was always careful of his reputation in the public estimation. However, Millais was able to paint *Knight Errant* because it was a medieval subject such as the Pre-Raphaelites favored and a new taste in nude subjects was now being fostered by Leighton, Poynter and Moore. The painting was altered to satisfy contemporary prejudices. Originally the face of the woman had been turned towards the knight but after some objections Millais turned her face away, not only from her rescuer but also from the viewer. This kept the relationship between the figures impersonal. The critics found the subject difficult to accept. The woman's clothes thrown on the ground and her disheveled appearance suggest she has been raped. Though the knight is performing his chivalric duty of rescuing her it was felt that the woman's plight too obviously invited enquiry for public exhibition. Also, although Millais' son assured critics that the figures had been posed separately the subject was insufficiently Classical to appease them. Nymphs could be ravished by gods and satyrs but mortal women could never be raped by mortal men. "Rape" was not a word in general use in Victorian England. The dominant male of the period preferred to believe that unless a woman was actually tied or held down by others the accusation was unfounded. They considered that, as a "one to one" act, rape was impossible. Attacks on women were seldom reported in the newspapers until the notorious Whitechapel murders ("Jack the Ripper") in 1888 coincided with the beginnings of a sensational press. It seems that at the time Millais was challenging his contemporaries, especially Leighton, but not on their terms. He had returned to an earlier mode, that of Etty, and mixed it with Pre-Raphaelite medievalism, unsuccessfully as it proved.

It was through the paintings of fairies and mermaids that Etty's influence really continued though the artists themselves probably did not recognize their mentor. Jeremy Maas[15] actually included Etty's *Eurydice* in his chapter on fairy painting but one must surely question this. Although Etty could paint "fancy pieces" when inclined, *Eurydice* is neither a fairy nor a fancy painting. It is a straightforward nude study in his normal manner. Much more like fairy paintings are his *Cupid and Psyche Reclining in the Clouds* and *Aurora and Zephyr*. The importance of fairy paintings in British art is a separate subject but it can be mentioned here since one of the reasons for its popularity was the opportunity it gave artists to paint the nude and to escape accusations of indecency. By being "little people" fairies were regarded as children and though child prostitution was rife in Victorian society most people remained unaware of this and did not regard children as offering sexual interest. Fairies are mentioned in British literature as early as the fourteenth century as a subject for painters but they first arose in the late eighteenth century as illustrations for Shakespeare's *Midsummer Night's Dream* and *The Tempest*. Between 1785 and 1790 Henry Fuseli painted *Titania's Awakening* and *Titania and Bottom*, subjects which appealed to his interest in dreams. It was indeed the re-emergence of Shakespeare as a popular dramatist that began the vogue in England and throughout the century Shakespeare provided endless subjects for every mode of art. After Richard Dadd (1819–1887) was confined to Bedlam for murdering his father he painted his most remarkable works, fairy paintings of surrealist complexity.

Joseph Noel Paton (1821–1901) was the most accomplished and well known painter of fairy subjects. These, based on *A Midsummer Night's Dream*, attracted much attention. In both *The Quarrel Between Oberon and Titania* (1849) and *The Reconciliation of Oberon and Titania* (1847) Paton litters the canvas with numerous male and female fairies, all nude, engaging in encounters which left little to the Victorian imagination. Fairyland was clearly a domain where free-love ruled but no one seemed to notice. Robert Huskisson, born in Langar near Nottingham (birthdate unknown, died 1854), exhibited fairy paintings at the Royal Academy and the British Institution

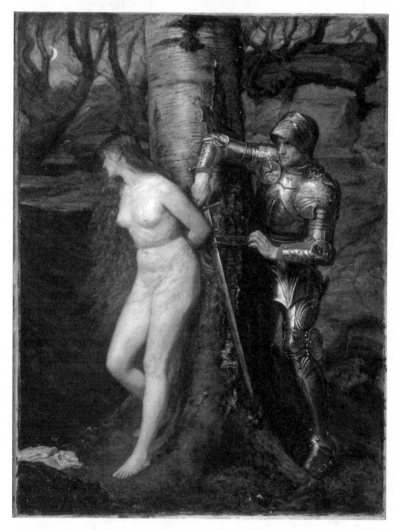

The Knight Errant, by John Everett Millais (72.5 × 53.25 ins) (1870), Tate, London 2005.

from 1838 onwards. His most well known works are *Titania Asleep* and *Come Unto These Yellow Sands*. His personal details are so obscure that some writers equate him with "H/L Huskisson" who was also born in Nottingham and exhibited at the Royal Academy in 1832. It is more likely he was related to him. Robert Huskisson attracted much attention in his day and his paintings were highly regarded. William Frith, who recorded meeting him, described him as a very common man, entirely uneducated, and doubted if he could read or write. Be that as it may, Huskisson appears to have had an adequate knowledge of some of Shakespeare's plays, perhaps from performances. He illustrated Mrs. S. C. Hall's *Midsummer Eve: A Fairy Tale of Love*. Huskisson, like many others, seems to have tapped into a temporary interest in fairies as an opportunity to depict childlike female nudes without obvious sexual interests.

Fairy painters became so numerous and so many of them were but merely competent that it is clear there was a great demand for their work. Fairy stories were now popular and all books, especially those for children, needed illustrations. Book illustrators ranged from the highly skilled to the barely adequate and covered all subjects. Among popular children's subjects were mermaids. Mermaids had long been a subject for artists and travelers recording their adventures. We can go back to the eighth century B.C. in Egypt but their modern use re-emerged in the late Middle Ages when they were depicted as alleged sightings by sailors. They were useful in Renaissance allegories but in the nineteenth century they became truly creatures of the imagination and as the subject of art they came into their own in the late decades of the century, being frequently used to depict the male longing for the unattainable female. Art presaged psycho-analysis. Mermaids were frequently confused with Nereids though in legend the latter were scaly fish-like creatures, being the daughters of the sea god Nereus and his wife Doris whose sisters were of similar appearance. The most famous Nereids were Amphitrite, who became the wife of Poseidon, and Thetis the mother of Achilles. Both were frequently the subjects of paintings from Hellenistic times to the last century. Several notable Victorian and Edwardian painters used mermaids as subjects: Frederick Leighton (*The Fisherman and the Siren*, 1856–58), Edward Burne-Jones (*The Depths of the Sea*, 1887), John Waterhouse (*The Siren*, 1900; *A Mermaid*, 1901), Charles Shannon (*The Fisherman and the Mermaid*, c. 1902), Herbert Draper (*The Water Baby*, 1890; *Ulysses and the Sirens*, c. 1909). There are now many books available on both fairies and mermaids to which the interested reader can refer

Fairy paintings continued to attract artists and purchasers, especially when they became more dream-like. Whilst, as Alison Smith rightly says,[16] all fairies look alike in these paintings, it was possible for artists to introduce elements of fantasy into their compositions. Attendant elves and goblins are small and grotesque and they frequently fill every available space. They cavort in the long grass and the bushes, engaging in pursuits denied to the principal subjects. But, as the *Spectator* wrote[17] of Paton's pictures, "[His] sense of the voluptuous ... carries him to the verge of what modern 'decorum' will tolerate, never beyond it." Since fairies were the subject of numerous children's books and exhibited paintings might reappear as engraved illustrations mothers had to maintain a watchful eye. Fairies gave way to mermaids as popular subjects for adult collectors in the final decades of the nineteenth century.

As early as 1851 William Frost had painted *The Sea Cave*, which depicted a sea nymph or siren sitting against the background of a cave mouth. She is not a conventional mermaid but may be seen as a precursor of what was to follow. Frost was merely justifying a nude female on a sea shore. Painters in the 1880s and 1890s often changed mermaids into sirens. John Waterhouse's *Siren* sits on a rock with the sea washing up over her lower legs and obscuring the tail which is slipping away. Similarly in Frederic Leighton's *The Fisherman and the Siren* of 1856–58 the siren's tail appears to be slipping away as she embraces the sailor. In Herbert Draper's *Ulysses and the Sirens* of c. 1909, as the naked sirens climb aboard the ship they lose their tails and one no longer has any vestige of a tail. Etty's sirens, *The Sirens and Ulysses*, have no mermaid or Nereid features. They are naked maidens with all their human features intact. Frederic Leighton's *Siren*

painting, executed so soon after Etty's death, suggests an influence which has hitherto been ignored. Born in 1830 in Scarborough, Leighton spent his childhood and early youth in Europe, studying in Rome, Dresden, Berlin, Frankfurt, Brussels and Paris. He quickly became influenced by the Italian Renaissance. During visits to London he assessed the likelihood of his interest in the figure affording him a profitable career.

It would be quite wrong to suggest that Etty had any direct influence on Leighton but it can hardly have escaped Leighton's notice that Etty had been a prominent painter of the nude figure in the first half of the century and that his paintings continued to change hands at reasonable prices. In fact, many of Etty's works increased substantially in price as they were sold in the years following his death and in the first decade they were among the few that commanded prices of four figures. Leighton was nineteen years of age when Etty died and had already left Scarborough but could not have been unaware of his fellow Yorkshireman. In 1851 Etty's *Wood Nymphs Sleeping* resold at £500, in 1852 *The Dance* resold at 1,100 guineas and in 1853 a version of *Musidora* passed to the painter Augustus Egg for 345 guineas. In 1856 *Aurora and Zephyr* sold for 710 guineas, *Hylas and the Nymphs* in 1859 for 400 guineas and *To Arms! To Arms! Ye Brave!* in 1866 for 660 guineas. Then in 1870 *Hesperus* changed hands for 1,005 guineas and in 1872 *The Judgement of Paris* sold for 810 guineas and *Pluto Carrying Off Proserpine* for 1,000 guineas. Although no Etty painting maintained its original price by the end of the century, during the two decades when Leighton was launching himself on the English art market there was sufficient interest in Etty's best work to encourage him to believe that the nude had once more become a lucrative subject. The wealthier manufacturers and bankers and others in the commercial field who now constituted the *nouveau riche* were establishing themselves in London as the new cultured class in English society. The classical gods returned.

Leighton did not start out determined to paint the nude figure. His training began in Frankfurt when he was aged sixteen and was mainly directed by his master, Edward von Steinle, towards the Nazarenes. His move to Rome in 1852 changed his direction towards the Italian Renaissance and then in Paris from 1855 to 1858 he absorbed contemporary French influences. In 1859 he

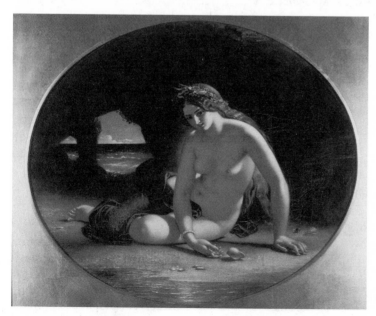

settled in London, experimented for a while with Pre-Raphaelitism but, having membership of the Royal Academy in mind, he began to exhibit works more congenial to that institution as Etty had in his day. After 1864 a series of successes placed him firmly on the road to wealth and importance. In that year he was elected associate of the Academy, full membership following in 1868. Leighton's first exhibited nudes were *Pan*, a languid male figure which was highly praised by Robert Browning who had been an admirer of Etty, and *Venus and Cupid*, both in 1856. Leighton continued to exhibit nude subjects, almost year after year as well as his large mythologies such as *The Syracusan Bride Leading Wild Animals in Procession in the Temple*

The Sea Cave, by William Edward Frost (16 × 18.5 ins) (c. 1851), Russell-Cotes Art Gallery, Bournemouth/Bridgeman Art Library, London; RUS150570.

of Diana, (1866), *Hercules Wrestling with Death for the Body of Alcestis* (1871), *The Daphnephoria* (1874) and *Captive Andromache* (1888), as well as numerous single figures.

Unlike Etty, Leighton, although maintaining a constant flow of nude subjects, did not concentrate solely upon the figure. Realizing the mixed nature of the art market and the general prejudice against the nude he appealed to the high-minded, idealistic pretensions of the new plutocrats and offered them a variety of subjects, including many fully draped classical figures. Other artists who preferred the nude subject were exhibiting in private galleries but Leighton's sights were always set on the Academy. In 1867 the *Art Journal*[18] had described *Venus Disrobing* as "eminently chaste" while the *Athenaeum*[19] declared that "nakedness is not the leading characteristic of this figure." The reviewer went on to welcome the painting as "far higher than the homely or humorous sort which obtains so commonly with us; something requiring ability beyond the painting of draperies with tact and skill."

These words remind us of Etty's own declaration that he was not interested in painting "materials." They also signal a diminishing interest in domestic and narrative genre, at least by discerning critics, for the taste continued among the general public for several decades. From the 1860s English art underwent considerable changes. The emphasis must be on the plural for in art, as in everything else, there was never a single "Victorian style." In the middle decades of the century there was a growing religious influence and for the arts this meant either, at one extreme, that religion and art became estranged or, at the other, that art became the tied servant of religion. The reaction of many artists and critics was to create art's own religion of beauty as a series of aesthetic experiences to awaken sensations of exquisite beauty. The most literary expression of this aesthetic is to be found in Walter Pater's *The Renaissance* of 1873 (the more familiar text is the revised fourth edition of 1893). His ideal of the sensual image was fully expressed in the effete nudes of Burne-Jones and in the concept "art for art's sake" or beauty sufficient unto itself. Walter Pater and Sidney Colvin sought to elevate the aesthetic, and therefore the nude, to forms of emotional sensation which, while not linked to morality or intellectual discipline, had the same appeal to the higher senses as music. The general public found difficulty in accepting the nude as an "autonomous" subject, pure, disinterested and detached from all physical interest. Artists might present themselves as seeking perfect beauty, whether in Edwin Long's *Search for Beauty* and *The Chosen Five* or in Burne-Jones' *Pygmalion and the Image* but the public, and especially the male members, could not ignore the appeals of the desirable. The middle decades were

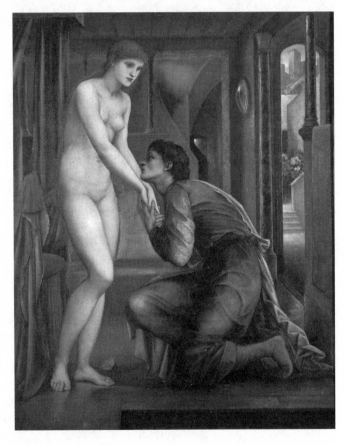

Pygmalion and the Image, the Soul Attains, by Edward Burne-Jones (39 × 30 ins) (1868–78), Birmingham Museums & Art Gallery.

The Chosen Five of Crotona, by Edwin Long (60 × 90 ins) (1885), Russell-Cotes Art Gallery, Bournemouth/Bridgeman Art Library, London; RUS068491.

therefore times of intense debate between the two wings of society. Moralists were joined by indignant fathers who feared that if their daughters saw images of their own bodies they would immediately take to a life of prostitution.

By the early 1880s the nude was once more established as a legitimate subject for art. Through the work of Frederick Leighton, Edward Poynter, Albert Moore and George Watts, the nude figure, and especially the nude female, was again present in large numbers in the exhibitions. All these artists and many others had been either educated or trained abroad, usually in Italy or France, and many of them impressed their patrons with their learning and impeccable manners. Generally they were concerned to express the ideals of high art through classical myths with elegant figures and sumptuous color but Albert Moore concentrated on wholly decorative figures both singly and in groups, often coldly marmoreal thereby exploiting the public preference for sculpture for such subjects, a typical example being his *Venus* in York Art Gallery. Moore belonged more to the Aesthetic Movement than the late Victorian Renaissance as usually understood.

But the return of the nude subject was not without its consequent opposition from the moralists who were renewing their campaigns against the living model. John Callcott Horsley, Treasurer of the Royal Academy until his resignation in 1897, was a leading opponent, famously masquerading as a "Model British Matron" in his letters to the press. *Punch* exposed him in October 1885 and Robert Browning joined in condemning him, particularly in his *Parleying with Francis Furini* in 1887. The moralists encountered other, unexpected, oppositions. Women themselves adopted differing standpoints. Women art students, whose number was increasing, generally insisted on their right to attend life classes and to draw, paint and exhibit the nude of either sex. Many young women of respectable families, making no claim to be artists themselves, saw no objection to nudity in art. There was a greater liberality in ideas and behavior and many women of social standing were frequenting artists' studios not only for the excitement of being

in the presence of models but often in the hope of becoming occasional models themselves and the mistresses of the artists. These were not ideal reasons for defending the nude as subject but the voices of these women assisted the debate.

There were, of course, other women who denounced the nude in art as demeaning their sex. They were fully aware of the *voyeuristic* appeal of the nude in art, especially when it was depicted with obvious allurement. There was also now a general awareness that pornographic photographs had for long been readily available. Although usually regarded as a French import, there was a constant supply in Britain. The Orientalists who had traveled to the Near East and come back with drawings—and subsequent paintings—of slave markets had encouraged the imagination of those who had never ventured beyond their shores. Paintings of totally naked slave girls being offered for sale in street markets were often accepted merely as records of foreign customs but to many it was apparent that they were intended to excite sexual fantasies. Understandably women were now demanding full equality with men and their customary social roles were redefined, even to the extent for some of denying men any sexual favors. Platonic friendships became the vogue ignoring even the biological necessities of the sexes.

For the most part British artists returned to ancient Greece and Rome to justify their subjects. This was the age of so-called Aestheticism when beauty alone was the declared aim of art. Artists again sought to elevate the female as the epitome of all perfection. A favorite theme was Zeuxis' search for an ideal beauty to portray Helen of Troy (e.g., Edwin Long). Paintings with rows of naked females in varying poses (e.g., *A Visit to Aesculapius*, Poynter) or bathing in forest pools (e.g., *Hylas and the Nymphs*, Waterhouse) were really no more than variants on the classical treatment of the three Graces or the Judgment of Paris.

Sculpture of the nude was more popular but its cost placed it out of reach of most collectors. The sculptured nude had always been less censured than the painted nude, possibly because it was held to have closer links with antiquity. Richard Jenkins in his *Dignity and Decadence* suggests that the fact that so much Victorian sculpture was in white marble encouraged acceptance of the nude figure as a "pure" subject. Thus, while Mrs. Elizabeth Barrett Browning could admire Hiram Power's *Greek Slave*, she could not accept John Gibson's *Tinted Venus*.[20] She was not the only one who found this work unacceptable. Although *Venus* was partly draped and the *Slave* was not, the latter suggested unwilling nudity (she was chained and held a small crucifix, suggesting a Christian captured by Turks) whereas, by being colored, *Venus* was regarded as altogether too lifelike and more suitable for a waxworks. Thus it was possible for Albert Moore's subjects to be readily accepted.

The greater acceptance of sculpture as a medium for depicting the nude figure was recognized by many painters who in the later 1860s combined this fact with the interest of the general public in the apparent mysteries of the artist's studio. The studio was often regarded as a secret sanctum where special relationships were established between artist and model, not necessarily erotic as portrayed in popular novels of bohemian life that were beginning to attract readers. Many preferred to see the relationship as approaching the spiritual where, as Alison Smith has said,[21] the role of the artist was seen as transforming the actuality of the model into the perfection of the Ideal. This was certainly what Etty had always attempted. We can see this idea in Albert Moore's *Venus* where the model, a painted image, is shown, not as flesh and blood, but as classical sculpture of a goddess. This is a double transmutation. The next step would be to transmute her yet again into a living goddess.

Paintings of artists painting models or carving from the model and achieving this transformation became popular. In 1868 William Morris published his version of Pygmalion and Galatea, *The Earthly Paradise*, based on Ovid's story in *Metamorphoses*. In this story the case was made as early as ancient Greece that the nude figure, and especially that of woman, could be transmuted by the romantic artist and poet into a symbol of ideal beauty. Several artists depicted the moment of transformation as marble turned to flesh before the astonished and adoring eyes of the sculptor.

Edward Burne-Jones preferred to present the sculptor as the humble instrument of the goddess Venus who, in his absence, had breathed life into the stone. It is tempting to suggest that Etty would have seen himself also as an instrument.

Sir Lawrence Alma-Tadema set his figures in scenes of architectural accuracy that gave them archaeological justification and nullified criticism. This was the kind of art that Gaunt and Roe condemned[22] as "an enfeebled medley of fake antiquarianism." The taste of the plutocracy had, by the end of the century, declined into the very degeneracy that the collectors of the first half of the century had tried so hard to avoid. The nude female as vulnerable victim and desirable object suited the Edwardian mood but not the "New Woman" who was making herself heard as an independent voice. There was no longer a public admitting only to a single morality. As many women argued more cogently than their predecessors against the exploitation of their sex many others also demanded the right to become as free as men to study the human figure. Details of the campaign against the nude in art can be read elsewhere (Alison Smith's *Victorian Nude* provides a useful summary). Suffice to say that the campaign was killed off, as so much else was, by the 1914 war and in the 1920s models formed their own professional association and many became so famous that they encountered no difficulty in entering so-called "Society."

By the first decade of the twentieth century there was greater willingness to look abroad, especially to France, for a true realism. Walter Sickert returned having absorbed much from his friend Edward Degas, bringing the idea that working class life was as worthwhile a subject as anything else. He retained an interest in the nude but accepted the unadorned *naked* bodies of working girls as preferred subjects. Gods and goddesses did not exist, nobody lived naked (even the Greeks had never done so, except in the male Games, and certainly never the women) and the only justifiable examples were people preparing for bed and taking a bath. It has always been difficult for "the man in the street" to justify the reality of the nude. In European history the nude in art has been an aristocratic interest. For several decades the new consumerism had expressed itself through an art more suited to the drawing rooms of the middle classes, but in the closing decades of the century a new generation of financial and industrial plutocrats re-established the old aristocratic interests. As usual, a new generation of artists also arose to satisfy these demands and, whether they realized it or not, Leighton, Watts, Poynter, Long, Tadema, Moore and their lesser known contemporaries owed much to William Etty's adoration of "God's most glorious work."

Etty in the twentieth century

For Etty the final three decades of the nineteenth century were years of silence until he was included in *The Royal Academy from Reynolds to Millais* published by *The Studio* in 1904, in the section written by Walter Shaw Sparrow. A new art of grand classical design was now fashionable and the English artists who had battled their way to the forefront earlier in the century were cast aside. Then came another decade of silence until in 1911 Etty was again fully remembered and this time it was, perhaps surprisingly, by the city of York. Surprisingly because his native city had so far paid him scant regard. In February of that year, thanks to the efforts of Wallace Hargrove, J.P., a retrospective exhibition of Etty's works was held in the City Art Gallery. A special committee was set up by the Corporation with Wallace Hargrove in the chair to make all the necessary arrangements. One hundred and sixty-four paintings were exhibited and the event was regarded by everyone as a considerable success. Even so, it proved impossible to obtain some of the larger works required. *The Yorkshire Herald* of 4th February 1911 reported that two ladies, descendants of Etty, resident at Bournemouth, absolutely refused to allow any pictures by Etty in their possession to be exhibited.

In addition to this belated tribute to a famous son, York Corporation decided to erect a statue in the artist's memory in the square fronting the Art Gallery. It was carved in Portland

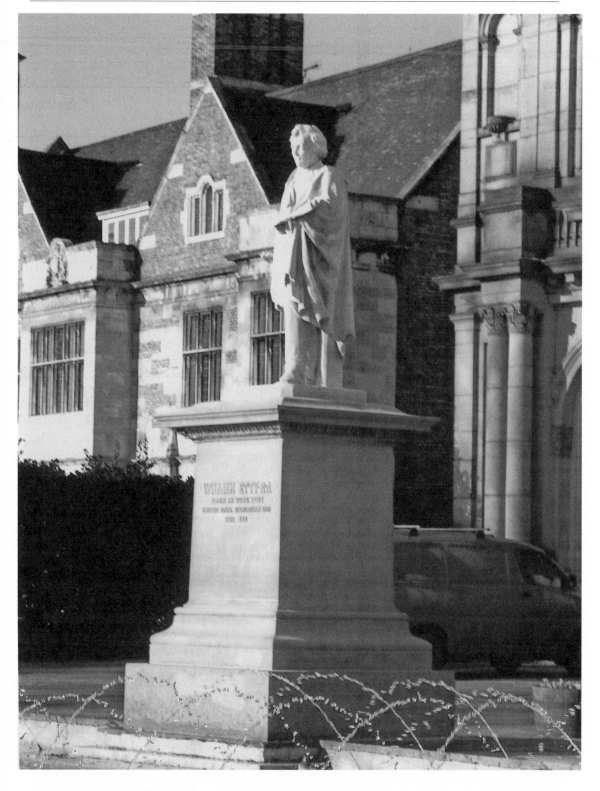

Statue, by G. W. Milburn, erected to William Etty outside York City Art Gallery, 1st February, 1911 (photograph by John Rhodes).

stone by G. W. Milburn, a local sculptor working near Bootham Bar. This was unveiled on the 1st February 1911 by the Lord Mayor, Alderman T. Carter, in the presence of the Sheriff, Mr. F. A. Cammidge, and his fellow Aldermen and Councilors who had walked in procession from the Guildhall to Exhibition Square. Wallace Hargrove gave an address, recalling that as a boy he had known the aged Etty. Photographs published in the newspapers at the time show the ceremony to have been well attended by the public. The statue remains to this day and has recently been cleaned by the York Civic Trust. Apparently Mr. Milburn found some difficulty in obtaining a likeness of Etty standing as he wished to depict him. *The Yorkshire Herald* was pleased to reveal on the 10th April 1911 a curious circumstance. Someone had brought to their offices, "for another purpose," a copy of the *Illustrated London News* of July 1845. On looking through it a member of the staff noticed a line drawing of Etty standing with his palette. By that time Mr. Milburn had completed his statue but reference to the drawing showed that he had portrayed the artist quite correctly, relying entirely on Mr. Hargrove's recollection.

The catalogue to the exhibition followed the custom of the time by confining itself to a list of the exhibits with a very brief introduction. This was written by Herbert Gilchrist, Alexander Gilchrist's son, who reminded readers that this was the first exhibition of Etty's works since the retrospective exhibition in the summer of 1849. He made the claim, "With the death of Etty the *first period* of British Art in figure painting closed." This misreading of the art of the Victorian Age was commonplace. *The Yorkshire Herald* gave a lengthy review of the exhibition consisting mostly of a series of descriptions of the works on display. However, the review did conclude with the words, "Mr. Etty is a great artist—an honour to the English school, and one who will live hereafter." York Art Gallery today possesses sixty-nine oil paintings and seventeen attributions acquired from various sources, many since 1946, and a large collection of drawings by Etty. York's holdings are by far the largest in a single collection and for many years a comprehensive selection was on permanent display in a separate room. The Gallery is now under new management and Etty will no longer enjoy a special place in the exhibited collection.

One of the most enduring forms of appreciation that any artist can hope for is that his work will continue to be collected. In this Etty has had a mixed success. Many galleries owning a single or perhaps only a few examples of his works have confined them in storage. The Tate Gallery, with twenty-one works mostly acquired from Robert Vernon via the National Gallery, has been particularly shy until recently of exposing its holdings to the public. The Victoria and Albert Museum possesses forty works, many of them studies or preliminary sketches; Manchester Art Gallery has thirteen paintings; the Lady Lever Gallery, Port Sunlight, has twelve, the Courtauld Institute of Art has ten, the Williamson Art Gallery, Birkenhead, has seven, the National Gallery of Scotland has six, Birmingham City Art Gallery has five. The National Trust owns at least seven paintings and numerous drawings. There is a fair sprinkling in other public collections.

Among private collectors two were exceptional, Lord Leverhulme and Lord Fairhaven. Both were greatly impressed by Etty's abilities and no doubt by his subjects. Lord Leverhulme formed his collection in the final decades of the nineteenth century and, though originally based on his love of china, it had been extended to encompass as much English art as he could accumulate. Born William Lever in Bolton, Lancashire, he was the son of a wholesale grocer. Becoming a partner in the business at the age of 21 he began to expand the business and then in 1884 decided to specialize in the manufacture of soap. His increasing wealth enabled him to begin buying works of art and then, after meeting the painter James Orrock, to begin collecting in earnest. The progress of Lever's collection from private interest to public exhibition is typical of the best philanthropists. He was encouraged by his wife and when he was made a peer after her death he added her maiden name, Hulme, to his own, becoming Lord Leverhulme. Much of his collection was made public in 1922 when he housed it in a specially constructed gallery at Port Sunlight. It was a notable feature of Lord Leverhulme's intentions that the general public

and his employees in particular could visit the gallery without payment at any time, it being his profound belief that art enriches man's spiritual life.

Leverhulme's interest in Etty sprang partly from approval of his work, especially his belief that the nude was a wholly appropriate subject for art, and also from the opportunity to purchase Etty's work cheaply since the artist had fallen out of fashion. From 1896 onwards, acting under the guidance of James Orrock, William Lever, as he still then was, had collected no fewer than forty of the painter's works. His admiration of Etty was such that he displayed the works in the entrance hall of his house, often to the embarrassment of visitors. When he established the Gallery in memory of his wife he transferred thirteen of the paintings to the collection, including *The Judgement of Paris, Cleopatra's Arrival in Cilicia, Aurora and Zephyr* and *Britomart Redeems Faire Amoret*. The gallery was but part of Lord Leverhulme's philanthropy which ran to the erection of model homes in a garden village, parks, gardens, recreation grounds and social clubs, a gymnasium and swimming bath, a hospital, church and schools.

In 1928 the Trustees of the Lady Lever Art Gallery at Port Sunlight commissioned the publication of illustrated catalogues of the works in their collection. These ran to three large volumes with an Introduction by Roger Fry who was then in his sixty-second year. In his Introduction Fry was concerned to demonstrate that the collection, though lacking examples of certain notable artists, was nonetheless representative of the taste of the best minds in the nineteenth century. As was customary with Fry he leaned towards those paintings which presented sensitivity to color and form rather than to representation and the expression of ideas. In this regard he criticized Turner and Wilkie for encouraging the illustrative in art—surely a curious criticism to make of Turner's mature works—and went on to couple the name of William Etty with them for responsibility in leading the Victorians to believe that illustration was the true purpose of art. Fry could not ignore Etty, which he would probably have preferred to do, since his works comprised a large proportion of Lord Leverhulme's collection. Fry stated that "Etty had a real sense of pictorial style" and "is a figure of great interest for the understanding of the period." Some of his works he declared to be "of a genuine and highly talented artist." These were Etty's single figure studies. His larger works with a number of figures, such as *Cleopatra's Arrival in Cilicia*, exhibited, he said, "a certain feeling for design and composition" but were "sacrificed to the striking theatrical decoration." With this criticism one cannot disagree. When Fry went on to complain that in Etty's later works "the extreme bad taste of contemporary life has begun to tell more and more," one may conclude that he was suggesting an increasing interest in the nude female figure as offering prurient satisfactions. As has been indicated earlier, such interest had always been present and the general changes in Victorian taste developed not to more and more nudity but to genre subjects suitable for family viewing. Fry had no interest in placing art in socio-historical contexts. For him art history was little more than placing artists and their works in chronological order and recognizing how each was influenced by other artists and whether they met his criterion of "truth to form," which did not mean truth to natural form but to his ideas of aesthetic form.

When, in the same Introduction, Fry considered Herkomer's *Last Muster* he had no interest in the social comment that Herkomer was making. The most he could concede was that the scene had "a certain sentimental pathos." More important to Fry were the varied tones of the soldiers' red coats and how they harmonized with the colors of the floor and the paneling. Of course any worthwhile artist will be concerned with such matters but Herkomer was above all a painter of social realism and the way Victorian society treated their old soldiers was of great importance to him. Remembering that Etty had always been praised for the quality of his flesh painting and that his subjects were always "other-worldly," one might have thought that Fry would have concentrated on "the glowing luminosity of its colour" (as he was willing enough to mention) rather than regarding him as an illustrator. However, Fry concluded with due praise. "Etty's work marks the last flicker of the great tradition of painting in the English School for

many decades." Coming from Roger Fry, that was praise indeed. The current catalogue of "Earlier British Paintings in the Lady Lever Art Gallery" by Alex Kidson includes detailed analyses of nine of Etty's paintings. A further thirty-four works originally in the collection have since been dispersed elsewhere.

Like Leverhulme, Lord Fairhaven owed his wealth to trade. Huttlestone Fairhaven's father was Urban Broughton, born 1896, whose fortune came from mining and railways in the United States. His mother, Cara Rogers, was a wealthy New York heiress and between her and her son Huttlestone there was a deep attachment. No doubt the son acquired his interest in the arts from his mother. The title which had been destined for Urban passed to Huttlestone on his father's death in 1929. The house was jointly owned until 1932 with his brother Henry. A second barony was conferred on Huttlestone in 1961 to which, on his death in 1966, his brother succeeded. Once Huttlestone had the house and the fortune to devote to collecting works of art he set about becoming an important patron while still maintaining an interest in various sports. Like Leverhulme before him he collected anything that appealed which at first revealed a fairly conservative taste in furniture and military and sporting pictures. He realized that as interest in the art market during the 1930s to 1950s was very weak in Great Britain he could acquire paintings comparatively cheaply. Although remaining traditional his taste did expand and soon he had a wide collection including some twenty paintings by Etty whose works apparently exercised a considerable attraction. Modern commentators might ascribe this to Lord Fairhaven's bachelor status and to the strong influence his mother had had over him.

Lord Fairhaven was also a keen gardener, creating a Georgian garden described by others as a masterpiece. Single-mindedly devoted to what interested him, punctilious in everything and renowned as a good employer he was highly regarded by his contemporaries. Of him Sir Arthur Bryant wrote: "He governed his life by a Roman sense of rule and duty, revealing himself only to his friends to whom his constancy was unshakeable."[23] Lord Fairhaven's collection of paintings remains in the care of the National Trust at Anglesey Abbey, Cambridgeshire. There is no published catalogue of this collection but a privately prepared account may be obtained on request.

Before the 1939 war a series of exhibitions devoted to Etty were held in London marking a renewed interest in his work. In November 1933 the Victoria and Albert Museum mounted an exhibition of *Paintings by William Etty, R.A.* The Museum's collection was acquired from various sources beginning as early as the 1860s. The drawings are similar to those in the York Art Gallery, whose collection is also very large. Most of the latter are simple studies of figures and parts of figures, often attempts at bold outlines in the manner of Flaxman, and sometimes mere scribbles suggesting compositions for paintings. It must be said that while most of Etty's drawings are of interest to students they are not material for a public exhibition. As it has been stated earlier, whilst Etty could, when occasion demanded, produce finished academic drawings, his real interest was color and he was more skilled with the brush.

In May and June of 1936 the Adams Gallery in London also mounted an exhibition of Etty's paintings for which Sir Charles Holmes wrote the introduction to the catalogue. Holmes said that Etty's

> figures are not "nudes" in the broad pictorial sense of the word, but London women who have just taken off their clothes and whose satin skins have never been tanned by the sun and the wind. So when they are composed into a picture in the grand style, they remain naked,—undressed. But when we see them in isolation, as studies from the life with a conventional background, this incongruity vanishes.

This was, as we have seen in the preceding pages, a problem which Etty's contemporaries could not face but in the more relaxed 1930s the public had no difficulty in accepting pictures of unashamedly naked women. Holmes thought it might have been better for Etty's art if he had not depended so heavily on the Academy Life Class but, as true as this is, Etty's personal

position, the Academic tradition within which he worked and his need of experienced models compelled him to rely on the Class. Holmes had, however, realized the important distinction between Etty and previous painters of the classical nude, though he did not pursue the matter further to discuss the essential development that Etty had made in the painting of this subject, one which was to be carried forward by Gustave Courbet in France.

In November 1938 the Brook Street Galleries in London mounted a further exhibition of Etty's works. It would appear that Etty was being promoted in these years as a significant figure in British Art but the war interfered with any further exhibitions of this nature. In March 1942 *The Connoisseur* published an article by F. Gordon Roe but the next serious re-assessment was *Etty and the Nude* by William Gaunt and F. Gordon Roe, privately published in 1943. This was a surprising choice of subject for publication during a war that was stretching the country's resources to the limit. Certainly a number of publications were being issued that stressed, as propaganda for the war effort, Great Britain's superior position in cultural achievements but Etty would surely not have sprung immediately to anyone's mind as an artist of international significance in 1943. The Authors' Preface suggests that this book was entirely their brainchild.[24]

> Great Britain, mistress of understatement, is so chary of commending her own stupendous genius, that the Authors determined to jog the memory in one particular with such completeness as wartime conditions would allow them to realize. Hence this revaluation of William Etty who, in any other country, would long ago have achieved a mighty fame, but who in the land of his birth is still regarded with a certain suspicion and indifference, despite the praise of discerning observers of every school of thought.

Gaunt and Roe confined themselves to re-evaluating Etty's treatment of the nude figure and especially the female nude. They hailed Etty as "the first, certainly the first English, painter to specialize in this one aesthetic research."[25] They deplored the neglect meted out to Etty and to the nude subject. They ranked him with the sculptor Flaxman and through him to "the classical integrity of Phidias and Praxiteles." "Before Etty's arrival, England had nothing to offset in nude-painting the tremendous performance of Titian or Paul Veronese.... 'The Nude' was an adventure for England." But they had to admit that Etty was no classicist. "In spirit he is far nearer to the great romantic Delacroix,"[26] though this has always been a contentious subject among critics interested in Etty. They compared Etty with Degas and so moved on to deal with the perennial and vexed subject of "the naked and the nude."

Surely such a straightforward comparison with Degas was erroneous. Degas, like Courbet and Manet before him, refused to depict the nude as a mythological subject. The naked female was, for Degas, always a subject of everyday life, engaged in her toilet, in her bath, dressing or undressing. A popular subject for Degas was the prostitute entertaining her client, especially in brothels. She inhabited parts of Paris that the polite visitor was unaware of, though well known to many of that city's citizens. Degas did not seek to idealize the nude anymore than did his disciple, Walter Sickert. For them the naked female was normal experience. It may be objected that Degas and Sickert, like so many others, concentrated on the female nude and never, or seldom, presented the male. If the human body really can be idealized why is it that it is always the female that is so transformed? The usual answer, and surely the true answer, is that it is precisely the female body that *can* be transformed because it needs so little improvement. "Art," said Aristotle,[27] "completes what nature cannot bring to finish. The artist gives us knowledge of nature's unrealized ends." There are, of course, many philosophical assumptions in this statement which today we cannot accept but man's age-long search for beauty has always assumed that, though it may occur in nature, it needs art to make it manifest. One can say that the mere fact that the back view of a naked woman so often presents a beauty independent of sexual implications in itself suggests that the female form is biologically fashioned to appeal to our aesthetic senses and is therefore a natural subject to be idealized. Kenneth Clark considered[28] that "the back view of the female body is more satisfactory than the front" and cited Velasquez's *Toilet of Venus* in support. The aesthetic appeal of the female is that she can be idealized into non-sexual forms.

It does not appear that Etty has ever been compared with Renoir but this could be a very rewarding exercise. This is not to propose that there is a similarity in painting styles but in many ways these artists approached their subjects with the same intentions. Both relied heavily on models, both looked to the Classical world and to the Renaissance. Although Renoir translated the classical into a modern idiom and Etty did not, both drew on the past and both glorified the female nude as the essence of beauty. Renoir's *Baigneuse au griffon* in particular and his many reclining nudes and bathers in general all reveal the same obsession with feminine beauty that compelled Etty to pursue his *idée fixe*. Renoir also could look back to Titian and Rubens. His *Judgement of Paris* has been regarded as a contradiction of traditional subject and modern style, a criticism that could equally be leveled at his nymph-like nudes in Arcadian landscapes. We are perforce driven back to Kenneth Clark's words—"The nude is an end in itself" and "The nude is not a subject of art, it is a form of art."[29]

It has been a problem, for over a hundred years now, to distinguish aesthetically between the naked and the nude. The need to make a distinction may have arisen with Courbet, especially his painting *The Origin of the World* (which many would claim also invites distinctions between art and pornography). Gaunt and Roe agreed that "naked" could be applied to "a number of Etty's most interesting productions"[30] but they quoted Etty's defenses against charges of painting the voluptuous and the lascivious and accepted that his concern was to paint the Nude "with wholesome enthusiasm." Etty always said that he was not interested in the major preoccupation of earlier English painters, the "painting of stuffs." It was not the human form dressed to present a false image to the world with a show of status that interested him. He wanted to paint human form itself just as Michelangelo had done. It was man that was the glory of God, not the clothes he dressed up in. If it is true, as Etty would have believed, that "The Word was made flesh and dwelt among us," then it cannot be perverse to glorify that incarnation in ordinary men and women.

Gaunt and Roe admitted,[31] as anyone must who has studied Etty in any detail, that he

> was not a profound thinker—nor do his letters and other writings contain a great deal that is of value apart from being evidence in matters of fact.... But Etty had managed to pick up the flowing style of the period, the pseudo-classical ornaments and prose flourishes, the profusion of capital letters, genteel abstractions and needless quotations which regrettably dehumanize his writing. A criticism of his literary style evidently does not directly concern his ability as a painter, but the banality it occasionally shows perhaps indicates the quality he lacks.

Certainly if we were to judge an artist's ability with the brush or pencil by his ability with the pen there would be many unable to pass the test. Gaunt and Roe added that "Etty was very simple and naïf" with a feeling "for a not very historical 'Olden Time,' ... complemented by a hatred of Progress." What Etty was attempting, of course, was to present the nude as a classical concept. The naked meant "warts and all" and for Etty the ideal female had no blemishes. Above all, the reality of her sex must be obscured, which predominantly meant, following Leonard's dictum, that the sexual parts must never be depicted. This was a principle included among the Renaissance requirements for "decorum" in all the arts. If these rules were observed then the naked was always the nude. Etty had a clear idea of the distinction between art and the erotic and mostly between art and pornography. With the example of Rowlandson before him he knew the nature of uncontrolled masculine curiosity.

Grant and Roe did not quote Rippingille but are we not reminded by their reference to Etty's not being a profound thinker of that artist's description of Etty's eyes as having "no character of thought in them"? Probably the one subject outside his art which concerned him was his religious faith and even here it was not so much the theological problems of moving from Anglicanism to Rome that concerned him but the social difficulty of adopting a faith that had not been readmitted into the British way of life. Etty was ever the conformist and the traditionalist and his art, like his religion, was grounded in established values. Gaunt and Roe regretted

that Etty was not able to be a discerning critic of contemporary art.[32] They likened his descriptions of the places he visited to the hollow words of travel advertisements and they also objected to his frequent *clichés*. It is true that everything that appealed to him was "beautiful," that all lawns were "velvet," all hillsides "verdant" and all skies "azure," but we must have regard to his limited education and to the lack of opportunities at the time for boys of his class. Gaunt and Roe found it curious that contemporary artists, even the French painters of the nude, had so little influence on him—though this is surely questionable since he frequently praised some of those whose works he saw in Paris. The "momentary contact between English and French art and the resultant kindling of a new force in the art of the century" (that is to say, the rise of Romanticism): "an exact appreciation of this on the part of Etty is sought in vain."[33] Their assessment of Etty the man was that he was naive but nonetheless "a happy man, a sunny nature without depth or morbidity."[34]

> It is not Etty's reading or scholarship (such as it was) that we admire, nor yet his imagination, but, as he interpreted it, the living miracle of flesh. Faced with a choice among the *Bathers, Reclining Nudes* and *Models*, it is hard to direct an enquirer to Etty's greatest work—it is a difficulty that may be solved by saying that they resolve into one great work—the painting of the human form, as it had not been done since Rubens.[35]

They go on to describe Etty as "one of the main ornaments of the English school and a master of European standing." Perhaps in their book Etty was being enlisted in the war effort to present British culture as superior to anything in Europe and certainly superior to the art of the enemy. At a time when the acquisition of paper for publications required a license Gaunt and Roe must have been able to persuade the authorities that Etty was a worthy subject.

After the war 1939 Etty again returned to public attention in 1948 when the York Art Gallery reopened in January of that year with an exhibition of thirty of Etty's works which the gallery possessed. In the Introduction to the catalogue the curator, Hans Hess, who did so much to advance the gallery, found it necessary to excuse Etty as "a child of his time and it may be unfortunate that the fashion for allegorical and historical painting was at its height during Etty's working life. He had no intention of breaking with tradition; he was, in fact, very much of it."

He went on to say that "Etty, by nature a conservative, chose to perpetuate in art the long and glorious tradition of Raphael, Titian, Rubens and Veronese" and described him as "an anachronism in his own day." The following year, between 13th November and 31st December, the York Art Gallery mounted a larger exhibition to commemorate the centenary of the artist's death. This time 108 works were assembled and a special publication, *Etty and York*, was commissioned to augment the catalogue. In his booklet of sixteen pages the author, James M. Biggins, dealt with Etty's relationship with York, his early life, his activities on behalf of York's historic memorials and the School of Design and his retirement in York. James Biggins did not deal with Etty as an artist or attempt an evaluation of his work, probably because the curator had already commented on this. It was very much an exhibition intended to present the image of "a son of York" for the local inhabitants to admire.

There had been no full length biography with a critical assessment of Etty since that by Alexander Gilchrist in 1855. In 1958, just over a century later, Dennis Farr published his book *William Etty* based, as he said in his Preface, on his thesis for the University of London. At the outset, on page 1, Farr regarded Etty as "an extremely gifted minor master" who "occupies a secure and enviable niche in the history of British art." Contrary to other critics' opinion that Etty pioneered the painting of the nude in England, Farr said that "in his own day he was not unique as a painter of the nude." This was surely a doubtful statement. If not unique, in the true meaning of that word, Etty was certainly the most notorious. What did mark off Etty from his contemporaries was "his intensive study of its problems and unwearied devotion to the Life School." Farr pointed to the "series of conflicting ideas ... struggling for supremacy at the time"

and that "Etty was attracted by elements of French academic painting which would seem at odds with his sensuous use of paint and rich colour, and this duality or compromise is found again and again in his work."

Moreover, Etty "never understood the implications of French romantic painting." One would go further. It is doubtful if Etty ever understood what Romanticism was about and probably did not even realize its existence as a powerful cultural force. He was familiar with a different kind of art that was being produced but very probably not aware of its significance. The romantic elements in Etty's paintings arose not from any recognition of the Romantic Movement but from his own nature. He idealized women with all the fervor of a Romantic poet but tried to maintain the propriety of the distant worship of a Dante. Farr's book is a sympathetic biography of both Etty's life and the development of his art but comes to the view[36] that Etty "appears to have been the victim of his own ambition to become a history painter. An aim which was always at odds with his limited but genuine talent.... Etty could never shake himself quite free from an outmoded classicism."

Farr concluded:

> he became not a prophet but a grand glittering relic of a past age. Even so, British painting would be infinitely poorer if bereft of the work of one of the greatest figure painters it has so far produced. Etty has left a rich and diverse artistic legacy, the scope of which is only now being fully understood.

Dennis Farr's book is an essential source book for anyone seeking to understand William Etty and his work. Farr stands alongside Alexander Gilchrist in rescuing this misunderstood man from undeserved oblivion. But he paid little attention to the historical and social factors determining the art of the time and especially of Etty's own ideas. It is true that Etty did not possess a romantic imagination but he possessed a traditional nature which could be expressed because there were still many traditional forces demanding allegiance to principles rooted in the nation's history. Somehow Etty had absorbed the aristocratic principles of the eighteenth century which had sought to establish a refined culture based on Classical ideals. He may not have understood the Enlightenment, may not even have heard of it, but he was by nature attuned to it. What he did know was that the contemporary clamor for change, equality and freedom, the extension of the franchise and all the other demands of the Chartists were dangerous because their consequences could not be foreseen. He always feared the unknown. The past was certain and it could be built on. Traditions must not be destroyed. The art of the classical past and of the Renaissance offered firm foundations. Modern revolutionary ideas did not.

Inevitably the name of Etty comes up in almost every study of the Victorian age, especially of its art. Typical examples are Graham Reynolds' *Victorian Painting* (1966), Quentin Bell's *Victorian Artists* (1967), Jeremy Maas' *Victorian Painters* (1969), Alison Smith's *The Victorian Nude* (1996), Lionel Lambourne's *Victorian Painting* (1999) and Dianne Macleod's *Art and the Victorian Middle Class* (1996), though the latter does little more than note that he was collected in his day. Inclusion in histories of Victorian art, as in the first three titles mentioned, is of course unavoidable but recognition of Etty as an important factor in the shaping of Victorian morality is less usual. Alison Smith gives Etty some space in her book but finds difficulty in absolving him from all blame in arousing the moral campaign against the nude in art. She suggests that by introducing movement of the figures, especially movement suggesting attraction between the figures, he encouraged the public perception that his nudes did not occupy the realm of art but that of vice. One can see some justification for this view. Traditional depictions of Adam and Eve had not implied sexual attraction; subsequent depictions of Venus and Adonis, or Venus and Mars, for example, did. Thus it could be said, "Etty's naked females offered erotic titillation."[37] In Victorian England this was unacceptable. At least, it was in public art. Many Victorians became famous after their deaths for their private collections of salacious and often pornographic images.

Of the general histories of English art perhaps two may be singled out. *The Oxford History*

of English Art: Vol. XI, 1800–1870 by T. S. R. Boase (1959) links Etty with Delacroix by quoting from the latter's collected correspondence in 1858.[38] Delacroix recalled with pleasure the work of Wilkie, Etty, Lawrence and the Fieldings, but especially of Constable and Turner. During his visit to England in 1825 Delacroix had singled out Etty's painting for special commendation. Boase considered that Etty never wholly succeeded in setting down his reaction to the nude "but in his glowing colour, occasionally in his handling of paint, he caught reflections of the Venetians and of Rubens that have escaped most other English artists."[39] Boase is less enthusiastic than Jean-Jacques Mayoux who, in his *English Painting from Hogarth to the Pre-Raphaelites* (1972), gives a considered appraisal of Etty. Mayoux regards Etty's stature to be

> difficult to appreciate because few English artists, beneath the surface of an apparently successful career, have been more fundamentally at variance with their time and country; so it is that his very real gifts were to some extent misapplied and wasted.[40]

Of his best paintings Mayoux says—"They prove that he was one of the finest colourists of his time. He knew what he was doing." Yet Mayoux decides that his subjects remain models. "His one concern, anyhow in his painting of nudes, is the rendering of flesh; he gives no thought to relating that flesh to its surroundings. He does not see the body he paints as part of a whole, he fails to place it in a composition."[41]

Mayoux does however regard Etty as having "had the makings of a great portraitist." This is a fair comment. Etty could have made a modest living as a portraitist painting minor notabilities had his interest not been elsewhere. Mayoux's concludes that Etty

> seems to have lived in a state of mental confusion, of shifting and undefined aims; perhaps because those by which he really set store would have isolated him too completely. The best, the only enduring part of his work centres on a single theme: the female nude. For this devout and conscientious artist, woman was "God's most glorious work."

Whilst it is true that history has shown that Etty was "at variance with [his] time and country," in the sense that English art developed *on the whole* in quite different directions and that this development was already emerging during his lifetime, nonetheless during his lifetime the tradition of history painting was still strong and there was still a large enough body of collectors desiring neo–Classical and Renaissance style paintings to make it attractive for artists to concentrate on these forms. Etty may not have foreseen the future but he did see sufficient of the present to justify his personal obsession.

Several attempts to re-establish the Victorian nude as an art form in the minds of the British public have been made but probably the most successful were Alison Smith's book referred to above and the exhibition entitled *"Exposed—The Victorian Nude"* which she curated at Tate Britain in 2002 and for which she edited the catalogue. The purpose of the exhibition was to encourage recognition that "the nude was to become one of the most prolifically produced, exhibited and collected categories of art in nineteenth-century Britain." Etty was represented by four works—*Youth on the Prow*, etc., *Britomart Redeems Faire Amoret*, *Musidora* and *The Wrestlers*. Alison Smith wrote the commentaries for each of these works and described Etty[42] as "the first British artist to paint the nude with both seriousness and consistency, combining visual pleasure with high moral purpose." The exhibition explored the whole range of the nude as subject within the nineteenth century. As a kind of epilogue it added a handful of paintings from the first decade of the twentieth century—by Wilson Steer, Walter Sickert, William Orpen, Gwen John and some others.

Alison Smith explained that there was then sought an explanation for the model's nudity by placing her, sometimes him, in a domestic setting, usually the bedroom, dressing or undressing, washing or simply reclining on a bed which critics immediately condemned as immoral. The final two decades of the nineteenth century had seen the nude placed in a *plein air* environment which was a reaction to Impressionism. The nude in a rural setting suggested arcadia,

Eden or merely innocence. Open air bathing in lakes and rivers had become the pursuit of a handful of naturists and the search for deserted islands or beaches was a feature of the holidays enjoyed by the middle classes, especially when taken in Greek islands, enough in itself to offer classical justifications. But by depicting women, who were obviously working girls, enjoying their leisurely toilets in back bedrooms, artists were inviting comparison with the eighteenth century world of courtesans and the *demi-monde*. The reason for nudity was no longer innocent. Washstands and iron bedsteads brought the scenes too close to possibility. Etty did not usually face this problem. Only rarely, as with *Candaules Shews His Wife* and *The Dawn of Love*, did he challenge his public, albeit unintentionally, to see innocence in what was clearly unambiguous. It is hardly true that "To the pure all things are pure." Only the naive will see purity in the obviously offensive. Etty may have been a natural innocent, he was certainly often naive. He never intended to offend but would sometimes illustrate a myth without realizing its import. But, at least, he was, as Kenneth Clark said,[43] "too humbly the servant of his times to offer direct transcriptions of the body for their own sakes. To do so required the gargantuan self-confidence of Courbet."

A final tribute was paid to William Etty in September 2005. On the 26th day of that month a plaque, provided by the York Civic Trust, was unveiled by a family descendant, Tom Etty, near the site of the artist's final home at the rear of St. Martin's Church in York. Unfortunately the actual site is now inaccessible but the place chosen was on a pathway to the public walk-way alongside the River Ouse, of which no doubt William Etty himself would have approved. Tom Etty was accompanied by his brother Walter, both having flown in specially from The Netherlands. The short ceremony was attended by the Lord Mayor of York, the chairman and secretary of the Civic Trust, the chairman and committee members of the Friends of York Art Gallery, a representative of the York Museums and Gallery Trust, the previous curator of the Art Gallery and various persons closely interested in the artist. Tom Etty delivered a very appropriate speech and afterwards everyone attended an informal reception in the Mansion House, the Lord Mayor's official residence.

Summation

To decide an artist's status it is necessary to ask two questions? Was he (or she) a *good* artist? By which we mean, is his (her) art appealing as an object of aesthetic interest? and, was he (she) an *important* artist? By which we mean, did he (she) play a leading role in the history of art? The answer to the first question must necessarily be subjective. Certainly it cannot be claimed that the depiction of classical mythologies offers much appeal to a modern public. We have lost our skills of interpreting allegories and most people appear indifferent to any moral lesson they purport to convey. This does not mean that the public as a whole have lost interest in morality or ethics or religion or politics. Merely that they no longer want them presented in terms of gods and goddesses from another age. Many modern works present puzzles—such as discerning the problematic significance of a pickled shark or an empty room. Most people reject such works as trivial, not worth the time required to examine their obviously spurious claims to be philosophically important. In every age art has been divided between "high" and "low," between "fine" and "applied," between "intellectual" and "popular." The first categories in these contrasts are always regarded as requiring an educated public trained by rigorous mental disciplines. The second categories are held to require no education or preparation. They spring from what used to be folk lore and rustic singing and dancing, the pleasures of the common people. They are seen as revolts by the "lower orders" against the claims of the aristocratic mind to be superior. "Popular art" can be regarded as the assertion by those without the skills required by modern society and who feel dispossessed of any social significance, that they have a place in society with values as important as those entrenched by convention. "Modern art" is clearly a revolutionary

movement that nevertheless continues to maintain that art has a purpose beyond mere entertainment, though it may not often appear so.

Etty unashamedly chose the first set of categories listed above. He came from a class that believed in hard work and discipline, demands that were associated with Methodism and which he took with him into the intellectualism of the Anglican Church. A work of art had to be seen to be difficult to execute and difficult to understand. It had to be obvious that many weeks and months had gone into its execution and the result had to be so perfect that that the proper public reaction was amazement. These had been the standards of the ancients and the Italian Renaissance. When Constable saw a life study by Etty in March 1837 he is said to have remarked, smacking his lips, "you might eat it."[44] Others were reputed to say sometimes of his work, that if a knife were stuck into the figures they would bleed. That was, for Etty, ultimate praise.

In Etty's lifetime new divisions in art were appearing. Against the old preferences for history painting there was a new interest in landscape painting, mainly due to the Romanticists, and another interest in domestic genre. As always, these divisions mirrored society's class divisions. Today's interest in Pop Art mirrors the emergence of a class raised on comics. Etty preferred the art of previous ages, of Titian and Rubens, which still captivated the minds of many of his generation. No doubt he failed to understand that this interest was largely historical. He lived at a time when it was still an aristocratic pastime to unearth "the treasures of the past." Many educated non-aristocrats were similarly interested and collections were being amassed which eventually would become "national treasures." The art of the Italian Renaissance and of a few other selected artists had been avidly collected and now new supplies were required. Etty met the demand. Even today, despite the attractions of modern art, exhibitions of acknowledged Old Masters still draw the crowds. There is still the general conviction that true art demands skill. But today the skill demanded is quite different.

Romanticism introduced a new relaxed style that owed much to the contemporary vogue for watercolors. Impression developed from this. Painting *alla prima*, often in a single day, even a single afternoon, sprang from watercolor. Already artists were exploring the problem of how much and how little paint need be applied to achieve a desired image. For its time Impression was the acceptable minimum. Today we accept much less. It is an intellectual and optical problem and minimalism has joined the category of "difficult" and therefore "clever" and "superior." For Etty it was not a problem of how little to apply to a canvas but how much, consistent with acceptable naturalism. For although the images depicted were not conventionally natural, their appearance had to be, but always within accepted norms. It was a rigorous discipline and its very rigor demonstrated its truth.

As a significant artist in his own time Etty was paramount. Of that, there can be no doubt. Modern critics may dismiss him as an anachronism because he did not embrace the new movements but the culture of the times did not encourage innovation as it does today. There was no television bombarding the public with pop music to instill into them the notion that no other form of music exists. Young boys and girls were not being manipulated into believing that by merely strumming a few chords on imitation guitars they could become millionaires overnight. Art history as a subject suffers periodic ebbs and flows in its appeal largely because it is so much easier to "appreciate" art if it means only asserting a vague aestheticism without the need to do any work on the subject. The author has suffered so many lectures devoted to assuring the audience that a work is "significant" without a word of justification being offered. Such is the legacy that Roger Fry and Clive Bell have left us.

As long ago as 1940 the critic Thomas Craven wrote in his book *Modern Art*[45] of listening to a lecture on a Picasso painting which was full of talk "of spiritual values, plastic symbols, sublimation of reality, extra-pictorial metaphors," etc., etc., "a glaring discrepancy between his memorized aesthetic slang and the thing on the easel." We have all heard such pointless effusions as lecturers endeavor to elevate a work into the realms of aesthetic significance that it does not

deserve. There are always those in the audience who gladly lap it all up as it assures them of their intellectual superiority over the masses. As the author well knows, having once been castigated by such a lady in the audience at one of London's leading galleries for "desecrating" a work by Jackson Pollock because he asked the lecturer whether the painting being discussed could be related to Pollock's state of mind when he painted it. The person concerned clearly regarded art as "sacred," as not merely expressing religion (as art has often done) but being a form of religion in itself that could not be questioned, only venerated. The artist was at least a high priest. A traditionally Romantic view. The lecturer agreed with the lady.

Etty made no such claims for his own work. But he did claim to be presenting beauty in its most divine form, the female body. Many Victorian women objected, claiming that any depiction of a naked female body was humiliating and a male device for encouraging sexual arousal. (Strangely it was never the other way round. The worst a naked male body could do was to encourage a young girl's curiosity.) What these Victorians did not understand was that they were dealing, not with a depraved form of art, but with a public that was not traditionally accustomed to art. The eighteenth century aristocratic collectors and connoisseurs understood through their education that art should be discussed with appropriate propriety. They were not surprised or shocked by the nude. They had grown up in houses where the nude in art was commonplace. (Of course, not all aristocratic young men were refined. But they did not purport to be interested in art. Their interests were in blood sports.) The new "*bourgoisie*" were unprepared for what confronted them. It is true to say they brought with them the culture of the streets, but most of them would discard it as they strove to be accepted as "gentlemen." Today that does not happen. No doubt, time will tell.

Today we are apt to believe that all Victorians strove for social advancement. That is far from true. In every age there are those, always a minority, who break through the social barriers and achieve a more comfortable and effective life. Nineteenth century England offered more opportunities than previous centuries but even so these opportunities were not limitless. Nor were they achievable by most poor people, denied, as they were, of education and even a modicum of capital to make a start. Lord Palmerston, commenting on the Reform Bill, had said in 1831 that the English did not want political change, they wanted more money and less labor. William Etty began with several advantages denied to most of his contemporaries. He had a mother who had known a good education, a father who was honest and industrious and above all an uncle and a brother who had achieved some wealth through the honorable employment of their talents. With these examples it was not enough merely to want more money. He had to rise in the world. Progress was the watchword of the age and this meant more and more material benefits and more and more money to buy them. It also meant personal improvement over one's former associates. Thackeray in his *Book of Snobs* (1848) recorded how the social climbers tried to kick away the ladder by which they had ascended to make sure no one could remind them of their origins. Etty to his credit never did this. He certainly set his sights on a desirable goal and this was to be a great painter. So it has to be asked, as it often is, was Etty an anachronism? In some respects it must be conceded that he was. When he joined the academy as a student the artistic principles he embraced still enjoyed considerable patronage but that was dwindling and by the time he died it was confined to a small body of *nouveau riches* who were no longer influential. But had Etty lived in the second half of the century he would doubtless have been numbered among those who comprised "the Victorian Renaissance." Whatever accusations that may be laid against Etty, particularly the modern popular accusation of pornography so beloved by feminists and which he fiercely denied, it must be conceded that he revered women. None of his female friends found anything offensive in his work and it says everything about the man that his historical heroines were Judith and Joan of Arc. The fact is that interest in the human figure has never died out and shows every intention of continuing. Although today artists do not depict the nude, but the naked, it means only that we now prefer reality.

Appendix. Betsy

One name has recurred throughout this account of William Etty's career, that of his niece Betsy. Surprisingly little is said of her in previous biographies and though Alexander Gilchrist referred to her many times as Etty's housekeeper and companion he never seemed aware of the full nature of their relationship. Betsy was brother John's fifth child, Elizabeth, born on the 21st November 1801, who lived with her family until grandmother Esther brought her to London in 1824 to assist in moving William Etty into no. 14, Buckingham Street. As we have seen, Etty was deeply worried by this move which seems to have been maneuvered by brother Walter, who probably assisted with the rent. Esther had hurried to help her troubled son and for some reason, never explained, she brought Elizabeth with her. Betsy, as she was known within the family, was to have stayed for a few weeks, perhaps even a few months, but she remained for the next twenty-five years and Etty became increasingly dependent on her.

In his first reference to her[1] Gilchrist said that she "daily [became] more necessary to her Uncle's comfort and happiness; in after times his domestic all-in-all, his companion and 'Right-Hand.'" This was how, in later life, Etty himself referred to her in a letter to his friend George Bulmer. Farr mentions Betsy only occasionally.

> Etty always had a strong affection for Betsy, and his letters to her reveal a fatherly solicitude for her well-being; as he grew older and more infirm, his dependence on her increased, while she, for her part, did all that could be expected in ministering to her uncle's needs and habits.[2]

It is usual for an artist to become dependent upon a wife or a female associate who has assumed the role of wife, but Betsy was neither, certainly not the former and of the latter we can speak with certainty. When Esther Etty brought her granddaughter to London she could have had no idea of the change she was introducing into his life. Probably she felt she needed dependable female company on her journeys to and from London and in London itself but it seems that Betsy enjoyed being away from home, as many country girls did, given the opportunity. Subsequent events reveal her as a very independently minded young woman, well able to take care of herself. No doubt she initially regarded her duties as no more than suitable employment for a young woman who ought to earn her own living. Domestic service was usual employment and country girls frequently had to find it in the nearest town and quite often in London. Parents were usually concerned for the safety of daughters who left home. There was a general opinion, which continued well into the nineteenth century, that girls put into domestic service might just as well be put into brothels because that was where most of them would end. Employers, their sons and acquaintances, often regarded these girls as legitimate targets, easily influenced by false promises, and when pregnancies or threats of exposure followed they were dismissed to live on the streets unless, if they were fortunate, a "protector" took them under his care. But such protectors were often no more than pimps or brothel keepers. It was a lucky girl who fell from grace into the arms of a rich man. In Betsy's case it must have been regarded by her parents as extremely fortunate that her employer was a trustworthy uncle.

Betsy was fourteen years younger than Etty and he had known her from childhood. The

first reference to Betsy that has survived is in a letter from Etty to Walter which the latter endorsed "Wm Etty/York/19 June 11" [1811] in which Etty states that "on Sunday John and I and his daughter Betsy took a gig and went to Castle Howard." At this time Betsy was ten years of age and Etty was twenty-four. In the same letter Etty said he had "painted his [John's] eldest daughter, Kitty." Kitty was then fifteen years old. By the age of twenty-four most men already had some relationship with a young woman and some expectation of marriage, or were indeed already married, but Etty was still quite unattached. He was showing some affection for Kitty who, he said, "is grown a tall genteel girl" and whom he regretted was working in her father's shop when he thought she was worthy of something better. But she was obviously too young and though a nine years' difference in ages was not uncommon, couples with this disparity were usually older. In any case, uncles and nieces could not marry. Etty was always at a disadvantage when meeting young women, being shy and, some considered, lacking good looks. He had none of his younger brother Charles' sociability. In his early years his female company seems to have been restricted to within the family. Even in his apprenticeship years in Hull he made no female companions.

After Betsy moved to Buckingham Street a bond of affection quickly grew between uncle and niece as Etty obviously came to realize how much he depended on her. Everything we know about Betsy is derived from the many letters that Etty wrote to her whenever they were separated, which was frequent. Thomas Etty of Nijmegen possesses over one hundred letters from Etty to his niece and which he has generously made available. There are few surviving letters from Betsy herself. She appears to have been a reluctant letter writer but those that are available reveal that she wrote with a good hand and command of language and, once she had commenced a letter, she would write at length. Unfortunately most letters passing between them are undated but sometimes it is possible to deduce a likely date from internal evidence.

The earliest letter to Betsy to which a date can be attributed after her arrival in Buckingham Street is post-marked "AU 5 1829" and was sent from Feasgate, York, where Etty had gone to attend his mother's funeral. This may well have been the first time he had had occasion to write to her.

> God bless thee, my dearest Betsy for writing for thou saved to me the object of my journey, for I fear without it my blessed Mother would probably have been underground! As it is, thank God, I have seen her dear remains, and followed her, till I could no farther till that blessed day when I hope we shall all meet in heaven.

The entire letter of nearly four pages consists of an account of his journey from London; how he had to go from Hull, where he had thought his mother's body was, to York; his report of the funeral, concluding with brief news of the family. This letter has been quoted more fully elsewhere. Etty signed himself "Thy Loving Uncle." It is in the opening and closing salutations to his letters that we can trace Etty's growing affection for Betsy. The contents of the letters are usually accounts of his activities since his previous letter and seldom betray his feelings for her, though they increasingly do so as the years pass. Nonetheless they afford useful information about the nature of his life, his invitations to dinners by people of local importance; descriptions of his long and tedious journeys as he moves from one patron's house to another's, but more often, when he is in York, details of family gatherings. The letters indicate Etty's increasing dependence on Betsy who was clearly a very efficient housekeeper and a very likeable young woman. On Etty's part there gradually developed a warmth of feeling for his niece which soon became a deep affection but never beyond the limits of propriety which his own pious nature could not have permitted. The few of Betsy's letters that are available demonstrate a deep attachment to her uncle but they also confirm that she remained level-headed and never entertained any feelings for him that would have been inappropriate. It may have become love on his side but it appears certain that it was only close affection on hers. He was her loving uncle but she was his kind niece.

There is every reason to believe that Etty was naturally drawn towards younger women. Early in his youth he had been fond of Kitty, who was nine years younger. In 1822 when he was thirty-five years old he had been attracted to his cousin Mary, who was about sixteen years old. She did not reciprocate his feelings. Later in the same year, in Italy, he reported to Walter that he had met "a fair Venetian of respectable family" whom he described as "a very fine girl" to whom he was much attracted though he did not pursue the matter. Much later, in 1830, while in Rome he met a young woman "who had barely ceased to be a school-girl" and to whom he declared his love but she "preferred a younger man." The age difference must have been at least twenty-five years. So Betsy, fourteen years younger, must have occupied the place in his affections that none of the others had filled.

Clearly what made Betsy attractive to Etty was her good nature and her business-like ability to manage his affairs. She began in the role of a general help about the house and soon became his housekeeper and then his personal assistant. At an early stage she began to take on the

Elizabeth Etty (known as "Betsy") (18.25 × 14 ins) (c. 1840), Eric Etty, Nijmegen, The Netherlands.

responsibilities of supervising the packing and transport of his paintings to and from exhibitions and to clients. This included arranging insurance for which Etty seems to have relied upon her, perhaps more so than he did on his official assistant, George Franklin. At some time Etty painted her portrait. It is no longer in good condition but it reveals her as being of attractive appearance and possessed of a very pleasant nature, which every account of her confirms. It is upon Etty's letters that we rely for our information and these are very revealing because, unlike the majority of his letters, when they express his feelings they are very intimate. From these we can build up a history of developments in their relationship. We have had many occasions to complain that Etty did not very often unburden himself in his letters to friends but seemed intent to protect himself from exposure. Of course, he wrote to Betsy only when he was away, either when he was visiting his family in York or his patrons and friends in the provinces or on the rare occasions when she went home to York leaving him in London. Of what passed between them during the many months they were together we know nothing except by inference. We can guess to some extent because he occasionally wrote when they were apart that he longed to be with her, with the two of them sitting either side of the fire drinking tea and talking. Generally the picture he paints of their life together was one of quiet domesticity.

Certain personal characteristics are revealed in his letters; a need for order in his life—he wrote several times "A place for everything and everything in its place" and frequently reminded Betsy in her role as housekeeper that meals must be ready at fixed times. He rose early and preferably retired by ten o'clock. Even in letters where he poured out his feelings for her he would often suddenly remind her that she had duties to perform, such as arranging the dispatch of

paintings to clients. Mainly his letters consisted of reports of his practical activities, of being entertained by family and friends with large dinners. He enjoyed being feted as an important painter and was particularly flattered by being asked to make a speech though he found this difficult. Such events he reported to Betsy knowing she would share his pleasure. Although he also told brother Walter and his friends the Bodleys of these occasions it was to Betsy that he betrayed his childlike happiness when life treated him well.

In his early letters Etty usually asked Betsy to undertake some business for him, to get Franklin to send off some paintings to a purchaser or to arrange some framing, often to undertake such tasks herself. She attended at least in part to some of his financial affairs since he always told her when he had made a good sale and how much he had obtained. That Betsy was regarded as having some authority over Franklin is indicated in a letter to her uncle in York as early as September 1837. In the letter dated the 28th September she told him how angry she had been with Franklin for not securing rooms in the Adelphi for a projected exhibition of Etty's paintings.

Both Etty and Betsy were frequently ill. His increasing attacks of asthma and rheumatism, especially and unfortunately in his hands, were frequently referred to. Betsy also suffered from recurrent illnesses which are not identified but which caused him constant concern. She apparently suffered from a general debility and a tendency to catch colds. The idea at the time that women suffered from particular complaints which out of delicacy could not be mentioned would have made it difficult for him to express more than an avuncular concern. London quite clearly did not suit either of them and both enjoyed better health when they were staying in York. We would now attribute the cause to London's polluted air due to bad drainage and extensive use of coal fires, a condition which lasted well into the twentieth century. Occasionally Etty was able to stay in Brighton, or later in Cheltenham, with his cousins the Bodleys and on these visits his health noticeably improved. Sometimes he went from York to Scarborough to visit Walter after his brother retired there, also for his health, and he sometimes took opportunity to bathe in the sea, a favorite "cure" at the time. All of these details frequently provide the subjects of his letters but similar incidents, usually of a comparatively minor nature, are so often repeated that a biographer can often look in vain for something unusual and significant. At first Betsy was reluctant to leave London for even short periods, probably because she feared her parents would insist on her remaining in York. We must assume, though there is no direct supporting evidence, that London life pleased her.

Whenever Etty was parted from Betsy, and this became more frequently the case, he habitually wrote to her every Sunday, often also during the week and sometimes even daily. He expected her to write with similar frequency. In letter after letter he chides her for not writing often enough and describes himself as in "agony" and "ready to die" and fearful of terrible calamities having befallen her when he has not received a letter from her. It must be admitted that so many letters repeating so many similar expressions of his devotion become somewhat tedious but, of course, it was the very ordinariness of the man that marked him off from so many of his more colorful contemporaries. No doubt Etty held the view common at the time that women lacked the ability to engage in serious conversation or letter writing, that politics and similar matters were beyond their understanding, and so he wrote only trivial gossip believing this to be her natural interest, which raises the question of what they talked about when they were together. It was always enough for him to receive a letter which confirmed her affection. It is very unlikely that Betsy was well educated but she had clearly had an education considered sufficient for a woman at that time. Her parents would have expected her to help in the family business and would have ensured she could read and write and do simple arithmetic. She could certainly read and write well and must have had an ability with figures since she often arranged the insurance of his paintings whenever they were sent about the country. Where she obtained this education is not known. It is doubtful that a Sunday School would have proved

sufficient so possibly she went for a year or so to a private school, but it is unlikely to have been even of the standard of the school Etty attended in Pocklington. It was more likely a "Dame School" of which there were plenty. Her father seems to have been sufficiently enlightened for the times to educate his daughters at least to a minimum standard.

The next surviving letter from The Mount, York, written on the 3rd November, postmarked "5 Nov 1831" also opens conventionally with "My Dearest Betsy" and concludes with "Thy Affect. Uncle Wm Etty." Although in the following year Etty is still using the same form of address, in the body of the letters he calls Betsy "my darling Child" or "Dearest Child" and on one occasion (letter post-marked "2 OC 32") he signs himself simply as "Septimus," referring to himself as his parents' seventh child and, what is probably more to the point, avoiding calling himself "Uncle." Later letters are more endearing. In one also written from The Mount on "Sunday September 9 1832" he addresses Betsy as "My Dearest Darling Child," refers to her within the letter as "my sweetest Darling Child" and signs off "My Darling Child From Thy Loving Uncle William." Betsy was, of course, thirty-one years of age at the time, not so young as to be influenced by such endearments, and we must suppose that his constant use of the phrase "darling child" was intended to emphasize the difference in their ages.

Very soon Etty was becoming concerned that Betsy might not stay with him. It was not long after she had joined him in London that he began to tease her and to engage in banter, confident that their relationship was now secure enough. Such a letter is one which has been noted in pencil by another hand as "June 8 1832" from 14 Buckingham Street.

Dear Niece

This comes hoping you are well, and have got safely home, as we have, and we mean to stay, hope you do the same, for we are very well off, and very comfortable, and I can do very well without you so you make up your mind and if anything offers in the way of *Tittilation* take it for fear we have not room for you when you come back. So wishing you well. No more at present from thy Loving Uncle except to say I am very well off now. I have no impudent lass putting her pretty feet on my fender and never stirring without a saucer full of Tea and a piece of crust, so stop where you are because you must, for I likes to have my T to myself so thou may have J.T. and I'll down My T. so don't give Thyself any further trouble from thy False Uncle Wm. Fare you well.

This was clearly a childish but elaborate joke which may have been occasioned by some teasing remarks between them pretending to have a lovers' tiff because on the same page Etty continues:

Extract of letter from J.T.

Dear Eliza [*a form of address he never again used*] I thank you for the little paper (three cornered) of Love to your dear J.T. enclosed in a letter to dear Sister Jane. Oh my dear Eliza, you cannot think what a sort of *twitter* that little bit of a *litter*—containing thy sweet love without any bitter—did give to me. In short my heart was unable to carry it all, so I bought a travelling bag for it and while I was waiting for it for dear Sister Jane to bring it in the room where the pretty *picters* is who should pop in but that old disagreeable Uncle of yours to see who I was. I turned up my nose at him and he bolted. Jane soon after brought your love. I bagged it and then thought I had better be off for fear worser should happen, for I did not like the looks of your Uncle at all and I was going to tell you so. I have a great many more things to say but I can't find time to-day and to-morrow I have other fish to fry, but dont think me a queer fish, dear Eliza, and I will send you bye and bye a letter as long as my arm and if it was as long as two it would not be too long to express the love of your tender hearted J.T.

"Sister Jane" was twelve years younger than Betsy, named after an earlier sister who had died in infancy. "That old disagreeable Uncle of yours" is a humorous reference to himself. This letter is reminiscent of the kind of nonsense written sometimes by "Lewis Carrol" though lacking his skill. Some middle-aged Victorian men (Etty was forty-five years old) would treat their younger female relations to this kind of childish communication as though unconsciously holding at bay more serious feelings that they had for them. There was a tendency to treat young women as even younger than they were. "J.T." was probably John Thackeray, a minor painter in York, who

is referred to in a letter of 30th October 1832 (reproduced later) as her "old flame." The letter "as long as my arm" was then written on three further pages and follows his usual style.

> My Bonny darling Bairn
> I thought I would plague thee a bit, how is thee, my Sweet, is t'better. I was alarmed when Mr. Bulmer wrote and said nothing about thee and not saying anything thyself, but thy letter came just as Jane and I had made up our mind to be miserable.

He proceeded as usual to write of family matters and said that while he was always pleased to have Robert and Kate to visit him, "only I fear we can't do with that roystering Lad. He would be smashing my casts and Pictures. He is such an active powerful Artist, he would soon produce some splinters."

"Robert and Kate" were Betsy's sister Catherine and her husband Robert Purdom. Their son must have been a troublesome child. The customary picture of the Victorian child, quiet and obedient, is far from true. Of course, Victoria had not yet ascended the throne and the full weight of Victorian Puritanism had not yet descended on families and the anarchic effects of the Regency period had not yet been obliterated but the child in most ages has always burst the bounds that adults have tried to set. This is the only known reference to young boys by Etty but there are several references to young girls and even some letters written by him to the young daughters of friends, all of which reveal his preference for them. Whether they were all as charming as he obviously believed them to be, they certainly conformed to the conventional Victorian image of delightful innocence. The letter concludes, as was often the case, thanking Betsy for looking after his birds and animals which he kept on the roof at Buckingham Street. Keeping birds and animals as pets was another of his foibles. He signs himself "Thy true Uncle William Etty." His oscillations between childlike teasing and attention to personal business suggests that Etty possessed a mind uncomplicated by serious concerns relating to his fellow men or mankind in general. At all times he thought mostly if not solely of matters affecting his own daily life, not because of selfish indifference but probably because wider issues were too complex for him. He seems to have believed that if everyone concentrated on his own affairs and interfered in no one else's the world would be a happy place. An individual's life should be concerned only with simple personal issues. Interest in wider matters suggested interference and meddling and, most likely, Whiggish opinions of which he disapproved. This was an age when notions of social responsibility were developing and many people in England feared that they would lead to the spread of revolutionary ideas as had happened, so they thought, in France.

In a letter dated "Sunday 3rd Sept." and which can be ascribed to 1834 since it records Etty's tour of North Yorkshire in that year, Betsy is addressed as "My ever dearest Child" and in the course of the letter he asks

> How is thou off darling? has thou got a little money to lend out at good interest—ample security—I only want one thing, that is *two—A & B—Annuity and thee Bairn*. If thou can come bring Annuity with thee— Oh thou bad one, mind and dont get Wed—or run over—or run away to nobody knows where.

The last page of this letter is missing so we do not know how Etty signed it. However, his enquiry regarding money is unusual. He may have been asking if she had some unspent housekeeping money available and, if so, to bring it with her. A month later, October 19th, Etty addressed Betsy as "My Dearest best-loved Child" and said "Dont think my Sweetest because I dont come that I do not wish to see thee" and continued:

> How gladly I shall meet my darling on the slope of the stairs. My eyes and heart are full when I think of thee my fond and faithful child, my sweet repose, my faithful friend. No one could replace in my affections my darling child.

But, as always, Etty maintained the family relationship between them, signing himself— "Believe me My Dearest Child Thy Affectionate Uncle Wm Etty." For those who know York his

letters occasionally provide short references to local places of interest, particularly New Walk on the river Ouse which had recently been replanted. He refers to excursions on foot to nearby villages such as Huntington, Wigginton, Acomb and Poppleton, which have now been incorporated into York, and these remind us how willing able-bodied people were in that century to walk quite considerable distances. No letter is without an expression of affection. It is in his form of addressing her that we see his growing fondness for her. "My Dearest Child" is his usual mode in the earlier letters but gradually this expands into "My Ever Dearest Child," "My ever dearest dearest Child," "My Ever Dearest Angel," "My ever dearest angel bairn," "My Sweetest, my best and bonniest" and even "My Dearest Love" and "My Sweetest Love and dearest Dove" and "My ever Dearest and best Beloved." Etty's method of signing off hardly varied, it was either "Thy loving Uncle William" or "Thy Affectionate Uncle William." He invariably described himself as "Uncle," as though to emphasize their relationship however lovingly he thought of her. The use of "Thou" and "Thy," dismissed by Gilchrist as a countryman's crudity of speech, was in fact a customary form of address among families and close friends. Etty often called her "Bab" and in letter after letter he so alludes to her, but it appears that this was intended as a diminutive for "Baby." It is difficult to know when he first called her "Bab" since most of his letters are undated. In letters actually dated or post-marked in the 1830s he did not do so. A curious familiarity was his occasional use of a dot in the middle of a circle at the end of his letters, sometimes with the word "Kiss." This may have been no more than an alternative to the more usual "X." It does indicate that he was probably in the habit of kissing her, perhaps only as greeting and farewell.

Etty had a childlike humor which is often revealed in many letters to his friends. Betsy was often addressed in terms that, in other contexts, would have suggested a love-sick young man. In a letter datable to late summer 1834 he wrote—"so I thought I would just scribble a line to my Dearest best-beloved Ducky" and in a post-script addresses her as "My Dearest Ducky." In a few letters he draws a duck swimming and clearly relates this to her. Though Etty increasingly used very personal affectionate terms when addressing Betsy it is clear she did not reciprocate. A letter as late as the 9th January 1845 makes it clear that she always addressed him as "My Uncle William."

After a few years Etty realized that he needed Betsy so badly that he could not contemplate her ever leaving him. There is a curious sheet of paper in the possession of Tom Etty of Nijmegen endorsed "Affidavit of Betsy's, London, 1835" and which reads:

> 1835
> The Day before Xmas Eve
> My Bairn did say
> "I'll stick by you to the last
> and never run away"
> As witness my hand
> Being in my Painting Room
> And in sound body and mind
> And in possession of all my faculties
> Betsy Etty Wm. Etty, R.A.
> Witness my mark
> and seal X (attached is a piece of sealing wax)

This was probably proposed as a half-joke but it is certainly signed by Betsy and we must conclude that she was humoring her uncle when she made this declaration. There must have passed between them some apprehensions on Etty's part that she might some day leave him and he needed an assurance on her part, no doubt easily given at the time, that she would not. As we know, she never did. Although this curious document claims to have been drawn up on Christmas Eve 1835, a letter of 14th September (no year given but endorsed "1835") addressed to Betsy says:

My Dearest Darling Child,

Mind! *thou art mine.* I have thy bond in black and white—dont forget—the time approaches when I if all is well will come and see whether thou has kept Thy bond or no....

I miss thee my darling—I miss thee....

In a letter to her from Marygate in York dated only Friday Oct. 7, but dateable as 1836 he wrote,

And now Miss Pussy, I have got something to tell thee. I am engaged and so thou may toddle when thou takes it into thy noddle. Yes, I am! So when it's convenient, thou knows, for further particulars *how* I am engaged, turn overleaf and—[*next page*] yes *I am* engaged to leave by the High Flyer Monday for Newark where *if* all's well I sleep and next morning take the Picture to Mr. Wright's and hope to be with my child, my darling child, by Thursday night or perhaps by the mail on Friday morning so that Mr. Hilton need not attend for me further than the first week in all probability and so *I am* engaged, thou sees. Till then Farewell

My Darling Child,

Wm Etty.

Such playful threats to leave each other were not uncommon and were designed to tease and strengthen the bonds between them. In this case Etty quite unusually omits to sign himself "Uncle." On another occasion writing from Blake Street, York (undated letter but certainly October 1837), he played a similar trick of teasing her on one page and reassuring her on the next.

Oh! has thou heard the news? No. Why then I will tell thee, I am going to *settle!* Isn't thou? If thou wish to know when and where and to whom I am going, why turn over leaf—When I get home some night to tea with t'Bairn, a cheerful fire, a kind welcome and an inviting chair at old Buckingham Street, shall thou be there? Yes! or else I could not settle. I am making myself busy, working away in my new Chambers, but I hope soon to be at work in my old, if I don't get picked up at these Races. Then *if* I do thou'll have to look out thou knows and not be a burden to thy friend, always thou knows, thou understands thou need not look out till I tell thee thou knows, that'll be time enough.

On the 2nd October 1837 he had also written to her from York:

My ever dearest child

Here I am once more safe and sound. I have got my pocket full of money from Manchester* but I want to see *thee here*, better, my dearest treasure. [*He tells her of his successes in Manchester and continues:*] And now with regard to thyself my dearest darling, I hope thou is coming to me—do, for "all things are ready" and what is the expense compared to thy health, thou are to me—more than all my money—and I could never spend any with more satisfaction than for thy good or gratification, but it is not much my Darling thou spends of my substance.... I trust and hope thou willt come, as it may be of consequence for me to stay a few weeks longer here—and I think it would be of service to thee, and I should be miserable if I did not think I had done all in my power to be of service to thee, my child, come and lay in as much fresh air and health as will last thee the winter. I have a bed prepared for thee! and I will bring thee thy breakfast to thee in bed and nurse thee till thou's well—I think thou would like my little place, and if does thee any good, I shall doubly like it.

After more news of a personal nature he Etty returns to his entreaties.

I fear my darling has been worse than she says she has been and I cannot rest long here unless I see her and know—and as I have this place, we may as well give thee the advantage of it this year as well as next, who knows whether we may be alive next year to see.

Etty tells her he has seen her portrait with one of the family at Huntington, a reference which enables us to correct the usually ascribed date of 1840 for this painting.

Thou looked at me and smiled. I talked to thee and patted thee on thy cheek, little knowing thou were so poorly.

Till then, Farewell thee well my dearest dear,

Thy uncle William

*He had visited that city where he was exhibiting at the Royal Institution. Gilchrist says he did not make any sales, recording Etty as declaring "Trade is bad" but this letter suggests otherwise.

On the 8th October 1837 he wrote another letter telling Betsy about York Races and the various activities that threatened to divert his attention. "York is so gay this week—the Concert and the Ball tomorrow evening, the Theatre open and I know not what." He told her that he would not go to the Ball as such occasions did not appeal to him but he would be going to the concert. Betsy replied, in one of her few surviving letters:

I see York has been gay this year by your account. It will be a wonder if you don't get picked up with some of the Gay Ladies. You say you are going to settle, so am I and very soon too. I tell and no joke and then I shall only be a Burden to one friend. I am afraid I might be in the way of your happiness so I shall and I have my mind to be off, so you see, you was fishing so it was only right you should have a Bite. You are aware that I have been hanging on my friend for the last 12 years so I think it is time to relieve them of the weight.... Now my dear Uncle I think I have told you all, but you must bear in mind that that you must either get Married or another Housekeeper and no joke. So it is, and I cannot help it, it will be so, as they say.

The friend to whom Betsy refers was either John Thackeray or Stephen Binnington whom she eventually married. Etty replied from Blake Street, York, on the 2nd November at "12 o'clock Night."

My Dearest Darling,
What does thou mean, thou does not mean to kill me, does thou? after all my protestations, thou knows or ought to know I was merely joking to amuse thee. Thou says, thine is no joke. What does thou mean. I love only thee, my Child, only thee. Why will thou torment me. I can never part with thee but with life. *Write by return of post, a line, and raise my aching heart* that beats but for thee and my only hope is that when we meet we part no more until death. I was only joking, why does thou say such cruel things. *"It's no joke."* Do not wound a heart that loves thee. I thought thou would understand I was joking. Oh write and ease my troubled spirit my life, my *only* love. Do not think of leaving
Thy Affectionate Uncle William

Next morning Etty added two more pages telling Betsy that he had spent a sleepless night worrying about her threat to leave him. In these pages he pleaded with her again not to go, assuring her that he could not live without her and telling her that he intends to return to London at once to persuade her to stay. So disturbed was he that he wrote again on Friday November 3rd.

My Dearest only Love
Thou has fluttered this poor heart of mine but I cling to the hope, after reading thy dear letter 20 times over, that thou wert only joking, tho' thou twice says "it is no joke." Thou art not so cruel as to give me so mortal a stab as to leave me after all the sweet hours we have spent together and I hope yet to spend together. No! I feel, notwithstanding my anxiety that "thou are faithful even unto death!" or I am much mistaken. My affection for thee is deep and pure, unsullied by any base passion, and bitter would be the hour that despatched thee from me for ever.
I bear the present privation of thy dear society only in the hope of soon seeing thee and enjoying it— but a second black Friday indeed would it be were I to be convinced thou wert in earnest. I passed a dreadful night last night and am nothing to boast of this morning but I hope the dove of peace will on Sunday bring me a line of consolation and prove my fears of losing thee groundless as John Bulmer said when he saw me so down when thou was poorly—"you would lose your right arm if you were to lose your Betsy." I cannot for a moment bear the thought. Thou had better shoot me thro' the head than thro' the heart. Thou has said and I believe thee "I will never leave thee or forsake thee!" May God grant my prayer and may we both wear out together.

So he continued for two more pages, reminding Betsy of her frequent undertakings never to leave him, impressing on her how much he needed her, how much he loved her, how he longed to be with her and always hating the times when they had to be parted. He referred to her many times as his "Darling" and pleaded like a lover that they should never part. It seems never to have occurred to him that she was teasing him but there was some truth in her words when she told him that she wanted to get married. As early as a letter to her of 2nd October 1832 from York, Etty had written—"I went with Mrs. Bulmer the other day to see thy old flame Mr. Thackeray"

so he could not have been unaware that she had sometimes thought of marriage. Thackeray was a painter working in York but apparently not doing very well. "He has got a nice painting room in a garden in Stonegate but I should think he is not overburdened with work." This is undoubtedly the "J.T." referred to earlier.

Sometimes when away from London and feeling lonely, Etty would settle down and "have a bit of talk with my bonny bairn," to quote from a letter dated 14th October 1837, written from "Mr. Stricklands Court, Blake Street, York." While he could not bear to be parted from her, his need to find commissions and sell his paintings required him to travel. He visited his family York whenever he could and the call of York and its Minster was always strong. "We must be separated again so long" he continued in this letter, "It seems an age dearest since I saw thee—how I long for that happy night when a fire at home, tea and thou, the chief of all my domestic comforts and blessings, welcomes me."

After sending her local news Etty went on—

> I am distrest lest any thing should happen thee. If any thing was to happen my child in my absence I should go distracted I think—so take care dearest. ... I wont be long darling, keep well till I come and *after* I come. I look forward to that day as a real holiday when I saw the fine days, day after day. How I wished thou was here. Like Zimmerman I love solitude, but I like much the idea of the French philosopher La Bruyere, who said "it is good to have somebody to whisper to, that solitude is sweet"—I'll whisper in thy ear when I come, *not blow.*

This letter Etty signed—"Thy Loving Uncle
William"

The significance of separating "Uncle" from "William" may not have been lost on Betsy. There is absolutely no doubt that Etty was growing deeply fond of Betsy and she of him and had their relationship and ages been different they might well have married but both knew that anything more than deep friendship was forbidden. Uncle and niece were intimate in the way that dear friends are intimate and the nearest we get to evidence of familiarity is in a letter when Etty is expressing his concern that Betsy is again ill and he promises that when he returns to London he will tuck her up in her warm bed. This is no more than a promise to nurse her back to health. There is a most revealing letter, which has also been referred to earlier, in which he declares

> Oh my darling, I like to be ever near thee. Love, such as angels might feel, for purity is mine for thee unmixed with base matter—that is the love I love best. ... I have done with the rest for ever. It is indeed Vanity, all is Vanity save that holy flame of sacred Love which lights us alone for happiness and peace and leaves no stain....

It seems clear from other writings that Etty left that he probably had experienced an early sexual relationship, possibly with a model or perhaps more than one. There is also the probability of some activity in Venice, all of which had left him feeling guilty and sinful with deep feelings of self-disgust. Apparently Betsy was not unaware of these occasions in his life, or at least some of them. It is inevitable that he had at some time revealed a desire to marry and now wished to assure her that he no longer entertained such feelings. The truest, to him the holiest, relationships did not need physical intimacies.

Letters between them were particularly frequent whenever Betsy was unwell. The nature of these illnesses is unknown. They may have been respiratory and perhaps, as with Etty himself, London aggravated her condition. Always these reports of her ill-health caused him great concern. He constantly urged her to join him in York during his summer visits, telling her that the air was purer there, but she had her duties as his housekeeper to attend to in London and only seldom took his advice. Perhaps she was distressed when he was away and her asthma, if that was her complaint, worsened because of this. On one occasion writing from Blake Street, York, (undated letter) he addressed her as "My ever dearest Child," and continued:

I am very sorry thou has been ill my dove. I long to see thee. It seems *such* a time since I did. Mary will be with thee if not already arrived. I shan't be long here so if thou is coming make haste my sweetest. I should like thee to come. I would come and meet thee and we would have a nice walk or two together. Oh! I find the loss of thee, my darling, a vacuum nothing can supply. I hope thou is better, much better, my sweetest. God bless thee ever and ever, Amen.

Ever Thy Affection. Uncle Wm.

There are so many letters expressing Etty's sentiments that only a few can be selected. It would have completed our knowledge of their relationship had we been able to judge how she responded to his displays of affection. It is disappointing that whereas Betsy kept his letters to her, he did not keep her replies, but Etty kept very few of the letters he received. Betsy's letters that have survived indicate that she kept their relationship strictly under control.

It seems that Betsy was very much "a woman of the world" when it came to managing Etty's and her own affairs. In February 1837 some disagreement apparently arose between Betsy and her brother. We learn of this from a letter written to her by Robert Purdom from Hull on 4th February of that year. Purdom was the husband of her elder sister Catherine and the book-keeper for a grocer in Micklegate, York. He appears to have been a frequent visitor to his brother-in-law Tom, the baker, in Hull. Betsy had earlier given her brother seven days' notice to vacate the house he shared with their father and this demand had upset the whole family. Which of her brothers this was is not known, she had five though one may already have died, and how it came about that he had a shared tenancy with their father is also a mystery, as is Betsy's apparent ownership of the house, but it may have arisen from John Etty's unsuccessful attempt to become a house builder. Betsy must have been able to buy a house for her parents and assist them over hard times. Possibly she assumed ownership so that it could not be seized from her father who had become bankrupt. Purdom urged her in his letter to be more charitable and to withdraw the notice, since it had made her mother ill. "Forgive and forget all past slight offence, let us all be on kind and friendly terms as all relations ought to be." Somehow this letter came to be among Etty's papers and is now in York Reference Library. It is clear that Betsy had a determined character—some would say "a Yorkshire character"—and allowed no one to get the better of her.

Given that Etty was somewhat timid and conciliatory, it is obvious that she was an asset to him. A letter from Etty to her, written on Sunday 17th September 1837, from the home of Mr. and Mrs. Bulmer, refers to another domestic problem in York which apparently also concerned Betsy.

My ever dearest Child

Why did thou keep me so long before thou wrote me a letter? Thou should not have done so. I should have written last Sunday but thou did not write to me. Thy letter, darling, that I got on Thursday night was most welcome. I had been after dinner into the city and had come round by Holdgate Lane, [*the original name of modern Holgate Road*] and the lane at the back of Mr. Bulmer's, when I saw the postman coming and caught him and met him at the gate. I paid for it and took it in and read it as soon as "tea over" and right glad I was to hear that thou and Riley were well. ... I went and saw thy Mother yesterday and delivered thy message. Thy Father and all were as well as usual. I have by repeatedly sending at last got most of my things from Bishophill, that were wanting, but I am sorry to tell thee that Mr. Pearson, the coal merchant in Marygate, whose bill I settled ere I left York last year, tells me they have run up a bill for coals of upward of a pound which on presenting she or him or both said he ought to look to me for it. Now this really too bad. Write me a word what I should do about it.

To whom this refers is impossible to deduce. It may relate to her father's house and to assistance that Etty gave his brother because of his business difficulties in Walmgate. On the other hand it may refer to one of her brothers. It certainly shows that Etty was assisting someone in the family whom he thought was taking advantage of his generosity. In 1837 Etty was negotiating to take the tenancy of a house in Blake Street, York, as he wished to have a home of his own whenever he visited the city, rather than rely on the hospitality of friends. Etty continued:

I have not yet been able to get into my new home, but it is now nearly ready, but I want somebody to *do for me*. I like the place very much and think thou would too. Will thou come and take breakfast, my dove, tea, coffee and hot York rolls. I feel to want thee. ... If thou'll come we'll have some nice walks together! Well, mind and take care of yourselves Kitty and thee and be good lasses and then folks will wonder, as poor father used to say.

In this letter and in one or two others the references to Kitty remind us that Walter and his family were still living in No. 31 Lombard Street, near enough for Walter's daughter Catherine (Kitty) to be a companion. Betsy also had a sister named Catherine who was sometimes called "Kitty" but she was already married by this date and was not living in London. Later in this letter Etty gave Betsy further advice.

Don't take *too much medicine*. I have just heard of a daughter of the respected Markham the Archdeacon, a delicate young woman, having sent herself to kingdom come by doing so. Mind be regular and don't drink *too much tea*. Give my love to Kitty and tell [*her*] I hope she does not [*get*] into mischief and I shall be glad when we meet my child—for good. I do not bear parting from thee so well as I used but I am being well treated and kindly. Mrs. Bulmer desires me to tell Walter to come. They can do with him. I wish he would, with all my heart. He would enjoy it. "Let him come by steam" if he will only come so he does come—and come thou with him. I am afraid of trusting either of you two by steam—come and come which way you like. Mrs. Bulmer invites Walter and I my dearest dove.

On the 23rd September 1837 Etty again wrote to Betsy urging her to come to York.

If all be well shall be back on Friday or Saturday at latest [*he had been in Manchester selling* The Sirens and Ulysses *to Daniel Grant*] and if York air and walks and my care does not mend thee, which I hope it will, I will take thee to Scarboro.

Anticipating she would come to York he added a second letter to Kitty (Walter's daughter) asking her to look after his house (at Buckingham Street) "with the assistance of a servant till my dear Betsy could get a little country air." He added—"she is to me my treasure and poor indeed should I be without her—do see if you can manage this." Later Etty again wrote on his usual day, Sunday, on the 8th October 1837.

Absence they say my dearest Child cures affection. So it may some foolish worldly sort but it does not apply to that I bear to thee. On the contrary, the longer I stay away the dearer thou seems to me and the more anxious I am to come to my dear bairn and old dear home if God will bless me so as to grant that happy meeting when it takes place, I trust it will be a long time before we part again for I bear it worse and worse every time and when I heard thou were so poorly had I not been fixed to go to Manchester I think I could not have rested here till I had see how thou was. Thanks to thee my dearest Child, for thy last consolatory letter which has set my heart comparatively at rest but I am not quite comfortable till I hear thou has somebody with thee that may be a comfort and a company and be a support if thou stands in need. I long to be with thee and come to thy tea and fireside after the Academy is over! We have had some happy days and some happy evenings and trust we shall again if God give us health and strength and life to meet once more and tell thou where I have been and what I have done and what I have seen and soon should I be with thee, very soon, had I not the prospect of getting a job which may be important and I think I should be wanting to leave any stone unturned that might lead to it. I mean the altar-piece I alluded to. ...

This was the altar-piece that Etty hoped to paint for a Roman Catholic chapel at Everingham. His friend, the architect John Harper, had wished to obtain the commission for him from his client, a Mr. Maxwell, but it did not materialize. Etty went on to say that he had moved into his house in Blake Street and has "an old woman to do for who does pretty well." Again he urged Betsy to come—

It wants somewhat, and that is my bairn, to be quite right but I am really pleased with it and if God spares us till next summer I think it will be of great service to her to come with me. I had prepared a bed and bed-room for her, one for me and one for a servant.

He concluded by expressing his concern that Betsy was now alone in the Buckingham Street apartment. She had dismissed one servant and had not yet replaced her.

Get someone decent as soon as thou can Love. I am uncomfortable at the idea of thy being alone, chance thou falls down and there is nobody near to pick thee up. Take care of thyself Darling. As I said when I heard thou was so poorly "what a wretch I should be if I was to lose my bairn." John Bulmer said—she is your right arm one may say. She is left and all, for I have left her and I feel it, but I hope to meet next time to part no more. Fare thee well love. Love to Walter. Thy Uncle William.

Etty's eagerness to receive letters from Betsy is revealed in a letter dated Friday 18th October 1839 written from Blake Street, York. He had returned home from a sketching trip to learn that the post-man had called with a letter but had not been able to deliver it because there was no one to pay the postage, that still being the custom. He went straightaway to the Post Office but the letter was not there, the post-man not having yet returned. Etty returned home and

waited and waited for hours but no one came. I was in agony of suspense. John Harper and I went again and I got it at last! I pocketed my treasure ... and this morning I had the bliss of conversing with my Child—what thou feels I feel, there is something wanting when thou art away—nothing can supply—I fancy all sorts of things.

As it happened the letter contained a £10 note though why Betsy was sending him money is not revealed. There was a previous occasion in October 1834 (referred to earlier) when Etty had asked her to send some spare money, so perhaps this was not unusual.

Most of the dateable letters that have survived were written either in 1836 and 1837 or in 1844 and 1845 but this does not mean that Etty did not write to Betsy in the intervening years whenever the need and opportunity arose. There are many letters impossible to date which may well have been written in this period. As will have been noted, Etty wrote regularly, at least once a week, when they were separated but when something troubled him, such as the threat in the autumn of 1837 that Betsy might leave him, he often wrote daily, even sometimes twice a day. One of the reasons for the lack of surviving letters between 1837 and 1844 may be that Etty was not so frequently away. In September 1840 he went to Antwerp, taking Betsy with him, and he went again in July 1841, this time alone and spent some time in York on his return. In April 1842 he was appointed as one of the judges for the decorations of the rebuilt Houses of Parliament which kept him in London and therefore in daily contact with her. There was another visit to York in late summer 1842 and Etty wrote to Betsy from there expressing his affection for her in quite childlike terms.

Plantation near York
 Monday 11th September
 My ever Dearest Child,
 My soul longs for a sight of my beloved Babe, like as the hart for the water brooks in summer!—Does ou luv thy yitty Boy?—I have first been to Acomb church and heard a good sermon from Mr. Spencer on Repentance—The day is fine but a slight tending to rain—I hope my dear child is happy. Oh! write a line to Gillygate to tell me how thou art. Absent yet present to my mind's eye—my only love—my darling child—I shall come soon as circumstances will allow me to do so, which I hope will be [illegible] many days have past ... Oh bless my Dearest Child, and bring us in peace and safety to our happy home. A Blessing on my bonny Bairn

Mr. Spencer was the Reverend Isaac Spencer, a long-standing friend, and Etty painted his portrait while he was there. Before visiting the Rev. Spencer, Etty had referred to Betsy in a letter of 21st June 1842 as

my faithful Friend, or as I jocularly call her, my right-hand man, has become so much a part and parcel of myself, that I feel lost when she is far from me. Her health is dear to me as my own. Though she has friends in and near York, who would be happy to receive her,—to say the truth,—we don't like to be separated.

In 1843 Etty was engaged on the disastrous fresco for the Prince Consort and in August he sought solace in a visit to Paris. In that year the arrival of brother Charles from Java and his

stay until July 1845 interrupted both Etty's general mode of life and his peace of mind. Etty's constant concern for Betsy is obvious from the letters he wrote to her when brother Charles visited England in 1843 and in the following year proposed taking Betsy on a short tour of the continent. He wrote to Betsy on the 8th August 1844:

> I had a very nice and kind long letter from dear Charley—all pleasant but one thing—he says "perchance I may before you run over to Rotterdam. Betsy goes with me, no mistake." Now my dear Child—I have to tell you that thou may go to Scotland, stop at York, Hull, Givendale, or anywhere but I shall esteem it a breach of thy love and duty to me if thou goes to Rotterdam or any where abroad by boat or sea, it would make me nervous. I should be wretched, therefore I beg to say that I cannot on any account consent to it. Go anywhere on our island and enjoy yourselves as you like, but do not go to sea by your love and duty to me

Etty clearly believed, either because he was her uncle, her employer or because she was bound to him in affection and by what he had chosen to call her "bond," that he had authority to prohibit her from going abroad. We know from other references that he was by this time becoming concerned that Charles wanted her to return to Java with him and, although he had a close brotherly affection for Charles, he may have wondered whether Charles had other plans for her. Charles was certainly much taken to Betsy. It might have been, as Gilchrist suggested,[3] genuine anxiety that a sea voyage would too uncomfortable for someone in such ill health. William himself had experienced some very stormy crossings. However, she did not obey her uncle and she and Charles had a short visit together to the Rhine and Holland. Etty and Betsy had already been together to Flanders, The Netherlands and the Lower Rhinelands in 1840 and although he had at the time commented on the difficult landing from the ship to the shore on their return it does not seem that he had at any time been concerned for Betsy's health. Unfortunately he left no record of their opinion of the trip. It may well be that it was more than Betsy's health that concerned him when Charles made his proposal.

Charles and Betsy were already in correspondence for some years before he visited England. A letter endorsed "1834" from Charles to her indicates that a close friendship was already established. He asks why was she angry with him and not writing to him. How had he displeased her? In this letter Charles tells that though he wants to see his "Native Land" again he could never settle in England. He had been away 22 years, times had changed and "the Old School will not go down nowaday." In another letter dated February (?) 24th 1839 Charles complains that he has heard that she is "fond of the show of a Catholic Church."

> I beg of you not to give way to such thoughts. It is my opinion of human nature that if you have no faith of the religion you were brought up in, you can have none in another. Remain steadfast in one and people will have some faith in you but not otherwise.

Charles goes on to admit that he could not accept the strictness of religious life in England where one could not cook on a Sunday. "I suppose you will soon have to shut up your windows and remain in the dark on that day and truly make it a day of rest."

After Charles and Betsy returned from The Netherlands, William still thought they were seeing too much of each other. When he returned to London for Christmas, Betsy remained in York and, as Etty thought, stayed there too long—until March. He wrote to remind her that he needed her in Buckingham Street.

> Friday 28th Feb (last day of the month) [this would be 1845]
> My ever dearest dearest Child
> Perhaps people may say with truth that I am in my dotage (if they like) for I dote upon thee my darling Betsy. Thy kind letters and sweet snowdrops—pure as thy mind and lovely like thy dear self—are now shedding their sweet influences here. Charley's box and kind letter were both received here this morning and duly appreciated.... How's Miss Etty many inquire—come love and answer for your dear self. It is now two months to the day since I last saw thee. On or about the conclusion of the ninth week I shall indeed be *deeply disappointed!* The Monday week is my birthday and if one or both dont be

here then, I shall be hurt. If Charles goes by Cheltenham I shall not, but what should hinder thee? ... My Cough and breath today I regret to say are very bad—a cold East wind cuts me up but I shall be better tomorrow and when I see my dear Babs for whom "I die daily" as St. Paul; says....

This letter Etty signed "Thine ever William" as though to emphasize that it was as friend, not uncle, that he was imploring her to return. Why, he wondered, was Charles staying so long in England away from his wife? It was now nearly two years and Charles showed no signs of leaving.

While Charles was staying in York over Christmas 1844, Etty had Walter and his wife with him in Buckingham Street and writing from here on Friday 31st January 1845 he told Betsy that he had been working on a painting for Charles. This was Etty's favorite Indian model Mendoo according to Gilchrist.[4] In sending this painting and another, *An Indian Alarmed*, to Charles, Etty says, in a letter dated 5th February 1845, that "your children will look at them and think of their Uncle William," perhaps a subtle reminder that Charles had a family in Java waiting for him. It was in January 1845 that Etty experienced the two fires which caused him so much distress and when he would have wished Betsy to be with him. When she finally returned to London is not known but a letter dated 2nd March 1845 from Etty to her thanks her for the "sweet coronal of snowdrops" she had sent him, telling her that they were "now before me in my bedroom." It is pleasing to note that gifts of flowers could be sent by coach from York to London just as they can be today by more modern means.

Now Etty became great friends with Joseph Gillott. He had first met Gillott in 1843 but the friendship began in 1845 when Gillott began to buy his paintings. Gillott is important in any account of Betsy because he immediately appealed to both Etty and Betsy for his "down-to-earth" good nature. There is no doubt that Betsy saw in him the kind of man she wished she had married. This is revealed in the letters that Etty sent Gillott, which have been considered elsewhere. In his letters to Betsy referring to Gillott he often called him "The Comet," apparently after one of the stage coaches (which always bore names suggesting exceptional speed) presumably because, as he said, Gillott would make short unannounced visits, rush in and out and usually stay just long enough to buy something. It was not long before Etty was visiting Gillott in Birmingham and staying with his family, who appear to have had the same generous nature as the man himself. In a letter from Edgbaston, Birmingham (Joseph Gillott's house), and so after 1845, Etty wrote to Betsy:

Oh my Sweetest, my best and bonniest!
Thy dear Letter with Golden Wafer was brought to me by one of the Misses Gillott's after breakfast this morning and glad was I to see it—but do not get up so soon for fear thou makes thyself ill—when I hope to meet thee well on Whistle Monday [*Whit Monday?*] which I look forward to with hope & pleasure. Thy kindest presents duly arrived and were duly appreciated and so will be the next I have no doubt. Everything is done here that can be thought of to make me comfortable and happy. I have a delightful warm and pleasant room looking over a pleasant landskip. Mind and dont get up over soon dearest—sleep on now and take they rest, soon I hope to meet thee dearest hope and anchor of my life! ... Thy lines are not so sharp as usual! however soon I hope to see for myself and face to face, for I long to see thee dearest once more—long as the hart desireth the water brooks—when thirsty! ...
God Almighty bless thee my Darling
Thy Ever Affectionate Uncle William

In due course Gillott would accompany Betsy on the journeys from London to York or vice-versa and sometimes Betsy would stay with the Gillott family in Edgbaston, as did Etty himself, where they were both soon very welcome. Sometimes Betsy stayed with the Gillotts without her uncle and not always when Joseph Gillott himself was there, she had been so taken into the family's affection. Whenever Betsy stayed with the Gillotts, Etty was soon writing to her urging her to come home. In one undated letter he wrote:

I want my Bab! I want my Bab! my bonny Bab! When Mr. Gillott comes, he said he was coming this week, and I asked him to bring my Babe in the Wood! Walter [*illegible*] with us on Sunday, & how I wish my Angel Bairn could fly to see us then, *if she is able, with safety.*

Although there is absolutely no reason to believe that the relationship between Etty and Betsy was any more than that of uncle and niece and employer and housekeeper, there appear to have been some who suspected their obvious affection for each other. On the 22nd July 1845 John Sheepshanks, the art collector, wrote to Etty from his retirement home at No. 11 London Road, Brighton, a somewhat suggestive letter:

> My Dear Sir,
> I feel exceedingly obliged to you for writing so kind a note and provided it suits your convenience, & Miss Etty's, you can have a most hearty Welcome here for a few days. I have *two* Beds quite at liberty, *in adjoining rooms*, both for Niece & Uncle. In short there are no persons in the House except myself & Servants!! If therefore you can leave Home, pray come hither, and at all events remain over Sunday next 27th July. On Monday night 28th I leave Home for a Month or 6 Weeks.

The innuendoes can hardly be ignored. Sheepshanks was a wealthy bachelor who pursued an unorthodox life with bouts of heavy drinking and other private misdemeanors. His commissioning of William Henry Hunt to paint a "large group of watercolours of little boys"[5] suggests interests, if not actual practices, of which Etty would doubtless have disapproved. Probably he thought that Etty was as unconventional as he was. Many middle aged men passed off their young female companions as nieces. It is possible that some of Etty's contemporaries thought he was doing this. Betsy was certainly aware that such relationships existed as the following letter reveals. From Buckingham Street on 3rd September 1846, Etty wrote her:

> Only think of Dicky Toppin! naughty man. A mutual Friend of our dear innocent Johnny Wood and Dicky went to Ramsgate the other day and Dicky introduced two bouncing girls, the youngest one lively and the other much older as "his daughter"! Only think Master Brook, such consternation. Has our Tea and Sally Lunns come to this. Miss Easton is in despair—"only think Mr. Etty."

In those days Ramsgate and Margate had a certain reputation, in the opinion of some being minor versions of Brighton, which had of course been made notorious by the Prince Regent and his friends. They were easily reached from London by steamer and, in addition to being convenient holiday resorts for Londoners, were favorite *rendez-vous* for young men with insufficient money to afford Brighton. Both were favorite places for Turner. It was at Margate that he kept his Mrs. Booth. We can well understand the shock of Etty's well-behaved friends on discovering that one of their circle was misconducting himself. Presumably Etty could rely on Betsy's not being shocked or he would not have told her. The tone of his letter suggests that both he and Betsy found their friends' reactions somewhat amusing. Which brings us to the question of Betsy's own reactions to the subjects of her uncle's paintings and the visits of models to No. 14 Buckingham Street. Most tantalizingly we know practically nothing on this subject. All we do know is that on the 15th June 1834 he took Jane (Walter's daughter), Cicely Bulmer and Betsy to the National Gallery to see the two paintings by Correggio which had just been acquired from Lord Londonderry. Correggio's *Mercury Instructing Cupid before Venus* was very much in Etty's own idiom. We may assume that this was not the only time he took Betsy to exhibitions. While there they would not have restricted themselves to viewing just one or two paintings. Betsy became her uncle's general factotum, supervising the packing and dispatch of paintings, arranging their insurance and transport. She would have had a close knowledge of his work. In regard to his models, all we know is that she sometimes helped in engaging them but apparently only those required for portraits and similar subjects.

A related question that is sometimes asked is whether Betsy ever posed for her uncle. On the face of it, judging by the nature of Etty's letters to his niece, it would seem most unlikely. Throughout all his letters which have survived—and there would seem to be very few, if any, that are missing—there is not a single word that suggests she ever did, not even to provide a facial image to be attached to a model's body. From the single portrait available Betsy does not

appear to have been a beauty, though pleasant enough but not sufficiently so to justify Etty's using her likeness for one of his nymphs or goddesses. We know he did sometimes use women friends to provide facial images and the fact that we have evidence of this suggests that we would also have evidence if he so used Betsy. The likelihood that she ever posed wholly nude seems out of the question. There are numerous studies which are clearly of the same model but he would have had no difficulty in obtaining models. It would have been merely to avoid costs that would have persuaded him to use Betsy and there was certainly no need for him to have been concerned on that account. Above all, Etty was very much aware of his responsibilities towards his brother John to ensure that he behaved towards her as a dutiful uncle and employer. Undoubtedly she met many of his models face to face and may even have been present in his painting room when they were posing. We can safely assume that she was no prude but it seems without doubt that she drew a strict line between their respective duties.

Although very occasionally Betsy reminded her uncle that she was casting around for a husband she was usually only teasing him, but the entry of Joseph Gillott into her life had an unexpected effect upon her. It was soon apparent that Betsy was becoming attracted to Gillott and Etty was not in favor of Betsy's having much of his company. He seems to have been fearful that she would get to like him more than was appropriate. This was the same apprehension that he had with Betsy and brother Charles. On one occasion Etty wrote to Betsy at Edgbaston (the letter is not dated but was shortly before 7th July 1844 as Etty refers to the forthcoming ringing of the Minster bells)—

> I found in conversation with Mr. G. that he wishes thee to remain after I am gone. [*Gillott was in York at the time with Etty and they were returning to Edgbaston together.*] This I should not like and Walter said you had better take her home with you. This will require firmness but I say if thou art strong enough we must stick to this point or when shall we meet again. God only knows. So be on thy guard. Our friends are kind. We should not in any way offend but this is a point we must stick to.

Gillott himself must have become aware of Betsy's regard for him and the two men recognized the situation and decided to treat it with good humor. In a letter dated 12th January 1845 written from Buckingham Street, Etty told Gillott that his failure to visit him as expected had very much upset Betsy.

> ... our hopes and fear has arisen to pressure pitch, and had not the "safety valve" of the post given us relief—I think *one of us*, I don't say which, you may guess, would have gone to the water-side and thrown *herself* in! Now she says she shall seek relief in the opposite element she was going to seek in *cold* water—in hot fire, for she is going to cook a pheasant on *Friday to be ready at 3* and hopes you will not a second time disappoint. Oh! this love! heigh ho! I will tell you when you come how she behaved when she found you did not come....

Etty took care as usual to include Betsy in sending "kind regards" to "Mrs. Gillott, daughters and little Montague" as if to reassure them all. In a well written and business like letter of 20th March 1846 Betsy wrote to Gillott (addressing him as "Dear Sir") informing him firstly of the weather in London, then giving him news of joint friends and proceeding to discuss the paintings that "Mr. Etty" was wanting for the Royal Academy exhibition. These were with Gillott and would have to be sent by him to London. Betsy was concerned about insurance. She gave Gillott some advice, making it clear that she usually dealt with such matters. She finished by entreating him to visit them again soon, sent "united regards to Mrs. Gillott, your Daughters, and the rest of your happy family" and added, "accept my best thanks for all your kindness to me on all occasions and may I prove still worthy of your future and much esteemed friendship whom [*sic*] I value above price."

Apparently she had misgivings about these final words since she added a postscript—"I pray when you have read this pray burn it, and don't expose my weakness." Today no one would assume that this letter, apart from the postscript, was more than a communication expressing normal

friendship and thanks for past kindnesses but in the *mores* of the time a wife discovering such a letter might well have suspected infidelity. The postscript reveals that both parties knew of her affection for him which she had failed to conceal and that alone was the dangerous part of the letter. Gillott was a good-hearted, generous and jovial man who had probably engaged in what he regarded as mere badinage. He was most likely not well versed in the etiquette of the class to which he aspired. But Betsy had found a man of the kind she wished for and had not concealed the fact.

By the time Etty decided to retire from professional life and return to York it had become accepted between them that Betsy would continue to live with him and look after him without any regard for her personal wishes to marry. Frequently Etty wrote to her while she stayed in London to clear the apartment in Buckingham Street in terms which made quite clear his dependence upon her. In a letter dated "York, Whitsunday, 1848" he wrote "If you don't look very sharp and come down there's no knowing but thy little Lamb will be toddled off with some Sheep or other" and signed it—"God bless thee my Lamb, Thy sheep William." Again, clumsy humor but perhaps significantly without the addition of "Uncle." In the summer of 1848 when Betsy was still in London, Etty began to refer to his York friends as "sheep" looking after him, teasing her that he was finding other female companions. On the 14th June he wrote to her:

> I'll tell thee what! my most dearly beloved young Sheep! If thou isn't very civil and makes merry sharp and turn down, there's so many little Lambs making offers I shall be snipped up like a [*illegible*] and nobody will know what has become of me! every day almost some new one. A [*illegible*] brought one yesterday and short bread and long love letters from Givendale with cream cheese and I know not what coming and only twopence to pay. [*It was still the system with the post that recipients paid for delivery of letters and parcels.*]

This letter he signed off—"Darling of my heart and best beloved! W. Etty."

This kind of banter was quite usual, playfully trying to make her jealous by claiming that he had innumerable lady friends ready and willing to take him into their care. Betsy, however, would sometimes retaliate by suggesting that it was only the "Gay Ladies" of York who would show interest in him. Why he chose to call his lady friends "sheep" is unclear but seems to refer to a private joke between them that he was like a helpless lamb needing not so much a shepherd but an older female guardian. Of course, Etty would never have suggested that he needed a shepherd, he had such a comforter and guide in Christ, and there would have been improper sexual connotations had he suggested the need for a shepherdess. He was always a strict observer of the proprieties of the age and never suggested anything that would offend the rules of good behavior or the principles of religion. Several of these later letters he signed merely "Thy William" and added a dot in a circle with the word "Kiss." In these final years he was no longer maintaining the strict family relationship but was quite willing to admit his deep affection. As she grew older Betsy's health began to deteriorate, largely due to the polluted atmosphere of London. A late letter endorsed by another hand "Sep. 3 (?) 1848" expresses concern for her health.

> My ever dearest Child
> I beseech thee attend to what I say—*Keep still and quiet*—thy Frame (?) will not allow much motion at present don't go to Birmingham don't go anywhere yet for some time to come—I *suffer* when Thou *suffers*—and I am sure Thou art not fit to move yet. ... I felt that thou had been attempting too much—dont dearest for thy little boy's sake—

This was clearly written at some such date as is endorsed because the reference to Birmingham is to Joseph Gillott's house at Edgbaston and by this time Betsy was a frequent visitor there.

In one of his last letters to Thomas Bodley (11th August 1849) from Buckingham Street, after telling Bodley of his last bout of illness—"I think I never was more so ill—burnt up with fever and thirst—and agonized with pain"—Etty writes: "My Dearest Betsy has been most exemplary and attentive. Her heart and head are worth a diadem!"

In the summer and autumn of 1848 Betsy was continually ill. She was on her own in No. 14 Buckingham Street and Etty was greatly disturbed that she had no one to look after her. He was busy finalizing arrangements to take possession of his house in Coney Street but he constantly wrote to her urging her to find a companion until she could join him in York. Betsy had left her uncle in York at the end of June and in a letter from him dated the 4th July he expressed his relief that she had arrived in London safely and promised that he would soon join her, though presumably not for long. At this period Etty wrote her daily, so great was his concern. He was never content unless he heard from her regularly and was always asking for letters. He expressed particular concern that she should take care when crossing a road, which reminds us that London streets were then very busy and that cabs, private carriages and horse riders observed no speed limits. Betsy must have been very ill for in September (the 1st) he cautioned her "Don't attempt to go down stairs yet, honey! Keep still in thy nice room and get well my best beloved." During this period Etty frequently signed himself "Thy loving William." It does not appear that he went back to London that summer as there was a continual flow of letters from York.

Self Portrait **(16.5 × 12.5 ins) (1849), Manchester Art Gallery.**

Etty visualized the two of them living out their lives together in "a Cottage in York." That Betsy wanted to marry he knew but was confident this would never happen. He had accumulated ample funds for their retirement together, as he frequently told her. Sometimes he playfully laid down conditions for the occupation of the Coney Street house. "Mind, there's no sweetheartings allowed! no followers, no admittance except on business." When in due course the Coney Street house was ready he took great pains to have Betsy's bedroom specially decorated, "the only thing wanting is her presence." Their last year together was spent in perfect friendship. In a letter of 7th October 1849 he told William Wethered, "Betsy and I toddle about. Yesterday we had a delightful walk." This was how Etty had always envisaged his final years, walking about York, attending services in the Minster and occasionally painting from the model which somehow he would be able to obtain, probably through the School of Design he had been instrumental in establishing. So it was to be, but not for long. When Etty died on 13th November 1849, Thomas Bodley recorded in a letter to Walter how distressed Betsy was. That very evening, very soon after her uncle's death, the first person Betsy wrote to was Joseph Gillott. It was brief letter but it is significant that it was to him that she turned in her grief.

My dear Mr. Gillott you will I know do all you can for a friend my dear
 Uncle paid the last debt to Nature at ¼ past Eight oclock tonight.
 I do not know what to do, I am almost broken hearted. I have lost my best friend. I now [sic] not what to do. I can say no more.
 Eliz Etty

The nature of the relationship between Etty and Betsy has never been fully examined and it cannot be as fully investigated as would be appropriate because the details are confined to the correspondence between them and much is so vague as to afford no evidence beyond that of a developing affection. In almost every letter he calls upon the Almighty to bless their days and ensure their good health and long lives, for them a necessary assurance since both suffered from recurrent ill health. Etty was so pious a man and so simple in his faith that he could not have stepped outside the bounds of propriety. That he did love Betsy cannot be denied but it was a love based on dependency and admitted only within the proper constraints of his religious faith. Outside his art Etty was an innocent, a man with simple needs, above all a need for friendship and support, and a man who needed to think well of his fellows. He needed the certainties of close love at all times but a love that did not require any physical demonstration which he appears to have found distasteful. Etty found Betsy wholly dependable and it was dependability he needed, just as married couples need it in each other. Betsy's love for her uncle was one of sacrifice, the kind of sacrifice that many daughters make for parents, and many wives make for their husbands. As Etty himself said, she was his right arm and often his left as well. Without her he could not have survived. She knew this and her sense of duty, no doubt encouraged by an underlying religious faith, of which incidentally we know nothing other than that she was a regular churchgoer, ensured that she remained faithful to him as would be expected from a wife. In some respects it may be said that she was his surrogate wife but only in the sense that she was his dependable companion. We must recall the letter that Etty wrote to Betsy some time earlier but unfortunately at a date not known. This has been reproduced in Chapter Ten under *Etty and marriage* but it is necessary to repeat it here as the final confirmation of the nature of his feelings for his niece and presumably of hers for him.

> Oh my darling, I like to be ever near thee. Love, such as angels might feel, for purity is mine for thee unmixed with base matter—that is the love I love the best. I wish for, I look for no other on earth or in Heaven—let others take all the rest for me. I have done with the rest I trust for ever. It is indeed Vanity, all is Vanity save the holy flame of sacred Love which lights us alone for happiness and peace and leaves no stain, no string behind and like the last gold rays of the setting sun on a cheerful hillside on which the sheep and lambs of the fold of Christ are feeding, inspires nothing but sweetness, gentleness and love towards Him who made and blesses us.

In May 1850 she married the chemist, Stephen Binnington, to whom she had long been attached. Binnington was a widower and it is recorded that he had a daughter, Elisabeth, known as Lissy, whom Betsy brought up. It is of interest, but hardly a coincidence, that the mother of Esther Calverley, i.e., William Etty's maternal grandmother (and Betsy's great-grandmother), had been Jane Binnington. It was, of course, quite customary for country people at that time to marry within families. Steve Binnington was the son of Robert Binnington of Ferriby near Hull, who apprenticed him to Bell Robinson and Robert Stabler, both of Beverley in the East Riding of Yorkshire, who were "Chemists, Druggists, Wine and Spirit Merchants" according to the Indenture of the 19th June 1817. His apprenticeship was for seven years but, being apprenticed to Freemen, he was made Freeman of Beverley on the 6th September 1821. Whether he lived and worked in York at any time is unclear but he was certainly living in London when Betsy married him. They lived at No. 35, Haymarket, which, according to contemporary reports, was in Victorian times "a great parade ground of abandoned women." At some time Binnington died, apparently while his daughter was still in Betsy's care. Betsy married a Mr. Ince of whom nothing is known. When she died in 1888, aged 87 years, she was living at No. 40, Edwardes Square, Kensington, a speculative building development erected between 1811 and 1819 in which, in due course, resided many notable writers including George Du Maurier, G. K. Chesterton and Leigh Hunt. She had apparently lived here with her second husband. Betsy had clearly done well for herself, as one must say she deserved.

CHAPTER NOTES

Abbreviations and Full References

Armstrong Armstrong, Alan. *Stability and Change in an English County Town; A Social Study of York.* Cambridge University Press, 1974.

Aylmer and Cant Aylmer, G.E., and Cant, Reginald (eds.). *A History of York Minster.* Clarendon Press, 1977.

Bagnamini & Postle Bagnamini, Ilaria, and Postle, Martin. *The Artist's Model: Its Role in British Art from Lely to Etty.* Exhibition catalogue 1991.

Barrell Barrell, John. *The Political Theory of Painting from Reynolds to Hazlitt.* Yale University Press, 1986.

Bell Bell, Quentin. *The Schools of Design.* Routledge and Kegan Paul, 1963.

Brownell Brownell, Morris. *The Prime Minister of Taste: A Portrait of Horace Walpole.* Yale University Press, 2001.

Burke Burke, Edmund. *A Philosophical Enquiry into the Origin of Our Ideas of the Sublime and the Beautiful.* Originally 1757, new edition 1812.

Camidge Camidge, William. *F. R. H. S.: The Poet-Painter of York, William Etty, R.A.* Burdekin, York, 1899.

Chesterfield *Letters to His Son by the Earl of Chesterfield.* Leigh, Oliver H. (ed.). Reprinted by Tudor Publishing Co. New York (undated).

Clark Clark, Kenneth. *The Nude.* John Murray, 1956.

Constable Leslie, C.R. *Memoirs of the Life of John Constable.* The Phaidon Press, 1951.

Etty Etty, William. Autobiography published in *The Art Journal,* Vol. XI. 1849.

Farr Farr, Dennis. *William Etty.* Routledge & Kegan Paul, 1958.

Fawcett Fawcett, Trevor. *The Rise of English Provincial Art, Artists, Patrons and Institutions Outside London, 1800–1830.* Clarendon Press, Oxford, 1974.

Feinstein Feinstein, C.H. (ed). *York 1831–1981: 150 Years of Scientific Endeavour and Social Change.* William Sessions Ltd., 1981.

Gaunt and Roe Gaunt, William, and Roe, F. Gordon. *Etty and the Nude: The Art and Life of William Etty, R.A.* F.Lewis, Publishers, Ltd., Leigh-on-Sea, 1943.

Gilchrist Gilchrist, Alexander. *Life of William Etty, R.A.* 1855, republished 1978 E.P.Publishing Ltd., Wakefield.

Heleniak Heleniak, Kathryn Moore. *William Mulready.* Yale University Press, 1980.

Hutchison Hutchison, Sidney C. *The History of the Royal Academy, 1768–1986,* Robert Royce Ltd., 1986.

Knowles Knowles, J.W. *The York School of Design.* Unpublished manuscript in York Reference Library.

Leslie Lectures on the Works of the late W. Etty, Esq., R.A. The Athenaeum, 30th March 1850.

Leslie Autobiography *Autobiographical Recollections of Charles Robert Leslie.* Tom Taylor (ed.). First published John Murray, 1860, republished E.P. Publishing Ltd., 1978.

Maas Maas, Jeremy. *Victorian Painters.* Barrie and Jenkins, London, 1969.

Macleod Macleod, Dianne Sachko. *Art and the Victorian Middle Class: Money and the Making of Cultural Identity,* Cambridge University Press, 1996.

Mayoux Mayoux, Jean-Jacques. *English Painting from Hogarth to the Pre-Raphaelites.* Skira, 1972.

Moorhouse Moorhouse, Geoffrey. *The Pilgrimage of Grace.* Weidenfeld and Nicolson, 2002.

Nuttgens Nuttgens, Patrick. *York: The Continuing City.* Maxiprint, 1976.

Redgraves Redgrave, Richard, and Samuel Redgrave, *A Century of British Painters.* Phaidon, 1947.

Richardson Richardson, Jonathan. *The Theory of Painting.* London, 1724.

Sandby Sandby, William. *The History of the Royal Academy of Arts.* Longman, Green, Longman, Roberts and Green, London, 1862. Facsimile Reprint by Cornmarket Press, London, 1970.

Smith Smith, Alison. *The Victorian Nude: Sexuality, Morality and Art.* Manchester University Press, 1996.

Steegman Steegman, John. *The Rule of Taste: George I to George IV.* Macmillan, 1968.

Uwins Uwins, Sarah. *A Memoir of Thomas Uwins, R.A.* Republished E.P. Press Ltd., 1978.

Vaughan & Postle *The Artist's Model from Etty to Spencer.* Exhibition Catalogue, Merrell Holberton Publishers Ltd., 1999.

Walpole Walpole, Horace. *Anecdotes of Painting with Some Account of the Principal Artists.* Revised and edited by Ralph N. Wornum. Swan Sonnenschein, Lowrey & Co., London, 1888.

Waterhouse Waterhouse, Ellis. *Dictionary of British 18th Century Painters.* Antique Collectors' Club, 1981.

Webb Webb, Gerry. *Fairfax of York.* Maxiprint, 2001.

Westerfield Westerfield, Ray. *Middlemen in English Business 1660–1760.* 1915, reprinted New York, 1968.

Wood Wood, Christopher. *Dictionary of Victorian Painters.* Antique Collectors' Club, 1971.

Wornum Wornum, Ralph A. *Collected Lectures of Barry, Opie and Fuseli.* Henry G. Bohn, London, 1848.

Young Young, G. M. (ed.) *Early Victorian England.* Oxford University Press, 1934.

The Notes

Introduction

1. Whinney, Margaret and Millar, Oliver, *English Art 1625–1714 (Oxford History of English Art)*, Clarendon Press, 1957, p. 7.
2. Walpole, II, p. 259.
3. Barrrell, p. 3.
4. Richardson, pp. 17–21.
5. *The Rambler, 7th January 1752*.
6. Chesterfield, Letter LXVIII, 19th April 1749, Vol. I, p. 170.
7. *Ibid.*, Letter LXXXVI, 17th October 1749, Vol. I, p. 227.
8. *Ibid.*, Letter LXXXIII, 27th September 1749, Vol. I, p. 217.
9. Brownell, p. 5.
10. Chesterfield, Letter LXVIII, April 19th 1749, Vol. I, p. 170.
11. Richardson, p. 26.
12. *Ibid.*, pp. 171–2.
13. Walpole, Horace, *Anecdotes of Painting in England*, Ralph N. Wornum (ed.), London, Vol. I, pp. 27–8.
14. *Ibid.*, Vol. I, p. 23.
15. *Ibid.*, Vol. II, p. 202.
16. Steegman, p. 180.
17. Burke, Section IV, p. 174.
18. *Ibid.*, Section XII, pp. 209–10.
19. Blake, William, *Marriage of Heaven and Hell*.
20. Gilchrist, II, p. 331.

Chapter One

1. Hargrove, William, "History and Description of the Ancient City of York," p. 8.
2. Gilchrist, I, p.2.
3. Camidge, p. 1.
4. Gilchrist, I, p. 10.
5. Gaunt and Roe, p. 24.
6. Nuttgens, Patrick (ed.), *History of York*, Blackthorn Press, 2001.
7. Webb, p. 43.
8. *Ibid.*, p. 196.
9. Gilchrist, I, p. 7.
10. *Ibid.*
11. *Ibid.*, I, p. 14.
12. Gaunt and Roe, p. 26.
13. Moorhouse, pp. 116, 261 and 299.
14. *Ibid.*
15. Gilchrist, I, p. 7.
16. *Ibid.*, I, p. 10.
17. *Ibid.*, I, p. 12.
18. *Ibid.*
19. London Guildhall Library, MS. 7859/1.
20. Gilchrist, I, p. 22.
21. Etty, p. 13.
22. Farr, p. 4.
23. Gilchrist, I, p. 16.
24. *Ibid.*, I, p. 17.
25. *Ibid.*, I, p. 20.
26. *Ibid.*
27. Fawcett, p. 158

28. *Yorkshire Gazette*, 20th September 1823.
29. Gilchrist, I, p. 19.
30. *Ibid.*, I, p. 22.
31. Gilchrist, I, p. 19.
32. Gilchrist, I, p. 22.
33. *Ibid.*, II, p. 91.
34. Benson, Edwin, "A History of Education in York, 1780–1902," unpublished thesis for Degree of Doctor of Philosophy in the University of London, October 1932, York Reference Library.
35. Aylmer and Cant, p. 10.
36. Benson, "Education in York."
37. *Ibid.*
38. Gilchrist, I, p. 25.

Chapter Two

1. Moorhouse, p. 107.
2. Aylmer and Cant, p. 33.
3. *Sun Life Insurance Company Records, Guildhall, London, MS 11936 Vol. 136*; quoted by Webb, p. 84.
4. Nuttgens, Patrick, "York." Studio Vista, 1970, p. 5.
5. Webb, p. 81.
6. Knight, Charles, *A History of the City of York*, Yorkshire Herald, 1844, p. 638.
7. Aylmer and Cant, p. 268.
8. Armstrong, p. 20.
9. Drake, F. "Eboracum," 1736, pp. 239–240.
10. Feinstein, pp. 121–122.
11. Green, Richard, *York Through the Eyes of the Art*, York City Art Gallery, 1990, p. 1.
12. "Diary of a Young Lady visiting York, 1812–13," Dr. W.A. Evelyn, Collection Box I, York Library Archives, quoted by Geoffrey G. Carr, "Who Saved York Walls? The Roles of William Etty and the Corporation of York," *York Historian*, 5:1984, p. 26.
13. Armstrong, p. 47.
14. Gilchrist, I, p. 28.
15. *Ibid.*, I, p. 49.
16. Etty, p. 13.
17. *Ibid.*
18. Gilchrist, I, p. 23.
19. *Ibid.*, I, p. 26.
20. Farr, p. 9.
21. *Ibid.*
22. Etty, p. 13.
23. Gilchrist, I, p. 31.
24. *Ibid.*
25. Farr, p. 8.
26. Gilchrist, I, p. 31.

Chapter Three

1. Gilchrist, I, p. 31.
2. *Ibid.*, I, p. 32.
3. Etty, p. 13.
4. *Ibid.*, p. 13.
5. Farr, p. 8.
6. Gunnis, Rupert, *Dictionary of*

British Sculpture, 1680–1851, Abbey Library, 1951.
7. Etty, p. 37.
8. *Ibid.*
9. *Ibid.*
10. *Ibid.*
11. Wornum, p. 244.
12. *Ibid.*, p. 245.
13. *Ibid.*, p. 251.
14. *Ibid.*, p. 255.
15. *Ibid.*, p. 327.
16. *Ibid.*, p. 342.
17. *Ibid.*, p. 325.
18. *Ibid.*, p. 332.
19. *Ibid.*, p. 335.
20. *Ibid.*, p. 272.
21. Hutchison, p. 27.
22. Wornum, p. 349.
23. *Ibid.*, p. 347.
24. *Ibid.*, p. 532.
25. Gilchrist, I, p. 86.
26. Wornum, p. 419.
27. *Ibid.*
28. *Ibid.*, p. 516.
29. *Ibid.*, p. 519.
30. *Ibid.*, p. 520.
31. Redgraves, p. 116.
32. *Ibid.*, p. 298.
33. *Ibid.*, 299.
34. *Ibid.*, 283.
35. Etty, p. 37.
36. Gilchrist, I, p. 96.
37. *Ibid.*, I, p. 36.
38. *Ibid.*
39. Grant and Roe, p. 17.
40. Etty, p. 39.
41. Gilchrist, I, p. 36.
42. Redgraves, p. 231.
43. Gilchrist, I, p. 37.
44. Blake, William, Preface to *Jerusalem*.
45. Hutchinson, *op. cit.*, p. 53.
46. Garlick, Kenneth, *Sir Thomas Lawrence*, Phaidon, 1989, p. 11.
47. *Ibid.*, p. 19.
48. *Ibid.*, p. 25.
49. *Ibid.*
50. *Ibid.*
51. *Ibid.*
52. Redgraves, p. 238.
53. Etty, p. 37.
54. *Ibid.*
55. *Ibid.*
56. Gilchrist, I, p. 39.
57. Etty, p. 39.
58. *Ibid.*

Chapter Four

1. Quoted in *The London Encyclopaedia*, Ben Weinreb and Christopher Hibbert (eds.), Macmillan, 1983 rev. 1992, p. 489.
2. Porter, Roy, *English Society in the Eighteenth Century*, Penguin Social History of Britain, 1982, p. 48.
3. Information provided by Tom Etty of Nijmegen from personal correspondence with Dennis Farr.
4. Farr, p. 27.

5. Farr, p. 132.
6. Maas, p. 105.
7. Treuhertz, Julian, *Victorian Painting*, Thames and Hudson, 1987, pp. 33 ff.
8. Etty, p. 37.
9. *Ibid.*
10. *Ibid.*
11. Gilchrist, I p. 48.
12. Leslie, pp. 349 ff.
13. Letter from William Etty to Walter Etty, 19th June 1811.
14. Bennett, Shelley M., *Thomas Stothard: The Mechanisms of Art Patronage in England, circa 1800*, University of Missouri Press, 1988, p. vii.
15. Gilchrist, I, pp. 65 to 72.
16. Farr, p. 21.
17. *Literary Gazette*, 17th May 1817, p. 264.
18. Gilchrist, I, p. 77.
19. Etty, p. 37.
20. Gilchrist, I, p. 79.
21. Etty, p. 37
22. Farr, p. 25.
23. *Ibid.*, p. 30.
24. *The Athenaeum*, No. 1170, 30th March 1850.
25. *The Gentleman's Magazine*, XCI, May 1821, p. 446.
26. Redgraves, p. 285.
27. Etty, p. 37.
28. *The Times*, 29th January, 1822.
29. *The Gentleman's Magazine*, XCI, May 1821, p. 446.
30. *The Examiner*, 3rd June, 1821, pp. 346–7.
31. *The Morning Post*, 5th May 1821, p. 3.
32. *The Observer*, 11th June 1821.
33. Farr, p. 29.
34. *Art Union*, Vol. X, April 1848, facing page 116.
35. Farr, p. 143.
36. *Ibid.*, p. 143.
37. Gilchrist, I, p. 98.
38. *Ibid.*, I, p. 100.
39. Gilchrist, I, p. 98.

Chapter Five

1. Letter, William Etty to Sir Thomas Lawrence, 12th October 1822 (Royal Academy Collection of Autograph Letters).
2. *Ibid.*, 14th November 1823.
3. *Ibid.*
4. *Ibid.*, 12th October 1822.
5. *Ibid.*
6. Gilchrist, I, p. 117.
7. *Ibid.*
8. Letter, William Etty to Walter Etty, 11th September 1822.
9. Etty, p. 38.
10. Farr, p. 37.
11. Waterhouse, p. 52.
12. Gilchrist, II, p. 181.
13. Etty, p. 38.
14. Pollock, Sir Frederick, *Macready's Reminiscences and Selections from*

His Diaries and Letters, 1875, I, xvi, p. 266.
15. Letter, William Etty to Walter Etty, undated, November 1822.
16. *Ibid.*
17. Letter, William Etty to Walter Etty, 6th December 1822.
18. Letter, William Etty to Walter Etty, 30th January 1823.
19. Etty, p. 38.
20. Letter, William Etty to Walter Etty, 30th January 1823.
21. Etty, p. 38
22. Letter, William Etty to Walter Etty, 30th January 1823.
23. Letter, William Etty to Sir Thomas Lawrence, 26th March 1823 (Royal Academy Collection of Autograph Letters).
24. Letter, William Etty to Walter Etty, 30th January 1823.
25. Garlick, Kenneth, *Sir Thomas Lawrence*, Routledge and Kegan Paul, 1954, p. 13.
26. Letter, William Etty to Sir Thomas Lawrence, 26th March 1823 (Royal Academy Collection of Autograph Letters).
27. Garlick, Kenneth, *Sir Thomas Lawrence*, Routledge and Kegan Paul, 1954, p. 13.
28. Etty, p. 39.
29. Letter, William Etty to Walter Etty, 28th July 1823.
30. Letter, William Etty to Thomas Bodley, 13th September 1823.
31. Gilchrist, I, p. 187.
32. Letter, William Etty to Thomas Bodley, 13th September 1823.
33. *Dictionary of National Biography*.
34. Letter, William Etty to Walter Etty, 15th November 1823.
35. Letter, William Etty to Sir Thomas Lawrence, 14th November 1823 (Royal Academy Collection of Autograph Letters).
36. *Ibid.*
37. Letter, William Etty to Walter Etty, 7th November 1823.
38. Gilchrist, I, p. 209.
39. *Ibid.*, I, p. 215.
40. *Ibid.*
41. *Ibid.*, I, p. 137.
42. *Ibid.*, I, p.59.
43. *Ibid.*, I, p. 139.
44. Letter, William Etty to Walter Etty, 20th October 1822.
45. Gilchrist, I, p. 97.

Chapter Six

1. Westmacott, Charles, *Descriptive and Critical Catalogue of the 1824. R.A. Exhibition*.
2. Gilchrist, I, p.221.
3. British Library, Add. MS. 38794 E ff. 109–10.
4. Gilchrist, I. pp. 220–222.
5. *Ibid.*, I, p. 225.

6. *The Times*, 4th November 1824.
7. Gilchrist, II, p. 193.
8. *The Times*, 4th November 1824.
9. Gilchrist, II, p. 193
10. *Ibid.*, II, p. 196.
11. *Ibid.*, I, p. 256.
12. *The Times*, 3rd May 1825.
13. Redgraves, p. 286.
14. Farr, p. 48.
15. Gilchrist, I, p. 228.
16. Farr, p. 48.
17. Huyghe, René, *Delacroix*, Thames and Hudson, 1963, p. 163.
18. *York City Reference Library*.
19. Clark, Kenneth, *The Romantic Rebellion*, John Murray, 1973, p. 199.
20. Gilchrist, I, p. 234.
21. Farr, p. 50.
22. *The Examiner*, 14th May 1826, p. 306.
23. *The Times*, 29th April, 1826.
24. Gilchrist, I, p. 235.
25. *Ibid.*, I, p. 231.
26. *Ibid.*, I, p. 233.
27. Gilchrist, I, p. 235.
28. Farr, p. 51.
29. *Ibid.*, p. 50. Gilchrist, I, p. 237.
30. Knox, John, title of a Pamphlet, 1558.
31. Stocker, Margarita, *Judith, Sexual Warrior*, Yale University Press, 1998, p. 144.
32. Gaunt and Roe, p. 77.

Chapter Seven

1. Gilchrist, I, p. 249.
2. *Ibid.*, I, p.246.
3. Waterhouse, p. 371.
4. Gilchrist, I, p. 253.
5. Frazer, Sir James, *The Golden Bough*, 1890.
6. Fry, Roger, *Reflections on British Painting*, London, 1934, repub. 1951, p. 187.
7. Farr, p. 54.
8. Wright, Christopher, *Poussin Paintings: A Catalogue Raisonné*, Hippocrene Books, 1985, p. 246.
9. Posner, Donald, *Annibale Carracci*, Phaidon, 1977, I, p. 46.
10. Hope, Charles, *Titian*, Jupiter Books, 1980, p. 158.
11. *Dictionary of National Biography*, 2004.
12. Leslie, p. 173.
13. *Ibid.*, p. 158.
14. Gilchrist, I, p. 242.
15. *Ibid.*, I, p. 257.
16. *Ibid.*, I, p. 266.
17. *Ibid.*, I, p. 279.
18. *Ibid.*, I, p. 280.

Chapter Eight

1. Etty, p. 37.
2. Sandby, Vol. II, pp. 15–16.
3. Layard, George Somes, *Sir Thomas Lawrence's Letter-Bag*, George Allen, 1906, pp. 227–228.

4. Gower, Lord Ronald Sutherland, *Sir David Wilkie*, George Bell & Sons, 1902, p. 72.

5. Haydon, Benjamin, *Autobiography and Memoirs*, 1926, Vol. II, p. 443. Ed. Toni Taylor.

6. Hutchinson, p. 83.

7. Sandby, *op cit.*, Vol. II, pp. 132–142.

8. *Ibid.*, Vol. II, p. 74.

9. *Ibid.*, Vol. II, p. 77.

10. *Ibid.*, Vol. II, p. 80.

11. Hutchinson, p. 96.

12. Sandby, *op cit.*, Vol. II, p. 142.

13. Harvey, A.D., *Sex in Georgian Britain*, Phoenix Press, 2001, pp. 21 ff.

14. Gilchrist, I, p. 285.

15. *The Times*, 23rd July, 1830.

16. Farr, p. 58.

17. Epigram in *The Atlas*, 28th April 1855.

18. Letter William Etty to Thomas Bodley. 3rd September 1830, York City Reference Library.

19. Etty, p. 40.

20. Gilchrist, I, p. 290.

21. *Ibid.*, I, p. 309.

22. *Ibid.*, I, p. 310.

23. *Ibid.*, I, p. 309

24. Defoe, Daniel, *Complete English Tradesman*, 1726, pp. 26 and 33 quoted by Stone, Lawrence, *The Family, Sex and Marriage in England, 1500–1800*, Weidenfeld and Nicolson, 1979, p. 326.

Chapter Nine

1. Gilchrist, I, p. 329.

2. Farr, p. 181.

3. *Ibid.*, p. 158.

4. Beckett, R.B., *John Constable's Correspondence*, 1965, III, p. 132, quoted by Smith, Alison, *Exposed: The Victorian Nude*, Tate Publishing, 2002, p. 57.

5. Smith, Alison, *op. cit.*, p. 57.

6. Farr, p. 64.

7. *Gentleman's Magazine*, February 1833, p. 170.

8. Gilchrist, I, p. 344.

9. *New Monthly Magazine*, 1st March 1824, p. 336.

10. Carey, William, *Some Memoirs of the Patronage and Progress of the Fine Arts in England and Ireland*, London, 1826, pp. 166–168.

11. Gilchrist, I, p. 345.

12. *Ibid.*, I, p. 363.

13. *Ibid.*, II, pp. 75/76.

14. Farr, p. 65.

15. Steegman, p. 121.

16. Farr, p. 131.

17. Gilchrist, I, pp. 75/76.

18. *Ibid.*, p. 351.

19. *Ibid.*

Chapter Ten

1. Etty, p. 40.

2. Farr, pp. 10–11.

3. Wornum, p. 240.

4. *Ibid.*, p. 319.

5. Bulwer, Sir Lytton, *England and the English*. London, 1840, Chap. IX, pp 497–8 quoted by Farr, p. 65.

6. *Ibid.*, p. 502.

7. Farr, p. 133.

8. Gilchrist, I, p. 240 and II, p. 220.

9. Sandby, Vol. II, p. 16.

10. Letter, William Etty to George Bulmer, 15th June 1834.

11. Letter, William Etty to Sir Thomas Lawrence, 14th November, 1823.

12. Letter, William Etty to Thomas Bodley, 18th July 1834.

13. *Ibid.*

14. *Ibid.*

15. Gilchrist, II, p. 45.

16. Feaver, William, *The Art of John Martin*, Oxford, 1974, p. 126.

17. *Ibid.*, pp. 126/127

Chapter Eleven

1. Letter, Thomas Myers to William Etty, 14th January 1834.

2. Gilchrist, II, pp. 102 and 114.

3. Wood, p. 104.

4. Gilchrist, II, p. 96.

5. Farr, p. 86.

6. Wittkower, Rudolf, *Art and Architecture in Italy, 1600 to 1750*, Pelican, History of Art, 1958, p. 232.

7. *Athenaeum*. 11th May 1849.

8. Butler, Martin, and Joll, Evelyn, *The Paintings of J. M. W. Turner*, Yale University Press, 1977, p. 211.

9. *Art Union*, May 1839, Vol. I, pp. 67–71.

10. Farr, p. 86.

11. Porter, Roy, *English Society in the Eighteenth Century*, Penguin Social History of Britain, 1982, p. 341.

12. Leslie Autobiography, Vol. I, p. 200.

13. George, Eric, *Life and Death of Benjamin Robert Haydon*, Oxford University Press, 1948, p. 5.

14. Hendy, Philip, *The National Gallery*, London, Thames and Hudson, 1960, p. 12.

15. *The Farington Diary*, George H. Doran Company, New York, 1924, entry for 19th June, 1803.

16. Porter, *op. cit.*, p. 185.

17. Gilchrist, II, p. . 61.

18. Hutchison, p. 87.

19. *Leslie Autobiography*, Vol. I, p. 128.

20. Select Committee Minutes, 1815–36, I, qq. 166–71.

21. *Ibid.*, I, q. 95.

22. Bell, p. 56.

23. Select Committee 1835–36, Report, p. x.

24. *Ibid.*, p. v.

25. Bell, p. 60.

26. *Yorkshire Gazette*, 16th July, 1825.

27. John Keeble, 1792 to 1868.

28. Cecil Frances Alexander, 1818 to 1895.

Chapter Twelve

1. Quoted by Edgar Trevor Williams, article on "Victoria" in *Encyclopædia Britannica*, 1964 edition, Vol. 23, p. 126(b), no source given.

2. Quoted by A.N. Wilson. *The Victorians*, Hutchinson, 2002, p. 54.

3. Gilchrist, II, p. 63.

4. Wilson, *op. cit.*, p. 57.

5. *Ibid.*, pp. 191–2.

6. Gilchrist, I, p. 32.

7. Letter, William Etty to Thomas Bodley, 27th October 1834.

8. *The Literary Gazette*, 1835, p. 314.

9. *The Times*, 29th January, 1822.

10. *The Times*, 4th February, 1828.

11. *The Times*, 23rd May, 1835.

12. Gilchrist, II, p. 98.

13. *Ibid.*, II, p. 99.

14. Bailey, Brian, *George Hudson: The Rise and Fall of the Railway King*, Alan Sutton Publishing Ltd., 1995, p. 149.

15. Gilchrist, II, p. 216.

16. *Ibid.*

17. Gaunt and Roe, p. 55.

18. Hunt, Holman, *Pre-Raphaelitism and the Pre-Raphaelite Brotherhood*, Macmillan, 1905, Vol. I, p. 95.

19. Farr, p. 110.

20. *Ibid.*

21. Gaunt and Roe, p. 56.

22. Farr, p. 34.

23. Gaunt and Roe, p. 53.

Chapter Thirteen

1. Etty, p. 13.

2. *Ibid.*

3. Young, Vol. II, p. 467.

4. Gilchrist, I, p. 235.

5. *Ibid.*, II, p. 107.

6. *Ibid.*, II, pp. 70–74 *passim*.

7. *Ibid.*, II, p. 107.

8. *Ibid.*, II, pp. 70–74 *passim*.

9. *Ibid.*, II, p. 108

10. Gilchrist, I, pp. 346–7.

11. York Reference Library.

12. Young, II, p. 468.

13. *Ibid.*, II, p. 332.

14. Gilchrist, I, pp. 346–7.

15. *Ibid.*

16. Young, p. 470.

17. *Ibid.*, II, p. 332.

18. Fawcett, p. 11.

19. *Ibid.*

20. *Ibid.*, p. 22 ff.

21. Gilchrist, II, p. 173.

22. *Ibid.*, II, p. 66.

23. *Ibid.*, I, p. 276.

24. Young, I, p. 146.

Chapter Fourteen

1. *The Times*, 6th May 1840.

2. Farr, p. 88.

3. Robertson, David, *Sir Charles Eastlake and the Victorian Art World*, Princeton University Press, 1978, p. 53.

4. Hendy, Philip, *The National Gallery London*, Thames and Hudson, 1960, p. 34.

5. Letter, William Etty to Betsy Etty, 6th July 1841.

6. Farr, p. 179.

7. Bond, Maurice, (ed.), *Works of Art in the House of Lords*, H. M. Stationery Office, 1980, p. 28.

8. Robertson, *op. cit.*, p. 62.

9. Grüner, Lewis, and Jameson, Anna, *The Decoration of the Garden-Pavilion in the Grounds of Buckingham Palace*, 1846.

10. Eastlake, Lady Elizabeth, *Letters and Journals of Lady Eastlake*, London, 1895, Vol. I, pp. 117–118.

11. *The Morning Chronicle*, 8th May 1844.

12. *The Observer*, 26th May 1844.

13. *The Spectator*, 11th May 1844.

14. *The Athenaeum*, 11th May 1844.

15. *Art Journal*, June 1844.

16. Letter, William Etty to Robert Davies, 12th May 1844.

17. Gilchrist, II, p. 170.

18. *Ibid.*, II, p. 171.

19. York Art Gallery Archives.

20. Gilchrist, I, p. 117.

21. *Ibid.*, I, p. 14.

22. York Art Gallery Archives.

23. Gilchrist, II, p. 148.

24. *Ibid.*

25. Letter, William Etty to William Wethered, 8th October, 1844.

Chapter Fifteen

1. Farr, p. 103.

2. Gilchrist, II, p. 158.

3. Letter, William Etty to Walter Etty, 23rd August, 1843.

4. Quoted by Hill, Rosemary, *A.W. Pugin, A Master of Gothic Revival*, p. 31.

5. Gilchrist, II, 219.

6. *Ibid.*, II, p. 223.

7. *Ibid.*, II, p, 228.

8. *Ibid.*

9. Ruskin, John, *Modern Painters*: George Allen, Sunnyside and Orpington, 1898, Vol. II, p. 245.

10. Gilchrist, II, p. 111.

11. *Ibid.*

12. Potter, David E., *The Bells and Bellringers of York Minster*, 1987.

13. *Ibid.*

14. *Dictionary of National Biography.*

15. *Birmingham Daily Post*, 6th January 1872.

16. Redford, George, *Art Sales*, 1888. Vol. I, p. 187.

17. *Ibid.*

18. Farr, p. 99.

19. *Ibid.*

Chapter Sixteen

1. Leslie Autobiography, I, p. 187.

2. Bignamini and Postle, p. 11.

3. *Ibid.*, p. 12.

4. Smith, p. 21.

5. Gilchrist, II, p. 145.

6. Farr, p. 93.

7. Leslie, Peter (ed.), *The Letters of John Constable R.A. to C.R. Leslie, R.A., 1836-1837*, London, 1931, pp. 164–65 (Letter 25th February 1837).

8. Smith, p. 51

9. Gilchrist, II, p. 44.

10. Smith, p. 51.

11. Smith, John, *Nollekens and his Times*, London, 1828, II, pp. 285–86.

12. Mulready, William, "Advice to Models," quoted by Alison Smith, p. 28.

13. Farr, p. 78.

14. Frith, William, *My Autobiography and Reminiscences*, 1903, I. p. 59.

15. Gilchrist, II, p. 206.

16. *Ibid.*, II, p. 207.

17. *Ibid.*

18. Mayoux, p. 172.

19. Leslie Autobiography, I, p. 188.

20. Gilchrist, I, Chapter VIII.

21. Camidge, p. 18.

22. Mayoux, p. 172.

23. *Ibid.*, p. 21.

24. Gilchrist, I, p. 309.

25. Heleniak, pp. 8–13.

26. Camidge, p. 19.

Chapter Seventeen

1. Bell, p. 125.

2. Gilchrist, II, p. 239.

3. Bell, p. 125

4. *Ibid.*

5. Bell, p. 113 in York City Reference Library.

6. Letter 4th April 1845 in the Library of the Victoria and Albert Museum, London.

7. Bell, p. 208.

8. Select Committee 1849, App. II, p. 364 and Bell, p. 126.

9. *Ibid.*

10. Knowles, J.W., The York School of Design, unpub. ms., p. 75 in York City Reference Library.

11. Smith, p. 16.

12. Bell, p. 135 (note).

13. Knowles, *op. cit.*

14. Bell, p. 247.

15. *Art Union Journal*, March 1852, p. 97.

16. *Ibid.*

17. Hunt, Holman, *Pre-Raphaelitism and the Pre-Raphaelite Brotherhood*, London, 1905, p. 93.

18. Gilchrist, II, p. 183.

19. Farr, p. 83.

20. *Ibid.*, p. 100.

21. Gilchrist, II, p. 219.

22. Toynbee, William (ed.), *The Diaries of William Charles Macready, 1823-1851*, 1912, Vol. II, p. 335.

23. Gilchrist, II, p. 233.

24. *Ibid.*

25. Farr, p. 80.

26. Gilchrist, II, p. 233

27. Gilchrist, II, p. 215, also Lindsay, Jack, J. M. W. Turner, Cory, Adams and Mackay, 1960, p. 197.

28. Gilchrist, II, p. 241.

29. *Ibid.*, II, P. 257.

30. *Ibid.*, II, p. 260.

31. *Ibid.*, II, 253.

Chapter Eighteen

1. Macleod, p. 1 quoting P. G. Hamerton, *Thoughts about Art*, London, 1871, p. 239.

2. Thackeray, William Makepeace, Newcomes, II, ch. 36, p. 322.

3. Leslie, C.R., *Constable's Correspondence*, III, Ch. 8, p. 41.

4. Cunningham, Allan. *The Life of David Wilkie.* 1948, I, p. 118.

5. *Ibid.*

6. Steegman, pp. 3–4.

7. *Ibid.*, p. 50.

8. Macleod, p. 18, note 6.

9. *The Works of the Rev. Sydney Smith, 1839* (3rd edition 1845), pp. 184–200, reprinted Penguin, 1973, p. 87.

10. Gilchrist, II, pp. 171/2.

11. *Ibid.*

12. *Ibid.*, II, p. 173.

13. Herrmann, Frank, *The English as Collectors*, Oak Knoll Press/John Murray, 1972, p. 28.

14. Uwins, I, pp. 124–5, Letter 14th January, 1850.

15. *Ibid.*

16. Gilchrist, II, p. 118.

17. *Ibid.*, II, p. 119.

18. *Ibid.*, I, p 233.

19. Farr, p. 73.

20. Gilchrist, II, p. 31.

21. Macleod, p. 394.

22. Gilchrist, I,. p. 100.

23. Fawcett, p. 168.

24. *Ibid.*, p. 137.

25. *Ibid.*, p. 175.

26. *Dictionary of National Biography.*

27. Agnew, Geoffrey, *Agnew's 1817 to 1967*, publ. by Agnew's, 1967, p. 9.

28. *Ibid.*, p. 10.

29. Macleod, p. 93.

30. Gilchrist, II, p. 33.

31. *Ibid.*, II, p. . 66.

32. Macleod, p. 93.

33. Macleod, p. 112.

34. Farr, p. 99.

35. Macleod, p. 123.

36. *Ibid.*, p. 112.

37. Farr, p. 99.

38. Macleod, p. 123.

39. *Ibid.*, p. 124.

40. Gilchrist, II, p. 236.

41. Fawcett, p. 95.

42. *Ibid.*, p. 173.

43. Morris, Edward and Roberts,

Emma, *The Liverpool Academy*, 1865, p. 6.

44. *Ibid.*, p. 13.
45. *Ibid.*, p. 14.
46. Macleod, p. 477.
47. Fawcett, pp. 184–5.
48. *Ibid.*, pp. 74 ff.

Chapter Nineteen

1. Gilchrist, II, p. 254.
2. Etty, p. 40.
3. Bailey, Brian, *George Hudson: The Rise and Fall of the Railway King*, Allen Sutton Publishing Ltd., 1995.
4. Gilchrist, II, p. 283.
5. *Ibid.*, II, p. 273.
6. *Ibid.*, II, p. 278.
7. *The Observer*, 11th June 1949.
8. *The Morning Post*, 11th June 1849.
9. Gilchrist, II, p. 274.
10. *Ibid.*, II, p. 279.
11. *The Art Journal*, June 1849, p. 223.
12. Gilchrist, II, p. 275.
13. Leslie Autobiography, Vol. I, p. 186.
14. Macleod, p. 104.

Chapter Twenty

1. Gilchrist, II, p. 299.
2. *Ibid.*, II, p. 300.
3. *Ibid.*, II, p. 298.
4. *Ibid.*, Subtitle to Chapter XXIX (Vol. II).
5. *Ibid.*, II, p. 301.
6. Farr, p. 32.
7. Letters in York Reference Library Archives.
8. Gilchrist, II, p. 308.
9. Farr, p. 108.
10. Gilchrist, II, p. 308
11. Gilchrist, II, p. 309.

12. *The Art Journal*, December 1949, p. 378.
13. *Penny Illustrated News* (date unknown).
14. Leslie, *op. cit.*, I, p 186.
15. *Ibid.*, I, p. 188.
16. *Ibid.*, I, p. 230.
17. Gilchrist, II, pp. 312/3.
18. *Ibid.*, II, pp. 326/7.
19. *Ibid.*
20. *Ibid.*, II, p. 324.
21. *Ibid.*, II, p. 325.
22. *Ibid.*, II, p. 329.
23. *Ibid.*, II, p. 328.
24. Stone, p. 675.
25. Cobbett, William, *Advice to Young Men*, 1829, pp. 196–7.
26. Uwins, Vol. I, p. 125.
27. *Ibid.*, II, p. 156.
28. *Ibid.*, II, p. 235.
29. Redgraves, p. 284.
30. *Ibid.*, p. 286.
31. *Ibid.*, p. 8.

Chapter Twenty-One

1. Gilchrist, II, p. 59.
2. Smith, p. 82.
3. *Ibid.*, p. 91.
4. *Art Journal*, 1st June 1856.
5. Smith, p. 91.
6. *Illustrated London News*, 18th May 1867.
7. *Ibid.*
8. Farr, p. 69.
9. *York Evening Press*, 21st February 2001.
10. Quoted by Wood, p. 121.
11. *Ibid.*, p. 79.
12. Waterhouse, p. 259.
13. Farr, p. 14.
14. Wood, p. 144.
15. Maas, p. 160.
16. Smith, p. 92.

17. *The Spectator*, 3rd August, 1850.
18. *Art Journal*, June 1867, p. 141.
19. *The Athenaeum*, 4th May 1867, p. 594.
20. Jenkyns, Richard, *Dignity and Decadence: Victorian Art and the Classical Inheritance*, HarperCollins, 1991, p. 116.
21. Smith, Alison, *Exposed*, p. 186.
22. Gaunt and Roe, p. 82.
23. Fedden, Robin, *Anglesey Abbey*, The National Trust Guide, 1997.
24. Gaunt and Roe, p. 15.
25. *Ibid.*, p. 17.
26. *Ibid.*, p. 19.
27. Clark, p. 9.
28. *Ibid.*, p. 141.
29. *Ibid.*, p. 3.
30. Gaunt and Roe, p. 21.
31. *Ibid.*, p. 48.
32. *Ibid.*, p. 36.
33. *Ibid.*, p. 37.
34. *Ibid.*, p. 46.
35. *Ibid.*, p. 81.
36. Farr, p. 110.
37. Smith, p. 89.
38. Boase, T.S.R. *Oxford History of English Art, 1800–1870*, 1959, p. 163.
39. *Ibid.*, p. 166.
40. Mayoux, p. 172.
41. *Ibid.*, p. 173.
42. Smith, *Exposed*, p. 57.
43. Clark, p. 150.
44. Farr, p. 77.
45. Craven, Thomas, *Modern Art*, Simon and Schuster, 1940, p. 229.

Appendix

1. Gilchrist, I, p. 222.
2. Farr, p. 59.
3. Gilchrist, II, p. 175.
4. *Ibid.*, II, p. 201.
5. Macleod, p. 58.

BIBLIOGRAPHY

A.W. *Pugin: Master of Gothic Revival*. Various contributors. Yale University Press,1995.

Agnew, Geoffrey. *Agnew's 1817–1967*. Agnew's, London, 1967.

Allsobrook, David Ian. *Schools for the Shires: The Reform of Middle-Class Education in mid-Victorian England*. Manchester University Press, 1986.

Alston, Rowland. *William Etty, R.A.: A Painter of the Nude*. The Studio, April 1934.

Altick, Richard D. *Paintings from Books, Art and Literature in Britain, 1760–1900*. Ohio State University Press, Columbus, 1985.

Anderson, Gail-Nina, and Wright, Joanne. *The Pursuit of Leisure*. Lund Humphries, London, 1997.

Armstrong, Alan. *Stability and Change in an English County Town: A Social Study of York 1801–51*. Cambridge University Press, 1974.

Ayling, S.E. *The Georgian Century 1714–1837*. George G. Harrap & Co., Ltd., 1966.

Aylmer, G.L., and Cant, Reginald (eds.). *A History of York Minster*. Clarendon Press, 1977.

Bailey, Brian J. *George Hudson: The Rise and Fall of the Railway King*. Alan Sutton Publishing Ltd., Stroud, 1995.

_____. *William Etty's Nudes*. Inglenook Publications, Bedford, 1974.

Barker, Rosalin. *Prisoners of the Tsar: East Coast Sailors Held in Russia, 1800–1801*. Highgate Publications (Beverley) Ltd., 1992.

Barker-Benfield, G.J. *The Culture of Sensibility: Sex and Society in Eighteenth-Century Britain*. University of Chicago Press, 1992.

Barrell, John. *The Political Theory of Painting from Reynolds to Hazlitt*. Yale University Press, New Haven and London, 1986.

Beckett, R.B. *John Constable's Correspondence*. 1965. qtd. in Alison Smith, *Exposed: The Victorian Nude*, Tate Publishing, 2002.

Bell, Quentin. *The Schools of Design*. Routledge and Kegan Paul, London, 1963.

_____. *Victorian Artists*. Academy Editions, London, 1975.

Bennett, Shelley M. *Thomas Stothard: The Mechanisms of Art Patronage in England circa 1800*. University of Missouri Press, Columbia, 1988.

Benson, Edwin. *A History of Education in York 1780–1902*. Unpublished thesis for degree of Doctor of Philosophy in the University of London, October 1932. Deposited in York Reference Library.

Biggins, James M. *Etty and York*. City of York Art Gallery, 1949.

Bignamini, Ilaria, and Allen, Brian. *The Accompaniment to Patronage: A Study of the Origins, Rise and Development of an Institutional System for the Arts in Britain*. Courtauld Institute of Art, 1988. Unpublished manuscript, British Library.

Bignamini, Ilaria, and Postle, Martin. *The Artist's Model: Its Role in British Art from Lely to Etty*. Nottingham, 1991.

Bindman, David (ed.). *John Flaxman*. Thames and Hudson, 1979.

Black, Jeremy. *The Grand Tour in the Eighteenth Century*. Sutton Publishing Ltd., 1999.

Boase, T.S.R. (ed.; various contributors) *Oxford History of English Art, Vol. IX, English Art 1714–1800; Vol. X, English Art 1800–1870*. The Clarendon Press, 1959.

Brand, Vanessa (ed). *The Study of the Past in the Victoria Age*. Oxbow Monograph 73, 1998.

Brewer, John. *The Pleasures of the Imagination, English Culture in the Eighteenth Century*. Farrar, Straus, Giroux, New York. 1997.

Brown, David Blayney. *Sir David Wikie: Drawings and Sketches in the Ashmolean Museum*. Morton, Morris & Co., in association with the Ashmolean Museum, Oxford, 1985.

_____; Woof, Robert, and Hebron, Stephen. *Benjamin Robert Haydon, 1786–1846*. The Wordsworth Trust, 1996.

Brownell, Morris B., *The Prime Minister of Taste: A Portrait of Horace Walpole*. Yale University Press, New Haven and London, 2001.

Burke, Edmund. *A Philosophical Enquiry into the Origin of Our Ideas of the Sublime and the Beautiful*. Originally published 1757.

Burke, Joseph. *English Art 1714–1800*. The Clarendon Press, 1976.

Buttery, Darrell. *The Vanished Buildings of York*. Maxiprint, York (undated).

Cameron, David Kerr. *London's Pleasures from the Restoration to the Regency*. Sutton Publishing, 2001.

Camidge, William. *William Etty, R.A.: The Poet Painter of York*. York, 1899.

Carey, William. *Ridolfi's Critical Letters on the Style of William Etty, Esq., R.A.* Privately published by the author, 1833.

_____. *Some Memoirs of the Patronage and Progress of the Fine Arts in England and Ireland*, London, 1826.

Carr, Geoffrey G. "Who Saved York Walls?" *York Historian*, volume 5. Yorkshire Architectural and York Archaeological Society, 1984.

Carter, Charles. *William Dyce, R.A., 1806–1864*. Thomas Agnew and Sons Ltd., London, 1964.

Catalogue of Etty Exhibition, City of York Art Gallery, 1948.

Catalogue of Loan Exhibition of Paintings by William Etty, R.A., Corporation Art Gallery, York, 1911.

Catalogue of Paintings, Volume II. City of York Art Gallery, 1963.

Catalogue of William Etty R.A., Centenary Exhibition, City of York Art Gallery, 1949.

Catalogue Supplement, City of York Art Gallery, 1974.

Chesterfield, *Letters to His Son by the Earl of Chesterfield*. Oliver H. Leigh (ed.), reprinted by Tudor Publishing Co. New York, undated.

Clark, Kenneth. *The Nude*. John Murray, London, 1956.
_____. *The Romantic Rebellion*. John Murray, London, 1973.

Cook, Dutton. *Art in England*. Sampson Low, Son and Marston, London, 1869.

Cooper, Anthony Ashley, 3rd Earl of Saftesbury. *Characteristicks of Men, Manners, Opinions, Times*. Two volumes, Clarendon Press, Oxford, 1999 (originally published, 1711).

Cornelissen, Julia (compiler). *The Illustrators: The British Art of Illustration 1800–1991*. Chris Beetles Ltd., London, 1991.

Coxhead, A.C. *Thomas Stothard, R.A.* A.H. Bullen, London, 1906.

Cragg, Gerald R. *The Church and the Age of Reason (1648–1789)*. Pelican Books, 1960.

Cunningham, Allan. *The Life of David Wilkie*. Murray, 1948.

Darcy, C. P. *The Encouragement of the Fine Arts in Lancashire, 1760–1860*. Manchester University Press for The Chetham Society, Manchester, 1976.

Davis, Frank. *Victorian Patrons of the Arts*. Country Life Ltd., London, 1963.

D'Hulst, R.A; Poorter, Nora de; Vandenven, Marc et Devisscher, Hans. *Jacob Jordaens*. Koninklijk Museum voor Schone Kunsten, Anvers, 1993.

Dictionary of National Biography. Various entries.

Earle, Peter. *The Making of the English Middle Class*. Methuen, 1989.

Edwards, Ralph, and Ramsey, L.G.G. (eds.). *The Regency Period, 1810–1830*. The Connoisseur, London, 1962.
_____, and _____. *The Early Victorian Period, 1830–1860*. The Connoisseur, London, 1962.

Eitner, Lorenz. *Neoclassicism and Romanticism, 1750–1850: Sources and Documents*. Prentice-Hall International, Inc., London, 1971.

Engen, Rodney K. *Victorian Engravings*. Academy Editions, London,1975.

Etty, William. *Autobiography. The Art Journal*, 1849.

Farington, Joseph (James Greig, ed.). *The Farington Diary*. George H. Doran Company, New York, 1922–25.

Farr, Dennis. *Etty*. Routledge and Kegan Paul Ltd., London, 1958.
_____. Introduction to Catalogue of an Exhibition of Paintings by William Etty. The Arts Council of Great Britain, 1955.

Fawcett, Trevor. *The Rise of English Provincial Art: Artists, Patrons, and Institutions Outside London, 1800–1830*. Clarendon Press, Oxford, 1974.

Fedden, Robin. *Anglesey Abbey*. The National Trust, 1997.

Feinstein, Charles (ed.). *York 1831–1981: 150 Years of Scientific Endeavour and Social Change*. Ebor Press with The British Association for the Advancement of Science, 1981.

Fenton, Roger. *School of Genius: A History of the Royal Academy of Arts*. Royal Academy of Arts, London, 2006.

Folmsbee, Beulah; Latimer, Louise Payson, and Mahony, Bertha A. *Illustrators of Children's Books 1744–1945*. The Horn Book Inc., Boston, 1947.

Ford, Boris (Ed.). *The Cambridge Guide to the Arts in Britain, Volume 5—The Augustan Age; Volume 6—Romantics to Early Victorians: Volume 7—Victorian Britain*. Cambridge University Press, 1990.

Fraser's Magazine. Various dates.

Frazer, Sir James. *The Golden Baugh*. 1890, London. Reprinted Macmillan Ltd., 1922.

Fry, Roger. *Reflections on British Painting*. Faber and Faber Ltd., 1934.

Garlick, Kenneth. *Sir Thomas Lawrence*. Routledge and Kegan Paul, London, 1954.

Gaunt, William. *Court Painting in England from Tudor to Victorian Times*. Constable, 1980.
_____. *The Restless Century: Painting in Britain 1800–1900*. Phaidon Press Ltd., Oxford, 1972.
_____, and Roe, F. Gordon. *Etty and the Nude*. F.Lewis Ltd., Leigh-on-Sea, 1943.

Gentleman's Magazine. Various dates.

George, Eric. *The Life and Death of Benjamin Robert Haydon, 1786–1846*. Oxford University Press, 1948.

Gibson-Wood, Carol. *Jonathan Richardson, Art Theorist of the English Enlightenment*. Yale University Press, 2000.

Gilchrist, Alexander. *Life of William Etty R.A.* Originally published by David Bogue, London, 1855, republished by E.P.Publishing Ltd., Wakefield, 1978.

Gillett, Paula. *The Victorian Painter's World*. Alan Sutton, Gloucester, 1990.

Gloag, John. *Victorian Taste*. David and Charles, Trowbridge, 1962.

Godfrey, Richard T. *Printmaking in Britain*. Phaidon, Oxford, 1978.

Goldman, Paul. *Victorian Illustrated Books 1850–1870*. British Museum Press, London, 1994.

Gower, Lord Ronald Sutherland. *Sir David Wilkie*. George Bell and Sons, 1902.

Great Victorian Pictures. Catalogue of Arts Council Exhibition, 1978.

Greaves, Margaret. *Regency Patron: Sir George Beaumont*. Methuen & Co. Ltd., 1966.

Green, Richard. *William Etty* in *The Dictionary of Art*. London and New York, 1996.

Gunnis, Rupert. *Dictionary of British Sculpture, 1680–1851*. Abbey Library, 1951.

Hadfield, John. *Every Picture Tells a Story: Images of Victorian Life*. The Herbert Press, 1985.

Hammelmann, Hans, edited and completed by Boase, T.S.R. *Book Illustrators in Eighteenth Century England*. Yale University Press, New Haven and London, 1975.

Hardie, Martin. *English Coloured Books*. Kingsmead Reprints, Bath, 1973 (originally published 1906).

Hargrove, William. *History and Description of the Ancient City of York.* W.M. Alexander, York, 1818.

Harrison, J.F.C. *The Early Victorians 1832–1851.* Panther Books Ltd., St. Albans, 1973.

Harvey, A.D. *Sex in Georgian Britain.* Phoenix Press, 2001.

Harvey, J.R. *Victorian Novelists and Their Illustrators.* Sidgwick and Jackson, London, 1970.

Haskell, Francis. *Patrons and Painters, Art and Society in Baroque Italy.* Yale University Press, New Haven, 1980.

Heleniak, Kathryn Moore. *William Mulready.* Yale University Press, 1980.

Herrmann, Frank. *The English as Collectors.* John Murray, London, 1999.

Hibbert, Christopher. *The Grand Tour.* Methuen, London, 1987.

Hogarth, William. *The Analysis of Beauty.* Printed by W. Strahan for Mrs. Hogarth and sold by her at her House in Leicester Fields, London, 1772.

Holme, Charles (ed.). *The Royal Academy from Reynolds to Millais.* "The Studio," London, 1904.

Hunt, W. Holman. *Pre-Raphaelitism and the Pre-Raphaelite Brotherhood.* Macmillan and Co. Ltd. London,1905.

Hutchison, Sidney C. *The History of the Royal Academy 1768–1986.* Chapman and Hall Ltd., London, 1968.

Huyghe, René. *Delacroix.* Thames and Hudson, 1963.

Illustrated London News. Various dates.

Jenkyns, Richard. *Dignity and Decadence: Victorian Art and the Classical Inheritance.* Harper Collins, London, 1991.

Kelly, Gerald. *The First Hundred Years of the Royal Academy, 1769–1868.* Exhibition Catalogue, Royal Academy of Arts, 1951–52.

Kidson, Alex. *Earlier British Paintings in the Lady Lever Art Gallery.* National Museums and Galleries on Merseyside, 1999.

Klingender, Francis D. *Art and the Industrial Revolution.* Augustus M. Kelly, New York, 1968.

Knight, C.B. *A History of the City of York.* Yorkshire Herald, 1944.

Knowles, J.W. *The York School of Design.* Unpublished manuscript in York Reference Library.

Lambourne, Lionel. *Victorian Painting.* Phaidon Press Ltd., 1999.

Laver, James. *The Age of Optimism: Manners and Morals, 1848–1914.* Weidenfeld and Nicolson, London, 1966.

_____. *Victorian Vista.* Hulton Press, London, 1954.

Layard, George Somes. *Sir Thomas Lawrence's Letter-Bag.* George Allen (editor). London, 1906.

Leslie, C.R. *Autobiographical Recollections.* Originally published by John Murray, London, 1860, reprinted by E.P. Publishing Ltd., East Ardsley, Wakefield, 1978.

_____. *Lecture on the Works of the Late W. Etty, Esq., R.A.* The Athenaeum, 30th March 1850.

_____. *Memoirs of the Life of John Constable.* The Phaidon Press, London, 1951.

Leslie, Peter (ed.). *The Letters of John Constable, R.A., to C.R. Leslie, R.A., 1836–1837.* London, 1931.

Lippincott, Louise. *Selling Art in Georgian London: The Rise of Arthur Pound.* Yale University Press, 1983.

Lochhead, Marion. *Elizabeth Rigby, Lady Eastlake.* John Murray, 1961.

London Literary Gazette. Various dates.

Maas, Jeremy. *Victorian Painters.* Barrie & Jenkins, London, 1969.

Macleod, Dianne Sachko. *Art and the Victorian Middle Class.* Cambridge University Press, Cambridge, 1996.

Martineau, Jane (ed.). *Victorian Fairy Painting.* Royal Academy of Arts and Merrell Holberton, London, 1997.

Mayoux, Jean-Jacques (Blunt, Anthony, ed.). *English Painting from Hogarth to the Pre-Raphaelites.* Skira, Geneva, 1972; Macmillan, London, 1975.

Monkhouse, W. Cosmo. *Pictures by William Etty, R.A. with Descriptions and a Biographical Sketch of the Painter.* Virtue, Spalding and Company, Ivy Lane, Paternoster Row, London (undated).

Moorhouse, Geoffrey. *The Pilgrimage of Grace.* Weidenfeld and Nicolson, 2002.

Muir, Percy. *Victorian Illustrated Books.* Praeger Publishers, New York and Washington, 1971.

Murray, Hugh. *Nathaniel Whittock's Bird's Eye View of the City of York in the 1850s.* Friends of the York City Art Gallery, 1988.

_____; Riddick, Sarah, and Green, Richard. *York Through the Eyes of the Artist.* York City Art Gallery, 1990.

Murray, Venetia. *High Society in the Regency Period, 1788–1830.* Penguin Books, 1998.

Newall, Christopher. *The Art of Lord Leighton.* Phaidon Press Ltd., London, 1990.

Newton, Eric. *The Romantic Rebellion.* Longmans, Green & Co., Ltd., London, 1962.

Nuttgens, Patrick. *York,* Studio Vista 1970.

Nuttgens, Patrick (editor; various contributors). *The History of York.* Blackthorn Press, Pickering, 2001.

Ormond, Richard. *Daniel Maclise, 1806–1870.* Arts Council of Great Britain, 1972.

Orr, Clarissa Campbell. *Women in the Victorian Art World.* Manchester University Press, 1995.

Pears, Iain. *The Discovery of Painting: The Gowth of Interest in the Arts in England, 1680–1768.* Yale University Press, 1988.

Phillpotts, Beatrice. *Mermaids.* Russell Ash/Windward, London, 1980.

Pilkington, Matthew. *A General Dictionary of Painters.* William Tegg & Co., London, 1851.

Plumb, J.H. *England in the Eighteenth Century (1714–1815).* Pelican Books, 1950.

_____. *The First Four Georges.* Collins, 1956.

Pointon, Marcia. *Mulready.* Victoria and Albert Museum, London, 1986.

Pollock, Sir Frederick. *Macready's Reminiscenses and Selections from His Diaries and Letters.* Two volumes, 1875, London.

Porter, Roy. *English Society in the Eighteenth Century.* Pelican Books, 1982, revised edition, Penguin Books Ltd., 1991.

Posner, Donald. *Annibale Carracci: A Study in the Reform of Italian Painting Around 1590.* Two volumes, Phaidon, 1971.

Postle, Martin, and Vaughan, William. *The Artist's Model, from Etty to Spencer.* Merrell Holberton, London, 1999.

Potter, David. *The Bells and Bellringers of York.* Friends of York Minster, 1987.

Pressly, William L. *James Barry: The Artist as Hero.* The Tate Gallery. 1983.

Pugh, R. B. (Ed.). *The Victorian History of the Counties of England—A History of Yorkshire—The City of York.* University of London, Institute of Historical Research, 1961.

Redgrave, Richard, and Samuel. *A Century of British Painters.* Phaidon Press Ltd., Oxford, 1947.

Reid, Forest. *Illustrators of the Eighteen Sixties.* Dover Publications, New York, 1975.

Reitlinger, Henry. *From Hogarth to Keene.* Methuen & Co. Ltd., London, 1938.

Reynolds, Graham. *Victorian Painting.* Revised edition. The Herbert Press, London, 1987.

Reynolds, Sir Joshua. *The Literary Works including The Discourses with a Memoir of the Author by Sir Henry William Beechy.* Two volumes. George Bell and Sons, Covent Garden, 1886.

Richardson, Jonathan. *An Essay on the Theory of Painting.* Originally published, 1715, enlarged second edition, 1725, London, facsimile reprinted by Scolar Press, 1971.

Rippingille, E.V. *Personal Recollections of Great Artists—William Etty, R.A.* The Art Journal, 1859.

Robertson, David. *Sir Charles Eastlake and the Victorian Art World.* Princeton University Press, 1978.

Roe, F. Gordon. *William Etty and the Nude.* The Connoisseur, March 1942.

Ruskin, John. *Modern Painters.* Five volumes. George Allen, London. 1898.

Sandby, William. *The History of the Royal Academy of Arts.* Two volumes. Longman, Green, Longman, Roberts and Green, London, 1862.

Seaman, L.C.B. *Life in Victorian London.* Batsford Ltd., London, 1973.

Sessions, William K., and Sessions, Margaret. *Printing in York from the 1490s to the Present Day.* William Sessions Ltd., York, 1976.

Seznec, Jean. *The Survival of the Pagan Gods: The Mythological Tradition and Its Place in Renaissance Humanism and Art.* Princeton University Press, Princeton, 1972 (translated from the French, originally published by the Warburg Institute, London, 1940).

Sigsworth, Eric M. (ed.). *In Search of Victorian Values: Aspects of Nineteenth Century Thought and Society.* Manchester University Press, Manchester and New York, 1988.

Smith, Alison. *The Victorian Nude.* Manchester University Press Manchester, 1996.

_____ (ed.). *Exposed—The Victorian Nude.* Exhibition Catalogue, Tate Publishing, 2002.

Smith, Charles Eastlake (nephew). *Journals and Correspondence of Lady Eastlake.* Two volumes. John Murray, 1895.

Smith, John Thomas. *Nollekens and His Times.* Two volumes. Henry Colburn, London, 1828¹q.

Solkin, David H. *Painting for Money: The Visual Arts and the Public Sphere in Eighteenth Century England.* Published for the Paul Mellon Centre for Studies in British Art by Yale University Press, New Haven and London, 1993.

Steegman, John. *The Rule of Taste.* Macmillan, London, 1936, republished, 1968.

_____. *Victorian Taste: A Study of the Arts and Architecture from 1830 to 1870.* National Trust Classics, 1987 (first published in 1950 as *Consort of Taste*).

Stocker, Margaret. *Judith, Sexual Warrior.* Yale University Press, 1998.

Stone, Lawrence. *The Crisis of the Aristocracy, 1558-1641.* Oxford University Press, 1967.

_____. *The Family, Sex and Marriage in England, 1500-1800.* Weidenfeld and Nicolson, 1979.

Tatlock, R.R., Fry, R., Hobson, R.L., MacQuoid, P., and Grundy, C.R. *The Leverhulme Art Collections.* Three volumes. B.T.Batsford, Ltd., London, 1928.

Taylor, Tom (Ed.). *The Autobiography and Memoirs of B. R. Haydon.* London, 1926.

Thompson, F.M.L. *The Rise of Respectable Society: A Social History of Victorian Britain, 1830-1900.* Fontana Press, 1988.

Thomson, David. *England in the Nineteenth Century (1815-1914).* Pelican Books, 1950.

Treble, Rosemary. (Introduction) Catalogue of Arts Council Exhibition, *Great Victorian Pictures.* Leeds, Leicester, Bristol, London, 1978.

Treuherz, Julian. *Hard Times.* Lund Humphries, London, 1987.

_____. *Victorian Painting.* Thames and Hudson Ltd., London, 1993.

Treheurz, Julian; Stevens, Mary Anne; Valentine, Helen; and Glanville, Helen. *Art in the Age of Queen Victoria.* Royal Academy, London, 1999.

Tromans, Nicolas. *David Wilkie, Painter of Everyday Life.* Dulwich Picture Gallery, 2002.

Turner, Frank M. *The Greek Heritage in Victorian Britain.* Yale University Press, 1981.

Turner, Michael J. *The Age of Unease: Government and Reform in Britain, 1782-1832.* Sutton Publishing, 2000.

Uwins, Sarah. *A Memoir of Thomas Uwins, R.A.* Originally published by Longman and Roberts, London, 1878, reprinted by E.P. Publishing Ltd., Wakefield, 1978.

Vaughan, William. *Romantic Art.* Thames and Hudson Ltd., London, 1978.

Victorian High Renaissance. Various contributors. Minneapolis Institute of Arts and Lund Humphries, London, 1978.

Vidler, Alec R. *The Church in an Age of Revolution (1789 to the Present Day).* Pelican Books, 1961.

Waagen, Gustav. *Works of Art and Artists in England.* Three volumes. Originally published, 1838 reprinted by Cornmarket Press Ltd.,1970.

Walpole, Horace. *Anecdotes of Painting in England, 1798.* Edited by Wornum, Ralph N. 1849.

Wardroper, John. *Kings, Lords and Wicked Libellers: Satire and Protest 1760-1837.* John Murray, London, 1973.

Waterhouse, Ellis. *The Dictionary of British 18th Century Painters.* Antique Collectors' Club, 1981.

Watson, J. Steven. *The Reign of George III (Oxford History of England,* Volume 12). Oxford University Press, 1960.

Webb, Gerry. *Fairfax of York.* Maxiprint, 2001.

Weiner, Martin J. *English Culture and the Decline of the Industrial Spirit, 1850-1980.* Penguin Books, 1985.

Weinreb, Ben, and Hibbert, Christopher (eds.). *The London Encyclopaedia.* Macmillan, London, 1983.

Westerfield, Ray. *Middlemen in English Business 1660-1760.* 1915, reprinted New York, 1968.

Whinney, Margaret, and Millar, Oliver. *English Art 1624-1714.* Oxford History of Art. Clarendon Press, 1957.

White, Christopher. *Peter Paul Rubens.* Yale University Press, 1987.

Williams, Basil. *The Whig Supremacy, 1714-1760 (Oxford History of England,* Volume 11). Oxford University Press, 1961.

Wilton, Andrew, and Bignamini, Ilaria. *The Grand Tour: The Lure of Italy in the Eighteenth Century.* Tate Gallery Publishing, London, 1996.

Wollstonecraft, Mary. *A Vindication of the Rights of Woman.* First published, 1791. Published by Penguin Classics, 1992.

Wood, Anthony. *Nineteenth Century Britain, 1815–1914.* Longmans, 1960.

Wood, Christopher. *Dictionary of Victorian Painters.* Antique Collectors' Club, 1971.

_____. *Fairies in Victorian Art.* Antique Collectors' Club, 2000.

Woodward, Sir Llewellyn. *The Age of Reform. 1815–1870* (*Oxford History of England*, Volume 13). Oxford University Press, 1962 .

Wornum, Ralph A. (Ed.). *Lectures on Painting by the Royal Academicians, Barry, Opie, and Fuseli.* Henry G. Bohn, Covent Garden, London, 1848.

Wright, Christopher. *Poussin-Paintings: A Catalogue Raisonné.* Hippocrene Books, New York, 1985.

York Historic Buildings in the Central Area. Royal Commission on Historical Monuments, H.M.S.O., 1981.

Young, G.M. (ed.). *Early Victorian England, 1830–1865.* Two volumes. Oxford University Press, London, 1934.

INDEX

ND
497
E8
R6
2007

Robinson, Leonard,
 1916-

William Etty.

$125.00

DATE		

WITHDRAWN

Library & Media Ctr.
Carroll Community College
1601 Washington Rd.
Westminster, MD 21157

WITHDRAWN

JAN 1 5 2007

BAKER & TAYLOR